«...gemäß den Regeln und
Gesetzen der Ästhetik und
der christlichen Kunst...»

PUBLICATIONS DU VITROCENTRE ROMONT
2014

Eva-Maria Scheiwiller-Lorber

«...gemäß den Regeln und Gesetzen der Ästhetik und der christlichen Kunst...»

Johann Jakob Röttinger:
Ein Glasmalerpionier im Dienste des Historismus

Herausgegeben von Brigitte Kurmann-Schwarz
und Stefan Trümpler, Vitrocentre Romont

PETER LANG
Bern · Berlin · Bruxelles · Frankfurt am Main · New York · Oxford · Wien

Bibliografische Information der Deutschen Nationalbibliothek
Die Deutsche Nationalbibliothek verzeichnet diese Publikation in der Deutschen
Nationalbibliografie; detaillierte bibliografische Daten sind im Internet über
‹http://dnb.d-nb.de› abrufbar.

Die vorliegende Arbeit wurde von der Philosophischen Fakultät der Universität Zürich im Herbst-
semester 2012 auf Antrag der Promotionskommission, Prof. Dr. Brigitte Kurmann-Schwarz [als
hauptverantwortliche Betreuungsperson], Prof. Dr. Tristan Weddigen [Zweitgutachter], als Disserta-
tion angenommen.

Sie entstand im Rahmen eines Forschungsprojekts des VITROCENTRE ROMONT mit dem
Titel *Schweizer Glasmalereien vom Historismus zum Jugendstil. Der Nachlass der Zürcher
Werkstatt Röttinger als Quelle neuer Forschungen,* das in Zusammenarbeit mit dem Kunst-
historischen Institut der Universität Zürich (zwei Dissertationen) sowie der kantonalen und der
städtischen Denkmalpflege Zürich durchgeführt wurde. Beiträge des Schweizerischen National-
fonds zur Förderung der wissenschaftlichen Forschung, der Denkmalpflegeämter des Kantons
und der Stadt Zürich sowie des VITROCENTRE ROMONT ermöglichten die Finanzierung
des Projekts.

Publiziert mit Unterstützung des Schweizerischen Nationalfonds zur Förderung der
wissenschaftlichen Forschung.

Unterstützt durch die Schweizerische Akademie
der Geistes- und Sozialwissenschaften
www.sagw.ch

Titelbild: Johann Jakob Röttinger, Bergpredigt, Chorfenster I, Oberentfelden, 1866
(©Vitrocentre Romont, Foto Hans Fischer)

Umschlaggestaltung: Thomas Jaberg, Peter Lang AG

ISBN 978-3-0343-1518-0

© Peter Lang AG, Internationaler Verlag der Wissenschaften, Bern 2014
Hochfeldstrasse 32, CH-3012 Bern, Schweiz
info@peterlang.com, www.peterlang.com

Printed in Hungary

Inhaltsverzeichnis

Vorwort der Herausgeber

Das 19. Jahrhundert darf als die große Epoche der Wiedererweckung der monumentalen Glasmalerei in der europäischen Kunstgeschichte nach ihrem fast gänzlichen Verschwinden im Zeitalter des Barocks gelten. Obwohl diese Bedeutung der Gasmalerei des Historismus längst erkannt wurde, sind bisher in der Schweiz lediglich die erhaltenen Werke der Stadt Basel systematisch erforscht. Die vorliegende Studie befasst sich mit der künstlerischen Produktion der Jahrzehnte zwischen 1840 und 1880 im allgemeinen und dem Werk Johann Jakob Röttingers (1817–1877), des Gründers einer der ältesten in der Schweiz tätigen Glasmalerei-Werkstätten dieser Zeit, im besonderen. Der Glasmaler ist 1844 von Nürnberg nach Zürich eingewandert und arbeitete, bevor er 1848 seine eigene Werkstatt eröffnete, zunächst im Atelier des ebenfalls aus Nürnberg stammenden Email- und Glasmalers Johann Andreas Hirnschrot. Er begründete damit eine familiäre Tradition, die über mehrere Generationen bis ins 20. Jahrhundert weitergeführt wurde. Es erweist sich als großer Glücksfall, dass die Nachkommen des Glasmalers das Firmenarchiv der Vorfahren aufbewahrten.

Basierend auf dem reichen Quellenbestand des Archivs Röttinger hat die Autorin grundlegend neue Erkenntnisse zum Künstler und seinem Werk erarbeitet und diese in ihrer Zeit und in der vorhandenen Forschung zur Kunst des 19. Jahrhunderts des süddeutsch-schweizerischen Raums verortet. Die Verfasserin hat erstmals klar die Voraussetzungen des glasmalerischen Werks von Röttinger aufzeigen können und grundsätzliche Überlegungen zur Ausbildung von Glasmalern in der ersten Hälfte des 19. Jahrhunderts vorgelegt. Die Lehrjahre in Nürnberg, die lebenslange Rezeption von Nürnberger Vorbildern und die Beziehung zur Münchener Glasmalerei formten den persönlichen Stil des Glasmalers. Durch die eingehende Untersuchung ikonographischer Aspekte des Werkes und den Nachweis eines Anknüpfens Röttingers an die in seiner Zeit propagierten «Regeln der christlichen Kunst» erarbeitete die Autorin Resultate, die weit über die engen Grenzen der Künstlermonographie hinausweisen. Von besonderer Aktualität sind die Überlegungen der Autorin zur gesellschaftlichen und geschäftlichen Integration eines Künstlers mit Migrationshintergrund in der Stadt Zürich des mittleren 19. Jahrhunderts. Es gelang ihm, unter den Vertretern der sich an den Hochschulen Zürichs als Disziplin etablierenden Kunstgeschichte sowie der noch jungen Denkmalpflege und der traditionellen antiquarischen Wissenschaften ein herausragendes Beziehungsnetz aufzubauen und sich gesellschaftlich einen Platz im gehobenen Mittelstand zu schaffen. Diese Beziehungen, die integrative Persönlichkeit des Künstlers und der Aufschwung der Sakralbaukunst nach 1848 bildeten die Grundlagen seines Erfolges.

Die schon bald einsetzende negative Rezeption des Werkes von Röttinger hatte unterschiedliche Gründe. Nach 1850 begann die Vorstellung von religiöser Kunst zu stagnieren, was zur Folge hatte, dass das Publikum, die Auftraggeber und damit

auch die vom geschäftlichen Erfolg abhängigen Künstler die nazarenischen Vorstellungen des Sakralen bis in die ersten Jahrzehnte des 20. Jahrhundert tradierten. Um 1900 setzte eine intensive Forschung zur mittelalterlichen und frühneuzeitlichen Glasmalerei ein, so dass Künstler, Auftraggeber und Publikum eine bessere Vorstellung von der Geschichte dieses Mediums erlangten und die zeitgenössischen Werke an denjenigen der Vergangenheit zu messen begannen. Die Kritik an den einst hochgelobten Chorfenstern des Zürcher Großmünsters erweist sich als exemplarisch für die Haltung gegenüber den Glasmalereien des 19. Jahrhunderts. Mit harschen Formulierungen wurden sie abgelehnt und durch eine moderne Verglasung ersetzt. Dennoch ist der Verfasserin zuzustimmen, dass gerade diese Werke wie keine anderen die Funktion einer *vitrine d'une société*, als gläserne Bilder einer Gesellschaft, funktionieren. Mit ihrer Studie gelang es Eva-Maria Scheiwiller-Lorber hervorragend, ein Stück Zürcher Kunstgeschichte in einen schweizweiten und länderübergreifenden Kontext sowie einen umfassenden kunsthistorischen und kulturwissenschaftlichen Diskurs einzuordnen.

Die Autorin erarbeitete die Studie im Rahmen eines Forschungsprojekts des VITROCENTRE ROMONT, dem in einer ersten Phase die Inventarisierung und Auswertung des Nachlasses der Glasmalereiwerkstatt Röttinger zugrunde gelegt wurde. Durch die kunstwissenschaftliche und konservatorische Auseinandersetzung mit der Glasmalerei des 19. und frühen 20. Jahrhunderts hatte es sich gezeigt, wie lückenhaft die Quellenlage zu den Entstehungsumständen dieser Werke bereits geworden ist. Umso größere Bedeutung, sowohl für die Schweiz als auch im internationalen Raum, muss den wenigen Hinterlassenschaften von Werkstätten und Künstlern beigemessen werden, unter denen das Archiv Röttinger durch seine Vollständigkeit hervorsticht. Teilweise vergleichbar ist in der Schweiz einzig der in Romont aufbewahrte Nachlass der Freiburger Werkstatt Kirsch und Fleckner, der jedoch nur die Bilddokumente enthält (Entwürfe und Kartons für

Glasgemälde). Deshalb war es das Anliegen des Forschungsvorhabens, den Nachlass in seiner ganzen Breite zu inventarisieren und auf dieser Basis vertiefte Untersuchungen durchzuführen. Das vollständige Inventar und die Bilddokumentation sind nunmehr über die wissenschaftlichen Datenbanken des Vitrocentre erschlossen. Drei auswertende Studien gingen aus dem Projekt hervor: die vorliegende Arbeit über die erste Zeit der Werkstatt unter dessen Gründer Johann Jakob Röttinger, eine zweite Dissertation von Eva Zangger Hausherr ‹Zur Erwirkung des einheitlichen harmonischen Ergusses›. *Von der Idee zur Glasmalerei: Studien zum Werk von Jakob Georg Röttinger* über die zweite Phase ab 1887 unter dessen Sohn Jakob Georg, sowie eine Studie von Fabienne Hoffmann mit dem Titel *L'atelier Röttinger en Suisse romande: une entreprise pionnière pour le renouveau du vitrail au XIXᵉ siècle.* Es ist vorgesehen, die beiden letzteren Untersuchungen in dieser Reihe folgen zu lassen.

Die Übergabe des Firmenarchivs an die Zentralbibliothek Zürich hat die Durchführung des Projekts immens gefördert. Die Herausgeber sind dem großzügigen Schenker Dr. Rudolf H. Röttinger für seine Offenheit gegenüber den Forschungen großen Dank schuldig. Die städtische und kantonale Denkmalpflege finanzierten die Vorarbeiten zum Projekt, die es erlaubten, den Nachlass zu inventarisieren. Den beiden Institutionen sei für ihre großzügige Unterstützung gedankt, ebenso der Zentralbibliothek Zürich, die allen am Projekt Beteiligten uneingeschränkt offen stand, und dem Kunsthistorischen Institut der Universität Zürich, das die Studie von Eva-Maria Scheiwiller-Lorber als Dissertation angenommen hat. Die Herausgeber danken dem Schweizerischen Nationalfonds zur Förderung der wissenschaftlichen Forschung für die großzügige finanzielle Unterstützung der Forschungen über die Glasmalereien der Werkstatt Röttinger und für den Beitrag an die Druckkosten der Studie zu Leben und Werk Johann Jakob Röttingers. Die Publikation wurde außerdem von der Schweizerischen Akademie der Geistes- und Sozialwissenschaften mit einem namhaften Beitrag gefördert. Es sei besonders dem Generalsekretär,

Herrn Dr. Markus Zürcher, für sein Interesse an den Belangen der Glasmalereiforschung bestens gedankt. Den Mitgliedern der begleitenden wissenschaftlichen Kommission des Forschungsprojekts Röttinger, Peter Baumgartner, Urs Baur, Christoph Eggenberger, Jochen Hesse, Barbara von Orelli-Messerli und Elgin van Treeck-Vaassen, sind die Herausgeber der vorliegenden Studie sehr verbunden. Allen, die das Projekt gefördert, und es ermöglicht haben, dass die ersten Früchte des forscherischen Bemühens im Rahmen des Nationalfondsprojektes in der Reihe des Vitrocentre Romont erscheinen können, sei unser verbindlichster Dank ausgedrückt.

Brigitte Kurmann-Schwarz
Stefan Trümpler

Vorwort und Dank

Das Interesse an den Glasmalereien aus dem Zürcher Atelier der Röttinger erwachte, als in der Turmkammer der reformierten Pfarrkirche von Pieterlen BE zwei ehemalige, verschollen geglaubte Chorfenster des Glasmalers Johann Jakob Röttinger zum Vorschein kamen, die in der Zwischenzeit restauriert und im Jahr 2002 wieder in den Chor der Kirche eingesetzt wurden. Das gut erhaltene Firmenarchiv aus dem über hundertjährigen Bestand des Ateliers versprach Licht in die noch lückenhaft erforschte Epoche der Schweizer Glasmalerei des 19. und frühen 20. Jahrhunderts zu bringen. Dr. Rudolf H. Röttinger, der Urenkel des Werkstattgründers, ermöglichte den Zugang zum Archiv in der ehemaligen Glasmalerwerkstatt an der Oetenbachgasse und leitete damit den Beginn einer regen Forschungstätigkeit in Kooperation mit dem Kunsthistorischen Institut der Universität Zürich und dem Vitrocentre Romont, des Schweizerischen Forschungszentrums für Glasmalerei und Glaskunst, ein. Mit der Schenkung des von der Familie Röttinger bewahrten Archivs an die Zentralbibliothek förderte er weitere Forschungsvorhaben, wofür ihm an dieser Stelle herzlich gedankt sei.

Die vorliegende Arbeit ist das Ergebnis meiner drei Jahre während wissenschaftlichen Mitarbeit im Projekt «*Schweizer Glasmalerei vom Historismus zum Jugendstil. Der Nachlass der Zürcher Werkstatt Röttinger als Quelle neuer Forschungen*», mit dem Ziel die Glasmalereiforschung des 19. Jahrhunderts in der Schweiz weiter zu verdichten. Nach einer langen Zeit der Geringschätzung der Glasmalerei des 19. Jahrhunderts hat deren wissenschaftliche Bearbeitung in den letzten Jahrzehnten den geschuldeten Impetus erfahren und dementsprechend zur Wertschätzung der überkommenen Kunsterzeugnisse beigetragen.

Im ersten Teil der monographischen Darstellung werden Herkunft und Ausbildung des Glasmalers in Nürnberg, die Auswanderung in die Schweiz sowie die Gründung von Werkstatt und Familie thematisiert, um in weiterer Folge auf die künstlerische Entwicklung, die stilbildenden historischen und zeitgenössischen Vorbilder, die Art der Bildkomposition sowie die bevorzugte Ikonographie vor dem Hintergrund der ökonomisch bedingten Anpassung an die Wünsche der Auftraggeber einzugehen. Das öffentliche und private Leben des immigrierten Künstlers, zugleich Hausvater, Arbeitgeber und Geschäftsmann, respektive die Rolle seiner Ehefrau als Vorstehende des großen Geschäftshaushalts im gehobenen Mittelstand interessieren ebenso wie Fragen der Werkstattorganisation und die Stellung des Ateliers als Lehrstätte für bekannt gewordene Glasmaler der Folgegeneration. Dem für die damalige Zeit enormen administrativen Aufwand, der Beschaffung des Materials aus dem In- und Ausland sowie den technischen Eigenheiten der Glasmalerei des 19. Jahrhunderts wird genauso Platz eingeräumt wie den Restaurierungen bedeutender mittelalterlicher Glasmalereien in Schweizer Kirchen. In Ermangelung einer Akzeptanz der Glasmalereien des 19. Jahrhunderts als schützenswerte Kunstwerke bis in die Sechzigerjahre des letzten

13

Jahrhunderts erhielten die Glasmaler dank der Ausübung von Restaurierungsarbeiten erst ihre Identität und weckten damit die Aufmerksamkeit der Glasmalereiforschung. Der letzte Teil der Arbeit umfasst die Stellung des glasmalerischen Werks Johann Jakob Röttingers innerhalb der zeitgenössischen Malerei vor dem Kontext der historischen Gegebenheiten in einer Ära der Revolutionen, Bildung von Nationalstaaten, religiösen Konflikten und philosophischen Umwälzungen und beleuchtet die Bedeutung des Kulturtransfers.

Die vielschichtige Forschungsarbeit inklusive der erforderlichen Recherchen erfuhr durch zahlreiche Personen Unterstützung. Zuallererst sei den beiden Projektleitern gedankt, unter deren Ägide der Antrag an den Schweizer Nationalfonds erfolgreich eingereicht und die Finanzierung des Vorhabens sichergestellt werden konnte. Brigitte Kurmann-Schwarz, die meine Dissertation wissenschaftlich begleitete, förderte die Forschungsarbeit impulsgebend dank konstruktiver Anregungen, Fachgesprächen und regelmäßiger ermunternder Feedbacks. Dem administrativen Leiter des Projekts, Stefan Trümpler, Direktor des Vitrocentre Romont, schulde ich Dank für den sachkundigen Beistand anlässlich fotografischer und beschreibender Dokumentationen eingelagerter Glasmalereien und für die praktische und theoretische Unterweisung im direkten Umgang mit den fragilen Artefakten.

Sowohl die Denkmalpflege des Kantons Zürich, vertreten durch Peter Baumgartner, als auch die Denkmalpflege der Stadt Zürich, vertreten durch Urs Baur, dem Leiter der praktischen Denkmalpflege, unterstützten das Projekt maßgeblich, indem sie von Dezember 2008 bis Juni 2009 die vorbereitenden Arbeiten, die Integration des Firmenarchivs in die Sammlungen der Zentralbibliothek und dessen Dokumentation durch die beiden Doktorandinnen, finanzierten und eine fotografische Erfassung des Glasmalereidepots in Andelfingen ZH übernahmen. Darüber hinaus brachten die beiden Denkmalpfleger ihre praktischen Erfahrungen im Gremium des wissenschaftlichen Beirates ein. Elgin van Treeck-Vaassen, ebenfalls Mitglied dieses Forums, danke ich besonders für die unkomplizierte Beantwortung meiner vielen Fragen und den aus ihren fundierten Kenntnissen und der langjährigen Praxis in der Glasmalereiforschung des 19. Jahrhunderts genährten wissenschaftlichen Austausch. Peter van Treeck gewährte mir einen Einblick in die Restaurierungsarbeit seiner Münchner Werkstatt, der Bayerischen Hofglasmalerei Gustav van Treeck, wo Glasmalereien von Franz Joseph Sauterleute, dem Lehrmeister Johann Jakob Röttingers, zur Anschauung standen. Die beiden Leiter der Spezialsammlungen der Zentralbibliothek Zürich, Christoph Eggenberger, Handschriftenabteilung, und Jochen Hesse, Graphische Sammlung, stellten jederzeit die zur Recherche und Dokumentation notwendige Infrastruktur ihrer Abteilungen zur Verfügung (Buchbinderei, Papierrestaurierung, Digitalisierungszentrum), während die Mitarbeiterinnen der Graphischen Sammlung, Tatjana Poppoff, Alice Robinson, Barbara Dieterich und Anikó Ladányi auch außerhalb der offiziellen Lesesaal-Öffnungszeiten Einlass zur Konsultation des Archivs gewährten. Barbara von Orelli-Messerli brachte als Mitglied des wissenschaftlichen Beirats Erkenntnisse aus ihren Forschungen bezüglich der Kunst und der angewandten Kunst des 19. Jahrhunderts ein. Fritz Dold, Glasmaler in Zürich, unterstützte die Fotodokumentation in Andelfingen und stellte fotografische Aufnahmen aus seinem Fundus zur Verfügung. Fotomaterial erhielt ich auch von Stefan Mathies, Kunstglaser in Sankt Gallen; ihm bin ich für die Bereitstellung und den Transport von Anschauungsmaterial sowie Glasmaler-Werkzeug anlässlich meines Vortrags im Liechtensteinischen Landesmuseum Vaduz zu Dank verpflichtet. Für die Publikation erstellte der Fotograf Hans Fischer einen Teil der Abbildungen neu und bearbeitete vorhandene Fotografien. Für seine professionelle Arbeit und zeitliche Flexibilität bin ich ihm sehr verbunden. Darüber hinaus gebührt meiner Lektorin, Katrin Miglar, für die beharrliche Korrekturarbeit ein herzlicher Dank sowie meiner Familie, nicht nur

für den moralischen Beistand, sondern meinem Sohn Thomas auch für Korrektur und Vereinheitlichung der Literaturliste und speziell meinem Mann, Raphael Scheiwiller, für seine Unterstützung in Fragen der Informatik, der formalen Textgestaltung, des Layouts der Abbildungen, der Bildmontagen und Verzeichnisse. Den hier genannten sowie unzähligen weiteren Personen in Pfarrämtern, Archiven, Institutionen, dem Team des Vitrocentre und allen, die diese Arbeit auf irgendeine Art und Weise unterstützt haben, sei mein Dank ausgesprochen.

Eva-Maria Scheiwiller-Lorber

Hinweise

Nummerierung der Fenster und Felder nach «Corpus Vitrearum»

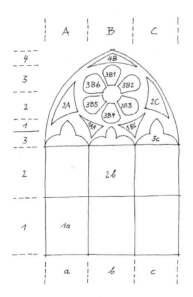

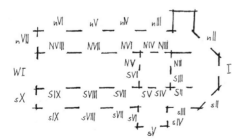

Fig. 1. Fensterskizze: S. Trümpler, aus: Dokumentation von Glasmalerei-Restaurierungen (2005).

Die Nummerierung der Fenster und der einzelnen Felder innerhalb der Fenster wurde nach den Richtlinien des vom Internationalen Corpus Vitrearum vorgeschriebenen Systems vorgenommen. Das axiale Chorfenster erhält jeweils die Bezeichnung I (die römische Zahl Eins) und steht am Beginn der fortlaufenden Zählung auf der Nord- und Südseite (n II, s II) der Kirche in Richtung Westen. Die westseitigen Fenster werden mit w (w I, nw II, sw II), Obergadenfenster mit Großbuchstaben (N II, S II, W I) angegeben.

Maßangaben in den Quellen

Zeichenerklärung:

' = Fuß, '' = Zoll und ''' = Linien.

Als Faustregel kann gelten:

Fuß = 30 cm, Zoll = 3 cm, Linie = 3 mm.

Zitate

Quellenzitate aus dem Nachlass und andere, die Johann Jakob Röttinger betreffen, werden kursiv hervorgehoben.

Katalog

Die auf dem Gebiet der Deutschschweiz erhaltenen Glasmalereien Johann Jakob Röttingers sind tabellarisch zusammengefasst und alphabetisch nach den Ortschaften ihres Vorkommens geordnet. Ikonographie, Maße und Verweise auf die Quellen sind weitere Parameter des Kurzkatalogs, der im Schlussteil der Arbeit zu finden ist.

Abkürzungen

AGZ	Antiquarische Gesellschaft Zürich
APAS	Association pour la promotion de l'art sacré
BA	Bürgerarchiv
BHStA	Bayerisches Hauptstaatsarchiv
CVMA	Corpus Vitrearum Medii Aevi
DBA	Deutsches Biographisches Archiv, Erfurt
EPHE Paris	École Pratique des Hautes Études
FZA HFS	Fürst Thurn und Taxis Hofbibliothek und Zentralarchiv, Regensburg
GA	Gemeindearchiv
GASZ	Gemeindearchiv Schwyz
GDKE	Generaldirektion kulturelles Erbe Rheinland-Pfalz
GHA	Geheimes Hausarchiv
GNM	Germanisches Nationalmuseum, Nürnberg
GSK	Gesellschaft für Schweizerische Kunstgeschichte
Ha	Haus- und Familiensachen
HLS (DHS/DSS)	Historisches Lexikon der Schweiz
KBA	Kirchbauarchiv
KDM	Kunstdenkmäler der Schweiz
KGA	Kirchgemeindearchiv
KiA	Kirchenarchiv
LA	Landesarchiv
LCI	Lexikon der christlichen Ikonographie
LDK	Lexikon der Kunst
LEXMA	Lexikon des Mittelalters
LThK	Lexikon für Theologie und Kirche
NZZ	Neue Zürcher Zeitung
OCK	Organ für christliche Kunst
ÖZKD	Österreichische Zeitung für Kunst und Denkmalpflege
PA (PFA)	Pfarrarchiv
Ref. DB	Referenz auf Inventar Datenbank, Vitrocentre, Romont
SA Nürnberg	Stadtarchiv Nürnberg
SIK	Schweizer Institut für Kunstgeschichte
SNM (LM)	Schweizerisches Nationalmuseum (alte Bezeichnung: Landesmuseum), Zürich
SMM	Stadt- und Münstermuseum, Basel
StA N	Staatsarchiv Nürnberg
StAAG	Staatsarchiv Aargau
StABS	Staatsarchiv Basel
StadtA …	Stadtarchive der Schweiz
StASZ	Staatsarchiv Schwyz
StAZH	Staatsarchiv Zürich
StdA München	Stadtarchiv München
TT	Thurn und Taxis
ZB	Zentralbibliothek Zürich

Einleitung

Das frühe 19. Jahrhundert gilt als Epoche der Wiederentdeckung der monumentalen Glasmalerei, nachdem sich im Barock und Klassizismus der Bedarf an bemalten Glasfenstern nicht nur stark reduziert hatte, sondern völlig in Vergessenheit zu geraten drohte[1]. Johann Jakob Röttinger (*1817 in Nürnberg, †1877 in Zürich), der sich im Stil der Spätnazarener vor allem der sakralen Glasmalerei widmete, galt als einer der frühen Vertreter seines Metiers, die durch ideenreiches Handeln und Experimentieren die Qualität der wieder aufgenommenen Glasmalerei verbesserten und die Wertschätzung für die gänzlich aus der Mode gekommene Kunstrichtung wieder aufleben ließen. Als künstlerisch ausgebildeter Porzellan- und Glasmaler trat Röttinger 1844 in die Zürcher Werkstatt des ebenfalls aus Nürnberg eingewanderten Email- und Glasmalers Johann Andreas Hirnschrot (1799–1845) ein und etablierte sich nach dessen frühem Tod als selbstständiger Glasmaler. Wie auch anderenorts haben sich die Glasmalereien aus der Zeit von 1840–1870 im Vergleich zu späteren Artefakten weit seltener erhalten[2]. Dennoch finden sich in den Kirchen neben vergleichsweise einfachen Damastfenstern mit standardisierten Medaillons kunstreich gestaltete Figurenfenster und szenische Darstellungen sowie Wappenscheiben. Obwohl sich in profanen Gebäuden lediglich *ein* Wappenzyklus in der Ratsstube zu Rapperswil SG erhalten konnte, lassen zahlreiche schriftliche Hinweise in der Buchhaltung auf eine große Anzahl ausgeführter, nicht mehr erhaltener Dessinscheiben in Privathäusern,

Geschäften und öffentlichen Bauten schließen[3]. Während Johann Jakob Röttingers Anerkennung als Lehrmeister die Zürcher Werkstatt zur Ausbildungsstätte bedeutender Glasmaler qualifizierte, machten ihn seine Zeichnungen mittelalterlicher Glasmalereien in Schweizer Kirchen zum Inventarisator wichtiger Kulturgüter und zum Famulus auf dem noch jungen Gebiet der Kunstgeschichte und Denkmalpflege. Aufgrund mangelnder Überlieferung an Skizzen und Kartons konzentriert sich die vorliegende Forschungsarbeit auf die Bearbeitung des schriftlichen Nachlasses in Korrelation mit der Erfassung der in der Deutschschweiz überkommenen Glasmalereien[4]. Dabei besteht jedoch keinerlei Anspruch auf eine umfassende Werkschau, sondern es wird versucht sich mit ausgewählten Beispielen rezenten kunsthistorischen und kulturgeschichtlichen Fragestellungen anzunähern. Das Hauptaugenmerk liegt auf dem schöpferischen Teil des Œuvres. Wenngleich Röttingers Arbeit als Restaurator ein Kapitel gewidmet wird, beschränkt sich dessen Erörterung ausschließlich auf die im Nachlass tradierten Quellen

1 FROMBERG, 1844, S. VII.
2 KLAUKE, 2009, S. 91.
3 Weitere Wappenscheiben stammen aus sakralen Gebäuden.
4 Das in der Suisse Romande überkommene Werk der Röttinger – des Vaters Johann Jakob und des Sohnes Jakob Georg – wird von der frankophonen Wissenschaftlerin Fabienne Hoffmann im Sinne einer Spezialisierung bearbeitet, auch um der Mehrsprachigkeit des schweizerischen Forschungsumfeldes Rechnung zu tragen. Eva Zangger Hausherr verfasst im Rahmen des Projekts ihre Dissertation über Jakob Georg Röttinger.

und Bestandsaufnahmen aus dem Vitrocentre, die Forschungsergebnisse der damit befassten Autoren einbeziehend.

Forschungsstand und Quellen

Forschungsstand

Eine Zerstörungswelle großen Ausmaßes rollte nach dem Zweiten Weltkrieg über die Glasmalereien des 19. Jahrhunderts und des Jugendstils hinweg. Die Kritiker klassifizierten die Glasmalereien als industrielle Erzeugnisse oder taten sie wegen ihrer intensiven Farbgebung gar als qualitativ minderwertigen Kitsch ab. Die Glasmaler des 19. Jahrhunderts, denen auch ein hohes Maß an Eklektizismus nachgesagt wird[5], schufen nicht nur Neuanfertigungen, sondern wirkten auch als Restauratoren mittelalterlicher Glasmalereien. Dies war schließlich der Grund, warum die Mitarbeiter des Corpus Vitrearum Medii Aevi[6] auf die Glasmaler dieser jüngeren Epoche aufmerksam wurden und erkannten, dass zwischen der Vervollständigung von Scheibenfragmenten aus dem Mittelalter und der Neuschöpfung von Glasmalereien enge Verbindungen bestanden. So stellte Johann Rudolf Rahn, der Begründer der Schweizer Denkmalpflege, in der ehemaligen Klosterkirche zu Königsfelden bereits im Jahre 1897 fest, dass keines der alten Glasgemälde «frei von fremden Einschiebseln» geblieben ist[7]. In Frankreich begann man bereits in den Siebzigerjahren des letzten Jahrhunderts mit der Aufarbeitung der Glasmalereien nach 1800, worauf einige Aufsätze in der Revue de l'Art 1986[8] über Ikonographie, Auftraggeber, Werkstätten, der Beziehung zwischen Architektur und Glasmalerei mit Bezug auf das 19. Jahrhundert sowie ein Kurzinventar folgten. Laurence de Finance fasste die Glasmalerei der Region um Paris zwischen 1830 und 2000 in einem Band[9] zusammen und Jean-François Luneau erarbeitete eine Monographie über die Werkstatt von Félix Gaudin, 1851–1930[10];

Forschungen, auf denen Elisabeth Pillet über die Glasmalereien des 19. Jahrhunderts in Paris[11] aufbauen konnte. In Deutschland engagierte sich besonders Elgin van Treeck-Vaassen für die europäische Glasmalerei dieser Epoche. Ihre Forschungsergebnisse flossen seit den frühen Achtzigerjahren regelmäßig in Publikationen ein. Zum umfangreichen Überblickswerk über die Glasmalereien zwischen 1780 und 1870 wurde der Band «Bilder auf Glas»[12], in dem die europäische Glasmalerei von den Anfängen im frühen 19. Jahrhundert bis zur Reichsgründung behandelt wird. Elgin van Treeck-Vaassens monographische Arbeit über «Die Glasgemälde des 19. Jahrhunderts im Dom zu Regensburg»[13] erschien zum 200. Geburtstag von Max E. Ainmiller (1807–1870), dem Glasmaler, ambitionierten Techniker und späteren Leiter der königlichen Glasmalereianstalt München. Das neueste Buch der Forscherin über die königliche Glasmalereianstalt Ludwigs I. in München erschien im März 2013 und wird von der Autorin als kunsthistorisch angelegtes «Werkverzeichnis» verstanden[14]. Die Zusammenführung der immensen Menge an Quellenmaterial sowie historischem und neuem Bildmaterial macht das Buch zu einem unverzichtbaren Nachschlagewerk für zukünftige Glasmalerei-Forschungen. Mit ihren Publikationen leistete Elgin van Treeck-Vaassen einen wichtigen Beitrag, obstinate Vorurteile und Missverständnisse sowohl in akademischen Kreisen als auch beim kunstinteressierten Publikum abzubauen. Die Forscherin widersetzte sich der Meinung einer

5 MARTIN, 2001, S. 6.
6 Internationale Vereinigung zur Inventarisierung von (ursprünglich) mittelalterlichen Glasmalereien, 1952 gegr. vom Berner Ordinarius Hans Robert Hahnloser.
7 RAHN, 1897, S. 1. Über die Bedeutung Johann Rudolf Rahns für die Erforschung der mittelalterlichen Glasmalerei in der Schweiz vgl. KURMANN-SCHWARZ, 2012 (2), S. 343–353.
8 REVUE DE L'ART, 1986, n° 72.
9 FINANCE, 2003.
10 LUNEAU, 2006.
11 PILLET, 2010.
12 VAASSEN, 1997.
13 VAASSEN, 2007.
14 VAASSEN, 2013.

strikten Grenzziehung zwischen der Münchner und der rheinischen Glasmaltradition, wonach erstere nur die malerische und letztere ausschließlich die musivische Technik angewandt hätten und versuchte darzulegen, dass trotz aller Vorbehalte, die dem Kunstzweig auferlegt wurden, aus dieser Zeit bedeutende Neuschöpfungen hervorgegangen waren. Mit dem Katalogbuch für die Ausstellung 1993/1994 im Angermuseum Erfurt, in dem die Autorin mit einem ausführlichen wissenschaftlichen Text über die facettenreiche Entwicklung der Glasmalerei des 19. Jahrhunderts ein breiteres Publikum erreichen konnte, wurden von Peter van Treeck erstmals auch denkmalpflegerische Aspekte über Konservierung und Restaurierung dieser Glasmalereien für die interessierte Öffentlichkeit angesprochen[15]. In vorbildhafter Weise haben die Mitarbeiterinnen und Mitarbeiter des Corpus Vitrearum Berlin Potsdam unter der Leitung von Frank Martin die Inventarisation der Glasmalereien in den Kirchen der neuen Bundesländer vorgenommen, die in der Zwischenzeit als handliche Taschenbücher erschienen sind[16]. Daniel Parello, wissenschaftlicher Mitarbeiter des Corpus Vitrearum in Freiburg im Breisgau, thematisiert in seiner Dissertation die Glasmalerei des 19. Jahrhunderts in Freiburg und die dort ansässigen Werkstätten[17], des Weiteren die rheinischen Glasmalereiwerkstätten Baudri und Oidtmann[18] und in Aufsätzen Glasmalereien im protestantischen Kirchenbau[19]. Ebenfalls mit Glasmalereien evangelischer Kirchen, der Protestantischen Landeskirche der Pfalz, beschäftigte sich Anke Elisabeth Sommer in ihrer Dissertation mit einer monographischen Abhandlung der Objekte[20]. In der Schweiz entstanden für die Zeit des Wirkens Johann Jakob Röttingers, also von 1835 bis 1877, zwei umfassende Studien, einerseits über die Glasmalereien zwischen 1830 und 1930 in Basel[21] und andererseits über die Glasmalereien in Genf zwischen 1830 und 1900[22]. An dieser Stelle sind auch die beiden Lizentiatsarbeiten über Johann Jakob und dessen Sohn Jakob Georg Röttinger zu nennen[23], die am Kunsthistorischen Institut der Universität Zürich angenommen worden sind. Erst über den Zeitraum um 1900, also

die Glasmalereien des Jugendstils, wurde wieder häufiger publiziert[24]. Stefan Trümpler beschäftigt sich im Rahmen seiner leitenden Funktion im Vitrocentre Romont mit der Problematik der Erhaltung und Restaurierung, der Erstellung von Expertisen und Bestandsaufnahmen von Glasmalereien sowie als Autor[25]. Inventarisationen der Glasmalereien des 19. und 20. Jahrhunderts erfolgten in den Städten La Chaux-de-Fonds[26], Genf[27] und Zürich, wobei letztere noch nicht abgeschlossen wurde. Die Problematik fehlender Signaturen, Datierungen und Dokumentationen wird häufig angesprochen – diese ist offensichtlich keine solitäre Angelegenheit im Werk Johann Jakob Röttingers. Auch die tragende Rolle der Architekten als Generalunternehmer bei der Vergabe der Aufträge schien allgemein Gültigkeit gehabt zu haben und wird am Werk Röttingers evident.

15 VAASSEN, 1993; VAN TREECK, 1993, S. 31 ff.
16 KUHL, 2001; KLAUKE/MARTIN, 2003; AMAN, 2003; HÖRIG, 2004; BORNSCHEIN/GASSMANN, 2006.
17 PARELLO, 2000 (1).
18 PARELLO, 2003.
19 PARELLO, 2005; PARELLO, 1997 (1).
20 SOMMER, 2007.
21 NAGEL/VON RODA, 1998.
22 SAUTEREL, 2008.
23 Eva Zangger verfasste ihre Lizentiatsarbeit über den 1863 geborenen Sohn des Werkstattgründers, Jakob Georg Röttinger; Eva-Maria Scheiwillers Arbeit («Gebrannte Glasmalereien in jeder Manier. Neue Glasmalkunst des 19. Jahrhunderts im Werk Johann Jakob Röttingers») über den aus Nürnberg eingewanderten Begründer des Ateliers, Johann Jakob Röttinger (1817–1877), wurde Brigitte Kurmann-Schwarz 2007 als Lizentiatsarbeit an der Philosophischen Fakultät im Fach Kunstgeschichte vorgelegt.
24 MICHEL, 1981; MICHEL, 1986; NAGEL/VON RODA, 1998 (Erfassungszeitspanne von 1830–1930); QUELLET-SOGUEL, 1996; In Österreich: JANDL-JÖRG, 2008, phil. Diss. in Wien.
25 TRÜMPLER, 2003; TRÜMPLER, 2002 (1) und (2); TRÜMPLER, 1999 u.a.
26 HOFFMANN, 2006, (1), (2).
27 SAUTEREL, 2008.

Der Nachlass Röttinger
in der Zentralbibliothek Zürich

Der aus der Werkstatt Röttinger auf uns gekommene Nachlass[28] aus dem Privatarchiv der Familie Röttinger wurde am 1. Dezember 2008 als Schenkung in die Zentralbibliothek Zürich transferiert. Bei den Archivalien handelt es sich um den schriftlichen Nachlass, die Kopierbücher mit Geschäftsbriefen, die Buchhaltung und die Verträge mit den Auftraggebern sowie um den graphischen Nachlass bestehend aus Kartons, Maquetten, Fotoplatten, Fotografien und Vorlagenbüchern.

Die konsequente chronologische Ordnung der Archivalien in Epochen: vor 1887[29], 1887 bis 1913 und nach 1913, haben rein quantitativ sehr anschaulich gezeigt, dass sich der Archivbestand des Werkstattgründers Johann Jakob Röttinger sehr bescheiden ausnimmt – im Gegensatz zu den reichhaltigen Beständen seiner beiden Söhne Jakob Georg und Heinrich Röttinger. Dies wird einerseits im schriftlichen Nachlass ersichtlich, der sich für Johann Jakob aus vier Buchhaltungsbüchern, einem Kopierbuch, zwei Auftragsbüchern, eines davon mit Handskizzen, und einer vergleichsweise begrenzten Auswahl von Korrespondenzen und Verträgen zusammensetzt, andererseits noch viel einschneidender im graphischen Nachlass, der kaum signierte Blätter beinhaltet. Während der schriftliche Nachlass zwar mengenmäßig gering erscheint, dokumentiert er doch die Auftragslage von 1855 bis 1877, dem Todesjahr des Glasmalers. Einzelne Verträge stammen sogar noch aus den frühen Werkstattjahren um 1850. Inhaltlich sind die vorhandenen Archivalien gut auswertbar. Der schriftliche Nachlass lässt unter anderem Rückschlüsse auf die Arbeitsweise, die Organisation der Werkstatt, auf Methoden der Akquisition und Werbung, auf die Löhne der Mitarbeiter, Preise, Material und Technik zu[30]. In den Verträgen finden sich häufig Hinweise auf die Wünsche der Auftraggeber in Bezug auf Ikonographie und Ausführung. Die Namen der Kunden von April 1860 bis Januar 1877 sowie stichwortartige Notizen zu den Aufträgen inklusive der Preise lassen sich den noch erhaltenen Buchhaltungsbüchern[31] entnehmen. Die wenigen Einzelblätter des durch Signaturen gesicherten graphischen Nachlasses, die in zwei Fällen aufgrund der Unterschrift des Glasmalers und im anderen Fall dank schriftlicher Hinweise Johann Jakob Röttinger zugeschrieben werden können, sind bestenfalls als Beispiele anzuführen. Das heißt, dass im Œuvre des Werkstattgründers keine Rückverfolgung vom Werk auf die Maquette beziehungsweise den Entwurf, erst recht nicht auf Kartons möglich ist, da sich kein einziger Karton der Werkstattphase aus der Zeit von 1848 bis 1877 erhalten hat. Einzig für eine nach Thalwil bestimmte Maquette ließen sich größere Glasmalereifragmente im Ortsmuseum finden, die zudem durch entsprechendes Archivmaterial gesichert sind. Der Grund für die relativ bescheidene Ausbeute im graphischen Nachlass der Röttinger aus der Zeit vor 1887 dürfte hauptsächlich in der Übernahme des Geschäftes nach dem Tod des Firmengründers durch Glasmaler Carl Wehrli (1843–1902) liegen, der vermutlich mit dem Inventar und den angefangenen Aufträgen auch den künstlerischen Nachlass Johann Jakobs mitgenommen hatte. Falls jedoch noch Maquetten oder Vorlagen aus der ersten Firmenepoche im Fundus der Röttinger verblieben wären, so sind diese durch Stempel und Beschriftungen Wehrlis respektive der Söhne Georg und Heinrich in deren Bestand einverleibt worden und wegen fehlender Signaturen beziehungsweise Jahreszahlen aus heutiger

28 Dieser wurde bis Ende Juni 2009 als Vorarbeit des Projekts von Eva Zangger und mir systematisch erfasst und in die Sammlungen der Bibliothek, die Handschriftenabteilung und die Graphische Sammlung, integriert.

29 Johann Jakob Röttinger ist im Januar 1877 gestorben – Sohn Jakob Georg konnte das Atelier jedoch erst nach Abschluss seiner Ausbildung im Jahr 1887 übernehmen. In der Zwischenzeit war die Werkstatt an den in Zürich ansässigen Glasmaler Carl Wehrli verkauft worden, mit der Option, bei Eigenbedarf durch die Söhne die Wiederaufnahme der Firma zu gewährleisten. Vgl. Kap. ‹Die Werkstatt nach dem Tode Johann Jakob Röttingers († 29. Januar 1877)›.

30 SCHEIWILLER, 2007 (Teilergebnisse).

31 ZB Nachl. Röttinger 1.204–1.207.

Sicht nicht mehr eindeutig Johann Jakob Röttinger zuzuordnen[32].

Pfarr-, Stadt- und Staatsarchive

Das Dilemma um fehlende graphische Archivdokumente erforderte eine groß angelegte Recherche in Archiven der Schweiz; aber auch in Nürnberg, der Heimatstadt Johann Jakob Röttingers, wurden Nachforschungen angestellt. So wurden neben den Staatsarchiven Zürich, Basel-Stadt, Schwyz, dem Landesarchiv Glarus u. v. a. in zahlreichen Gemeinden Archive von Pfarreien, Kirchgemeinden, Gemeinden, der Bürgerschaft, der Stadt oder von Ämtern der Denkmalpflege konsultiert[33]. In den meisten Fällen war es möglich, bestehende Informationen aus dem Nachlass durch zusätzliches Archivmaterial zu ergänzen. Während im Nürnberger Stadtarchiv die Dokumente der Familie Johann Jakob Röttingers aufbewahrt werden, sind im Staatsarchiv die Schriftstücke bezüglich der königlichen Kunstschule Nürnberg, wo Johann Jakob in den Schülerlisten erscheint, untergebracht. Weitere Archive in Deutschland ließen sich per Schriftverkehr oder online erschließen – das Landes- und das Stadtarchiv sowie das Archiv der Kunstakademie in Düsseldorf, das Stadtarchiv München und weitere Archive in Furtwangen, Nördlingen, Regensburg, Rottweil und Weingarten.

Datenbank

Seit Beginn der Inventarisation des in die Sammlungen der Zentralbibliothek integrierten Nachlasses der Röttinger wurden die transkribierten Archivdokumente, Verträge, Briefe, Familiendokumente, wie auch die einzelnen Seiten des Skizzen- und Auftragsbuches in die vom Vitrocentre Romont zur Verfügung gestellte Datenbank eingegeben. Ebenfalls im elektronischen Werkver-

zeichnis aufgenommen sind die im Staatsarchiv Zürich aufgefundenen Zeichnungen Johann Jakob Röttingers, die dieser im Auftrag von Ferdinand Keller[34], dem Leiter der Antiquarischen Gesellschaft Zürich, von den mittelalterlichen Glasmalereien der Klosterkirche in Königsfelden herstellte. Darüber hinaus ließen sich einige Zeichnungen auch von den Glasmalereien der Klosterkirche Hauterive FR, von der ehemaligen Klosterkirche in Kappel am Albis sowie vom Chorfenster in Oberkirch bei Frauenfeld TG finden – also von den Kirchen, in denen Johann Jakob Röttinger Restaurierungen vorgenommen hatte. In der Folge wurden von den fotografisch dokumentierten Glasmalereien, ob in situ vorliegend oder in Lagern deponiert, Datenblätter angelegt; eine Vorgehensweise, die ergänzt durch Beschreibungen, einer detaillierten Inventarisation entspricht.

32 So geschehen beispielsweise mit dem Vorlagenblatt aus der Serie des Vereins zur Verbreitung religiöser Bilder in Düsseldorf: *«Jesus baptisatur ab Joanne (C. Müller invt./H. Nüsser fculpt)»*, gestempelt: *«Glasmalereianstalt J.G. Röttinger Zürich»*. Das vom Spätnazarener C. Müller gestaltete Blatt hält sich an das Vorbild der «Taufe Christi» von Pietro Perugino (1498/1500, Olivenholz 30×23 cm, Kunsthistorisches Museum Wien, Inv.-Nr. GG_139). J. Röttingers Taufe Christi von 1871 in der evangelischen Stadtkirche Solothurn nimmt sich dieses Blatt wohl in Komposition, Haltung der beiden Hauptfiguren (Assistenzfiguren fehlen) und der Landschaft zum Vorbild.

33 Aarburg AG, Alt Sankt Johann SG, Alterswil FR, Andelfingen ZH, Appenzell AI, Baden AG, Biel BE, Gams SG, Glarus, Gonten AI, Heitenried FR, Herdern TG, Mettmenstetten ZH, Ossingen ZH, Thalwil ZH, Pieterlen BE, Rapperswil SG, Regensdorf ZH, Schwyz, Solothurn SO, Steinhausen ZG, Sankt Gallen, Villmergen AG, Zug Stadt, Menzingen-Finstersee ZG, Unterägeri ZG, Wildhaus SG, Zürich. Vgl. ‹Quellenverzeichnis›. In den aufgeführten Orten haben sich jeweils Glasmalereien Röttingers in situ oder im eingelagerten Zustand erhalten. Ein Grundstock an Archivarbeit konnte bereits im Rahmen der Lizentiatsarbeit angelegt werden.

34 Schweizer Altertumsforscher, 1800–1881.

Fragestellungen

Ein erster Schwerpunkt der Forschungsarbeit war die künstlerische Ausbildung Johann Jakob Röttingers, dessen stilbildende Vorbilder sowie weitere prägende Einwirkungen auf die stilistische Entwicklung des Glasmalers. Unklar waren bisher sowohl Aufenthalt und Studium in Düsseldorf, die vermeintliche Reisetätigkeit nach Italien und Frankreich sowie die Art der Beziehung zur Münchner Glasmalerei. Weitere Fragen ergaben sich einerseits zur Tätigkeit beim Glasmaler Franz Joseph Sauterleute und Röttingers Mitarbeit in der Gruftkapelle zu Sankt Emmeram derer von Thurn und Taxis in Regensburg[35], andererseits in Bezug auf die Wappenscheiben im Schloss Lichtenstein[36] sowie die Mitarbeit in Nördlingen und Rottweil. Die Form des Arbeitsverhältnisses in der Werkstatt Hirnschrot unter der Witwe des Meisters, die erste Zeit der Selbstständigkeit, die Aufträge zur Herstellung von Zeichnungen in Königsfelden, in der Klosterkirche zu Hauterive FR, im Kreuzgang des Klosters Muri, in Frauenfeld Oberkirch und in Kappel am Albis sowie die Zusammenarbeit mit der Nürnberger Glasmalerfamilie Kellner, insbesondere zu Georg Konrad Kellner (1811–1892) im Zürcher Grossmünster, waren ebenfalls nicht vollständig geklärt. Überhaupt gab es bisher über Beziehungen zu Künstlerkollegen kaum Hinweise; so wird auch die Etablierung in der Zürcher Gesellschaft, namentlich die Bekanntschaften mit dem Zürcher Altertumsforscher Ferdinand Keller und dem jungen Johann Rudolf Rahn (1841–1912), des späteren Professors der Kunstgeschichte und Vaters der Denkmalpflege in Zürich, näher untersucht. Röttingers Selbsteinschätzung als Spätnazarener warf zweifellos Fragen zur Art der Verbindungen mit den Nazarenern auf, nach künstlerischer Anpassung, nach Eingriffen durch Wünsche der Auftraggeber, nach Eigenständigkeit beziehungsweise Flexibilität des Künstlers. Die Etablierung in Zürich, persönliche Beziehungen am Standort der Werkstatt als Folge der Integration waren für den geschäftlichen wie auch künstlerischen Erfolg

in Zürich entschieden notwendig. Dazu beigetragen hatte wohl auch die Eheschließung mit der Einheimischen Verena Fehr aus Ossingen ZH. Dementsprechend ist die Rolle der Frauen in Bezug auf das Geschäftliche Gegenstand des Interesses sowohl bezüglich Johann Jakob Röttingers Firma, bei Lebzeiten und darüber hinaus, wie auch bei seinem Meister Johann Andreas Hirnschrot, dessen Witwe ebenfalls für eine gewisse Zeit versuchte, das Geschäft zu halten. Als Schüler Röttingers interessant sind die Namen der Mitarbeiter, vor allem derer, die später selbst bekannte Glasmaler wurden, wie Gustav van Treeck, Adolph Kreuzer oder Friedrich Berbig; für letzteren war nach dem Tode Röttingers die Übernahme der Geschäftsleitung unter dem Patronat der Witwe vorgesehen. Ein weiterer Schwerpunkt ist die Darstellung des Werkes vor dem kulturhistorischen und politischen Kontext, einer Zeit der Revolutionen, Neuerungen und Fortschritte. Wie auch in anderen Kunstgattungen reflektierten die Glasmalereien des 19. Jahrhunderts gesellschaftspolitische Themen. Nach solchen Bezügen wird sowohl in sakralen wic in profanen Glasmalereien gesucht. In der sakralen Fenstergestaltung müssen im Hinblick auf die Religiosität der damaligen Zeit einerseits Untersuchungen über Zusammenhänge mit bevorzugten ikonographischen Themen angestellt werden, andererseits gilt es, sich die Glasmalerei unter dem Gesichtspunkt der religiösen Krise vorzustellen, sei es die Verkündigung des Syllabus von 1864[37], die Unfehlbarkeitserklärung von 1870 und die daraus entstandene Glaubensspaltung oder ganz allgemein die Gegensätze zwischen liberalen, aufklärerischen beziehungsweise sozialis-

35 Das Fürstenhaus Thurn und Taxis erwarb 1810 das Klostergelände des aus dem 8. Jahrhundert stammenden Klosters Sankt Emmeram in Regensburg und ließ es in der Folge zur Residenz ausbauen.

36 Das im Stil des Historismus erbaute Schloss aus dem 19. Jahrhundert liegt über dem Ort Honau, Gemeinde Lichtenstein im Landkreis Reutlingen, Baden-Württemberg.

37 Syllabus von Papst Pius IX. (Liste von 80 Thesen, die von Papst Pius IX. als falsch verurteilt wurden).

tischen Kräften und der römisch-katholischen sowie der reformierten Kirche. Die profanen Glasmalereien werden auf die Frage hin erforscht, ob sie als nationales Kunstwerk im Sinne des stark ausgeprägten Selbstverständnisses beziehungsweise Patriotismus als «Nachfolge» der Schweizerscheiben des 16. und 17. Jahrhunderts zu betrachten seien[38]. Dies besonders vor der Kulisse der Gründung des modernen Nationalstaates 1848 und der in mancher Hinsicht konservativen Haltung der Gesellschaft des 19. Jahrhunderts mit ihrer Huldigung historischer Begebenheiten[39]. Schließlich wird den Fragen nachgegangen, die sich mit der sich wandelnden Rezeption der Glas-

malereien des Historismus beschäftigen. Aus ganz unterschiedlichen Gründen, beispielsweise künstlerischen, religiösen oder philosophischen Motiven, wie auch wegen der «Säuberungen der Kirchen von der religiösen Bildwelt des 19. Jahrhunderts»[40] mussten viele Glasmalereien des Historismus spätestens ab den Zwanzigerjahren des 20. Jahrhunderts Neuverglasungen weichen. Ein prominentes Beispiel dafür war der Disput um die Chorfenster Röttingers nach Entwürfen Georg Kellners von 1853 im Grossmünster in Zürich, als Augusto Giacometti von der Kirchgemeinde 1933 den Auftrag erhielt, diese durch moderne Glasmalereien zu ersetzen[41].

38 Vgl. KÖPPEL, 2007, S. 143 ff.
39 MARCHAL, 2007, S. 89–96.
40 TOBLER, 1985, S. 93.
41 NZZ, 5. Mai 1933, «Neue Chorscheiben im Grossmünster» (ohne Autor).

Das Werk Johann Jakob Röttingers

Der Künstler, seine Herkunft und seine Ausbildung

Herkunft und handwerkliche Tradition

Gewerbe, Handwerk und Kunsthandwerk haben in Nürnberg eine lange Tradition. So ist es nicht verwunderlich, dass Johann Jakob Röttinger als Sohn des Nadlermeisters Conrad Röttinger einer eingesessenen Nürnberger Handwerkerfamilie entstammte, denn bereits sein Großvater, Johann Stephan Röttinger[42], übte dieses alte Handwerk aus. Die Eisenverarbeitung, wie auch die Kunst des Drahtziehens und der Nadelherstellung, sind im Raum Nürnberg bereits seit dem 12. und 13. Jahrhundert nachweisbar [43] und entwickelten sich dort in der Folge zu hoher Spezialisierung. Die 1408 bis 1415 vom Rat geförderte Erfindung des Drahtzugs mit Wasserkraft bewirkte eine beachtliche Steigerung der Produktion, welche wiederum die Vor- und Folgegewerbe expandieren ließ[44]. Neben handwerklichen Fähigkeiten benötigte der Nadler entsprechende Einrichtungen – Haspel, Richtholz, Feuerstelle, Fallwerk u. v. m. – für die unzähligen Schritte, die zur Produktion von Nadeln notwendig waren. Das bedeutete, dass obendrein finanzielle Mittel für die Beschaffung der Infrastruktur vorhanden sein mussten. So erlernte auch Conrad Röttinger das Handwerk in der Werkstatt seines Vaters. Die Produktion der Nadeln geschah in den meisten Fällen in kleinen Einheiten auf Familienbasis beziehungsweise durch Meister und Gesellen, während die Beschaffung der Rohstoffe und der Absatz der fertigen Produkte durch Nürnberger Kaufleute und potente Handwerkermeister, so genannte Verleger, abgewickelt wurde[45]. Wegen des Quarzstaubes, der beim Schleifen von Nadeln und Drähten zwischen Sandsteinen entstand und der dabei anfallenden feinen Metallpartikel, trat bei den Nadlern und Drahtziehern häufig eine Staublunge – die so genannte Silikose – auf, was die Lebenserwartung der Betroffenen stark verkürzte[46]. Dies erklärt vermutlich auch den frühen Tod des Nadlermeisters Conrad Röttinger, der in der Ehe mit Susanna Helena Schuster, Tochter des Nürnberger Soldatiers Johann Georg Schuster[47], nur einen einzigen Sohn, nämlich Johann Jakob, hinterlassen hatte. In der Folge wird die Mutter Johann Jakob Röttingers als Nadlerswitwe Susanna Helena Zeitler[48] aktenkundig, was auf ihre Wiederverheiratung

42 SA Nürnberg: C7_II_00984_01: Conrad (*1782) ist als zweiter Sohn des Nürnberger Nadlermeisters Johann Stephan Röttinger (*1745) eingetragen. Conrad hatte zwei Brüder, Christoph und August.

43 STADTLEXIKON NÜRNBERG, 2000, S. 240, Stichw. *Eisenverarbeitung* (Horst-Dieter Beyerstedt). CARL, 2002–2010, Online-Bibliothek, Stichw. *Nadler.*

44 STADTLEXIKON NÜRNBERG, 2000, S. 221, Stichw. *Drahtzieher auf dem groben Zeug (am Wasser)* (Horst-Dieter Beyerstedt).

45 STADTLEXIKON NÜRNBERG, 2000, S. 1135, Stichw. *Verlagswesen* (Michael Diefenbacher).

46 ELEXIKON, Meyers Konversations-Lexikon, 1885–1892, Stichw. *Nadeln.*

47 SA Nürnberg: C7_II_00984, C7_II_11886_00 und 01.

48 SA Nürnberg: C7_II_00984, C7_II_11886_00 und 01.

nach dem Tod ihres verstorbenen Mannes hinweist.

Johann Jakob Röttinger wurde am 24. März 1817 in Nürnberg geboren und war zumindest vor seinem Weggang in die Schweiz 1844 in der Lorenzer Altstadt an der Graßersgasse 961 bei seiner Mutter wohnhaft[49]. Zum Werdegang des jungen Röttinger gibt ein Protokoll vom 17. März 1849 Auskunft, welches bezeugt, dass die Mutter Susanna Helena Röttinger[50] für ihren Sohn Johann Jakob beim Magistrat in Nürnberg um Aufnahme als Schutzbürger ersuchte: *«Mein Sohn Johann Jakob Röttinger, 32 Jahre alt, welcher dahier die Glasmalerei erlernt hat, auch eine Zeitlang Gehilfe des berühmten Glasmalers Sauterleiter gewesen ist, befindet sich schon seit 5 Jahren in Zürich, wo ihm die Erlaubnis zum temporären Aufenthalt und der Ausübung seiner Kunst gegeben ist [...]»*[51].

Ausbildung in Nürnberg

Die vom Ratsherrn Joachim Nützel von Sündersbühl in der Tradition der privaten Malerakademien 1662 eingerichtete Ausbildungsstätte für bildende Künstler in Nürnberg war 1695 unter der Leitung Jacob von Sandrarts in eine öffentliche Anstalt umgewandelt worden. Direktor Johann Daniel Preißler gründete 1716 die Zeichenschule für Handwerkslehrlinge, deren Besuch kostenlos und ab 1766 für Lehrlinge des Bauhandwerks verpflichtend war. Ab dem Jahre 1806 wurde die Anstalt zu einer Einrichtung des Königreichs Bayern und unter Direktor Albrecht Reindel (1784–1853), der während Röttingers Ausbildungszeit die Schulleitung innehatte, in die Räumlichkeiten der Nürnberger Burg verlegt. Um Münchens Status als Kunststadt herauszuheben, stufte der Bayerische König Ludwig I. nach Antritt seiner Regierungszeit 1825 die Nürnberger Akademie zur Kunstschule herab. In der Folge galt die Einrichtung als Ausbildungsinstitut für die traditionellen Nürnberger Gewerbe, vor allem für die graphischen Künste sowie die Porzellan- und Dosenmalerei. Die offizielle Bezeichnung ab 1833 lautete nun «Kunstgewerbeschule»[52].

Johann Jakob Röttinger war gemäß den Schülerlisten der «Königlichen Kunstgewerbeschule» zu Nürnberg in den Schuljahren 1830/1831 sowie 1831 bis Mai 1832 in der «Zeichnungsschule»[53] zu Nürnberg eingeschrieben. Als Maler vermerkt, genoss er dort Zeichenunterricht bei J. J. Penzold[54]. Die Zeichenschule stand mit der Königlichen Kunstgewerbeschule in Verbindung, wobei beide Einrichtungen, zumindest auf wirtschaftlicher Basis, gemeinsam geführt wurden[55]. Im nun folgenden Schuljahr wird Röttinger im Verzeichnis

49 SA Nürnberg: C7_II_11886_11: Im Jahre 1849 bestätigt Georg Friedrich Brunner, *«Districtsvorsteher»*, dass der ledige J. J. Röttinger von hier vor ungefähr 5 Jahren, zu jener Zeit bei seiner Mutter, der Feinbäckerin Susanna Helena Röttinger, in der Graßersgasse 961 in dessen Districte wohnte und damals als fleißiger, braver Mann mit gutem Leumund bekannt war. Der damalige Standort des nicht mehr erhaltenen Hauses entspricht der heutigen Adresse Grasersgasse 8.

50 Wechselnde Namensbezeichnung der Mutter in den Akten: Nadlermeisterswitwe Röttinger, Nadlerswitwe Zeitler usw.

51 SA Nürnberg: C7_II_11886_09: Protokoll vom 17. März 1849. (Im Zitat wurde die alte Bezeichnung «Sauterleiter» übernommen, welche dem in der Literatur üblichen Namen «Sauterleute» entspricht).

52 STADTLEXIKON NÜRNBERG, 2000, S. 54, Stichw. *Zeichenschule (Akademie der Bildenden Künste)* (Edith Luther); S. 600, Stichw. *Kunstgewerbeschule* (Edith Luther); S. 879, Stichw. *Reindel, Albert (eigentlich Albrecht) Christoph* (Matthias Mende). KLUXEN, 1999, S. 167 ff.

53 StA N: Nr. 252 Acta d. königl. Kunstgewerbeschule zu Nürnberg, Betr. Schülerlisten der Zeichnungsschule 1820/21–1841/42, Nr. 11: Verzeichnis der Schüler der Zeichnungsschule im Jahre 1830/31 unter *«23. Rettinger Johann Jakob»*; Nr. 12: Verzeichnis der Schüler der Zeichnungsschule im Jahre 1831/32 unter *«61. Rettinger Johann Jakob, Rubrik: Name der älteren Schüler, Maler, Austritt Mai des laufenden Jahres»*.

54 NAGLER'S KÜNSTLER-LEXICON 11, 1841, S. 85, Stichw. *Penzold, J. J.*: Zitat: «Penzold J. J., Zeichner und Maler zu Nürnberg, ein geschickter Künstler, der bereits seit 1830 als solcher öffentlich bekannt ist. Er fertigte mehrere schöne Zeichnungen nach Dürer, Rafael u. a., grösstentheils Bildnisse, und solche malte er auch in Oel.»

55 StA N: Nr. 449 Akademie der Bildenden Künste, Blatt 94: *«Holz Naturalrechnung der Königlichen Kunstschule und der damit in Verbindung stehenden Zeichnungsschule zu Nürnberg 1824»* (Hinweis auf zwei verschiedene Schulen, die jedoch offensichtlich gemeinsam bewirtschaftet wurden).

der Eleven der Königlichen Kunstschule im Etats-jahre 1832/1833 als Porzellanmaler aufgeführt. Er wird unter der Rubrik «Aufnahme am 1. Mai» sowie unter denjenigen vermerkt, die die Probe-zeichnung gemacht haben[56]. In der Aufnahmelis-te vom 21. Mai 1834 erscheint Johann Jakob Röttinger abermals als Aufgenommener in der «Ersten oder unteren Klasse»[57]. Die Akten der Königlichen Kunst- und Kunstgewerbeschule attestieren dem jungen Röttinger also eine min-destens vierjährige künstlerische Ausbildung, wobei er demnach in den ersten beiden Jahren in der oben erwähnten Zeichenschule für Hand-werkslehrlinge in die Grundbegriffe des Zeichnens eingeführt worden war. Die Schulbezeichnung variierte im Laufe der Jahre: war die Benennung zwischen 1826 und 1834 als «Kunstschule» und 1830 als «Königliche Kunstschule» in den Akten manifest, so tauchte ab dem Jahr 1835 der Name «Kunstgewerbeschule Nürnberg» auf, um 1839 noch einmal als «Königliche Kunstschule» in Er-scheinung zu treten[58]. Diese Änderungen der Namensgebung des Schulbetriebs sind wohl mit den oben beschriebenen Umbrüchen der Schule erklärbar.

Außer dem Namen Röttinger lassen sich vor seiner Zeit noch weitere Namen bekannter Glas- und Porzellanmaler in den Schullisten finden[59]. Hier seien nur die in diesem Zusammenhang wichtigs-ten genannt: Christian Hirnschrot (1785 bis min-destens 1837) als Freskomaler und Lackierer[60], Michael Sigmund Frank (1770–1847), der Dosen-, Porzellan- und Glasmaler[61], Franz Joseph Sauter-leute (1793–1843)[62] sowie Johann Konrad[63] bezie-hungsweise Johann Jakob Kellner (1788–1873), die Porzellan-, Glas- und Porträtmaler waren[64]. Da die Eintrittsdaten verschiedener Mitglieder der Kellner-Familie, die in der Folge berühmte Glas-maler hervorgebracht hatte, für die Jahre 1827 (Johann Georg Kellner), 1828 (Johann Stephan Kellner) und 1830 (Johann Gustav Hermann Kellner) dank des Schularchivs festzumachen sind[65], ist davon auszugehen, dass Johann Jakob Röttinger bereits während der Ausbildung Kon-takte zu den Kellners knüpfen konnte und somit

den Grundstein für eine spätere punktuelle beruf-liche Zusammenarbeit legte.

In der Schulchronik von 1840 wird außerdem festgehalten, dass die Glasmalerei durch Kellner und dessen drei Söhne in den letzten Jahren auf eine sehr bedeutende Stufe gelangt sei. Ihre Ar-beiten in der Sankt Lorenzkirche, in der sie auch fünf Fenster sehr gelungen ergänzten, seien von einer Qualität, die *«unter den Alten kaum aufgefunden werden kann [...]»*[66]. Wie schon erwähnt, stand die

56 StA N: Nr. 253 Acta d. Königl. Kunstgewerbeschule zu Nürnberg, betr. Schüler-Verzeichnisse d. Königl. Kunst- und Kunstgewerbeschule Nürnberg (1820–1853/54), Fasc. Nr. 2, 13. In der Liste erscheint der Name *Redinger* (durch-gestrichen und durch Röttinger ersetzt) unter der Aufnah-menummer 13: *im Fach Porzellanmalerei, Stunden von 8–10; Angaben zur Person: 16 Jahre, geb. in Nürnberg, Wohnung: L[orenz] Nr. 931, Stand des Vaters: Nadler †, Nürnberg.*

57 StA N: Nr. 253 Acta d. Königl. Kunstgewerbeschule zu Nürnberg, betr. Schüler-Verzeichnisse d. Königl. Kunst- und Kunstgewerbeschule Nürnberg (1820–1853/54), Fasc. Nr. 2, 14. In der Liste erscheint der Name Röttinger, *Probe-zeichnung gemacht Nr. 12, Eintrittsnummer 8 im Fach Porzellan-malerei, Stunden von 10–12; Person: 17 Jahre, Nürnberg L[orenz] Nr. 968, Penzold.*

58 StA N: Nr. 95 Acta d. Königl. Kunstgewerbeschule zu Nürnberg, Betreff: versch. Betreffs 1824–1843.

59 StA N: Nr. 95 Acta d. Königl. Kunstgewerbeschule zu Nürnberg, Betreff: versch. Betreffs 1824–1843, S. 19 und 20: Verzeichnis der hier befindlichen Künstler für statisti-sche Zwecke 1827–1830.

60 NÜRNBERGER KÜNSTLERLEXIKON 2, 2007, S. 662, Stichw. *Hirnschrot, Christian.* Ob es sich bei Christian Hirnschrot um einen Verwandten Joh. Andreas Hirnschrots, des Nürn-berger Glasmalers, handelte, dessen Werkstatt J. Röttinger in Zürich später übernommen hat, geht aus dem Eintrag nicht hervor.

61 VAASSEN, 1997, S. 159 ff.

62 VAASSEN, 1997, S. 162 ff.

63 NÜRNBERGER KÜNSTLERLEXIKON 2, 2007, S. 762 (Hier kommen altersmäßig zwei Namensvettern in Frage: Johann Conrad I., Johann Jakob I.).

64 NÜRNBERGER KÜNSTLERLEXIKON 2, 2007, S. 762, Stichw. *Kellner, Johann Conrad I.,* Stichw. *Kellner, Johann Jakob.*

65 StA N: Nr. 253 Acta d. Königl. Kunstgewerbeschule zu Nürnberg, betr. Schüler-Verzeichnisse d. Königl. Kunst- und Kunstgewerbeschule Nürnberg (1820–1853/54), Fasc. Nr. 2, 7.

66 StA N: Nr. 95 Acta d. Königl. Kunstgewerbeschule zu Nürnberg, Betreff: versch. Betreffs 1824–1843, Blatt 60, S. 61.

Schule von 1819 bis 1843 unter der Leitung von Direktor Albrecht Christoph Reindel, Kupferstecher und Lehrer der Zeichenkunst sowie Konservator der Königlichen Gemäldegalerie[67]. Unter seiner Führung erscheinen in den Akten immer wieder Textabschnitte, die die damals herrschenden künstlerischen Strömungen beschreiben. Aus solchen Niederschriften geht hervor, dass sich die Luftmalerei in lebhaftestem Schwung befinde, und weiter: *«Die Glasmalerei ist es gleichfalls, nur die Porzellanmalerei ist durch den geringen Verbrauch an gemalten Porzellan-Pfeifenköpfen nicht mehr so lebhaft in Betrieb und viele Maler, die sich sonst damit beschäftigten, sind zu anderen Kunstfächern übergegangen. [...]»*[68]. Die Notizen bestätigen den damals herrschenden Trend, von der Porzellan- zur Glasmalerei zu wechseln, wie dies zum Teil bei den oben genannten Künstlern, insbesondere bei Johann Andreas Hirnschrot (1799–1845), dessen Geschäft in Zürich *post mortem* von Johann Jakob Röttinger weitergeführt wurde, der Fall war. Die Porzellanmanufakturen von Sèvres und die Hinwendung vieler Porzellanmaler zur Glasmalerei werden im Kapitel über die künstlerische Ausführung genauer erörtert.

Lehr- und Arbeitsplätze in der Heimat, Reisepläne

Für die Zeit zwischen dem Abgang an der Nürnberger Kunstgewerbeschule und dem Anstellungsverhältnis bei Hirnschrot in Zürich sind bezüglich Aus- und Weiterbildung keine Archivdokumente verfügbar. Jedoch lassen sich die weiteren Schritte Johann Jakob Röttingers bis zur Erlangung seiner beruflichen Selbstständigkeit, wenn auch lückenhaft und teilweise im Ausschlussverfahren, nachverfolgen. Entgegen der Behauptungen einschlägiger biographischer Lexika beziehungsweise Künstlerlexika[69] ist eine Fortsetzung der künstlerischen Ausbildung an der Kunstakademie Düsseldorf nicht belegbar[70]. Weder in den Schülerlisten noch in den in Frage kommenden Findbüchern erscheint der Name des Glasmalers[71]. In der fraglichen Zeitspanne zwischen 1835 und 1844 konnte außerhalb der Akademie in Düsseldorf keine weitere Kunstschule ausgemacht werden. Das Archiv der Kunstakademie stellte die Namen derjenigen Professoren für Malerei zur Verfügung, deren Dienstzeit das gefragte Dezennium tangierte. Karl Ferdinand Sohn, Wilhelm Schirmer, Ferdinand Theodor Hildebrandt, Dr. Wilhelm von Schadow sowie Joseph Wintergerst unterrichteten damals in Düsseldorf und nahmen auch Studenten in ihre Privathäuser auf[72]. Die Adressen des Lehrkörpers sind bekannt; Meldeunterlagen sind im Stadtarchiv Düsseldorf jedoch erst ab dem Jahr 1850 nachweisbar. Aus diesem Grund ist ein Beleg über den Aufenthalt Röttingers weder bei einem der Professoren noch bei einer Zimmerwirtin zu eruieren[73]. Plausibel ist die Vermutung Elgin Vaassens,

67 StA N: Nr. 95 Acta d. Königl. Kunstgewerbeschule zu Nürnberg, Blatt 46, Personal der Kunstgewerbeschule.

68 StA N: Nr. 95 Acta d. Königl. Kunstgewerbeschule zu Nürnberg, S. 69.

69 SCHWEIZERISCHES KÜNSTLER-LEXIKON 2, 1908, S. 661, Stichw. *Röttinger, Johann Jakob* (H. Appenzeller).

70 Dies stellte bereits 1997 Elgin Vaassen fest: VAASSEN, 1997, S. 49, Anm. 52. sowie im BIOGRAPHISCHEN LEXIKON DER SCHWEIZER KUNST 2, 1998, S. 887, Stichw. *Röttinger, Johann Jakob.*

71 LA NRW: In den Beständen der Regierung Düsseldorf («der Regierungspräsident als Kurator der Kunstakademie») sind keine Hinweise auf J. Röttinger fassbar. Die Akten, die die Kunstakademie Düsseldorf betreffen, haben insgesamt eine Laufzeit von 1816–1919 und sind in den Findbüchern 212.01 «Regierung Düsseldorf, Präsidialbüro» (Seiten 250–260, Klassifikationspunkt «23. Kunstakademie Düsseldorf») und 212.23.1 «Regierung Düsseldorf, Kunst-, Kultur- und Heimatpflege, Erwachsenenbildung» (Seite 5, Klassifikationspunkt «Id. Kunstakademie Düsseldorf») verzeichnet. Im Personenindex der überlieferten Schülerlisten mit Laufzeit von 1830–1895 ist Johann Jakob Röttinger nicht aufgeführt. Die Überlieferung der Kunstgewerbeschule Düsseldorf betrifft hauptsächlich das 20. Jahrhundert, einzelne Akten beginnen frühestens im Jahr 1879 (Freundliche Mitteilung von Maren Althaus, Landesarchiv NRW).

72 Archiv der Kunstakademie Düsseldorf (Freundliche Mitteilung von Dawn Leach, Carl-von-Ossietzky Universität Oldenburg, Leiterin des Archivs mit Sammlungen der Kunstakademie).

73 SA Düsseldorf (Freundliche Mitteilung von Elisabeth Scheeben, Stadtarchiv).

dass Röttinger möglicherweise in einem der Meisterateliers privaten Unterricht erhielt[74].

Vermeintliche Reisen des jungen Glasmalers nach Italien und Frankreich standen bisher ebenfalls im Raum und dies aus gutem Grund[75]. Die Mutter Johann Jakob Röttingers ersuchte im August 1846 beim Magistrat zu Nürnberg um einen Reisepass für ihren erstehelichen Sohn, damit dieser seinem Wunsch gemäß die Länder Italien und Frankreich bereisen könne. Der Pass wurde mit einer Gültigkeit von drei Jahren durch die Nürnberger Behörden ausgestellt[76]. Der schon 1844 bewilligte und für ein Jahr gültige Reisepass für die Schweiz war zu dieser Zeit bereits abgelaufen. Wie der folgende amtliche Auszug zeigt, machte Röttinger von der Bewilligung keinen Gebrauch. Zitat aus einem Schreiben des Magistrats der Stadt Nürnberg aus dem Jahr 1847: «*Die Zeit, welche ihm zum Aufenthalt in der Schweiz bewilligt wurde ist, wie aus diesem allen hervorgeht, längst abgelaufen und hat ihn Röttinger bis jetzt daselbst fortgesetzt, so folgt, dass er von dem vorigen Jahr ihm ertheilten Pass für Italien und Frankreich keinen Gebrauch gemacht hat [...]*»[77]. In der darauf erbrachten amtlichen Verlängerung der Aufenthaltsbewilligung für die Schweiz erscheint eine Rechtsmittelbelehrung, die die Mutter wegen Abwesenheit ihres Sohnes, J. Jakob, an seiner statt zu unterschreiben hatte: «*Bestätigung der Susanna Helena Zeitler, Mutter von Johann Jakob Röttinger, dass ihr Sohn nur nach Frankreich reisen darf, wenn er die Erlaubnis des Königlich Bayerischen Ministeriums des Innern erwirkt haben wird. Ad acta 23. Febr. 1848*»[78]. Der komplexe Sachverhalt – durch die verschiedenen Zuständigkeiten der Bayerischen Instanzen entstanden – lässt die Reise des Gesuchstellers als eher unwahrscheinlich erscheinen. Zudem war es Röttinger im Jahre 1848 – nunmehr mit dem Aufbau seines eigenen Ateliers beschäftigt – wohl nicht mehr möglich, das erst seit kurzer Zeit von seinem 1845 verstorbenen Arbeitgeber Johann Andreas Hirnschrot übernommene Geschäft für einen längeren Zeitraum zu verlassen.

Durch schriftliche Dokumente belegbar ist hingegen die Mitarbeit beim bekannten Nürnberger Glasmaler Franz Joseph Sauterleute (1793–1843).

Dies bestätigt die Mutter, Susanna Helena Röttinger, im bereits zitierten Gesuch um die Schutzbürgerschaft ihres Sohnes beim Magistrat Nürnberg[79]. Dabei legt sie eine ganze Reihe von Dokumenten vor, die sich zwar nicht erhalten haben, jedoch im amtlichen Protokoll aufgezählt werden[80]. Darunter befand sich offensichtlich ein Zeugnis des Glasmalers Sauterleute. Einen weiteren Hinweis auf die Mitarbeit in der berühmten Nürnberger Werkstatt gibt ein Empfehlungsschreiben, das Johann Jakob Röttinger 1872 anlässlich seiner Bewerbung für

74 BIOGRAPHISCHES LEXIKON DER SCHWEIZER KUNST 2, 1998, S. 887, Stichw. *Johann Jakob Röttinger* (Elgin Vaassen).
75 SIKART: Vaassen, letzte Änderungen 15. April 2009.
76 SA Nürnberg: C7_II_11886_03 und 04.
77 SA Nürnberg: C7_II_11886_04.
78 SA Nürnberg: C7_II_11886_05 und 06: Erläuterung: Zitat: «*Die Königliche Regierung wird angewiesen bey Vorlagen von Pässen zum längeren Aufenthalte in solche Länder, für welche nach den vorliegenden Bestimmungen für gewisse Standes-Categorien ein allgemeines Verbot besteht, behufs der etwaigen Ausnahmebewilligung nach erforderlicher Instruktion unter Einsendung der Verhandlungen an das unterzeichnete Königliche Ministerium zu berichten und hiernach das Königliche Stadtkommissariat Nürnberg anzuweisen. München, den 5. Febr. 1848.*»
79 SA Nürnberg: C7_II_11886_09, Protokoll vom 17. März 1849, Gesuch der Nadlermeisterswitwe Röttinger beim Magistrat der Stadt Nürnberg um Aufnahme ihres Sohnes J. J. Röttinger als Schutzbürger, Protokollführer Nachtigall, Antragstellerin Susanna Helena Röttinger: «*Mein Sohn J. J. Röttinger, 32 Jahre alt, welcher dahier die Glasmalerei erlernt hat, auch eine Zeitlang Gehilfe des berühmten Glasmalers Sauterleiter gewesen ist, befindet sich schon seit 5 Jahren in Zürich, wo ihm die Erlaubnis zum temporären Aufenthalt und der Ausübung seiner Kunst gegeben ist. Er hat sein Geschäft, welches das Einzige der Art in der Eidgenossenschaft ist, möglichst zu vergrößen und zu vervollkommnen versucht, so dass er gegenwärtig sein Auskommen findet [...].*»
80 SA Nürnberg: C7_II_11886_09, beigelegte (nicht erhaltene) Dokumente: «*Den Impfschein, den Schulentlassschein, den Confirmat. Schein, den Militair Entlassschein, ein [...] Zeugnis, ausgestellt von dem verstorbenen Glasmaler Sauterleiter*», ferner ein amtlich beglaubigtes Leumundszeugnis der Malerfrau Hirnschrot in Zürich, ein Leumundszeugnis, eine Niederlassungsbewilligung, ein Zeugnis über die Besteuerung seines jährlichen Erwerbs von 600 Schweizerfranken, eine amtliche Schätzung seiner «*Effecten*», ein Vermögenszeugnis bezügl. seiner Verlobten, den Zunftschein, den Schulentlassschein, den «*Tauf-, Communion- und Leumundschein*», die elterliche Einwilligung, das Übersiedlungszeugnis, das Vermögenszeugnis.

gemalte Fenster im Rütlihaus verfasste[81]. In diesem Schreiben macht er deutlich, dass er bereits Wappenscheiben für die Grabkapelle der Thurn und Taxis zu Regensburg, im Schloss Lichtenstein und an verschiedenen anderen Orten ausgeführt habe. Die Werkstatt Sauerleute in Nürnberg lieferte tatsächlich Ende der Dreißigerjahre die Glasmalereien für die Grabkapelle Thurn und Taxis zu Regensburg[82].

Aus dem von Erich Sauer im Rahmen seiner Magisterarbeit ausgearbeiteten Quellenmaterial des Fürstlichen Zentralarchivs in Regensburg geht hervor, dass 1836 der Akkord für die Glasmalereien abgeschlossen und am 30. Januar 1837 ein Protokoll über Änderungen an den Fenstern – einer Vergrößerung der Wappenmedaillons – verfasst wurde. Aus diesen Schriftstücken lässt sich ableiten, dass Johann Jakob Röttinger frühestens im Jahr 1836 bei Sauerleute gearbeitet haben wird[83]. Da jedoch 1840 immer noch über den Akkord der Wappenscheiben verhandelt wurde und Sauerleute mit seinen Arbeiten schwer in Verzug gekommen war, ist es durchaus möglich, dass Röttinger erst zu einem späteren Zeitpunkt hinzugezogen wurde[84]. Der Umstand, dass Johann Jakob in den Bauakten nicht namentlich erwähnt wird[85], erschwert eine genaue Eingrenzung seines Aufenthalts in Regensburg beziehungsweise der Mitarbeit bei Sauerleute. Nach P. Beck waren dessen Schüler Röttinger, Böhmländer und Itzel bei der Vollendung von Sauerleutes letzten Aufträgen hilfreich beigestanden. Der an einem Rückenmarksleiden Erkrankte erhielt Aufträge auf der Burg Lichtenstein für den Grafen Wilhelm von Württemberg, in der Stadt Nördlingen[86] und in Rottweil. Im bereits erwähnten Empfehlungsschreiben Röttingers für die Wappenfenster auf dem Rütli erwähnte dieser neben der Arbeit in der Gruftkapelle auch die Mitarbeit im württembergischen Schloss. So liegt die Vermutung nahe, dass Johann Jakob Röttinger bis zum Ableben seines Lehrmeisters und Arbeitgebers in der renommierten Nürnberger Werkstatt tätig war. Als Sauerleute am 21. März 1843 unerwartet verstarb[87], musste sich der junge Glasmaler wohl nach einem neuen Meister umsehen. Ob Röttinger bereits im Alter von 25 Jahren die berufliche Selbstständigkeit in seiner Heimatstadt erwog oder ob er sich gar um die Nachfolge seines Lehrmeisters bewarb, lässt sich nach jetzigem Forschungsstand nicht erschließen.

Wie jedoch schon mehrfach angedeutet, verlegte Johann Jakob Röttinger im Jahre 1844 seinen Wohn- und Arbeitsort nach Zürich.

81 ZB Nachl. Röttinger 1.144: An die Rütli Commission. *«[…] Darüber bemerke Ihnen nur, dass ich die sämtlichen Wappenfenster für Fürst Thurn u. Taxis in der Familiengruft in Regensburg, die Wappenfenster auf Schloss Lichtenstein […] ausführte. Zürich, den 18. Juni 1872.»*

82 SAUER, 2003, S. 43–44, FZA HFS 1767, 1836 V 24. Am 24. Mai 1836 wurde mit ihm [Sauerleiter] ein Vertrag geschlossen, der bis ins kleinste Detail in 31 Paragraphen die Aufgaben beider Vertragspartner regelte. Sauerleute hatte demnach auf seine Kosten zu stellen: Alle zu den 8 Gruft- und 6 Kapellenfenstern erforderlichen farbigen und anderen Gläser (einschließlich Transport), alle nötigen Farben, Oxyde, Pinsel und Öle einschließlich Hilfsarbeiter. Zitat: «Dann das erforderliche Papier und die Beischaffung der Vorbilder von den Figuren nämlich die Zeichnungen von den 12 Aposteln des Peter Fischer, eine Zeichnung von der Maria und von König David, und von den 4 Propheten nach den Figuren von Peter Fischer.» Jedes der 8 Gruftfenster solle drei verschiedene Wappen in Farbe erhalten, die vor einem damastartigen, grauen Hintergrund zu platzieren seien. Die Fenster der Kapelle sollen reich koloriert sein. (Erich SAUER, Studien zur Gruftkapelle Thurn und Taxis im Kreuzgang Sankt Emmeram, Unveröffentlichte Magisterarbeit der Phil. Fak. I der Universität Regensburg, 2003). Vgl. Abb. 1.

83 Vgl. VAASSEN, 1997, S. 164 f.

84 SAUER, 2003, Anm. 202, Ha 1840, Bericht vom 30. April 1840: Gesuch des Glasmalers Sauerleute um Erhöhung seines Akkordes: Sauerleute erneuerte sein Gesuch vom 21. Juni 1838, dem schließlich stattgegeben wurde, indem er pro Wappen 12 fl. 30 zusätzlich erhielt; FZA HFS 1770, 1836 IV 09; FZA HFS 1770, 1840 V 06.

85 Freundliche Mitteilung von Erich Sauer, Regensburg.

86 Dies bestätigte Xaver Hönle, Archivar der Pfarre Sankt Salvator: Das Chorfenster auf der Epistelseite stammt von F. J. Sauerleute und wurde 1842 gefertigt.

87 BECK, 1890, Stichw. *«Sauerleute, Franz Joseph»*, in: ALLGEMEINE DEUTSCHE BIOGRAPHIE 30, 1890, S. 770–772 [Onlinefassung].

Auswanderung in die Schweiz

Die privaten Gründe für die Übersiedlung des jungen Malers in die Schweiz sind nicht mehr zu eruieren, weil es zu seinen persönlichen Beweggründen keine Quellen gibt. Es ist zu vermuten, dass Röttinger ein Stellenangebot des Nürnberger Porzellan- und Glasmalers Johann Andreas Hirnschrot angenommen hatte, einerseits weil er sich nach dem Tode Sauterleutes ein neues berufliches Umfeld suchen musste, andererseits weil er die Herausforderung, im Ausland arbeiten zu können, wahrnehmen wollte und sich bessere Bedingungen als jene seiner Heimatstadt erwartete[88]. Nürnberg kannte keine Selbstverwaltung durch Zünfte, sondern unterstand seit 1470 der strikten Kontrolle durch das Rugamt[89]. Die konsequente Einhaltung der aufgestellten Grundprinzipien[90] erforderte Reglementierungen, die langfristig eine Erstarrung des Handwerks und den Verlust seiner Konkurrenzfähigkeit zur Folge hatten[91]. Außerdem galt in den rechtsrheinischen Regierungsbezirken Bayerns bis 1868 Konzessionspflicht, das heißt, dass bis dahin keinerlei Gewerbefreiheit bestand und strenge Monopole und andere Gewerbebeschränkungen die Entfaltung von Handel und Gewerbe stark einengten[92].

Johann Jakob Röttinger reiste also im Jahr 1844 in die Schweiz ein[93] und nahm zunächst im Atelier Johann Andreas Hirnschrots als Geselle seine Arbeit auf[94]. Seine erste Niederlassung in Zürich wird durch einen amtlich gestempelten Auszug der Einwohnerkontrolle bestätigt, der als frühestes Domizil Röttingers in der Zeit vom 7. Mai 1844 bis 3. Mai 1848 die *Kleine Stadt Nummer 7a* (Zum Talgarten) nennt[95].

Unter Anmerkung 94 wird in der handschriftlichen Aufzeichnung der Einwohnerkontrolle außerdem festgehalten, dass Röttinger in den Jahren 1846 oder 1847, nunmehr als Niedergelassener unter der Witwe des am 21. Dezember 1845 verstorbenen J. A. Hirnschrot, weiter in dessen Werkstatt arbeitete, die schließlich zwischen 1848 und 1850 liquidiert worden sein soll. Röttinger eröffnete im Jahr 1848 in der Neustadt seine eigene

88 Vgl. PARELLO, 2009, S. 113. Der Autor stellte im Rahmen seiner Forschungen über die Werkstätten in Freiburg i. Br. aufgrund der Revolutionswirren in der Jahrhundertmitte sehr schlechte wirtschaftliche Bedingungen fest. So wanderte Glasmaler Ferdinand Helmle wegen miserabler finanzieller Aussichten 1853 nach Philadelphia aus. FEULNER, 2008, S. 291: 1806 verlor Nürnberg durch die Angliederung an Bayern ihre herausragende Rolle als freie Reichsstadt. Die Stellung der Nürnberger Künstler veränderte sich nach den napoleonischen Kriegen drastisch und die staatlichen und kirchlichen Kunstförderungen flossen nur noch spärlich. Dem bei der Suche nach neuen privaten Auftraggebern ausgelösten Konkurrenzkampf versuchten die Künstler durch die Gründung entsprechender Vereinigungen zu begegnen.

89 STADTLEXIKON NÜRNBERG, 2000, S. 408, Stichw. *Handwerksordnungen* (Horst-Dieter Beyerstedt). Das Rugamt entstand aus der Teilung des Fünfergerichts und der Herren ob dem Amtsbuch.

90 Bei den Prinzipien handelte es sich neben der Bewahrung der Ratsherrschaft um die Sicherung des Auskommens für alle, Gerechtigkeit im Sinne einer Vermeidung zu großer Ungleichheit zwischen den Meistern eines Handwerks und dem Schutz überkommener Besitzstände.

91 Vgl. LEHNERT, 1983, S. 71–81.

92 STADTLEXIKON NÜRNBERG, 2000, S. 357, Stichw. *Gewerbefreiheit* (Michael Diefenbacher); GÖTZ, 1981, S. 107: Der konservative Architekt und Leiter der «Bauhütte Nürnberg» K. A. Heideloff lehnte Volkssouveränität und Gewerbefreiheit nicht nur als politische Konsequenz national fundierter Gotikrezeption ab, sondern er gewahrte mit seiner radikalen Einschätzung in der Gewerbefreiheit die Vorboten des Sozialismus, Kommunismus und des Materialismus.

93 SA Nürnberg: C7_II_11886_03, C7_II_11886_04; Zitat: *«Der erste ihm nach der Schweiz bewilligte 1844 für 1 Jahr ausgestellte Reisepass befindet sich in dem Actenband Fol. 109–115, der im Beyschluss gehorsamst überreicht wird […].»*

94 ZB Nachl. Röttinger 1.71: in der handgeschriebenen Notiz wird festgehalten, dass Joh. Jakob Röttinger seit 1844 als *«Ansäßer in Zürich»* als Geselle für Hirnschrot gearbeitet hat, der ihn als Glasmaler hierher berief.

95 ZB Nachl. Röttinger 1.192: 1. Domizil: Kleine Stadt Nummer 7a, zum «Talgarten» (seit 1865 Talacker 40), vom 7. Mai 1844 – 3. Mai 1848. 2. Domizil: Grosse Stadt Nummer 210d, «Zum grossen Erker» (seit 1865 Napfgasse 2), bei Georg Eberle, Pastetenbäcker, vom 27. April 1848 – 26. Juni 1849. Im gleichen Hause in eigener Wohnung vom 26. Juni 1849 – Ende März 1850. 3. Domizil: Grosse Stadt Nummer 150a, zum «Tannenbaum» (seit 1865 Frankengasse 25), vom 5. April 1850 – 21. April 1854. 4. Domizil: Kleine Stadt Nummer 359, zur «Königskrone» (seit 1865 Fortunagasse 36, später Nummer 40), vom 21. April 1854 – 16. September 1869. Eigentümer vor 1865. Verkauft 1869. 5. Domizil: Kleine Stadt Nummer 325a, zum «St. Paul», (seit 1865 Oetenbachgasse 13), 1869 erworben, eingezogen am 16. September 1869.

Firma[96], wobei er vermutlich Material und Einrichtung von seiner ehemaligen Arbeitgeberin übernehmen konnte.

Gründung von Werkstatt und Familie

Aus frühen Aufträgen der Werkstatt Röttinger geht hervor, dass sich Johann Jakob in der ersten Zeit seiner Selbstständigkeit mit einem Glaser namens Weiss zusammenschloss[97], der einst ebenfalls als Mitarbeiter bei Hirnschrot tätig war. Ob die Kooperation rechtlich notwendig gewesen war, weil der junge Werkstattgründer einerseits erst seit vier Jahren in Zürich ansässig und andererseits zum Zeitpunkt der Firmengründung noch nicht verheiratet war, wird in den Dokumenten nicht fassbar. Naheliegend ist ein Zusammenschluss aus praktischen Gründen, denn wie Elgin Vaassen festhielt, beherrscht ein ausgebildeter Glasmaler nicht ohne Weiteres auch die Aufgaben eines Kunstglasers[98]. Indessen wurde 1837 die obligatorische Handwerksgesellschaft aufgelöst und damit für den Kanton Zürich die Handels- und Gewerbefreiheit weitgehend verwirklicht. Daraufhin seien viele ausländische Handwerker – besonders aus dem süddeutschen Raum – in den Kanton Zürich eingewandert, weil sie dort die erstrebte Freiheit in der Ausübung ihres Berufes vorgefunden hatten, die sie zuhause vermissten[99]. Da Johann Jakob Röttinger wohl unmittelbar nach dem Tod Hirnschrots dessen Witwe in der Geschäftsführung[100] unterstützt und gemeinsam mit dem Glaser Weiss die Aufträge koordiniert haben wird, kann davon ausgegangen werden, dass die Übernahme über eine längere Zeitspanne erfolgt war und das Familienunternehmen Röttinger aus diesen Gründen das Jahr 1845 als Gründungsjahr wählte und entsprechend das 100-jährige Firmenjubiläum 1945 beging[101]. Aus einem am 23. Juli 1851 aus München an Ferdinand Keller gerichteten Brief geht hervor, dass Johann Jakob Röttinger bald seine *«Geschäfts ‚Verhältnisse' so geordnet haben wird, dass alles lästige beseitigt sein wird»* und im selben Brief berichtet er über *«[...] die*

Entfernung des Weiss, welche erst nächste Kirchweih erfolgt»[102], was auf ein unerfreuliches Arbeitsverhältnis zwischen den beiden schließen lässt.

Laut Protokoll vom 17. März 1849[103] ersuchte die Nadlermeisterswitwe Susanna Helena Röttinger beim Magistrat der Stadt Nürnberg um die Erlaubnis einer ehelichen Verbindung ihres Sohnes mit der Schweizerin Verena Fehr und dem gleichzeitigen Antrag für die Schutzbürgerschaft der Reichsstadt Nürnberg. Ein Bayer, so heißt es in der Rechtsbelehrung, konnte sich nur aufgrund einer *«von der inländischen Behörde verlangten Ansäßigmachung und Heimath-Bewilligung im Auslande trauen lassen. Jede, ohne vollständige Erschöpfung dieser Voraussetzung eingegangene Ehe wird als bürgerlich ungültig betrachtet und entzieht nicht nur, falls der Bayer eine Ausländerin heiratet, dieser sowohl, als den mit ihr erzeugten Kindern jeden Anspruch auf Heimatrechte, als auch tem-*

96 ZB Nachl. Röttinger 1. 71 und 1.192. Es wird vermerkt, dass die Etablierung als Glasmaler am 13. März 1848 erfolgte.

97 Vgl. GA Aarburg: Mappe Bauwesen, Kirchenbau 1841–1846. In einem Schreiben aus dem Jahr 1844 (Bestellung gemalter Kirchenfenster in Aarburg) wird deutlich, dass Weiss in der Werkstatt Andreas Hirnschrots beschäftigt war. Die früheste gemeinsame Nennung von *«Röttinger und Weiss»* erscheint im Vertrag mit der Pfarre Benken SG vom 1. April 1849 (ZB Nachl. Röttinger 1.17). In einem Dokument (ZB Nachl. Röttinger 1.47) wird für die Arbeit in Hauterive festgehalten, dass Weiss 1850 mit Röttinger zusammengearbeitet habe (*«la maison Röttinger et Weiss à Zürich»*).

98 ZB Nachl. Röttinger 1.170: Textentwurf für Lexikon (E. Van Treeck-Vaassen).

99 ZB Nachl. Röttinger 1.53: NZZ, 15. September 1966, Blatt 5, Abendausgabe Nr. 3890 (Zürcher Lokalchronik): Die Formulierung der Zeitung lautete: *«Was hingegen sehr rasch zum Hauptproblem wurde, war das Eindringen kantonsfremder und auch ausländischer Handwerker in den Kanton Zürich. [...] Die Handels- und Gewerbefreiheit wirkte auf sie wie ein Magnet. Diese Tatsache mag wohl einerseits zu einer Blutauffrischung im Handwerk geführt haben, bewirkte aber auch das spürbare Anwachsen des Konkurrenzkampfes [...].»*

100 SA Nürnberg: C7_II_11886_07: Im vom Königreich Bayern 1847 ausgestellten Heimatschein wird bestätigt, dass J.J. Röttinger, Zitat: *«[...] sich dermalen als Glasmaler und Geschäftsführer zu Zürich in der Schweiz aufhält, [...]»*

101 ZB Nachl. Röttinger 1.51.

102 StAZH W I 3 AGZ 174 12, Müller-R 1851–58, 194/1851.

103 Vgl. Anm. 79.

porär ein[en] Aufenthalt in dem Königreich Bayern, sondern unterwirft auch denjenigen, welcher eine solche Ehe im Auslande geschlossen hat, bei seiner Rückkehr nach Bayern dem maxim der polizeilichen Arreststrafe»[104]. Der Heimatschein wurde im November 1847 ausgestellt, besaß drei Jahre Gültigkeit und war daher immer wieder zu erneuern[105]. Verena Fehr, Bürgerin von Ossingen, wurde demnach durch ihre kirchliche Heirat mit Johann Jakob Röttinger im Juni 1849 bayerische Staatsbürgerin[106], wie auch die aus der Ehe entstandenen Kinder bis zum Jahre 1863 rechtlich Bayern waren, bis Röttinger im Herbst 1863 das Zürcher Kantons- beziehungsweise Stadtbürgerrecht der Stadt Zürich erhielt[107]. Wichtige Forderung beim Heimatrecht beziehungsweise der Erlangung der Schutzbürgerschaft war neben der Vorlage sämtlicher Ausweise und Dokumente die Bescheinigung der Vermögenslage. Die Mutter des Gesuchstellers legte deshalb beim Magistrat Nürnberg eine ganze Reihe von Ausweispapieren vor, die sich leider nicht erhalten haben. Zitat: «*Nach den Zeugnissen Nr. 11 und 12 besitzt mein Sohn ein Vermögen von 1000 Fr. bestehend in 400 baar und in einem Effectenwerth von 600 Fr., was er sich lediglich zusehonds gespart hat. Seine Verlobte Fehr hat nach dem Zeugnis Nr.18 ein baares Vermögen von 300 Fr. und ihre Aussteuer ist 200 Fr. werth. Schließlich lege ich noch eine schriftliche Vorstellung meines Sohnes vor, in welcher er in einem Postscript bezüglich seiner Erwerbsverhältnisse bemerkt, dass jener durch das Zeugnis Nr. 14 der Versteuerung eines jährlichen Erwerbs von 600 Schweizerfranken nachgewiesen ist, dass er aber seit der Zeit seiner Niederlassung in Zürich, bei welcher dieses Einkommen liquidiert wurde, das Geschäft so vervollkommnet habe, dass es jetzt jährlich 1000 Schweizerfranken oder 687 Gulden beträgt*»[108]. Die kirchliche und somit im Staate Bayern gültige Trauung erfolgte also am 25. Juni 1849[109] im Grossmünster, nachdem die erstgeborene Tochter, benannt nach ihrer Großmutter, Susanna Helena, am 8. Mai 1849 in Zürich zur Welt gekommen war[110].

In der Schweiz galten zu dieser Zeit ähnliche gesetzliche Regelungen und die obligatorische zivilrechtliche Trauung wurde erst ab 1876 eingeführt[111].

Künstlerische Entwicklung und Stilbildung

Nürnberg – Albert Reindel

Die Jahre in der Zeichen- beziehungsweise Kunstgewerbeschule, die Lehr- und Gesellenjahre bei Sauterleute und später bei Hirnschrot, also etwa 1831 bis 1845, sind für den jungen Glasmaler Röttinger Zeiten, die seinen künstlerischen Stil maßgeblich geprägt haben. Danach wird mit einer intensiven Schaffensperiode zu rechnen sein, in

104 SA Nürnberg: C7_II_11886_08.
105 SA Nürnberg: C7_II_11886_21, C7_II_11886_22, C7_II_11886_23.
106 SA Nürnberg: C7_II_11886_20, vgl. Anm. 109.
107 ZB Nachl. Röttinger 1.38; Kantonsbürgerrecht 10. Oktober 1863, Bürger der Stadt Zürich 19. November 1863.
108 SA Nürnberg: C7_II_11886_11.
109 SA Nürnberg: C7_II_11886_7, 8, 17 (Copulationsanzeige des Grossmünsters in Zürich). Eine zivilstandesamtliche Trauung hat es in Bayern bis zur Einführung der reichseinheitlichen Personenstandsgesetzgebung 1876 nicht gegeben. Wollte ein Bayer, der sich im Ausland aufhielt, seine Heimatrechte auch bei Heirat behalten (wie dies bei J. Röttinger offensichtlich der Fall war), musste die Ehe (auch im Ausland) nach den einschlägigen bayerischen Vorschriften, die eine durch die zuständigen Behörden genehmigte kirchliche Trauung vorsahen, geschlossen werden. (Freundliche Auskunft von Herbert Schmitz, Stadtarchivar in Nürnberg, vom 2. Dezember 2010). «Ungereimtheiten» der Daten entstanden durch die im Nachlass der Röttinger (Zentralbibliothek Zürich) erhaltenen Dokumente, einen Familienschein sowie einen Auszug der Einwohnerkontrolle, welche die Heirat am 23. Juli 1848 bescheinigen. Sicherheit brachte schließlich der Blick in das Tauf- und Ehebuch des Grossmünsters 1818–1856 (Sign. VIII.C.9), das eindeutig das Datum der Eheschließung am «*25. VI. 1849*» bestätigt (mit Dank an Max Schultheiss, Leiter Abt. Archivierung und Recherche, StadtA Zürich) sowie der Eintrag im Bürgerbuch der Gemeinde Ossingen StAZH E III 86.8 S. 32. Das Rätsel um die beiden Hochzeitsdaten bleibt hingegen weiterhin bestehen, notiert doch Verena Röttinger in einer handschriftlichen Aufstellung vom 18. Februar 1877: «*1848 haben wir uns verehelicht wie folgt mit J. Jakob Röttinger v. Nürnberg, Baiern 23. Juni [...]*» (ZB Nachl. Röttinger 1.184, 1.178).
110 SA Nürnberg: C7_II_11886_17, C7_II_11886_18.
111 WEISS, 1989, S. 132.

37

der er sich vermehrt mit dem Aufbau und der Etablierung seiner Werkstatt zu beschäftigen hatte.

Der zeitgleich zu Röttingers Schulaufenthalt amtierende Direktor der Kunstakademie, Albert Christoph Reindel (1784–1853) aus Nürnberg, war ein bekannter Kupferstecher, welcher nach seiner Lehre bei Heinrich Guttenberg (1749–1818) mit diesem nach Paris ging, um dort seine Kenntnisse zu erweitern und zu verfeinern. Nach wichtigen Aufträgen in Paris beschäftigte sich Reindel im Anschluss an seine Rückkehr in die Heimatstadt vor allem mit Werken der Vergangenheit, insbesondere mit den zwölf Aposteln von Peter Vischers Grabmal zu Sankt Sebaldus[112]. Dies geschah kurz bevor der junge Röttinger in die Nürnberger Kunstschule eintrat. So ist es naheliegend, dass die Kupferstiche des Direktors sowohl in der Zeichenschule wie auch in der Akademie als Vorlagen benutzt worden sind. Ebenso haben wohl die mittelalterlichen Kirchen Nürnbergs, Sankt Sebaldus, Sankt Lorenz und die Frauenkirche mit ihren gemalten und plastischen Kunstwerken sowie den Glasmalereien auf den jungen Künstler Einfluss genommen. Reindel hat – wie alle Kupferstecher dieser Zeit – vorzugsweise Vorlagen Albrecht Dürers verwendet. Daher kann davon ausgegangen werden, dass die Graphiken Dürers allgegenwärtige Vorbilder waren, die den Absolventen der Kunstschule als Lehrmittel gedient haben. So hat Hans Hoffmann bereits 1942 auf die stilistische Ähnlichkeit der Apostel Röttingers im Grossmünster[113] mit den «Vier Aposteln» Dürers von 1526 hingewiesen[114].

Regensburg – Franz Joseph Sauterleute – Carl Alexander Heideloff

Weitere Berührungspunkte mit Apostelfiguren aus der Dürerzeit, nämlich mit Peter Vischers Sebaldusgrab beziehungsweise mit den davon angefertigten Kupferstichen Albert Reindels, hatte Johann Jakob Röttinger im Rahmen seiner Arbeit als Gehilfe bei Franz Joseph Sauterleute. Wie bereits

ausgeführt, hielt sich Sauterleute bei der Gestaltung der Fenster für die Grabkapelle der Thurn und Taxis zu Regensburg eng an die Kupferstiche des Kunstschuldirektors[115]. Die dort abgebildeten Apostelfiguren sowie die Figuren König Davids, der Muttergottes und der vier Propheten sind Nachbildungen der Reindelschen Kupferstiche, was aus einem Bericht im Fürstlichen Zentralarchiv zu Regensburg hervorgeht[116]. Sauterleute habe demnach für die Erstellung der Entwürfe zwölf Apostelfiguren aus dem Stichwerk ausgeschnitten, diese auf Zeichenpapier geklebt und koloriert[117]. Erich Sauer verglich im Rahmen seiner Forschungsarbeit über die Grabkapelle die entsprechenden, in den Plansammlungen des Fürstlichen Zentralarchivs erhaltenen Zeichnungen[118], die nach Art des dreiteiligen spätgotischen Altars mit Mensa, Retabel und Gesprenge aufgebaut sind, mit den Figuren des nordwestlichen Fensters und

112 STADTLEXIKON NÜRNBERG, 2000, S. 879, Stichw. *Reindel Albert (eigentlich Albrecht) Christoph* (Matthias Mende); Das Dürer-Stammbuch von 1828, hrsg. von den Museen der Stadt Nürnberg, AK 4 Dürerhaus 1973; Deutsches Kunstblatt 1819–1872, Nr. 14, 1853, S. 117–118. Weitere Werke Reindels sind erwähnt im ALLGEMEINEN KÜNSTLERLEXIKON 2. Theil, 1810, Abschnitt 5, S. 1229, Stichw. *Reindel oder Reimdel (A.C.)*.

113 ZB Ms.T111.5: Actum vom 5. April 1852: Die Entwürfe für die Chorfenster stammen vom Nürnberger Glasmaler Georg Kellner und sind am 5. April 1852 von einer Kommission begutachtet worden.

114 HOFFMANN, 1942, S. 263. SCHEIWILLER, 2007 (unveröffentlichte Lizentiatsarbeit). GERSTER, 2012, S. 8.

115 SAUER, 2003, S. 43. Vgl. die Abb. 26, 27, 30.

116 SAUER, 2003, S. 43: Anm. 203: FZA HFS 1770, 1836 IV 09, Zitat: «Die Glasmaleryen wurden nach der ursprünglichen Skizze hergestellt und selbst die Wahl der Farben, von der Architektur, die der mitunterzeichnete Domainenrath Keim bestimmte und worüber die Skizzen noch vorliegen, und von den 12 Aposteln, die der Glasmaler Sauterleute bestimmte und solche auf die von dem Kupferstecher Albert Rindel gefertigte Kupferstiche mit Waßerfarben angab, – von den 4 Propheten, den König David und der Maria hat der Glasmaler Sauterleute keine gemalten Skizzen gemacht – strenge beibehalten.»

117 Sauer bezieht sich hier auf: GROBLEWSKY, 1986, S. 114, Anm. 28.

118 SAUER, 2003, Abb. 17, S. 69 (FZA Plansammlung Nr. 1, Längsschnitt der Gruftkapelle: Entwurf-Zeichnung aquarelliert von Carl Keim).

stellte weitgehende Übereinstimmung fest[119]. In-
wieweit Johann Jakob Röttinger als Gehilfe in die
Gestaltung der Kapellenfenster eingebunden war,
lässt sich in den Quellen nicht nachvollziehen. Das
im Nachlass Röttinger erhaltene Empfehlungs-
schreiben des Glasmalers an die Kommission für
das Rütlihaus[120] beinhaltet lediglich dessen Emp-
fehlung bezüglich der Ausführung der Wappen-
scheiben im Gruftraum (Abb. 1)

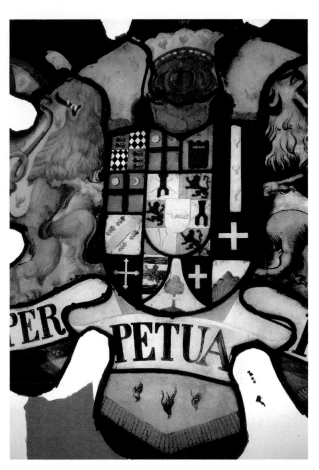

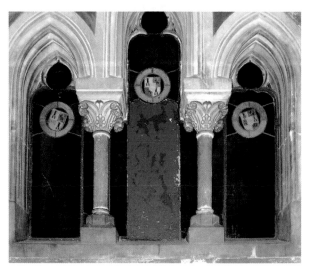

1. Franz J. Sauerleute/Johann Jakob Röttinger, Wappen-
scheiben im Gruftraum, Regensburg, Gruftkapelle Thurn und
Taxis, ca. 1841.

2. Franz J. Sauerleute/Johann Jakob Röttinger(?), Wappen-
scheibe in der Gruftkapelle Thurn und Taxis, Regensburg,
1837–1843.

und lässt offen, ob er auch bei der Herstellung der
Wappen in der Kapelle (Abb. 2), der Figuren oder
der Architekturelemente mitgewirkt habe. Erich
Sauer erwähnt in seiner Arbeit die vertragliche
Forderung der Auftraggeber, die Wappenfenster
«damastartig grau in grau» zu halten[121]. Heute
präsentieren sich diese jedoch in einem dunkelrot
marmorierten Überfangglas, was den Autor an
Schinkels Luisen-Mausoleum erinnerte. Für die
24 Wappenschilder sind keine Entwürfe mehr
vorhanden. Offensichtlich habe der Sohn des
Architekten Keim, der damals zusammen mit Carl
Alexander Heideloff die Planung der Gruftkapel-
le innehatte, Karl Keim, ebenfalls Architekt, am
1. November 1912 die Skizzen der Wappenfenster
zusammen mit einem Unterstützungsgesuch an
das fürstliche Zentralarchiv (FZA)[122] übersandt,

die heute jedoch als verloren gelten[123]. Das Besonde-
re an diesem Auftrag ist wohl die für die Familie
Thurn und Taxis außerordentliche Bedeutung der

119 SAUER, 2003, S. 44, vgl. Abb. 38 bei Sauer S. 88 (Gruftka-
pelle Thurn und Taxis: Entwicklungsstadien der Glasma-
lerei am Beispiel des NW-Fensters mit den Aposteln Ja-
kobus major, Thaddäus und Andreas (n IV): Sauer stellt
eine Abbildung der drei Apostelfiguren von Vischers
Sebaldusgrab sowie die Stiche von A. Reindel, also jene
drei Apostelfiguren, die Sauerleute ausgeschnitten und
koloriert haben soll, den Glasmalereien Sauerleutes ge-
genüber). Vgl. dazu auch die Gegenüberstellung der
Darstellungen des Apostels Petrus: Abb. 26–29.
120 ZB Nachl. Röttinger 1.144, vgl. Anm. 81, 789.
121 SAUER, 2003, S. 45.
122 Fürst Thurn und Taxis Hofbibliothek und Zentralarchiv,
Regensburg.
123 SAUER, 2003, S. 45 u. 46, bes. Anm. 216: Erich Sauer
stellte in diesem Zusammenhang Ungereimtheiten fest.

Wappenscheiben. Dies geht schon daraus hervor, dass der Schriftwechsel zu den Wappenbildern in den Akten ungewöhnlich umfangreich ausfiel[124]. Diese Auffälligkeit und der Umstand, dass nachträglich – als schon einige der Wappenscheiben fertig waren – eine Vergrößerung derselben verlangt wurde, brachte Sauer mit Groblewski[125] zu dem Schluss, dass sich die Fürsten von Thurn und Taxis als «Emporkömmlinge» mittels Zeremoniell und Präsentation als Reichsfürsten zu legitimieren versuchten, zu Zeiten als die von ihnen gepflegte universale Reichsidee bereits überholt war. Die augenfällige heraldische Selbstdarstellung unterstreicht dieses Verhalten. Röttinger, der offensichtlich bei seinem Arbeitgeber ein großes Vertrauen genoss, war mit Recht stolz auf den Auftrag, der an Sauerleute ergangen war und setzte die Arbeit noch später gerne als Empfehlung ein.

Elgin Vaassen beschreibt die Fenster der Gruftkapelle als extrem bunt[126], da gemäß Sauerleutes Arbeitsweise starke Farbgläser ohne viel Abstufung durch deckende Bemalung nebeneinander gereiht wurden. Er verwendete alle damals bei der Glasherstellung zur Verfügung stehenden Farbtöne. Dies sei nicht erstaunlich, so Vaassen, da die Vorbilder aus der Dürerzeit, die seinerzeit vorherrschten, ebenfalls kräftige Farbzusammenhänge favorisierten. Selbst unter Berücksichtigung der wegen Korrosion fehlenden Malschichten spricht sich die Autorin für die plakative Wirkung des Nürnbergers aus, weil die feinen Farbnuancen fehlen, die die Münchner Schule hervorzubringen vermochte. Johann Schraudolph, Vertreter der Münchner Schule und Entwerfer der Kartons für München-Au, differenzierte die oft kritisierte plakative Buntheit, indem er mit einer Erweiterung des künstlerischen Repertoires hinsichtlich seiner Vorbilder aufwartete[127]. P. Beck verweist auf die stilistischen Ähnlichkeiten Sauerleutes mit Glasmaler Michael Frank, als dessen «Nachfolger» er bezeichnet wurde. Letzterer verfolge daher das Prinzip höchstmöglicher Durchsichtigkeit, indem er mit Schwarzlot auf farbigem Glas zeichne, statt das Glas mit den Mitteln der Malerei zu gestalten[128]. Positiv formuliert sind die Glasmalereien in der Gruftkapelle,

die tatsächlich im starken Gegensatz zu jenen in der Münchner königlichen Glasmalereianstalt hergestellten Scheiben stehen, als expressiv und farbenfroh zu bezeichnen. Die polychrome Gestaltung gibt den Figuren eine Frische, die über die Regungslosigkeit hinwegtäuschen, der monofigurative Glasmalereien häufig verhaftet sind (Abb. 3).

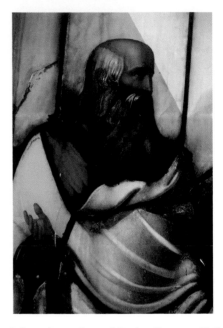

3. Franz J. Sauterleute, Apostel Paulus, Fenster s II, Regensburg, Gruftkapelle Thurn und Taxis, 1837–1843.

Den kompetenten Umgang mit Farben wird man dem gelernten Porzellanmaler und Vergolder, der nach fundierter vierjähriger Ausbildung sieben Jahre in der Porzellanmanufaktur Ludwigsburg als Obermaler, Farbenlaborant und Glasmaler gewirkt hatte, zugestehen müssen[129]. Erich Sauer verteidigt

124 SAUER, 2003, S. 46, Anm. 217.

125 SAUER, 2003, S. 47 mit Verweis auf Anm. 7, S. 2: GROBLEWSKI, 1986, S. 99–132.

126 VAASSEN, 1997, S. 164f.

127 JÖCKLE, 2012, S. 30, Schraudolph verwendete neben der Orientierung an die italienische Renaissance bzw. die deutschen Alten Meister auch Farbeffekte von Tintoretto und Tizian sowie Elemente aus der Barockmalerei (Lichteffekte nach Caravaggio), um dadurch einen sinnlicheren Ausdruck zu erzielen. Vgl. Anm. 356, 362.

128 BECK, 1890, Stichw. *Sauterleute, Franz Joseph*, S. 770–772 [Onlinefassung].

129 FLACH, 1997, 936 ff.

4. Johann Jakob Röttinger, Wappenscheibe Bayern, Schloss Lichtenstein, Baden Württemberg, nach 1837.

zum Abschluss seines Kapitels die Glasmalereien Sauterleutes in der Gruftkapelle. Er würdigt dessen Werk, indem er die Technik hervorhebt, die sich von der Münchner Glasmalereitechnik durch die Verwendung möglichst durchgefärbten Glases unterscheidet. Die ungebrochene Buntheit, die (zu) großen Farbflächen und vor allem die gut sichtbaren Windeisen und Stehbolzen wirkten störend[130]. Ohne an dieser Stelle bereits auf Stil und Technik Johann Jakob Röttingers genauer eingehen zu wollen, ist darauf hinzuweisen, dass bei dessen Glasmalereiwerken eine relativ starke Farbigkeit nicht zu leugnen ist. Bernhard Anderes bemerkte dies im Kunstdenkmälerband des Kantons Sankt Gallen, als er die Wappenscheiben Röttingers im Rathaus zu Rapperswil SG beschrieb. Darin bezeichnete er den Wappenzyklus als sehr ansprechend, wenn auch etwas bunt[131].

Schloss Lichtenstein – Nördlingen – Rottweil

In den Briefen der ausführenden Architekten, Carl Alexander Heideloff (1789–1865) und dessen Eleven Georg Eberlein, der mit den Entwürfen für die Ausstattung des romantischen Schlosses Lichtenstein in Baden Württemberg betraut war, werden die Glasmaler Franz Joseph Sauterleute und Friedrich H. Pfort aus Regensburg, ein Schüler des Ersteren, genannt. Christian Bührlen aus Ulm — ebenfalls ein Lehrling Sauterleutes — dürfte die Rolle des Kunstglasers übernommen haben[132]. Aus der Empfehlung Röttingers, die schon mehrmals angeklungen ist, geht auch hervor, dass er es war, der sich einmal mehr für die Ausführung der Wappenscheiben verantwortlich zeichnete. Elgin Vaassen erwähnt hübsche Wappen, die in den Nonnenköpfen der kleinen spitzbogigen Fenster sitzen, platziert auf hellem und mit Schwarzlot beziehungsweise Silbergelb gemalten Rankengrund[133]. Ganz ähnlich gestaltete Johann Jakob Röttinger 1855 die Geschlechterwappen (Abb. 5) im Ratssaale zu Rapperswil SG.

130 SAUER, 2003, S. 47. Die Untersuchung der Fenster in der Werkstatt (Bayerische Hofglaserei Gustav van Treeck, München) zeigte, dass die Windeisen gebogen und entlang der Bleiruten geführt wurden (Abb. 143).
131 ANDERES, 1966, S. 360.
132 VAASSEN, 1997, S. 50f.
133 VAASSEN, 1997, S. 53. Die Autorin schreibt die Wappenscheiben allerdings Friedrich Pfort (1816–1868) zu. Ich danke Elgin Vaassen für das Diapositiv.

41

5. Johann Jakob Röttinger,
Familienwappen Fornaro und
Schneider, Rathaus, Ratssaal,
Rapperswil SG, 1855.

Dort mussten aus Platzgründen in jede Scheibe, ebenfalls mit als Nonnenkopf bezeichnetem Maßwerk, zwei Wappen eingefügt werden. Wie in Lichtenstein (Abb. 4) setzte er diese auf helles Rankenmuster, die mit den kleinen Schilden einen ansprechenden Kontrast bilden. Im Jahr 1837 erwarb Wilhelm Graf von Württemberg das damalige Jagdschlösschen seines Vaters und ließ angeregt durch den Roman «Lichtenstein» von Wilhelm Hauff eine deutsche Ritterburg im mittelalterlichen Stil errichten. Der Bauherr als erster Vorsitzender des württembergischen Altertumsverbandes und der Nürnberger Architekt Heideloff[134], der zugleich auch den Denkmalkult[135] pflegte, ergänzten einander in der Planung und Entwicklung des historistischen Bauwerks.

Aus Nördlingen erhielt die Werkstatt Sauterleute einen weiteren Auftrag. Die Salvatorkirche, die nach der Reformation erstmals 1825 wieder als katholisches Gotteshaus genutzt wurde, war in der Folge sukzessive den liturgischen Bedürfnissen anzupassen. 1842 bekam Sauterleute das Mandat für die Ausführung eines großen Chorfensters auf der Epistelseite (s II)[136]. Das dreilanzettige Maßwerkfenster zeigte Tabernakelarchitekturen und im Bereich von 5b, 6b den segnenden Christus als Patron der Kirche «Salvator». Obwohl die Chorfenster die beiden Kriege unbeschadet überlebt haben sollen, sind diese anlässlich einer Renovation in den Fünfzigerjahren des 20. Jahrhunderts

134 BOECK, 1958, S. 319.
135 HEINIG, 2010 (Rezension der Monographie über Heideloff von Andrea Knop): Unter dem Begriff des Denkmalkults subsumieren sich Rittertum, Patriotismus, Herrschaftslegitimation und Religion.
136 BECK, 1890, wie Anm. 128; Abb. in: VAASSEN, 1997, Tafel 69, Abb. 118.

ersetzt worden. Überreste der Fenster, die eine Rekonstruktion zulassen würden, sind nicht mehr vorhanden[137]. Beck erwähnt zwar die Mitarbeit von «Rettinger, der nachmals in Zürich die Glasmalerei betrieb»; welcher Art jedoch die Mitarbeit war, geht daraus nicht hervor.

Im August 1841 brachte Architekt Carl A. Heideloff für die Ausführung der fünf Chorfenster in der Rottweiler Heiligkreuzkirche, deren Restaurierung er als Denkmalpfleger leitete[138], neben der Glasmalerfamilie Kellner auch Franz Joseph Sauterleute ins Spiel. Dieser solle zusammen mit seinem Schüler Pfort einen Teil der Fenster (in S II den figurativen Teil – Beweinung, Auferstehung und Himmelfahrt – sowie ein Weihnachtsfenster (N II) und acht Rosenfenster im Chor) in Auftrag nehmen. Einerseits durch die zeitlich parallele Beauftragung in Nördlingen, von der die Verantwortlichen in Rottweil offenbar nichts gewusst hatten, andererseits durch Krankheit Sauterleutes verzögerte sich die Fertigstellung der Fenster. Als der Meister im März 1843 verstorben war, erboste sich Heideloff über die Gehilfen Sauterleutes und bezeichnete sie als «schlechte Porzellanmaler, welche nur nach Rottweil gekommen waren, um sich Geld geben zu lassen [...]»[139]. Welche Gehilfen der Architekt dabei angesprochen hatte, geht aus den Briefen nicht hervor. Elgin Vaassen zitiert Quellen bezüglich der neugotischen Farbverglasung der Stiftskirche Stuttgart, wo Röttinger und Itzel von Nürnberg namentlich genannt werden, «die Glasmalereien für die Kirche von Rottweil übernommen zu haben». Offensichtlich waren die beiden jungen Glasmaler nach dem Tode Sauterleutes im Gespräch, zusammen mit einem «tüchtigen Künstler aus München», mit den Arbeiten in Stuttgart beauftragt zu werden[140]. In Rottweil bemerkenswert ist die farbig intensive Gestaltung der Chorfenster, die nach Heideloffs Willen dem Chor ein «mystisches Dämmerlicht verleihen» sollte[141].

Frühe künstlerische Prägung

Zusammenfassend ist zu konstatieren, dass an drei Bauwerken – der Gruftkapelle zu Sankt Emmeram in Regensburg, zu Rottweil und im Schloss Lichtenstein – Hinweise für die Mitarbeit J. Röttingers gegeben sind. Architekt Carl A. Heideloff hatte jeweils leitend, wie in Lichtenstein und Rottweil, oder unterstützend, wie in Regensburg, seine Hände im Spiel. Als Maler, Architekt und Entwerfer von Glasmalereien nahm er stets Einfluss auf die künstlerische Gestaltung, welche er in jedem Fall in einem konservativ historisierenden Stil auszuführen wusste. Als Professor an der polytechnischen Schule Nürnberg von 1822–1854 machte er sich vor allem um die Restaurierung altdeutscher Bauwerke verdient[142]. Sowohl er wie auch Sauterleute lehnten sich in ihrer Kunst dem so genannten alten deutschen Stil[143] an, also der deutschen Kunst und Kultur des 15. beziehungsweise frühen 16. Jahrhunderts. Die alte deutsche

137 Freundliche Mitteilung von Xaver Hönle, PA Sankt Salvator, Nördlingen. VAASSEN, 1997, S. 374, Quellenangabe: Nördlingen kath. PA Salvator: Acta des königl. Stadtkommissariats Nördlingen: Herstellung der kath. Kirche betr ; Acta der kath. Kirchenverwaltung N., betr. des Ausbaus der kath. Kirche 1841–1893. Mittels der Übersichtsfotografie (Abb. in: VAASSEN, 1997, Tafel 69, Abb. 118.) des Chors in Nördlingen, Salvatorkirche sind exakte Vergleiche nicht möglich. Vgl. VAASSEN, 2007, S. 30.

138 GÖTZ, 1986, S. 543; BOECK, 1958, S. 322.

139 VAASSEN, 1997, S. 166, Anm. 69: E. Vaassen zitiert nach E. Mack, Briefe Heideloffs; Abb. in: VAASSEN, 1997, Tafel 29, Abb. 51. Rottweil, Hl. Kreuzkirche, Chor (N II), Verkündigung an Maria/die Hirten, 1842, F.J. Sauterleute.

140 VAASSEN/NIEDERHUBER, 2004, S. 303, zitiert nicht publizierte Quellen nach: Hauptstaatsarchiv Stuttgart, E 14 Bü 1078 ff. (Stiftskirche Verglasung, Juni 1843). Es sollte jedoch noch eine Weile dauern, bis die Arbeiten in Stuttgart begonnen werden konnten, so dass eine Mitarbeit J. Röttingers beinahe auszuschließen ist (Arbeitsantritt in der Schweiz im März 1844).

141 BOECK, 1958, S. 324.

142 WESSELY, 1880, Joseph Eduard Wessely, «Heideloff, Karl Alexander von», in: ALLGEMEINE DEUTSCHE BIOGRAPHIE 11 (1880), S. 299–330 [Onlinefassung]; vgl. SAUER, 2003, S. 42–47; SENG, 1995, S. 56; BOECK, 1958, S. 324.

143 LDK 1, 2004, S.127/128, Stichw. Altdeutsch.

Kunst wurde von den Romantikern als Zeugin einer großen Vergangenheit, als Zeichen ihres ausgeprägten Patriotismus und der rückwärtsgewandten, konservativen Sichtweise idealisiert. Heideloff meint mit der romantischen Kategorie die altdeutsche Architektur und ihre Fähigkeit an phantasievolle und christliche Werte der Gotik zu erinnern[144]. Die gewollt intensive Farbwirkung der Glasmalereien, die Heideloff konzipiert hat, zeigt freilich Auswirkungen auf die Stilbildung des jungen Glasmalers Röttinger. Nicht umsonst gewahrte er sich selbst im Kreise der Spätnazarener[145], die sich wie ihre berühmten Vorbilder, dem Künstlerkreis um Friedrich Overbeck, neben der religiösen Bindung vor allem durch die Verehrung der frühitalienischen und altdeutschen Kunst auszeichneten. Daraus ergeben sich kunsttheoretische Verbindungen in Bezug auf den Einsatz von Farben, der Flächenwirkung und der Hervorhebung des Linearen[146]. Die Forscherin Sabine Fastert zitiert eine Notiz des Auftraggebers der Fresken in der Münchener Ludwigskirche, König Ludwig I., der 1841 etwas enttäuscht konstatiert, dass der Nazarener Peter Cornelius zwar «ein Meister der Zeichnung und der Komposition sei, aber kein Maler»[147]. So verurteilte auch Wilhelm Schadow (1788–1862) die «fast nur aus Contouren bestehenden, magern und trockenen Figuren des 12. und 13. Jahrhunderts als Typus des Christentums», der den Nazarenern als Vorbild galt[148]. Die spezielle Technik der Glasmalerei macht Konturen und Binnenzeichnungen besser sichtbar; durch Bleiruten, Schwarzlotmalerei oder schlichtweg durch die angrenzenden Farbflächen werden Umrisse deutlicher hervorgehoben. Die Umsetzung des nazarenischen Zeichen- und Malstils auf das Medium Glas bietet sich daher an. Möglicherweise ist der Eintrag in das Schweizerische Künstler-Lexikon[149], dass Johann Jakob Röttinger Studien an der Kunstakademie Düsseldorf betrieben hätte, die ab 1826 unter der Leitung des Spätnazareners Friedrich Wilhelm Schadow stand, aus solchen stilistischen Überlegungen entstanden. Schadows nazarenische Bindungen, mit denen er jedoch durchaus kritisch umzugehen wusste[150], sowie seine Orientierung

an der Historienmalerei ermöglichten eine Kunst, die gleichsam poetisch war und sich der Naturnähe und Farbe verschrieb[151]. Ebenfalls in der «altdeutschen Zeichnungsmanier»[152] verhaftet war der erwähnte, als Mitarbeiter Sauterleutes nachweisbare Porzellan- und Glasmaler Friedrich H. Pfort (1816–1868) aus Regensburg, der spätestens in Lichtenstein mit Röttinger zusammengearbeitet haben muss. Der 1818 in Erlangen geborene Leopold Itzel und der Nürnberger Chr. Philipp Böhmländer (1809–1893) waren als Schüler Sauterleutes[153] in Lichtenstein, Nördlingen und Rottweil beschäftigt und dürften dort gemeinsam mit Johann Jakob Röttinger gearbeitet haben[154]. Mit der Münchner Glasmalerei hingegen kam Röttinger spätestens 1844 in Berührung, als er die bayerische Metropole das erste Mal besuchte[155].

144 HEINIG, 2010 (Rezension von Andrea Knop); vgl. GRENTZSCHEL, 1989, Tafel 1, Abb. 1 u. 2: Oschatz Ägidienkirche, Altar nach Entwurf von C.A. Heideloff, 1849.

145 Nach einer mündlichen Überlieferung im Familienkreis (freundliche Auskunft Dr. Rudolf H. Röttingers).

146 WEDDIGEN, 2003, S. 25–34. Die Zeichnung stellte den gemeinsamen Nenner für die Architektur, Skulptur und Malerei dar – im so genannten Paragone-Streit werden die Skulptur und die Malerei als Zwillingsschwestern desselben Vaters, des Disegno, bezeichnet. Von Zuccaro als «segno di Dio», als Funken Gottes und somit als Fundament jeder Wissenschaft, benannt.

147 Vgl. FASTERT, 2010, S. 291 f.

148 GREWE, 1998, zitiert nach Schadows «Jugenderinnerungen» (in: Kölnische Zeitung von 1891, Nr. 717), S. 127.

149 SCHWEIZERISCHES KÜNSTLER-LEXIKON 2, 1908, S. 661, Stichw. Röttinger, Johann Jakob (H. Appenzeller).

150 GREWE, 1998, S. 123–132.

151 HABERLAND, 2012, S. 47; LDK 2, 2004, S. 245 ff., Stichw. Düsseldorfer Malerschule.

152 VAASSEN, 1997, S. 53, zitiert nach K. Ehrlich (VAASSEN, 1997, Anm. 66, S. 304).

153 VAASSEN, 1997, S. 167.

154 Vgl. Kap. ‹Lehr- und Arbeitsplätze in der Heimat, Reisepläne› bzw. ‹Aktuelle Vorbilder – frühes künstlerisches Umfeld Röttingers – Nazarener›. VAASSEN/NIEDERHUBER, 2004, S. 303.

155 StAZH, W I 3 AGZ 174 12, Müller-R 1851–58. 1852 besuchte er München von der Schweiz aus und verwies in einem Brief an Ferdinand Keller auf seinen ersten Besuch vor acht Jahren, also wohl bevor er im Mai 1844 in die Schweiz eingereist war. Frühere Aufenthalte in München werden nicht aktenkundig.

6. Johann A. Hirnschrot, Lünettenengel 36.2×96.4cm (signiert), ehemals Augustinerkirche Zürich, 1844, SNM, Depot Affoltern am Albis (LM-30157).

Zürich – Johann Andreas Hirnschrot

Der gebürtige Nürnberger Johann Andreas Hirnschrot (1799–1845) erlangte Bekanntheit als Porträt-, Email- und Glasmaler und ließ sich 1828 in Zürich nieder[156]. Wie Röttinger besuchte er die Nürnberger Kunstakademie[157], arbeitete anschließend in der Porzellanmanufaktur Sèvres und betätigte sich in der Folge als Porträtmaler in Genf, Bern, Aarau und Zürich. Reisen nach München und Nürnberg regten ihn offensichtlich dazu an, sich der Glasmalerei zuzuwenden[158]. Von seinem glasmalerischen Werk hat sich nur wenig erhalten. So wird im Schweizer Landesmuseum eine von Hirnschrot signierte Lünette mit einer Engelsdarstellung (Abb. 6) aufbewahrt[159], die ursprünglich das Nordportal der Augustinerkirche in Zürich zierte.

Im Gemeindemuseum zu Aarburg haben sich eine Anzahl von Wappenscheiben Aarburger Geschlechter sowie Fragmente der früheren Verglasung der evangelischen Stadtkirche erhalten. Auch diese Glasmalereien sind teilweise signiert. Jenny Schneider erwähnt Wappenscheiben im Schützenhaus Sihlhölzli, das in der Zwischenzeit einer Überbauung weichen musste. Über den Verbleib der Scheiben ist nichts bekannt[160]. Darüber hinaus besitzt das Landesmuseum noch einige Blätter des graphischen Werkes, nämlich 16 Scheibenrisse[161], zwei Lithografien und einen Kupferstich von Johann Andreas Hirnschrot. Die Scheibenrisse zeigen stehende Heiligenfiguren, wie Simon Petrus (Abb. 28), Thomas, Johannes, Jacobus major unter anderen, die mit reichem Dekor unter Bogenarchitektur dargestellt werden. Leider fehlen die Informationen über den Bestimmungsort der Glasmalereien.

Wie in den einleitenden Kapiteln bereits ausgeführt, war Johann Jakob Röttinger nach seiner Ankunft in Zürich bei Hirnschrot als Gehilfe tätig.

156 SA Nürnberg: C7/II NL, Nr. 8906; VAASSEN, 1997, S. 48/49; SIKART.

157 STADTLEXIKON NÜRNBERG, 2000, S. 54, Stichw. *Zeichenschule (Akademie der Bildenden Künste)* (Edith Luther); S. 600, Stichw. *Kunstgewerbeschule* (Edith Luther); Hirnschrot war in den Jahren 1821–1826 eingeschrieben; 1825 wurde die Kunstakademie in Kunstschule umbenannt.

158 Hirnschrot heiratete in Zürich die Hauptmannswitwe Martha Emilie Wegman, geb. Freudweiler (v. Zürich); der Sohn, Emil Clemens Robert, wurde 1843 geboren (ZB Nachl. Röttinger, 1.71).

159 SNM, Sign.: LM–30157.

160 SCHNEIDER, 1971, Bd. II., S. 487 und 475.

161 SNM, Sign.: LM-9209, 1–16.

In den Akten des Gemeindearchivs Aarburg wird diese Zusammenarbeit offenkundig. Das Antwortschreiben Hirnschrots an die Kirchenbaukommission, die eine Preisanfrage für Glasmalereien in die Kirche Aarburg veranlasst hatte, trägt das Datum des 6. Mai 1844[162] – am Tag darauf nahm Röttinger Wohnsitz im Hause Hirnschrots, Talgarten Nr. 7a. Hirnschrot bearbeitete mit seinem Mitarbeiter, dem Glaser Weiss[163], den Auftrag für die zehn Bogenfenster mit je drei Wappen und stellte die entsprechende Offerte inklusive Zeichnungen. Hirnschrot starb am 21. Dezember 1845, ohne die Bestellung der Kirchgemeinde Aarburg abgeschlossen zu haben. Aus einem Schreiben der Witwe Hirnschrots vom 4. März 1846 geht hervor, dass die ersten Ausschreibungen wohl zu teuer gekommen wären, die nun geänderten Pläne zu einem günstigeren Preis angeboten werden könnten und sie sich sehr wünschte, dass diese nun zur Ausführung kämen. Es ist davon auszugehen, dass Johann Jakob Röttinger dabei die künstlerische Fertigstellung des Auftrags übernommen hat, die Glaserarbeit der Mitarbeiter Weiss. Das Gemeindemuseum zeigt ein Rundfenster, ein Fragment aus dem Bogenfenster über dem Hauptportal der Kirche mit einer Darstellung des Heiligen Georg. Es weist die Signatur «Röttinger» auf, wobei das «H.» für Heinrich nur teilweise erkennbar ist. Ein Brief Heinrich Röttingers aus dem Jahr 1927 an die Gemeindekanzlei Aarburg bezeugt die Herstellung beziehungsweise Signatur der Scheibe durch seinen Vater und die Beifügung seines Namens anlässlich einer Renovation 1923[164]. Mit dieser Arbeit in Aarburg begann also 1845/1846 das selbstständige Wirken Johann Jakob Röttingers als Geschäftsführer der Werkstatt Witwe Hirnschrot-Freudweiler. Zwei Jahre später, am 13. März 1848, konnte er sich schließlich als eigener Herr und Meister der Glasmalerei Röttinger etablieren. Die gemeinsame Arbeit Hirnschrots und Röttingers dauerte wegen des plötzlichen Todes des Lehrmeisters nur eineinhalb Jahre. Dennoch ist anzunehmen, dass der junge Röttinger vom erfahrenen Porzellan-, Porträt- und Glasmaler künstlerisch profitierte. Vor allem was die Modellierung der Gesichter, die Wahl des Inkarnats und die Ausgestaltung anatomischer Details betrifft, wird der Porträtmaler seinem jungen Gehilfen Vorbild gewesen sein. Johann Jakob Röttinger beherrschte ebenfalls die Kunst des Porzellanmalens, was vor allem in der Darstellung von Köpfen und Gesichtern zum Ausdruck kommt. Durch den Einsatz von Farbwerten – Inkarnate wurden in mehreren Schichten aufgebaut – erschienen die Glasmalereien mehr als Gemälde, denn als Glasfläche[165].

Das graphische Werk

Da sich im Nachlass des Glasmalers nur wenige eindeutig zuweisbare Zeichnungen und Maquetten finden ließen, die durch Signaturen zweifelsfrei bestimmt werden können, brachte die Ausweitung des graphischen Werks des Künstlers durch Zeichnungen der mittelalterlichen Glasmalereien aus den ehemaligen Klosterkirchen Königsfelden AG sowie aus der Abtei Hauterive bei Fribourg einen wichtigen Fund im Staatsarchiv Zürich. Deren Autorschaft ist nämlich durch die Korrespondenz zwischen Ferdinand Keller, dem Präsidenten der Antiquarischen Gesellschaft Zürich, und Johann Jakob Röttinger belegt. Die fast 200 Zeichnungen und Aquarelle wurden damit erstmals dokumentiert[166].

162 GA Aarburg, Mappe Bauwesen, Kirchenbau 1841–1846.
163 Mit diesem Glaser schloss sich Röttinger während der ersten Zeit seiner Selbstständigkeit (ab 13. März 1848) zusammen.
164 GA Aarburg, Mappe Bauwesen: KBA, Schreiben Heinrich Röttingers an die Gemeindekanzlei Aarburg; die Signatur J. Röttingers ist auf der erhaltenen Rundscheibe nicht mehr ersichtlich. Die Scheibe scheint auch künstlerisch sehr stark überarbeitet worden zu sein (Anm. der Verf.). Die Gemeinde wollte offensichtlich die Ungereimtheiten bezüglich der Akten bzw. Signaturen mit den verschiedenen Namen (Röttinger, Hirnschrot, Weiss) klären und fragte deshalb in der Firma H. Röttinger nach.
165 VAASSEN, 2000, S. 49.
166 Dokumentation und Aufnahme in die Forschungsdatenbank.

Maquetten

Aus den im Nachlass erhaltenen Verträgen geht hervor, dass im Atelier für die meisten Aufträge Skizzen, Kartons oder Maquetten zur Kundenpräsentation hergestellt wurden, die von den Auftraggebern gutgeheißen, geändert oder verworfen werden konnten. Sehr häufig werden in der Korrespondenz *«Entwürfe»* beziehungsweise *«Zeichnungen»* erwähnt[167]. Der Hinweis auf *«Maquetten»*[168], wie Reinzeichnungen der Entwürfe der Glasmaler in der Fachsprache genannt werden, ist in diesem Fall umso wichtiger, weil vom graphischen Archivmaterial nur wenige Dokumente vorhanden sind. Ein Skizzenbuch[169], das neben den Maßen auch Angaben über Motive und Formalitäten enthält, muss daher als wertvolle Quelle für den Beleg vieler Aufträge gesehen werden. Röttinger sendete eine Zeichnung als Skizze an den Architekten Joseph C. Jeuch: *«Beifolgend sende Ihnen eine Zeichnung als Skizze für die Fenster im Schiff der Kirche in Zeiningen. Wie Sie sehen habe ich 2 Muster von der Randverzierung angegeben. Da es 8 Fenster sind so würden demnach 4 verschiedene Zeichnungen in die 8 Fenster kommen, so daß per 2 Fenster, welche sich gegenüber stehen gleich in Farbe und Zeichnung sind. [...] Gleichzeitig bin ich so frei eine nähere Beschreibung der Arbeit wie auch einen Vertrags Entwurf beizulegen. [...] Bitte die Zeichnung wieder retour zu senden»*[170]. Auch nach Olten versprach der Glasmaler eine Zeichnung zu senden, mit dem Vorsatz die Glasmalereien ohne große Preisdifferenz gegenüber weißen Fenstern zu liefern. Für den *«Quadratfuß»* würde er 1.25 Franken berechnen[171]. Pfarrer Casanova in Henau erhielt eine Nachricht vom Glasmaler, dass die Zeichnungen der 12 Apostel in Arbeit seien und davon bisher acht fertiggestellt waren. Röttinger hoffte für diese Fenster eine besonders gelungene Ausführung zu finden, damit man nicht sagen könne, die Fenster seien gewöhnlich[172]. Häufig erscheint die Bitte, die Zeichnungen wieder zurückzusenden. Daher liegt die Annahme nahe, dass die Skizzen mehrmals verwendet worden sind[173]. Glasmaler Adolph Kreuzer bittet seinen ehemaligen Prinzipal in einem Brief aus Furtwangen: *«[...]*

die Architekturzeichnungen (in natürlicher Größe) gefälligst aufzubewahren, da Sie mir seiner Zeit eine große Gefälligkeit damit leisten würden, wenn Sie so freundlich wären, mir dieselben zur Ausführung zu überlassen; natürlich gegen Vergütung [...]». Sebastian Strobl erwähnt, dass es gegen Ende des 19. Jahrhunderts wegen der enormen Nachfrage an Glasmalereien besonders häufig zu Vielfachverwendungen von Kartons gekommen sei[174]. Hartmut Scholz konnte dieses Phänomen schon für die Zeit um 1500 nachweisen, wo sich umsatzstarke Meister in Straßburg und Nürnberg zu konkurrenzlosen Werkstattgemeinschaften zusammengeschlossen hatten, um den gegenseitigen Austausch und Zugriff von Vorlagen und Arbeitsmitteln zu gewährleisten[175]. Manchmal erscheint Melchior Paul Deschwanden als Entwerfer in den Akten Röttingers, wie dies für Alt Sankt Johann belegt ist oder in Cham für das Kloster Frauenthal[176]. Als Entwerfer trat auch Georg Konrad Kellner (1811–1892) aus der berühmten süddeutschen Glasmalerfamilie auf, der die Kartons für die Chorverglasung im Grossmünster lieferte[177]. Die Zusammenarbeit zwischen Künstlern und Werkstätten wird im Kapitel ‹Glasmalerwerkstätten: Konkurrenz und Zusammenarbeit› als werkstattübergreifende Vernetzung präziser beleuchtet.

167 ZB Nachl. Röttinger 2.371, 3 Jettingen/Herzog 1875, ZB Nachl. Röttinger 2.371, 35 Waldkirch/Baumgartner 1875 u. a.
168 *maquette* (französisch: grobe Skizze, Modell).
169 Das Skizzenbuch wird im Kap. ‹Auftrags- und Skizzenbuch› ausführlicher behandelt.
170 ZB Nachl. Röttinger 2.371, 59 Zeiningen/Architekt C. Jeuch 1876.
171 ZB Nachl. Röttinger 2.371, 67 Olten/A. Glutz 1876.
172 ZB Nachl. Röttinger 2.371, 78 Henau/Casanova 1876. Die Glasmalereien in Henau haben sich nicht erhalten.
173 ZB Nachl. Röttinger 2.371, 86 Waldkirch/Baumgartner 1876; ZB Nachl. Röttinger 2.371, 89 Rodersdorf/Jaeggi 1876.
174 STROBL, 1999, S. 12.
175 SCHOLZ, 1991, S. 306.
176 ZB Nachl. Röttinger 1.34.
177 ZB Ms. T 111.5: Actum vom 5. April 1852.

Die chronologische Ordnung des Nachlasses der Werkstatt Röttinger hat gezeigt[178], dass der Firmengründer im Gegensatz zu seinen Söhnen Jakob Georg und Heinrich außer den erwähnten Lichtpausen kaum Entwürfe hinterlassen hatte. So sind nur einzelne Blätter durch Signaturen beziehungsweise Beschriftungen als sicher zuzuordnende Maquetten Johann Jakob Röttingers überliefert. Dieser Umstand macht weitgehend die Rückverfolgung vom Werk auf die Maquette unmöglich, erst recht auf Kartons, von denen sich aus der Zeit des Firmengründers kein einziger erhalten hat. Wie bereits erwähnt, liegt der Grund für die relativ bescheidene Überlieferung aus der Zeit vor 1887 (beziehungsweise 1877, dem Todesjahr Johann Jakobs)[179] wohl am Verkauf des Geschäftes postum an den Glasmaler Carl Wehrli, der unter Umständen nicht nur das Inventar und die fertigzustellenden Arbeiten, sondern möglicherweise auch den künstlerischen Nachlass Johann Jakob Röttingers übernommen hatte. Darauf weisen einige mit dem Stempel Wehrlis versehene Entwürfe im Nachlass der Firma Röttinger hin. Darüber hinaus lassen Stempel und Beschriftungen der Söhne Georg und Heinrich auf Blättern im «alten Stil» vermuten, dass falls noch Maquetten oder Vorlagen aus der ersten Firmenepoche im Fundus der Röttinger verblieben wären, diese in den Bestand der Nachkommen einverleibt worden und wegen fehlender Signaturen beziehungsweise Jahreszahlen aus heutiger Sicht nicht mehr eindeutig Johann Jakob zuweisbar sind. Im folgenden Kapitel sollen die signierten oder anderweitig beschrifteten beziehungsweise durch Schriftquellen gesicherten Entwürfe erörtert werden. Es handelt sich bei den ersteren um die beiden einzigen signierten Entwürfe Johann Jakob Röttingers, die im Nachlass überliefert sind.

Signaturen

Im Kunstwerk – als Produkt eines persönlichen Schöpfungsaktes – ist die Inschrift des Künstlers als Urbaustein zu werten. Bereits Plinius Secundus berichtet in seinen kunstgeschichtlichen Abhandlungen der *Naturalis historia* über Künstlerinschriften und obwohl das Mittelalter dafür bekannt ist, kein ausgeprägtes Profilierungsstreben zu besitzen, was die Identität von Künstlerpersönlichkeiten betrifft, so treten dennoch bereits in Italien im 14. Jahrhundert in Statuen eingetragene Meisternamen hervor[180]. Die Signatur stellt neben dokumentarischen Quellen und stilistischen Vergleichen das wichtigste Kriterium für die Zuordnung eines Werkes zu einem bestimmten Autor dar[181]. Signaturen sind «Bezeichnungen» des Künstlers entweder mit dessen vollausgeschriebenem Namen, einer Abkürzung desselben oder den Initialen[182]. In den meisten Fällen handelt es sich dabei um den Urheber des signierten Werks. Künstler, die größere Werkstätten betrieben, haben auch Werkstattprodukte[183] signiert. So galt die Signatur im 17. Jahrhundert in den Werkstätten der Maler als Qualitätsgarantie, ähnlich einem Gildenstempel. Claus Grimm resümiert in seiner Untersuchung zu Rembrandts Porträts, dass die Signaturen als Werkstattzeichen ohne Rücksicht auf die Anteile von Eigenhändigkeit gehandhabt wurden[184]. Diese möglicherweise überlieferte Praxis relativiert das Vorhandensein von Signaturen auf den Entwürfen der Glasmaler. Im Handwerk galt das Signieren mit dem Namen des Werkstattinhabers als Normalfall und als Qualitätsbeweis beziehungsweise -garantie für den Auftraggeber[185]. Dieses Phänomen lässt sich bei Jakob Röttinger an seinen Glasmalereien beispielhaft beobachten. Dort signierte er vorzugsweise mit «*J. Röttinger Glasmaler Zürich*» unter Anfügung der entsprechenden Jahreszahl. Signaturen von Glasmalereien in Kirchen – die

178 Vgl. Kap. ‹Der Nachlass Röttinger in der Zentralbibliothek Zürich›.

179 1887 fand die Werkstattübernahme durch Sohn Jakob Georg statt; in der Zeitspanne 1877–1887 war die Werkstatt in Händen des Glasmalers Carl Wehrli, Zürich.

180 DIETL, 2009, S. 11 f.

181 BURG, 2007, S. 11.

182 LDK 6, 1994, S. 663, Stichw. *Signatur.*

183 GRIMM, 1991, Anm. 131: dies geschah bereits in den Werkstätten von L. Cranach d. Ä. u. P.P. Rubens.

184 GRIMM, 1991, S. 114.

185 Vgl. GRIMM, 1991, Anm. 131, 132.

häufigsten Auftraggeber Röttingers stellten Kirchenbaukommissionen oder Architekten dar – waren insofern überzeugend, als dass potentielle Kunden aus der Umgebung einen bekannten Namen und eine gewisse Reputation zu schätzen wussten. Bei den Entwürfen könnten unter Umständen dieselben Argumente angebracht werden – allerdings haben sich davon nur sehr wenige Exemplare erhalten. Weil die Entwürfe meist nur kurze Zeit bei der Kundschaft und darüber hinaus nicht öffentlich einsehbar waren, wurden sie möglicherweise mehr als Arbeitsmittel denn als Kunstwerk betrachtet. Das Anbringen des Werkstattnamens auf den Glasgemälden stellte hingegen einen guten «Werbeeffekt» für die Firma dar und galt als Empfehlung für weitere Aufträge ohne den Anspruch zu erheben, dass das signierte Objekt, der Entwurf oder die Glasmalerei vollständig vom Unterzeichnenden selbst stammen musste. Es gab wohl keine bessere Publicity für ein Glasmalereiatelier als die Präsenz seines Namens in so bedeutenden Kirchen wie dem Grossmünster, dem Münster in Basel oder den Stadtkirchen Solothurn oder Glarus, handelt es sich bei diesen Bauten doch um einige der bedeutendsten Monumente der Schweizerischen Evangelisch-Reformierten Kirche[186]. Die Signaturen der Glasmalereien hatten daher einen wichtigen wirtschaftlichen Stellenwert, im Gegensatz zum unterschriebenen Entwurf, der nach wenigen Tagen seiner Versendung an die Kundschaft vom Glasmaler wieder zurückverlangt wurde[187].

Im Rahmen der Künstlerinschriften spielten im Atelier Röttinger so genannte «Mitarbeiterscheiben» eine wesentliche Rolle. Es handelt sich dabei um in Blei gefasstes, gefärbtes Glas, meist als Rundscheibe gestaltet, auf der alle am Werk beteiligten Künstler und Handwerker namentlich, häufig mit der Bezeichnung ihrer Herkunft versehen, genannt wurden. Manchmal erschienen auch Mitteilungen über damals gültige Preise des täglichen Lebens, über durchgemachte Epidemien oder die Bitte um den Segen Gottes[188]. Ein besonderes Augenmerk ist dabei auf die im Kirchgemeindearchiv noch erhaltene Scheibe in Unter-

ägeri (Abb. 7, 8) zu legen, wo der Meister einerseits wie üblich mit «*J. Röttinger Glasmaler Zürich*» signiert, andererseits unter den Malern nochmals mit «*J. Röttinger, Nürnberg, Bayern*» erscheint[189].

7. Johann Jakob Röttinger, Detail Mitarbeiterscheibe, ehemals für die Katholische Pfarrkirche Peter und Paul, Unterägeri, 1860, PA Unterägeri.

186 J. Röttinger arbeitete für Kirchen beider Konfessionen, siehe Kap. ‹Motive sakraler Thematik›.

187 Vgl. Anm. 170: Röttinger bittet Architekt Jeuch, die Zeichnung gleich wieder zurückzusenden.

188 ZB Nachl. Röttinger 1.94 (für Meilen); Scheibe im PA Unterägeri; Basler Münster: NAGEL/VON RODA, 1998, S. 45; HAUSER, 2001, S. 119; Kappel am Albis (N IX): dokumentiert von TRÜMPLER/DOLD, 2005 o.p. im Vitrocentre Romont: Kappel am Albis, Ehemalige Klosterkirche Glasmalereien, Konservierung und Bestandskontrolle 2003–2005.

189 Vgl. Kap. ‹Mitarbeiter verschiedener Berufe, Künstler und deren Selbstverständnis›.

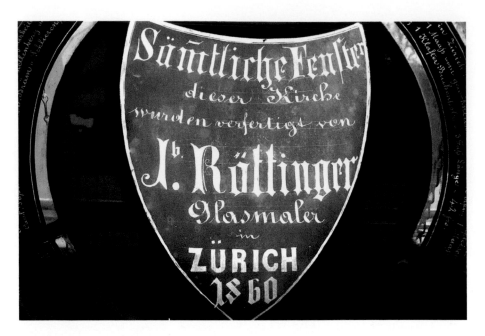

8. Johann Jakob Röttinger, Werkstattsignatur auf Mitarbeiterscheibe, ehemals für die Katholische Pfarrkirche Peter und Paul, Unterägeri, 1860, PA Unterägeri.

Dies verdeutlicht die Differenzierung zwischen der Signatur als «Werkstattgarantie» mit dem Aspekt der Qualitätssicherung respektive der Kundenwerbung und der eigentlichen Künstlersignatur. In der Katharinenkirche zu Oppenheim konnte eine Mitarbeiterinschrift auf dem Chorfenster I, 1a/b aus dem Jahre 1857 konstatiert werden, die «die Verfertiger der fünf Chorfenster L. Schiffman Glasermeister/A. Mieg Maler + F. Brilmayer Maler Bingen 1857» nannte[190]. Nach der Definition von Albert Dietl gelten alle Arten von Inschriften, die Künstlernennungen enthalten, also Signaturen im engeren Sinne wie Grabinschriften von Künstlern sowie Stifter-, Bau- und Weiheinschriften mit Künstlernamen, als Künstlerinschrift[191]. Röttinger machte mit dieser expliziten Künstlersignatur, also mit dem Einbezug seines Namens in die Malergilde des Ateliers deutlich, dass er nicht nur als Garant für die Herstellung qualitätsvoller Glasmalereien, den reibungslosen Ablauf des Einbaus und das Besorgen von Akquisition und Korrespondenz gesehen werden wollte, sondern, dass ihm auch die Präsentation des eigenen künstlerischen Schaffens am Herzen lag. Die kleine Signatur auf den Fenstern der südlichen Chorempore in Leuggern, wo der Meister mit *Gemalt A:D:1854 von J. Röttinger aus Nürnberg in Zürich.* im aufgeschlagenen Buch

des Augustinus (Abb. 9) unterschreibt, wirkt sehr persönlich. Noch mehr Individualität legte er in das Signum *«R 1854»* auf dem rückseitigen Buchdeckel des Gregorius (Abb. 10) auf der nördlichen Chorempore. Die autographischen Zeichen des Künstlers markieren in ihrer versteckten Lage keinen Werbeeffekt, sondern kommen einer Identifikation mit den dargestellten Personen gleich. Und dies, obwohl die Entwürfe der Kirchenväter nicht aus der Werkstatt Röttinger, sondern aus der Königlichen Glasmalereianstalt München stammten[192]. Möglicherweise beabsichtigt der Einsatz von Signaturen eine Wandlung und den Aufstieg des Produzenten zum Autor, um als Medium der Selbstdarstellung dessen Wertschätzung mit einzuschließen[193]. Darüber hinaus ist davon auszugehen, dass die Inskriptionen mit der Bitte um den Segen Gottes einen memorialen Charakter aufwei-

190 RAUCH, 1996, S. 187, Anm. 120.
191 DIETL, 2009, S. 31, Anm. 89.
192 VAASSEN, 2013, S. 217–219, vgl. Abb. 14 und 169 a–d; VAASSEN, 2007, S. 68 mit Abbildungen. Die Kirchenväter waren schon 1830 Bestandteil des Johannesfensters (sw II) im Regensburger Dom und wurden 1841 für Saint Saviour in Kilndown übernommen (VAASSEN, 2013, S. 218).
193 GLUDOVATZ, 2011, S. 19; DIETL, 2009, S. 31.

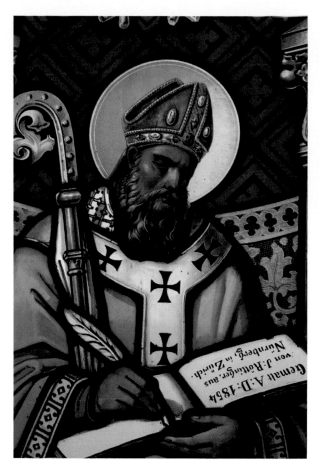

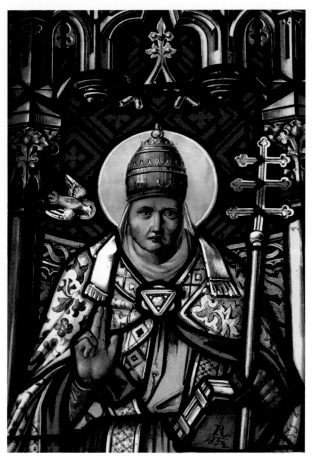

9. Johann Jakob Röttinger, Sankt Augustinus, Inschriften, Signatur, Chorempore S III, Katholische Pfarrkirche Leuggern, 1854.

10. Johann Jakob Röttinger, Sankt Gregorius, Inschriften, Signatur, Chorempore N III, Katholische Pfarrkirche Leuggern, 1854.

sen[194] – ein Aspekt, der bei Röttinger wohl zum Tragen kommt[195].

Signierte Entwürfe

Der kolorierte Entwurf einer Rundscheibe[196] mit den Blattmaßen 27.3×21.7 cm entspricht einer stilisierten Blüte – zusammengesetzt aus ornamental verzierten, konzentrischen Kreisen. Die Rose im Zentrum rahmt ein Weinlaubkranz auf blauem Grund, der von einer Perlschnur eingefasst wird. Zwischen dieser und dem nächsten Kreis fügt sich ein geometrisches Grisaillemuster, mit Blättern gefüllte Dreiecke, ins Rund; es folgen Halbkreise, die blütenförmig auf rotem Grund angeordnet und wiederum von einer Perlschnur eingesäumt sind. Die Rahmung und die zukünftigen Bleiruten hob

der Entwerfer entsprechend zeitgenössischen Entwürfen[197] mittels einer hellgrauen Aquarellfarbe hervor (Abb. 11). Rundscheiben dieser Art wurden für sakrale Räume hergestellt und zierten als Teil einer größeren Rosette oder als Vierpass häufig die Westfassade von Kirchen oder schmückten als Medaillon die Bogenausmündungen von einfach gestalteten Langhausfenstern. Vermutlich wegen der universellen Einsatzmöglichkeiten erscheint auf dem Entwurf kein Hinweis auf einen Orts-

194 GLUDOVATZ, 2011, Schlussbetrachtungen; DIETL, 2009, S. 31.
195 Die Besprechung weiterer Mitarbeiterscheiben erfolgt im Kap. ‹Schriftquellen auf Papier und auf Glas›
196 ZB Nachl. Röttinger 1.1.6 Blatt 1.
197 Vgl. VAASSEN, 2007, z.B. Abb. S. 93: Farbenskizze für das Schlüsselübergabe-Fenster im Dom zu Regensburg S VIII, 1853.

11. Johann Jakob Röttinger, Zeichnung aquarelliert, signiert
«Röttinger» o. J., Zürich, 27.3×21.7 cm, Zentralbibliothek (ZB
Nachl. Röttinger 1.1.6 Blatt 1).

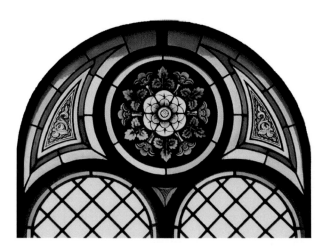

12. Johann Jakob Röttinger, Ornamentscheiben, n III-n VIII,
s III-s VI, Evangelisch-Reformierte Pfarrkirche Stäfa, 1871.

namen. Diese Form ornamental gestalteter *Oculi*
hat sich auf vielfältige Weise unter anderem in der
Kirche Oberentfelden AG als Teil eines Rundfens-
ters und dort auch in den Schifffenstern, des Wei-
teren in den Kirchen von Meilen, Stäfa (Abb. 12)
und Rüti ZH ebenfalls als Teil der Schifffenster
sowie in Ossingen ZH im Ovalfenster s VI erhal-
ten. Exakt dasselbe Muster als im überlieferten
Entwurf war jedoch in keinem der aufgezählten
Gebäude festzumachen. Die Signatur des Glasma-
lers erscheint auf dem Blatt rechts unten als aus-
geschriebener Name *«Röttinger»*.

Die zweite signierte Zeichnung[198] verweist dank
einer auf der Rückseite des Blattes angebrachten
Notiz, Fislisbach, auf den Bestimmungsort der
ausgeführten Glasmalereien. Es handelt sich dabei
um den Entwurf für ein Segmentbogenfenster
(Abb. 13), der auf die übliche Weise mit hellgrauer
Umrahmung plastisch mit Fensterlaibung gezeich-
net und koloriert wurde[199]. Die Fensterfläche wird
von einem Grisaille-Damastmuster mit Ranken
ausgefüllt, wobei im Bogenfeld farbige Blattgir-
landen mit Früchten auf blauem Grund abgebildet
sind und der gemalte Rahmen aus abwechselnd
auftretenden, roten und weißen Blüten auf grünem
Grund gebildet wird. In den Ecken erscheinen
kleine hellblaue Blattmotive, die auf die Farbe im
Segmentbogen Bezug nehmen. Tatsächlich ließen
sich im Kirchgemeindearchiv zu Fislisbach alte
Fotografien (Abb. 14) finden, auf denen diese
Schifffenster noch ersichtlich sind.

Darüber hinaus bestätigt eine Rechnung vom
18. Dezember 1871[200] den Auftrag an Röttinger
für zwei Chorfenster in die katholische Kirche
Sankt Agathe in Fislisbach. Die Scheiben aus dem
19. Jahrhundert wurden 1969 anlässlich einer Kir-
chenrenovierung durch eine farblose Wabenver-
glasung ersetzt und an einen Kunstglaser verkauft.
Heute erinnert lediglich ein in Blei gefasstes Me-
daillon im Pfarrarchiv, das den heiligen Jakobus
zeigt, an die früheren Glasmalereien.

198 ZB Nachl. Röttinger 1.1.6 Blatt 2, Maße: 55.5×21 cm.
199 Vgl. VAASSEN, 1993, Kat. Nr. 34–36, 39.
200 PA und KGA, kath. Kirche Fislisbach.

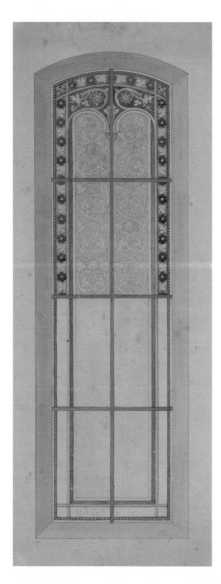

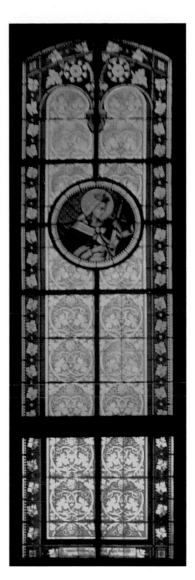

13. Johann Jakob Röttinger, signierte Maquette für die Katholische Pfarrkirche Fislisbach, 55.5×21 cm, 1871, Zürich, Zentralbibliothek (ZB Nachl. Röttinger 1.1.6 Blatt 2).

14. Johann Jakob Röttinger, alte Fotografie der nicht erhaltenen Fenster der Katholischen Pfarrkirche Fislisbach von 1871 (Kopie), Originalfoto: PA Fislisbach.

Links unter der Entwurfszeichnung verweist die Ordnungszahl «50.» auf das Vorhandensein einer ganzen Reihe von Entwürfen in der Werkstatt Jakob Röttingers. Offensichtlich hatte der Glasmaler seine Maquetten durchnummeriert, um sie bei Anfragen von Interessenten schneller griffbereit zu haben. In der rechten unteren Ecke des gemalten Fensterrahmens signierte der Glasmaler wiederum mit dem ausgeschriebenen Namen «Röttinger». Auf der Rückseite schließlich zeigt die kleine Bleistiftskizze eines rechteckigen Fensters

mit aufgemaltem Rundbogen und Medaillon unter Girlanden ein weiteres Beispiel einer baulichen Lösung.

Unsigniert –
und doch aus der Werkstatt Johann Jakob Röttingers

Gerade, weil im Nachlass der Röttinger-Arbeiten mehrerer Werkstattleiter, nämlich des Vaters und der beiden Söhne Georg und Heinrich sowie deren Mitarbeiter überliefert und mögliche Remi-

53

niszenzen aus der «Übergangszeit»[201] nicht auszuschließen sind, spielen Signaturen nicht nur für die Unterscheidung der einzelnen Hände eine Rolle, sondern auch für das Vorhandensein von Vorlagenmaterial und deren Tradierung. Der Signatur als Qualitätsmerkmal kommt dabei eine zentrale Aufgabe zu. Die überlieferten Zeichnungen wurden demzufolge auf etwaige Notizen oder Beschriftungen untersucht, um anhand von Ortsbezeichnungen, Jahreszahlen oder Namen von Auftraggebern eventuelle Verbindungen zu Schriftquellen herstellen zu können und so das Blatt zweifelsfrei einer bestimmten Werkstattepoche zuordnen zu können. Diese Methode der Zuweisung gelang bei den nachfolgenden Entwürfen.

Eine kolorierte Skizze für ein Spitzbogenfenster[202] (Abb. 15) mit der Darstellung der «Mariä Himmelfahrt mit Engeln» über dem Stadtwappen von Rapperswil SG, zwei roten Rosen mit Stiel auf Silber beinhaltend, zeigt die Inschrift:

«18 Die Stadtgemeinde Rappersw[il] der Kirchgem[einde] Jona zum Andenken 52»

Das Jahr 1852 war für die Kirchgemeinde «Mariä Himmelfahrt» in Jona ein bedeutungsvolles, ersetzte man doch damals das Kirchenschiff durch einen größeren Neubau und erhöhte den Kirchturm[203]. Eine Ehre für Jona und Anlass genug für eine Scheibenstiftung aus der Nachbarschaft. Schließlich war die Pfarre Jona seit 1819 unabhängig und stolz auf ihr Wachstum, das bewirkte, dass das Platzangebot im alten Kirchenschiff nicht mehr ausreichte. Die Erhöhung des Kirchturms schließlich darf als Zeichen des neuen Selbstverständnisses der Kirchgemeinde gewertet werden. Auf dem kolorierten Blatt im Nachlass wird die Himmelfahrt Mariens dargestellt – die Arme betend ausgebreitet und von einer knienden Engelschar umgeben, steigt die Muttergottes dem Licht entgegen. Faltenreich umschmeichelt der blaue Mantel das rote figurbetonte Kleid, goldene Locken rahmen das liebliche Gesicht und ein gelb leuchtender Nimbus zeichnet die Schwebende als die Mutter Christi aus. Die Engelschar, im Vordergrund deutlich erkennbar, verliert sich nach

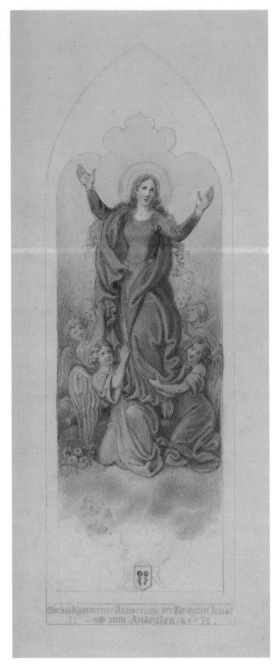

15. Johann Jakob Röttinger (o. Sign.), Himmelfahrt Mariä, aquarellierte Zeichnung mit Inschrift, 24.4×9.7 cm, 1852, Zürich, Zentralbibliothek (ZB Nachl. Röttinger 1.1.8 Blatt 1).

201 Damit wird die Zeit zwischen 1877 und 1887, dem Todesjahr J. Röttingers und der Wiederaufnahme des Geschäfts durch Sohn Jakob Georg, als Epoche des Geschäftsinhabers Carl Wehrli bezeichnet. (Anm. der Verf.).
202 ZB Nachl. Röttinger 1.1.8 Blatt 1, Maße: 24.4×9.7 cm.
203 Jona SG, Pfarrei Mariä Himmelfahrt, Homepage, Geschichte.

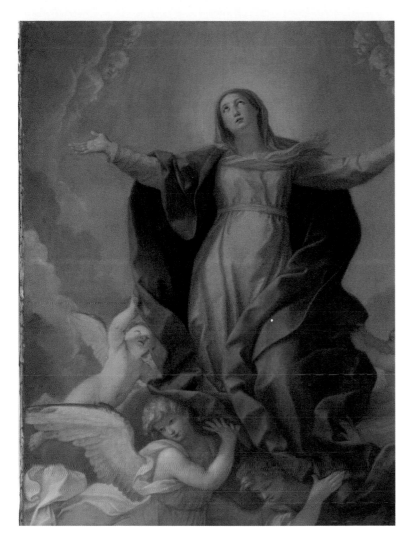

16. Guido Reni, Himmelfahrt Mariä, Seide, 295×208 cm, 1642, München, Bayerische Staatsgemäldesammlungen, Alte Pinakothek (Inv. Nr.446).

hinten und ist dort nur noch andeutungsweise auszumachen.

Der in Anlehnung an Guido Renis (1575–1642) Altarbild der «Himmelfahrt Mariä»[204] (Abb. 16) ausgeführte Entwurf wäre durchaus als Wunsch des Auftraggebers denkbar, denn die klassische Richtung des Spätstils des Künstlers war besonders im 19. Jahrhundert sehr geschätzt[205].

Im Pfarrarchiv der katholischen Kirche in Rapperswil-Jona konnten ein Vertragsentwurf der Baukommission[206] beziehungsweise eine diesem vorausgegangene *«Calculation»*, verfasst von Johann Jakob Röttinger[207], ermittelt werden, die belegen, dass Schifffenster *«nach eingegebener Zeichnung mit gemalten Bogenverzierungen und den Wappen der Stifter [...]»* beim Zürcher Glasmaler in Auftrag gege-

ben worden waren. Aus einem Protokoll einer Gemeinderatssitzung im Januar 1956 geht hervor, dass sich vier von sechs Familienwappenscheiben

204 Vgl. PEPPER, 1984, Kat. Nr. 183, S. 284, Abb.: Taf. 213: Himmelfahrt Mariä München, Alte Pinakothek (Inv. no.1170). Seide, 2.9×2.04 m, 1638/39.

205 MAURER, 1992 – Emil Maurer, Guido Reni: Süchtig nach Perfektion. Zur Reni-Ausstellung in Bologna, 1988, in: Im Bann der Bilder. Essays zur italienischen und französischen Malerei des 15.–19. Jahrhunderts, Zürich 1992, S. 83–90, hier S. 84; vgl. auch zur Reni-Rezeption SCHMIDT-LINSENHOFF, 1979, S. 1 f., 6 ff.

206 PA Rapperswil-Jona, B 06.00, 10. Dezember 1851.

207 PA Rapperswil-Jona, B 06.00, 11. Oktober 1851. Die von J. Röttinger unterschriebene Kalkulation umfasst *«eilf gotische Fenster»* und beinhaltet Maßwerk und Ornamentdekor.

aus «früheren» Kirchenfenstern erhalten hätten, deren Verbleib heute nicht mehr bekannt sei[208]. Über ein mögliches Fenster mit dem Thema der «Himmelfahrt Mariens» beziehungsweise einer Fensterstiftung der Stadt Rapperswil ließen sich im Archiv keine Nachweise finden. Die Darstellung der Himmelfahrt Mariä wurde nach einer Reni-Kopie des Malers Ferdinand Wagner (pinxit nach Reni 1851) zu Papier gebracht[209]. Das von Guido Reni (1575–1642) gemalte Hochaltarbild für die Confraternità di Santa Maria degli Angiolo in Spilamberto (Modena) wurde seit dem frühen 19. Jahrhundert in der Münchner Alten Pinakothek[210] aufbewahrt. Dort kopiert, erschien das Bild seither in Varianten in zahlreichen schwäbischen Dorfkirchen und kennzeichnete eine neue Periode der Reni-Rezeption. Das Gemälde war 1805/06 aus der Düsseldorfer Galerie nach München gelangt und dort den Studierenden der Akademie leicht zugänglich. Die hohe Wertschätzung des Tafelbildes in Akademiekreisen gewann durch eine Rede des Philosophen F.W. Schelling noch an Bedeutung. Die Frontalansicht sowie die Beschränkung auf die Einzelfigur kamen, wie dies im Kapitel über die künstlerische Ausführung gezeigt werden wird, der nazarenischen Ausdrucksweise sehr entgegen, was der Verbreitung als Andachtsbild gewiss förderlich war[211]. Melchior Paul Deschwanden beschäftigte sich ebenfalls mit denselben Vorbildern; dies zeigt ein Gemälde der Maria in der Friedhofkapelle zu Stans. Johann Jakob Röttinger gelangte wohl 1851 anlässlich seines München-Aufenthalts[212] an die Münchner Kopien – vielleicht hatte sogar der Glasmaler selbst zusammen mit Malerkollegen Kopien des Altarblatts Renis' hergestellt? Der Fensterentwurf Röttingers zeigt keine eigentliche Wiedergabe des Originals, sondern vielmehr eine Komposition in Anlehnung an das Gemälde Renis, die jedoch der besonderen Lichtinszenierung des Barockmalers entbehrt[213] und auch in der Darstellung der begleitenden Engel vereinfachend verändert wurde. Dabei handelt es sich um eine für die Zeit des Historismus typische Retrospektive auf verschiedene frühere Epochen und soll daher an dieser Stelle einen exemplarischen Stellenwert erhalten[214]. Darüber hinaus zeigt das Beispiel, dass der Geschäftsmann und Künstler durchaus am Puls der Zeit war, neue Kunstströmungen erkannte und umsetzte. Diese Vorgehensweise attestiert überdies dessen Bemühungen um den Kulturtransfer von seiner Heimat Bayern in die Schweiz[215].

Ein weiteres Blatt[216] kann dank einer rückseitigen Notiz «Thalwil» und eines uns im Nachlass überlieferten Schriftdokuments[217] der Pfarrkirche Thalwil zugeordnet werden, wenngleich der Großteil der ehemaligen Kirchenfenster dem Kirchenbrand vom 19. Mai 1943 zum Opfer gefallen sind[218]. Im Ortsmuseum Thalwil haben sich drei größere Fragmente der ehemaligen Glasmalereien aus der reformierten Pfarrkirche erhalten. Der Akkord zwischen dem Stillstand Thalwil und J.J. Röttinger bestimmte die Ausführung von *«zwei ganz gemalten*

208 PA Rapperswil-Jona, lose Materialsammlung. Freundlicher Hinweises der Theologin in der Pfarrei Jona, Henrike Kammer, auf 5 Wappenscheiben aus dem Jahr 1917 von Heinrich Röttinger, die in die Blankverglasung der Liebfrauenkapelle zu Rapperswil integriert sind. Die Verwendung gotischer Schrift auf den Schriftbändern lässt vermuten, dass Sohn Heinrich die Stifterwappen nach den Vorlagen seines Vaters herstellte (es handelt sich um die Wappen der Familien Helbling-Wössner, Bauer-Breny, Louise Kuster, Pfenninger-Rothenfluh sowie Curti-Motta) oder, dass es sich dabei um die in der Kirche zu Jona eingepassten Familienwappen aus der Hand Johann Jakob Röttingers handelt.
209 KAT. AUSSTELL. AUGSBURG, 1990, S. 53–54.
210 Alte Pinakothek München: Guido Reni, Himmelfahrt Mariae, Seide, 295×208 cm, aus der Düsseldorfer Galerie, Inv.Nr. 446.
211 KAT. AUSSTELL. AUGSBURG, 1990, S. 53–54.
212 StA ZH, W I 3 AGZ 174 12, Müller-R 1851–58, 193/1852.
213 WIMBÖCK, 2002, S. 253.
214 Weitere Hinweise zur Reni-Rezeption im 19. Jahrhundert folgen im Kap. ‹Ikonographie›.
215 Vgl. die Ausführungen im entsprechenden Kap. ‹Kulturtransfer›.
216 ZB Nachl. Röttinger 1.1.8 Blatt 2, Entwurf für Glasmalereien in die Kirche Thalwil ZH.
217 ZB Nachl. Röttinger 1.163, Akkord für Glasmalereien in die Kirche Thalwil ZH vom 16. August 1860, unterschrieben vom Vertreter der Kommission J. J. Schmid-Schäppi.
218 ZWICKY, 1995, S. 163 f.; Thalwil, Homepage der Evangelisch-reformierten Kirchgemeinde.

17. Johann Jakob Röttinger, Reformator Calvin, aquarellierte Zeichnung (o. Sign., Notiz: *Thalwil*), Maße: 38.3×13.6 cm, ehemals für Fenster s II der Pfarrkirche Thalwil, 1860, Zürich, Zentralbibliothek (ZB Nachl. Röttinger 1.1.8 Blatt 2).

Fenstern links und rechts an der Kanzel auf deren Jedem je 2 Evangelisten u. 2 Reformatoren in nach Zeichnung ausgeführter Darstellung angebracht sein sollen»[219]. Jener Entwurf, der für die Gestaltung der Fensterhälfte mit dem Reformator Calvin geschaffen wurde, hat sich im Nachlass Röttingers[220] erhalten. Die kolorierte Zeichnung (Abb. 17) stellt das Bogensegment eines Rundbogenfensters dar. Die Abbildung der gotischen Architektur im unteren Teil des Entwurfs lässt darauf schließen, dass es sich dabei um den oberen Abschluss des Fensters gehandelt habe und darunter eine Figur zu denken sei, die vermutlich auf einem Sockel gestanden hatte. Über dem Wimperg mit Fialen auf rotem Grund kontrastiert das Firmament in intensivem Blau, von dem sich ein Grisaille-Medaillon mit der Büste des Reformators Johannes Calvin (1509–1564) farblich abhebt. Das Bild Calvins wird im Profil gezeigt und lehnt sich an den bekannten Kupferstich Conrad Meyers[221] an. Der Reformator wird in damals üblicher Weise mit Bart und Bundhaube sowie einem über die Haube gestülpten Barett dargestellt. Dazu trägt er einen Mantel mit Pelzkragen. Das Bogenfeld der Scheibe weist eine Blankverglasung mit angedeuteten Rhomben aus Blei auf sowie eine Rahmenverzierung aus weißen Blättern auf grünem Grund. Ebenfalls eingezeichnet ist die Lage der beiden Quereisen. Rechts oben erscheint die erwähnte Notiz: *«Thalwil»*. Dank der Übereinstimmung des zwischen der Kirchgemeinde Thalwil und dem Glasmaler Röttinger abgeschlossenen Akkords mit dem ausgeführten

219 Zitat aus dem Akkord; vgl. Anm. 217.
220 ZB Nachl. Röttinger 1.1.8 Blatt 2.
221 MORTZFELD, 1987, S. 157; Katalog, A 3325, Calvin (eig. Cauvin), Jean (1509–1564), 170×139 cm; Beschreibungsband, Reihe A 3325, S. 75, Portr.I 2228. Halbf[igur]. Profil nach l[inks] an Tisch mit Tintenfaß und Schreibfeder stehend, mit l[inker] Hand aufgestütztes Buch haltend, in eingefaßtem Kreuzschraffur-Rechteck. Unter dem Bild 3zeil[ige] lat. Legende «IOH. CALVINUS THEOLOGUS / NATUS NOVIODUNI X. IUL. MDLXIII.» Darunter lat. Distichon wie in A 3317. Kupferstich/Radierung: u.r. Con[rad] Meyer fecit. Bl. 218×140 cm; Bild 171×139 cm; beschn[itten]. Beschädigung in der Bildmitte. Lit.: Hollstein G. 27.77 (Nr. 86).

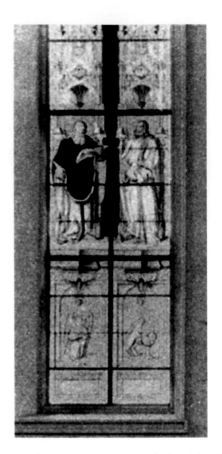

18. Johann Jakob Röttinger, alte Fotografie des nicht erhaltenen Fensters s II der Pfarrkirche Thalwil (Kopie), Originalfoto: Ortsmuseum Thalwil.

19. Johann Jakob Röttinger, alte Fotografie des nicht erhaltenen Fensters n II der Pfarrkirche Thalwil (Kopie), Originalfoto: Ortsmuseum Thalwil.

Entwurf, der explizit auch die Ortschaft bezeichnet, kann die Urheberschaft desselben durch Röttinger beziehungsweise seiner Werkstatt auch ohne Signatur eindeutig festgemacht werden. Ein Teil der Glasfenster konnte im Ortsmuseum Thalwil ermittelt werden; die Übereinstimmung war sowohl aufgrund der Beschreibung im Akkord wie auch anhand der formalen und farblichen Gestaltung als Umsetzung des vorhandenen Entwurfs gegeben. Wie erwähnt sind drei Fragmente aus dem ursprünglichen Zyklus überliefert, der den historischen Fotos aus dem Ortsmuseum (Abb. 18, 19) zufolge im Sinne der chronologischen Evangelisten-Reihenfolge der Vulgata angeordnet war[222].

Der auf dem Entwurf abgebildete Teil der Scheibe hat sich zwar nicht erhalten, jedoch handelt es sich um die Fortsetzungen des südlichen Chorfensters

s II, um die Felder 7b, 8b, 9b. Dank der grün-weißen Randverzierung und den Abbildungen auf den Fotos ist der dargestellte Evangelist Matthäus (Abb. 20) als eine der vier Figuren der beiden Fenster (n II, 3a, 4a) identifizierbar.

Vom selben Fenster stammend wird in einem zweiten Fragment der Löwe als Evangelisten-Symbol des Markus (Abb. 21) mit dem Bibelzitat in der Sockelzone «*Alle Dinge sind möglich. Dem, der da glaubt, Mk (10, 42)*»[223] dargestellt (n II, 2b). Darüber hinaus stimmt das Rautenmuster auf dem Entwurf mit dem Hintergrund auf dem Glasgemälde

222 LCI 1, 1968, Sp. 696 f., Stichw. *Evangelisten, Evangelistensymbole* (U. Nilgen). Zur Ikonographie der Evangelisten im Kap. ‹Ikonographie›.
223 Mk 10, 23 mit Verweis auf die Vulgata: «Wenn du glauben kannst. Dem, der glaubt, ist alles möglich.»

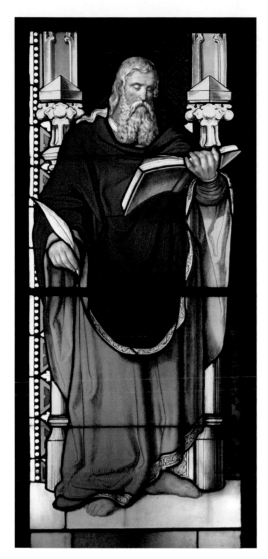

20. Johann Jakob Röttinger, Evangelist Matthäus, Scheibenfragment (ehem. n II, vgl. Abb. 19), ehemals Pfarrkirche Thalwil, 1860, Ortsmuseum Thalwil.

des Evangelisten zwischen den beiden flankierenden Säulen überein. Im Akkord werden weitere Fenster erwähnt, nämlich *«zwei ganz in Damast Malerei ausgeführte Fenster, wiederum rechts und links an beiden obigen»* sowie *«zehn gemalte Fensterköpfe»*[224]. So zeigt das dritte Fensterfragment eine mit so genannten Schweizerrauten ausgeführte Blankverglasung[225], die lediglich am Rand einen gelb-roten Zierstreifen mit aus diesem «heraus wachsenden» weißen Blumen und Blättern aufweist — wohl ein Rest der ehemaligen Schifffenster mit den im Vertrag erwähnten gemalten Fensterköpfen.

21. Johann Jakob Röttinger, Löwe als Evangelistensymbol des Markus mit Inschrift, Scheibenfragment (ehem. n II, vgl. Abb. 19), ehemals Pfarrkirche Thalwil, 1860, Ortsmuseum Thalwil.

224 Zitat aus dem Akkord; vgl. Anm. 217.
225 TRÜMPLER, 2003. Der Name hat sich für die abwechslungsweise Anordnung von Sechsecken und Rauten eingebürgert.

Die unter der Leitung Ferdinand Stadlers 1845 gebaute Kirche erhielt ihre Glasmalereiausstattung laut Beschluss der Protokolle der Kirchenpflege erst im Jahre 1860[226]. *«Da die in der Kirche aufgestellten Proben von in Glasmalerei verfertigten Damastfenstern allgemein aber zu einfach befunden wurden, so hatte Herr Glasmaler Roedinger in Zürich die Güte, einige in Glas gemalte Bilder zur Ansicht einzusenden. Der Stillstand hat solche in der Kirche aufstellen lassen und geprüft und hat übereinstimmend Wohlgefallen daran gefunden. Er glaubt, dass es sehr passend und die höchste Zierde für unsere Kirche wäre jedes der beiden Fenster neben der Kanzelwand mit solchen gemalten Bildern (die vier Evangelisten vorstellend) u. dann die beiden anstoßenden Fenster mit Damastmalereien zu versehen [...]»*[227]. Obwohl die freiwillig gezeichneten Beiträge der Bürgerschaft für diese Mehrauslagen von etwa 2000 Franken nicht ausreichten, beschloss die Kirchgemeinde auf Empfehlung des Stillstandes einen Kredit für die geplanten Verschönerungen zu versprechen und vereinbarte mit Glasmaler Röttinger einen Liefertermin am 27. Oktober 1860.

Die Skizze eines weiteren Rundbogenfensters verweist auf eine Arbeit Röttingers in der Westschweiz, nämlich in der Pfarrkirche Tafers FR[228]. Das gezeichnete einfach verzierte Fenster erscheint in einer im 19. Jahrhundert häufigen Variante der Bleiverglasung nach dem Muster der so genannten Schweizerrauten. Ein Dekor aus weißen Blättern und roten Rosen auf grünem Streifen rahmt die Blankverglasung und die übliche hellgrau gemalte Einfassung verweist auf das Gewände. Die Andeutung vier horizontaler und eines vertikalen Windeisens teilt die Fensterfläche. Die Notiz links unter der Skizze *«1/10 nat. Größe»* bezeichnet den Maßstab der Maquette und die Ordnungszahl *«30.»* gibt die Nummerierung des Entwurfs an. Besonders von Bedeutung ist in diesem Fall die Beschriftung auf der Rückseite, weil diese die fehlenden Schriftdokumente ersetzt: *«Von der Kirchenbaukommission von Tafers, Kanton Freiburg angenommen. Tafers, den 20. Octbr. 1874. Für die Baukommission Joh. Christoph Fasel, Pfarrer; J. Stritt, Pfarreirath; Sturny Ulrich, Pfarreirath.»* Die ent-

sprechenden Scheiben sind in diesem Falle nicht mehr erhalten[229].

Das vierte Entwurfsblatt aus dem Nachlass[230], das dank der Beschriftung und der überlieferten Schriftdokumente eindeutig der Urheberschaft Johann Jakob Röttingers und seiner Werkstatt zuzuordnen ist, wurde für die Kirchgemeinde Châtonnaye FR angefertigt. Es handelt sich um die Zeichnung eines plastisch in die Mauernische integrierten Rundbogenfensters mit drei Querstangen beziehungsweise Windeisen. Durch den zweibahnigen Aufbau ergeben sich im Bogenfeld zwei gemalte Rundbogen und darüber ein Medaillon, das im Entwurf Kelch, Hostie und Weintrauben aufweist. Die farbig gerahmten Fensterflächen sind mit einem Grisaille-Teppichmuster gestaltet, deren Rauten abwechslungsweise durch Blüten- und Blattornamente gefüllt sind. In den unteren zwei Abschnitten des Fensters sind leere Rauten eingezeichnet mit dem Vermerk: *«aussi grisaille»*. Weitere Notizen lauten: *«32.»* und *«o 40 fr.»* (unten links) sowie *«11/2″ = 1 Fuss»*, plan N° 1er und vor allem die Bestätigung des Pfarrers von Châtonnaye: *«Vu à Châtonnaye. Pre Roux»*.

Die Bemerkungen auf dem Entwurf stimmen mit der Korrespondenz zwischen Pfarrer Roux, als Vertreter der Kirchenbaukommission, und dem Glasmaler bestens überein. Im Brief des Pfarrers vom 15. Januar 1872 wird schon erwähnt, dass die übersandten Pläne retourniert würden und die Ausführung des Medaillons nicht notwendig sei, da er das Fenster auch so schön genug fände. In der am 18. Januar 1872 datierten Vereinbarung wird schließlich festgehalten, dass die Herstellung

226 KGA Thalwil, IV.B.1.9. Protokoll der Kirchenpflege 1858–1874. ZB Nachl. Röttinger 1.163.

227 Zitat aus: KGA Thalwil, IV.B.1.9. Protokoll der Kirchenpflege 1858–1874.

228 ZB Nachl. Röttinger 1.1.8 Blatt 3; Maße 58×21.7 cm.

229 Trotz intensiver Mithilfe des Pfarreirats Tafers Peter Ledergerber und des Lehrers und ehemaligen Präsidenten des Pfarreirates in Alterswil FR Charles Folly bei der Suche nach Archivalien und Scheibenresten, denen hiermit bestens gedankt sei, ließen sich für Tafers keine weiteren Dokumente finden.

230 ZB Nachl. Röttinger 1.1.8 Blatt 4, Maße: 58×21.5 cm.

der Fenster nach Plan 2 zu erfolgen habe, das heißt die sieben Fenster im Schiff wie diese in Promasens, also in weißem Glas mit Filet, Bordüren und Emblemen, wohingegen die Chorfenster in Grisailletechnik laut Promasens Plan 1 zu gestalten seien. Im weiteren Text werden die Ausführung der Sakristeifenster und der Rosette über dem Seitenportal, die Lieferungsmodalitäten und der Preis besprochen. Letzterer sollte Fr. 1000 nicht übersteigen[231]. Auch diese Glasmalereien haben sich nicht erhalten[232].

Zeichnungen und Lichtpausen mittelalterlicher Glasmalereien

Im Gegensatz zu den spärlich überlieferten Maquetten und Entwürfen sind im Archiv der Antiquarischen Gesellschaft Zürich (heute im Staatsarchiv) in großer Zahl Zeichenblätter von mittelalterlichen Glasmalereien auf uns gekommen – es sind 243 an der Zahl. Johann Jakob Röttinger erhielt von Ferdinand Keller (1800–1881) den Auftrag für die Antiquarische Gesellschaft Zürich die berühmten Glasmalereien der ehemaligen Klosterkirche Königsfelden zeichnerisch festzuhalten. Da es sich dabei um möglichst identische Wiedergaben der Glasmalereien gehandelt hatte, musste eine Art Pausverfahren zur Anwendung gekommen sein. Johann Rudolph Rahn (1841–1912) erzählt in den «Erinnerungen aus den ersten 22 Jahren» seines Lebens die folgende Episode: Der Zeichner A. Gräter (vgl. Anm. 241) sei auf einem fliegenden Gerüst in der ehemaligen Klosterkirche zu Königsfelden vom Aufseher «vergessen» worden [...][233], was bedeutet, dass der Zeichner seine Arbeit nahe am Fenster frei schwebend auf einem Holzbrett sitzend ausgeführt hatte, um möglicherweise mit Papier oder Stoff, das durch Öl oder Petroleum[234] lichtdurchlässig gemacht wurde, «Lichtpausen» anzufertigen. Bei Gräter erlernte der junge Rahn das Pausen seiner «glasmalerischen Lieblingsstücke» – so werden im Staatsarchiv Zürich auch Durchzeichnungen vom späteren Professor und Denkmalpfleger aufbewahrt[235].

Der Archäologe und Gründer der Antiquarischen Gesellschaft in Zürich[236], Ferdinand Keller, und Glasmaler Röttinger standen offenbar in freundschaftlichem Kontakt[237]. Als Immigrant profitierte der junge Unternehmer vom weitreichenden gesellschaftlichen Netz Kellers und dessen Empfehlungen, die ihm manchen Erwerb von Aufträgen erleichterte. Dies geht aus einigen Briefen Röttingers im Staatsarchiv Zürich hervor, die an den Altertumsforscher gerichtet sind und diesen über den Fortgang der Durchzeichnungen[238] in Königsfelden informieren. Obwohl die Zeichnungen ebenfalls jeglicher Signatur entbehren, ist aufgrund der Briefinhalte auf kolorierte Zeichnungen beziehungsweise Pausen durch Johann Jakob Röttinger zu schließen. So weist er in seinem Schreiben vom 23. Juli 1851 darauf hin, dass die Arbeit dort [in Königsfelden] einen guten Fortgang genommen habe, dass bereits drei Fenster durchgezeichnet, Verbleiung und Schattierung fast vollendet seien und demnach die Arbeit nicht bis zum Ende des Sommers dauern würde[239]. Indem sich Röttinger in seinen Briefen jeweils für die erhaltene Antwort Kellers bedankt, was auf eine rege Korrespondenz schließen lässt, fährt er in seinem Bericht vom 31. Juli 1851 fort: *«Nächsten Sonntag werde ich wieder nach Königsfelden verreisen um eine Parthie Zeichnungen zu vollenden, dass Sie mit der Ihnen gesendeten Zeichnung des Simern [Simon] nicht unzufrieden sind, freut mich ungemein und gibt mir umso mehr Mut fortzufahren. [...]*

231 ZB Nachl. Röttinger 1.29.

232 MARADAN, 2004, HLS, Stichw. *Châtonnaye*. Die Kirche aus dem Jahr 1700 wurde 1884 durch die Sankt Annen-Kirche ersetzt.

233 RAHN, 1920, S. 12–14.

234 LDK 5, 1993, S. 483, Stichw. *Pausen*.

235 Johann Rudolph Rahn, Fragment der Maßwerkfüllungen des Kreuzgangs (Fenster VII) Wettingen, 25. Mai 1861, Pinsel, aquarelliert auf Pauspapier (Universität Zürich Kunsthistorisches Institut Fotothek, Gx314).

236 Antiquarische Gesellschaft Zürich, Kantonaler Verein für Geschichte und Altertumskunde, gegründet 1832.

237 StAZH Briefwechsel Sign.: W I 3 AGZ 174 12, Müller-R 1851–58.

238 StAZH W I 3 AGZ 193/1852.

239 StAZH W I 3 AGZ 194/1851.

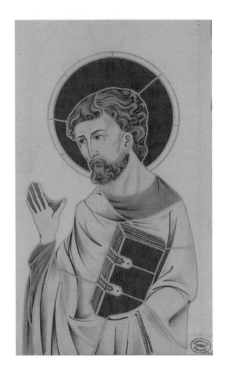

22. Johann Jakob Röttinger (o. Sign.),
heiliger Simon [„*Simern*'], 90×60 cm,
Ausschnitt Durchzeichnung (Pause)
der Glasmalereien in Königsfelden,
aquarelliert, 1851/52, Staatsarchiv Zürich
(StAZH W I 3 400. 9 C, Blatt11).

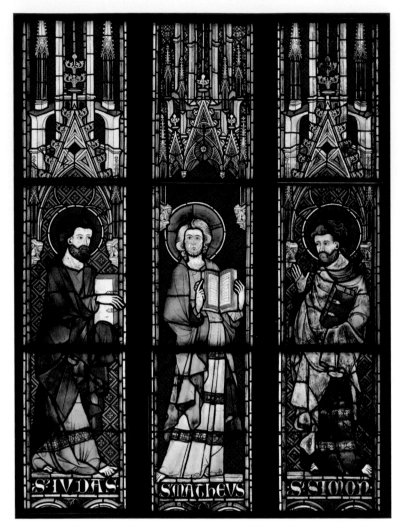

23. Ausschnitt aus dem Apostelfenster, Heilige Judas, Matthäus und Simon,
Chorfenster n IV, 7–9b-c, ehemalige Klosterkirche Königsfelden, um 1340.

Sollte es der Fall sein, dass Sie mich in meinem Fache empfehlen könnten, so sollte es mich herzlich freuen zumal mir jetzt eher Gelegenheit geboten ist meine Arbeiten ohne Hemmschuh auszuführen.»[240] (Abb. 22, 23)
Ferdinand Keller war selbst als versierter Zeichner bekannt, daher ist die Unsicherheit des Glasmalers verständlich. Professor Dr. Johann Rudolf Rahn vermerkte dazu in der oben erwähnten Publikation[241]: «Keller ist außerdem ein gewandter Zeichner gewesen, dessen scharfes Auge die feinsten Besonderheiten entdeckte. Es war darum kein Leichtes, ihn auf diesem Gebiete zufrieden zu stellen, und manchen Seufzer hat mich seine Kritik gekostet, wenn etwas ganz nach seinem Wunsch gerathen

musste»[242]. An einer anderen Stelle seiner Aufzeichnungen nennt Rudolf Rahn den Zeichner Albert Gräter (†1909) als Kellers rechte Hand, der Rahn wie schon erwähnt das «Scheiben pausen» lehrte und als dessen Hauptwerk die Durchzeichnungen der Königsfelder Glasgemälde gelten, die er im Auftrage der Antiquarischen Gesellschaft

240 StAZH W I 3 AGZ 196/1851. Beim *«Hemmschuh»* handelte es sich wohl um den Geschäftspartner der ersten Jahre namens Weiss.
241 RAHN, 1920, S. 1–90, hier S. 9.
242 Im StAZH haben sich signierte Zeichnungen Kellers der Glasmalereien der Kirche von Maschwanden erhalten. Sign.: W I 3 AGZ 400 9k K11–12.

Ende der Fünfziger beziehungsweise Anfang der Sechzigerjahre durchführte[243]. Da die erhaltenen Königsfelder-Zeichnungen im Staatsarchiv weder datiert noch signiert sind, könnten diese auch Gräter zugeschrieben werden. Möglicherweise hatten beide, Röttinger 1851 und Gräter am Ende des Dezenniums beziehungsweise Anfang der Sechzigerjahre, einen Auftrag für die Herstellung von Durchzeichnungen erhalten, wobei die Autorschaft der überlieferten Zeichnungen weiterhin unklar bleibt. Der Vergleich mit graphischem Material Albert Gräters, von dem sich Zeichnungen der Glasfenster aus dem ehemaligen Kloster Wettingen erhalten haben, zeigt jedoch, dass dieser jedes Blatt signierte beziehungsweise datierte (zum Beispiel: «A. Gräter Mai 58»). Die dabei verwendeten Titel mittels einer Zierschrift kommen sonst nur noch auf den Blättern von Hauterive vor. Die «gestochen schönen» Schriftbilder auf den Durchzeichnungen von Wettingen beziehungsweise der Scheiben des Freiburger Klosters unterscheiden sich nur wenig voneinander. Die Beschriftungen der Königsfelder Blätter erscheinen im Vergleich dazu als reine Arbeitsnotizen. Vermutlich war es Usus, Titel und Überschriften durch die Anwendung der lateinischen Schrift hervorzuheben, hingegen Nebentexte, Alltagskorrespondenzen und Notizen in alter deutscher Schrift zu verfassen. Dass Johann Jakob Röttinger in den frühen Fünfzigerjahren an den Glasfenstern in Königsfelden gearbeitet hatte, bezeugt jedoch nicht nur der erwähnte Briefwechsel mit Ferdinand Keller in den Jahren 1851/1852, sondern wird auch durch die Ritzung seines Namens auf der Außenseite des Glases im Chorfenster n II, 5b, Jugend Christi, Anbetung der Könige: «J. Röttinger 1851 Glasmaler» offenbar[244]. Die außenseitige Ritzinschrift auf dem Glasstück, das das Geschenk des mittleren Königs darstellt, stammte möglicherweise von einer Restaurierungsarbeit Röttingers, was allerdings durch Schriftdokumente nicht belegbar ist[245]. Die Frage bezüglich der Autorschaft der Abbildungen in der Publikation von Theodor von Liebenau und Wilhelm Lübke nach Johann Jakob Röttingers Pausen ist wegen der fehlenden Beweislage weiterhin nicht

schlüssig zu beantworten[246]. Johann Rudolf Rahn erläutert 1897 anlässlich einer Bestandsaufnahme an der Konferenz des Vorstandes der Schweizerischen Gesellschaft für die Erhaltung historischer Kunstdenkmäler den Befund, der sich bei der Herausnahme der Glasmalereien gezeigt hatte. In Anbetracht der Tatsache, dass die Fenster in den Siebzigerjahren das letzte Mal restauriert worden seien, bedauerte er deren Zustand. Die Fenster E (n II) sowie D (n III) und E (n IV) wurden bei dieser Gelegenheit explizit *nicht* genannt[247].

Im Jahre 1860 erhielt J. Röttinger von der aargauischen Regierung den Auftrag, die berühmten Glasmalereien des Kreuzganges im Kloster Muri zu inventarisieren, die im Zuge der Aufhebung des Stiftes 1841 herausgenommen und verwahrt worden waren. Ob sich die Dokumentation auch zeichnerisch vollzog, konnte archivalisch nicht erschlossen werden. Festgehalten wird das Ereignis im oben genannten Zürcher Taschenbuch durch Johann Rudolf Rahn, der vom Glasmaler aufgefordert wurde, ihn zu begleiten [«solche Gunst zu nutzen»] und jener ihm daraufhin anbot, das Bestandsverzeichnis der 54 Scheiben aufzunehmen[248]. Röttinger erwähnt in einem der oben genannten Briefe außerdem *«Zeichnungen der Freiburger Fenster»*[249], die er Keller offenbar ausgeliehen

243 RAHN, 1920, S. 12–14.

244 KURMANN-SCHWARZ, 2008, S. 94 mit Abb. 86.

245 Vgl. BRINKMANN, 1996, S. 102, Abb. 68. Die Abbildung zeigt eine außenseitige Ritzung des 17. Jahrhunderts («Meister Carolus Pütz»), Köln, Dom, Chor SÜD VIII, 2d. TRÜMPLER, 2002 (1), S. 72, Abb. 91: Die Abbildung zeigt die Ritzinschrift Johann Heinrich Müllers aus Bern mittels eines Diamantschneiders, was Stefan Trümpler als weitverbreitete Sitte anlässlich ausgeführter Renovationsarbeiten bezeichnet.

246 KURMANN-SCHWARZ, 2008, S. 94. Anm. 133–135. Vgl. die Abb. in LIEBENAU/LÜBKE, 1867–1871.

247 RAHN, 1897, S. 1–9, Konferenz vom 4. Januar 1897.

248 RAHN, 1920, S. 29; vgl. HASLER, 2002, S. 43, Anm. 71: Darüber hinaus wurde J. Röttinger 1860 von der Aargauer Regierung der Transport der Scheiben von Muri nach Aarau übertragen (StAAG, Akten zu den Scheiben im Staatsbesitz, DB 01/05 91).

249 StAZH, W I 3 AGZ 194/1851.

hatte und sie nun zurückzuerhalten wünschte. Es handelte sich dabei um Zeichnungen der Fenster der Klosterkirche Hauterive FR, von denen noch zwei unsignierte Blätter im Staatsarchiv Zürich überliefert sind[250]. Die Blätter sind mit einer Überschrift versehen, die darauf hinweist, dass die Zeichnungen vor der Restauration beziehungsweise der Versetzung in die *«Cathedrale Saint Nicolas in Freiburg»* angefertigt worden waren. Ein Auftrag, der ebenfalls von der Werkstatt Röttinger durchgeführt wurde[251]. Der Glasmaler wandte sich in einem Brief an Ferdinand Keller und schrieb: *«Zugleich mache Ihnen die Anzeige der Altenryffen Fenster, welche ich noch in ihrer Verwahrung glaubte in meinen Kästen sich vorgefunden. Sie haben dazumal, als ich Ihnen dieselben zeigte mir bemerkt, dass die Durchzeichnungen für Sie das gleiche sei, daher habe sie dazumal gleich wieder mitgenommen. Ich bitte dieses Versehens halber um Entschuldigung»*[252].

Ellen J. Beer berichtet im entsprechenden Corpusband über die mittelalterlichen Glasmalereien in der Schweiz[253], dass im Zuge einer Gesamtrenovierung der Abteikirche des ehemaligen Zisterzienserklosters Kappel am Albis in den Jahren 1873–1876 die Werkstatt H. Röttinger[254] mit Restaurierungsarbeiten an den Glasgemälden beauftragt gewesen sein soll. Gleichzeitig seien Lichtpausen[255] angefertigt worden, von denen noch acht Blätter im Staatsarchiv Zürich aufbewahrt würden. Dabei handelt es sich ebenfalls um unsignierte und mit dem Stempel der Antiquarischen Gesellschaft Zürich versehene Zeichnungen beziehungsweise Aquarelle in ähnlicher Ausführung als diejenigen von Königsfelden. Es scheint jedoch, dass die Figuren der Kappeler Blätter im Detail weniger ausgearbeitet wurden, was sich vor allem in der Andeutung der Gewandfalten und der Modellierung der Gesichter und Frisuren zeigt. In weiterer Folge erwähnt die Autorin die Restaurierung der erst 1829 und 1830 wiederentdeckten Glasmalereien der Kirche Sankt Laurentius in Frauenfeld Oberkirch TG. Die mittelalterlichen Glasmalereien sollen zwischen 1850 und 1864 vom Zürcher Glasmaler Jakob Röttinger restauriert und bei dieser Gelegenheit graphisch festgehalten worden sein[256].

24. Johann Jakob Röttinger (o. Sign.), Ornament, 80×45 cm, Durchzeichnung (Pause) der Glasmalereien in der ehemaligen Klosterkirche Kappel a. Albis, aquarelliert, 1870–1876, Staatsarchiv Zürich (StAZH W I 3 400. 9 K, Blatt 5).

250 StAZH, W I 3 410. 70 (Inv.Nr. 1847, 1848).
251 ZB Nachl. Röttinger 1.47, 1.48; vgl. Kap. ‹Kunst – Kunsthandwerk, Restaurierung›.
252 StAZH, W I 3 AGZ 196/1851.
253 BEER, 1965, S. 18.
254 Das «H.» steht für Heinrich Röttinger, der später an den Fenstern arbeitete und seine Signatur hinterließ.
255 StAZH, W I 3 AGZ 400 9k K1-K8.
256 BEER, 1965, S. 42 und Abb. 17; RAHN, 1901–1910, S. 3: «Unter den flüchtigen Durchzeichnungen, die Röttinger zu Ende der Fünfzigerjahre für die Antiquarische Gesellschaft in Zürich besorgte, kommen drei Buntmuster vor, die an Ort und Stelle sich nicht mehr finden […]».

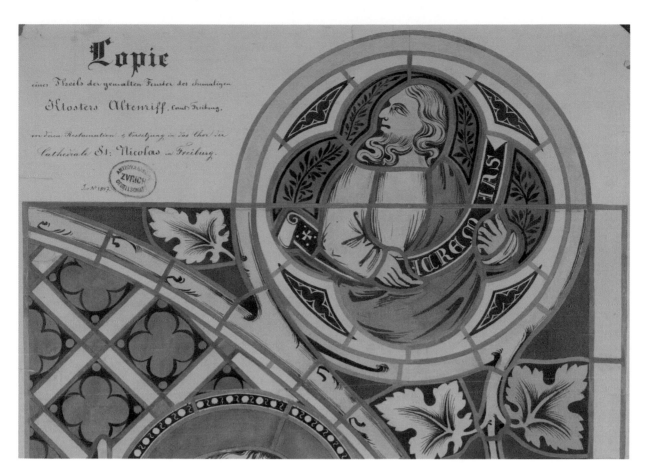

25, Johann Jakob Röttinger (o. Sign.), 80×45 cm, Ausschnitt Durchzeichnung (Pause) der Glasmalereien in der Klosterkirche Hauterive, aquarelliert mit Inschrift, vor 1848, Staatsarchiv Zürich (StAZH W I 3 410. 70).

Im Archiv der Antiquarischen Gesellschaft Zürich (Staatsarchiv Zürich) haben sich aus Frauenfeld zwölf unsignierte Blätter, kolorierte Lichtpausen des Chorfensters, in Oberkirch erhalten, die mit Arbeits- und Korrekturnotizen versehen sind[257]. Die Zeichnungen der mittelalterlichen Glasmalereien der ehemaligen Klosterkirche von Kappel (1310–1330) (Abb. 24), der Kirche Sankt Laurentius (Abb. 63) in Frauenfeld Oberkirch (um 1330), der Klosterkirche Hauterive (1320–1328)[258] (Abb. 25) sowie der ehemaligen Klosterkirche in Königsfelden (1330–1340)[259] stammen – also mit großer Wahrscheinlichkeit – aus der Hand des Glasmalers Johann Jakob Röttinger. Zahlreiche Indizien sprechen – trotz der fehlenden Signaturen – für seine Autorschaft. Mit Signatur und Datum versehen sind allerdings die Graphiken Albert Gräters, welche der Zeichner von den

Glasmalereien des Klosters Wettingen angefertigt hatte. Dessen Gewohnheit, auf seinen Zeichnungen den ganzen Namen und das Entstehungsdatum zu hinterlassen, sowie die sehr präzise Malweise schließen ihn für alle anderen überlieferten Blätter aus. Röttinger und Gräter waren jedoch

257 StAZH W I 3 AGZ 400 22. Die Korrekturnotizen stammen in diesem Fall von B. Recordon und wurden 1900 angebracht. Richard A. Nüscheler machte entsprechende Notizen wohl anlässlich seines Restaurierungsauftrags 1896–1900 auf den Zeichnungen von Königsfelden. Vgl. KURMANN-SCHWARZ, 2008, Corpusband Königsfelden, S. 95 f.

258 TREMP, 2007, HLS, Stichw. *Hauterive*. Unter Abt Peter Rych (1320–1328) wurde der Kreuzgang durch Maßwerkfenster überhöht und die Kirche um den gotischen Chor mit einem sechsteiligen Maßwerkfenster und Glasmalerei erweitert.

259 Die Langhausfenster sind älter und stammen zum Teil aus der Zeit um 1312/1313.

nicht die einzigen Künstler, die Zeichnungen von historischen Schweizer Glasmalereien hergestellt haben. Von Heinrich Müller, dem Berner Glasmaler, der ab etwa 1870 als Restaurator im Kanton Aargau auftrat, haben sich hunderte von Zeichnungen als Grundlage seiner Restaurierungsarbeiten erhalten[260]. Auch Ferdinand Keller selbst hat Zeichnungen von Glasmalereien angefertigt und diese signiert beziehungsweise mit dem Datum versehen. So haben sich im Archiv der Antiquarischen Gesellschaft Zürich kolorierte Zeichnungen Kellers aus der Kirche in Maschwanden erhalten, die die drei Patrone der Stadt Zürich – Felix, Regula und Exuperantius – zeigen[261]. Dass Ferdinand Keller seine Zeichnungen signierte, ist für das 19. Jahrhundert typisch, da sich zu jener Zeit auch Laien intensiv mit der Zeichnung auseinandersetzten; das bekannte und zugleich prominenteste Beispiel ist J.W. Goethe, der sich eingehend mit dieser Kunstgattung beschäftigt hatte[262]. Johann Rudolf Rahn, der im 19. Jahrhundert die Grundlagen für die Erforschung der mittelalterlichen Glasmalerei in der Schweiz schuf, war bei der Betrachtung der Werke auf Fernglas und Zeichenstift angewiesen, da ihm die moderne Technik der Fotografie noch nicht zur Verfügung stand[263].

Die graphische Reproduktion von Glasmalereien und deren Forschungslage

Die Geschichte der graphischen Reproduktion von Glasmalereien beginnt sich mit der Neugotik zu verdichten, als das Interesse an alten Glasmalereien gegen Ende des 18. Jahrhunderts eine einsetzende Sammelleidenschaft begründete[264]. Aus der Sammeltätigkeit und der Bewahrung ergaben sich schließlich erste Ansätze einer wissenschaftlichen Erforschung beziehungsweise Dokumentation. 1808 begann Sulpiz Boisserée (1783–1854) mit der wissenschaftlichen Vermessung und Erforschung des Kölner Doms, deren Ergebnisse er in seinem berühmten, umfangreichen «Domwerk» (1821–1831) publizierte. Darin sind zwei der 18 Kupferstiche den Glasmalereien des Doms gewidmet – heute ein archäologisches Zeugnis einiger inzwischen

zerstörter Glasmalereien von unschätzbarem Wert. Als eine der frühesten Kopien, aus der ersten Hälfte des 17. Jahrhunderts, kann die aquarellierte Skizze eines Wurzel-Jesse-Fensters des Prämonstratenserstiftes Speinshart auf einem Streifen Wollpapier bezeichnet werden, das sich im Regensburger Museum erhalten hat. Aus dem 18. Jahrhundert werden in der Stiftsbibliothek des Augustinerchorherrenstifts Klosterneuburg weitere aquarellierte Zeichnungen der klösterlichen Glasmalereien von B. Prill überliefert[265]. Die Glasgemälde der Katharinenkirche in Oppenheim sind von Franz Hubert Müller (1784–1835) auf 11 kolorierten Tafeln zur Nachahmung gotischer Bauformen festgehalten. Des Weiteren nennt die Forscherin Claudia Schuhmacher Architekt Gottlob A.G. Engelhard (1812–1876), der eine unveröffentlichte Monografie der Zisterzienserkirche Haina mit erstklassigen Tuschezeichnungen der Hainaer Grisaillen verfasste, ebenso Kopien der Altenberger Grisaillen, die als zeitgenössische Vorlagen für Ornamente dienten, sowie die aquarellierte Zeichnung des Kölner Malers Michael Welter (1808–1892), der die Glasmalereien des Kreuzgangflügels im Kloster Wienhausen reproduzierte. Für Frankreich nennt Claudia Schumacher, stellvertretend für Kopien im Zuge von Restaurierungsarbeiten der Kathedrale in Bourges, die farbigen Nachbildungen der Jesuitenpatres für die «Monographie de la cathédrale de Bourges, Vitreaux du XIIIe siècle», Paris 1841–1844. Die Durchzeichnung mittelalterlicher Glasmalereien, der die Forschung bisher keine allzu große Beachtung geschenkt zu haben scheint[266], war im 19. Jahrhundert das Mittel der Wahl, wollte man

260 TRÜMPLER, 2002 (1), S. 72.

261 StAZH W I 3 AGZ 400 9k.

262 GRAWE, 2005, S. 257.

263 KURMANN-SCHWARZ, 2012 (2), S. 343.

264 SCHUMACHER, 1998, S. 111 ff; HESS, 1997, S. 2–6.

265 SCHUMACHER, 1998, S. 113 f. mit weiteren Literaturangaben.

266 Elgin van Treeck-Vaassen sei für die Ergänzung von Literaturangaben zum Thema des «Kopierens» herzlich gedankt.

einerseits sehr genaue Kopien, die farbig gestaltbar waren, zur Rekonstruktion beziehungsweise Restaurierung herstellen oder andererseits, wie wohl im Falle der Antiquarischen Gesellschaft Zürich, den Zustand der Scheiben zu einem bestimmten Zeitpunkt festhalten. So erwähnt Falco Bornschein[267] die Anfertigung von rund 200 Kopien nach mittelalterlichen Chorfensterfeldern von Chr. Lang 1858, die im Maßstab 1:1 oder 1:2 mit Tusche oder Bleistift ausgeführt, zum Teil koloriert und im Archiv des DBA Erfurt aufbewahrt wurden. Der Autor vermutet, dass die Aquarellkopien vor allem dem Glaser als Orientierungsgrundlage etwa für Neuverbleiungen gedient haben und zitiert ein Regest von 1867: «[…] daß vor dem Beginn der Arbeit die Fenster Tafeln einzeln in einem etwas großen Maßstab gezeichnet werden sollten, damit die Zusammenstellung leichter ausgeführt werden kann»[268]. Ebenfalls zu Restaurierungszwecken erstellte 1875 Architekt Memminger, der von Naumburg an die Soester Wiesenkirche bestellt wurde, Zeichnungen der Glasmalereien, deren Ergebnisse zum endgültigen Restaurierungsvorschlag des Architekten führten[269]. Darüber hinaus sei bemerkt, dass das Zeichnen im 19. Jahrhundert einen Ausweis der Bildung darstellte und nach Johann Rudolph Rahn «erlernbar» sein soll. Er selber bezeichnete sich dabei als Dilettant, in nicht abwertender Weise von *delectare* ableitend, hinterließ er doch mit seinen Zeichnungen wertvolle Bildquellen von Gebäuden, deren Details und ausgewählten Glasmalereien[270]. Bereits Pierre le Vieil (1708–1772) forderte, in der von Joh. Conrad Harrepeter übersetzten Publikation «Die Kunst auf Glas zu malen und Glasarbeiten zu verfertigen», die Schulung der Glasmaler an historischen Vorbildern und empfahl das Studium der Glasmalereien der Abtei Saint-Victor in Paris als Vorlagen für Neuschöpfungen[271].

Zusammenfassend ist festzuhalten, dass in erster Linie der einheitliche Zeichenstil der Blätter aus Königsfelden, Kappel, Oberkirch und Hauterive für die Urheberschaft Johann Jakob Röttingers spricht. Das Fehlen der Signaturen ist dabei, wenn nicht als «Markenzeichen», dann doch als Eigenart des Glasmalers Röttinger anzusehen. Möglicherweise billigte er das Durchpausen von Glasmalereien nicht als angemessene künstlerische Tätigkeit, da sie jeder kreativen Eigenständigkeit entbehrt. In einer Zeit, in der Fotogrammetrie und Fotografie als gängige Methoden angewendet wurden und die Daguerreotypie bereits seit 1839 bekannt war[272], verlor die zeichnerische Reproduktionstechnik an Ansehen und vermochte ihren Mehrwert wohl nur noch über die Möglichkeit einer farbigen Gestaltung zu rechtfertigen. Überdies lässt sich ein Bild, in diesem Falle die aquarellierte Zeichnung, und erst recht die Architektur, als deren Bestandteil die Glasmalerei bezeichnet werden kann, in der Fotografie viel leichter erfassen als in Wirklichkeit. Schließlich waren die neuen mechanischen Reproduktionstechniken eine Verkleinerungstechnik und erleichterten nicht nur die Inventarisation, sondern verschafften dem Betrachter einen gewissen Grad von «Herrschaft» über das Werk[273]. Dementsprechend hält Heinrich Oidtmann am Ende des 19. Jahrhunderts[274] in seinem «Handbuch» über die Glasmalerei nicht mehr viel von Handpausen. Er fordert, «[…] wenn irgend möglich, [die Fenster] vor der Herausnahme an Ort und Stelle, sonst sofort nach derselben in möglichst großem Maßstabe photographisch aufzunehmen» und attestiert diesen Bildern einen urkundlichen Beleg für den bisherigen Zustand und die Funktion eines wertvollen Arbeitsmittels

267 BORNSCHEIN, 1996, S. 54, Abb. 17–20.
268 BORNSCHEIN, 1996, S. 54, Anm. 172: Bornschein zitiert nach SCHOLZ, 1994.
269 LANDOLT-WEGENER, 1959, S. 19.
270 Ausstellung Zürich, Predigerchor, Johann Rudolf Rahn (1841–1912): Zeichnender Forscher und Pionier der Denkmalpflege (von Oktober 2011 bis Februar 2012), kuratiert von Barbara Dieterich und Jochen Hesse, Graphische Sammlung Zentralbibliothek Zürich.
271 BEINES, 1979, S. 93, zitiert aus der deutschen Übersetzung von Joh. Conr. Harrepeter 1779.
272 LDK 5, 1993, S. 578, Stichw. *Photographie*.
273 BENJAMIN, 1977, S. 60 f.
274 OIDTMANN, 1893, S. 136 f.

bei der Wiederherstellung der Scheiben. Vergrößerungen dieser Aufnahmen ergäben außerdem die zuverlässigsten Pausen der Zeichnung. Er spricht jedoch der Anfertigung von Handpausen nicht per se jegliche Berechtigung ab, sondern akzeptiert diese Vorgehensweise zur Herstellung von Pausen in natürlicher Größe, bei denen eine Farbgebung sinnvoll erscheint. Aufwand und Kosten würden hingegen schon fast eine gläserne Reproduktion rechtfertigen[275]. In den meisten Fällen waren diese Pausen auf sehr dünnem Pauspapier mit einem Kohlestift hergestellt worden, wobei auf eine farbige Gestaltung fast immer verzichtet wurde[276]. Im Wettstreit um die Vergabe der Verglasung der Saint Mungo Cathedral 1856 wurden vom Auftraggeber, Charles Heath Wilson, Pausen von Skizzen angelegt, die man zur Genehmigung nach London schickte und später zur Überprüfung, der durch die Münchner Glasmalereianstalt ausgeführten Fenster, heranzog[277]. Die Erwähnung dieser völlig anderen Anwendung von Pausen soll die Vielfalt und die weite Verbreitung der Technik des Pausens im Zusammenhang mit der Glasmalerei ergänzen. Den Beispielen zufolge haben Röttingers Durchzeichnungen der Glasmalereien von Kappel, Hauterive, Oberkirch und Königsfelden hauptsächlich restauratorischen Zwecken gedient; außerdem leistete der Glasmaler damit bedeutende Inventarisationsaufgaben für die Antiquarische Gesellschaft und somit frühe denkmalpflegerische Arbeit. Bemerkenswert an diesem Aspekt der Dokumentation ist die fast durchgehend farbige Gestaltung, was diese Pausen, ausgeführt in Tusche und Aquarell, nicht nur zu «originalen» Urkunden werden lässt, sondern sie in ihrem Überlieferungswert über die neue Reproduktionsmethode der Fotografie stellt. Trotz allem beschränken sich die Zeichnungen Röttingers auf das Wesentliche, nämlich die Erfassung der Bleilinien und die korrekte Wiedergabe der Farben[278]; auf die mit Schwarzlot ausgeführte Binnenmalerei wurde weitgehend verzichtet. Johann Rudolph Rahn zollte – als Verfechter der Zeichnung – dieser die alleinige Berechtigung als wissenschaftliches Hilfsmittel[279]. Es ist daher durchaus überzeugend, wenn Monika Böning die Praxis der kolorierten graphischen Entwürfe und Nachzeichnungen von Glasmalereien als wertvollen Nachweis des Originalzustandes erhaltener und insbesondere verlorener Glasmalereien hoch einschätzt, denn diese Vorgehensweise war im 19. Jahrhundert häufig anzutreffen[280].

Auftrags- und Skizzenbuch

Nach der Betrachtung einzelner signierter und unsignierter sowie zahlreicher Zeichnungen wird in diesem Kapitel das wohl wichtigste noch erhaltene Arbeitsinstrument Johann Jakob Röttingers, das Skizzen- beziehungsweise Auftragsbuch[281], untersucht und ausgewertet. Die Überlieferung dieses Dokuments ermöglichte es, wenigstens fünf Jahre des künstlerischen beziehungsweise handwerklichen Schaffens des Glasmalers mehr oder weniger lückenlos zu erfassen. Dort erscheinen die wichtigsten Aufträge in chronologischer Reihenfolge ergänzt mit Notizen, Maßen und Skizzen. Das Dokument stellt darüber hinaus ein sehr persönliches Notizbuch dar, in dem ausschließlich der Meister selbst Eintragungen vorgenommen hat. Auftraggeberwünsche, Bemerkungen zur Ikonographie wie auch technische Angaben finden sich ebenso wie Kirchengrundrisse mit Lageplänen der Fenster, Maßwerkberechnungen oder Namen der Verantwortlichen in den Baukommissionen.

275 OIDTMANN, 1906, Sp. 257 ff.
276 Freundliche Mitteilung von Elgin van Treeck-Vaassen. Sie wies außerdem darauf hin, dass Durchzeichnungen der Glasmaler bisher von der Forschung kaum erwähnt worden seien.
277 VAASSEN, 1997, S. 207 ff.
278 Dass sich dabei auch manchmal Fehler eingeschlichen haben, zeigen spätere Notizen von Richard A. Nüscheler (1877–1950, aus der im 15. Jh. nach Zürich eingewanderten Glasmalerfamilie), die dieser direkt auf einzelnen Blättern vermerkte.
279 Vgl. Anm. 263.
280 BÖNING, 1993, S. 50.
281 ZB Nachl. Röttinger 1.202.

Vor dem Beginn der wissenschaftlichen Aufarbeitung des Nachlasses der Röttinger galt die Auflistung der darin vorkommenden Aufträge gewissermaßen als Werkliste der ersten Werkstattepoche unter Johann Jakob. Der größte Teil, der von Röttinger belieferten sakralen und profanen Bauten, sind in dieser Werkliste enthalten, zumindest jene, die uns bis heute bekannt geworden sind.

Auf dem Frontispiz des Büchleins erscheint das Wappen des Bischofs Eugenius, Eugène Lachat von Basel (1819–1886)[282], mit der Inschrift: «suaviter ac fortiter» [283]; ein Wappen, das der Glasmaler 1868 in das Bogenfeld des Chorfensters s II der Pfarrkirche Selzach SO integriert hat. Auf derselben Buchseite wird ein Stempel der Gemeinde Selzach SO platziert, der aus einem Briefcouvert ausgeschnitten worden ist[284]. Gegenüberliegend notiert sich der Glasmaler fünf lateinische Psalmenverse, wahrscheinlich aus eigenem Interesse im Sinne einer Auswahl bei möglichen Anfragen, da kein einziger einem bestimmten Fenster zugeordnet werden kann.

In der Folge erläuterte Johann Jakob Röttinger den Zweck des Buches: *«Verzeichnis der Kirchen und Kapellen in welchen sich aus der Glasmalerei v. J. Röttinger in Zürich Arbeiten befinden vom Jahr 1844–1865»*[285]. Offensichtlich wurde das Büchlein bereits nach dem Eintreffen des jungen Glasmalers aus Nürnberg angelegt, was jedoch nicht erklärt, warum die Eintragungen erst im Jahr 1865 einsetzen. Möglicherweise gab es ursprünglich mehrere dieser «Buchabschnitte», in die Röttinger nachträglich jeweils dieselbe Einleitung notierte, als Teilkapitel der Aufträge und Notizen der Zeitspanne von 1844–1865. Die einzelnen Werke trug er chronologisch ein; manchmal wurde eine Doppelseite beansprucht – dagegen genügte für kleinere Aufträge eine Seite pro Gebäude. Manche Buchseiten enthalten nur den Titel und die ebenfalls von Hand geschriebenen Seitenzahlen[286], so als ob der Glasmaler beabsichtigte, später noch weitere Eintragungen vorzunehmen. Einige Bauwerke erscheinen mehrmals, wie beispielsweise Zug Sankt Oswald, die Pfarrkirche Zufikon AG oder die Kapelle Sankt Wolfgang ZG. Dabei handelt es sich

meist um Folgeaufträge in Kirchen, für die das Atelier schon einmal gearbeitet hat. Insgesamt wurden 152 Seiten beschrieben, die fortlaufende Nummerierung hingegen endet auf Seite 106. Die Reihenfolge der Gebäude erfolgt chronologisch, wobei nicht jeder Auftrag mit Datum oder Jahreszahl versehen wurde. Dies ist nur der Fall, wenn die Jahreszahl wechselt oder bei einzelnen Aufträgen, wie beispielsweise für die *«Kapelle auf dem Born b. Kappel, Solothurn»*, 26. Juni 1865[287]. Sehr häufig erscheint die Bemerkung *«fertig»*, womit Röttinger die Vollendung der Arbeit notierte. Ob diese Anmerkung auch die Bezahlung des Auftrags einschloss, bleibt unsicher, da sich die endgültige Begleichung der vereinbarten Summe wegen der Garantieleistungen häufig über Jahre hinauszog[288]. Die Maße der einzelnen Fenster wurden praktisch immer als wichtigster Parameter des handwerklich Tätigen angegeben. Um die Korrektheit der Maße zu garantieren, wurden sie stets vom Meister persönlich genommen, der die Maßeinheiten mit Fuß, Zoll und Linien angab. Er rechnete noch Zeit seines Lebens mit der Basisgröße Fuß, was etwa 0.3 Metern gleichkam und je nach Region variierte. 1 Zoll entsprach 3 cm und 1 Linie 3 mm[289].

282 Vgl. Kap. ‹Konfessionelle Spaltung›.

283 Das Zitat *«fortiter in re, suaviter in modo»* stammt von Claudio Aquaviva (1543–1615), General der Societas Jesu, (Industriae ad curandos animae morbos, 2, 4; zu Deutsch: stark in der Sache, mild in der Art) und wurde von Bischof Lachat in der oben angegebenen Weise modifiziert. Zu Bischof Lachats Rolle im Kulturkampf vgl. Kap. ‹Konfessionelle Spaltung›, Anm. 1381.

284 In der katholischen Kirche Selzach haben sich die Fenster J. Röttingers bis auf das modern veränderte Chorfenster I im Originalzustand erhalten.

285 ZB Nachl. Röttinger 1.202.

286 J. Röttinger hat einen Teil des Buches durchnummeriert.

287 ZB Nachl. Röttinger 1.202, S. 8.

288 Vgl. Kap. ‹Vertragsbestimmungen›.

289 DUBLER, 2009, HLS, Stichw. *Masse und Gewichte*. 1875 schloss die Schweiz mit 17 anderen Staaten die Meterkonvention in Paris und verpflichtete sich auf die internationalen Maßeinheiten. Definitiv eingeführt wurden Meter, Liter und Gramm im Januar 1877, also zum Zeitpunkt J. Röttingers Tod.

Das Dokument enthält mehrheitlich Aufträge, die sich entweder durch die Erhaltung der Glasmalerei oder zumindest durch Schriftdokumente nachweisen lassen. Manche Einträge, wie beispielsweise die Maße für 15 Fenster[290] in einer katholischen Kirche in *«Kraz, Steyermark»* [Graz, Steiermark], die in *«österreichischem Fuß»* mit entsprechender Umrechnung angegeben wurden, sind vermutlich nicht zur Ausführung gekommen[291]. Die Angabe in der regional üblichen Maßeinheit lässt vermuten, dass dem Glasmaler die Daten zur Erstellung eines Kostenvoranschlags übermittelt worden sind[292]. Ob Johann Jakob Röttinger eventuell mit dem in Österreich tätigen Johann Friedrich Walzer (1818–1874), der ebenfalls bei Glasmaler Sauterleute seine erste Ausbildung genossen haben soll[293], in Verbindung stand, ob Beziehungen zum Wiener Glasmaler Carl Geyling (1814–1880) oder zur 1861 gegründeten Tiroler Glasmalereianstalt bestanden hatten, geht aus dem Nachlass nicht hervor.

Während es sich bei den Notizen, Handzeichnungen und Maßen mit wenigen Ausnahmen um reale Aufträge gehandelt hatte, sucht man darin vergeblich freie Skizzen von Vorlagen, Studien oder Anregungen des Künstlers. Offenbar haben sich aus dieser Zeit nur wenige Skizzenbücher und Zeichenmappen erhalten, die während Studienreisen oder Lehrjahren angefertigt wurden[294]. Von Gustav van Treeck (1854–1930), dem Begründer des heute noch bestehenden Glasmalerateliers der «Bayerischen Hofglasmalerei» an der Münchner Schwindstrasse, hat sich ein Notiz- und Skizzenbuch als Dokument seiner Lehr- und Wanderjahre erhalten[295]. Der talentierte Jungglasmaler, Gustav van Treeck, praktizierte im Jahre 1872 bei Johann Jakob Röttinger in Zürich, eine Bereicherung seines künstlerischen Repertoires anstrebend, was auch aus seinem dort angelegten Skizzenbuch hervorgeht[296]. Vor allem in der ersten Hälfte des Dokuments lassen sich zahlreiche Tapetenmuster, christliche Symbole, Randverzierungen, Ornamente und Embleme erkennen, die an Glasmalereien aus der Werkstatt Röttinger erinnern. Es ist davon auszugehen, dass sich der Hospitant mit Vorlagenmaterial und Entwürfen, die in der Zürcher Werk-

statt vorhanden waren, zeichnerisch beschäftigte. Inwieweit der Achtzehnjährige schon selbst Entwürfe beziehungsweise Glasmalereien herstellte, geht aus dem Skizzenbuch nicht hervor. Ende desselben Jahres zog Gustav van Treeck weiter nach München – ein sehnlicher Wunsch des jungen Künstlers, wo er in der Folge zehn Jahre für die Firma Zettler arbeitete[297]. Der Vergleich der beiden Arbeitsbücher zeigt den Unterschied; während der junge van Treeck künstlerische Ideen sammelte, Studien von Körperteilen, Gewandfalten, Ornamenten etc. anstellte, sind die Skizzen und Eintragungen des Geschäftsmannes und Werkstattinhabers Johann Jakob Röttinger jeweils mit der Verpflichtung verbunden, einen Auftrag nach Wunsch des Kunden zu erfüllen und daher als ergänzende Dokumentation zu den Maquetten, Kartons und Werkverträgen zu verstehen.

Vergleiche mit zeitgenössischen Skizzen und Maquetten

Johann Jakob Röttinger lehnt sich bei der Gestaltung seiner Entwürfe an zeitgenössische Gepflogenheiten an, indem er die Zeichnungen aquarellierte und als Struktur lediglich die Quereisen andeutete. So werden beispielsweise auch

290 ZB Nachl. Röttinger 1.202.47: Es handelte sich um Maßwerkfenster mit Mosaik und Randverzierungen.

291 Nachforschungen im Stadtarchiv Graz, im Kulturamt sowie punktuell in Grazer Pfarrkirchen, deren Bau bzw. Umbau in die Zeit um 1867 fällt, schließen die Arbeit Röttingers in einer der Kirchen praktisch aus.

292 Die falsche Schreibweise *«Kraz»* statt Graz weist wohl darauf hin, dass Röttinger die Stadt nicht selbst besucht hat.

293 VAASSEN, 1997, S. 68: Dieser arbeitete ab 1845 an den Glasmalereien des Stiftes Heiligkreuz.

294 VAASSEN, 1993, S. 24.

295 VAASSEN, 1997, S. 261. Die Firmengründung Gustav van Treecks erfolgte im Jahre 1887.

296 Das Buch wurde am 15. Mai 1872 angelegt. Das Ehepaar van Treeck-Vaassen stellte freundlicherweise eine Kopie zur Verfügung, wofür ich herzlich danke.

297 VAASSEN, 1997, S. 261.

die Entwurfszeichnungen Heinrich Horns (1816–1874) aus Niedersachsen beschrieben, die sich im Niedersächsischen Landesmuseum befinden[298]. Horn stellte seinen aquarellierten Entwurf darüber hinaus in einen breiten grauen Rahmen unter Weglassung des Bleinetzes[299] – genau auf dieselbe Art und Weise gestaltete Johann Jakob Röttinger seine Entwürfe. Von den im Krieg zerstörten Glasmalereien in der Maria-Hilf-Kirche in München Au konnten sich außer einigen Glasmalereifragmenten insgesamt 691 kolorierte Blätter (Kartonstücke der Fenster) sowie 21 kleine Zeichnungen erhalten[300]. Während nur einige 1:1 Originalkartons überliefert sind, konnten die kleinen aquarellierten Entwürfe, die dem Stifter, König Ludwig von Bayern, zur Begutachtung gereicht wurden, noch vollständig bewahrt werden. Wie bereits im Kapitel ‹Zeichnungen und Lichtpausen mittelalterlicher Glasmalereien› erwähnt, ist die große Bedeutung dieser Graphiken – insbesondere als die Glasmalereien im Krieg fast vollständig zerstört wurden – unumstritten[301]. Elgin Vaassen nennt eine Folge von 19 Blättern (plus einer Variante), die der künstlerische Leiter, Heinrich Maria Hess, nach eigenen Ideen von seinen Schülern ausführen ließ. Diese Zeichnungen veranlassten den König immer wieder Änderungen zu fordern und Kritik zu üben[302]. Die Autorin bezeichnet die damals gültige Manier, durch Steinwerk Entwurfszeichnungen plastisch wiederzugeben, als die in München übliche Methode[303]. Johann Jakob Röttinger reiste spätestens 1844 nach München, um dort – und dies ist archivalisch belegt – die Glasmalereien der Maria-Hilf-Kirche zu studieren.

Die Glasmalereien

Vorbilder aus dem Mittelalter – Anlehnung an die «zeitgenössische» Kunst

Glasmalereien der Gotik und der Renaissance

Die Ausführungen zu den Zeichnungen im vorangegangenen Kapitel attestierten Johann Jakob Röttinger die Herstellung von Pausen und Zeichnungen mittelalterlicher Glasmalereien in verschiedenen Schweizer Kirchen. Dabei handelte es sich um Fenster aus der ersten Hälfte des 14. Jahrhunderts in den ehemaligen Klosterkirchen zu Königsfelden und Kappel, in der Kirche des Zisterzienserkonvents Hauterive sowie in der reformierten Kirche zu Frauenfeld Oberkirch. Neben der Herkunft Röttingers aus Nürnberg, wo sich in den Stadtkirchen Sankt Lorenz und Sankt Sebaldus zahlreiche Glasmalereien aus dem ausgehenden Mittelalter beziehungsweise der Frührenaissance[304] erhalten hatten, ist die Ausbildung in der dort ansässigen Kunstgewerbeschule sowie die Beschäftigung mit dem Stil der musivischen Glasmaltechnik beim Durchpausen in den Schweizer Kirchen von herausragender Bedeutung für den Künstler gewesen.

298 KLAUKE, 2009, 92 f.; VAASSEN, 1997, S. 131 f.
299 Vgl. weitere Abbildungen von Farbenskizzen bei VAASSEN, 1997, Tafel 78, 79, 80, 83.
300 VAASSEN, 2013, zur Maria-Hilf-Kirche S. 93–104, bzgl. Entwürfe S. 95, 96.
301 BÖNING, 1993, S. 50.
302 VAASSEN, 1993, S. 118. In der Graphischen Sammlung München haben sich außerdem Entwürfe von J. A. Fischer und J. Schraudolph erhalten (Signatur: Mappe 181 II).
303 VAASSEN, 1993, S. 134.
304 In der Sankt Lorenzkirche u. a. von Michael Wolgemut, Peter Hemmel, Hans Baldung Grien und Albrecht Dürer bzw. Hans Süß von Kulmbach (FUNK, 1995, Glasfensterkunst in Sankt Lorenz, Nürnberg 1995). In Sankt Sebald teilweise ältere Glasmalereien aus dem späteren 14. Jahrhundert sowie um 1500 aus der Werkstatt Veit Hirsvogel d. Ä. n. Entwürfen von Albrecht Dürer und Hans von Kulmbach (SCHOLZ, 2007, Sankt Sebald in Nürnberg. Meisterwerke der Glasmalerei 3, Regensburg 2007, S. 5–13).

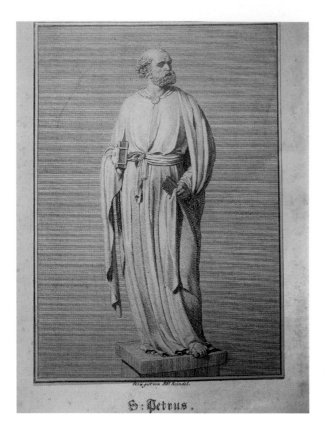

26. Albert Reindel, Apostel Petrus, gezeichnet und gestochen von Albert Reindel, Nürnberg, 1838.

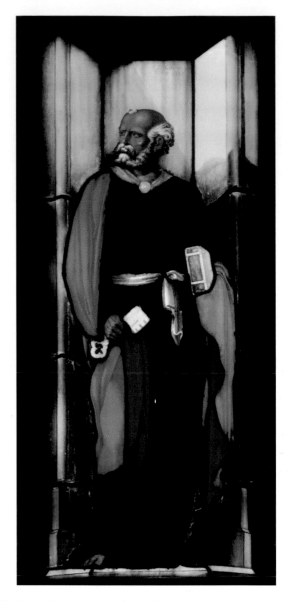

27. Franz J. Sauterleute, Apostel Petrus, Fenster s II, Gruftkapelle Thurn und Taxis, Regensburg, 1837–1843.

Dort konnte er sich die gotischen Formen der Tabernakel, Architekturbekrönungen und Damasthintergründe und nicht zuletzt die Haltung der Figuren verinnerlichen, um sie im Sinne des Historismus in neu geschaffenen Glasmalereien umzusetzen. Wie schon im Kapitel über die Ausbildung des angehenden Glasmalers dargestellt, hielt man sich in der Kunstgewerbeschule an Nürnberger Vorbilder – allen voran an die Stiche Albrecht Dürers und die Bronzefiguren am Sebaldusgrab des Peter Vischer des Älteren. Letzterer begegnete Röttinger erneut bei seinem Lehrmeister Franz Joseph Sauterleute, der die Reindelschen[305] Kupferstiche der Grabfiguren (Abb. 26) für die Gruftkapelle von Thurn und Taxis zu Regensburg in Glasmalereien umsetzte (Abb. 27). Auch Johann Andreas Hirnschrot und Röttinger selbst bedienten sich dieser Vorlagen (Abb. 28, 29), wie dies der Scheibenriss und das Fenster in Kirchdorf bestätigen.

Offensichtlich sind auch die Anleihen an Dürer, vor allem was die Apostelarstellungen betrifft. Karl Ballenberger schuf 1831/1832 zusammen mit dem Architekten Franz Xaver Keim für das Schloss Hohenschwangau bei Füssen nach Vorlagen Dürers ein Fenster (Abb. 31), auf dem Dürer selbst unter einem gotischen Baldachin stehend

305 Albert Reindel, Kupferstecher und Direktor der Kunstgewerbeschule in Nürnberg, vgl. Kap. ‹Ausbildung in Nürnberg›.

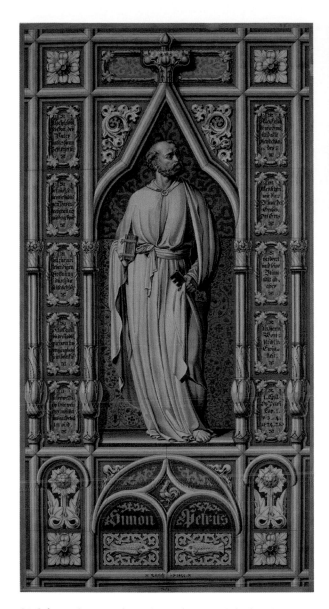

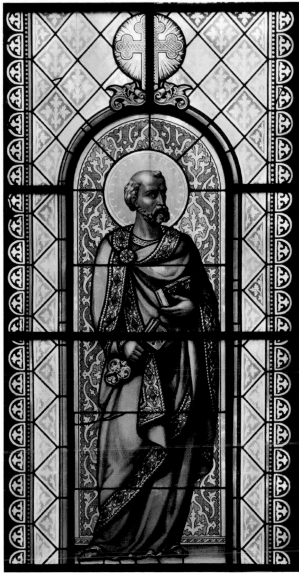

28. Johann A. Hirnschrot, Apostel Petrus, Scheibenriss, 1844, Zürich, SNM (LM-9209.2).

29. Johann Jakob Röttinger, Apostel Petrus, Schifffenster n III, Katholische Pfarrkirche Kirchdorf AG, 1865.

von den vier, von ihm gemalten Aposteln und Evangelisten[306] flankiert wird[307].

Röttingers Kenntnis dieses Glasgemäldes ist nicht auszuschließen. So erinnern die beiden Apostelfürsten Petrus und Paulus im Grossmünster (Abb. 32), deren Entwürfe von Georg Konrad Kellner (1811–1892) stammten, an Albrecht Dürers *Die vier Apostel* von 1526 (Abb. 30), was nicht nur formal – Farbe der Kleider, Faltenwurf, Haltung[308] –, sondern auch inhaltlich bemerkenswert erscheint.

Laut Schreibmeister Johann Neudörffer (1497–1563), der die Tafeln Dürers mit Unterschriften versehen hatte, stellte das Gemälde ein Bekenntnis zur Reformation dar. Als Reminiszenz erscheint die damalige Mahnung an den Nürnberger Rat,

306 Alte Pinakothek München: Albrecht Dürer (1471–1528), Vier Apostel: Hl. Johannes Ev. und Petrus (1526), Lindenholz, 212.8×76.2 cm, Inv.Nr. 545; vgl. Kap. ‹Ikonographie›.
307 VAASSEN, 1993, S. 150.
308 HOFFMANN, 1942, S. 263.

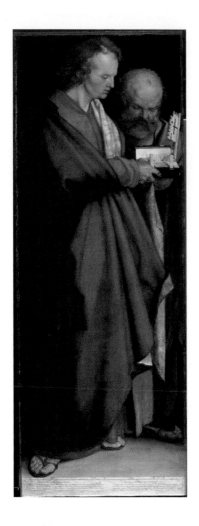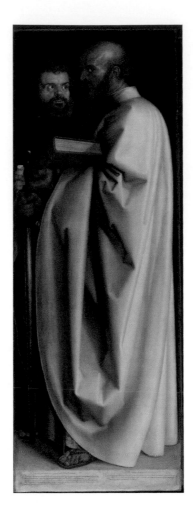

30. Albrecht Dürer, Die vier Apostel,
Gemälde, 212.8×76.2 cm, 1526, München,
Bayerische Staatsgemäldesammlungen,
Alte Pinakothek (Inv.Nr. 545).

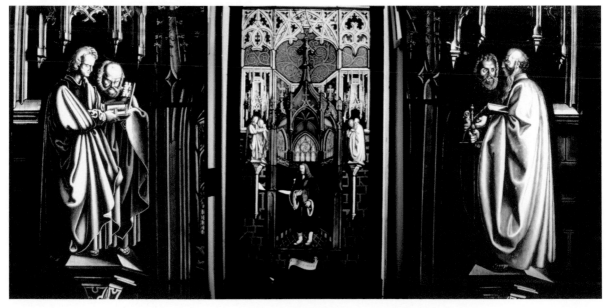

31. Friedr. Hoffstadt (Entwurf)/Karl Ballenberger/Franz X. Keim, Dürer-Standbild, 144×63 cm, für Schloss Hohenschwan-
gau bei Füssen, 1831/32, München, Wittelsbacher Ausgleichsfonds (WAF Inv.Nr. M VI a 48).

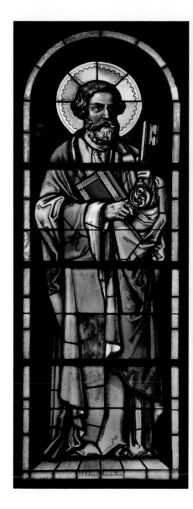
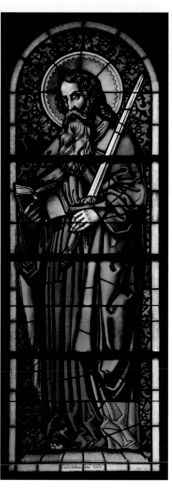

32. Georg K. Kellner (Entwurf)/Johann Jakob Röttinger, Apostel Petrus und Paulus (Petrus ws II, Paulus wn II), ehemals Chorfenster n II, s II, Zürich Grossmünster, 1853.

nicht von der Lehre Luthers abzuweichen, über-tragen auf Zwingli – für die Hauptkirche der Schweizer evangelisch-reformierten Kirche –, als passend[309]. Der Druck einer Zeichnung Dürers[310] im Nachlass erinnert, wenngleich wie die meisten Vorlagen und Blätter mit dem Stempel «*J. G. Röttinger*», dem Sohn Johann Jakobs, Jakob Georg Röttinger, versehen sind, an die Verwendung des Blattes als Vorlage bereits unter Vater Röttinger. Noch offensichtlicher werden die Anklänge an Dürer bei der Christusdarstellung im ehemaligen Chorscheitelfenster des Grossmünsters (Abb. 33). Der frontal dargestellte so genannte «Lehrende Christus»[311] zeigt in Haltung, Blick und dem schulterlangen gescheitelten Haar große Ähnlichkeiten mit dem Selbstbildnis Dürers von 1500[312]. Die Kartons der ehemaligen Chorverglasung im Grossmünster lieferte der Glasmaler Kellner aus

Nürnberg, Absolvent der Kunstgewerbeschule vor Ort und ältester Sohn des Johann Jakob Kellner (1788–1873), des Begründers der bekannten fränkischen Porzellan- und Glasmalerfamilie[313].

309 ANZELEWSKY, 1988, S. 240; vgl. KAT. AUSST. HAMBURG, 1983, S. 117.
310 ZB Nachl. Röttinger 4.5.6: «*Zwey Gemählde von Albrecht Dürer aus der Gallerie auf der Burg zu Nürnberg.*» Vgl. Kap. ‹Apostel, Evangelisten und Propheten›, die Glasmalereien in der Pfarrkirche Rapperswil BE.
311 Das Chorfenster I lagert in der Turmkammer des Grossmünsters. Die beiden Apostelfenster wurden 1933 an die Westfassade versetzt, um im Chor für die neuen Glasmalereien Augusto Giacomettis Platz zu machen.
312 Alte Pinakothek München: Albrecht Dürer (1471–1528), Selbstbildnis im Pelzrock (1500), Lindenholz, 67.1×48.9 cm, Inv.Nr. 537.
313 VAASSEN, 1997, S. 167 f.

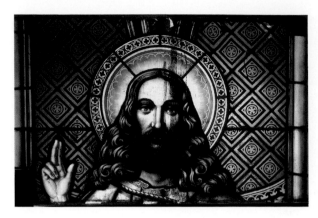

33. Georg K. Kellner (Entwurf)/Johann Jakob Röttinger, «Lehrender Christus», Detail, ehemals Chorfenster I, Zürich Grossmünster, 1853, Depot Turmkammer.

Ob die Entwürfe zu diesem Werk, die nicht erhalten sind, von Kellner allein oder in gegenseitiger Absprache entstanden sind, ist nicht mehr nachprüfbar. Die Vorbilder der Nürnberger Künstler und deren Rezeption waren jedoch konform, da die künstlerische Ausbildung an derselben Schule erfolgte. Bezüglich der maltechnischen Art und Weise kamen in der Werkstatt Röttinger beide im 19. Jahrhundert üblichen Methoden der Glasmalerei zum Einsatz. Während große Figuren und szenische Darstellungen mehrheitlich mittels der so genannten «Peinture en apprêt» unter Verwendung von Schmelzfarben *und* durchgefärbten Glastafeln erscheinen, wandte man bei kleinteiligeren Scheiben, Wappen oder Ornamentfenstern eine Mischform aus musivischer Technik und der genannten malerischen Methode an.

Die Eindrücke der gotischen Glasmalereien, die Johann Jakob Röttinger in zahlreichen Durchzeichnungen studierte, sind in seinen Neuschaffungen weit weniger offenbar, als dies aufgrund seiner Vorbildung anzunehmen wäre. Vor allem die Haltung seiner (Einzel-)Figuren ist statischer und schwerfälliger, im Vergleich mit den lebendigen Gestalten des 14. Jahrhunderts, die ihrer neuen Funktion der narrativen Lebendigkeit[314] zum Zwecke der Initiierung religiöser Emotionen gerecht wurden. Sowohl Figuren wie auch die Landschaftsdarstellungen in den szenischen Glasgemälden lehnen sich in ihrer Dreidimensionalität

viel eher an die deutsche und italienische Tafelmalerei um 1500 an. August Reichensperger (1808–1895), Förderer des Kölner Dombauprojekts, postulierte zwar für die Neugotik den Stil des dreizehnten Jahrhunderts, ließ jedoch den «Renaissancestil» der Bayernfenster, die in der Münchner Glasmalereianstalt geschaffen worden waren, aufgrund ihrer Technik und ihres Glanzes gelten[315]. Faktoren und Motive des künstlerischen Wandels, von den erzählerischen Bildkompositionen zu den statischen Einzeldarstellungen im 19. Jahrhundert, werden im Kapitel über die Malerei der Nazarener dargelegt.

Gemalte Architekturen

Die auf Glas gemalten Architekturen wurden von mittelalterlichen Vorbildern aus der Glasmalerei übernommen. Die gemalten Tabernakelformen entwickelten sich ursprünglich aus den gleichartigen Darstellungen in der Buchmalerei des 9. Jahrhunderts, von wo aus sie sich ab dem 12. Jahrhundert in der zeitgleichen Glasmalerei manifestierten. Im 13. Jahrhundert wandelte sich diese Art der aus byzantinischem Illusionismus entstandenen Formierung geschachtelter Häuschen zum gotischen Giebelmotiv und verlässt somit die Tradition der Malerei, um sich den krabbengeschmückten, von Maßwerk geprägten Wimpergen, den Formen der zeitgenössischen modernen Kathedralarchitektur, zu verschreiben[316]. Rüdiger Becksmann wies darauf hin, dass die mittelalterlichen Glasmaler die Baurisse, die sie in den Bauhütten fanden, mehr oder minder getreu auf die Glasfenster übertrugen, so auch die Rosen als Teile der Fassadenrisse erscheinen[317]. Peter Kurmann zollte den neuen Zierarchitekturen, den «gläsernen Baurissen», die Funktion einer pragmatischen Problemlösung

314 LDK 2, 1989, S. 810, Stichw. *Gotik, Tafelmalerei*.
315 VAASSEN/VAN TREECK, 1981, S. 38: zitiert nach REICHENSPERGER, 1854, Fingerzeige, S. 47; vgl. LYMANT, 1980, S. 331 ff.
316 FRODL-KRAFT, 1956, S. 9.
317 BECKSMANN, 1967, S. 12.

hinsichtlich der Gestaltung der Fenster für die Baukunst des Rayonnant[318]. Merkmale seien einerseits die flächengebundene Projektion ohne Berücksichtigung der Perspektive, was dem Vorgehen der zeitgenössischen Bauzeichner entspricht, und andererseits die «Dehnbarkeit» dieser Formationen je nach Länge der Fenster von einfachen Arkaden bis hin zu monumentalen Turmaufbauten. Mit diesem Bildelement war es möglich, die hohen Bahnen der Maßwerkfenster zu strukturieren, ohne in den Wettstreit mit der realen Architektur des *style rayonnant* zu treten, in dessen Anlehnung sich die neuen Gestaltungsformen der Glasmalerei als architektonische Versatzstücke entwickelten. Der preziöse Ausdruck, von Goldschmieden an Geräten und illuminierten Büchern praktiziert, ging auf die höchst aufwendigen Baurisse der Glasmaler über und veranlasste diese, in Silber und Gold gemalte Architekturvisionen herzustellen, die, wie Peter Kurmann zeigen konnte, wohl als Metaphern des Himmlischen Jerusalem zu sehen sind und in korrelierender Weise die Architektonisierung der gotischen Bildkunst vorangetrieben hatten[319].

Christine Hediger beschäftigte sich mit dem Architekturrahmen der Einzelscheibe und hob in diesem Zusammenhang den Medienwandel[320] der Glasmalereien zu den Wappenscheiben hervor. War diese im monumentalen Kirchenfenster des Mittelalters gemeinsam mit den Inschriften Teil des Rahmens, im untersten Register, im Maßwerk oder in den seitlichen gemalten Architekturelementen, so rückte das Stifterwappen in der frühneuzeitlichen Einzelscheibe als Hauptmotiv ins Zentrum derselben und erschien nun nicht mehr als «Glosse» oder Kommentar, sondern als Mittel der Identifikation des Schenkenden. Der architektonische Rahmen verband die selbstständig gewordene, vom Bau getrennte Einzelscheibe wieder mit dem Gebäude und demonstrierte damit den Beitrag des Stifters an dessen Entstehung beziehungsweise Finanzierung. Der Rahmen ist außerdem Symbol für die seit der Antike bestehende Vorstellung der Funktion des Fensters – losgelöst von seiner Materialisierung – nämlich des gleichzeitig

schützenden und durchlässigen, eben vermittelnden Bauelements[321].

Die Personaleinteilung bei größeren Bauvorhaben sah vor, dass Künstler zur Verfügung standen, die – wie es für den Fensterzyklus der Maria-Hilf-Kirche in der Münchner Vorstadt Au belegt ist – ausschließlich für die Zeichnung der Architekturen und Ornamente verantwortlich waren. Dies galt 1835 für Max Emanuel Ainmiller, dem späteren Leiter der Münchner Glasmalereianstalt, damals noch Schüler von Heinrich Maria Hess[322]. Elgin Vaassen charakterisierte eine Rangordnung unter den an Glasmalereien beteiligten Künstlern. So gab es neben den Kartonzeichnern auch Spezialisten für Schriften und Ornament, Draperien und Köpfe, wobei für letzteres Motiv, insbesondere für Madonnenköpfe, die höchsten Anforderungen gestellt wurden[323]. Stephan Dahmen verglich in einer Studie die Architekturrahmungen und Darstellungsweisen der Glasmalereien in Bezug auf die Nachahmung mittelalterlicher Modi im Dom zu Regensburg (1829–1830), der so genannten Bayernfenster im Kölner Dom (1846–1848)[324] und der Fenster in der Münchner Maria-Hilf-Kirche – alle aus der Königlichen Glasmalereianstalt in München stammend. Dabei stellte er fest, dass die Bayernfenster aufgrund ihrer flächenhaften Wirkung – jeder auch noch so kleine hervorblitzende Hintergrund sei mit kleinteiligem Teppichmuster ausgefüllt und die Architekturrahmen sehr fein

318 KURMANN, 1998, S. 37 ff.
319 KURMANN, 1998, S. 42; vgl. BANDMANN, 1971, S. 141: Das Material Glas nimmt wegen seiner Härte, Reinheit, Lichtdurchlässigkeit und Verwandtschaft zum Kristall den höchsten Rang ein und steht für die Himmelsstadt in der Apokalypse.
320 HEDIGER, 2010, S. 167–179.
321 Christine Hediger beschäftigt sich in ihren Forschungen im Rahmen des NF-Projekts: Medienwandel-Medienwechsel-Medienwissen (Universität Zürich und Vitrocentre Romont) mit der Medialität mittelalterlicher Glasmalereien.
322 VAASSEN, 1997, S. 191; vgl. Kap. ‹Aktuelle Vorbilder – frühes künstlerisches Umfeld Röttingers – Nazarener›.
323 VAASSEN, 1993, S. 23.
324 Dabei handelt es sich um die Fenster s XXI – s XXV.

strukturiert worden – das Bemühen um Vermeidung konkreter Raumstrukturen am stärksten aufgegriffen haben, um sich an Modellen mittelalterlicher Glasmalereien zu orientieren[325]. Im Dom zu Regensburg konstatierte er zwar gotisierende Glasgemälde, sprach den Werken jedoch keine Annäherung an mittelalterliche Darstellungsweisen zu[326]. Elgin Vaassen unterscheidet im Regensburger Dom zwischen Fenstergruppen aus der Zeit von 1829/1830, deren Architekturen nach Art spätmittelalterlicher Schnitzaltäre gestaltet sind und den späteren Glasmalereien, die sich durch die Darstellung von Architekturen der klassischen Gotik auszeichneten. Dementsprechend bilden die eingestellten plastischen Figuren einen starken Gegensatz zur Architektur des 14. Jahrhunderts[327].

Johann Jakob Röttinger hielt sich bezüglich der Gestaltung der gemalten Architekturen einerseits an romanische und gotische Vorbilder beziehungsweise an solche aus der Zeit der Renaissance, andererseits lehnte er sich an gegebene architektonische Elemente in den einzelnen Kirchen an. Im letzteren Fall handelte es sich durchaus um Versatzstücke, die nicht nur in der betreffenden Kirche zum Einsatz kamen, sondern auch in anderen Gotteshäusern verwendet wurden. Aus einigen im Nachlass erhaltenen Verträgen geht hervor, dass der Glasmaler häufig in jenen Kirchen einen Auftrag erhielt, die vom Zürcher Architekten Ferdinand Stadler (1813–1870) geplant oder ausgeführt worden waren[328]. Ob Stadler dem Glasmaler Baurisse zur Verfügung stellte oder ob die Kartons teilweise vom Architekten selbst angefertigt wurden, wird nicht erwähnt. Hingegen wird in den Akten deutlich, dass Ferdinand Stadler die künstlerische Oberaufsicht der von ihm geplanten Gebäude innehatte. So musste im Falle der Stadtkirche Glarus «der künstlerische Wert der Arbeit den Ansprüchen des Architekten Ferdinand Stadler gerecht werden» und falls es Streitigkeiten gäbe, sei nicht das Gericht, sondern in erster Linie der Architekt zuständig[329]. Auch für die Kirche Sankt Oswald in Zug wird explizit die Gutheißung der Glasmalereiarbeit durch den Architekten gefordert[330]. Solche An-

merkungen in den Verträgen zwischen Auftraggeber und Glasmaler lassen vermuten, dass der ausführende Architekt auf Wunsch der Auftraggeber Einfluss auf die Gestaltung der Glasmalereien genommen hatte und daher aktuelle oder archivierte Baurisse in die Planung der Fenster miteinbezogen wurden[331]. Es sind meist kleine, eher unauffällige Reminiszenzen, die nach Bedarf individuell zu neuen Formen komponiert wurden. So fallen an der Fassade der Pfarrkirche in Bünzen[332] vier Fialen als Grundmotiv auf, zwei die Eckpunkte der Fassade überragende und zwei an der architektonischen Rahmung des großen zentralen Spitzbogenfensters über dem Portal neben dem treppenartigen Giebel an der Westseite der Kirche. Diese Fialen erscheinen in den beiden Chorfenstern in verdichteter Form jeweils als gemalte Architektur ohne in Konkurrenz zu treten; es sind keine Kopien, dennoch schaffen sie sichtbare Verbindungen zwischen Baukunst und Glasmalerei. Im Maßwerk der Chorfenster hingegen wiederholen sich die Vierpässe der Turmbalustrade. In Villmergen, der von Wilhelm Keller (1823–1888) geplanten und ausgeführten neugotischen Kirche, Sankt Peter und Paul, sind die ursprüng-

325 DAHMEN, 2000, S. 215.

326 DAHMEN, 2000, S. 209 ff.

327 VAASSEN, 2007, S. 122.

328 Beispiele dafür sind Baar, ref. Kirche (ZB Nachl. Röttinger 1.9), Basel, französische Kirche (ZB Nachl. Röttinger 1.12), Stadtkirche Glarus (ZB Nachl. Röttinger 1.56), Friedhofkapelle Schwyz (ZB Nachl. Röttinger 1.153), Sankt Oswald Zug (ZB Nachl. Röttinger 1.194) u. v. m.

329 ZB Nachl. Röttinger 1.56.

330 ZB Nachl. Röttinger 1.194.

331 VAASSEN, 2007, S. 105. Die Architekturformen richteten sich immer nach dem vom Auftraggeber geforderten Stil. Neben früh-, hoch- und spätgotischen Gehäusen kamen trotz des neugotischen Diktats auch romanische bzw. solche in Anlehnung an den Stil der Renaissance und des Barock zum Einsatz.

332 Die kath. Pfarrkirche Sankt Georg wurde 1860–1861 vom Architekten Caspar Jeuch (1811–1895) in Anlehnung an die Kirche zu Leuggern (1851–1853) errichtet, deren Entwurf ebenfalls von ihm stammte. In beiden Gebäuden wurde J. Röttinger mit der Ausführung der Fenster beauftragt (vgl. GERMANN, 1967, Bd.V, Der Bezirk Muri, S. 118 f.).

lichen Chorfenster Röttingers durch Glasmalerei- en der Mayerschen Hofkunstanstalt München[333] ersetzt worden. Dadurch sind mögliche frühere Bezüge zwischen Architektur und «gläsernem Riss» verloren gegangen. Die Schifffenster und das gro- ße Maßwerkfenster auf der Orgelempore sowie die kleinen Oberlichter in den Türen sind noch im Originalzustand[334] und zeigen zahlreiche Vierpäs- se, ein Architekturelement, das auch die Brüstung der Empore sowie die Fassade ziert. Melchior Paul Deschwanden (1811–1881), der bekannte Inner- schweizer Kirchenmaler, schuf die Altarbilder sowohl in Villmergen, Bünzen und Zufikon[335]. Eine zeitweilige Zusammenarbeit zwischen De- schwanden und Röttinger wird dank überlieferter Briefe aktenkundig – stilistische Vergleiche erfol- gen im Kapitel über die nazarenische Malerei[336] – es ist jedoch nicht davon auszugehen, dass sich Deschwanden auch an der gemalten Architektur beteiligt hatte. In Bünzen wird vor allem im Ver- kündigungsfenster N II der Stil des Altarmalers offenbar. Ob dieser sich auf die Entwürfe der Figuren beschränkte oder ganze Kartons lieferte, geht aus den Schriftdokumenten nicht hervor. In der 1867–1868 von Carl Reichlin erbauten katho- lischen Pfarrkirche Sankt Michael zu Gams haben sich zwei Chorfenster n II und s II von Johann Jakob Röttinger erhalten[337]. Unmittelbar neben dem Hauptaltar, in Tabernakeln stehende Einzel- figuren[338] darstellend, werden Analogien zum zeitgleichen, reich verzierten Schnitzaltar der Mayerschen Hofkunstanstalt München offenbar – die Altargemälde stammen auch hier von Mel- chior Paul Deschwanden[339]. Eine ähnliche Situa- tion wird in der Pfarrkirche Sankt Peter und Paul in Leuggern evident, wo im 2009 rekonstruierten Hochaltar die formale Anlehnung des Glasmalers zutage tritt. Die Aufbauten über den beiden Kir- chenpatronen Petrus und Paulus, die Doppelnon- nenköpfchen und Fialen im Altar finden sich in den gemalten Bekrönungen der Heiligen in den Chorfenstern wieder, was den differenzierten Umgang des Glasmalers mit der «Umgebung» seiner Glasmalerei zeigt[340]. In der Pfarrkirche Gonten AI ist das Chorscheitelfenster von Johann

Jakob Röttinger Bestandteil eines Schnitzaltars aus der Werkstatt Anton Klarers von 1864. Das kleine spitzbogige Glasfenster mit dem Bild der Kirchen- patronin Sankt Verena (Abb. 34) wird vom voll- plastischen Hauptgeschoss des Altaraufsatzes, entsprechend einer gotischen Turm- oder Retabel- monstranz, umrahmt. Übereck gestellte Baldachin- türme sowie eine Vielzahl von Türmchen und Fialen führen hinauf in den durchbrochenen Helm des Altars und ersetzen auf diese Weise die gemal- te Architektur der Glasmalerei[341].

Das so genannte Königsportal der Kirche Sankt Oswald in Zug (Abb. 35) aus dem 15. Jahrhun- dert zeigt oberhalb der beiden Türflügel zur Linken König Oswald, den Heiden Cadwalla tötend, die Muttergottes im Zentrum und rechts Sankt Michael im Kampf mit dem Teufel. Ver- bunden werden die drei Figuren durch kreuz- blumengeschmückte Kielbogen. Der Kielbogen taucht als in der Spätgotik beliebtes Element in der gemalten Architektur der Chorfenster auf, in denen die Einzelfiguren der beiden seitlichen Fenster, s II und n II, je zwei Heilige darstel- lend, ebenfalls mit Kielbogen bekrönt werden.

333 FELDER, 1967, S. 391 f.
334 Signatur J. Röttingers im Zentrum des großen Maßwerk- fensters W I.
335 FELDER, 1967, S. 434; ZB Nachl. Röttinger 1.202.146: In Zufikon schuf Röttinger 1870 ebenfalls eine figürliche Chorverglasung. Das axiale Chorfenster mit der «Aufer- stehung Christi» hat sich nicht erhalten, wohl aber s II mit den Heiligen Joseph und Martin, im Medaillon Xaverius, n II mit Anna und Barbara, im Medaillon Magdalena.
336 ZB Nachl. Röttinger 1.4 und 1.34.
337 ZB Nachl. Röttinger 1.202.109 und 1.202.110: Ursprüng- lich stammten alle 16 Fenster der Kirche aus der Werkstatt Röttingers.
338 Es handelt sich um Stifterfenster mit den Namenspatro- nen: Ulrich, Emil, Christian und Johannes Baptist.
339 SCHEIWILLER, 2007, S. 55 f. (Ulrich, Emil n II; Christian, Johannes Baptist s II).
340 BOSSARDT/KAUFMANN, 2012, S. 29. Auch hier stammen die Altarbilder von M.P. Deschwanden.
341 FISCHER, 1984, S. 410. Fischer erwähnt, dass Röttinger 1865 gemahnt werden musste, das Verenabild baldmög- lichst zu liefern, da die Altarweihe am 26. März geplant war. PFA Gonten AI, Protokolle der Baukommission (7. u. 14. März 1865).

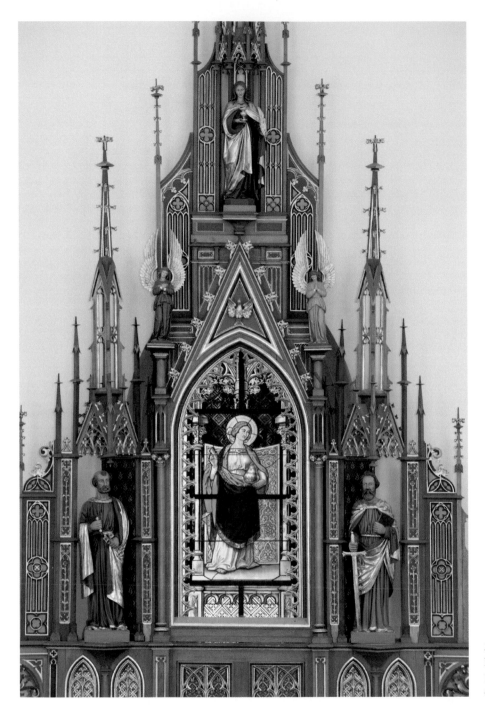

34. Johann Jakob Röttinger,
heilige Verena, Chorfenster I,
Katholische Pfarrkirche
Gonten AI, 1864.

Das mittlere Chorfenster, die Auferstehung Christi, zeigt nach oben hin eine aufwendige Architektur mit Wimpergen und Zierrat, ähnlich den Baldachinen der seitlichen Portalfiguren. Der ikonographische Bezug zwischen den plastischen Skulpturen am Portal und den Glasmalereien ist durch die Figuren des heiligen Michaels (n II, 2a,

3a) und des Königs Oswald (n II, 2b, 3b) gegeben. Die Anordnung erfolgte nach dem Schema des gotischen Flügelaltars.

Demnach scheinen die von Johann Jakob Röttinger hergestellten Zeichnungen der mittelalterlichen Glasmalereien einige Berührungspunkte zwischen den mittelalterlichen Vorbildern und dem Werk

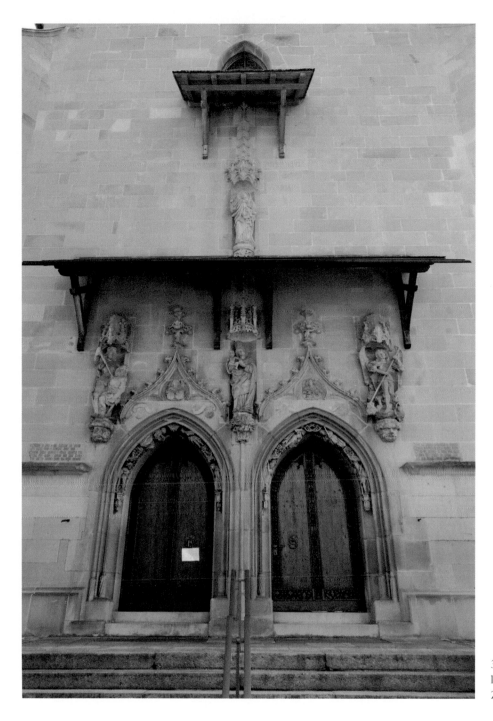

35. Königsportal, Katholische Kirche Sankt Oswald, Zug, 15. Jahrhundert.

des Glasmalers bewirkt zu haben. Gewiss gelang es Röttinger im Rahmen dieser Tätigkeit, die Formen und Strukturen der mittelalterlichen Glasmalerei in sein Repertoire aufzunehmen. Er vermied vorhandene Kompositionen nachzuahmen und griff stattdessen einzelne Elemente heraus, um sie in Eigenkreationen unter Einbezug baulich gegebener Formen in die Glasmalereien einzuarbeiten. Zu seinen Favoriten zählten die Astwerkbaldachine beziehungsweise architektonische Aufbauten, die er zusätzlich mit Ast- oder Laubwerk verzierte (vgl. den Architekturaufbau im mittleren Chorfenster in Abb. 36). Dies wohl in Anlehnung an die Glasmalereien der Maria-Hilf-Kirche in

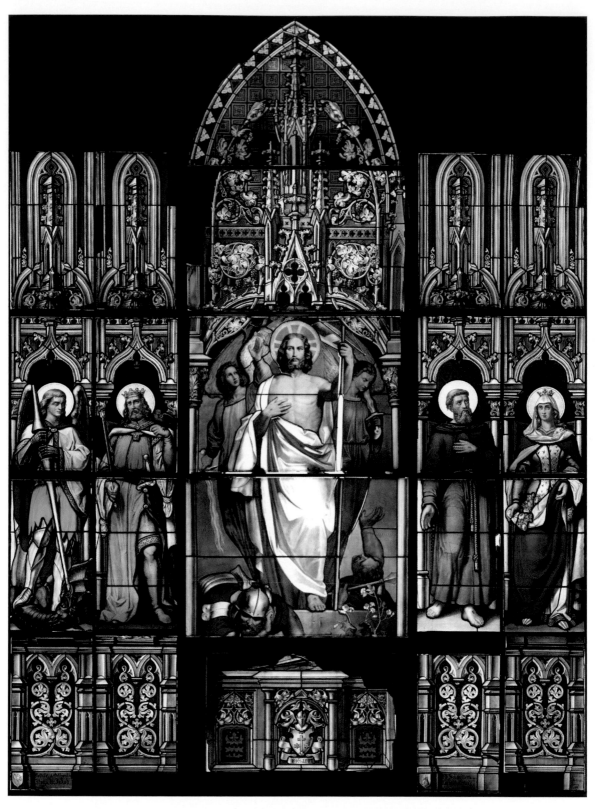

36. Johann Jakob Röttinger, von links nach rechts: Sankt Michael, Sankt Oswald (ehem. Chorfenster n II), Auferstehung Christi (ehem. Chorfenster I), Sankt Franziskus, die heilige Elisabeth (ehem. Chorfenster s II), 1866, Depot Bauhütte Sankt Oswald, Zug, (Montage mit 21 Fotos).

37. J. Schraudolph/J. Fischer/M. Ainmiller, Propheten, kolorierte Lithographie, total 114×31 cm, Ausschnitt (Geburt-Christi-Fenster, Maria-Hilf-Kirche, München-Au), 1838.

München, wo die gemalten Architekturen ebenfalls durch reiches Rankenwerk (Abb. 37) geschmückt waren[342].

Als weiteres Relikt verschiedener Stilepochen – in der Glasmalerei der Neuromanik respektive Neugotik sind es Rückgriffe auf die jeweiligen historischen Kunstrichtungen – ist das Ornament ein wichtiges gestalterisches Element der Glasmalerei, ein Thema, das im Kapitel über die Ikonographie behandelt wird. Aus technischer Sicht ist zu bemerken, dass alle Glasmaler für die Darstellung des «architektonischen Beiwerks», fast ausschließlich die klassischen Glasmalerfarben Schwarzlot, Silbergelb beziehungsweise eine Überzugsfarbe

verwendet hatten, wobei auch Radiertechniken üblich waren[343]. Der Farbaufbau für Ornamente und Architekturen gestaltete sich dementsprechend einfacher und korreliert mit den Vorbildern aus dem 13. bis 15. Jahrhundert[344]. Wie aus einem Restaurierungsbericht der im Estrich «wieder aufgefundenen Glasmalereien» in der Pfarrkirche Pieterlen hervorgeht, lehnte sich Johann Jakob Röttinger an damals übliche Gepflogenheiten

342 KAT. AUSST. NEUSS, 1981, Abb. S. 12–23. EGGERT, 1865, o.p. Franz Eggert gestaltete ein Musterbuch mit gotischen Verzierungen aus dem Ulmer Münster (Abb. 55).
343 VAASSEN, 1997, S. 186.
344 VAASSEN, 2007, S. 44.

an[345]. Dass diesbezüglich verallgemeinernde Aussagen nicht statthaft sind, zeigt ein Beispiel in der Kirche Sankt Oswald in Zug. Dort war explizit beim Michaelsfenster festzustellen, dass die Farbe Gelb, sowohl Dunkelgelb wie auch Hellgelb, mittels durchgefärbten Glases und nicht durch das übliche Silbergelb erzeugt wurde, wenn auch an den benachbarten Fenstern der Auftrag von Silbergelb nachgewiesen werden konnte[346].

Aktuelle Vorbilder – frühes künstlerisches Umfeld Röttingers – Nazarener

Die Maria-Hilf-Kirche in der Münchner Vorstadt Au als Künstlermagnet

Die 1831–1839 vom Architekten Joseph Daniel Ohlmüller (1791–1839) erste im neugotischen Stil[347] errichtete Kirche Süddeutschlands erhielt einen dem Thema des «Marienlebens» verpflichteten Glasmalereizyklus, der für diese Kunstrichtung im 19. Jahrhundert wegweisend wurde. Der Auftraggeber der Kirche, König Ludwig I., machte die Glasmalereien zum herrschaftlichen Geschenk. Als Teil eines Gesamtkunstwerks erzeugten sie damals den «schönsten, erhebendsten» Eindruck bei Sulpiz Boisserée, der die Kirche 1839 besuchte[348]. Der bereits zitierte Briefwechsel zwischen Ferdinand Keller, Zürich, und Johann Jakob Röttinger gibt Aufschluss über dessen Aufenthalte in München, wo letzterer die berühmten Glasmalereien in der Maria-Hilf-Kirche in der Au[349] studiert hatte. Der Korrespondenz ist zu entnehmen, dass sich Röttinger mindestens zweimal in der Münchner Vorstadtkirche aufgehalten haben musste. Am 3. Januar 1852 wandte sich der Glasmaler in einem Brief aus Nürnberg an Ferdinand Keller: «*In München habe mich genau über alles was Glasmalerei betrifft erkundigt. In der Auer Kirche meine längste Zeit zugebracht, es sind herrliche Gemälde in den Fenstern. Schade ist es, dass man ganz und gar vergessen, dass es eben Fenster sind. Die Kirche ist zu dunkel und wird es jeden Tag mehr werden. Ich maße mir kein Urtheil über diese herr.[lichen] Arbeiten an, aber ich bin fest überzeugt, daß in zwanzig Jahren die Schönheit der Auer*

Glasgemälde durch den Staub und die aufgeschmolzenen Deckfarben, welche sich auf denselben befinden so schwinden wird, dass man glauben könnte, man habe nachgedunkelte Ölgemälde vor sich. Ich kann Ihnen versichern, dass die Fenster, welche ich vor 8 Jahren gesehen, gar nicht mehr die gleichen sind [...].»[350] Aus diesen Zeilen geht unter anderem hervor, dass sich Röttinger bereits 1844, also im Jahre seiner Auswanderung nach Zürich, in München aufgehalten hatte. Ab 7. Mai in Zürich als «Ansäßer» gemeldet, könnte Röttinger die Zeit vor seinem Schweizer Stellenantritt in München verbracht haben. Möglicherweise könnte er sogar eine längere Periode in der bayerischen Metropole verbracht haben, da sich der junge Glasmaler nach dem Tode seines Arbeitgebers Franz Joseph Sauterleute im März 1843 nach einer neuen Stelle umsehen musste. Wie bereits im Kapitel ‹Künstlerische Entwicklung und Stilbildung› ausgeführt, waren mit ihm Friedrich H. Pfort (1816–1868), Leopold Itzel (1817–1881) sowie Christoph Philipp Böhmländer (1809–1893)[351] zu dieser Zeit in Rottweil beschäftigt. Allenfalls folgte Röttinger einem seiner Arbeitskollegen nach München. Pfort, der

345 GYSIN/REHBERG, 2002/2003 (Restaurationsbericht im Pfarrarchiv Pieterlen); vgl. Kap. ‹Material und Maltechnik›.

346 Diese Details wurden im Rahmen der fotografischen und schriftlichen Dokumentation der Glasmalereien in der Bauhütte der Sankt Oswaldkirche am 29. September 2009 durch Stefan Trümpler, Peter Barth und Eva-Maria Scheiwiller festgestellt.

347 SCHÖNENBERG, 1989, S. 12, Anm. 31 zitiert nach Rudolph Marggraff, München mit seinen Kunstschätzen und Merkwürdigkeiten, München 1846: «im germanischen Styl der besten Zeit».

348 OTTO, 1981, S. 7 f.

349 Die Kirche wurde im Zweiten Weltkrieg bis auf Außenmauern und Turm gänzlich zerstört. Von den Glasmalereien haben sich nur einzelne Fragmente, ein Jünglingshaupt, die Figur des Evangelisten Markus, das Bruchstück zweier Engel sowie einige Teile des Ornaments erhalten (KAT. AUSST. NEUSS, 1981, S. 7, vgl. dort Anm. 1). VAASSEN, 1997, Fragment Marienkopf (Tafel 76, 134).

350 StAZH, W I 3 AGZ 174 12, Müller-R 1851–58, 193/1852.

351 VAASSEN, 1997, S. 167, Anm. 71: Böhmländer sei «beim Kunstmaler Sauterleiten 1832 «ausgestellt» worden [...]», Vaassen zitiert nach: SA Nürnberg: C 7/II NL, Nr. 2972; BECK, 1890: Beck geht davon aus, dass Böhmländer bis zu Sauterleutes Tod in dessen Werkstatt beschäftigt war.

Aufträge in Reutlingen und Vollmaringen erhielt, und Böhmländer scheiden eher aus. Leopold Itzel hingegen begab sich auf Wanderschaft, deren erste Station München war[352]. Itzel besuchte ebenfalls die Kunstgewerbeschule Nürnberg und ging bei Schwänlein in seinem Heimatort Erlangen von 1831–1836 in die Lehre[353]. Jakob Röttinger und Leopold Itzel waren etwa gleich alt und kannten sich, wenn nicht schon vorher, spätestens von der Zusammenarbeit in der Werkstatt Sauterleutes[354]. Wenngleich Johann Jakob Röttinger den Zustand der Münchner Glasmalereien in der Maria-Hilf-Kirche bedauerte und ihrer Machart nicht ganz kritiklos gegenüberstand, waren sie nachweislich Studienobjekte, was einen Blick auf die Entwurfszeichner und ausführenden Glasmaler rechtfertigt. Vom Maler Heinrich Maria Hess (1798–1863), königlicher Stipendiat in Rom, existiert ein Grundrissplan mit von König Ludwig genehmigten Bildthemen der geplanten 19 Fenster aus dem Jahr 1835[355]. Christoph Christian Ruben, Joseph Anton Fischer, Johann Baptist Schraudolph und Wilhelm Röckel, allesamt Schüler von Hess, wurden von ihrem Lehrer und künstlerischem Leiter der königlichen Glasmalereianstalt aufgefordert, Entwürfe anzufertigen. Max Emanuel Ainmiller zeichnete für die Architekturen und Ornamente verantwortlich und zusammen mit Darée, Eggert, Faustner, Hämmerl, Kirchmair, Müller, Röckel, Schön, Sutner und Wehrsdorfer für die Übertragung auf Glas. Michael Sigmund Frank (1770–1847) war für den technischen Teil der Arbeit ausschlaggebend[356]. Frank kam wie zahlreiche andere Glasmaler aus dem Fach der Porzellanmalerei und galt als Pionier unter den Wiederentdeckern der Glasmalerei; er war ein angesehener Erfinder und Tüftler sowie der erste Leiter der königlichen Glasmalereianstalt. Er verstand viel von «Behandlung und Einbrennung der Farben»[357], betätigte sich nach Aufhebung der üblichen Geheimniskrämerei als Verfasser eines *Arcanums* und befleißigte sich selbst in der Herstellung von in der Masse gefärbten Glases[358]. Als ebenfalls wichtiger Vertreter der neuen Glasmalergeneration, der Altersgruppe Röttingers, ist auf Max

Emanuel Ainmiller (1807–1870) besonders hinzuweisen, der nicht nur wie Frank in erster Linie technische, sondern auch künstlerische Fähigkeiten in hohem Maß besessen hatte, jedoch erst ab 1851, nach dem Tod König Ludwigs, mit der Direktion der Münchner Glasmalereianstalt betraut wurde[359]. Johann Baptist Schraudolph (1808–1879) leitete als Freskenmaler ab 1846 die Innenausmalung im Dom zu Speyer und erhielt 1849 als Nachfolger von Hess die Professur für das Fach Historienmalerei an der Akademie[360]. Als Spätnazarener, eine Bezeichnung, die auch Johann Jakob Röttinger[361] für sich in Anspruch nahm, waren Schraudolph wie auch sein Lehrer Hess der religiösen Historienmalerei verpflichtet. So reiste der Künstler nach Annahme des Auftrags in Speyer zunächst nach Rom, um sich beim befreundeten Maler Johann Friedrich Overbeck (1789–1869) Rat für Komposition und Ausführung der Freskenmalerei zu holen[362]. Im Nachlass der Röttinger ist ein Auftrag für die katholische Kirche Saint-Imier dokumentiert, in der Johann Jakob 1864/1865 einen Glasmalereizyklus im Chor auszuführen hatte.

352 VAASSEN, 1997, S. 167.
353 Leopold Itzel reiste im Rahmen seiner Wanderjahre außerdem nach Halle, Leipzig, Zürich und nach Tirol. Er arbeitete als Maler, Glasmaler, Steinzeichner und war ab 1850 bei Gustav Hermann Kellner in Gostenhof als Lithograph beschäftigt. 1845–1853 mit Unterbrechungen außerdem bei N. Prager in München. (VAASSEN, 1997, S. 167, Anm, 70: S. 328). Im NÜRNBERGER KÜNSTLERLEXIKON 2, 2007, S. 724, Stichw. *Itzel, Leopold*, hier wird der Erlanger Porzellanmaler «Schwämmlein» genannt.
354 Johann Jakob Röttinger besuchte die Schule von 1830/31 bis 1834 (vgl. Kap. ‹Ausbildung in Nürnberg›). Itzel kam nach 1836 nach Nürnberg, trat jedoch erst 1839 in die Kunstgewerbeschule ein (VAASSEN, 1997, S. 167).
355 VAASSEN, 1997, S. 191, Anm. 55: zitiert nach München BHStA, Abt. III: GHA: Nachlass Ludwig I: 50/4/7.
356 VAASSEN, 1997, S. 191.
357 Zitiert nach VAASSEN, 1997, S. 179, Anm. 2.; vgl. Kap. ‹Die Porzellanmaler›.
358 VAASSEN, 1997, S. 159 f., 178 ff.
359 VAASSEN, 1997, S. 198 f.
360 VERBEEK, 1961, S. 157.
361 Vgl. Kap. ‹Frühe künstlerische Prägung›.
362 VERBEEK, 1961, S. 144 f.

38. Johann Jakob Röttinger, Evangelisten
Matthäus und Markus, Chorfenster N II,
Katholische Kirche Saint-Imier, 1866.

Im Chorscheitelfenster werden die Schlüsselübergabe an Petrus, darunter die Verkündigung Mariens, im nördlichen Chorfenster die vier Evangelisten (Abb. 38) und im südlichen die vier Kirchenväter als Ganzfiguren dargestellt. Auftraggeber Pfarrer Mamie habe in einem Brief an Johann Jakob Röttinger explizit nach Kupferstichen von Schraudolph gefragt[363]. Die in einer Festschrift abgedruckten Quellenfragmente deuten zumindest eine Anlehnung der Malerei an die Schraudolphs respektive Overbecks an[364]. Die vier Evangelisten seien nach der Düsseldorfer Schule – Matthäus *nach* J. F. Overbeck, die Kirchenväter hingegen *von* Schraudolph – wie der Chronist Pfarrer Pierre Mamie, dessen Aufzeichnungen teilweise in der erwähnten Festschrift veröffentlicht wurden, notierte[365]. Beim direkten Vergleich mit Bildmaterial von Overbeck (Abb. 39) und Schraudolph[366] ist zwar die künstlerische Orientierung an den Vorbildern unbestritten, der Einsatz von Kartons der angeführten Künstler kann jedoch ausgeschlossen werden.

363 Freundlicher Hinweis von Fabienne Hoffmann nach einem Brief von Pfarrer Mamie an J. Röttinger vom 17. Oktober 1865 (Fabienne Hoffmann wertet derzeit die Quellen des PAs in Saint-Imier aus – die Ergebnisse werden in ihrer Publikation über die Arbeit der Röttinger in der Westschweiz Eingang finden). ZB Nachl. Röttinger 2.371, 121 Sankt Immer/Kirchen Rath 1876; ZB Nachl. Röttinger 1.202, S. 18. Bezügl. Ikonographie vgl. Kap. ‹Apostel, Evangelisten und Propheten›.

364 In der Festschrift, die anlässlich des 150-jährigen Bestehens der Kirche und der abgeschlossenen Restaurierung herausgegeben wurde, sind Fragmente des Archivmaterials bezügl. der Glasmalereien abgedruckt. Der Chronist bringt jedoch zum Ausdruck, dass er sich mit seiner stilistischen Einschätzung nicht ganz sicher ist. (GIRARDIN, 2008, S. 20: «[…] Saint Matthieu est d'Overbeck, et je suppose que les autres sont du même Chef d'école, mais je n'en suis pas certain.»

365 GIRARDIN, 2008, S. 20 f.

366 Elgin Vaassen stellte dafür entsprechendes Vergleichsmaterial sowie ihr Fachwissen zur Verfügung, wofür ich herzlich danke.

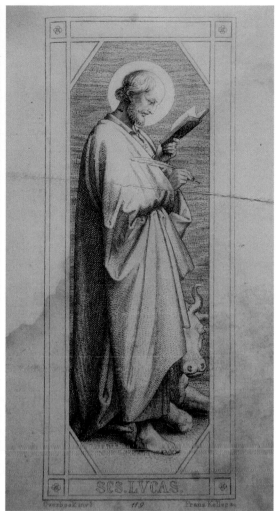

39. Links: Franz Keller, «S. Mathaeus» (Nr. 131), rechts: «SCS. Lucas» (Nr. 119) nach J. Friedrich Overbeck, Verein zur Verbreitung religiöser Bilder, Düsseldorf (Dépôt à Paris chez A.W. Schulgen, Editeur, 25 rue St-Sulpice); Kopien Vorlagenmaterial, Atelier Gustav van Treeck, München.

Die ungenauen Größenrelationen zeigen dies deutlich – Unvollkommenheiten, die auch Melchior Paul Deschwanden an der Arbeit der Werkstatt Röttinger kritisierte[367]. Daher ist davon auszugehen, dass die genannten Künstler wohl als Vorbilder herangezogen wurden und die Interpretation in der Festschrift auf den berechtigten Stolz des Chronisten und auf die insgesamt sehr gelungenen Glasmalereien zurückzuführen ist. Absolute Übereinstimmung herrscht hingegen zwischen den Chorobergadenfenstern in Leuggern und Glasmalereien der Königlichen Glasmalereianstalt. Die von der Werkstatt Röttinger 1854 geschaffenen

Kirchenväter[368] sind eine getreue Wiedergabe der 1841 von den Münchnern nach Kilndown/Kent gelieferten Glasmalereien. Gregor und Augustinus sollen nach Kartons von J. B. Schraudolph stammen, Hieronymus und Ambrosius von J. A. Fischer. Die von Franz Xaver Eggert 1852 herausgegebenen Lithographien samt Inschriftentafeln kamen vermutlich gerade recht, um Röttinger für den Auftrag in Leuggern als Vorlagen zu dienen.

367 ZB Nachl. Röttinger, 1.4.
368 Vgl. Kap. ‹Signaturen›, Abb. 9, 10.

87

Aber schon die Kilndowner Kirchenväter waren damals nicht für den englischen Auftraggeber geschaffen worden, sondern sind als Übernahme aus dem Johannesfenster im Regensburger Dom anzusehen[369]. Augustinus, einer der oben erwähnten Kirchenväter in Saint-Imier, entspricht ebenfalls dem gleichnamigen Vertreter aus dieser Serie. Im Gegensatz zu den in Regensburg dargestellten und den von Eggert reproduzierten Kirchenlehrern, die flächig in ihre Arkadenhäuschen eingestellt waren, ließ Röttinger die heiligen Gestalten etwas hervortreten und schuf auf diese Weise Plastizität und Raum.

Der Nürnberger Baumeister Hermann Keim, geboren 1811[370], arbeitete in den Jahren vor dem Auftrag der Thurn und Taxis in Regensburg unter Joseph Daniel Ohlmüller an der Münchner Maria-Hilf-Kirche, wo er auch die Idee des Rautensterngewölbes aufnahm, um das architektonische Element in der Gruftkapelle umzusetzen[371]. Er hat sich mit seinem Cousin, dem Architekten Carl Alexander Heideloff zusammengetan, der selbst Glasmalereien entworfen hatte, und etablierte sich später als Zeichenlehrer in Nürnberg und Regensburg[372]. Keim und Röttinger müssten sich spätestens aus der Regensburger Zeit gekannt haben, wo der Glasmaler als Gehilfe Sauterleutes für die Wappenscheiben in der Gruft verantwortlich zeichnete. Aus wessen Hand die Entwürfe dazu stammten, geht allerdings aus den Archivalien nicht hervor. Wenn nicht Röttinger selbst, so hatte sie wohl Hermann Keim oder sogar dessen berühmter Vetter, C. A. Heideloff, skizziert[373].

Stil und Malweise der Nazarener, denen der Scheibenzyklus in München verpflichtet war, werden im nachfolgenden Kapitel ausführlich behandelt mit dem Fokus, Verbindungen zwischen der nazarenischen Kunst sowie der zeitgleichen Glasmalerei zu suchen. Dabei interessiert insbesondere die Tauglichkeit einer Stilnachahmung der nazarenischen Vorbilder für die Anwendung auf dem Medium Glas.

Die Nazarener als Vorbilder für den Stil der Glasmalerei im 19. Jahrhundert

Die «Rückkehr des Religiösen» wird von Christa Steinle bezüglich der Dialektik von Romantik und Rationalismus beleuchtet und liefert ein wichtiges Argument in der Kunstauffassung der Nazarener[374]. Breite Bevölkerungsschichten – auch Teile der Elite – bekannten sich zur Zeit des frühen 19. Jahrhunderts wieder zur Religion. Dabei spielten nicht nur Reaktionen gegen die Ideologie der Aufklärung eine Rolle, sondern auch Verunsicherungen der Menschen in Bezug auf die Industrialisierung.

Max Hollein attestiert der «frömmelnden Bruderschaft», wie die Nazarener von ihren Kritikern wertend genannt wurden, revolutionäres Denken sowie zukunftsweisendes künstlerisches Tun und bezeichnet die Lukasbrüder als erste Sezessionisten[375]. Die Gründungspersonen[376] sind schließlich aus dem traditionellen Umfeld der Wiener Akademie ausgebrochen, um sich in Rom nach eigenen Vorstellungen künstlerisch zu betätigen beziehungsweise individuelle und zugleich kollektiv wirksame Lebensformen nach klösterlichem Vorbild zu wählen. Die Ursachen, warum sich die

369 VAASSEN, 2013, S. 218, 219, Abb. 14 und 169 a–d; VAASSEN, 2007, S. 66–68 mit Abbildungen.

370 Vgl. Kap. ‹Regensburg – Franz Josef Sauterleute – Carl Alexander Heideloff›. Hermann Keim war ab 1836 drei Jahre lang maßgeblich am Bau der Gruftkapelle in Regensburg beteiligt, um dort seinen Bruder Carl Viktor zu unterstützen und unter anderem Kanontafeln für die Seitenaltäre in der fürstlichen Gruft in Sankt Emmeram herzustellen. Kanontafeln waren in der lateinischen Liturgie gebräuchliche Gedächtnisstützen in Form von drei auf den Altar gestellten Tafeln mit Teilen der unveränderlichen Messtexte (MEYERS ENZYKLOPÄDISCHES LEXIKON 13, 1975, S. 401, Stichw. *Kanontafeln*).

371 SAUER, 2003, S. 42 bzw. Hinweis des Autors.

372 NÜRNBERGER KÜNSTLERLEXIKON 2, 2007, S. 757, Stichw. *Keim, Hermann*.

373 Vgl. Abb. 1, 2.

374 STEINLE, 2005, S. 19.

375 HOLLEIN, 2005, S. 9.

376 Friedrich Overbeck, Franz Pforr, Ludwig Vogel, Karl Hottinger, Joseph Sutter, Joseph Wintergerst schlossen sich 1809 in Wien zum Lukasbund zusammen.

Menschen im 19. Jahrhundert von der nazarenischen Art der Darstellung religiöser Kunst angezogen fühlten, sind wohl in der Art der Kunstvermittlung der Künstler selbst zu suchen. Friedrich Overbeck, der auf dem Gebiet der Theologie sehr bewandert war, visualisierte als Initiator der Malergruppe biblische Szenen, indem er diese zuerst reflektierte und in eine poetische Bildsprache übersetzte, um sie als Metapher den akademischen Historienbildern, die vom Betrachter viel Wissen voraussetzten, gegenüberzustellen[377]. Diesen Überlegungen gehen Cordula Grewes Forschungen voraus, aus denen die These einer «Historie ohne Handlung» resultierte. Die Autorin konnte in ihren Ausführungen glaubhaft machen, dass die Künstler auf die umfassende geisteswissenschaftliche Krisensituation insofern reagierten, als sie mit dem Wegfall narrativer Elemente in den Gemälden die Stilllegung von Handlungen sowohl in der profanen wie auch sakralen Kunst evozierten[378]. Schließlich akkreditiert sie Berührungspunkte zwischen der Bildsprache der Nazarener und der herrschenden Volksfrömmigkeit und macht deren angewandte Strategien und künstlerische Ausdrucksmittel, mit Michael Thimann, für den Erfolg der Künstler verantwortlich. In einer weiteren Forschungsarbeit der Autorin[379] wird das Spannungsfeld zwischen Italia und Germania, der Oszillation zwischen dem *Idealen*, dem zeitlos Schönen Raffaels, und dem *Charakteristischen*, dem zeitbedingt Schönen Dürers, als Beispiel für die Stilaneignung der Nazarener herangezogen. Ihre Kunst ist demnach als Fragment der göttlichen Offenbarung, als eine Art Reliquie, zu begreifen. Dabei werden repräsentative Merkmale der nazarenischen Malerei evident, deren Umsetzung für die Münchner Glasmaler in das Medium der Glasmalerei von namhafter Bedeutung waren. Dass die nazarenische beziehungsweise spätnazarenisch-idealistische Malerei in die Glasmalerei transformiert worden ist, kann nicht nur beim Streifzug durch die Kirchen des Landes festgestellt werden, sondern wird auch in der Literatur immer wieder offenbar[380]. Die Rezeption Raffaels geschah in der den Nazarenern eigenen Art des Kunstzitats, das

heißt reflektiert[381], wodurch das Gleichgewicht von Linie und Farbe, wie es sich beim Renaissancemaler präsentierte, verloren ging. Die Bilder der Alten Meister wurden analysiert beziehungsweise demontiert und büßten dadurch deren «Natürlichkeit» ein. Die Gemälde der Nazarener erhielten so ihre steife und abstrakte Diktion und zeigten die bekannten Darstellungseigenschaften der Lukasbrüder. Ob Merkmale wie geometrische Liniengefüge, die Verwendung von Lokalfarben, die durch Mangel an räumlicher Perspektive fehlende Luftperspektive oder die emailartige Geschlossenheit der Bildoberfläche[382] – sie alle entstanden durch die oben ausgeführte Art der Reflexion und Rezeption. Gerade die zuletzt genannte Eigenart, die emailartige Geschlossenheit, stellt ein in der Glasmalerei bis in die Sechzigerjahre des 19. Jahrhunderts häufig auftretendes Phänomen dar, das mit verschiedenen Mitteln wie Mattschleifen und Überziehen der Außenseite – im Jargon auch «zu ziehen» genannt – oder mittels der additiven Malweise zu erreichen versucht wurde. Das Auftragen mehrerer Malschichten erzeugte einen geschlossenen Bildcharakter in der Art der religiösen Tafelmalerei analog der altdeutschen, flämischen und italienischen Bildsprache der Frührenaissance[383]. Elgin Vaassen bezeichnet den Stil der Nazarener in der Glasmalerei, zur Zeit der Anfänge in der königlichen Glasmalereianstalt in München, als Novum, der sich im Fensterzyklus im Dom zu Regensburg zu etablieren begann[384].

377 Thimann, 2005, S. 169 ff.
378 Grewe, 2000, S. 61–78.
379 Grewe, 2006, S. 401–425.
380 Aman, 2003, S. 19; Vaassen, 1993, S. 24 f.; Mahn, 1990, S. 4 f; Von Roda, 1990, S. 231–243; Grentzschel, 1989, S. 70; u.v.a.
381 Vgl. Thimann, 2005, Anm. 315; Benjamin, 2008, S. 19: Die Reflexion ist die häufigste Kategorie im Denken der Frühromantiker. Nachahmung, Manier und Stil lassen sich unter diesem Terminus anwenden. S. 22: Fichte versteht unter Reflexion das umformende Reflektieren auf eine bestimmte Form.
382 Grewe, 2006, S. 410 ff.
383 Vgl. Vaassen, 1997, S. 185 f.
384 Vaassen, 1997, S. 186.

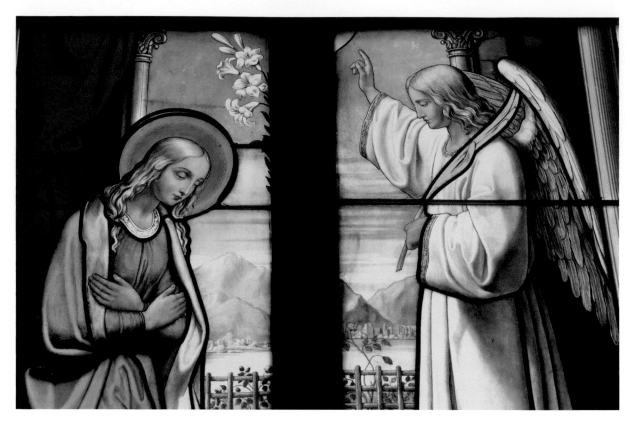

40. Johann Jakob Röttinger, Mariä Verkündigung, «Porzellanmanier», Ausschnitt aus dem Chorfenster N II, Katholische Pfarrkirche Sankt Georg und Anna Bünzen AG, 1861.

Zur gleichen Zeit beschäftigten sich die Brüder Boisserée mit Porzellan- und Glasfarben und bevorzugten für ihre private Glasmalereisammlung, die «porzellanhafte», auf Nahsicht bestimmte Feinmalerei[385].

In der zweiten Hälfte des Jahrhunderts verließ man diese Technik der «Frühzeit» und ging zu einem großflächigerem, jedoch immer noch feinporigen Farbauftrag über[386]. Der Glasmaler Jakob Georg Röttinger (1862–1913), der ältere der beiden Söhne Johann Jakobs, erwähnte in einem Schreiben von 1901 *«die veraltete ‚Porcelanmanier' als fälschlicherweise ‚Münchener Manier' benannte Malweise»*[387] (vgl. Abb. 40, 41). Der Nachkomme setzte sich durch die Bevorzugung der musivischen Glasmalereitechnik und Ablehnung der Technik des «Glasgemäldes» klar von der älteren Glasmalergeneration ab, der sein Vater noch angehörte[388]. Auf die Provenienz der Glasmaler, die mehrheitlich aus dem Metier der Porzellanmalerei stammten, wird

im nachfolgenden Kapitel über die künstlerische Ausführung genauer eingegangen.

Auf die Zusammenarbeit Johann Jakob Röttingers mit dem Innerschweizer Kirchenmaler, Melchior Paul Deschwanden[389], wurde bereits im Zusammenhang mit den Kirchenbauten in Bünzen und Gams hingewiesen, weitere Berührungspunkte sind zu vermuten, wie beispielsweise in der Kapelle auf dem Gubel in Menzingen oder in der

385 VAASSEN, 1997, S. 189.

386 VAASSEN, 1997, S. 267.

387 ZANGGER, 2007, S. 122, zitiert nach R/KB 111–84, 408 (alte Signatur); neu: ZB Nachl. Röttinger 2.379, Rechnungs- und Kopierbuch.

388 ZANGGER, 2007, S. 119–128. Dass Johann Jakob Röttinger selbst Kritik an der «Ölmalerei» auf Glas übte (vgl. die zitierte Korrespondenz mit Ferdinand Keller bzgl. der Maria-Hilf-Kirche in München Au), wird im Kap. ‹Material und Maltechnik› erwähnt.

389 Vgl. Kap. ‹Gemalte Architekturen›; ZB Nachl. Röttinger 1.4, 1.34.

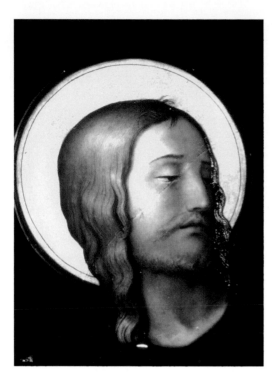

41. Königliche Glasmalereianstalt München, Fragment eines Christuskopfes, «Porzellanmanier», Maria-Hilf-Kirche, München-Au, 1838.

Wallfahrtskirche Maria Bildstein zu Benken, wo beide Künstler zeitgleich beschäftigt waren; des Weiteren in der Sankt Oswald Kirche in Zug[390], im Basler Münster usw. Die beiden im Nachlass Röttinger befindlichen Briefe des Innerschweizer Kunstmalers belegen eine Kooperation für die Ausführung der Glasmalereien in der ehemalige Klosterkirche im Toggenburgischen Alt Sankt Johann, in denen Deschwanden Kritik an den Zeichnungen aus der Werkstatt Röttinger übt und Anleitungen für Verbesserungen der Proportionen gibt[391]. Deschwanden begegnete den Nazarenern 1839/1840 in Rom und zeigte sich offensichtlich sowohl von den Bildinhalten wie auch vom Stil angetan, was ihn veranlasste sich fortan ausschließlich mit der Kirchenmalerei zu beschäftigen[392]. Bereits 1844 schmückte Melchior P. Deschwanden die Chorbogenwand der Augustinerkirche in Zürich, wohl in Anlehnung an Peter Cornelius' «Jüngstes Gericht» in der Münchner Ludwigskirche[393], als der junge Röttinger, damals noch unter seinem Patron J. A. Hirnschrot, an der Herstellung

von Glasmalereien in derselben Kirche beteiligt war[394]. Trotz Deschwandens Bevorzugung der Malerei der italienischen Frührenaissance, beeindruckte ihn während seiner Reise nach Colmar Martin Schön, genannt Schongauer[395]. Entsprechungen mit der Malerei der Nazarener zeigten sich bei Deschwanden in der Betonung des Linearen, in der Art der Komposition mit Akzentuierung der Figuren, deren Umgebung von der Bedeutung her klar in den Hintergrund trat, sowie in der Vernachlässigung des «Plastischen». Vor allem war es jedoch die religiöse Einstellung des Innerschweizer Künstlers, die die künstlerische Verwandtschaft zu den Lukasbrüdern ausmachte. Als höchste Aufgabe des christlichen Künstlers galt es «Gott zu verherrlichen», eine Auffassung, die sich aus der langen Tradition der *devotio moderna* entwickelt hatte und im Pietismus neue Impulse erfuhr[396]. Deschwandens tiefe Verankerung im Katholizismus[397] entsprach voll und ganz den Ansprüchen der Nazarener an einen Maler, der wie sie imstande war, die christliche Kunst zu

390 TOBLER, 1985, S. 54–93.
391 ZB Nachl. Röttinger, 1.4: *«[…] Ihr Zeichner mag geschickt, aber auch etwas zu anmaßend sein und im Nackten fehlt ihm jedenfalls Proportionskenntnis und Schönheitssinn […]»*; in der Folge notiert Deschwanden die wichtigsten Proportionsregeln, dass Röttinger diese an seinen Zeichner weiterleite.
392 TOBLER, 1985, S. 69 f. Erste Kontakte z. B. mit dem Nazarener Ludwig Vogel ergaben sich schon während Deschwandens Zürcher Ausbildungszeit 1827. An der Münchener Akademie, die in diesen Jahren (1830) von Peter Cornelius geleitet wurde, erhielt Deschwanden u. a. Unterricht von Julius Schnorr von Carolsfeld.
393 TOBLER, 1985, S. 72. Die beiden Apostelfürsten Deschwandens werden 1869 fast identisch auf dem Chorfester s II in der Pfarrkirche Nottwil wiedergegeben (Abb. 86; ABEGG/WIENER, 2002, S. 201, Abb. 234).
394 Ein von J. A. Hirnschrot signiertes Fragment aus der Augustinerkirche, ein Engelskopf einer Lünette, hat sich im Landesmuseum erhalten (Abb. 6). Archivalisch lässt sich die Mitarbeit Röttingers nicht explizit belegen. Vgl. ABEGG/WIENER, 2002, S. 174 ff.
395 KUHN, 1882, S. 78.
396 GREWE, 2005, S. 82.
397 TOBLER, 1985, S. 69 f., bes. Anm. 89: Möglicherweise spielte die Angst vor der damals mit Sünde beladenen eigenen Neigung zur Homophilie eine Rolle.

erneuern. Johann Jakob Röttinger gehörte als geborener Nürnberger der evangelisch-lutherischen Richtung des Protestantismus[398] an und erfuhr bei reformierten wie katholischen Auftraggebern eine hohe Wertschätzung. Ob mit Angehörigen von Konventen, katholischen oder reformierten Geistlichen verhandelnd, Röttinger fand mit den Vertretern beider Konfessionen immer den richtigen Ton. Seine christliche Einstellung zeigte jedoch keinerlei Tendenz zu außergewöhnlicher Frömmigkeit im Sinne der konfessionellen Einstellung der Nazarener. Der große Erfolg des Glasmalers lag, neben seiner ausgeprägten Geschäftstüchtigkeit, wohl in der gelungenen künstlerischen Umsetzung der stilistischen Vorbilder im Sinne seiner Auftraggeber und der professionellen Maltechnik bei der Übertragung der Kartons[399] auf das Medium Glas. Dem allgemein verbreiteten puristischen Stilideal der Gotteshäuser des 19. Jahrhunderts entgegentretend, wurde diesen zunehmend wieder ein «Raumgefühl» eingehaucht, das sich häufig im Zusammenspiel von Wandmalerei, liturgischer Einrichtung und Glasmalerei als Gesamtkunstwerk präsentierte. Theologisch reflektierte ikonographische Programme waren demnach in der Glasmalerei des 19. Jahrhunderts keine Seltenheit[400]. Dazu kommt, wie bereits festgehalten, dass das Lineare mit Betonung der Konturen – augenfälliges Merkmal der Malerei der Nazarener – besonders gut in die Technik der Glasmalerei umsetzbar war. Ob die Fassung der Figuren durch die eher selten angewandte Methode der alleinigen Anwendung von Schwarzlotmalerei oder durch die damals übliche Mehrschichtbemalung – die «Tafelmalerei auf Glas» – geschah, Konturen ergaben sich praktisch aus jeder Vorgehensweise. Gewänder und Hintergrund waren farblich meist reich differenziert und das Inkarnat beeindruckte angesichts seiner feinen Modellierung, die durch Auftragen halbtransparenter dünner Farblasuren mit dem Pinsel entwickelt wurde. Diese Methode der additiven Malerei ließ die Figuren umso plastischer erscheinen, als die blassen cremefarbigen Inkarnatfarben mit grünlichen, rosa und violetten Akzenten ergänzt wurden[401], was wiederum im

Gegensatz zur Malweise der Nazarener stand (Abb. 42, 43). Die Anordnung einiger weniger Figuren im Vordergrund, ein Kompositionsschema, das auch M. P. Deschwanden bevorzugte[402] und bei Johann Jakob Röttinger ebenfalls zu beobachten ist, ließ sich nicht zuletzt auch materialbedingt leichter bewerkstelligen als komplexe figurenreiche Arrangements.

398 Nürnberg, Evangelisch-Lutherisches Dekanat, Homepage, Geschichte-online: 1530 unterzeichnet Nürnberg als eine der ersten evangelischen Städte Deutschlands die *Confessio Augustana*, das grundlegende Glaubensbekenntnis des Protestantismus. In der fränkischen Reichsstadt wurde ausschließlich die evangelisch-lutherische Konfession innerhalb des protestantischen Lagers geduldet; untersagt war zwinglianisches Gedankengut. Aus dem Niederlassungsakt von Johann Jakob Röttinger geht nicht hervor, welcher Glaubensgemeinschaft er angehörte (die Zugehörigkeit zur evangelisch-lutherischen Richtung war damals für Nürnberger Bürger wohl selbstverständlich). Eine Prüfung der Kirchenbuchzweitschrift, die Christof Neidiger vom SA Nürnberg freundlicherweise ausführte, ergab eindeutig, dass Röttinger von Geburt an der evangelisch-lutherischen Glaubensrichtung angehörte. Er wurde am 24. März 1817 in L. 1236, der späteren Pfeifergasse 7, geboren und in der Pfarre Sankt Jakob getauft (C 21/II Nr. 13, S. 26, Eintrag 205). Bemerkung zur Nummer L. 1236: Vor der Einführung von Straßenbezeichnungen in Nürnberg behalf man sich mit der Bezeichnung der beiden Stadthälften L[orenz] und S[ebald]; vgl. NÜRNBERGER STADTLEXIKON, 2000, S. 1025, Stichw. *Stadtteile (nach 1806)* (Hartmut Frommer). Es ist nicht auszuschließen, dass Röttinger anlässlich seiner Eheschließung mit der Schweizerin Verena Fehr das helvetische Bekenntnis angenommen hatte (C7/II Nr. 11886, im Familienschein von Zürich, 31. März 1863 wird die Familie als ,ref[ormiert]' eingetragen).

399 Da sich im Nachlass aus der Zeit des Werkstattgründers keine Kartons erhalten haben, ist die stilistische Verbindung zwischen Glasmalerei und Kartons nicht gegeben. Aus den Quellen geht zwar hervor, dass beispielsweise M.P. Deschwanden für J. Röttinger entworfen hatte; umgekehrt jedoch gibt es keinen expliziten Hinweis darauf, dass Röttinger selbst Kartons anfertigte.

400 GRENTZSCHEL, 1989, S. 25 f. bzw. S. 66.

401 VAASSEN, 1993, S. 32.

402 TOBLER, 1985, S. 71 f.

42. Johann Jakob Röttinger, heiliger Franziskus, Detail des ehemaligen Chorfensters s II, Katholische Kirche Sankt Oswald Zug, 1866, Depot Bauhütte Sankt Oswald, Zug.

43. Johann Jakob Röttinger, heiliger Franziskus, Detail des ehemaligen Chorfensters s II, Katholische Kirche Sankt Oswald Zug, 1866, Depot Bauhütte Sankt Oswald, Zug.

Sowohl die Gemälde der Gründer des Lukasbundes wie auch diejenigen des Malers M. P. Deschwanden lassen den Effekt der ausgeprägten Körperlichkeit vermissen. In diesem Punkt wird auch deren Abkehr vom Klassizismus evident, wo Körpersprache, Mimik und Gebärden die Figuren lebendig machten[403]. Zugunsten der Empfindsamkeit sowie der Idealisierung der Personen wurde bei den Nazarenern – jedoch nicht bei den Glasmalern – jegliche Art des Naturalismus vernachlässigt, was vor allem in der Darstellung der Figuren Transzendenz evozierte.

Nach diesen Ausführungen zu einem Stil, der sich in Anlehnung an zeitgenössische Vorbilder herausgebildet hatte und bei den Glasmalern im 19. Jahrhundert und explizit bei Johann Jakob Röttinger anzutreffen ist, sollen im folgenden Kapitel Facetten der künstlerischen Schöpfung erörtert werden. Die traditionelle Herkunft aus der Porzellanmalerei, die Farbigkeit und die Betonung des Zeichnerischen sowie Komposition und Anlage der Figuren im Werk sollen darin zur Sprache kommen. Ferner sollen auch die Wünsche der Auftraggeber thematisiert werden, weil deren Einflussnahme nicht unterschätzt werden darf. Die starke Gewichtung der so genannten «Porzellanmanier» in der Glasmalergeneration Johann Jakob Röttingers sowie die kunstgewerbliche Herkunft der Glas-

maler aus der Porzellanmalerei bedingen eine ausführlichere Betrachtung der Porzellan-Manufakturen in Sèvres und in Ludwigsburg, also in den Manufakturen, in denen Röttingers Lehrmeister die Porzellanmalerei erlernt haben.

Künstlerische Ausführung

Die Porzellanmaler

Die Glasmaler der ersten Jahrhunderthälfte, die in der Literatur häufig als Wiederentdecker dieser Kunstgattung bezeichnet werden, stammten bezüglich ihrer Ausbildung meist aus den Porzellanmalerei-Klassen der Kunstschulen. Nicht nur Johann Jakob Röttinger selbst[404], sondern auch seine Patrons, Franz Joseph Sauterleute in Nürnberg und Johann Andreas Hirnschrot in Zürich, lernten zuerst die Kunst des Porzellanmalens. Beide übten ihren erlernten künstlerischen Beruf in bekannten Porzellanmanufakturen aus, Sauterleute in Ludwigsburg, Hirnschrot in Sèvres.

403 SPICKERNAGEL, 1977, S. 111 f.
404 StA N: Nr. 253 Acta d. Königl. Kunstgewerbeschule zu Nürnberg, betr. Schüler-Verzeichnisse d. Königl. Kunst- und Kunstgewerbeschule Nürnberg (1820–1853/54), Fasc. Nr. 2, 13.

Schlüsselfigur in dieser Zeit war wohl der Nürnberger Dosen- und Porzellanmaler Sigmund Frank (1770–1847)[405], der sich im Streben nach Gewinn, Ehre und Anerkennung in der Glasmalerei erfolgreich als Autodidakt versuchte und dank der Unterstützung von König Max I. Joseph im «Zwinger» zu Nürnberg eine Bleibe fand, die ihm nicht nur Wohnung, sondern Platz für die Herstellung seiner Glasbilder bot. Schließlich erhielt er von Kronprinz Ludwig eine Stellung als Glasmaler in der Münchner Porzellanmanufaktur, wo er 1827 mit der Leitung des königlichen Instituts für Glasmalerei betraut wurde[406]. Franz Joseph Sauterleute, der 1796 in Weingarten geborene Lehrer Röttingers, kam 1813 als Malerlehrling in die Porzellanmanufaktur nach Ludwigsburg und wurde gegen Ende seiner Lehrzeit 1816/1817 in den Listen als Schüler des römischen Bildhauers und Stuckateurs am württembergischen Hof, Antonio Isopi (1758–1833), sowie als Maler- und Vergolderlehrling geführt[407]. Drei Jahre nach Beendigung seiner Ausbildung erscheint er in den Archivalien als Obermaler, dessen Aufgaben neben der Lehre auch das Reisen zum Zwecke von Studien und des Einkaufs von Material, wie Farben und Kupferstiche etc., beinhalteten. 1824 wird Sauterleute auch zum künstlerischen Leiter der Manufaktur berufen. Nachdem er bereits 1822 die Erlaubnis zur beruflichen Selbstständigkeit erhielt, machte er in der Folge Gebrauch davon[408] und widmete sich zunehmend seinen Versuchen in der Glasmalerei und des Laborierens in einer Glashütte. Die finanzielle Begünstigung durch seinen Mäzen, den Kaufmann Hertel in Nürnberg, durch ein Staatsstipendium vom König sowie die Bekanntschaft mit dem Fürsten von Fürstenberg erlaubten ihm die Herstellung kleiner Kabinettscheiben, die er allein zu bewerkstelligen im Stande war und dem Porzellanmaler zunächst künstlerisch näher lagen als monumentale Bilder. Dies gab ihm Gelegenheit sich vor allem mit den Studien zur Farbengewinnung zu beschäftigen[409]. Bekannt sind vor allem sechs Kabinettstücke im Germanischen Nationalmuseum, signierte Dürer-Kopien von 1834/1835 nach der Kupferstichpassion, die der Künstler teilweise aus farbigem Glas herstellte[410]. An große Scheiben wagte sich Sauterleute erst ab 1835, als er für die Fürther Michaelskirche ein Chorfenster schuf und danach den Prestigeauftrag der Glasmalereien für die Gruftkapelle derer von Thurn und Taxis in Regensburg erhielt. Wie schon erwähnt[411], gestaltete Sauterleute diese Fenster sehr farbenfroh, ganz im Sinne der Nürnberger Glasmalerei um 1500, mit plakativer Wirkung, jedoch ohne auf Schattierungen, die der Münchner Glasmalerei eigen waren, gänzlich zu verzichten. Das vordergründig optische Ergebnis entstand durch das Aneinanderfügen von verschieden farbigen Glastafeln, die kaum deckenden Übermalungen unterzogen wurden, um mit Farbkontrasten und Helldunkel-Effekten auf den Betrachter zu wirken[412]. Nimmt man die Glasmalereien auf dem Leuchtpult[413] in Augenschein, kann die Entwicklung der Farbschattierungen aus der Fläche heraus nachvollzogen werden, weil dann der auf Weitsicht angelegte Effekt einer Tafelmalerei auf Glas erzeugt wird. Geprägt vom Schadbild der Korrosion, dem Wegfall ganzer Malschichten, üben die Glasmalereien auf den heutigen Besucher nach wie vor die Faszination von kräftig leuchtenden «Lichtquellen» aus, die an den kahlen Wänden der Gruftkapelle starke Akzente setzen.

Der Nürnberger Portrait-, Email- und Glasmaler Johann Andreas Hirnschrot (1799–1845)[414] be-

405 VAASSEN, 1997, S. 159 ff., zitiert nach A. von Schaden, 1829.

406 Die genauen Umstände der Entstehung der Glasmalereianstalt München bei VAASSEN, 1997, S. 159 ff. u. 178 ff. und in der Monographie über die kgl. Glasmalereianstalt in München 1827–1874 (VAASSEN, 2013).

407 FLACH, 1997, S. 936 ff.

408 1824 gab die Manufaktur ihre Produktion auf, s.u.

409 VAASSEN, 1997, S. 162 f.

410 VAASSEN, 1997, S. 163–164.

411 Vgl. Kap. ‹Frühe künstlerische Prägung›.

412 VAASSEN, 1997, S. 164 u. 165.

413 Diese Gelegenheit bot sich der Autorin dank der freundlichen Einladung Peter van Treecks in dessen Münchner Atelier, wo 2011 ein Teil der Glasmalereien aus der Gruftkapelle der Thurn und Taxis in Regensburg restauriert worden sind.

414 Vgl. Kap. ‹Auswanderung in die Schweiz›.

suchte von 1821–1826, wie später Johann Jakob Röttinger, in der Heimatstadt die Malerakademie, um anschließend in Sèvres als Porzellanmaler und in einigen Schweizer Städten als Porträtist zu arbeiten. 1830/1831 besuchte er München und Nürnberg, wo ihn das Wiederaufkommen der Glasmalerei bewog, sich dieser Kunstrichtung zu verschreiben[415]. In die Schweiz zurückgekehrt eröffnete er in Zürich eine Werkstatt, in die Röttinger 1844 als Gehilfe eintrat. Noch deutlicher als bei Sauterleute scheinen bei Hirnschrot Anklänge an die Porzellan- beziehungsweise Emailmalerei hervorzutreten. Das bereits erwähnte Engel-Fragment, das sich aus der Zürcher Augustinerkirche im Landesmuseum erhalten hat, zeigt den «Porzellanstil», der sich unter anderem durch eine besonders feine, auf Nahsicht angelegte Maltechnik[416] auszeichnete. Für den geübten Porträtmaler war es wohl ein Leichtes, all die für die plastische Wirkung notwendigen Schattierungen mit verschiedenen Schmelzfarben sowie Schwarzlot anzubringen, um dem Lünettenengel[417], der vom Blickwinkel des eintretenden Kirchenbesuchers aus gut zu sehen war, ein fein gemaltes Mädchengesicht zu verleihen. Weitere Scheiben aus der Hand Hirnschrots, nämlich Wappenscheiben im Schützenhaus Sihlhölzli in Zürich, werden im Glasmalereikatalog des Landesmuseums erwähnt[418]. Darüber hinaus haben sich diverse Wappenscheiben von Aarburger Geschlechtern im Gemeindemuseum zu Aarburg erhalten, die ursprünglich die Kirchenfenster zierten und nun auf die Fenster des Museums verteilt sind. Weitere Fragmente, darunter auch signierte Stücke Hirnschrots, werden im Estrich aufbewahrt[419]. Das Landesmuseum bewahrt eine Reihe graphischer Blätter des Porträtisten und einige Scheibenrisse[420]. Über die Art der Tätigkeit Hirnschrots als Emailmaler in Sèvres ist jedoch nichts überliefert[421].

In der Geschichte der Ludwigsburger Manufaktur wird zu jener in Sèvres[422] eine Parallele besonders deutlich, nämlich die finanzielle Förderung und Vergabe von Privilegien durch das Herrscherhaus. 1758 gründete Herzog Carl Eugen von Württem-

berg (1728–1793) die «Herzoglich ächte Porcelaine-Fabrique» in Ludwigsburg, um den Glanz seiner Hofhaltung aufzuwerten und im Wetteifer der Höfe mithalten zu können[423]. Die kostspielige Herstellung machte die Porzellanproduktion zur Luxusindustrie, die praktisch nur in ihrer Heimat Meißen Gewinn generierte. Der Arkanist Joseph Jakob Ringier aus Wien brachte das «Geheimnis» und Modelleur Gottlieb F. Riedel sorgte für das Design. Ende des 18. Jahrhunderts verursachten das Hartporzellan von Sèvres und das englische Steingut von Wedgewood einen harten Konkurrenzkampf und das Ende der Rokokozeit den Niedergang. 1824 wurde der Betrieb in Ludwigsburg aufgehoben[424].

Die Porzellanmanufaktur in Sèvres, ursprünglich in Vincennes am Stadtrand von Paris gegründet, kam 1756 unter die königliche Oberaufsicht und 1760 in den Besitz von Louis XV., wobei der Gründung der Manufaktur die Konkurrenz mit Meißen zugrunde lag[425]. Die Jahre bis 1772 waren eine prosperierende Epoche. 1768 entdeckte der

415 ZB Nachl. Röttinger 1.71; VAASSEN, 1997, S. 18f.

416 VAASSEN, 1997, S. 186ff.

417 SNM, LM–30157, Glasgemälde, Abb. 6. Aus: Zürich, Augustinerkirche, bemalt. Zweimal signiert *J.A. Hirnschrot 1844, J.A. Hirnschrot fecit*; 36.2×96.4 cm.

418 SCHNEIDER, 1971, S. 487, Abb. 475.

419 ZB Nachl. Röttinger 1.1; GA Aarburg, Mappe Bauwesen, KBA.

420 Im Nürnberger Künstlerlexikon werden vier Porträts erwähnt, die 1830 in der Kunstschule Nürnberg ausgestellt wurden sowie eine Porzellanmalerei, Maria mit dem Kinde nach Tizian, ebenfalls dort gezeigt und im Schornschen Kunstblatt 1830 gelobt (NÜRNBERGER KÜNSTLERLEXIKON 2, 2007, S. 662, Stichw. *Hirnschrot, Johann Andreas II.*).

421 Die Manufaktur in Sèvres führte ihre Abteilung für Emailmalerei, also dem Einbrennen von Schmelzfarben auf Metall, bis ins Jahr 1872. Man arbeitete in Anlehnung an die berühmte Maltechnik von Limoges des 16. Jahrhunderts, wählte jedoch weit größere Dimensionen. (KAT. AUSST. DÜSSELDORF, 1975, S. 20ff).

422 Dies gilt auch für viele andere Porzellanmanufakturen (Meißen, München etc.).

423 PFEIFFER, 1907, S. 702ff.

424 Im 20. Jahrhundert wurde die Porzellanproduktion wieder aufgenommen.

425 KAT. AUSST. DÜSSELDORF, 1975, S. 5ff.

Chemiker Macquer das für die Herstellung des Hartporzellans unentbehrliche Kaolin. Die Miniaturmalerei sowie die Herstellung firmenspezifischer Farben machten die Manufaktur berühmt und die für Sèvres typische Goldmalerei wurde in den Produktionen von Meißen, Berlin und Wien übernommen. Die französische Revolution gilt als Zäsur im Betrieb, und unter dem neuen Direktor, Alexandre Brongniart (1770–1847), eines Geologen und Chemikers, wurde ab 1800 nicht nur das Hartporzellan, sondern eine Palette von Schmelzfarben entwickelt, was in der Folge für die manufaktureigene Entwicklung der Glasmalerei von großer Bedeutung war. Nach zahlreichen Versuchen in der Manufaktur auch Glasmalereien herzustellen, was jedoch in Paris nicht goutiert wurde, ließ man die Verglasung für die Elisabeth-Kirche aus England kommen. Erst 1828 gelang es auf königlichen Wunsch hin, nach dem Vorbild Münchens eine Abteilung für Glasmalerei anzugliedern. Dort entstanden auf weißen und farbigen Glastafeln Malereien mit Porzellanfarben; die Entwürfe und Kartons stammten von berühmten Malern wie Ingres und Delacroix[426]. Nach einer Blütezeit königlicher Aufträge zwischen 1830 und 1846 wurde die Glasmalereianstalt in Sèvres 1854 wieder geschlossen[427].

Die geschilderten Vorgänge und die Entwicklungen bezüglich der Porzellanherstellung, vor allem der Porzellanmalerei, die ihren Zenit um 1800 überschritten hatte, machen deutlich, dass es für die jungen Porzellanmaler neben der fachlichen Verwandtschaft der beiden Kategorien[428] sehr wohl auch wirtschaftliche Gründe gab, sich für die aufstrebende Glasmalerei zu interessieren. Die königlichen Zuschüsse in die «Grundlagenforschung» und vor allem die Vergabe wichtiger Aufträge von Fürsten und Königen in den größeren Städten sowie die längst fälligen Restaurationen mittelalterlicher Fenster und der einsetzende Kirchenbauboom ermutigten die Künstler zum Wechsel in die Glasmalerei und ließen die Kunstrichtung wieder aufleben. Diese Entwicklung geht auch aus dem zeitgenössischen Quellenmaterial der Königlichen Kunstgewerbeschule zu Nürnberg

hervor[429]. Möglicherweise vermochte dieser Trend, zumindest für eine gewisse Zeit, das durch den Rückgang der gehobenen Porzellanherstellung entstandene wirtschaftliche Defizit etwas auszugleichen.

Farbigkeit, Farben und Zeichnung als Metapher für die Wahrheit

Wie schon mehrmals gezeigt werden konnte, zieht sich die intensive Farbgebung der Glasmalereien als Charakteristikum durch das Werk Johann Jakob Röttingers. Die spätmittelalterlichen Vorbilder in den Kirchen Nürnbergs einerseits, die gewollte Erzeugung mystischer Stimmungen in den Gotteshäusern, wie sie von den Neugotikern, z.B. dem Architekten Carl Alexander Heideloff, gefordert wurden andererseits und die Folgen des experimentellen Umgangs mit durchgefärbtem Glas[430], Überfangglas sowie Schmelzfarben trugen dazu bei, dass die Glasmalereien in ihrem optischen Erscheinungsbild als sehr farbenfroh wahrgenommen wurden. So stellte Daniel Parello anlässlich seiner Untersuchung der Glasmalereien in der Abendmahls- und Grablegungskapelle im Freiburger Münster fest, dass die gedämpften Farbakkorde der Hintergründe einen angenehmen Kontrast zur Buntheit der Figuren bildeten. In diesem Falle stammten die gemäßigten Farben aus der Eigenproduktion der Helmle-Werkstatt, die Buntheit hingegen ging auf die Verwendung mundgeblasenen Hüttenglases zurück, das man für die Gewandteile der Figuren einsetzte[431]. Bereits die

426 BEZUT, 1997, S. 97 ff.; VAASSEN, 1997, S. 76 ff.
427 TOURNIÉ/COLOMBAN/MILANDE, 2007, S. 219–224.
428 VAASSEN, 1993, S. 14.
429 StA N, Nr. 95: Acta der königlichen Kunstgewerbeschule zu Nürnberg, Blatt 46, S. 69: «Die Luftmalerei ist im lebhaftesten Schwung, die Glasmalerei ist es gleichfalls, nur die Porzellanmalerei ist durch den geringen Verbrauch an gemalten porzellanenen Pfeifenköpfen nicht mehr so lebhaft in Betrieb und viele Maler, die sich sonst damit beschäftigten, sind zu anderen Kunstfächern übergegangen.»
430 VAASSEN, 1993, S. 15.
431 PARELLO, 2009, S. 112.

Kunstgeschichtsschreibung des 19. Jahrhunderts lobte die Klarheit, Frische und Tiefe der von Siegmund Frank entwickelten Farben und dessen Fähigkeit auf ein und dieselbe Scheibe jene Farbenstimmung und Haltung zu bringen, die die alten Glasmaler nur durch das Zusammenfügen farbiger Gläser zu erzeugen vermochten[432]. Darüber hinaus wird die Farbwirkung auch vom Schadensbild beeinflusst. Korrosionen, der so genannte Wetterstein, der die bei den Zeitgenossen so beliebte Patina erzeugte, fiel an manchen Stellen ab und ließ auf diese Weise die betroffenen Glasteile edelsteinartig aufleuchten, wie dies das abgebildete Fenstersegment aus der Gruftkapelle Regensburg verdeutlicht (Abb. 44)[433].

44. Franz J. Sauterleute, Detail aus einem Sockelfeld, Regensburg, Gruftkapelle Thurn und Taxis, 1837–1843.

Dass sich Johann Jakob Röttinger an Experimenten mit Farben und gefärbtem Glas beteiligte, geht aus einem Briefwechsel[434] hervor, den er mit der Glashütte in Moutier unterhielt. Darin regte er den Versuch an, Glas mit dem Rest eines *Tiegels* zu verschmelzen, um zu sehen, welche Farbe dabei herauskomme[435].

Ein weiteres entscheidendes Argument für die intensive farbige Gestaltung der Glasmalereien in der nazarenischen Malweise entsprang der Ideologie der Lukasbrüder. Spezielle Charakteristika der Malerei der Frührenaissance – wie die Vereinfachung der Anatomie und die starke Buntfarbigkeit – wurden von den Nazarenern als Stilmittel übernommen, um die vermeintliche Glaubenswahrheit sowie Unverdorbenheit der dargestellten Personen zu verdeutlichen[436]. Der Nazarener Philipp Veit brachte in seinem Aufsatz «Über die christliche Kunst» den Begriff der «Schönheit», mit Rückgriff auf das Denken Augustinus' und der Scholastik – als der Terminus noch nicht auf die Kunst Bezug nahm, sondern das Seiende auf einer metaphysischen Ebene bezeichnete – mit der Offenbarung Gottes und dem Bild des Paradieses, also der «Wahrheit», in Verbindung[437]. Veit übersetzte Albertus Magnus und legte Schwerpunkte auf die «Magie der Farbe» und das farbenprangende Gewand der Kirche, das als «Manifestation des göttlich Urschönen» galt[438]. Dass Peter Cornelius als Zeichner von König Ludwig sehr geschätzt war, wurde im Zusammenhang mit den Fresken in der Ludwigskirche bereits angesprochen[439].

432 GESSERT, 1839, S. 251.
433 VAASSEN, 1997, S. 28f.
434 ZB Nachl. Röttinger 2.371, 19 u. 21 Moutier/Châtelain 1875.
435 Vgl. Kap. ‹Material und Maltechnik›.
436 GREWE, 1998, S. 123.
437 SUHR, 1998, S. 120f.
438 SUHR, 1998, S. 121, zitiert nach: Veit, 1869, «Über die christliche Kunst», in: Broschüren Verein Bd. 5, Nr. 2, 1869, S. 6; Friedrich Overbeck sah «Die Wahrheit im Gewande der Schönheit» (HOWITT, 1886, Friedrich Overbeck. Sein Leben und sein Schaffen, Bd. 2, Freiburg im Breisgau, S. 353).
439 Vgl. Kap. ‹Frühe künstlerische Prägung›.

Frank Büttner versuchte anhand Cornelius' Graphiken Motive für die Betonung auf das Zeichnerische, das Lineare, bei den Nazarenern zu finden[440]. Dazu definiert er die Umrisslinie, indem sie anschwillt und wieder dünner wird, als Abstraktion und gesteht ihr Reminiszenzen an die Plastizität der Form zu – als Ergebnis kontinuierlicher Reduktion[441]. Bei Cornelius hingegen komme bisweilen eine differenzierte Art des Werkprozesses zutage, der das Neben- und Übereinanderlegen feinster Umrisslinien voraussetze, um ihn mit einer terminalen kräftigeren Linie zum Abschluss zu bringen. In Cornelius' Werk hatten *Modello* und *Karton*, die er für die Ausführung von Fresken entwickelte, einen zweifachen künstlerischen Wert, waren doch die Umrisslinien des Modello Grundlagen für die Reproduktion zur Verbreitung als Kupferstiche angelegt und der Karton im Maßstab 1:1 Vorlage für die Fresken. Büttner geht in der Folge auf philosophische Hintergründe des Linearen ein und beruft sich auf Kant, der der «Zeichnung» von allen bildnerischen Künsten höchste Signifikanz zugestand[442]. Schelling entwickelte diesen Gedanken Kants weiter und attestierte der Malerei «überhaupt Kunst nur durch die Zeichnung, so wie sie nur durch die Farbe Malerei sei». In diesem Zusammenhang nannte Schelling die «Wahrheit der Zeichnung» als Hauptforderung an den Künstler, der statt die Natur abzubilden, das Innere der Natur zu veranschaulichen habe. Indem die Umrisszeichnung die Konzentration auf das kennzeichnende Wesentliche darstellt, folgte Cornelius dem von Schelling geforderten Verzicht auf das «Zufällige und Überflüssige»[443]. Schelling ebnete den Nazarenern mit seinem Votum zur Befreiung von der Naturnachahmung beziehungsweise seiner Definition der Darstellbarkeit von Wahrheit deren individuellen Weg künstlerischer Umsetzung zur Erneuerung der religiösen Malerei. Wenn Franz Pforr von einer «moralischen Revolution» spricht, dann sollte diese in «Farbe und Form» zum Ausdruck kommen. Das Lineare versinnbildlicht dabei die «reine Lehre»[444] in Bezug auf die Religion, was auf den Umgang mit den Farben übertragbar ist. Die Verwendung der «reinen» Farbe, um der angestrebten Einheit von Zeichnung und Farbe gerecht zu werden, ermöglichte schließlich die Schaffung einer «Poesie in Formen und Farben», Forderungen, die Wilhelm Schadow an das Kunstwerk stellte[445].

Überlegungen zur Reinheit und Klarheit des Linearen und deren Funktion der Begrenzung sind letztlich Wesensmerkmale der Glasmalerei und lassen sich mehrheitlich auf die Arbeit mit Glas transponieren. Das Aneinanderfügen von verschiedenfarbigen Glasstücken in der musivischen Technik, die durch Bleiruten entstehenden linearen Formen sowie das Malen auf Glas mit Schmelzfarben verbinden gewissermaßen die von den Nazarenern geforderten Kriterien. So ist es naheliegend, dass die Glasmaler diese in ihr Metier gut umsetzbaren aktuellen Ideen aufnahmen. Inspiriert von den Vorbildern in den Kunstschulen und Akademien, wie von den Altarbildern der Nazarener, ließen die Glasmaler im 19. Jahrhundert die erwähnten Aspekte in die Glasmalerei einfließen. Andererseits brachte die additive Auftragung von Schmelzfarben auf Glas, den «Bildern auf Glas», eine körperliche Auffassung, die sich dem Modus der nazarenischen Malerei widersetzte.

440 BÜTTNER, 2001, S. 97 f.

441 BÜTTNER, 2001: Frank Büttner zieht in diesem Zusammenhang Beispiele vom englischen Bildhauer John Flaxmann (1755–1826) heran.

442 BÜTTNER, 2001, S. 109.

443 BÜTTNER, 2001, S. 110; zitiert nach: Immanuel Kant, Kritik der Urteilskraft, hrsg. von Karl Vorländer (Philosophische Bibliothek, Bd. 39a), Hamburg 1968, S. 64 (§ 14, 62); Friedrich Wilhelm Joseph Schelling, Philosophie der Kunst, Darmstadt 1974, S. 163–171.

444 KAT. AUSST. FRANKFURT, 2005, S. 179.

445 PIANTONI, 1981, S. 24. Die Suche nach der «reinen Farbe» war auch das Votum Augusto Giacomettis, deren Umsetzung in Entwürfe für die Chorfenster in das Grossmünster in Zürich schließlich 1933 den Austausch der Glasmalereien J. Röttingers bewirkte. Zur hier besprochenen Problematik vgl. Kap. ‹Philosophisch-kunsthistorischer Diskurs›.

45. Johann Jakob Röttinger, Bergpredigt, Ausschnitt Chorfenster I, Evangelisch-Reformierte Kirche Oberentfelden AG, 1866.

Die auf Formalismus und religiösen Inhalt ausgelegte Malerei der Nazarener erschien immer seltener im Original in den Kirchen, sondern in Reproduktionen, die durch die Freiheit der Glasmaler, die die Kartons umsetzten, entsprechende Anpassung erfuhren[446]. Die hier zusammengetra-

genen Gegebenheiten lassen also vermuten, dass sich die Glasmaler zur Zeit des Historismus dem Stil der Nazarener anlehnten, da dieser nicht nur dem Zeitgeschmack entsprach, sondern darüber hinaus die Umsetzbarkeit in das Medium der Glasmalerei erlaubte[447]. Die bedingende Rolle des Materials bei der Stilbildung war einer der Semperschen Grundgedanken, dass das verwendete Material dem Gegenstand jeweils bestimmte Züge vermittle[448]. Demgegenüber überraschten die Glasmaler jedoch mit einer klaren Eigenständigkeit in der künstlerischen Ausführung, wie dies am Beispiel der aus der Fläche modellierten plastischen Bildhaftigkeit ihrer Figuren festzustellen ist. Der Naturalismus wird bei den Glasmalern nicht ausgeblendet, sondern ergänzt das zweidimensionale Bild aus Glas, um die Figuren mithilfe von Farbe und Malweise «ans Licht» treten zu lassen (Abb. 45).

Eigenheiten in der Komposition

Neben den vorgestellten künstlerischen Eigenschaften der Malerei der nazarenischen Vorbilder, die größtenteils auch auf die zeitgleiche Glasmalerei übertragbar sind, soll nun ein kompositorischer Aspekt zur Sprache kommen, der sich mit dem Bildtypus der Einzelfigur befasst. Lebte die barocke Freskenmalerei noch von der Darstellung mythologischer beziehungsweise religiöser Protagonisten, die handelnd und gestikulierend einem Figurenensemble vorstanden, um der damals gültigen Kunsttheorie, der Einheit von Raum, Zeit und Interaktionen, zu folgen, so fand in der zweiten Hälfte des 18. Jahrhunderts eine Zäsur statt[449].

446 HEINIG, 2004, S. 49.
447 Vgl. dazu AMAN, 2003, S. 20: Carl Gottfried Pfannschmidt, dem Nazarenertum verpflichteter Protestant und Professor an der Berliner Akademie (1865), erachtete biblische Kompositionen mit klaren Umrissen als außerordentlich gut geeignet für die Umsetzung in die Glasmalerei. Vgl. dazu VAN TREECK, 2007, S. 182: Nazarenisch geprägten Künstlern genügten die Bleiumrisse häufig nicht, um ihre Forderung nach gestalterischer Perfektion zu befriedigen.
448 BANDMANN, 1971, S. 143.
449 TELESKO, 2000, S. 40 f.

46. Johann Jakob Röttinger, Der heilige Borromäus heilt die Pestkranken, Chorfenster I, Katholische Pfarrkirche Finstersee ZG, 1869–1871.

Die Entdeckung der Laokoon Gruppe und die methodische Beschäftigung damit durch Winckelmann und Lessing als wichtige Prämisse für die ästhetische Auseinandersetzung der deutschen Aufklärer[450] leiteten eine Veränderung der Bildregie ein, die das Ende der Bildordnung Giottos, die Mensch, Körper und Flächen im Raum ihre Plätze zuwies, ankündigte und am additiven Bildaufbau sowie an der Bezugslosigkeit der dargestellten Figuren mit ihrer Umgebung erkennbar sind[451]. Die Abkehr vom illusionistischen Raumgefühl und vom Figurenreichtum im Sinne des Barock führte zur Reduktion der Anzahl der Figuren und zur kompositorischen Aufwertung der Einzelfigur. Als weiterer Faktor der Veränderung im Bildgefüge nennt Werner Telesko die Wechselbeziehung zwischen Bild und gemaltem Rahmen und nennt dafür das Beispiel «Das Bildnis des Malers Franz

Pforr»[452] von Johann Friedrich Overbeck, das sich durch das Bildnis im emblematisch gestalteten Rahmen vor einem gemalten Scheinraum auszeichnet[453]. In geistesverwandter Weise arrangierten die Glasmaler des 19. Jahrhunderts, in Anlehnung an mittelalterliche Vorlagen, Einzelfiguren beziehungsweise zahlenmäßig kleine Figurengruppen zwischen den gemalten Rahmenelementen, wo sich ebenfalls «Scheinräume» ergaben, die im Hintergrund der Figuren häufig durch gemalte Vorhänge[454] begrenzt waren. Auf die symbolische Aufladung der Rahmenarchitektur als Metapher für das Himmlische Jerusalem beziehungsweise deren mediale Funktion als Fenster wurde im Kapitel über die mittelalterlichen Vorbilder bereits ausführlich hingewiesen. Entsprechende Beispiele sind im Werk Röttingers evident. So kamen beispielsweise in den ehemaligen, heute im Archiv aufbewahrten Glasmalereien der katholischen Kirche Unterägeri ZG die vier Kirchenväter zur Ausführung, die in der beschriebenen Art vor weißen, zwischen Säulen gespannten Vorhängen Aufstellung nahmen.

450 LDK 4, 1992, S. 223 f., Stichw. *Laokoongruppe*, vgl. LESSING, 1994, Laokoon. Oder: Über die Grenzen der Malerei und Poesie. Mit beiläufigen Erläuterungen verschiedener Punkte der alten Kunstgeschichte (Reclams Universal-Bibliothek, 271), Stuttgart 1994.

451 TELESKO, 2000, S. 41. Werner Telesko zitiert dabei hauptsächlich Werner Hofmann, Desintegration und Multirealität um 1800, in: Thomas W. Gaethgens (Hrsg.), Künstlerischer Austausch. Artistic Exchange, Akten des XXVIII. Internationalen Kongresses für Kunstgeschichte, Bd. II, Berlin 1993, S. 529–542 (dort Anm. 9); Emil Kaufmann, Von Ledoux bis Le Corbusier – Ursprung und Entwicklung der autonomen Architektur, Wien 1933 (Reprint Stuttgart 1985), S. 13–41 (dort Anm. 11) und Theodor Hetzer, Francisco Goya und die Krise der Kunst um 1800, in: Wiener Jahrbuch für Kunstgeschichte 14, 1950, S. 7–22 (dort Anm. 1 und 12). Rahmdor kritisierte Caspar David Friedrichs Tetschener Altar ob seiner «ungehörigen und unvernünftigen Art der Zusammensetzung» (zahlreiche Literaturangaben in TELESKO, 2000, Anm. 13, S. 53).

452 NATIONALGALERIE BERLIN, Katalog Nr. 366 (Inv.-Nr. A II 381).

453 TELESKO, 2000, S. 42 u. 43.

454 Auf die Bedeutung von Vorhängen wird im Kap. ‹Ikonographie› eingegangen.

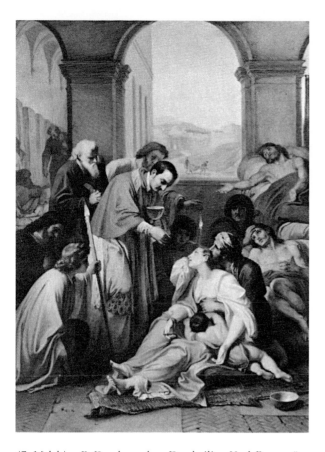

47. Melchior P. Deschwanden: Der heilige Karl Borromäus spendet Pestkranken die Kommunion, 185.5×127.5 cm, Öl auf Leinwand, bezeichnet unten links: Nach Mignard von M. Paul von Deschwanden 1859, Bischöfliches Palais, Solothurn, 1859.

Chorfensters lehnt sich stark an Melchior Paul Deschwandens Gemälde für Bischof Arnold von Solothurn von 1859 an (Abb. 47). Nicht nur die diagonal angeordneten, am Boden kauernden Pestkranken, deren Anzahl im Glasgemälde reduziert wurde, auch die Architektur in der Andeutung der Loggien sowie der Habitus des Heiligen lassen auf eine Zusammenarbeit zwischen Deschwanden und Röttinger an diesem Glasgemälde schließen[455].

Wünsche der Auftraggeber

Der Beschriftung einer Visitenkarte, die Röttinger auch als Briefkopf drucken ließ (Abb. 48), ist folgendes zu entnehmen: *«Verfertigt gebrannte Glasmalereien in jeder Manier [...] Verzierungen in jedem Styl [...] und empfiehlt sich unter Zusicherung prompter und billiger Bedienung [...]»*[456].

Auf dieselbe Weise präsentierte Röttinger die meisten seiner Einzelfiguren – so auch die heilige Verena in Gonten AI (vgl. Abb. 34). Das Chorfenster I erhielt einen besonderen Status, war es doch in seiner Funktion als «Retabel» gleichzeitig integrierter Bestandteil des Altars. Eine ähnliche Funktion weist das Chorscheitelfenster in der Kirche zu Finstersee ZG (Abb. 46) auf. Das Fenster mit der Abbildung des heiligen Karl Borromäus – in der Auffassung wie er die Kranken heilt – dient oberhalb der Mensa als Altarbild.

Der scheinbare Raum wird von einer gemalten Säulenreihe, den bittenden Pestkranken und dem Heiligen begrenzt; die Symbolhaftigkeit weitet sich hier auf Karl Borromäus selbst aus, der mit verschiedenen, ihm ikonographisch zugeordneten Attributen ausgestattet ist. Die Komposition des

455 TOBLER, 1985, S. 80, Abb. 22: Melchior Paul von Deschwanden: Der hl. Karl Borromäus spendet Pestkranken die Kommunion, 1859, Öl auf Leinwand, 185.5×127.5 cm, bezeichnet unten links: Nach Mignard von M. Paul Deschwanden 1859, Bischöfliches Palais, Solothurn; als Vorlage benutzte Deschwanden wohl einen Stich nach dem Altarbild, das Pierre Mignard (1610–1695) für die Kirche San Carlo ai Catinari in Rom gemalt hatte. Für die Vorstellung weiterer Beispiele aus dem Oeuvre Röttingers sowie für die ausführliche Stellungnahme bezüglich der Ikonographie im 19. Jahrhundert wird auf das Kap. ‹Ikonographie› verwiesen.

456 ZB Nachl. Röttinger 1.173. Die Bemerkung auf der Rückseite der Visitenkarte *«letztes Exemplar vom Vater (1817–1877)»* und die Adresse: *«Hintere Hofgasse»* deuten nicht darauf hin, dass die Karte aus Röttingers letzter Schaffensperiode stammt, in der der Meister in der Oetenbachgasse wohnte, sondern aus seiner Zeit in der Fortunagasse 36 bzw. 40 (4. Domizil Röttingers: 21. April 1854 – 16. September 1869, ZB Nachl. Röttinger 1.192, vgl. Kap. ‹Auswanderung in die Schweiz›). Dies belegt ein Brief aus dem PA Court von 1862, auf dem dieselbe Visitenkarte als Briefkopf diente. Die Verlängerung der Fortunagasse in Richtung Rennweg wurde als «Hintere Hofgasse» bezeichnet (MATHIS, 1979, S. 113, Tafel 33: Plan von Zürich 1864, Kupferstich von Johann Jakob Scheuermann nach Zeichnung von Heinrich Keller, Maßstab ca. 1:6600. Neunte und letzte Ausgabe von Kellers Stadtplan 28×33.5 cm, (Katalog Nr. 50 I, Zentralbibliothek Zürich)).

48. Johann Jakob Röttinger, Briefkopf, 1862, Archives de la paroisse réformée évangélique de Court BE.

Die genannten Kriterien verweisen bereits auf die wichtigsten Forderungen der Kundschaft, nämlich den Stil der Glasmalereien an die Wünsche beziehungsweise den Geschmack der Auftraggeber anzupassen und preislich auf die häufig bescheidenen finanziellen Verhältnisse der Pfarreien Rücksicht zu nehmen. Wie bereits im Kapitel ‹Auftrags- und Skizzenbuch› dargelegt, musste der Glasmaler verschiedene Dokumente, Entwurfsskizzen beziehungsweise Maquetten und Kartons anlegen, um den eigentlichen Werkvertrag, den so genannten Akkord, der die Verbindlichkeiten zwischen dem Unternehmer und dem Auftraggeber regelte, zu illustrieren und auf diese Art dessen Erwartungen gerecht zu werden. Dem Glasmaler brachte das Schriftstück die Absicherung auf termingerechte Bezahlung der Kunden. Die zeichnerische Dokumentation als Vorarbeit zur eigentlichen Glasmalerei hat eine lange Tradition. Bereits im Mittelalter war es üblich, in einer ersten flüchtigen Skizze die Wünsche des Auftraggebers festzuhalten. Diesem wurde eine Vorzeichnung zur

Billigung vorgelegt und erst nach deren Genehmigung eine maßstabgetreue Reinzeichnung angefertigt[457]. Grundsätzlich kann die Kundschaft Johann Jakob Röttingers aus finanzieller Sichtweise zwei Kategorien zugeordnet werden. Einerseits waren es Auftraggeber für repräsentative Stadtkirchen, die den Anspruch eines Gesamtkunstwerkes erhoben[458], andererseits gab es finanziell schlecht gestellte Pfarreien und Klostergemeinschaften, bei denen der Wille zur Machbarkeit trotz des kleinen Budgets im Vordergrund stand. Folgendes Beispiel aus Schlieren zeigt die Einflussnahme der Kirchgemeinde, vertreten durch den Kirchgemeinderat, der durch einzelne Mitglieder unter Druck geraten konnte: *«Da diese Ausgabe [für das gemalte Chorfenster] nicht eine absolut nothwendige war und dieselbe von unverständigen oder Kunstfeindlichen Bürgern, wenn sie ganz in*

457 SCHOLZ, 1991, S. 1–15.
458 Vgl. Kap. ‹Ornamentik›; Vgl. VAASSEN, 2013, S. 93, 94 : Kap. ‹Ludwigs Eingreifen in Gestaltung und Themenwahl›.

Rechnung erscheine beanstandet oder getadelt werden könnte, obschon sich bisher noch keine Stimme gegen dieses Gemälde vernehmen liess, so wird doch auf Antrag des Pfarrers beschlossen, freiwillige Beiträge zu sammeln [...]»[459]. Im Kopierbuch, das ausschließlich die Korrespondenzen der letzten beiden Schaffensjahre des Glasmalers beinhaltet, lassen sich verschiedene Hinweise auf Wünsche wie auch Beschwerden der Auftraggeber finden. Aus einem Brief an Pfarrer Herzog in Jettingen geht hervor, dass «6 Stück der zur Ansicht gestellten Monogramme theils nicht brauchbar waren, theils nicht befriedigend»[460] ausfielen. Der Glasmaler bekundete im Antwortschreiben sein Verständnis für diese Kritik und war zufrieden, dass die sechs anderen Werkstücke den Wünschen des Auftraggebers entsprochen hatten, zudem der Auftraggeber seine Wünsche nicht klar definiert hatte. Überdies galt es im Rahmen dieses Auftrags die Namen der Stifter in die einzelnen Scheiben zu integrieren. Ebenfalls verbesserungswürdig waren offenbar die bereits hergestellten christlichen «Monogramme» für die Kirche von Gündelhart TG. Pfarrer Erni arrangierte sich jedoch, indem er Rundscheiben übernahm, die Röttinger für die Nachbargemeinde Herdern geliefert hatte. Weil sie dort nicht exakt zu passen schienen, konnte sie Pfarrer Erni zum «billigsten Preis» erwerben[461]. In Waldkirch SG befürchtete man, dass die Fenster «zu bunt» ausfallen würden, worauf der Glasmaler den Auftraggeber beruhigte und darauf hinwies, dass Farben auf Papier anders wirkten als am fertigen Fenster[462]. Sehr häufig gaben Kunden Wünsche bezüglich der Ikonographie bekannt. Entweder, wie in Zeiningen AG: ganz allgemein «[...] zwei Monogramme, und zwar in rein kath.[olischer] Ausführung»[463]. Im andern Fall sehr konkret wie in Oberbüren, wo Pfarrer Germann sich für die Altarfenster Petrus und Paulus je als Ganzfigur wünschte und in den Bogenausmündungen das Herz Jesu und das der Maria[464]. Johann Jakob Röttinger riet dem Pfarrer wegen der bestehenden zentrierten Eisenstange pro Fenster zwei Figuren einzuplanen oder die Windeisen zu versetzen. Pfarrer Oehen aus Geis LU bestellte die beiden Figuren «Jesus und Maria mit den heiligen Herzen»

unter vertretbarster Rücksichtnahme auf die Lichtverhältnisse, das heißt der Altar sollte möglichst gut beleuchtet werden[465]. Ebenso ging es in der Schulkapelle in Baden um die Kontroverse bezüglich der Helligkeit bei vollständiger Bemalung der Fenster. Röttinger brachte schließlich eine provisorische Verglasung an, bis sich die Kommission einigen konnte[466]. In Kirchdorf AG[467], wo explizit Helligkeit der Fenster geordert wurde[468], war wie so häufig die Darstellung der Apostel Petrus und Paulus erwünscht und für die Kirche in der Strafanstalt zu Lenzburg sollten nach einer beiliegenden Skizze die Figuren Christus und Moses[469] zur Ausführung kommen. Nicht immer waren die Wunschvorstellungen der Auftraggeber künstlerisch überzeugend. So empfahl der Glasmaler Pfarrer Herzog in Jettingen auf die gewünschten Engelsköpfchen zu verzichten, da sie «zu klein seien, um sie auch in geringer Entfernung deutlich zu sehen»[470]. Wunschtermine für die Fertigstellung von Kirchenfenstern waren wiederholt Patronatsfeste und Jubiläen, an denen die Gotteshäuser im neuen Licht erstrahlen sollten[471].

459 KGA Schlieren III.B.01.119, Jahresrechnung 1854, Seite 14, Traktandum 3.

460 ZB Nachl. Röttinger 2.371, 3 Jettingen/Herzog 1875.

461 ZB Nachl. Röttinger 2.371, 12 Gündelhart/Erni 1875, 101 Gündelhart/Erni 1876.

462 ZB Nachl. Röttinger 2.371, 100 Waldkirch/Kirchenverwaltungs Rathspräsident 1876.

463 ZB Nachl. Röttinger 2.371, 79 Zeiningen/Jeuch 1876. Zur «katholischen Ausführung» siehe unten.

464 ZB Nachl. Röttinger 2.371, 96 Oberbüren/Germann 1876.

465 ZB Nachl. Röttinger 2.371, 130, 131 Geis LU/Andr. Oehen 1876.

466 ZB Nachl. Röttinger 2.371, 9 Baden/Jeuch 1875.

467 ZB Nachl. Röttinger 1.78.

468 «[...] Bitte Sie, bei der Ausführung doch dafür besorgt zu sein, dass die Fenster nicht zu dunkel machen. Dann wäre die Colorierung zu Licht raubend, so müsste das Glas düster werden, was das Volk durchaus nicht liebt. In der Erwartung, Sie werden die Fenster zu unseres und des Volkes Zufriedenheit ausführen zeichnet mit vollster Hochachtung Schürmann Pfr.» (ZB Nachl. Röttinger 1.78).

469 ZB Nachl. Röttinger 1.82.

470 ZB Nachl. Röttinger 2.371, 202 Jettingen/Herzog 1876.

471 ZB Nachl. Röttinger, 2.371, 6 Mümliswyl/Sury 1876.

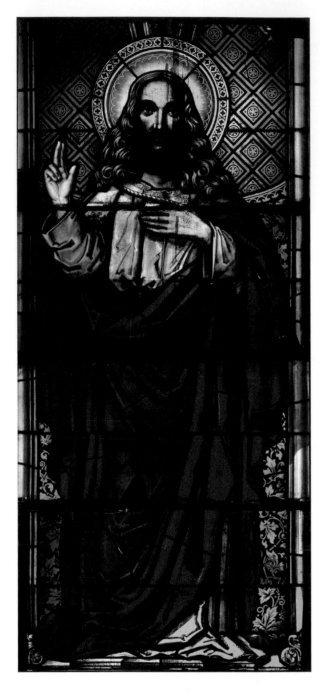

49. Georg K. Kellner (Entwurf)/Johann Jakob Röttinger, «Lehrender Christus», ehemaliges Chorfenster I, Zürich Grossmünster, 1853, Depot Turmkammer, (Montage mit 4 Fotos).

zu liefern und formulierte seine schriftlichen Angebote möglichst modular[472], so dass der Auftraggeber durch kleine Aufzahlungen die Möglichkeit hatte eine reicher verzierte Glasmalerei zu erhalten. Manchmal half der Glasmaler der künstlerischen Ausführung etwas nach und setzte, wie aus Oberbüren überliefert, nach eigenem Ermessen Damastscheiben ein, die er bei Missfallen an einem anderen Ort wieder verwenden konnte[473]. Der Konkurrenzkampf zwischen Künstlern beziehungsweise Kunsthandwerkern im Bereich der Kirchenausstattung war groß, dass das billigste Angebot den Vorzug erhielt, sofern nicht persönliche Beziehungen zum Auftraggeber, Netzwerke beziehungsweise Empfehlungen zufriedener Kunden bestanden hatten[474]. Hohes künstlerisches Niveau forderten hingegen die betuchteren Pfarrgemeinden, wo von Seiten der Baukommission und vom Architekten eine Gesamtlösung angestrebt wurde. «*Arbeiten, die nicht nach Muster von [...] ausgeführt sein sollten, hat der Übernehmer ohne Widerrede wegzunehmen und durch vorschriftsgemäße Arbeit zu ersetzen*», heißt es in einem Vertrag mit der «Direktion der öffentlichen Arbeiten des Kantons Zürich» bezüglich des Auftrags für die Nordfenster

472 ZB Nachl. Röttinger, 2.371, 104: «*Zürich, den 27. Febr. 1876. Herrn Ant. Glutz in Olten. Die Fenster in Ihrer Kirche habe in Arbeit genommen, finde aber für gut doch noch einmal Anfrage zu stellen, ob es nicht erlaubt wäre oben in der gotischen Spitze eine neue, wenn auch ... Verzierung anbringen zu dürfen. [...] ohne auch wie eine geringe Ausschmückung wirklich zu ärmlich aus. Ich würde mich verpflichten diesen Übelstand zu beseitigen und Ihnen in diesem Falle offerieren ein Fenster und um die geringe Zulage von 15 Franken (per 1 Fenster) dieses ausführen. Sie dürfen versichert sein, dass ich dieses Anbieten nicht des Gewinnes halber stelle, sondern weil mir um die Sache zu tun ist. Glaube auch, dass dieser geringe Betrag, welchen die Fenster mehr kosten, leicht zu verantworten wäre, besonders da er der ganzen Kirche ein freundliches Aussehen verleihen und den ... Charakter des Ganzen beseitigen würde. Ich werde, bevor ich die oberen Teile ausführe erst noch Ihrer gflg. [gefälligen] Mitteilung entgegen sehen, hoffe aber, dass Sie dieses geringe Opfer nicht abhalten wird, die Kirche auch in diesem Punkte zu würdigen. Hochachtungsvoll grüßt Sie Ihr ergebener J.R. Glasmaler.*»

473 ZB Nachl. Röttinger 2.371, 22 Oberbüren/Kirchenverwaltung Oberbüren 1875, Begründung des Glasmalers: «*weil die Kirche im Chor so hell wie eine Laterne [...]*».

474 ANDERES, 1985, S. 7.

Häufig ging es jedoch, wie oben erwähnt, um die Finanzen, das heißt, die Glasmalereien mussten so günstig wie möglich und trotzdem wunschgemäß gestaltet werden. Johann Jakob Röttinger war also in vielen Fällen gezwungen, zum billigsten Preis

und dem großen Emporenfenster im Grossmüns-ter[475]. Und im Akkord für die Anfertigung der Chorfenster wird neben der Erwähnung des ge-wünschten Themas, *«in die beiden Seitenfenster die Figuren der Apostel Petrus und Paulus unter paßender architektonischer Umgebung [...]»* – im mittleren Fens-ter wurde die Darstellung des *«Lehrenden Chris-tus»* verlangt (Abb. 49) – gleich bekanntgegeben, was bei Unzufriedenheit zu geschehen hatte: *«sollten hiebei einzelne Theile dem Ausschuße nicht gelungen erscheinen so verpflichtet sich Herr Röttinger solche umzu-arbeiten, oder aber auf Verlangen des Vereines durch Herrn Kellner in Nürnberg anfertigen zu laßen»*[476]. Für den Auftrag im Basler Münster hatte sich Röttinger gar einem Wettbewerb zu stellen, an dem sich namhafte Glasmaler der Zeit beteiligten[477].

«...gemäß den Regeln und Gesetzen der Ästhetik und der christlichen Kunst [...]»

Die Baukommission der katholischen Kirche zu Alt Sankt Johann SG, der ehemaligen Klosterkir-che im Toggenburg, forderte, dass die *«Ausführung der Bilder [Glasmalereien] als Gemälde behandelt werden in künstlerischer und auch technischer Beziehung allen ge-machten Anforderungen entsprechen [...]»*[478]. Für die Kirche in Wollerau SZ wurde eine Ausführung *«gemäß den Regeln und Gesetzen der Ästhetik und der christlichen Kunst»* verlangt[479] und in Oberentfelden AG musste sich der Glasmaler für eine Arbeit nach vorgelegtem Plan und den Regeln der Kunst ver-pflichten[480]. Gabriele Wimböck untersuchte an-lässlich ihrer Forschungen über den Barockmaler Guido Reni die Forderungen an den christlichen Künstler beziehungsweise an die Bildinhalte reli-giöser Darstellungen[481]. Am Konzil von Trient (1545–1563), hauptsächlich als Reaktion der ka-tholischen Kirche auf die Reformation zu werten, wurde die klerikale Überwachung der Bildinhalte beschlossen, um die *lascivia* zu vermeiden mit dem Ziel, Apokryphes und somit «Unrichtiges» aus den Kirchen zu verbannen. Forderungen an den christ-lichen Künstler bezüglich seines Lebensstils und seiner moralischen Grundhaltung, weil sich die Charaktere der Maler in ihren Gemälden wider-

spiegeln würden, sind aus der Antike übernommen worden und erscheinen bereits bei Plutarch, Seneca und Quintilian[482]. Yves-Jean Riou verweist in seinen Forschungen zur Ikonologie der Glasma-lereien in Frankreich auf Unterschiede in den Programmanforderungen, indem er die ungleich-mäßige Verteilung des gelehrten Wissens sowie die Einflussnahme der Theologen dafür verantwort-lich macht[483]. Was unter den «Regeln der christ-lichen Kunst» zu verstehen war, soll anhand einer Untersuchung über die theologische Relevanz der Bildkunst erläutert werden[484]. Im 19. Jahrhundert sind die unsterblich-geistigen Werte der christ-

475 ZB Nachl. Röttinger 1.198.

476 wie Anm. 475.

477 StABS 319 I D1: Nachlass von Christoph Riggenbach. Protokoll der Kommission zu den Kirchenfenstern des Münsters 1855–1858. S. 3: 18. August 1855: *«7. Fensterver-zierung in den Seitenschiffen und von den zwei Langhaus[...] wurde Hr. Röttinger in Zürich übertragen. 8. Die 6 Rosen im oberen Umgange wurden Herrn Mieg (Adolf Mieg, 1812–1857) übertragen [...]. 9. Hr. Architekt Riggenbach übernimmt es mit den Hr. Röttinger und Mieg sich in Rapport zu versetzen und den Beiden Pläne [...]. [...] 11. Hinsichtlich der beiden großen Rosen in der St. Gallus- und St. Stephanskapelle wurde einstweilen noch nichts festgesetzt. Sollte aber das Geld zureichen, so wird es hier ebenfalls in Arbeit genommen werden. Es wird in diesem Falle be-rathen werden, ob (die Arbeit) Herrn Röttinger übertragen werden soll oder einem anderen Glasmaler.»* Vgl. dazu die Ausführun-gen in NAGEL/VON RODA, 1998, S. 44–59.

478 ZB Nachl. Röttinger 1.4; ZB Nachl. Röttinger 1.202, 123.

479 ZB Nachl. Röttinger 1.191.

480 ZB Nachl. Röttinger 1. 122. Vgl. Titelbild und Abb. 45.

481 WIMBÖCK, 2002, S. 21 ff.

482 WIMBÖCK, 2002, zitiert Raupp, 1984, S. 263 (Raupp, Hans-Joachim, Untersuchungen zu Künstlerbildnis und Künst-lerdarstellungen in den Niederlanden im 17. Jahrhundert (Diss. Bonn 1979), Hildesheim u.a. 1984). SMITMANS, 1980, S. 19, Anm. 9. Smitmans zitiert B. Eckls Beitrag im «Organ der christlichen Kunst»: B. Eckl, Über die beiden Haupt-arten der christlichen Kunst: Sculptur und Malerei. b. Die kirchliche Malerei, OCK 23 (73), S. 185 f.: Die Beschlüsse der 25. Sitzung des Trienter Konzils bildeten für die ka-tholischen Autoren des 19. Jahrhunderts die wichtigste lehramtliche Äußerung zur christlichen Kunst. Smitmans Untersuchung beginnt bei einschlägigen Texten der Siebzigerjahre; zahlreiche Literaturangaben u.a. auf S. 17, Anm. 1.

483 RIOU, 1986, S. 41.

484 ROMBOLD, 2004, S. 39 ff.

lichen Kunst mit der sinnlich-schönen Natur der Antike konfrontiert worden. Diese Dialektik ist nach Günter Rombold unter der Einwirkung der Ästhetik Hegels – und dessen «Philosophie der schönen Kunst» – entstanden, was dazu führte, dass das «Christliche» in die Ikonographie und somit in das «nur Bildhafte» abgedrängt wurde. Wolfgang Kemp, auf dessen Thesen er sich stützt, verfolgte einen neuen Forschungsansatz und gewahrte in der christlichen Kunst einerseits Gesetze, die die Kombination und die Positionierung der einzelnen Elemente regeln, andererseits eine Ordnung des Verhaltens der Elemente untereinander erkennen lassen. Das Wesen der christlichen Kunst läge demnach in der Komposition bestimmter Elemente auf eine definierte Art und Weise[485]. Diese Haltung war konfessionell geprägt und konnte sich auf ganze Stilrichtungen ausweiten; so wurde zu einem späteren Zeitpunkt von einem Teil der Institution Kirche versucht, die Neogotik beziehungsweise Neoromanik zu favorisieren, wenn nicht zu monopolisieren, um Kirchen im Jugendstil beziehungsweise im Stil der Moderne abzuwenden[486]. Im «Organ für christliche Kunst» von 1863 wird zwar der Glasmalerei die enge Verbindung mit der Architektur zugestanden, inhaltlich jedoch stehe sie mit Lehre, Dogma, Liturgie und Leben der Kirche so eng verbunden, dass diesbezüglich die volle Übereinstimmung gefordert werden müsse[487]. Mit den oben genannten «Regeln der christlichen Kunst» war demnach der katholische Kanon gemeint, den es unbedingt einzuhalten galt. Die Pfarreien sicherten sich auf diese Weise beim Glasmaler ab, dass dieser, der für beide Konfessionen Glasmalereien herstellte, die im 19. Jahrhundert üblichen Grundsätze der katholischen Kirche in Bezug auf die Ikonographie kannte und auch anwendete. Zur Einhaltung der definierten Regeln waren Handbücher verfügbar, die meist von kunstsinnigen Theologen verfasst, Auftraggebern wie Künstlern als Nachschlagewerke dienten. Die Publikation von Carl Atz aus dem Jahr 1876, «Die christliche Kunst in Wort und Bild. Geschichtlich und vorzugsweise praktisch dargestellt nach den Vorschriften der Kirche und den

allgemein giltigen Regeln der Gegenwart», dokumentiert beispielhaft mit lexikalischem Aufbau nicht nur die Methodik der Forschungsgeschichte des 19. Jahrhunderts, sondern versucht die darin bevorzugten Kriterien der Vergangenheit mit der Gegenwart zu vereinen, ohne den Vorschriften der Kirche und den Regeln der Kunst entgegenzuhandeln[488]. Für die Glasmalerei fordert der Autor, dass sowohl die Figuren wie auch die Teppichmuster jeglicher Plastizität entbehren sollen, dies galt auch für die gemalten Architekturen, die nur der Dekoration zu dienen hatten und keine Perspektive zeigen durften[489]. Die Bedeutung der ikonographischen wie auch der künstlerischen Ausführung lässt sich am Beispiel der Kirche Sankt Oswald in Zug konstatieren, als der Stadtrat von Zug in einem zusätzlichen Vertrag bestimmte, dass der Glasmaler Johann Röttinger die drei Glasgemälde im

485 Rombold, 2004, S. 40; Atz, 1915, S. 7, Stichw. *Ästhetik*: «Kant, Hegel, Schelling, von Hartmann und andere stellten über die Schönheit idealistische Grundsätze auf, welche für die christliche Kunst unbrauchbar sind».

486 Gerhards, 2004, S. 106.

487 Christlicher Kunstverein für Deutschland, 1863, Bd. 5, S. 52 ff.: Bereits im Bd. 3 des Organs wird auf S. 29 darauf hingewiesen, dass das innerste Wesen der christlichen Kunst darin bestehe, dass in ihr bei aller Freiheit des schöpferischen Geistes, alles auf bestimmten Gesetzen beruhe und auf *ein* Ziel ausgerichtet sei; Heinig, 2004, S. 51, Zitat: «Die Flexibilität und Modernität des kirchlichen Reglements zeigte sich indessen darin, dass den kurialen Dogmen, z. B. zur «Unbefleckten Empfängnis Mariens» und zum Herz-Jesu-Kult, stets auch aktuelle Gestaltungsvorschriften für die Malerei erfolgten.» Vgl. dort Kap. ‹Kunst nach Vorschrift? – Katholische Anliegen zum Kultbild›, S. 224.

488 Atz, 1876. Einleitung.

489 Atz, 1876, S. 86; Der Autor hebt die musivische Glasmalerei hervor, die aus vielen kleinen Glasstücken besteht, die durch Bleilinien kräftig abgegrenzt sind. Atz, 1915, S. 263–269: Im Nachfolgewerk wird unter Neubearbeitung von Stephan Beissel der Glasmalerei bereits mehr Platz eingeräumt. Darin wird unter anderem gefordert, dass die Figuren nicht zu klein gehalten werden, da sie das Kirchenvolk unterrichten und erbauen sollen. Ferner sind Abwechslung und Gehalt erwünscht, Zyklen wie Kreuzweg oder Rosenkranzgeheimnisse sowie Ähnlichkeiten von mit Schablonen hergestellten Figuren sind zu vermeiden, da die Fenster sonst langweilig wirken.

Chor, «*nach den von der Düsseldorfer Kunstschule gefertigten Farbenskizzen*» auszuführen habe[490]. Die Düsseldorfer Spätnazarener bürgten hinsichtlich der geforderten Kriterien für höchste Qualität – waren doch die Fresken der Sankt Apollinariskirche in Remagen weit über die Grenzen hinaus bekannt[491]. Unterschiedliche Ausprägungen in der Formulierung lassen sich durch Vergleiche mit anderen Verträgen, so zum Beispiel für die protestantische Pfarrkirche in Niederhasli ZH erkennen, wo Johann Jakob Röttinger verpflichtet wird die Glasmalereien «*kunstgerecht und solid*» anzufertigen[492]. Die protestantischen Auftraggeber legten überdies Wert auf «*gerechte Anforderungen*» und eine Abgrenzung zum katholischen Darstellungsmodus, was ebenfalls einem Regulativ gleichkam. Auf evangelischer Seite fokussierte sich das Problem der christlichen Kunst sehr stark auf die Darstellungen Christi, haben sich die Protestanten doch mit der Leben-Jesu-Forschung um die Christus-Vorstellung verdient gemacht[493]. Die Aktualität der Debatte um den Kanon der christlichen Kunst zeigt der im Sommer 2007 gerade noch abgewendete «Kölner Domfensterstreit» zwischen Kardinal Joachim Meisner und dem Kunsthistoriker Werner Spies. Dabei ging es um einen Artikel Meisners über Gerhard Richters Domfenster in der *Frankfurter Allgemeinen Zeitung*, der von Werner Spies als Affront gegen «Richters Lebenswerk», als Vorbehalt gegenüber der Freiheit des Künstlers, ja sogar als Boykott der Moderne interpretiert wurde[494]. Meisners Kritik richtete sich allerdings nicht gegen das Kunstwerk an sich, sondern er bezweifelte dessen Tauglichkeit als Gestaltungselement in einem christlichen Kirchenraum: «Wenn wir schon ein neues Fenster bekommen, dann soll es auch deutlich unseren Glauben widerspiegeln und nicht irgendeinen»[495]. Der kleine Exkurs in die Gegenwartskunst markiert die anhaltende Gültigkeit der «Regeln christlicher Kunst» innerhalb der Katholischen Kirche, deren Vertreter sich gegen die Profanierung von Kirchenkunst aussprechen. Die zeitgenössische Kritik im 19. Jahrhundert fiel noch harscher aus, wenn das «Organ für christliche Kunst» in einem Artikel über die «Stellung der Kirche zur christlichen Kunst und Kunst-Industrie» Glasmaler Heinrich Oidtmann vorwirft, dass er mit seiner marktschreierischen Art versuche das Gebiet der Kirche zu gewinnen und auszubeuten. Hierbei standen freilich auch technische und qualitative Belange zur Diskussion[496] – die von den Auftraggebern beider Konfessionen geforderte Solidität kunstgerechter Arbeit.

Der wissenschaftliche Ästhetik-Begriff wurde erst im 18. Jahrhundert vom deutschen Philosophen A. G. Baumgarten in der Schrift *Aesthetica* (1750–58) geprägt; davor zielten von Praktikern aufgestellte Regeln – der Symmetrie, der Reihung, des Rhythmus und der Dynamik – direkt auf die Praxis ab[497]. Es ist anzunehmen, dass sich weder Röttinger noch seine Auftraggeber im täglichen Geschäftsgebahren mehrheitlich von neuen philosophischen Strömungen leiten ließen, daher sei auch auf diesem Gebiet ein anwendungsorientiertes Handbuch genannt, dass möglicherweise im 19. Jahrhundert an den Akademien als Lehrmittel eingesetzt und wohl auch in der Gesellschaft als

490 BA Zug: A39 Nr. 26, 75, S. 206, Ratsprotokolle, Nr. 233, Stadtrat 14. April 1866.

491 Vgl. Kap. ‹Johann Jakob Röttinger zwischen den Stilen›.

492 ZB Nachl. Röttinger 1.115: Vertrag von 1854: «*1. In das mittlere Kirchenfenster soll das Bild: Christus als Lehrer darstellend angebracht werden, mit passenden ornamentalen Verzierungen umgeben, in der Größe von 6 Fuß Höhe und drei Fuß Breite. 2. In den beiden Seitenfenstern soll in das Eine die Gesetzzahl des Alten Testaments, in das Andere im offenen Evangelienbuch in passender, ornamentaler Einfassung angebracht werden. 3. Obige Arbeit soll in jeder Beziehung kunstgerecht und solid ausgeführt werden und allen gerechten Anforderungen entsprechen. [...]*»

493 SMITMANS, 1980, S. 101; SMITMANS, 1980, S. 17. Der Autor konstatiert in seiner Untersuchung der Periodika für christliche Kunst 1870–1914 in den Siebzigerjahren eine Reihe kritischer Texte von Seiten der Katholiken, eine explizit evangelische Ästhetik vermochte er nicht auszumachen; Vgl. Kap. ‹Der «Lehrende Christus»›.

494 ULLRICH, 2011, S. 15 ff.

495 ULLRICH, 2011, S. 17, zitiert nach: Andreas Rossmann, Richters Domfenster. Altbackene Vorurteile eines Kardinals, in: Frankfurter Allgemeine Zeitung, 31. August 2007.

496 ORGAN FÜR CHRISTLICHE KUNST, 1863, S. 141/142. Vgl. Kap. ‹Produktion›.

497 LDK 1, 1987, S. 300, Stichw. *Ästhetik*.

«Proportionslehre» bekannt geworden ist[498]. Demnach sei Schönheit dann gegeben, wenn an einem Gegenstand unter seinen Teilen Abwechslung, Proportion, Ebenmaß und Ordnung anzutreffen ist. Nicht nur die Darstellung der Personen, sondern auch der Einsatz der Farben trägt zur Schönheit bei, die in geistlicher, leiblicher, natürlicher und künstlicher Hinsicht bestehen müsse. Das «griechische Ideal» verkörpere die genannten Eigenschaften und als Prototyp nennt Georg H. Werner die *Laokoon-Gruppe* als Skulptur nach «den vollkommenen Regeln der Kunst»[499]. Da sich die christliche Kunst nicht an der heidnisch antiken Kunst orientierte[500] und diese nicht zuletzt wegen der Nacktheit der dargestellten Personen und der körperbetonten Kleidung ablehnte, besteht zweifellos ein Widerspruch innerhalb der Forderung *«…gemäß den Regeln und Gesetzen der Ästhetik und der christlichen Kunst […]»*. Obwohl die antike Kunst «die vollkommenste Menschengestalt in möglichst vollkommener Formschönheit» hervorbrachte, ruhen auf ihr die Schatten des Todes, wogegen die christliche Kunst trotz der Mängel der mittelalterlichen Form das Gemüt erhebt, weil sie von einer Aura der göttlichen Liebe und Gnade umgeben ist[501]. Die christliche Ästhetik lässt das Geistige im Äußern erscheinen; es zeigt das himmlisch Schöne, das das Geistesleben im Leibe widerspiegelt[502].

Es war wohl keine leichte Aufgabe für die Glasmaler sich situativ den polarisierenden Anforderungen der Auftraggeber anzupassen. Sei es für einen möglichst niedrigen Preis die Besteller zufriedenzustellen oder den hohen künstlerischen Ansprüchen der Baukommissionen der großen Stadtkirchen gerecht zu werden, um die gegensätzlichen Mandate im Hinblick auf den konfessionellen Kanon, nach den Gesetzmäßigkeiten der christlichen Kunst beziehungsweise unter Beachtung *«gerechter Anforderungen»*, auszuführen. So attestiert Werner Hofmann den angewandten Künsten im 19. Jahrhundert eine Spaltung, die «das Nützliche vom Kunstvollen trennt»[503]. Dass dabei analog zu den Preisen auch die qualitativen Dis-

positionen Unterschiede aufweisen, muss wohl entsprechend den Gepflogenheiten des Geschäftslebens als angemessen erachtet werden.

Ikonographie

Die Auflösung hierarchischer Gefüge, die Hinterfragung von Dogmen und die Zerrüttung hergebrachter Ordnungen, die vormals Glauben und Gesellschaft strukturierten, penetrierten das Wertesystem des 19. Jahrhunderts[504] und nährten Thesen, die das Fortbestehen der Ikonographie um 1800 sogar in Frage stellten[505]. Die Aufgabe der Ikonographie ist es – für die Kunst als wichtige Trägerin unseres kollektiven Gedächtnisses – für deren Verständnis und die Aufrechterhaltung der Erinnerung zu sorgen[506]. Bruchlinien zwischen Religion und Geschichte führten zu einer neuen Definition der christlichen Ikonographie, worauf eine Anpassung in der Kombination der Bildtypen folgte[507]. Die Neubewertung der Darstellung von Einzelfiguren wurde in diesem Zusammenhang bereits erörtert und wird anhand einzelner Beispiele wieder aufgegriffen. Analog zur Architektur hat sich auch die Malerei im 19. Jahrhundert der historischen Rezeptur bedient,

498 WERNER, Georg Heinrich, Nöthige Anweisung in der Zeichenkunst, wie die Theile des Menschen durch Geometrische Regeln und nach dem vollkommenen Ebenmaß ganz leicht zu Zeichnen zusammen zusetzen um die schön Gestalt eines Gantzen vorzustellen, Erfurt, 1768.

499 WERNER, 1768, Einleitung. Im zweiten Teil des Büchleins werden die verschiedenen Gesetze der Proportionslehre erläutert.

500 SMITMANS, 1980, S. 20; Smitmans über Eckls Beitrag zur Abgrenzung der christlichen Kunst gegenüber der antiken Kunst. Vgl. Anm. 482; vgl. auch SMITMANS, 1980, S. 26–28 *(Horror nudi)*.

501 SMITMANS, 1980, S. 18; Smitmans zitiert J. DIPPEL, Unterschied der christlichen von der antiken Kunst, OCK 21 (71), 260–262. (OCK Organ für Christliche Kunst)

502 wie Anm. 500.

503 HOFMANN, 1991, S. 258.

504 HOFMANN, 1991, S. 254.

505 BÜTTNER/GOTTDANG, 2006, 2009, S. 273.

506 BÜTTNER/GOTTDANG, 2006, 2009, S. 275.

507 TELESKO, 1996, S. 282–288.

wo oft in unschöpferischer Weise aus Vorhandenem ausgewählt oder paraphrasiert wird[508]. Klarerweise treten auch Innovationen ergänzend zutage. Die Forschung bescheinigt vor allem dem historistischen kirchlichen Kunstgewerbe Mischformen, die in der Glasmalerei ebenfalls evident werden[509]. Das Nachahmende führte zu einer gewissen Formelhaftigkeit, die nicht nur den Stil, sondern auch ikonographische Elemente tangiert. Davon betroffen sind vor allem die «christlichen Symbole», aber auch immer wiederkehrende Darstellungen Christi, der Evangelisten, Propheten und Heiligen, ob als Ganzfiguren oder auf Medaillons, die die Eigenart der Ikonographie jener Zeit erkennen lassen. Für die Besprechung der Bildinhalte liegt eine Auswahl an Beispielen vor, die Charakteristika im Werk herausgreift. Schwerpunkte sind die typischen Motive und ihre Darstellungsweisen, die nicht nur für Johann Jakob Röttinger, sondern allgemein für das 19. Jahrhundert verbindlich waren und den Kanon der epochentypischen Bilderwelt erkennen lassen. Daher wurde auf die Beschreibung und Herleitung von Szenen, die sich in Röttingers Werk vergleichsweise nur noch selten erhalten haben, wie die Geburt und Taufe Christi, Kreuzigung und Auferstehung, der englische Gruß etc. verzichtet. Die Tradierung von Ornamenten und deren Einsatz als schmückende Elemente passen sich dem jeweiligen Stil an und ergänzen auf diese Art die gezeigten Motive. Als Damastfenster behaupten sie ihre lange Tradition als symbolische Abgrenzung für die sakrale geistige Welt zur Außenwelt[510].

Auf der bereits zitierten Visitenkarte empfiehlt sich der Glasmaler *«für gebrannte Glasmalereien in jeder Manier hauptsächlich Kirchenfenster mit historischen Bildern, wie auch mit ornamentalen Verzierungen in jedem Styl [...]»*[511]. Die Herstellung von Kirchenfenstern für Auftraggeber beider Konfessionen muss als Hauptgeschäft der Werkstatt Röttinger bezeichnet werden. Dementsprechend liegt der ikonographische Schwerpunkt auf sakralen Bildmotiven beziehungsweise auf der glasmalerischen Ausstattung von Kirchen. Im folgenden Teilkapitel wird auf die Umsetzung der traditionellen ornamentalen

Formen im Historismus eingegangen, am Beispiel von Johann Jakob Röttingers bevorzugten Zierelementen.

Ornamentik

Als nicht selbstständiges Schmuckwerk erfordert das Ornament, ob als Bauornament oder im Kunstgewerbe, einen Träger. Ursprünglich in der Funktion des elementaren Schmucks beziehungsweise als Apotropaion unterstützt oder steigert es die ästhetische Wirkung des jeweiligen Trägerobjekts oder setzt verschiedene Zonen voneinander ab[512]. Als Hauptgruppen werden geometrische und vegetabile Formen unterschieden, wobei sich Sonderformen wie Flechtband, Ohrmuschelstil oder Rollwerk entwickelt haben[513]. Häufig kommt es zur Verknüpfung der beiden Grundarten – in der Glasmalerei sind es die so genannten Teppichmuster, denen beispielsweise Rauten, Kreise oder Dreiecke gefüllt mit Blattmotiven zugrunde liegen. Aus der Romanik haben sich unter anderem verschiedene Rankenformen, der Rundbogenfries und das aus der Antike überkommene Flechtband tradiert; die Gotik brachte die Entwicklung des Maßwerkes mit mehrheitlich geometrischen Grundzügen. Pflanzenornamente, die den Akanthus der Romanik durch einheimische Gewächse wie Weinrebe, Efeu oder Eiche ersetzten, bildeten im 13. Jahrhundert einen naturalistischen Gegenpol – Motive, die in der Glasmalerei stark vertreten sind[514].

508 HOFMANN, 1991, S. 258.
509 TELESKO, 1996, wie Anm. 507, hier S. 282, 283.
510 KOZINA, 2011, S. 33, vgl. Anm. 584, 542.
511 ZB Nachl. Röttinger 1.173.
512 WETTSTEIN, 1996, S. 16 f.
513 LDK 5, 1993, S. 311 ff., Stichw. *Ornament*.
514 SIMADER, 2005, S. 148: Im Reiner Musterbuch (Wien, Österreichische Nationalbibliothek, Cod. Vindob. 507, aus dem Zisterzienserstift Rein bei Graz, 1. Hälfte 13. Jahrhundert, wahrscheinlich 1208–1213) werden neben Szenen und Figuren Rankeninitialen dargestellt, die vorwiegend palmettenartige, schraffierte und geäderte Blätter mit kleinteilig gebogten Blattlappen besitzen. Zu Musterbüchern im 19. Jahrhundert vgl. WETTSTEIN, 1996, S. 73–88.

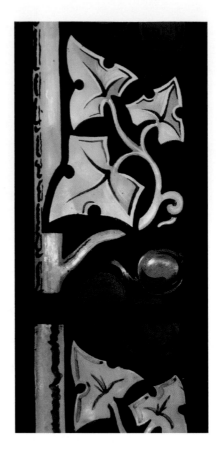

50. Johann Jakob Röttinger, Rankenornament, Emporenfenster S II, Evangelisch-Reformierte Kirche Sankt Laurenzen, Sankt Gallen, 1853.

51. Johann Jakob Röttinger, Rankenornament, Emporenfenster N VII, Evangelisch-Reformierte Kirche Sankt Laurenzen, Sankt Gallen, 1853.

Die italienische Renaissance griff schließlich wieder auf antike Formen zurück, deren Weiterentwicklungen bis ins 19. Jahrhundert vorherrschten. Der Historismus brachte eine Vielfalt aus allen Stilepochen hervor; neu aufgelegte Mustersammlungen schufen Ordnung im großen Spektrum und machten durch ihre Reproduzierbarkeit aus der Kirchenarchäologie[515] gezogene Schlüsse evident. So finden sich auch im Nachlass der Röttinger Vorlagenbücher; aus der Zeit des Werkstattgründers hat sich eine Ausgabe des bekannten Werks von Carl Heideloff «Ornamentik im Mittelalter» erhalten[516].

In den Kirchen des 19. Jahrhunderts waren nicht ausschließlich die Fenster Träger der Ornamentik. Die Ornament- und Damastscheiben ergänzten vielmehr die damals übliche ornamentale Kirchenausmalung, um die gewünschte Stimmung in den

sakralen Raum zu bringen. Der österreichische Kunsthistoriker Alois Riegl (1858–1905) zollte dem Ornament, entgegen der Kunsttheorie Gottfried Sempers, der es als künstlerisches Nebenprodukt kategorisierte, eine beinahe metaphysische Bedeutung[517].

515 HEINIG, 2004, S. 272.
516 ZB Nachl. Röttinger 4.5.7: HEIDELOFF, 1844–46.
517 HEINIG, 2004, S. 71 zitiert nach KROLL, 1987, Das Ornament in der Kunsttheorie des 19. Jahrhunderts, S. 62 ff. Semper betätigte sich unter anderem auch in den Porzellanmanufakturen in Sèvres und Meißen als Entwurfszeichner von Prachtvasen. Diese Fähigkeiten wurden ihm von der Forschung noch lange Zeit abgesprochen. Erst um die Jahrtausendwende sind seine diesbezüglichen Talente anerkannt worden. VON ORELLI-MESSERLI, 2010, S. 11 ff. Vgl. zu Ornament und Textilien Kap. ‹Ikonographie der gemalten textilen Bildraumbegrenzung in der Glasmalerei›, Anm. 536.

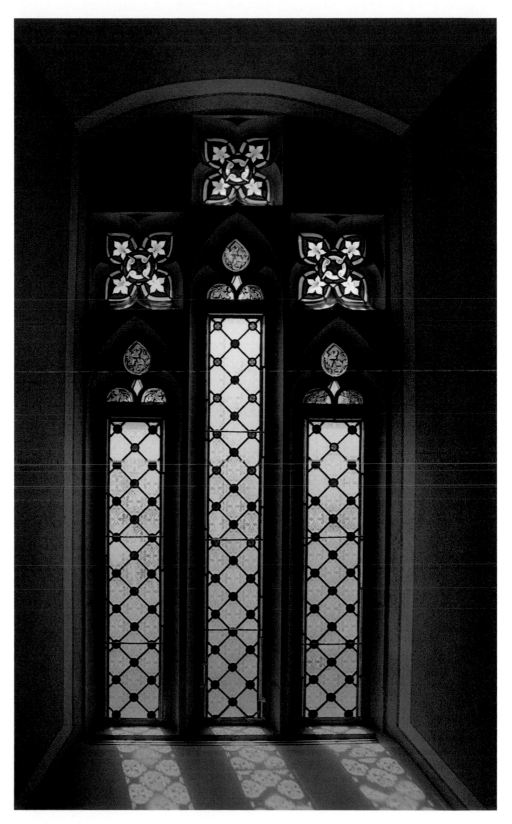

52. Johann Jakob Röttinger, Damastfenster ws II, Evangelisch-Reformierte Kirche Sankt Laurenzen, Sankt Gallen, 1853.

53. Johann Jakob Röttinger, Maßwerkverglasung mit Ornament, Lanzetten umlaufend mit Blüten- und Blattranken, Rautenverglasung, großes Westfenster W I, Evangelisch-Reformierte Kirche Sankt Laurenzen, Sankt Gallen, 1853.

54. Franz Eggert, Gotische Verzierung aus der Lorenzkirche zu Nürnberg, EGGERT, 1865, o.p., Zürich, ETH Bibliothek, Alte und Seltene Drucke.

So muss man sich die Glasmalereien in ihrer ursprünglichen Anschauung häufig als Bestandteile farbiger Architektur vorstellen. Wichtige Vertreter der farbigen Innenraumgestaltung in der Schweiz waren bekannte Architekten, an deren Bauwerken Johann Jakob Röttinger als Glasmaler mitwirkte. Felix Wilhelm Kubly (1802–1872) aus Altstätten SG zum Beispiel, in dessen Entwürfen die Innenraumpolychromie als Bestandteil seiner Architektur zu verstehen war, lehnte sich der spätklassizistischen Tradition an[518]. In den von Kubly ausgeführten Ostschweizer Kirchen in Oberbüren und Quarten war Johann Jakob Röttinger als Glasmaler beauftragt. Es gibt jedoch keine archivalischen Hinweise auf eine direkte Zusammenarbeit. In der reformierten Stadtkirche Sankt Laurenzen in Sankt Gallen bekam der gotisierende Entwurf einer Innenausmalung von Architekt Johann Georg Müller (1822–1849) gegenüber dem Entwurf Kublys den Vorzug; dieser kam jedoch wegen des frühen Todes von Müller nicht zur Ausführung. Johann Jakob Röttinger schuf dort mit Ausnahme des szenischen Teils des Chorfensters alle Fenster der Kirche[519] und gestaltete diese mit verschiedenen Ornamenten – Teppichmustern, Randverzie-

rungen und Maßwerk. Die Fenster in den Seitenschiffen sind dem Auftrag folgend in Rauten gefasster Blankverglasung ausgeführt; Scheibenränder, Nonnenköpfe und das Maßwerk in den Bogenfeldern wurden mit mannigfaltigem Ornamentdekor farbig verziert. Meist kamen vegetabile Elemente, wie Wein- und Efeublätter, Blüten und Früchte in diversen Kompositionen und wechselnden Farben zur Anwendung – kein Fenster gleicht dabei dem anderen (Abb. 50–53). Die beiden kleineren ebenerdigen Westfenster der Kirche sind ganzflächig mit weißem Damastmuster versehen und an den Kreuzungspunkten der Rauten beziehungsweise im Maßwerk farblich akzentuiert. Das große Westfenster zeigt reiches Maßwerk im Bogenfeld (Abb. 52, 53). Franz Xaver Eggert, Münchner Dekorations- und Glasmaler, sammelte im Historismus häufig verwendete «gothische Verzierungen» in einem Musterbuch (Abb. 54, 55), in dem sich unter anderem Ornamente aus Nürnberger Kirchen finden[520].

518 WETTSTEIN, 1996, S. 18 f.
519 ZB Nachl. Röttinger 1.158.
520 EGGERT, 1865, o.p.

Aus dem Münster zu Ulm.

55. Franz Eggert, Gotische Verzierung aus dem Ulmer Münster, EGGERT, 1865, o.p., Zürich, ETH Bibliothek, Alte und Seltene Drucke.

Dass sich Röttinger gerne an solchen Muster-sammlungen orientierte, geht aus den gezeigten Ornamentbändern hervor.

Als weiteres wichtiges Bauwerk ist die paritätische Stadtkirche von Glarus des bekannten Architekten Ferdinand Stadler zu nennen, der unter anderen mit Dekorationsmaler Karl August Jäggli aus Win-terthur[521] und Glasmaler Johann Jakob Röttin-ger[522] die Gestaltung des Kirchenraums durch-führte. Während die Wandmalerei im Chor mit einem dunkel gemalten und vergoldeten Teppich-muster eine Steigerung erhielt, waren die übrigen Wandflächen mit einem feingliedrigen Raster und punktuellen Farbakzenten überzogen[523]. Dem entsprach die Arbeit des Glasmalers, der für die drei Chorfenster die Apostelfiguren Petrus, Johan-nes und Paulus schuf und die Fenster des Quer- und der Seitenschiffe mit Blankverglasung und gemalter ornamentaler Randverzierung ausführte.

Die drei großen Rundfenster[524], auf der Empore und in den Querschiffen, sowie die Lünetten der beiden Eingänge Süd und Nord aus dem Jahr 1865 haben sich bis heute erhalten.

Erstere sind als Maßwerkrosetten (Abb. 56) mit Weinlaub und Ranken sowie mit floralen Ornamen-ten verziert angefertigt, die Türoberlichter zeigen an der Südseite einen Engel (Abb. 57) umgeben von Ornamenten und an der Nordseite das Wappen der Glarner mit dem heiligen Friedolin (Abb. 56) ebenfalls vor einem ornamentierten Hintergrund.

521 WETTSTEIN, 1996, S. 20.
522 ZB Nachl. Röttinger 1.56, LA Glarus, Gemeinderatspro-tokolle XI, 352, 363; DAVATZ, 2000, S. 72.
523 WETTSTEIN, 1996, S. 20 f.
524 Weitere Rosetten, die sich aus der Werkstatt Röttinger erhalten haben, werden im angehängten Kurzkatalog aufgeführt.

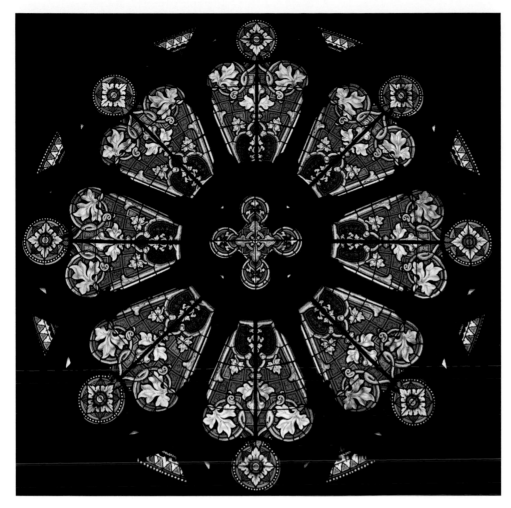

56. Johann Jakob Röttinger, Rosette im nördlichen Querschiff, Evangelisch-Reformierte Stadtkirche Glarus, 1865.

Ähnliche von Ornamenten umgebene Portalengel (Abb. 58) haben sich von Hermann Kellner in Stein bei Nürnberg erhalten[525].

Die Bemerkungen in den Werkverträgen, dass vom Glasmaler nur Ornamente verwendet werden durften, die entweder vom Architekten gezeichnet oder von ihm genehmigt worden sind, zeigen den hohen Anspruch der Bauherrschaft an das Gebäude als Gesamtkunstwerk, das auch in der Innengestaltung den Ambitionen von Baukommission und Architekt entsprechen musste[526].

Acht Kilometer nördlich vom Kantonshauptort Glarus liegt die Gemeinde Mollis GL mit seiner 1761 vom Schweizer Baumeister Hans Ulrich Grubenmann (1709–1783) errichteten Pfarrkirche.

Anlässlich einer neugotischen Umgestaltung der Kirche blieb die Rundbogenform der Fenster zwar unverändert, die Glasmalereien wurden jedoch von Johann Jakob Röttinger neu geschaffen[527].

525 Röttingers Lünettenengel lehnt sich an die beiden Engel Hermann Kellners an, die um 1860–1865 für das Portalfenster in der Grabkapelle von Faber-Castell in Stein bei Nürnberg entstanden sind. Engel in ähnlicher Haltung fanden im 15. Jahrhundert als Wappenengel Verbreitung.
526 ZB Nachl. Röttinger 1.56 unter Punkt 9 des Vertrags: *«Herr Röttinger verspricht, eine in jeder Beziehung vorzügliche und besonders in der Malerei künstlerisch gestaltete Arbeit zu liefern […] der Ausspruch [sic!] des Hrn. Architekt Ferd. Stadler ebenfalls maßgebend.»* Vgl. WETTSTEIN, 1996, S. 20.
527 THÜRER, 1954, S. 226; ZB Nachl. Röttinger 1.99.

115

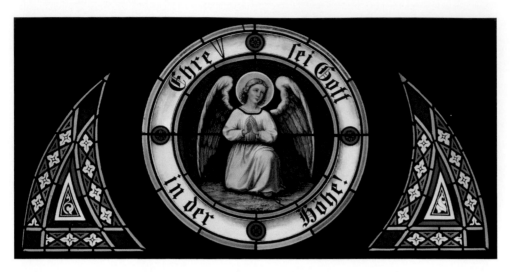

57. Johann Jakob Röttinger, Lünette Südeingang mit Engel, Maßwerk mit Ornament, Evangelisch-Reformierte Stadtkirche Glarus, 1865.

58. Hermann Kellner, Portalfenster mit dem Detail des Engels, Grabkapelle von Faber-Castell, Stein bei Nürnberg, um 1860–1865.

Der Autor des Geschichtsbuchs über die Gemeinde Mollis erwähnt, dass die beiden Ornamentfenster nach Vorbildern im gotischen Dom zu Salisbury (Abb. 60) als Geschenk von Landammann Dietrich Schindler und seinem Bruder Hauptmann Friedrich Schindler angefertigt wurden.
Im Werkvertrag mit Röttinger von 1868 forderte Schindler, dass die beiden Chorfenster nach Muster des links neben der Kanzel befindlichen Fensters in der Abdankungshalle Zürich auszuführen wären[528]. Die beiden Rundbogenfenster der Kirche in Mollis (Abb. 59) zeigen zweibahnig vertikal angeordnete Kreisreihen, die sich mit übereck gestellten Rauten überschneiden. Die in Grisaille gearbeiteten Kreise werden durch einen konzentrischen Ring aus rotem Überfangglas und einem Zentrum aus hellblau gefärbten Gläsern als stilisierte Blüte farblich akzentuiert. Der Rahmen ist in den Farben gelb, rot und blau gehalten und als Aneinanderreihung von Akanthusornamenten gemalt.

528 ZB Nachl. Röttinger 1.99.

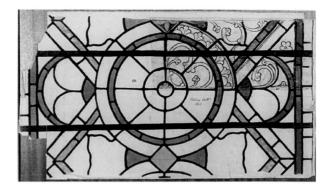

60. Zeichnung Ornamentfeld Salisbury Cathedral, CVMA International, GB Picture Archive (CVMA inv. no. 009955).

Des Weiteren haben sich eine Rosette als Fünfpass mit Ranken- und Blattmotiven sowie die einfachen Schifffenster in Blankverglasung mit schlichter Rahmenverzierung erhalten. Die Anlehnung an das Grundmuster in Salisbury[529] aus dem 13. Jahrhundert ist erkennbar, was jedoch keineswegs für einen Zufall sprechen muss (Abb. 60). Die Entstehung anglikanischer Kleinkirchen in Schweizer Kurorten um 1870 brachte offensichtlich nicht nur die Verbreitung auf Sicht belassener architektonischer Struktur und dekorierte Ausfachung im sakralen Interieur[530], sondern auch einen die Glasmalerei betreffenden Kulturtransfer aus England. Johann Jakob Röttinger zeichnete sich nämlich im Auftrag des Hoteliers Seiler für die Einsetzung von Glasmalereien in die englische Kirche zu Zermatt verantwortlich[531]. Immerhin hatte er dort

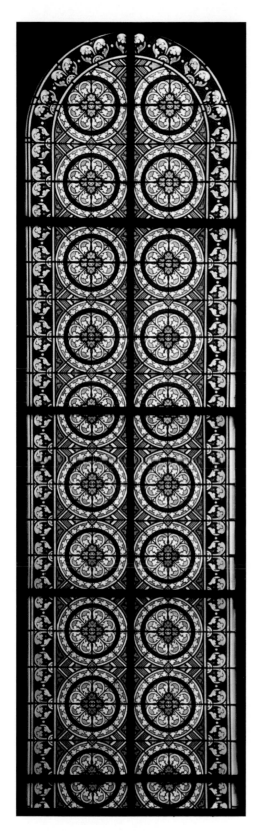

59. Johann Jakob Röttinger, Ornamentfenster, s II, Evangelisch-Reformierte Kirche Mollis GL, 1868.

529 Abb. in: BROWN, 1999, S. 51, Abb. 37, S. 124, Abb. 100; MILLS, 2008 [Vidimus on-line magazine, 23], Fig. 2 und 3.; CVMA International (GB) Picture Archive.

530 WETTSTEIN, 1996, S. 22.

531 ZB Nachl. Röttinger 1.206: Rechnung über Wiederherstellung der gemalten Fenster in der englischen Kapelle in Zermatt, Kanton Wallis für Herrn Alex Seiler, Hotelbesitzer Zermatt von Johann Jakob Röttinger, Glasmaler in Zürich. 1874 April: *«Eine Reise von Glis nach Zermatt, um den Zustand der zerschlagenen Fenster zu ermitteln und wieder retour. Arbeitslohn (Taglohn). Ausgaben 20.– Franken.»* 1875 Juli: *«Eine Reise von Zürich nach Zermatt, um die Fenster in der engl. Kapelle wieder zu ergänzen, im Ganzen 324 St. kl[eine] Scheiben ergänzt. Ferner ein Fenster herausgenommen, ein gemaltes Fenster, welches aus England kam, dafür eingesetzt und wieder retour gereist. [...].»*

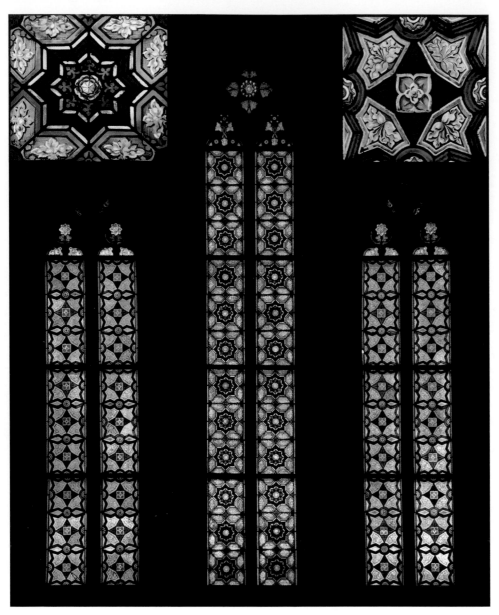

61. Johann Jakob Röttinger/R. Weiss, dreiteiliges Ornamentfenster W I mit Details, ehemalige Fried-
hofkapelle, Promenadengasse 9, Zürich, 1848(?), seit 1896 Englische Kirche.

Scheiben, die aus England geliefert wurden, mon-
tiert. Die im Vertrag mit dem Auftraggeber
Schindler in Mollis erwähnte Zürcher Abdan-
kungshalle an der Promenadengasse[532], deren
Fenster für Mollis als Vorbild gedient haben, zeigt
im dreiteiligen Westfenster (Abb. 61) ähnliche
Ornamentmuster. Die Glasmalereien in der Maß-
werkzone, im Supraporte und in den Schifffenstern
s III und n III der ehemaligen 1847 erbauten
Friedhofskapelle sind Johann Jakob Röttinger

532 Die ehemalige Friedhofskapelle wurde 1847 nach Plänen
 des Architekten Ferdinand Stadler erbaut und diente für
 den öffentlichen Friedhof der drei Kirchgemeinden
 Grossmünster, Fraumünster und der Prediger vorwiegend
 als Totenkapelle bei Begräbnissen und Gedenkfeiern. Eine
 Fensterrechnung erscheint 1864 in der Buchhaltung
 Röttingers; 1866 erfolgte eine Reparatur (ZB Nachl.
 Röttinger 1.206). Die Kirche ist 1895 nach Aufhebung des
 Friedhofs an die englische Kirche Zürich verkauft worden.
 Erst dann wurden Chor und Sakristei angebaut; das Got-
 teshaus wurde nun als Saint Andrews Church bezeichnet

62. Johann Jakob Röttinger, Ornamentfenster, n IV, Katholische Pfarrkirche Bünzen Sankt Georg und Anna, 1862.

zuzuschreiben; die im Rot-Blau-Akzent gehaltenen Ornamentfenster dürften ebenfalls aus dem Atelier Röttinger stammen, was jedoch wegen des fehlenden Archivmaterials nicht eindeutig festzulegen ist[533]. Die beiden Schifffenster n V und s V (Signatur von J. Röttinger/R. Weiss und die Jahreszahl 184[8]) dürfen wohl als die ältesten erhaltenen und signierten Glasmalereien der Werkstatt Röttinger angesprochen werden. So hinterließen die beiden Unternehmer ihre Initialen [IR RW] auch im Zentrum des Türoberlichts an der Südseite der Kirche.

In Burgdorf verlangten die Auftraggeber für die reformierte Stadtkirche grau in grau gemaltes gotisches Ornament nach Art der Schifffenster zu Sankt Elisabeth in Basel[534]. Bezüglich der Ornamente wird zudem eine Orientierung an von Röttinger durchgepausten Mustern in den mittelalterlichen Schweizer Kirchen erkennbar. So kann in Bünzen am Schifffenster n IV (Abb. 62) ein aus Vierpässen gebildetes Ornament festgestellt werden, das sich an Schemata aus der Zeit um 1320 anlehnt[535] (Abb. 63).

(VON ARX, 1997, S. 1–30). Vor 1895 war die anglikanische Kirche in der Sankt Anna-Kapelle, Annagasse in Zürich, untergebracht. Johann Jakob Röttinger erhielt 1863 von Architekt Baur im Seefeld den Auftrag, einfache Saalfenster im neuen Asyl und Betsaal bei Sankt Anna *gefasst in verzinntem Blei und angenehmer Einteilung*» für Frl. Escher im Felsenhof, Escher, Wyss & Cie., auszuführen (Vertrag: ZB Nachl. Röttinger, 1.199).

533 Die beiden Schifffenster n III, s III mit schuppenartig angeordneten, in Blei gefassten, weißen und blauen Glasstücken stammen von 1915 und sind mit H. Röttinger signiert. Die Maßwerkzonen stammen jedoch aus der Werkstatt Röttinger/Weiss. Heinrich [H.] Röttinger 1866–1948 ist der jüngere der beiden Söhne Johann Jakobs.

534 ZB Nachlass Röttinger 1.27. Vom ehemaligen Scheibenzyklus in Burgdorf haben sich lediglich zwei Wappenscheiben erhalten (Abb. 116).

535 KURMANN-SCHWARZ, 2008, S. 131, Abb. 143 (Frauenfeld, Oberkirch, Fenster I, 1b); Abb. 145 (Köniz, Chorfenster s II); S. 128, Abb. 136 (Königsfelden, z. B. N XII, 2b), S. 177, Abb. 234 (Königsfelden, n XIII 2a) u.a.

64. Johann Jakob Röttinger, Detail des Rautenmusters mit Weinblättern, Chorfenster n II, Evangelisch-Reformierte Pfarrkirche Salez, 1859.

63. Johann Jakob Röttinger (o. Sign.), Ornament, 80×40 cm, Durchzeichnung der Glasmalereien in der Sankt Laurentiuskirche in Frauenfeld Oberkirch, aquarelliert, 1850–1864, Staatsarchiv Zürich (StAZH W I 3 400. 22, Blatt 7).

Häufig sind jedoch einfache Damastmuster zu finden, die – mittels Schablonen meist in Grisaillemalerei ausgeführt – den Hintergrund für Medaillons oder für Einzelfiguren innerhalb von Architekturgehäusen bilden. Die Rautenmuster zeigen verschiedene Varianten, wie etwa in der Pfarrkirche Glis VS, wo innerhalb der Rauten umgekehrte Lilien einbeschrieben sind, aus denen zwei Ranken und ein Weinblatt wachsen beziehungsweise zwei weitere Weinblätter das Gebilde zu einem auf die Spitze gestellten Karree formen.

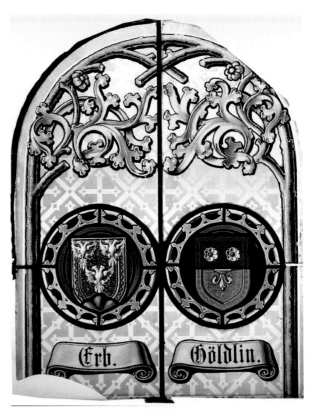

65. Johann Jakob Röttinger, Fragment eines Kapellenfensters mit Rankenornament, «Geschlechterwappen» Erb und Göldlin, der ehemaligen Friedhofskapelle Schwyz, 1867, deponiert.

Weinblätter füllen auch die Rauten der Ornamentfenster in Salez (Abb. 64).

Schlichter wirkt das ebenfalls in Grisaille gehaltene Damastmuster mit in Rauten eingefügten Kreuzen, das die Medaillons mit Geschlechterwappen der ehemaligen Friedhofkapelle in Schwyz aufnimmt (Abb. 65). Als Rahmenverzierung dienen verschlungene «goldene» Ranken – mit Silbergelb erzeugt – sowie die kleinen Schriftrollen mit den Namen der Schwyzer Geschlechter.

Ikonographie der gemalten textilen Bildraumbegrenzung in der Glasmalerei

Die Einzelfiguren des Christus, der Apostel, der Evangelisten und Heiligen zeigen eine einheitliche Komposition, nämlich die Stellung der Figuren unter einem Bogenelement, gestützt durch zwei Säulen, die auf einem Sockel lagern. Auf die bereits unter «Gemalte Architekturen» ausgeführten Rahmungen der Glasmalereien, den kunstvoll gestalteten Baldachinen und der Bedeutung dieser gemalten Architekturelemente soll hier nicht mehr eingegangen werden. Vielmehr wird nun versucht eine Motivgeschichte des häufig hinter den Figuren erscheinenden Vorhangs zu erstellen und seiner ikonographischen Tradition beziehungsweise liturgischen Funktion nachzugehen. Außer in den Fenstern der Kirchen zu Rapperswil BE und Lenzburg, auf denen die «textile» Hintergrundgestaltung fehlt, erscheint der Vorhang bei einer Vielzahl von Heiligendarstellungen als ein zwischen die Säulen gespanntes, mit Teppichmuster versehenes, gemaltes Stück Stoff. Für den Architekten und Kunsttheoretiker Gottfried Semper (1803–1879) ist die Textilkunst eine Förderin des ornamental-architektonischen Schaffens und gilt als ursprünglichstes Aufkommen menschlicher Kunsttätigkeit. Unter «Befriedigung materieller Lebenserfordernisse» fallen bei Semper auch das Spannen von Matten und Vorhängen zum Schutz und zur Unterteilung im Gebäudeinneren[536]. Christian Spies kommt in seiner Analyse mit Semper zum Schluss, dass das Ornament zwar von Material und Technik gewissermaßen

abhängig ist, dass es jedoch auch als verselbstständigte Form invers Einfluss nehmen kann[537]. Daraus ist zu schließen, dass die Ornamente der Glasmalereien textiler Herkunft sind – worauf die Bezeichnung «Damastmuster» hinweist – und dass dieselben Ornamente in der Glasmalerei zum Schmuck gemalter Textilien zum Einsatz kommen. Das in der Ikonographie der «Autorenbilder» in der ostchristlichen Buch- und Ikonenmalerei häufig anzutreffende Velum, das zwischen Architekturen aufgespannt ist, soll ein Wandbild aus Pompeji (Neapel, Museo Nazionale), auf dem der «Theaterkrawall» aus der Zeit um 59 n. Christus abgebildet ist, zum Vorbild haben[538]. Das *Parapetasma* ist ein in der Sarkophagplastik hinter den Bildnissen der Verstorbenen in zwei Punkten befestigtes beziehungsweise von Eroten gehaltenes Tuch[539], das in der Ikonographie der Porträtmalerei als *Parapetto* weiterlebte. Mittels der speziellen Hintergrundgestaltung war es geeignet, die porträtierten Personen hervorzuheben. So wies auch die *cathedra velata* Insigniencharakter auf und erinnerte angesichts ihrer hintergrundbildenden Eigenschaft an die mittelalterliche Gepflogenheit, Wände mit Textilien zu verhängen. Das *Velum*, ein Begriff, der mit dem Himmlischen, des *coelum* (*caro Christi* und *velum* als Konstriktion), in Verbindung

536 KROLL, 1987, S. 47 f., zitiert nach Gottfried Semper, Die vier Elemente der Baukunst. Ein Beitrag zur vergleichenden Baukunst 1851. S. 56 ff. Semper attestiert der Decke – entstanden aus dem Schutzbedürfnis der Urmenschen – frühestes handwerkliches Tun, das einer Dekoration unter Vermeidung beunruhigender Elemente bedurfte und durch «Stoff-Wanderung» die verschiedensten Formen angenommen habe und ist so zum Plafond, zum Fußteppich, zur Wand geworden. (MUNDT, 1971, S. 325 f.)

537 SPIES, 2011, S. 42.

538 GLUDOVATZ, 2011, S. 23. LDK 7, 1994, S. 579, Stichw. *Velum*; LCI 1, 1968, Sp. 707, 708, Stichw. *Evangelisten, Evangelistensymbole* (U. Nilgen).

539 EBERLEIN, 1982, S. 3.; KESSLER, 2000, S. 53 ff. In der Parousie-Miniatur symbolisiert der Vorhang das Firmament, das den Himmel von der Erde trennt und erscheint daher in den Farben Blau und Gold.

gebracht wird[540], tendiert jedoch ab der Spätantike wieder vermehrt zum Symbol der Öffnung des Jenseits zum Diesseits[541]. Diese Deutung verweist erneut auf die Funktion des Damastmusters, der symbolischen Abgrenzung der sakralen geistigen Welt zur Außenwelt[542]. Eine weitere Möglichkeit für die Herkunft der Bildtradition des Vorhanges ergibt sich aus den Vorschriften des orientalischen Hofzeremoniells. Die Etikette forderte, dass sich der König in seinen Gemächern verborgen hielte und dass selbst die Höflinge und staatlichen Würdenträger nur durch den vorgeschriebenen Vorhang mit ihm im Kontakt zu stehen hätten[543]. Die liturgische Bedeutung des *velum templi* geht auf die Bibelstelle zurück, in der es heißt: «Und der Vorhang des Tempels riss in der Mitte entzwei» (Lk 23, 45), was zur Illustration des dramatischen Höhepunktes im Passionsbericht beigetragen und sich in katholischen Gegenden im Brauch der Fasten- beziehungsweise Hungertücher erhalten hat[544].

Die Glasmaler des Historismus dürften sich dennoch – gemäß der Tradition Arkaden und Tabernakel als nach hinten begrenzte Bildräume zu gestalten – in erster Linie an die überlieferten Glasmalereien angelehnt haben. So ist in den Glasmalereien des 15. Jahrhunderts wie auch in der gleichzeitigen Tafelmalerei diese Art der gemalten textilen Gestaltung evident. In Frankreich erscheinen die gemalten Vorhänge auf Glasmalereien beispielsweise in der Kathedrale von Bourges, in der Sainte-Chapelle von Riom, in der Abteikirche von Mozac oder in der Kathedrale von Tours in der Mitte des 15. Jahrhunderts[545]. In der Kathedrale von Genf setzten die Glasmaler in der zweiten Hälfte des 15. Jahrhunderts Anregungen aus Bourges um[546]; in Nürnberg erscheinen gemalte Vorhänge um 1502 beispielsweise in der Sankt Sebaldus-Kirche (Abb. 66), im Bamberger-Fenster (Chorfenster n II aus der Werkstatt Veit Hirsvogel des Älteren)[547].

Das bekannte Hoheitsmotiv findet sich in der Nürnberger Glasmalerei bereits in der Mitte des 15. Jahrhunderts und zeigt dort einen starken Bezug zu den spätgotischen Schnitzretabeln, wo die Textilie meist von Engeln gehalten wird[548]. In den älteren Glasmalereien, zum Beispiel in der Pfarrkirche Sankt Nikolaus auf dem Staufberg, aus dem ersten Drittel des 15. Jahrhunderts, sind die Damastmuster im Hintergrund der Figuren ebenfalls ersichtlich, allerdings ohne den Eindruck aufgehängter Vorhänge zu erwecken. Die Bogenstellungen unter den Baldachinen werden auf diesen Glasmalereien von den Ornamentmustern völlig ausgefüllt[549]. In der Tafelmalerei kann eines der beiden Hauptwerke des Meisters des Bartholomäus-Altares, der Thomas-Altar von 1481 für die Kölner Kartause Sankt Barbara, als Beispiel herangezogen werden[550]. Hier erscheint in den Seitenflügeln ein tapetenartiger Hintergrund – in der Nachfolge des ornamentierten Goldgrundes, der oberhalb der Köpfe endet und so den Blick in die dahinterliegende Landschaft freigibt. Für die Buchmalerei ist exemplarisch der Meister des Herzogs von Bedford

540 EBERLEIN, 1982, S. 32.

541 EBERLEIN, 1982, S. 48. Dabei ist nicht zu vergessen, dass diese Interpretationen einem ständigen Wandel unterzogen waren.

542 KOZINA, 2011, wie Anm. 510.

543 KLAUSER, 1960, S. 141 f. Die gedankliche Weiterentwicklung der These Klausers würde konsequenterweise bei Abbildungen des Gottessohnes bzw. von Heiligen vor einem gemalten Vorhang die Präsenz Gottes im hinteren Bildraum miteinschließen.

544 LDK 2, 1989, S. 457 f., Stichw. *Fastentuch*, Fastentücher verhüllen den Altar von Aschermittwoch bis zur Mitte der Karwoche; wo keine Fastentücher mehr vorhanden sind, erfolgt die «Kreuzverhüllung» mit dem «Hungertuch», das am Passionssonntag (5. Fastensonntag) über dem Kruzifix angebracht, den Gläubigen bis Ostern – durch die Anschauung des Leibes Christi – erfahrenen Trost und Erbauung versagt.

545 KURMANN-SCHWARZ, 1988, zahlreiche Abbildungen z.B. S. 129–136.

546 BEER, 1965, S. 236, Abb. Tafel 17.

547 Abb. in: SCHOLZ, 2002, S. 71; SCHOLZ, 2007, S. 23.

548 SCHOLZ, 1991, S. 265 ff.

549 BEER, 1965, Tafel 9.

550 Abb. in: KRINGS/SCHMITZ/WESTERMANN-ANGERHAUSEN, 1999, Farbtafel S. 43 (Köln, Wallraf-Richartz-Museum WRM 179). Die vorangegangenen Beispiele dienen lediglich der Veranschaulichung des ikonographischen Themas und erheben keinerlei Anspruch auf Vollständigkeit.

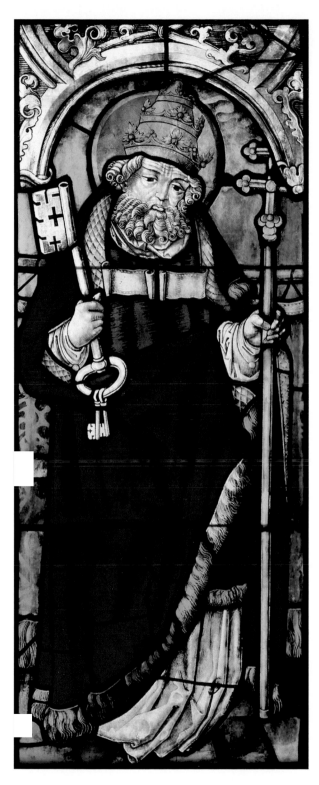

66. Werkstatt Veit Hirsvogel nach Entwurf von Albrecht Dürer, Chorfenster n II, Ausschnitt Bambergerfenster, Sankt Sebald Nürnberg, 1501/02 (CVMA Freiburg i. Br. Bildarchiv).

zu nennen, der im Stundenbuch «The Bedford Hours» den Duke John of Bedford in andächtiger Pose vor seinem Namenspatron dargestellt hatte[551]. Hier dient der «Vorhang» einerseits als Rückenbehang am Thron des Herzogs und in diesem Sinne als Zeichen seiner Würde, andererseits begrenzt er einen apsidial gestalteten Raum, wo er den Blick ins Gewölbe und auf die Fenster freilässt.

Während die spätmittelalterlichen beziehungsweise frühneuzeitlichen Beispiele meist mit «Stoffen» von kräftigen, deckenden Farben «visuell materialisiert» wurden, gestaltete Johann Jakob Röttinger, wie auch seine Zeitgenossen[552], überwiegend weiße dünne Vorhangstoffe, die ebenfalls mit Ornamentmuster versehen andeutungsweise auf die alte Darstellungstradition hinwiesen (z.B. Abb. 67 u.v.m.).

Die abgebildeten Figuren wurden daher nicht nur farblich durch einen hellen oder farblich abgesetzten Hintergrund akzentuiert, sondern darüber hinaus auch in ihrer Stellung, so dass die textilen Bildraumbegrenzungen dementsprechend auch im 19. Jahrhundert als Auszeichnung der Personen beziehungsweise als Insignie anzusprechen sind.

Motive sakraler Thematik

Wie bereits gezeigt werden konnte, lehnten sich die ikonographischen Inhalte der Glasmaler im 19. Jahrhundert an historische und zeitgenössische Vorbilder an[553]. Neben den Vorlagen aus Mittelalter und Frührenaissance hatten die Künstler verschiedene inhaltliche Beziehungen – etwa zu den Nazarenern – und wählten diese als formale wie motivische Grundlagen. Jedoch auch Glasmalereien, wie der bekannte Münchner Glasmalerei-

551 «The Duke John of Bedford in Adoration before his Patron Saint», als Detail einer Miniatur; abgebildet in: RING, 1949, S. 20, Katalognummer 78, S. 202; British Library, London, Online-Galerie.

552 Vgl. VAASSEN, 1997, Tafel 20, Abb. 35; Tafel 46, Abb. 76 etc.; KUHL, 2001, S. 73 u.v.m.

553 Vgl. Kap. ‹Vorbilder aus dem Mittelalter – Anlehnung an die «zeitgenössische» Kunst› bzw. VAASSEN, 1997, S. 279 ff.

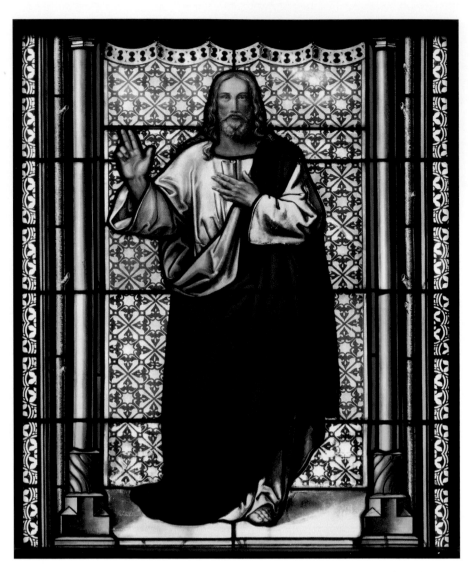

67. Johann Jakob Röttinger, «Lehrender Christus», Chorfenster I, Evangelisch-Reformierte
Pfarrkirche Niederhasli ZH, 1854.

zyklus der Maria-Hilf-Kirche in der Vorstadt Au, galten als *en vogue* und wurden entsprechend nachgeahmt beziehungsweise kopiert[554]. Wiederholt wünschten sich die Auftraggeber Sujets nach Vorbildern von Glasmalereien in ihnen bekannten Kirchen[555]. Reproduktionen, beispielsweise die Kupferstiche Albert Reindels, waren, wie schon ausführlich dargelegt, bei Franz Joseph Sauterleute sehr beliebt, wobei dieser die Reindelschen Vorlagen 1:1 übernommen hatte. Die von Elgin Vaassen beschriebenen zeitgenössischen Ikonographie-Zyklen, wie der im Regensburger Dom,

wo dynastische und patriotische Intentionen der Vollendung des göttlichen Heilsplanes dienten[556], kommen im Werk Johann Jakob Röttingers nicht

554 Vgl. KURMANN-SCHWARZ, 2010 (2), S. 231–251. Die Autorin bezeichnet (für das Mittelalter) das Zusammenspiel aus der Formensprache der Vorzeichnung und dem eigenen künstlerischen Ausdruck der Glasmaler treffend mit «paraphrasieren» (hier 238 f.).
555 Vgl. Anm. 528.
556 VAASSEN, 1997, S. 284; vgl. Kap. ‹Wappenzyklen in öffentlichen Bauten als Reminiszenzen Eidgenössischer Aristokratie›.

in dieser Form und diesem Ausmaß vor. Selbst die großen Kirchen der Schweiz, wie das Grossmünster in Zürich, die Stadtkirchen in Glarus und Sankt Lorenz in Sankt Gallen, waren in ihren Glasmalereien ikonographisch bescheidener ausgestattet und die Schifffenster meist nur ornamental oder vereinzelt figurativ gestaltet. Die Elisabethenkirche und das Münster zu Basel bildeten diesbezüglich eine Ausnahme. Hier kamen im Rahmen der Innenrestaurierung 1856–1860 gleich mehrere Glasmaler zum Zug, so dass Johann Jakob Röttinger «nur» Teilaufträge erhielt. Diese umfassten in der Elisabethenkirche das große Fenster auf der Orgelempore und im Münster sechs ornamentale Rundfenster im Triforium[557], die Maßwerkfüllungen der 15 Seitenschifffenster, 12 Obergadenfenster und ein Radfenster im nördlichen Querhaus. Letzteres, das Fenster in der so genannten Galluskapelle, zeigt die Taufe Christi, ein Motiv, das der Glasmaler nach einem Karton von Ludwig Adam Kelterborn umsetzte, nachdem Röttingers eigener Entwurf (Abb. 68) nicht zur Ausführung gekommen war[558]. Fenster mit üppiger Sequenz von Medaillons, angelehnt an die mittelalterlichen Vorbilder, waren im 19. Jahrhundert rar; als prominentestes Beispiel gilt eines der im Atelier Dr. Ludwig Stantz entstandenen Chorfenster s II im Berner Münster aus dem Jahr 1868. Die sieben großen Medaillons in der Mitte des südlichen Chorfensters zeigen biblische Szenen, wie die Geburt Christi, die Taufe im Jordan, das Abendmahl, die Kreuzigung, die Auferstehung und die Himmelfahrt sowie das Pfingstfest. Begleitet werden die Darstellungen durch Ovale, in denen Wundertaten, Parabeln und Stationen des Wirkens Christi (Abb. 69) gezeigt werden[559]. Ebenfalls mit dem Leben Christi befasst sich ein auf mehrere Fenster aufgeteilter, aus der Werkstatt Röttinger stammender Glasmalereizyklus aus der ehemaligen Kapuzinerkapelle zu Baden (Abb. 70). Die Glasgemälde der noch im 19. Jahrhundert abgebrochenen, so genannten Schulkapelle [Kapuzinerkapelle] von 1857 präsentierten sechs Szenen aus der Christus Vita: die Verkündigung, die Geburt Christi, den zwölfjährigen Christus im

68. Johann Jakob Röttinger, Entwurf zur Taufe Christi für das Basler Münster, D: 26.9 cm, aquarellierte Bleistiftzeichnung, 1857, Staatsarchiv Basel Stadt (SMM, Inv. AB.341).

Tempel, die Taufe Christi, die Kreuzigung und die Auferstehung[560]. Die Glasmalereien befinden sich heute in einem sehr schlechten, teils fragmentarischen Erhaltungszustand[561]. Dies ist umso bedauernswerter, da es sich um einen einzigartigen, geschlossenen, szenischen Zyklus im Werk Johann Jakob Röttingers handelte.

557 NAGEL/VON RODA, 1998, S. 44ff.; StABS Planarchiv T 206.
558 NAGEL/VON RODA, 1998, S. 57ff.; VAASSEN, 1997, S. 49; StABS 319 I D1; BHATTACHARYA, 2008, HLS, Stichw. *Kelterborn, Ludwig Adam,* (*1811 in Hannover, †1878 in Basel) schuf als Dessinateur und Zeichenlehrer von den Nazarenern und von Hieronymus Hess beeinflusste Genrebilder sowie politische Karikaturen.
559 VAASSEN, 1997, S. 47f.; KURMANN-SCHWARZ, 1998, S. 97ff.; Im zweiten Chorfenster s III aus dem Berner Atelier wird die Steinigung des heiligen Stephanus abgebildet.
560 ZB Nachl. Röttinger 1.11.
561 HÖGGER, 1995, S. 196. Die 117×62cm großen Fenster sind im Luftschutzkeller der Sankt Michaelskirche zu Ennetbaden deponiert. Die gebrochenen Scheiben konnten wegen ihres schlechten Erhaltungszustandes nicht aus den mit Holzwolle ausstaffierten Kisten genommen werden.

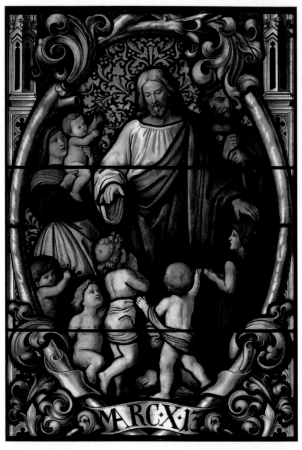

69. L. Stantz (Entwurf), H. Müller, R. Gleichauf, Th. Spiess, Jesus und die Kinder (Mk 10, 13), Chorfenster s II 2d, Münster Bern, 1868.

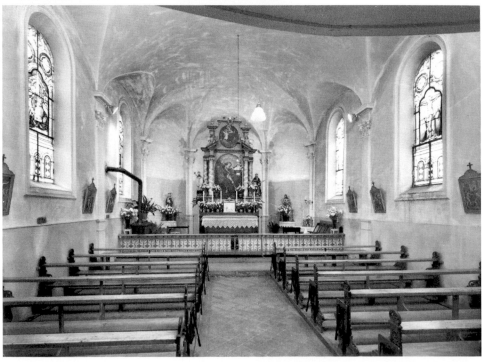

70. Johann Jakob Röttinger, Glasmalereizyklus aus der abgebrochenen Kapuzinerkapelle Baden (1858–1876), versetzt in die Michaelskapelle (1880–1966), deponiert.

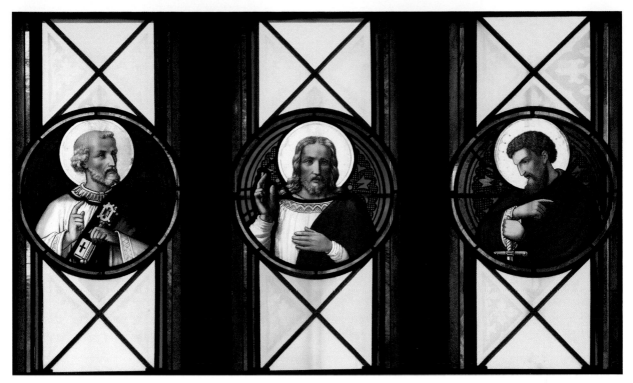

71. Johann Jakob Röttinger, «Lehrender Christus» (Medaillon) flankiert von Petrus und Paulus, Ausschnitt aus dem Chorfenster I, Evangelisch-Reformierte Pfarrkirche Mettmenstetten ZH, 1869.

Um über die einzelnen Sujets und ikonographischen Themen im Werk Röttingers – für das Gebiet der Deutschschweiz – einen Überblick zu bekommen, wurden die in situ erhaltenen oder in Depots gelagerten Glasmalereien aus dem Atelier Röttinger nach Orten und Motiven methodisch erfasst und tabellarisch als Kurzkatalog ausgewertet[562]. Einzelne im Werk Röttingers dominierende und epochentypische Bildmotive[563] werden in der Folge ikonologisch befragt und analysiert, als Versuch eine, wenn auch lückenhafte Motivgeschichte für das 19. Jahrhundert zu formulieren. Dabei stand eine Analyse im Vordergrund, die Identifikation und Interpretation des Sujets im Sinne Erwin Panofskys vor dem Kontext historischer Prozesse versteht[564].

Der «Lehrende Christus»

Die Wertschätzung der Einzelfigur in der Kunst des 19. Jahrhunderts wurde im Kapitel über die künstlerische Ausführung, Eigenheiten in der Komposition› ausführlich dargelegt. Diesem Votum kommt insbesondere die Darstellung des so genannten «Lehrenden Christus» entgegen. Im Werk Johann Jakob Röttingers konnte sich dieser ikonographische Typus, dessen Bezeichnung zweifellos gewisse Widersprüchlichkeiten in sich birgt, noch in zehn reformierten Kirchen der Deutschschweiz in situ beziehungsweise in Depots erhalten. Auf neun Fenstern erscheint Christus als Ganzfigur – auf einem als Halbfigur. Letztere ist als Medaillon ausgeführt und Teil des Chorfensters I in der reformierten Pfarrkirche zu Mettmenstetten ZH (Abb. 71).

562 Siehe Katalog.
563 Dabei ist nicht immer die quantitative Dominanz ausschlaggebend. Bei der Auswahl wurden ebenso konfessionelle bzw. ikonographische Besonderheiten berücksichtigt.
564 PANOFSKY, 2002, S. 49.

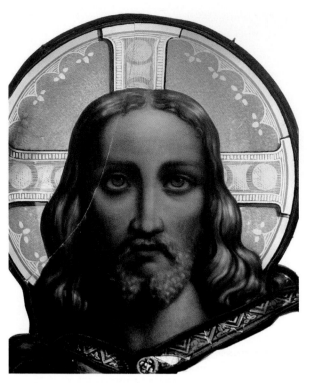

72. Johann Jakob Röttinger, Fragment Christushaupt, Chorfenster I der ehemaligen Klosterkirche Alt Sankt Johann SG, 1869, Probsteiarchiv Alt St. Johann.

Aus der ehemaligen Klosterkirche und jetzigen katholischen Pfarrkirche zu Alt Sankt Johann SG[568] konnte sich nur noch ein Fragment des einstigen Chorfensters (Abb. 72) erhalten, das ursprünglich als «Altarbild» gedient hatte. Das bewahrte Teilstück zeigt das Haupt Christi mit Kreuznimbus und folgt dem Eintrag im Skizzenbuch des Glasmalers: *«1 Fenster als Altarblatt mit dem Bilde Jesu und St. Joh. Ev. u. St. Joh. der Tfr.»* [...Sankt Johannes Evangelist und Sankt Johannes der Täufer][569]. Auf einer alten Fotografie des Kircheninnenraums[570] vor 1939 ist das Chorfenster nur schwach erkennbar: Christus in der Mitte überragt die beiden «Assistenzfiguren» um die halbe Körperlänge, was wohl auf eine kniende Haltung der beiden Begleiter zurückzuführen ist. Unklar bleibt der Gestus der Hände, wobei sich das Motiv des «Lehrenden Christus» nicht auf eine eindeutig definierte Haltung der Arme beziehungsweise Hände festlegen lässt, wie dies noch zu zeigen sein wird. In der Folge soll nun der Herkunft und Bedeutung dieses ikonographischen Themas nachgegangen und die Darstellung der Figur Christi in den Kontext zeitgenössischer Strömungen der sakralen Bildhauerei und Malerei im 19. Jahrhundert gestellt werden.

Die Darstellungen des Sujets als Einzelfiguren haben sich in den reformierten Kirchen im Kanton Zürich in Niederhasli, Regensdorf, Wädenswil[565], Schlieren und Weiningen, im Sankt Gallischen Salez, im Bernischen Rapperswil, in der Kirche der Strafanstalt Lenzburg sowie in der Turmkammer des Grossmünsters, wo vier grosse Glasfelder als Bestandteile der Christusfigur gelagert werden, erhalten. Dazu kommen – neben zwei Chorfenstern mit dem Sujet der Auferstehung in Zug Sankt Oswald und Bünzen AG (Abb. 108) – drei weitere szenische Darstellungen Christi, das im Dachboden der reformierten Stadtkirche Solothurn aufbewahrte, ehemalige Chorfenster s II[566], auf dem der Gottessohn sitzend mit Kind beziehungsweise mit Aposteln und Kindern abgebildet wird, das in der reformierten Kirche zu Baar ZG in ähnlicher Komposition ausgeführte Chorfenster I[567] sowie ein weiteres axiales Chorfenster in der reformierten Kirche zu Oberentfelden AG, das die Bergpredigt zeigt.

565 Der untere Teil der Figur auf der Höhe der Oberschenkel fällt wegen der ovalen Fensterform weg. Bemerkenswert erscheint der Umstand, dass die Christusfiguren in Rapperswil BE, Niederhasli und Regensdorf ohne Nimben dargestellt sind, in Oberentfelden Christus zwar mit, die Apostel jedoch ohne Nimbus auftreten.

566 Nach einer Analyse Stefan Trümplers für die Denkmalpflege Solothurn.

567 Christus mit Aposteln in der Auffassung: «Und er nahm ein Kind und stellte es in ihre Mitte und sprach: Wenn Ihr nicht werdet wie die Kinder, so werdet ihr nicht ins Himmelreich kommen.» (Mt 18,1–5)

568 Vgl. Kap. ‹Wünsche der Auftraggeber›.

569 ZB Nachl. Röttinger, 1.202, 123.

570 Abb. in: STUDER, 2002, S. 11, aus Archiv Koller, Alt Sankt Johann (vgl. Huber Johannes, Kloster St. Johann im Thurtal. Benediktinerabtei – Pfarreizentrum – Begegnungsort, Alt Sankt Johann und Sankt Gallen 2007, S. 111, 112).

Überlegungen zur Bildtradition

Das 19. Jahrhundert ist die große Zeit der Leben-Jesu-Forschung, die im 18. Jahrhundert ihren Anfang nahm und als Konsequenz der Aufklärung und somit als Absage an die totalitären Strukturen der Dogmatik aufgefasst werden kann[571]. Die starke Gewichtung der historischen Theologie, als deren Begründer im deutschsprachigen Raum Ferdinand C. Baur (1792–1860) gilt sowie die Mythologisierung der Evangelien durch David F. Strauß (1808–1874) brachten im 19. Jahrhundert unter anderem publizistische Jesus-Biographien hervor, die den Gottessohn in romanhaftem Ambiente als sanft und liebenswürdig charakterisierten[572]. Heinrich J. Holtzmann (1832–1910) leitete eine strikte Entmythologisierung ein und postulierte die Rückkehr zur kritischen Exegese der christlichen Quellen. Unter Rudolf Bultmann (1884–1976) setzte sich schließlich die Wandlung des historischen Jesus zum kerygmatischen Christus durch[573]. So ist es nicht verwunderlich, dass die intensive Beschäftigung mit dem historischen Jesus von Nazareth in der sakralen Kunst des Historismus insbesondere in protestantischen Kirchen ihre Spuren hinterlassen hat. Dementsprechend wurzelt die Bildtradition des 19. Jahrhunderts in den Darstellungen des frühen Christentums.

In der Bibel wird an mehreren Stellen auf die Lehrtätigkeit Christi verwiesen. So heißt es in Lk 4, 14, 15: «In der Kraft des Geistes kehrte Jesus nach Galiläa zurück. Sein Ruf verbreitete sich in der ganzen Gegend. Er lehrte in den dortigen Synagogen und wurde von allen gepriesen.» In der «Predigt vom Boote aus» (Lk 5, 2, 3) lehrte er [Christus] sitzend aus dem Boote Simons[574]. Die Inschrift am Grabe des Aberkios aus Hierapolis in Phrygien aus dem Jahr 216 gilt als wichtiges Zeugnis, in dem Aberkios als «Schüler des Hirten» bezeichnet wird[575]. Der Hirte als Offenbarungsträger, der nicht nur im übertragenen Sinne die Schafe weidet, sondern auch den Kindern als Erzieher dient, nimmt seinen Ausgangspunkt beim Gelehrten Origenes [576]. Das frühe Christentum verstand die heilsbringende Lehre Christi als alt-

bekannte, aufrichtige und nützliche Philosophie wie sie aus den Dialogen des Märtyrers Justin mit dem Juden Tryphon[577] hervorgeht, was schließlich das Motiv – «Christus als philosophischer Lehrer»[578] – hervorbrachte. Christus mit Aposteln als Philosophenversammlung zeigt einen Christus mit Bart, das eigentliche Zeichen des Lehrers[579]. Als Vorbilder erwiesen sich die Philosophendarstellungen auf den Sarkophagen, wie beispielsweise auf dem Stadttorsarkophag in San Ambrogio in Mailand aus dem 4. Jahrhundert[580]. Vor dieser Zeit sind bedeutende Szenen, wie der «Christus als Lehrer» und «Orans zwischen Aposteln», nicht belegbar[581].

571 STROTMANN, 2012, S. 11.
572 SCHMID, 2012, HLS, Stichw. *Straussenhandel*: Der württembergische Theologe David Friedrich Strauß wurde am 26. Januar 1839 zum Professor für Dogmatik und Kirchengeschichte an die Universität Zürich berufen. Heftiger Widerstand gegen ihn führte zu einer vom Grossen Rat beschlossenen Pensionierung auf Lebenszeit. Die konservative Landbevölkerung ortete fehlende Religiosität in den Schulen und forderte die Schließung der Universität. Der nun folgende Aufstand, in denen auch das Militär involviert wurde, führte zur vorübergehenden Auflösung der Regierung und muss schließlich als Vorbote des Sonderbundskriegs gesehen werden [HLS Online-Version]. Vgl. Kap. ‹Von der Revolution zum neuen Bundesstaat› bzw. ‹Konfessionelle Spaltung›; STROTMANN, 2012, S. 24–27. V.a. Ernest Renan (1823–1892) zeichnete für die romanhaften Lebensbeschreibungen Jesu verantwortlich.
573 THEISSEN/MERZ, 1996, S. 24.
574 LCI 3, 1971, Sp. 86 f., Stichw. *Lehrer, Lehrszenen* (P. Bloch). Weitere Bibelquellen sind: Jo 14, 6; 18, 37; Mt 28, 18–20; Mk 16, 15.
575 WIRBELBAUER, 2002, S. 359–382 [Online-Version].
576 LCI 1, 1968, Sp. 358 f., Stichw. *Christus, Christusbild* (H. Bauer), zit. n. Origenes (185–254), Kirchenschriftsteller und Theologe, Homilien über das Buch Joshua. Libro Iesu Nave homiliae 7, 6: «magistri pastoris sequamur exempla».
577 Just, Dial. 8, 1: Justinus, Dialoge, 8, 1; Anno 158 in Ephesus aufgezeichnet.
578 LCI 1, 1968, Sp. 355 f., Stichw. *Christus, Christusbild* (H. Bauer).
579 KOLLWITZ, 1936, S. 49, zitiert nach Joseph Sauer, Das Aufkommen des bärtigen Christustypus in der frühchristlichen Kunst, in: Strena Buliciana 303–29, Zagreb 1924.
580 TRE, 1976–2004, Bd. 31, Stichw. *Sepulkralkunst*, Berlin 1976–2004, S. 160–165, hier: S. 161.
581 KOLLWITZ, 1936, S. 46 f.

Johannes Kollwitz interpretiert die Darstellung des «Lehrenden Christus ohne komplexe Sinnbilder» als den menschenfreundlichen Christus und Prediger der Synoptiker, der die einfachen Leute um sich zu versammeln wusste und als Lehrer der heilbringenden Wahrheit und Erretter aufgetreten war. Beliebte Lehrszenen im Mittelalter stellten jene Abbildungen dar, in denen sich Christus stehend oder thronend den Aposteln offenbarte[582]. Die gotische Kunst zeigte sich hinsichtlich der Ikonographie von Lehrenden zurückhaltend. Betreffend der Darstellung Christi als stehende Einzelfigur bildete die Trumeau-Figur an den französischen Kathedralportalen, der so genannte *Beau-Dieu,* eine Ausnahme. Christus, der mit Segensgestus und das Buch präsentierend über Löwe und Schlange «schreitet», wird als Siegessymbol über das Böse dargestellt. Viollet-le-Duc interpretierte diese Christusfiguren 1857 noch dahingehend, dass Jesus das Evangelium lehrte, sich mit der segnenden Hand an seine Kirche wandte und die Portalgewände mit ihrem Vorplatz die Gläubigen repräsentierten[583]. Wilhelm Schlink konzediert der Trumeau-Figur hingegen eine Demonstration von Macht und Hoheit, sieht Christus als Logos und Ratschluss Gottes und bezeichnet die Portale des 12. und 13. Jahrhunderts als «Werbefläche an der Grenze zwischen dem profanen Stadtraum und der Wohnung Gottes»[584]. Um der bereits wiederholt angesprochenen These zu folgen, die der Glasmalerei eine Schwellenfunktion zwischen irdischem und überirdischem Bereich einräumt, hätten Portale und Fenster gemeinsame räumliche und liturgische Aufgaben. Sie könnten als Medien zwischen weltlicher und himmlischer Sphäre gesehen werden, was durch die Ikonographie der Christus-Darstellung zum Ausdruck gebracht wird[585].

Erst in der Renaissance berief man sich wieder auf die Thematik des Lehrens. Das berühmteste Beispiel stellt die Disputation zwischen Platon und Aristoteles, Raffaels «Schule von Athen» (1510–1511), dar[586].

Es handelte sich dabei zwar um eine «weltliche Versammlung» (Abb. 73), die jedoch nachfolgenden Künstlern als wichtiges Vorbild auch im sakralen Umfeld diente. Im Gegensatz zum Mittelalter verstand die Renaissance das Kunstwerk – auf einer Grundlage rhetorischen Denkens – als Hervorbringungsakt und als Ergebnis dramaturgischen Handelns. Neben der Gestik zählten nun weitere appellative Formen, wie Mimik, Physiognomie und Beredsamkeit, der naturalistisch dargestellten Körper. Wolfgang Brassat beruft sich dabei auf Albertis Traktat *De pictura*, wonach dem Kunstwerk wie dem Vortrag des Redners eine unmittelbare affektive und ethische Wirkung zukommt[587]. Aus dem Vermächtnis Martin Schongauers hat sich im British Museum eine Zeichnung des «Lehrenden Christus» erhalten, die eine Beschriftung aus der Hand Dürers aufweist: «Diess hat hubsch martin gemacht. Im 1469 jor.» Ein Druck dieses Blattes ließ sich auch im Nachlass der Röttinger finden[588]. Rembrandt drückte im calvinistischen Holland mit dem Bild des «Lehrenden Christus» die Hoffnung auf den Erlöser aus. Die berühmte Radierung «Das Hundertguldenblatt» (1640–1645) ist als Versuch Rembrandts interpretierbar, Christi Leben und Lehre zu subsumieren[589].

582 LCI 3, 1971, Sp. 87, Stichw. *Lehrer, Lehrszenen* (P. Bloch). Bsp. früher Elfenbeinschnitzereien: Lipsanothek von Brescia, 4. Jh.; Grosse Berliner Pyxis um 400.

583 SCHLINK, 1991, S. 36, Anm. 7, Schlink zitiert Eugène Emmanuel Viollet-le-Duc, Dictionnaire raisonné de l'Architecture Française, Band 3, Paris 1857, S. 244. BOERNER, 1998. S. 196, Bruno Boerner nimmt diese Ergebnisse in seine Forschungen auf und bezeichnet das triumphierende Stehen über Aspis und Basilisk als Zeichen, dass Christus als Salvator Mundi dargestellt wird. Die Quelle für die Darstellung ist im AT zu finden. Zitat: «Über Löwen und Ottern wirst du gehen und junge Löwen und Drachen niedertreten» (Psalm 91, 13).

584 SCHLINK, 1991, S. 39; vgl. KOZINA, 2011, siehe Anm. 510.

585 Vgl. unten: ‹Der «Lehrende Christus» in der Kunst des 19. Jahrhunderts›.

586 Vatikan, Rom, Stanza della Segnatura, Fresko, Basis 770 cm, (Angaben aus: BECK, 1999, S. 413).

587 BRASSAT, 2000, S. 157 ff.

588 CHÂTELET, 1991, S. 40. ZB Nachl. Röttinger 4.5.6.

589 VON EINEM, 1972, S. 349.

73. Raffael, Schule von Athen, Ausschnitt
Fresko, Stanza della Segnatura,
Basis 770 cm, Vatikan, Rom, 1510/11.

Rembrandts Streben nach einem Symbolcharakter, der über das Historisch-Dogmatische hinausgeht, fand erst mit der Radierung «La petite tombe» von 1652 eine Umsetzung[590]. Hier gelang es dem Künstler das Herrscherliche durch die leise Neigung des Hauptes zu vergeistigen und Christi Wort mit der Gestik der erhobenen Hände zu begleiten[591].

Der «Lehrende Christus» in der Kunst des 19. Jahrhunderts

Nach der christologischen Vorstellung des Idealismus, wie sie von Georg W.F. Hegel (1770–1831) vertreten wurde, galt Christus als Mittler zwischen der Welt und dem Transzendenten. Dieselbe Denk-

weise kann bei der Gestaltung der klassizistischen Christusfigur des Heilands vom Stuttgarter Bildhauer Johann Heinrich Dannecker (1758–1841) vorausgesetzt werden, der weder das Erlösungsdenken noch das historische Leiden Christi darstellen mochte, sondern sich im Spannungsfeld

590 HINTERDING, 2011, S. 154, Kat. Nr.: 64–67: neuere Datierung um 1657. Beim Kupferstich «La petite tombe», der Vorlage für die gleichnamige Radierung, handelt es sich um einen predigenden Christus. Der Name, der seit dem 18. Jahrhundert gebräuchlich ist, leitet sich wohl vom mutmaßlichen Auftraggeber ab, Nicolaes de la Tombe, und lautete ursprünglich «het Latombisch printje».
591 VON EINEM, 1972, S. 356.

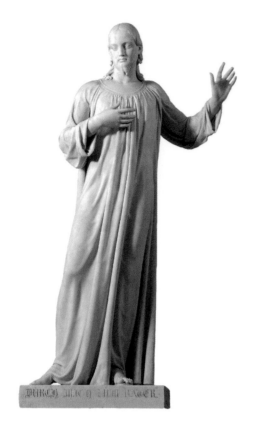

74. Johann H. Dannecker, Christus, 2. Fassung der Skulptur
für die Grabkapelle Thurn und Taxis, Regensburg, 1825–1832.

75. Hoff/Ehrtinger, Christus, Stahlstich nach J. H. Dannecker,
Verlag Benziger Einsiedeln, 23.5×16 cm, Zürich, Zentralbiblio-
thek, (ZB Nachl. Röttinger 4.5.9 o.p.).

zwischen Naturtreue und dem Ideal schöner Men-
schen bewegte[592]. Danneckers Heiland (Abb. 74),
der 1818–1822 für die Stuttgarter Hospitalkirche
ausgeführt und von Kaiserin Maria Feodorowna
für Zarskoje Selo in Auftrag gegeben wurde, kam
in einer zweiten Fassung 1825–1832 in die Grab-
kapelle der Thurn und Taxis in Regensburg[593].
Johann Jakob Röttinger, der dort in den späten
Dreißigerjahren, während er beim Glasmaler Sau-
terleute in Diensten gestanden hatte, tätig war,
musste die Skulptur demnach gekannt haben.
Dieser Christus mit dem jugendlich bärtigen Ge-
sicht nach griechisch-klassischem Vorbild und der
erhobenen Linken, während die Rechte an die
Brust angelegt wird, dürfte den jungen Glasmaler
wohl in der Grundidee seiner Christusdarstellun-
gen inspiriert haben. Dass sich Johann Jakob
Röttinger mit der Christusfigur des württember-
gischen Bildhauers auseinandergesetzt hatte, be-
stätigt die im Nachlass des Glasmalers erhaltene
Zeichnung (Abb. 75) des Hauptes Christi nach
Dannecker[594].
Es ist davon auszugehen, dass die erhobene
Hand der Christusfigur nicht bedingungslos für
die Darstellung der «Repräsentation göttlicher
Macht» spricht, wie Thomas Michels diese Ges-
tik, allerdings für die rechte Hand, beschreibt[595].

592 LCI 1, 1968, Sp. 442f., hier 444, Stichw. *Christus, Christus-
bild* (H. Bauer); LDK 2, 1989, S. 79, Stichw. *Dannecker,
Johann Heinrich.*

593 LCI 1, 1968, Sp. 444, Stichw. *Christus, Christusbild*
(H. Bauer); KUNSTBLATT, 1831: Eine zeitgenössische Be-
schreibung der Figur findet sich im Kunstblatt Nr. 99,
Dienstag, 20. December 1831.

594 ZB Nachl. Röttinger 4.5.6: Blatt mit der Büste Christi
nach Dannecker, gezeichnet von Hoff.

595 MICHELS, 1967, S. 277 ff. Der Autor richtet die Kritik in
seinem Aufsatz vehement gegen die Meinung vieler Kunst-
historiker, nämlich, dass es sich bei der erhobenen Hand
Christi um einen Segensgestus handle. Allerdings gesteht
er manchen Darstellungen aus Gründen der künstlerischen
Komposition einen Seitenwechsel zu, d.h., dass auch die
erhobene Linke Zeichen der Hoheit bzw. Repräsentation
göttlicher Macht ausdrücken könne. Vgl. dazu: WACKER,
1997, S. 245f.; LCI 2, 1970, Sp. 215, Stichw. *Handgebärden*
(O. Holl): E. Segen, F. Hoheitsgestus, G. Redegestus.

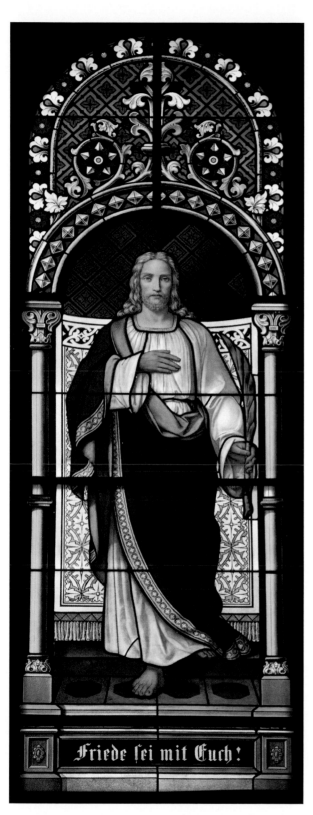

76. Johann Jakob Röttinger, «Lehrender Christus», Chorfenster I, Evangelisch-Reformierte Pfarrkirche Regensdorf ZH, 1875.

In der griechischen Kunst versinnbildlichte die Hochhebung der Hand mit nach außen sichtbarer Handinnenfläche oder die an die Brust gelegte Rechte einen Gebetsgestus, verbunden mit einem Zeichen der Bitte oder des Dankes[596]. Bewegungen des Sprechens sind in der archaischen Kunst durch das Erheben einer oder beider Hände angezeigt worden beziehungsweise in der klassischen Kunst durch die erhobene Hand respektive das Senken des Unterarms schräg gegen den Boden mit verschieden gestreckten Fingern[597]. Ob sich die an die Brust angelegte Rechte auf die *tunsi pectoris*, das Klopfen an die Brust, also eine offenbarte Bußgesinnung bezieht oder ob mit dem Gestus die *cancellatio*[598], der Gebetsgestus mit überkreuzten angewinkelten Armen, angedeutet wird, geht aus der Darstellung Danneckers nicht hervor. Dem Gebetsgestus wird, sofern er mit der Hervorhebung der rechten Hand einhergeht, die Gewichtung der Auferstehung zugeschrieben, was die Christusfigur als Hoffnungsträger – in der Stuttgarter Hospitalkirche wie auch in der Regensburger Gruftkapelle – legitimiert.

Das Christusbild des mittleren Chorfensters in der Pfarrkirche zu Regensdorf ZH aus dem Jahr 1875 (Abb. 76) von Johann Jakob Röttinger lehnt sich in einigen Punkten an die Figur Danneckers an. Das junge bärtige Gesicht zeigt formale Ähnlichkeiten, zudem sind die Alben der beiden Figuren am Halsausschnitt in ähnlicher Weise in kleine Falten gelegt. Während Röttingers Christus die linke Hand absenkt und einen Palmzweig als Zeichen des Sieges über den Tod umfasst, legt er seine Rechte an die Brust – als Sinnbild für Passion und Auferstehung. Die Chorfenster der reformierten Kirche zu Regensdorf sind das Vermächtnis des Landolt von Spar[r]enberg, der die Glasmalereien im Gedenken an seine verunglückte Gattin stiftete[599]. Die Gestik der Christusdar-

596 NEUMANN, 1965, S. 77 f.
597 NEUMANN, 1965, S. 10 f.
598 SUNTRUP, 1978, S. 170; DESCOEUDRES, 1999, S. 23.
599 PA Regensdorf, 02. Protokolle der Kirchenpflege 02.02 1847–1901: 13. August 1874, unter Punkt 4; Vgl. GRUNDER, 1997, S. 383.

stellung sowie die Inschrift «Friede sei mit Euch» ist als Stiftung in Verbindung mit dem Totengedenken als angemessen zu erachten und verweist auf die eingangs angesprochene Charakterisierung Christi als Mittler zwischen dem Weltlichen und Transzendenten[600]. Johann Jakob Röttinger hielt sich häufig an Bilder der Firma Benziger in Einsiedeln, die in großen Mengen Gemälde und Stiche als Devotionalien vertrieben hatte – so auch die Abbildung des Hauptes Christi nach Dannecker. Melchior Paul von Deschwandens Beispiel einer Herz-Jesu-Figur (Abb. 77) mit sichtbaren Gebrauchsspuren zeigt, dass diese Abbildung mehrfach als Vorlage für Köpfe, Gewänder und Haltung von Christusfiguren verwendet worden war[601]. Johann B. Schraudolph soll im Freskenzyklus des Speyerer Doms die Figur des «Jesus als Lehrer» auf Stufen erhöht dargestellt haben, die rechte Hand auf dem Herzen, die linke im Redegestus – in seitlich ausgestreckter Position[602].

Den wohl populärsten Beitrag zur Erneuerung des Christusbildes im 19. Jahrhundert erbrachte Bertel Thorvaldsen (1770–1844), der 1839–1842 die monumentalen Skulpturen «Christus und die 12 Apostel» (Abb. 78) für die Kopenhagener Frauenkirche schuf.

Kritiker unter den Autoren heben zwar hervor, dass das Streben des Künstlers nach Ruhe, Harmonie und idealer Schönheit einer gewissen Formelhaftigkeit verfällt, halten ihm dennoch zugute den Zeitstil getroffen und maßgeblich die Entwicklung der europäischen Plastik beeinflusst zu haben[603]. An anderer Stelle wird Thorvaldsens Christus-Darstellung hingegen als «Emblem des protestantischen Glaubens» bezeichnet und die verwendeten Bibelzitate als Hinweise auf eine gelungene Fusion des Himmlischen und des Menschlichen, des Leidens, des Todes und der Auferstehung Christi[604]. Diesem Christustyp entspricht der Christus des Chorscheitelfensters in Rapperswil BE (Abb. 79) in Bezug auf Gestik, Umhang und Beinstellung.

Während die Christusfigur des dänischen Bildhauers den auferstandenen Christus verkörpert – die Wundmale sind deutlich sichtbar – orientieren sich

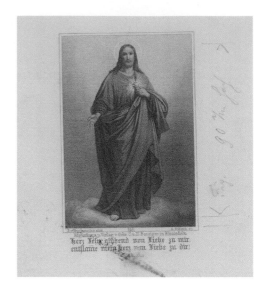

77. A. Schleich, Herz-Jesu, Druck aus dem Verlag Benziger Einsiedeln nach Melchior P. Deschwanden, 22.5×16 cm, Zürich, Zentralbibliothek (ZB Nachl. Röttinger 4.5.6 o.p.).

Röttingers Figuren des so genannten «Lehrenden Christus» insbesondere in ihrer Haltung ebenfalls an der Ikonographie des Auferstandenen. Obwohl aus einigen Quellen explizit die Bestellung eines «Christus als Lehrer» hervorgeht[605], bleibt eine Diskrepanz zwischen der ikonographischen Bezeichnung und der Darstellungsweise. Eine Abbildung des Chorfensters in der ehemaligen All Saint's Church in Baden-Baden[606] von der Münchner Glasmalereianstalt zeigt Christus dem Grab entschwebend in dieser Haltung. Die Rechte wird im Segnungs- oder Sprechgestus beziehungsweise im Sinne einer Demonstration der Macht Gottes

600 Die beiden flankierenden Chorfenster zeigen links Sankt Paulus und rechts Sankt Johannes.

601 ZB Nachl. Röttinger 4.5.6.

602 SCHÖNENBERG, 1989, S. 139.

603 LDK 7, 1994, S. 307, Stichw. *Thorvaldsen, Bertel*.

604 GRAVGAARD, 1997, S. 55 ff.; Bibelzitate: Mk 9, 7; Mt 28, 20; Mt 21, 28. PRIEBE, 1932, S. 7 zitiert Thorvaldsens Freund und Biograf Thiele: «Sein Verhalten zum Christentum war vielleicht mehr auf die Schönheitsidee als in einem religiösen Bewusstsein gegründet» (Thorvaldsens Leben, deutsch von H. Helius II 69).

605 ZB Nachl. Röttinger 1.10 (ref. Kirche Baden AG), ZB Nachl. Röttinger 1.115 (ref. Kirche Niederhasli), ZB Nachl. Röttinger 1.146 (ref. Kirche Salez).

606 VAASSEN, 2013, S. 196, Abb. 94, S. 395.

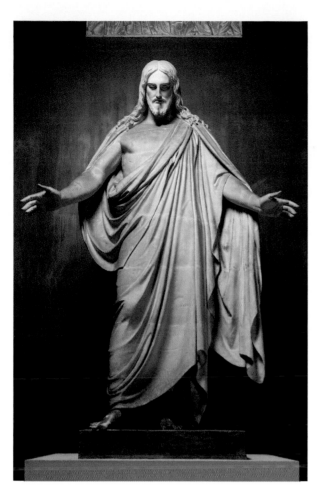

78. Bertel Thorvaldsen, Christus, Gipsfigur, 345 cm, 1821,
Kopenhagen, Thorvaldsen Museum (Inv. Nr. A82).

emporgehoben, die Linke verweist auf die Wunde
an der Brust. Sehr ähnlich präsentieren sich Röt-
tingers als «Lehrer» bezeichnete Christusfiguren,
deren Oberkörper sich jedoch jeweils von einer
Albe verhüllt zeigen und der Abbildung von
Wundmalen entbehren. Wie der in der deutschen
Kunst des hohen Mittelalters beliebte Typus des
frontal abgebildeten Auferstandenen, der die Rech-
te zum Segensgestus erhebt und somit einen sak-
ramentalen, übernatürlichen Charakter bekam[607],
stehen die Figuren des «Lehrenden Christus» im
19. Jahrhundert mit beiden Beinen ebenfalls fest
auf dem Boden, um in protestantischen Kirchen
das Wort Gottes zu verkünden.

Johann Jakob Röttinger wählte bei allen Christus-
figuren den nazarenischen Kopftypus mit dem

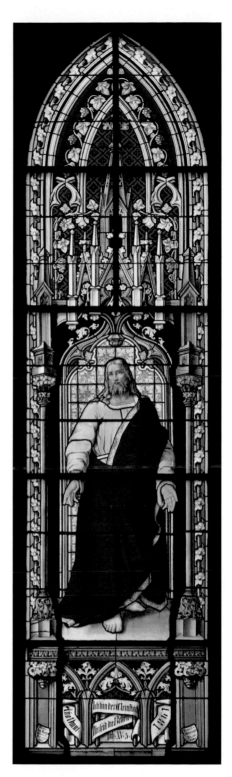

79. Johann Jakob Röttinger, «Lehrender Christus», Chorfenster I,
Evangelisch-Reformierte Pfarrkirche Rapperswil BE, 1861.

607 LCI 1, 1968, Sp. 208, Stichw. *Auferstehung Christi* (P. Wil-
 helm).

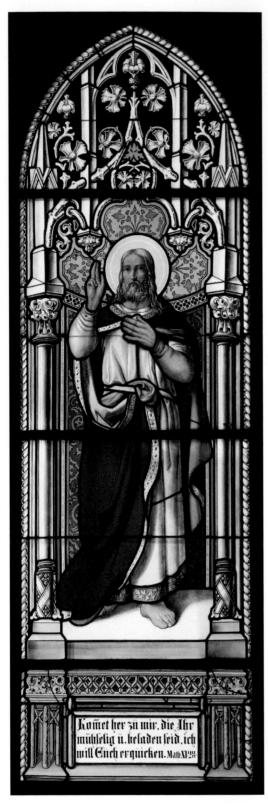

80. Johann Jakob Röttinger, «Lehrender Christus»,
Chorfenster I, Evangelisch-Reformierte Pfarrkirche
Salez SG, 1859.

gescheitelten, gewellten langen Haar und dem häufig geteilten Vollbart. Dass sich Röttinger intensiv mit der Problematik des Bildes Christi auseinandergesetzt hatte, geht aus der im Nachlass überkommenen «Kupfersammlung aus Johann Kaspar Lavaters Physiognomischen Fragmenten zur Beförderung der Menschenkenntnis und Menschenliebe»[608] hervor. Sowohl bei den Nazarenern wie auch bei Thorvaldsen werden Entsprechungen mit Lavaters Physiognomischen Fragmenten evident. Die Glasmaler orientierten sich offensichtlich an denselben Vorbildern wie die zeitgenössische Tafelmalerei und die plastische Kunst. So sollen sich die Apostelfiguren des Bildhauers in der Kopenhagener Frauenkirche – wie bei Sauterleute – ebenfalls auf Peter Vischers Apostel am Sebaldusgrab zu Nürnberg beziehen[609]. Die bei Thorvaldsens Christus offenbarte Haltung der Arme wird als begütigend beziehungsweise grüßend beschrieben und ist von der Forschung als körpersprachliches Motiv der Einladung interpretiert worden[610]. In einem Brief an August Kestner proklamierte Thorvaldsen seine Christusfigur als überzeitlichen Herrn der Geschichte[611]. Die einladende Geste wird von der Sockelinschrift noch unterstrichen, die Mt 11, 28 folgt: *«Kommet zu mir alle, die ihr mühselig und beladen seid, ich will Euch erquicken»*. Dieselbe Sockelinschrift zeigt auch Röttingers «Lehrender Christus» auf dem Chorscheitelfenster der reformierten Kirche in Salez SG (Abb. 80) von 1859[612].

608 ZB Nachl. Röttinger 4.5.5 (Lavater, 1806, Erstes Heft). «Und Gott schuf den Menschen zu seinem Bilde, zum Bilde Gottes schuf er ihn […] (1. Mose, 27).
609 Gohr, 1977, S. 344.
610 Leuschner, 2009, S. 220 f.
611 Jöckle, 1988, S. 122.
612 Eine fast identische Christusfigur fertigte J. Röttinger für die reformierte Pfarrkirche in Pieterlen, die sich nicht erhalten hat (abgebildet bei Rauscher, 2008, S. 67). Dieser Christustyp, durch die aufkommenden Reproduktionstechniken bald als Massenware auftretend, prägte das Kunstverständnis einer breiten Öffentlichkeit, dem man in den Gotteshäusern entgegenkam. (Grentzschel, 1989, S. 60 ff.).

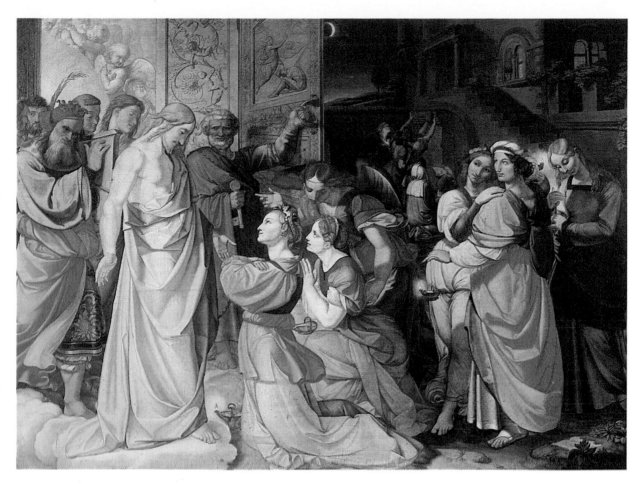

81. Peter Cornelius, Die klugen und die törichten Jungfrauen, Öl auf Leinwand, 116×155 cm, 1813–1816, Museum Kunstpalast Düsseldorf (Inv. Nr. 4011).

Die Anlehnung Thorvaldsens an den Christus auf Peter Cornelius' Gemälde «Die Klugen und die Törichten Jungfrauen»[613] (Abb. 81) aus den Jahren 1813–1816 ist unübersehbar. Peter Cornelius, der 1819–1824 als Direktor der Düsseldorfer Akademie vorstand, ließ das Bild in der Werkstatt J. A. Kochs zurück, von wo es in den Besitz Thorvaldsens gelangte und viel später schließlich für die Düsseldorfer Galerie gekauft wurde[614].

Auch in der Beschreibung Eckhard Leuschners impliziert die Figur Thorvaldsens das Motiv des auferstandenen Christus, der seine Wundmale zeigt, was – wie erwähnt – deutlich sichtbar ist. Während sich das Gewand an die antike römische Bildhauerkunst anlehnt, ist das Lockenhaar als Reminiszenz an das Quattrocento zu deuten. Das jugendlich bärtige Gesicht wird innerhalb der

Forschung stets auf Michelangelos «Christus» in Santa Maria sopra Minerva verwiesen[615]. Diese Verknüpfung anerkannter Formen geschah nicht nur im historistischen Sinne des Pluralismus und der Konkurrenz der Stile[616], sondern muss auch in Bezug auf die Forderung nach universeller

613 Peter Cornelius, Die klugen und die törichten Jungfrauen, 116×155 cm, Öl auf Leinwand, Museum Kunstpalast Düsseldorf, 1813–1816.

614 SPICKERNAGEL, 1977, S. 120, Kat. Nr. C 2: Zwischenzeitlich, im Jahr 1848, tauchte das Tafelbild wieder in Rom auf; 1861 auf der Kunstausstellung in Köln, von wo aus es in die Düsseldorfer Galerie gelangte.

615 LEUSCHNER, 2009, S. 224, Anm. 18 mit zahlreichen Literaturangaben.

616 OEXLE, 2007, S. 37 ff.; vgl. Kap. ‹Johann Jakob Röttinger zwischen den Stilen›, Anm. 1347.

Harmonie als Symbol des Göttlichen gesehen werden – ein Anspruch, der im 19. Jahrhundert im Vordergrund stand. Der Bildhauer Johann Gottfried Schadow (1764–1850), Vater Friedrich Wilhelm Schadows, des 1826 auf Cornelius folgenden Direktors der Kunstakademie Düsseldorf, vermaß sowohl Thorvaldsens Christus wie auch die Christusfigur Michelangelos und stellte bei beiden Mängel fest. Diese begründete er damit, dass ein Kunstwerk, dessen Eidos auf «schöner als schön» abziele, wider die Gesetze der Natur strebe[617]. Caspar Gsell und Émile Laurent schufen 1848 im Chorobergaden der Eglise Saint-Gervais in Paris einen «Lehrenden Christus» mit Maria im zentralen Fenster, links davon die Apostelfürsten und rechts die beiden Kirchenpatrone Gervasius und Protasius[618]. Die bereits erfassten Chorfenster evangelischer Kirchen in den neuen Bundesländern Deutschlands, die das Motiv des «Lehrenden Christus» aufweisen, sind meist später entstanden; dies zeigen Beispiele in Thüringen[619], wo diese Darstellungsweise gegen Ende des 19. Jahrhunderts häufiger auftritt. Röttingers Christusdarstellungen repräsentieren mit Ausnahme der Glasmalereien in Regensdorf ZH und Rapperswil BE eine recht einheitliche Haltung, nämlich das Anlegen der linken Hand an die Brust, während die rechte einen Segnungs- beziehungsweise Redegestus zeigt[620]. Zwei Skizzen im Thorvaldsen Museum[621] um 1821 entsprechen exakt der von Röttinger bevorzugten Typologie. Diese Art der Christusdarstellung soll Thorvaldsen 1819 anlässlich eines Besuchs im Atelier Danneckers in Stuttgart gesehen haben, wo letzterer mithilfe der schreitend hinweisenden Figur das Zitat «Durch mich zum Vater» visuell umsetzte. Thorvaldsen habe anlässlich seiner Rückreise von Rom nach Kopenhagen den Bildhauerkollegen in Stuttgart besucht[622] und dort Skizzen angefertigt. Clemens Jöckle deckt eine weitere Widersprüchlichkeit der Darstellungsweise des «Lehrenden Christus» auf, wenn er den starken Kontrast zwischen den plastisch gestalteten Figuren, die er als «gemalte Plastik» bezeichnet, und den typisierten, ausdrucks- und kraftlosen Gesichtern der Christusfiguren hervorhebt[623].

Sprechendes Beispiel für diese These ist J.C.H. Koopmanns Kreidezeichnung: «Die Gnadenmittel der evangelischen Kirche» (1852), auf der die überproportionalen Körperformen des thronenden Christus durch die üppige Gewandung gesteigert und dieser somit als Person überhöht wird[624]. Der Gegensatz zwischen dem formelhaften Antlitz und der plastischen Präsenz der Christusfigur ist hier offenkundig. Johann Jakob Röttinger reihte sich in den «Mainstream» der zeitgenössischen Diktion ein, wohl nicht zuletzt auch als Ausdruck der Zufriedenstellung seiner Auftraggeber, um je nach konfessioneller Ausrichtung den Gesetzen und Regeln der christlichen Kunst zu folgen beziehungsweise ein Emblem des protestantischen Glaubens zu schaffen und den Symbolgehalt des Darstellungskanons zu tradieren[625].

617 LEUSCHNER, 2009, S. 221 ff.

618 PILLET, 2010, S. 95, Abb. S. 94 (Fig. 32).

619 BORNSCHEIN/GASSMANN, 2006, S. 34, 408, 541, 683. Die Übergänge zu Bezeichnungen wie «Einladender Christus», «Segnender Christus» sind fließend. Vgl. Anm. 620.

620 LCI 4, 1972, Sp. 145 f., Stichw. *Segen* (J. Poeschke): mit einem Verweis auf Apuleius, Metamorphosen II 21; Das Ausstrecken der rechten Hand ist freilich nicht immer eindeutig als Segensgebärde von einem Hoheits-, Lehr- oder einfachen Anredegestus zu unterscheiden. Das Ausstrecken von Daumen, Zeige- und Mittelfinger und dem Einbiegen der letzten beiden Finger der rechten Hand hat sich jedoch seit dem 4. Jahrhundert als Segnungsgestus etabliert und bis in die Neuzeit erhalten. Diese Übernahme einer antiken Rednergeste, des so genannten «lateinischen Segens», unterscheidet sich vom «griechischen Segen», indem sich beim letzteren Ringfinger und Daumen zusammenschließen, während die übrigen Finger ebenfalls gestreckt sind. Daneben sind noch weitere Segenshaltungen anzutreffen, die sich durch das unterschiedliche Verhältnis von gekrümmten und gestreckten Fingern unterscheiden.

621 Bertel Thorvaldsen: Skizzen zum «Christus», um 1821. Kopenhagen, Thorvaldsen Museum (Inv. Nr. 228, 229) abgebildet bei GOHR, 1977, S. 354, 355.

622 JØRNÆS, 1993, S. 331 ff.

623 JÖCKLE, 1988, S. 120.

624 SPICKERNAGEL, 1977, S. 121, C 11, Abb. S. 148. Die Gnaden- und Erbauungsmittel der evangelischen Kirche, Johann Carl Heinrich Koopmann, 1852, Kreide, weiß gehöht auf Papier, 97.5×79 cm, Staatliche Kunsthalle Karlsruhe, Inv.-Nr. 712.

625 Vgl. Kap. ‹Wünsche der Auftraggeber›.

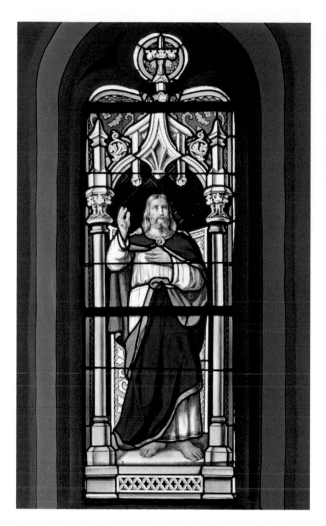

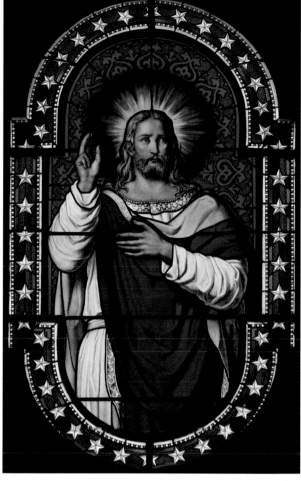

82. Johann Jakob Röttinger, «Lehrender Christus», Chorfenster I, Evangelisch-Reformierte Pfarrkirche Weiningen, 1860.

83. Johann Jakob Röttinger, «Lehrender Christus», Hochchorfenster I, Evangelisch-Reformierte Pfarrkirche Wädenswil, 1862.

Das häufige Vorkommen des Motivs des «Lehrenden Christus» in den reformierten Kirchen der Schweiz, vor allem im Kanton Zürich, lässt sich mit der Orientierung am Zentrum der Schweizer protestantischen Kirche, dem Grossmünster, erklären. Die Chorfenster – nach Entwürfen des Glasmalers Georg Konrad Kellner (1811–1892) von Johann Jakob Röttinger ausgeführt – wurden auf Ostern 1853 hin bestellt und galten fortan wohl als ikonographisches Vorbild für die Pfarrkirchen im Kanton Zürich. So entstanden in zeitlicher Reihenfolge 1854 die Chorfenster der Pfarrkirchen in Schlieren und Niederhasli, 1860 in Weiningen (Abb. 82), 1862 in Wädenswil (Abb. 83), 1869 in Mettmenstetten (Abb. 71) und 1875 in Regensdorf

(Abb. 76), jeweils mit Darstellungen des «Lehrenden Christus».

In Wädenswil und Mettmenstetten wurde der Modellcharakter des Zürcher Vorbilds noch intensiviert, indem auch die beiden Apostelfürsten Petrus und Paulus[626] aus dem ikonographischen

626 Vgl. Kap. ‹Apostel, Evangelisten und Propheten›. KGA Schlieren IV.B.03.02, Stillstandsprotokolle 1820–1885, S. 363, 20. Oktober 1861, Traktandum 2: Auch für Schlieren sollen ursprünglich Glasmalereien mit den Apostelfürsten vorhanden gewesen sein: *«Der Pfarrer [Friedolin Leuzinger] macht aufmerksam, dass noch eine gemalte alte Scheibe die Apostel Petrus und Paulus darstellend bei Glasmaler Röttinger sei, welche dessen Arbeiter Johannes Bräm «Büebels» [auch Ueli-Büeblis genannt] von hier [Schlieren] versprochen habe, in einem Schreiben der Studierstube zufolge».*

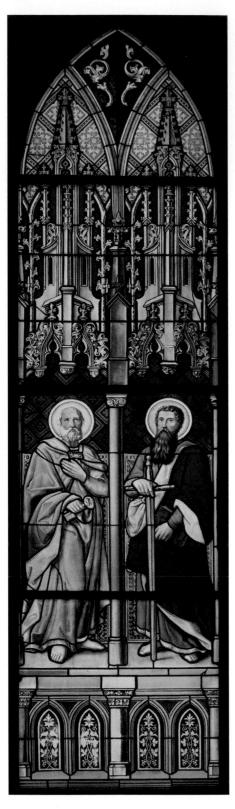

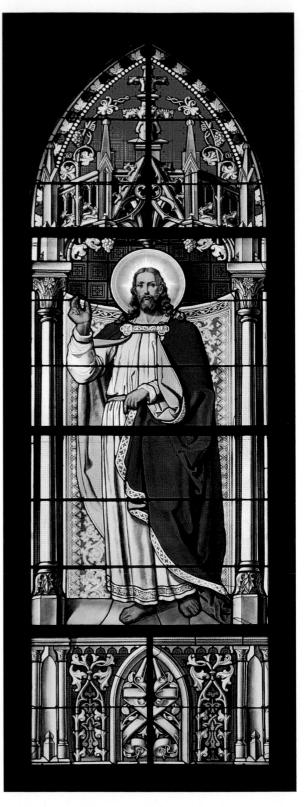

84. Johann Jakob Röttinger, Apostel Petrus und
Paulus, Chorfenster I, Evangelisch-Reformier-
te Pfarrkirche Kilchberg ZH, 1858.

85. Johann Jakob Röttinger, «Lehrender Christus», Chorfenster
I, Evangelisch-Reformierte Kirche Court BE, 1862.

Programm des Grossmünsters übernommen wurden. In Kilchberg schuf Johann Jakob Röttinger 1858 ebenfalls ein Chorfenster mit Petrus und Paulus (Abb. 84) und die Kirchen Stäfa und Regensdorf erhielten 1871 beziehungsweise 1875 Glasmalereien mit den Aposteln Petrus und Johannes. Im Vertrag für Stäfa wird eine große Christusfigur für das mittlere Chorfenster genannt, die sich nicht erhalten hat[627]. Die Vorbildfunktion des Grossmünsters, wo Kellners Christus offensichtlich in Anlehnung an das Selbstbildnis Dürers im Pelzrock[628] entworfen wurde, beschränkte sich jedoch nicht nur auf eine wertschätzende Nachahmung innerhalb des Kantons, sondern schien sich mancherorts als Kanon für die evangelisch-reformierte Kirche in der Schweiz zu etablieren. So schuf Johann Jakob Röttinger 1859 den «Lehrenden Christus» im Sankt Gallischen Salez, 1861 im Bernischen Rapperswil und für die Glarner Stadtkirche 1865 Chorfenster mit Petrus, Paulus und Johannes. Die Christusfiguren für die reformierten Pfarrkirchen in Baden AG sowie in Pieterlen[629], Rüegsau und Tavannes im Kanton Bern haben sich nicht erhalten, hingegen ein Chorfenster mit dem «Lehrenden Christus» in Court BE (Abb. 85)[630].

Diese Beobachtungen untermauern die These von den «Regeln der christlichen Kunst» in einem allgemeinen und überkonfessionellen Sinne, deren Einhaltung einem bestimmten Kanon folgt und durch Nachahmung jemandem die Ehre erweist. Parallelen, wie dies die Architekturzitate im Mittelalter bezogen auf das Heilige Grab in Jerusalem darstellten, sind nicht auszuschließen. Dabei bestand weder damals noch im 19. Jahrhundert der Anspruch auf vollkommene Übereinstimmung[631]. In den evangelisch-reformierten Kirchen konnten vor allem Bilder aus dem diskursiven Themenbereich der Soteriologie Einzug halten, um als rhetorische Instrumente zur Ergänzung und Erhöhung des Wortes beizutragen[632]. Das Motiv des «Lehrenden Christus» qualifizierte sich im 19. Jahrhundert zur Ausübung einer medialen Funktion, um gemäß seiner dominanten Stellung im Chor reformierter Kirchen das gesprochene Wort

zu unterstreichen. Während sich der «Lehrende Christus» in der Schweiz als Einzelfigur ausschließlich in reformierten Kirchen etablierte, sind Aposteldarstellungen sowohl in reformierten wie auch katholischen Kirchen gleichermaßen vertreten. Dieses Phänomen sowie die Tatsache einer eingeschränkten Existenz reicher glasmalerischer Zyklen in Schweizer Kirchen aus dem Untersuchungszeitraum zwischen 1845 und 1877 ist neben dem Fehlen monastischer Stifter wohl als ikonographische Annäherung der beiden Konfessionen in schweren, konfliktreichen Zeiten zu werten und als Zeichen der damals herrschenden katholischen Kulturinferiorität gegenüber den Protestanten[633].

Apostel, Evangelisten und Propheten

Neben der Darstellung des «Lehrenden Christus» belegen demnach die Apostelfürsten Petrus und Paulus in zahlreichen Schweizer Kirchen einen weiteren ikonographischen Themenschwerpunkt. Im Werk Johann Jakob Röttingers haben sich in der Deutschschweiz in sechs Gotteshäusern großfigurige Glasmalereien eines oder beider Apostelfürsten sowie in einigen anderen Kirchen Medaillons mit demselben Motiv erhalten.

627 ZB Nachl. Röttinger 1.155.

628 Die Anlehnung an Dürer erwähnten bereits frühere Autoren, zuletzt GERSTER, 2012, S. 8–9.

629 Abb. «Christus als Lehrer» in: RAUSCHER, 2008, S. 67.

630 Dies belegen die erhaltenen Verträge im Nachlass: ZB Nachl. Röttinger 1.10, Baden AG 1867; ZB Nachl. Röttinger 1.140, Ruegsau BE 1874; ZB Nachl. Röttinger 1.162, Tavannes BE 1867 (Offerte); ZB Nachl. Röttinger 1.30, Court BE.

631 APPUHN, 1991, S. 122; Architekturzitate im Mittelalter insbes. «Das Heilige Grab» vgl. DIETERICH, 2006, S. 7 f. mit entsprechenden Literaturangaben; Architekturzitate im 19. Jahrhundert vgl. MAHN, 1990, S. 5.

632 HOEPS, 2010, S. 101–116.

633 Vgl. Kap. ‹Konfessionelle Spaltung› (ALTERMATT, 2009, S. 123 ff.); BORNSCHEIN/GASSMANN, 2006, S. 37. Die römisch-katholische Frömmigkeit konnte sich auch in Thüringen unter protestantischen Herrschaftsverhältnissen nur schwer behaupten, was entweder dazu führte, dass ausgeprägte katholische Programme in die Kirchen Einzug hielten oder dass man sich zu arrangieren versuchte.

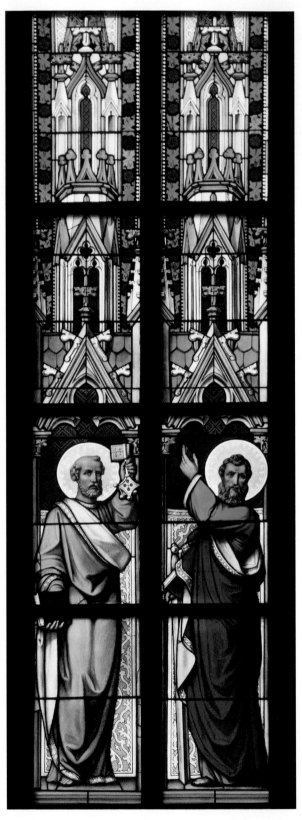

86. Johann Jakob Röttinger, Apostel Petrus und Paulus, Chorfenster s II, Katholische Pfarrkirche Nottwil LU, 1869.

Zur ersten Gruppe zählen die reformierten, im Kanton Zürich gelegenen Pfarrkirchen Kilchberg, Regensdorf, Wädenswil, das Grossmünster sowie die katholischen Pfarrkirchen zu Nottwil LU und Kirchdorf AG; zur zweiten Gruppe die reformierten Pfarrkirchen in Stäfa ZH und Mettmenstetten ZH sowie die katholischen Pfarrkirchen in Alterswil FR und Glis VS. Die Glasmalereien in den Kirchen zu Nottwil (Abb. 86), Regensdorf und Stäfa (Abb. 87) werden durch die Abbildung des Apostels und Evangelisten Johannes ergänzt, wobei in Nottwil neben Johannes auch Jakobus im nördlichen Chorfenster (n II) erscheint.

In der katholischen Kirche zu Unterägeri war gemäß Vertragsentwurf von 1858 vorgesehen, die zwölf Apostel in den Chorfenstern unterzubringen, was nicht zur Ausführung kam[634]. Heute befinden sich die ehemaligen Fenster im Depot des Pfarrarchivs.

634 PA, Unterägeri: Die Regesten des Vertragsentwurfs vom 28. Januar 1858 «zwischen Herrn J. Röttinger, Glasmaler in Zürich einer- und der Tit. Kirchenbaukommission von Unterägeri Ct. Zug anderseits». J. Röttinger drückte sein Vergnügen aus, Aegeri bzgl. der Chorfenster der neuen Kirche zu besuchen – es bestand der Wunsch, dass in den Bildern die 12 Apostel angebracht würden. Röttinger beeilte sich diesem Wunsch zu entsprechen, Zeichnungen anzufertigen, um die Anordnung zu veranschaulichen. In der (damals) vorgelegten Zeichnung des Mittelfensters waren in der Mitte die Apostelfürsten Petrus und Paulus als Patrone der Kirche dargestellt; unten die Bilder der Heiligen Apostel Andreas und Jakobus Major. 3 Chorfenster – je 4 Apostel in dieser Anordnung, jedoch in die beiden neben dem Mittelfenster sich befindenden Fenster in abwechselnder Architektur und Färbung. Falls wegen der Höhe des Hochaltars die unteren beiden Apostel nicht mehr ganz sichtbar würden: Vorschlag je in einem Fenster links und rechts (neben den drei mittleren) noch 2 Bilder anzubringen und zwar in eines die zwei in der gewöhnlichen Reihenfolge zuletzt des Apostels Sankt Thomas und Mathias und in das andere Matthäus und Sankt Johannes d. T. Den verdeckten Teil des mittleren Fensters sollte ein Teppichgrund schmücken, in harmonischem Einklang zu den Hauptfenstern, ohne dass die Gesamtkosten bedeutend erhöht würden. «Sehr erwünscht, mir Ihre Meinung baldmöglichst mitzutheilen. Jakob Röttinger». ZB Nachl. Röttinger 2.371.75: 1876 wurden in die Kirche von Henau SG 10 Fenster bestellt, «/...]in je ein Fenster das Brustbild eines hl. Apostels in schöner Ausstattung». Die Glasmalereien in Henau haben sich nicht erhalten.

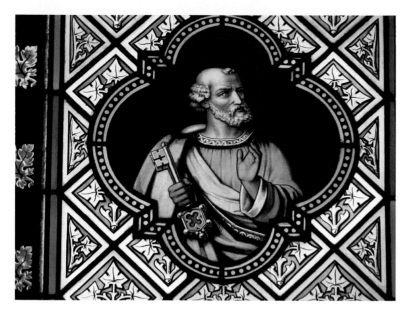

87. Johann Jakob Röttinger, Apostel Petrus, Vierpass, Chorfenster n II, Evangelisch-Reformierte Pfarrkirche Stäfa ZH, 1871, (Bleilinien und Farbunterschied im roten Damasthintergrund lassen beim Haupt des Petrus eine Ergänzung vermuten).

Auf den vom Zivilschutz angefertigten Fotos sind neben zahlreichen Familienwappen die Evangelisten Matthäus und Markus sowie die Propheten Jesaias und Jeremias als Ganzfiguren zu erkennen, was für eine Planänderung der Fenstergestaltung spricht. Betreffend der Evangelistendarstellungen sind vor allem die beiden Standorte Glis (s III· vlnr. Matthäus, Markus, Lukas, Johannes) sowie Rapperswil BE (n II Matthäus und Markus; s II Lukas und Johannes) hervorzuheben, die sich an prominenter Stelle im Chor in situ erhalten haben. Im Thalwiler Ortsmuseum sind zwei Fragmente der ehemaligen, figurativ gestalteten Fensterverglasung der alten reformierten Pfarrkirche auf uns gekommen. Es handelt sich einerseits um den Evangelisten Matthäus und andererseits um das Evangelistensymbol des Markus, dem Löwen, mit dem Zitat: «*Alle Dinge sind möglich / Dem der da glaubt, Marcus X, 42*». Die im Nachlass der Röttinger erhaltene Maquette mit dem Bildnis des Reformators Calvin, die als Vorlage für das Fenster mit dem Evangelisten Lukas gedient haben muss[635], sowie die trotz Kirchenbrand überlieferten Scheibenfragmente wurden im Kapitel über den graphischen Nachlass bereits erörtert[636]. Als weiterer Prophet erscheint Moses neben Christus in der Kirche der Strafanstalt Lenzburg AG. Die Forderung an die Insassen sich der Einhaltung der Zehn Gebote zu besinnen, dürfte hier Programm sein. In Glis VS erscheinen auf dem Chorfenster s III die vier großen Propheten als alttestamentliches Pendant zu den Evangelisten; sie wurden auf dieselbe Art in einer Reihe unter gotische Baldachine gestellt.

Petrus und Paulus

In der westlichen Kirche erlangte die Namensliste in der Vulgata allgemeine Gültigkeit, die nach der Liste des Matthäus aufgebaut ist. Wahrscheinlich ist, dass diese Apostelliste ursprünglich nur die fünf Namen Petrus, Paulus, Andreas, Jakobus und Johannes umfasste und erst ab dem 5. Jahrhundert mit den weiteren Namen bis zur Zwölfzahl aufgefüllt wurde[637]. Paulus (um 10–67), der den Beinamen «Apostel aller Völker» (Röm. 1, 5) trägt, wurde erst *nach* Christi Himmelfahrt die urkirchliche Anerkennung der Apostelwürde zuteil.

635 Die Anordnung der Fenster ließ sich dank alter Fotografien aus dem Ortsmuseum rekonstruieren. Vgl. Kap. ‹Signierte Entwürfe›. Aufgrund der schlechten Fotoqualität sind die drei weiteren Reformatoren nicht erkennbar (Abb. 18, 19).

636 Vgl. Kap. ‹Unsigniert – und doch aus der Werkstatt Johann Jakob Röttingers›.

637 LCI 1, 1968, Sp. 150 ff., Stichw. *Apostel* (J. Myslivec).

Typologisch erscheint Petrus in der Frühzeit mit kurzem Haar und Bart, Paulus mit Glatze und spitzem Bart; die Beschreibung des Johannes Malalas, des oströmischen Historikers (um 500) wird für den Typus der beiden Apostel kanonisch, die zusammen mit Andreas und Johannes zu den Hauptaposteln in Liturgie und Andacht zählten[638]. Das persönliche Attribut des Schlüssels für Petrus, eigentlich Simon mit Beinamen Petros, wird im 7. Jahrhundert in einem Fresko mit der Schlüsselübergabe[639] in der Commodillakatakombe in Rom gebraucht. Im Weltgericht in Santa Cecilia in Trastevere in Rom um 1293 wird Petrus mit Kreuz und Paulus mit Schwert, neben anderen Aposteln mit denselben Attributen, dargestellt. Petrus' Bedeutung für die Geschichte ist mit der Tradition nach Mt 16, 1 ff. verknüpft, wonach der Primat des Petrus begründet und dieser an den Bischofsstuhl gebunden wird[640]. Der mittelalterlich-westliche Typus des Paulus erscheint in der Buchmalerei wie auch in der Plastik zum Teil mit hoher kahler Stirn und langem spitzen Bart, oft auch mit kahlem Vorderschädel und kurzem Bart, wie zum Beispiel in Reims am Gerichtsportal der Kathedrale um 1230.

«Die gemalte Predigt»

Paulus nimmt als «Verkünder des Wortes» in den reformatorischen Bildaussagen eine zentrale Stelle ein, was in den so genannten Konfessionsgemälden bei der Übergabe des Augsburger Bekenntnisses zum Ausdruck kommt[641]. Auf Ähnlichkeiten zwischen Dürers Gemälde «Vier Apostel»[642] und den Aposteldarstellungen, insbesondere des Paulus im Grossmünster, wurde bereits im Kapitel ‹Nürnberg – Albert Reindel› hingewiesen. Wie bereits erwähnt, nimmt das Apostelbild Dürers Bezug auf das Bekenntnis zur Reformation[643], was durch die textliche Ergänzung Johann Neudörffers (1497–1563), des Nürnberger Schreibmeisters und Mathematikers, mit Bibeltexten aus der Lutherübersetzung herausgehoben wird. Die Zitate der abgebildeten Botschafter[644] mahnten das Stadtregiment, sich vor den «falschen Propheten» zu

hüten und ihr Tun durch das Wort der Bibel lenken zu lassen[645]. Bemerkenswert für die Überlieferung ist jedoch die Tatsache, dass Kurfürst Maximilian I. von Bayern (er regierte von 1598–1651), der die Tafeln 1627 in seine Sammlung aufgenommen hatte, die Textteile absägen ließ und diese erst 1922 wieder mit den Bildern vereint wurden[646]. Seit 1836 befinden sich die Gemälde jedoch am heutigen Standort, in der Alten Pinakothek in München[647].

638 LCI 1, 1968, Sp. 153, Stichw. *Apostel* (J. Myslivec).

639 Der Schlüssel galt als apostolisches Prädikat zur Begründung der richterlichen Gewalt der Bischöfe (FICKER, 1886, S. 18).

640 DER KLEINE PAULY 4, 1979, Sp. 675, Stichw. *Petros* (Klaus Wegenast). LDK 5, 2004, S. 480ff., Stichw. *Paulus*; FICKER, 1886, S. 9: Im Missale Gothicum b. Mabillon, De liturgia Gallicana t. III, p. 273 werden Petrus und Paulus als «Doppellicht für die Kirche» bezeichnet. Die gemeinsame Darstellung von Petrus und Paulus ist auf die so genannten Passionssarkophage der 2. Hälfte des 4. Jahrhunderts zurückzuführen, wo Repräsentationsdarstellungen, Christus mit Petrus und Paulus als *Traditio legis*, die untrennbare Ikonographie der beiden Apostel begründeten.

641 BRÜCKNER, 2007, S. 32, Abb. 9: «Paulus (1 Kor 11, 23 26), Matthäus (26, 26–28), Markus (14, 22–24), Lukas (22, 15–22) halten eine Abendmahlstafel»; S. 51, Abb. 24: «Apostelschiff der christlichen Kirche wider alle falschen Lehrer», Radierung von Matthias Zünd, Nürnberg 1570 (Eckbild rechts oben: Pauli Bekehrung, schriftlich); S. 61 ff., Abb. 29: «Das lutherische Bekenntnisbild von Roßtal» (zugeschrieben Hans Springklee 1490/95–1540). Die Sockelfiguren Petrus und Paulus bezeugen die Richtigkeit mit weisenden Gebärden; S. 219, Tafel 14: Augsburger Kupferstich zur Säkularfeier von 1648 im Jahre 1748 nach einem Vorbild von 1630 (Paulus feiert mit den drei Evangelisten, Markus, Matthäus und Lukas das Abendmahl).

642 BAUMSTARK, 2002, S. 35: Albrecht Dürer (1471–1528), Die Vier Apostel (1526), Lindenholz, pro Flügel 215×76 cm. Alte Pinakothek München.

643 Vgl. Kap. ‹Glasmalereien der Gotik und der Renaissance›, Anm. 305, 306.

644 Es handelt sich dabei um den Apostel und Evangelisten Johannes, den Apostel Petrus, den Evangelisten Markus und den Apostel Paulus.

645 LÜDECKE/HEILAND, 1955, S. 277 ff.; Martin SCHAWE, Dürer, Albrecht: Vier Apostel, in: Historisches Lexikon Bayerns [Online-Version].

646 ARNDT/MÖLLER, 2003, S. 249.

647 SCHAWE, 2006, Inv.Nr. 545, 540; vgl. Anm. 645.

Das heißt, dass in den fast drei Jahrhunderten, die eigentliche Funktion der Bilder, «die gemalte Predigt»[648], abhanden gekommen ist. Jedoch wurden anlässlich des Verkaufs an den Kurfürsten dank des Nürnberger Rates beim Maler Georg Vischer[649] Kopien bestellt, die zusammen mit den abgetrennten Texten im Nürnberger Rathaus der Öffentlichkeit zugänglich waren[650]. Somit blieb der ursprüngliche geistige Inhalt des Dürerwerks für die nachkommenden Generationen erhalten. Bei Simon Petrus entwickelte sich seit dem 4. Jahrhundert bis etwa 1300 der Typus mit rundem Kopf, krausem oder kurzem Haar, rundem oder eckigem Bart, wobei szenische Darstellungen, wie auch die Repräsentationsbilder der *Traditio legis,* gegenüber den Einzeldarstellungen im Vordergrund standen. Im Spätmittelalter veränderte sich der Petrustypus, indem sein Haupt nun mit einer Tonsur versehen wurde und sich die Kopfbehaarung auf eine Stirnlocke beschränkte[651].

Die Apostelfürsten in der Glasmalerei des 19. Jahrhunderts

Die Kunst des 19. Jahrhunderts nimmt den spätmittelalterlichen Typus auf und stellt den Apostelfürsten Petrus im Sinne einer Akzentuierung der Einzelfigur entweder allein oder zusammen mit Paulus oder seltener szenisch bei der Schlüsselübergabe dar. Peter Cornelius fertigte 1843/1844 die Kartons für die Heilig-Blutkapelle im Dom zu Schwerin, die von Ernst Gillmeister in Glas umgesetzt wurden. Die Fenster zeigen die Himmelfahrt Christi mit Maria und Johannes sowie Petrus und Paulus, Moses und Jesaias auf Konsolen unter Baldachinen in reicher Architektur[652]. Noch vor 1860 entstanden die Scheiben mit dem Motiv der beiden Apostelfürsten, die König Max II. für Papst Pius IX. nach Rom unter Max Emanuel Ainmiller in München anfertigen ließ[653]. Darüber hinaus schuf die königliche Glasmalereianstalt Apostelfürsten für Kirchen in Innichen, Kilndown, Bensheim und Winterthur[654]. Die Münsterbaukommission zu Basel entschied sich 1855 bei der Neugestaltung der Chorfenster für die Evangelisten als Einzelfi-

guren sowie in den anschließenden Fenstern für Petrus, Paulus (Abb. 90), Moses und David[655]. 1865 berichtete der Münchner Kunstanzeiger über zwei im Rathaus ausgestellte Glasgemälde mit den Aposteln Petrus und Paulus aus der Privat-Glasmalerei des Herzogs von Nassau für die Salzburger Bürgerspitalkirche[656]. Im Werk Johann Jakob Röttingers erscheint das Apostelpaar gleich mehrfach. Die ältesten Petrus- und Paulusfenster aus der Werkstatt Röttinger haben sich im Grossmünster in Zürich erhalten (Abb. 32) und wurden 1852/1853 nach Kartons des Nürnberger Glasmalers Georg Konrad Kellner ausgeführt[657]. In den frühen Dreißigerjahren des 20. Jahrhunderts beauftragte die Kirchenbaukommission im Rahmen einer Gesamtrenovierung den Künstler Augusto Giacometti mit der Neugestaltung der Chorfenster. Seit 1933 sind die beiden Apostelfürsten an die Westseite des Grossmünsters versetzt, wo sie die Stilepoche der ersten Hälfte des 19. Jahrhunderts würdig vertreten; wenngleich sie aus der gemalten Architekturumrahmung gelöst wurden[658].

648 ARNDT/MÖLLER, 2003, S. 249. In der Zusammenstellung Joseph Hellers von 1827 scheinen die Tafeln nicht auf.

649 ALLGEMEINES LEXIKON DER BILDENDEN KÜNSTLER 34, 1940, S. 416, Stichw. *Vischer, Georg, Maler in München.* 1625 als Meister aufgenommen, später Hofmaler; Werke: u. a. Kopie der «Vier Apostel» von Dürer.

650 POSSELT, 2010, Kommentar im Sandrart.net.

651 LDK 5, 2004, S. 541, Stichw. *Petrus.*

652 VAASSEN, 1997, S. 133 f.

653 VAASSEN, 2013, 193, 194; VAASSEN, 1997, S. 236 f.

654 VAASSEN, 2013, S. 328 (Winterthur, Laurenzkirche).

655 VAASSEN, 1997, S. 238; NAGEL/VON RODA, 1998, S. 51, Abb. 24: Franz Xaver Eggert, Petrus und Paulus, 1857.

656 VAASSEN, 1997, S. 245.

657 ZB, Ms. T 111.5: In den Protokollen des Vereins für das Grossmünster wird der Glasmaler als *Herr Kellner* genannt (Ms. T 111.5: Kommissionalbeschluss vom 16. Juni 1852: Zitat: *«Infolge einer Zirkularanzeige des Präsidiums, dass a) ein Theil der Kartons für das Mittelfenster im Chore von Herrn Glasmaler Kellner in Nürnberg an Herrn Glasmaler Röttinger dahier eingekommen sey [...]»*); bei Hoffmann wird *Georg Kellner* genannt (HOFFMANN, 1942, S. 263); ebenfalls bei VAASSEN, 1997 S. 167 f.; zuletzt bei GERSTER, 2012, S. 4–9.

658 Vgl. Abb. 32. Die Rezeption der historistischen Glasmalereien im 20. Jahrhundert wird im Kap. ‹Philosophisch-kunsthistorischer Diskurs› bzw. im Kap. ‹Rezeption› erörtert.

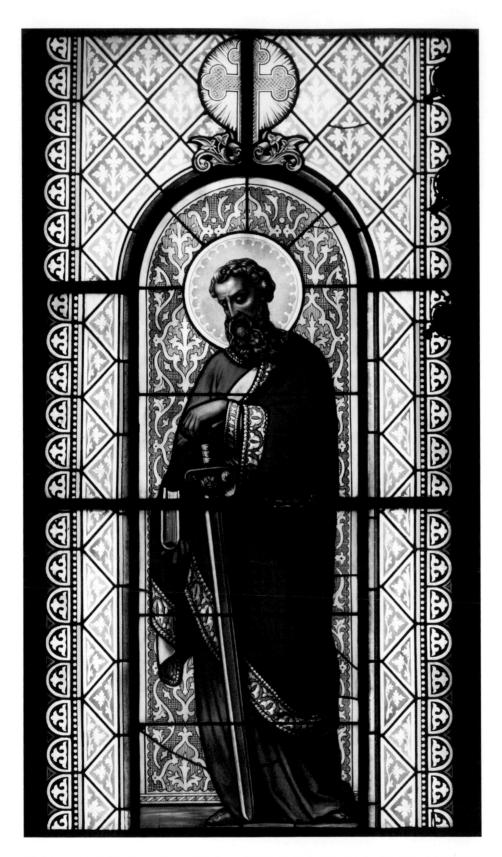

88. Johann Jakob Röttinger, Apostel Paulus, s III, Katholische Pfarrkirche Kirchdorf AG, 1865.

146

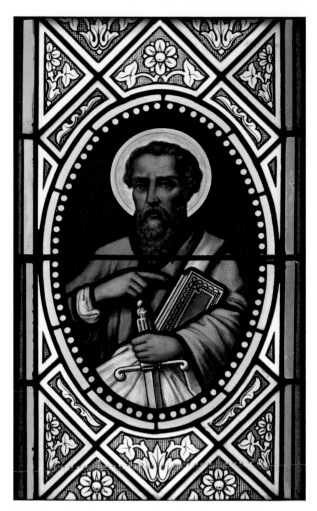

89. Johann Jakob Röttinger, Apostel Paulus, Medaillon, Chorfenster s II, Katholische Pfarrkirche Alterswil FR, 1873.

Im Vergleich mit Kellners Figuren sind Unterschiede im Typus, in der Haltung und in der Ausführung der Gewänder mit den nachfolgenden Darstellungen der Apostelfürsten Johann Jakob Röttingers festzustellen. Obwohl bei Petrus der Grundtypus in Anlehnung an die Reindelschen Stiche der Figuren am Sebaldusgrab offenbar wird, war es dem Glasmaler gelungen, die Petrusgestalten in den verschiedenen Kirchen des Landes individuell zu gestalten. Das Haupt des Petrus zeigt zwar praktisch immer das Schema des Kahlkopfes mit dem weißen Haarkranz, der Stirnlocke und dem kurzen Vollbart; doch sind es kleine Veränderungen in der Erscheinung, der Neigung des Hauptes, im Gesichtsausdruck, die den Köpfen eine gewisse Eigenständigkeit verleihen. Die Petrusdarstellun-

gen auf den Medaillons in Stäfa ZH (n II) und im Chorscheitelfenster in Mettmenstetten ZH stimmen hingegen ziemlich überein (vgl. Abb. 71, 87). Das Gewand Petri schuf Jakob Röttinger in einheitlicher Farbe – einem gelben (goldenen) Talar mit blauem Pallium – es variierte allerdings im Schnitt und in der Ausstattung. Die prächtigste Ausstattung findet sich bei den Apostelfürsten in Kirchdorf AG (Abb. 29, 88) aus dem Jahr 1869[659]. Dort zieren aufwendige Bordüren das Gewand des Petrus und eine edelsteinbesetzte Agraffe hält den Umhang an der Schulter zusammen. Als Attribute werden Schlüssel und Buch beigefügt. Paulus erscheint jünger als Petrus, trägt einen langen dichten Bart und volles braunes Haar. Ihn kleidet ein grüner Talar, der von einem roten Pallium umhüllt wird. Die Attribute Schwert und Buch zeichnen Paulus als Verkünder des Wortes Christi aus und verweisen auf seine Enthauptung. In den Jahren 1873/1874 lieferte der Glasmaler Fenster für die Pfarrkirche in Alterswil FR[660]. Hier wurde das südliche Chorfenster mit den beiden Apostelbüsten auf längsovalen Medaillons gestaltet. Petrus trägt auch hier eine Stirnlocke und einen kurzen, zweigeteilten Bart, wobei jedoch das Haupt etwas in die Länge gezogen wurde. Das längliche Gesicht passt sich der Form des ovalen Medaillons an. Dasselbe ist auch mit dem Haupt des Paulus geschehen, der mit dichtem braunen Haar und langem Vollbart abgebildet wird. Petrus umfasst mit seiner Linken zwei Schlüssel und hält seine Rechte segnend nach oben. Paulus (Abb. 89) hält links

659 Die ursprünglich für den Chor der Kirche angefertigten Fenster wurden anlässlich der Neuausrichtung des Altars in Richtung der Gläubigen in das Langhaus versetzt.

660 PA Alterswil, Niederschrift (1900) basierend auf den Notizen des Kaplans (1870–1885) bzw. der verschollenen Bauakten, S. 15–16: *«Die Glasarbeiten wurden einem Herrn Glasmaler, J. Röttinger, von Zürich übergeben, der auch für verschiedene andere Kirchen des Kantons Freiburg Kirchenfenster lieferte [...]»*; ZB Nachl. Röttinger 2.371, 234 Alterswyl/ Bäriswyl 1877: Zürich, 29. Januar 1877 (Sterbetag Johann Jakob Röttingers), *«An Herrn Bäriswyl, Präsident der Baukommission Alterswyl. Geehrter Herr. Ich beehre mich Ihnen den Empfang der mir per Postmandat übermachten Fr. 464.- zu bescheinigen. Achtungsvoll per J. Röttinger, Fr. Ver. Röttinger»* (beide Unterschriften stammen von Verena Röttingers Hand).

das Schwert und klemmt die Heilige Schrift unter den Arm; mit seiner rechten Hand verweist er auf das Buch. Besonders bei Paulus hatte der Glasmaler Schwierigkeiten in der anatomisch korrekten Darstellung der Arme, die viel zu kurz geraten sind.

Bei beiden Heiligen erscheinen die Köpfe im Verhältnis zu den Schultern zu groß, was teils zweifellos auf die ungewohnte Arbeit mit Längsovalen zurückzuführen ist. Nicht nur die kräftigen Farben der Kleider lassen das Vorbild erkennen, auch typologisch lehnt sich Röttinger an den Paulus im Basler Münster (1857) von Franz Xaver Eggert an (Abb. 90).

Letzterer erhielt die Weisung vom Auftraggeber, sich für die Darstellung des Paulus' nach dem Vorbild Overbecks zu halten und die Glatze des Petrus mit einer Stirnlocke zu versehen[661]. Das Chorscheitelfenster in Kilchberg ZH von 1858 zeigt nach den beiden Apostelfiguren im Grossmünster, die beiden ältesten Vertreter, die dementsprechend etwas statisch wirken und frontal dargestellt sind. Starke Ähnlichkeit mit dem Kilchberger Paulus weist der zwei Jahre später geschaffene Apostelfürst in Wädenswil auf. Insgesamt kennzeichnet die Figuren in den Sechzigerjahren jedoch ein lebendigerer und abwechslungsreicherer Ausdruck mit dem Bestreben für jede Kirche ein individuelles Kunstwerk zu stellen. Als Beispiele für szenische Petrusdarstellungen kann einerseits das Fenster aus dem Jahr 1864 in Saint-Imier genannt werden, wo im oberen Teil des Chorachsenfensters die «Schlüsselübergabe» dargestellt wird[662], andererseits das Fenster der «Bergpredigt» (I) in der reformierten Kirche Oberentfelden AG von 1866, in dem Petrus als aufmerksamer Zuhörer (Abb. 45) am rechten Bildrand erscheint.

Die beiden Autoren Falko Bornschein und Ulrich Gaßmann verweisen in ihrer Kompilation der Glasmalereien des 19. Jahhunderts in Thüringen ebenfalls auf die Betonung christologischer Themen in evangelischen Kirchen, wobei Evangelisten und Apostel als Botschafter des Evangeliums sowie als moralische Vorbilder aus dem Kreise Jesu – häufig ohne Nimbus – abgebildet wurden. In katholischen Kirchen übten die nimbierten Apostel, Evangelisten und Heiligen aufgrund der komplexen Liturgie und dem anders geprägten Bildverständnis ihre Funktionen als Vermittler, Märtyrer, Fürbitter und Nothelfer aus[663].

Evangelisten

Als Zeugen des irdischen Lebens Christi und Autoren der Evangelien im Neuen Testament haben die Abbildungen von Matthäus, Markus, Lukas und Johannes seit dem 2. Jahrhundert einen hohen ikonographischen Stellenwert. Als Repräsentanten der neutestamentlichen Kirche stellen sie das Pendant zu den Propheten des Alten Testaments dar[664]. Meist sind sie in Haltung und Kleidung dem Schema der antiken Rhetoren- und Philosophenbildnisse angenähert und repräsentieren sich schreibend, lesend oder lehrend. Die Art und Weise der Darstellungen resultiert aus dem immer wieder stattgefundenen Wandel der äußeren Erscheinung. Große Bedeutung erlangten dabei die so genannten Autorenbilder, welche gelegentlich in der Monumentalmalerei, häufig jedoch in der Buchmalerei anzutreffen sind und deren Kunst sich dadurch auszeichnete, dass der Beginn des Textes jeweils durch ein ganzseitiges Einzelbild des Autors gestaltet wird. Entgegen dem Darstellungskanon des frühen Mittelalters, wo sich Matthäus und Johannes als bärtige Greise und Lukas und Markus als jüngere Männer präsentieren, erscheint Johannes im späteren Mittelalter als junger Mann, ein Typus, den die Glasmaler des 19. Jahrhunderts übernommen haben. Das häufige Modell des stehenden Evangelisten in der Glasmalerei, frontal oder im Halbprofil, hat allerdings seine Wurzeln in der frühchristlichen Kunst.

661 NAGEL/VON RODA, 1998, S. 46.
662 ZB Nachl. Röttinger 1.202.18; ZB Nachl. Röttinger 2.371, Nr. 121, 166. Die Glasmalereien Johann Jakob Röttingers in der Westschweiz werden im Rahmen des Projekts von Fabienne Hoffmann bearbeitet.
663 BORNSCHEIN/GASSMANN, 2006, S. 34–36.
664 LDK 2, 2004, S. 395 ff., Stichw. *Evangelisten*.

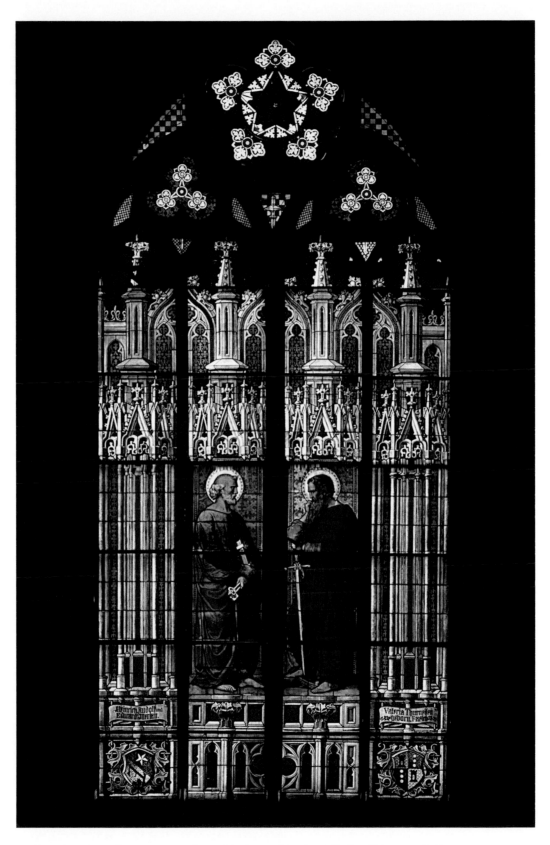

90. Franz X. Eggert/A. Hövemeyer, Apostel Petrus und Paulus, S II, Basel Münster, 1857.

Entsprechend erfolgte die Rahmung mittels einer Arkade oder einer Ädikula, wobei eine gelegentliche Ausstattung mit Vorhängen im spätantiken und frühchristlichen Repräsentations- beziehungsweise Autorenbild aufkommt[665]. Die Existenz von Evangelisten auf mittelalterlichen Glasmalereien[666] hatte wohl gleichermaßen Vorbildwirkung auf die Glasmaler des Historismus wie auf die zeitgenössische Tafelmalerei.

Evangelistenreihen des 19. Jahrhunderts

Die frühesten glasmalerischen Darstellungen von Evangelisten im 19. Jahrhundert entstanden 1823 im Freiburger Münster[667] beziehungsweise 1828 für die Nürnberger Frauenkirche und etwa gleichzeitig für den Dom zu Regensburg[668]. Weitere Glasmalereien mit diesem Thema sind für den Kölner Dom fassbar, dessen Kartons Heinrich M. v. Hess[669] zeichnete sowie für die Kathedrale in Sion VS. Die Fenster in Sion stammten aller Wahrscheinlichkeit nach aus der Werkstatt J. Röttingers[670]. Das mittlere Chorobergadenfenster im Basler Münster aus dem Jahre 1857 zeigt ebenfalls die vier neutestamentlichen Zeugen unter Kielbogen, vor gemalten Vorhängen und mit den üblichen Schreibutensilien ausgestattet, über einer Reihe den Evangelisten zugeteilten Symbole. Auf diesem von Franz Xaver Eggert ausgeführten Fenster erscheinen Matthäus und Markus sowie Lukas und Johannes einander zugewandt, letzterer legt seine Rechte, die die Feder hält, an die Stirn und sieht in dieser Pose die Apokalypse[671]. Im Vertrag mit der Kirchgemeinde Rapperswil BE von 1861 werden vom Auftraggeber Darstellungen der «vier Evangelisten oder Apostel» gewünscht[672]. Wie schon erwähnt, sind die damals ausgeführten Glasmalereien Johann Jakob Röttingers für die drei Chorfenster, des «Lehrenden Christus» und der vier Evangelisten, noch in situ erhalten[673]. Hier wenden sich die beiden Evangelistenpaare, Matthäus und Markus auf n II und Lukas und Johannes auf s II (Abb. 91), einander zu, ähnlich wie in Basel. Dabei wird das Vorbild der «Vier Apostel» Dürers[674] besonders evident (vgl. Abb. 30). Johannes und

Paulus (bei Röttinger Lukas und Johannes) erscheinen in Rapperswil seitenverkehrt, wobei beim Evangelisten Lukas nur Körper, Gewand und Haltung übernommen und das Haupt individualisiert wurde.

Ein weiteres Evangelistenfenster entstand 1866 in Saint-Imier (n II), auf dem im unteren Fensterteil Lukas und Johannes und darüber Matthäus und Markus dargestellt sind. Hier lehnte sich Röttinger stark an Vorlagen Friedrich Overbecks an.

665 LCI 1, 1968, Sp. 708, 709, Stichw. *Evangelisten und Evangelistensymbole* (U. Nilgen).

666 KURMANN-SCHWARZ, 2001, S. 111, 160, 161 bezügl. der Kathedrale in Chartres, Glasmalereien des 13. Jahrhunderts; KURMANN-SCHWARZ, 2008, CVMA Königsfelden, Farbtafeln 32–41: Auf dem Apostelfenster erscheinen die beiden Apostel und Evangelisten, Matthäus und Johannes (um 1340).

667 PARELLO, 2000 (2), S. 9, Abb. 3, ehemals Fenster s XXII von Glasmaler Andreas Helmle.

668 VAASSEN, 2007, S. 47–48. Hier zeichneten sich der Glasmaler M.S. Frank und der Künstler J. Schraudolph verantwortlich.

669 DAHMEN, 2000, S. 201–206; VAASSEN, 1997, S. 192–193: sog. Bayernfenster, die 4 großen Propheten, Evangelisten und die lateinischen Kirchenväter.

670 VAASSEN, 1997, S. 175. Glasmaler Johann Klaus gibt an in Sion die 4 Evangelisten sowie die Kaiser Karl und Sigismund ausgeführt zu haben. Im Hinblick auf andere Schlüsselwerke, wie die Darstellung Christi und zweier Apostel im Grossmünster, musste Klaus die Evangelisten in Sion während seiner Zeit bei Johann Jakob Röttinger gefertigt haben. Nach: JENNY, 1934, Kunstführer der Schweiz, 1934–1945, S. 478 wurden die Glasmalereien der Kathedrale von Sitten von Johann Jakob Röttinger ausgeführt (S. 478, ohne Jahresangabe). Später lieferte Sohn Jakob Georg Röttinger zwei Fenster für die Barbarakapelle (nach freundlicher Auskunft Herrn Renaud Buchers; Hinweis von Eva Zangger auf zwei Briefe im Nachlass Jakob Georg Röttingers, in denen *«die Arbeit Ihres geehrten Vaters»* erwähnt wird: ZB Nachl. Röttinger, 2.219 Sion).

671 NAGEL/VON RODA, 1998, S. 48 u. 49.

672 ZB Nachl. Röttinger 1.133.

673 Die Komposition verweist inhaltlich auf das Frühchristentum, als sich die Evangelisten – allerdings noch ohne Evangelistensymbole – um den «Lehrenden Christus» versammelten, wie dies die Abbildung in den Katakomben der Heiligen Marcus und Marcellianus zeigt. (LCI 1, 1968, Sp. 696 f., Stichw. *Evangelisten und Evangelistensymbole* (U. Nilgen)).

674 Vgl. Anm. 114, 306–310.

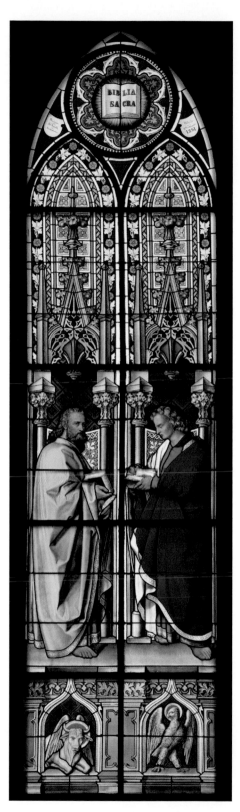

91. Johann Jakob Röttinger, Evangelisten Lukas und Johannes, Chorfenster s II, Evangelisch-Reformierte Pfarrkirche Rapperswil BE, 1861.

Matthäus lässt sich in diesem Fall als Kopie identifizieren, der Evangelist Lukas nach Overbeck diente bei Markus als Vorbild und Röttingers Lukas lässt die seitenverkehrte Darstellung von Overbecks Apostel Simon erkennen[675] (vgl. Abb. 38, 39). 1871 entstanden vier Evangelisten-Medaillons für die Fenster mit «Geschlechterwappen» in der Friedhofkapelle in Stans (Abb. 131).

1875 führte Johann Jakob Röttinger schließlich die vier Evangelisten für den Chor der Kirche in Glis VS aus (s III, Abb. 92), die mit der Werkstattsignatur sowie einem Hinweis auf den Stifter versehen wurde[676]. Die in einer Reihe positionierten Evangelisten nehmen aufeinander keinen Bezug und stehen künstlerisch wegen ihrer schlichten Ausführung schon dem Stil der zweiten Jahrhunderthälfte nahe[677]. Die gedrungenen Gestalten zeigen eine stärkere Betonung der Umrisse, wirken plakativ und eignen sich zur Betrachtung auf Weitsicht.

675 Elgin van Treeck danke ich für wertvolle Hinweise bzgl. der Vorlagen nach Overbeck für die Glasmalereien in Saint-Imier. Die Vergleiche wurden mit damals kursierenden Drucken angestellt; hier mit Blättern des Vereins zur Verbreitung religiöser Bilder in Düsseldorf aus dem Fundus der Glasmalereiwerkstatt Gustav van Treecks (numeriert und bezeichnet: Overbeck inv!/Franz Keller se). Angaben zu den Stichen nach Friedrich Overbeck: Howitt, 1886, Bd. II, S. 423; Kat. Ausst. Köln, 1980, S. 42. Die Stiche entstanden 1842–1853 nach Kohlezeichnungen F. Overbecks. Diese dienten als Entwürfe für kleinformatige Fresken in der Kapelle der Villa Torlonia/Castel Gandolfo (1835–1844); Vgl. Kat. Ausst. Mainz, 2012, S. 218–223, bes. Abb. 6, S. 221.

676 ZB, Nachl. Röttinger 1.58.

677 Vaassen, 1993, S. 23: Elgin Vaassen bezeichnet die Malweise zwischen 1850 und 1880 als ein großflächiges, feinporiges Vertreiben der Farbe, die ab etwa 1880 durch breitere Konturen und eine betontere Strichführung abgelöst wird.

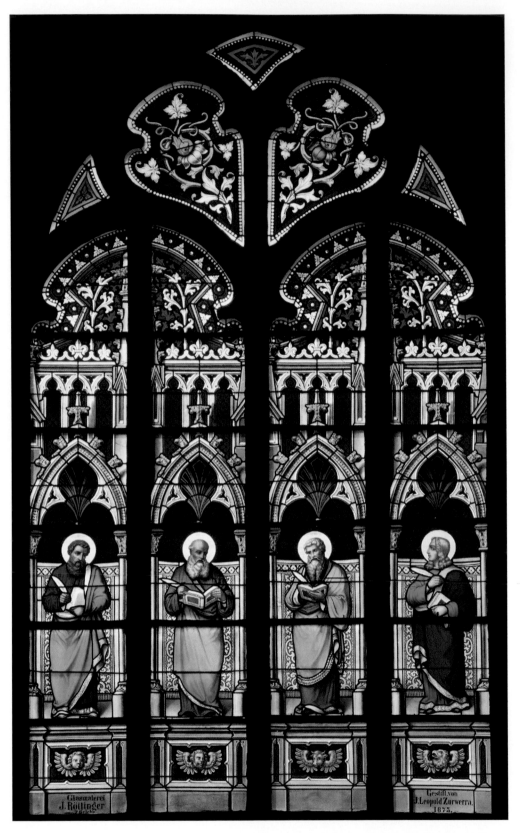

92. Johann Jakob Röttinger, Evangelisten, Chorfenster s III, Katholische Pfarrkirche Glis VS, 1875.

Propheten

Die Darstellung von Propheten neben neutestamentlichen Personen und Szenen verdeutlicht die Einheit des Heilsgeschehens[678]. Die Symbolik des christlichen Kosmos schafft den Bezug zwischen den vier Evangelisten, den vier großen Propheten und den vier Himmelsrichtungen – hierarchisch sind die Propheten unterhalb der Apostel platziert. Während sie im Frühchristentum und im frühen Mittelalter in ihrer Erscheinung den Aposteln gleichen – frontal stehend und in antiker Philosophentracht mit Schriftrolle – werden sie später mittels Judenhut, langen Bärten und der offenen Schriftrolle charakterisiert. Auf diese Weise präsentieren sie sich in den berühmten Prophetenfenstern um 1140, im romanischen Scheibenzyklus des südlichen Obergadens des Augsburger Doms. In den Glasmalereien von Saint-Denis und Chartres bezeugen die Propheten, neben der Wurzel Jesse stehend, die Erfüllung der Messiashoffnung[679].

Von Prophetenbüsten und Prophetenreihen im 19. Jahrhundert

Prominentes Beispiel sind die vier Prophetenbüsten im Fenster der «Anbetung der Könige» (nw III) im Dom zu Regensburg von 1829. Sie wenden sich den Vorfahren Christi zu, wo Salomo und David in den mittleren Vierpässen «aus Stein» erscheinen[680]. In den Entwürfen für die Münchner Maria-Hilf-Kirche wurden die Propheten, in der Architekturbekrönung des Fensters der Geburt Christi[681] sitzend, von Johann Schraudolph und Joseph A. Fischer gezeichnet (Abb. 37); die Architekturmalerei stammte von Max Ainmiller.

Johann Jakob Röttingers Prophetenreihe im Chorfenster der Kirche zu Glis VS (s II, Abb. 93) von 1873 zeigt die drei biblischen Gestalten Jesaias, Jeremias und Ezechiel stehend und frontal abgebildet, als alte bärtige Männer mit Kopftüchern, die sich der Mitte zuwenden und im Sockel mit ihrem Namen bezeichnet sind.

Lediglich Daniel, als vierter im Bunde, erscheint als jüngerer, bärtiger Mann mit nach oben zeigender Geste und goldenem Stirnband. Hinter ihm

lugt als Zeichen seiner Vision ein Widder hervor (Dan 8, 1–27). Bemerkenswert ist das Bild des Jeremias, der an einem langen Stab einen siedenden Kessel hält, welcher nach Jer 1, 13 überkocht und in Richtung Norden weist, von wo das Unheil über Jerusalem hereinbrechen wird. Die Beigabe dieses Attributs ist selten und kommt auf einer Jeremiasstatue in der Kathedrale zu Lausanne von 1240 vor[682]. Dank Johann Jakob Röttingers Engagement in der Lausanner Kathedrale, als er 1862 einen Auftrag über ein oder mehrere heraldische Fenster im Glockenturm[683] ausführte, kannte er offensichtlich die seltene Jeremias-Darstellung mit dem Attribut des Kessels. Prophet Isaias hält eine Schreibtafel und einen Griffel, Prophet Ezechiel das Schwert und eine Rolle, während Daniel nach dem vereinzelnd vorkommenden Maiestas-Schema dargestellt wird[684]. Bei diesen so genannten Prophetenreihen handelt es sich um ein nachmittelalterliches Phänomen, dessen berühmtestes Beispiel in Michelangelos Sixtina zu finden ist[685];

678 LThK 8, 2009, Sp. 635–636, Stichw. *Propheten*, V. Ikonographie (Helga Sciurie).

679 LThK 8, 2009, Sp. 635–636, Stichw. *Propheten*, V. Ikonographie (Helga Sciurie).

680 VAASSEN, 2007, S. 54 ff. Bei den Vierpässen handelt es sich um gemalte Architektur.

681 KAT. AUSST. NEUSS, 1981, S. 34, Kat. Nr. 8, Abb. S. 12.

682 LCI 2, 1970, Sp. 387 ff., Stichw. *Jeremias* (Adelheid Heimann). Die Verfasserin Adelheid Heimann zitiert nach PETER MEYER, Schweizerische Münster und Kathedralen des Mittelalters, Zürich 1945. Vgl. BOERNER, 2004, S. 185 u. 194: Jeremias hält in Lausanne einen Feuertopf aus dem die Flammen schlagen. «Einen im Feuer stehenden Topf erblicke ich, er kehrt seine Vorderseite von Norden her zu.» (Jer 1, 13) Damit wird ikonographisch ausgedrückt, dass Christus das Böse in Brand setzt und es überwindet.

683 ZB Nachl. Röttinger 1.81. Des Preises über 900 Franken nach zu urteilen, handelte es sich um mehr als ein einziges Fenster.

684 LCI 1, 1968, Sp. 472, Stichw. *Daniel* (H. Schlosser). Das Maiestas-Schema bezieht sich auf den Gestus und wurde um 1085 in Ste-Radégonde (Poitiers) angewandt.

685 LCI 1, 1968, Sp. 469 ff., Stichw. *Daniel* (H. Schlosser). In der Sixtina werden die Propheten jedoch in sitzender Pose dargestellt.

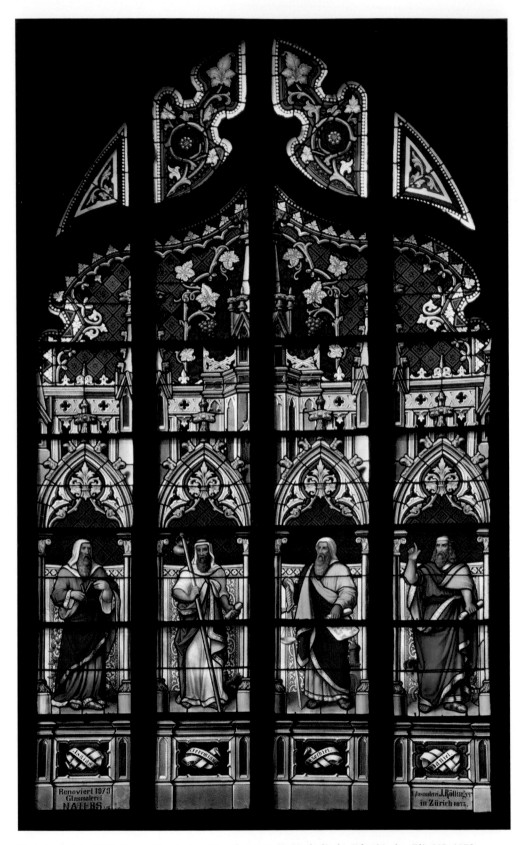

93. Johann Jakob Röttinger, Propheten, Chorfenster s II, Katholische Pfarrkirche Glis VS, 1873.

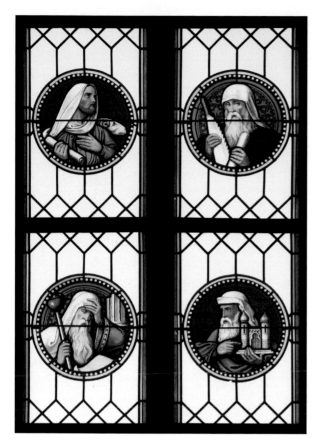

94. Johann Jakob Röttinger, Propheten, Schiffenster n V,
Katholische Pfarrkirche Nottwil LU, 1869.

eine Darstellungsweise, die sich bis ins 19. Jahrhundert halten konnte. Johann J. Röttingers Fenster in Glis lehnt sich in Komposition und Ausführung stark an die Prophetenreihe der Bayernfenster im Kölner Dom von 1848 an. Letztere wurde von der Münchner Glasmalereianstalt unter der künstlerischen Leitung von Heinrich Maria von Hess von Joseph A. Fischer und J. Hellweger unter Inspektor Max E. Ainmiller hergestellt und erfuhr damals eine außerordentliche Wertschätzung[686]. Selbst die Schriftbänder mit den Namen der einzelnen Figuren fehlen in Glis nicht. In Nottwil gestaltete Röttinger die Schifffenster nach Wunsch des Auftraggebers mit Medaillons Heiliger und biblischer Gestalten[687]. Auf dem Fenster n V erscheinen Daniel mit der Schriftrolle und dem Widder, Prophet Isaias mit der Säge, Prophet Ezechiel mit dem verschlossenen Tor der Vision sowie Prophet Jeremias (Abb. 94) auch hier mit

einem Stab – wohl für den Kessel – ausgestattet. In Unterägeri gab Röttinger dem in ganzer Figur dargestellten Isaias ebenfalls das Attribut der Säge bei, um auf dessen Martyrium hinzuweisen.

Maria und Joseph als Repräsentanten der Zeitgeschichte

Im Werk Johann Jakob Röttingers lassen sich verschiedene – noch in situ verbaute Glasmalereien – aus dem marianischen Themenkreis finden. Der Entwurf für ein Stifterfenster in Jona mit der «Mariä Himmelfahrt» nach Reni wurde im Kapitel über unsignierte Entwürfe bereits ausführlich dargelegt. Des Weiteren haben sich in katholischen Pfarrkirchen ein Medaillon der Himmelskönigin mit Kind in Alterswil FR, ein Fenster mit der Muttergottes und dem Jesuskind als Ganzfigur in Leukerbad VS, eine Verkündigungsszene in Bünzen AG sowie eine Maria Immaculata auf der Mondsichel stehend in Leuggern AG erhalten. Sowohl in Leukerbad wie in Leuggern sind die Marienfenster neben Josephsabbildungen platziert. Die häufige Darstellung des Heiligen Joseph im 19. Jahrhundert entsprang einer besonderen Verehrung des Nährvaters Christi, ab 1870 *der* katholische Sozialheilige, dessen Wertschätzung schließlich in der päpstlichen Enzyklika Quamquam pluries vom 15. August 1889 kumulierte[688]. Josephs Patronat des Handwerkers wurde auf den Arbeiter transponiert, der wie der Nährvater bescheiden und christlich tugendhaft zu leben hatte: «[...] Ein Arbeiter ist es, dem er seinen eingeborenen Sohn und dessen hochgebenedeite Mutter

686 Vaassen, 2013, S. 115, 116; Wolff, 2005, S. 42; Vaassen, 1997, S. 192–195.
687 ZB Nachl. Röttinger 1.119.
688 Johannes Paul II, 1989: In der «Redemptoris Custos» erinnert der Papst an den vor hundert Jahren getätigten Aufruf an die Gläubigen, den heiligen Joseph um den Schutz der bedrohten Kirche anzuflehen. Bereits 1847 wurde das Fest des heiligen Josephs von Pius IX auf die ganze katholische Kirche ausgeweitet. Korff, 1973, S. 103.

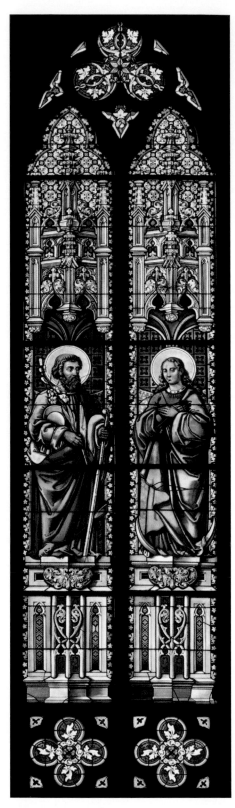

95. Johann Jakob Röttinger, Joseph, Maria Immaculata, Chorfenster n II, Katholische Pfarrkirche Leuggern AG, 1853.

anvertraute!»[689]. In der reformierten Pfarrkirche zu Pieterlen wurden zwei der ehemaligen Chorfenster Johann Jakob Röttingers aufgefunden und nach erfolgter Restaurierung wieder eingesetzt. Dabei handelt es sich um eine Kreuzigungsgruppe mit Maria und Johannes sowie um ein Weihnachtsbild mit der Anbetung der Hirten[690]. Bis auf häufig auftretende christologische und mariologische Monogramme, die wiederholt die Bogenausmündungen von Schifffenstern zieren, gibt es im Werk Johann Jakob Röttingers kein erhaltenes Marienmotiv, das immer wiederkehrend vorkommt. Während es sich beim mariologischen Monogramm um den in den Buchstaben M einbeschriebenen Namen «Maria» handelt, wird manchmal auch ein mit Rosen eingefasstes Herz Mariä als Pendant zum «Herz-Jesu» verwendet, das mit einer Dornenkrone beziehungsweise einem kleinen Schwert verletzt dargestellt wird.

Die «Maria Immaculata» in der Glasmalerei des 19. Jahrhunderts

Der Typus der Madonna auf der Mondsichel in der Pfarrkirche zu Leuggern aus dem Jahre 1853 ist die älteste erhaltene Mariendarstellung Röttingers (Abb. 95) und soll aus zeitgenössisch passendem Kontext der Erlassung der päpstlichen Bulle «Ineffabilis Deus» ikonographisch untersucht werden. Die Madonna auf der Mondsichel wurzelt in der Darstellung Mariens als Apokalyptisches Weib und gilt im Allgemeinen als Metapher für die Maria Immaculata. Die Dogmatisierung der «Unbefleckten Empfängnis» durch die Katholische Kirche erfolgte am 8. Dezember 1854 und galt gewisser-

689 KORFF, 1973, S. 105. Gottfried Korff diskutiert den ideologischen Einsatz der Heiligenverehrung durch die katholische Kirche in Bezug auf den Familiarismus, der Lösung der sozialen Frage (Josephverehrung statt Sozialdemokratie), Verklärung der Arbeit sowie die Lösung des Armutsproblem durch Caritas und Fürsorge.
690 Auch hier wird Joseph als fürsorglicher, beschützender Familienvater dargestellt. Ein weiteres Fenster Röttingers mit der Geburt Christi befand sich in der Stadtkirche Sankt Nikolaus in Wil SG, das sich nicht erhalten hat (KiA Wil, 40.10.05.01; 40.10.05, Briefe und Verträge).

maßen als Abschluss einer Entwicklung, die damals für den Frömmigkeitsstil der katholischen Restauration bedeutungsvoll war[691]. In diesem Sinne ist die Madonna in Leuggern im Chorfenster n II ein aktuelles ikonographisches Zeugnis, das die historischen Entwicklungen der Kirchengeschichte widerspiegelt. Die weibliche Bezeichnung von Städten, Tochter Zion beziehungsweise Jungfrau Jerusalem, besitzt lange Tradition und führt auf die Schriften der Propheten Jesaia und Jeremia zurück. Bezeichnend ist für den sprachlichen Code des Alten Orients, dass Städte in schlechten Zeiten als Frau benannt wurden – nämlich, wenn ihr Untergang drohte, wie dies die Beispiele «Tochter Babel» beziehungsweise «Jungfrau Babel» zeigen[692]. Dieser Sprachcode wurde Jahrhunderte später auf die Mariologie – Maria als Jungfrau, Braut und Mutter – gemäß dem Sinnspruch «aus der Krise erwächst das Heil» übertragen. Die Frau als Symbolfigur für Schwäche wird als Metapher eingesetzt und erscheint als Himmelsfrau von der Sonne umstrahlt – die Mondsichel unter den Füßen – am Firmament[693]. Die seit dem 14. Jahrhundert geläufige Darstellung zeigt die (schwangere) Frau bekränzt und mit zwölf Sternen umgeben, während im 16. Jahrhundert die Schlange[694] zu ihren Füßen hinzukommt. Die Figur wird im Mittelalter und darüber hinaus von den Katholiken als Muttergottes, als Gebärerin Christi, interpretiert, verkörperte jedoch ursprünglich das alttestamentliche Gottesvolk, das den Messias und die Kirche hervorgebracht hatte[695]. Die ewige Kirche ist ein Sinnbild, das mit der Geburt Jesu in Verbindung gebracht wird, da im Alten Testament und in der jüdischen Literatur die Wehen einer gebärenden Frau für Zeiten der äußersten Not und der Drangsale Israels standen, die so überwunden wurden und den Anbruch einer neuen Zeit signalisierten[696]. Bruno Boerner hebt anlässlich seiner Untersuchung des Marienportals der Kathedrale von Lausanne hervor, dass selbst große Marienverehrer, wie Bernhard von Clairvaux im 12. Jahrhundert, sich gegen die «Erbsündenfreiheit» Mariens bei deren Empfängnis durch Anna ausgesprochen haben. Auch Thomas von Aquin und

Bonaventura vertraten die Auffassung, die Lehre der Immaculata Conceptio sei im Sinne der christologischen Lehre abwegig, da Maria im Falle ihrer erbsündenfreien Empfängnis den Heiland als Erlöser nicht mehr notwendig gehabt hätte[697].
Die Madonna Röttingers nimmt in Leuggern die rechte Fensterhälfte des Chorfensters n II ein. Auf einem Sockel stehend wendet sich die Mariengestalt Joseph zu, dessen Ganzfigur die linke Fensterseite füllt. Beide stehen unter einer gemalten gotischen Tabernakelarchitektur mit grünem Gewölbe mit Goldfarbe akzentuierten Rippen (4a, 4b). Der Hintergrund der beiden Heiligen wird mit einem Damastmuster aus schwarzen Quadraten auf lila Untergrund und Zierleisten aus Blüten und Blättern gebildet, wobei die Obergrenze der gemalten Vorhänge etwa die Schulterhöhe der Figuren erreicht. Röttingers Immaculata wird dem Kanon entsprechend auf der Mondsichel stehend, mit vor der Brust gekreuzten Händen dargestellt. Auf dieselbe Weise schuf Reni das Altarbild der «Immaculata Conceptio» in Forlì, San Biagio (Abb. 96)[698].

691 BRÜCKNER, 2003, S. 35; Das Dogma von der Unbefleckten Empfängnis des Gottessohns durch Maria wurde ausgeweitet auf die Empfängnis Mariens durch Anna, daher wird der Festtag am 8. Dezember also 9 Monate vor Mariä Geburt (8. September) begangen (KELLER, 1968, 2001, S. 409).

692 LOHFINK/WEIMER, 2008, S. 234 ff.

693 Der Mond soll für «Pulchra ut luna» aus dem Hohelied stehen. (KELLER, 1968, 2001, S. 400 ff.)

694 Die Schlange steht für das Böse, deren Kopf Maria zertritt. Häufig windet sich die Schlange um eine Weltkugel. Vgl. Offb 12, 9: die alte Schlange, die Teufel und Satan heißt und die ganze Welt verführt. Im Nachlass hat sich ein Stahlstich aus dem Verlag Benziger, Einsiedeln nach Deschwanden (24.5×16 cm) erhalten, der die «unbefleckte Empfängnis der heiligsten Jungfrau Maria (Die hl. Kirche)» zeigt. (ZB Nachl. Röttinger 4.5.6).

695 KELLER, 1968, 2001, S. 238 ff.; Offb 12, 1–6.

696 SCHILLER, 1976, S. 77 f. Als Präfiguration für die jungfräuliche Empfängnis wurde der brennende Dornbusch gesehen, vgl. PARELLO, 2009, S. 114.

697 BOERNER, 2004, S. 190.

698 WIMBÖCK, 2002, Tafel X. Guido Renis «Immaculata Conceptio» in Forlì, S. Biagio zeigt dieselbe Haltung. Möglicherweise hat sich Röttinger auch hier an Reni angelehnt. JÖCKLE, 2012, S. 30–32: Der Autor bezeichnet die

149. *The Immaculate Conception.* 1628–9. Forlì, S. Biagio. (Cat.no.123)

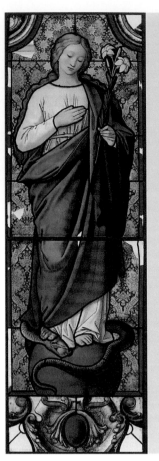

96. Guido Reni, Mariä unbefleckte Empfängnis, Leinwand, 325×220 cm, Forlì, S. Biago, 1628/29.

97. Königliche Glasmalereianstalt München/Heinrich M. v. Hess, Maria Immaculata, Erzengel Michael, ehemals Katholische Pfarrkirche Breitbrunn am Chiemsee, 1851 (Werkstätten Gustav van Treeck, München/Breitbrunn katholisches Pfarramt).

Das Mondsichelattribut soll als Sinnbild für die Vergänglichkeit auf Offenbarung 12,1 basierend verdeutlichen, dass die Immaculata Concepta von der vergänglichen Welt unberührt blieb[699]. Die Bildkomposition des Chorfensters in Leuggern unterstreicht die Unantastbarkeit Mariens, durch die Anwesenheit Josephs in der linken Fensterhälfte, der mit der Lilie der Keuschheit ausgestattet, Wanderstock und Hut des Zimmermanns trägt und als reifer, bärtiger Mann der graviden Gottesmutter Schutz und Unterhalt bietet. Das Haupt des Leuggerer Joseph wurde in Anlehnung an das Haupt des Petrus im Grossmünster (Entwurf Georg Konrad Kellner, Abb. 32) gebildet; beide Fenster entstanden im selben Jahr[700]. Der Entwurf einer Maria Immaculata für die Pfarrkirche Breit-

brunn am Chiemsee (Abb. 97) stammt aus dem Umkreis Heinrich Maria Hess' (1798–1863) und wurde 1851 von der Königlichen Glasmalereianstalt München, also zwei Jahre vor Röttingers

vor der Brust *gefalteten* Hände der Maria Immaculata als für das 19. Jahrhundert typisch und verweist auf Altarbilder des Malers Joseph Schlotthauer (1789–1869) z.B. in Sankt Martin, Lingenfeld, einem Schüler von Peter Cornelius und Inspektor an der Akademie München; vgl. Anm. 1348.

699 MARIENLEXIKON 3, 1991, S. 74–75, Stichw. *Halbmond* (G. Ramsauer).

700 KGA Leuggern: K III 2 4: Kirchenvorstand: Akten des Kirchenbaus 1838–1855: Der Vertrag mit J. Röttinger wurde am 23. März 1853 erstellt, der Einbau der Fenster erfolgte am 15. Juni 1853; die Chorfenster im Grossmünster wurden auf Ostern 1853 geliefert.

158

98. Johann Jakob Röttinger, Maria mit Kind, Chorfenster n II, Katholische Pfarrkirche Leukerbad VS, 1864.

99. Johann Jakob Röttinger, Joseph mit Kind, Chorfenster s II, Katholische Pfarrkirche Leukerbad VS, 1864.

100. Johann Jakob Röttinger, Maria mit Kind, W I, Katholische Pfarrkirche Alterswil FR, 1874.

Madonna in Leuggern, ausgeführt[701]. Die Besuche des Glasmalers während der Fünfzigerjahre in München lassen die Kenntnis dieses Fensters vermuten. Wenn auch die Hess'sche Madonna eine viel zartere Zeichnung aufweist, kann sie als Vorbild nicht ausgeschlossen werden.

Die drei Chorfenster in der neuromanischen Pfarrkirche zu Leukerbad VS zeigen in der Mitte die heilige Barbara, links davon im Fenster n II Maria (Abb. 98) und im rechten Chorfenster Joseph (s II, Abb. 99). Im Gegensatz zur Darstellung in Leuggern erscheint Maria hier als Mutter, die ihr Kind mit beiden Händen umfasst. Der Schleier bedeckt ihr rückenlanges Haar und weist sie als verheiratete Frau aus. Das Glasgemälde aus den Jahren 1864–1866 lehnt sich in der Haltung der Personen sowie der Neigung der Häupter an die Strahlenkranzmadonna Dürers an. Heinrich Horns (1816–1874) Chorscheitelfenster von 1854 in der Kirche Sankt Peter und Paul in Handorf befasst sich mit derselben Thematik. Die Himmelskönigin mit Christuskind steht im Strahlenkranz auf der Mondsichel, unter dem sich ein siebenköpfiger Drache windet. Das Kind streckt seine Ärmchen nach einer Traube in der rechten Hand seiner Mutter[702]. Joseph wird als bärtiger, älterer Mann mit kahler Stirn gezeigt, der den Blick hinab auf den kleinen Jesusknaben richtet, der nach dessen Hand greift. Seiner Linken entspringt wiederum das Reinheitssymbol – die Lilie. Die Jungfrau Maria sollte mit

demjenigen Brautwerber verlobt werden, zu dessen Gunsten ein Wunder geschieht – Josephs Stab bringt eine Lilienblüte hervor[703]. Beide Figuren, Maria und Joseph, sind in gemalte, rundbogige Tabernakelarchitekturen gestellt, deren Hintergrund dementsprechend mit Damastmuster und Vorhängen gebildet wird. Eine dritte Josephsfigur konnte sich in der Pfarrkirche Zufikon erhalten (s II). Hier erscheint der Nährvater in der linken Fensterhälfte, 3 a, 4 a, als jüngerer Mann mit dem Jesuskind auf dem Arm. In seiner Rechten hält er den Stab, aus dem die Lilie erwächst[704]. Als Vorbild diente ein Stich von J. Settegast aus der Serie des Vereins zur Verbreitung religiöser Bilder in Düsseldorf[705].

Die Gottesmutter auf einem Medaillon in der Pfarrkirche zu Alterswil FR (Abb. 100), kann stilistisch ebenfalls der Werkstatt Johann Jakob Röttingers zugeschrieben werden[706]. Auf dem

701 VAASSEN, 2013, S. 149, S. 382, Abb. 66, vgl. Wasserburg am Inn S. 383, Abb. 69; VAASSEN 1993, S. 126, Kat. Nr. 38.2.
702 KLAUKE, 2009, S. 91.
703 HELMSDÖRFER, 1839, S. 28.
704 Die Felder 3 b und 4 b zeigen Sankt Martin, der seinen Mantel für den Bettler teilt.
705 KAT. AUSST. KÖLN, 1980, S. 42, Nr. 58.
706 PA Alterswil, Niederschrift (1900) basierend auf den Notizen des Kaplans (1870–1885) bzw. der verschollenen Bauakten, S. 15–16 (Glasarbeiten): Darin wird ausschließlich die Arbeit Röttingers bezüglich der Medaillons in den

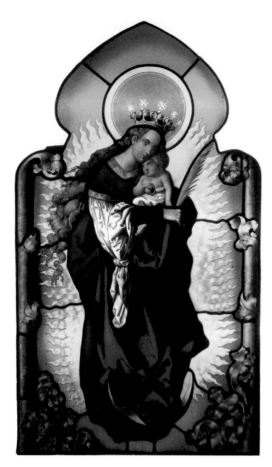

101. Kellner-Familie, (Signatur «Kellner in Nürnberg, 1849»),
Maria im Strahlenkranz, Palacio de Pena, Sintra, 1849.

Emporenfenster W I «thronend» trägt Maria Attribute der Himmelskönigin: die Krone und den
Hermelinmantel. Sie präsentiert das Jesuskind, das
sein Antlitz dem Betrachter zuwendet, jedoch den
Blick senkt. Seine linke Hand ist zum Segensgestus
erhoben, mit der rechten umfasst es den Reichsapfel. Die Darstellung lehnt sich in Komposition
und Haltung an die Mariensäule in München von
1598–1613 an, wo ebenfalls eine Immaculata Conceptio abgebildet wird. Die Alterswiler Himmelskönigin entbehrt jedoch des Zepters und das
Christuskind hält den Reichsapfel[707] in seiner
rechten statt in der linken Hand[708]. Die beiden
schauen aus dem Bild heraus, suchen allerdings
keinen Blickkontakt mit dem Betrachter – wohl
als Zeichen ihres Zwiegesprächs, das durch die
leichte Neigung der Häupter angedeutet wird. Der
Sohn erhebt die Hand als Geste seiner bestätigen-

den Antwort[709]. Wolfgang Kemp formuliert mit
dem «impliziten Betrachter» eine Rezeptionsästhetik, die davon ausgeht, dass das Bild zum Betrachter spricht, indem es ihn am Zwiegespräch, hier
zwischen Mutter und Kind, teilhaben lässt[710]. Die
Kunst der Romantik ist nach Rainer Matzker als
Erscheinungsform des Übernatürlichen, Transzendenten zu verstehen, wobei der romantische
Künstler gegenüber dieser Transzendenz medialisiert wird[711]. Ob sich der Kartonzeichner dieser
Aufgabe bewusst war oder nicht – die vermittelnde Wirkung zwischen dem Zwiegespräch und dem
Betrachter ist augenfällig. Elgin Vaassen zitiert aus
einem zeitgenössischen «Kunstblatt» von 1841[712],
in dem von einer Glasfenster-Bestellung für das
Jerónimos-Kloster in Belém/Lissabon berichtet
wird[713]. Der vom Architekten Carl Heideloff an
die Kellner-Familie vermittelte Auftrag beinhaltete
unter anderem ebenfalls eine Maria nach Dürer,
eine gekrönte, auf einer Mondsichel stehende
Madonna im Strahlenkranz mit dem Jesuskind
(Abb. 101)[714]. Während der Knabe die Weltkugel

Chorfenstern genannt (ohne Nennung der Motive); die
 Madonna wird in den Akten nicht erwähnt. Die Dokumente wurden von Charles Folly in Alterswil zur Verfügung
 gestellt, wofür ich ihm an dieser Stelle herzlich danke.
707 LCI 3, 1971, Sp. 531 ff., Stichw. *Reichsinsignien und Reichskleinodien* (H. Fillitz): Der Reichsapfel ist das Attribut des
 römischen Gottes Jupiter und verweist auf die römische
 Weltherrschaft; das Symbol des Erdballs wird zum Kennzeichen des künftigen Königs.
708 Abb. in LCI 3, 1971, Sp. 208, Stichw. *Maria, Marienbild*,
 Abb. 31 (M. Lechner). Anpassungen in der Komposition
 waren wohl wegen der beengten Platzverhältnisse auf dem
 Medaillon nötig.
709 Mrass, 2005, S. 114, dort Beschreibung der Abb. 71 u. 72.
710 Kemp, 1996, S. 241 ff.
711 Matzker, 2008, S. 88 ff.
712 Vaassen, 1997, S. 328 für Anm. 74 (s. u.): Kunstblatt 22,
 1841, S. 51 und S. 323 (Kunstblatt=Morgenblatt für gebildete Stände, Abt. Kunstblatt, hrsg. von L. Schorn,
 1818–1949).
713 Vaassen, 1997, S. 168 u. Anm. 74.
714 Die signierten Glasmalereien (Kellner in Nürnberg, 1841),
 die auch König Emanuel, Vasco da Gama und den heiligen
 Georg zeigen, sind in Sintra (Palacio de Pena) zu besichtigen (freundliche Mitteilung von Brigitte Kurmann-
 Schwarz).

hält, umfasst seine Mutter mit ihrer Linken einen Palmzweig im Sinne der «compassio Mariae», des Mitleidens der Muttergottes mit ihrem Sohn.

Maria wird so zum «Medium» in verschiedener Hinsicht: Als *mediatrix* des Heils und auch der *compassio* des Betrachters schließt sie in ihrer Mittlerinnenfunktion auch die *contritio* des Rezipienten mit ein, der so als Mitschuldiger zur Verantwortung gezogen wird[715]. 1852 stiftete König Ludwig das «Patrona Bavariae-Fenster» (Abb. 102) für den Regensburger Dom. Den Mittelpunkt des fünfbahnigen Fensters bildet Maria mit dem Kinde als Patrona Bavariae umgeben von den vier Vertretern der Altbayerischen Bistümer. Maria wird als Himmelskönigin mit Krone und Zepter dargestellt – unter dem Saum des Mantels lugt die Mondsichel hervor. Elgin Vaassen nennt Ainmiller als Zeichner der Architekturen und Hess für die Figuren verantwortlich[716]. Das zweilanzettige Görres-Fenster[717] im Kölner Dom, das 1855 von der königlichen Glasmalereianstalt München zum Andenken an den verstorbenen katholischen Publizisten Joseph von Görres geschaffen wurde, zeigt die Himmelskönigin mit den Insignien, wobei das Jesuskind die Weltkugel in der linken Hand hält[718].

Erzengel, Heilige sowie szenische Darstellungen

Im Zusammenhang mit dem Motiv der Gottesmutter als Apokalyptisches Weib steht gewissermaßen auch die Darstellung des heiligen Michael, der eine Frau vor zwei Drachen schützt und ihr Kind rettet[719]. Von Johann Jakob Röttinger haben sich zwei Michaelsdarstellungen erhalten. Eine der beiden Glasmalereien befindet sich in situ im Chor der alten Kirche zu Heitenried FR, die andere im Depot der Bauhütte zu Sankt Oswald in Zug. Beide Male nimmt Sankt Michael die den Teufel beziehungsweise Drachen mit der Lanze tötende Gestalt des Erzengels ein, ein Motiv, das sich im 9./10. Jahrhundert zu entfalten beginnt[720]. In dieser Zeit wird Michael ausschließlich als Jüngling von edler Gestalt, als bartloser, kräftiger junger Mann dargestellt. Der männliche Typus wird in der Hochrenaissance wieder aufgenommen, vor

allem in der Ikonographie des Teufelsbezwingers im Sinne einer gegenreformatorischen Siegesallegorie. Vom 10. bis ins 15. Jahrhundert dominiert hingegen ein mädchenhafter Ausdruck des Erzengels[721]. Im ehemaligen Chorfenster von Sankt Oswald in Zug (n II) aus dem Jahr 1866 tritt Sankt Michael (Abb. 103) als geharnischter junger Edelmann in Erscheinung, dessen Speer bereits tief im Maul des Ungeheuers steckt.

Röttinger, der sich an die Farbenskizze der Düsseldorfer Kunstschule zu halten hatte, setzte den grünen Rock und den gelben Umhang, der mit einer edelsteinbesetzten Agraffe verschlossen wird, farblich und technisch gekonnt um[722]. Am Übergang zwischen Haupt und Nimbus ließ er einen weißen durchschimmernden Saum stehen und die Emailfarben an den Flügeln verwendete er zart ineinanderfließend. Das Beinzeug, das die unteren Extremitäten des Geharnischten schützt, setzt sich aus Beinröhren und metallenen Schnabelschuhen zusammen, die die in der Gotik übliche Mode nachahmen[723]. Mit beiden Händen umklammert der Erzengel den Speer; die Hände stecken in gefingerten Panzerhandschuhen, wobei die Unterarme bis zum Ellbogen mittels metallenen Unterarmschienen gerüstet sind.

715 LAQUÉ, 2009, S. 1004.

716 VAASSEN, 2007, S. 83ff. Vgl. VAASSEN, 1985, S. 14–20. Das Fenster wurde im zweiten Weltkrieg zerstört, die Farbskizze hat sich erhalten (Regensburg, Städtisches Museum).

717 Joseph von Görres (1776–1848), Lehrer, kath. Publizist und Mitbegründer des Zentral-Dombau-Vereins zu Köln.

718 VAASSEN, 2013, S. 165–167; Abb. in: VAASSEN, 1997, Tafel 77, Abb. 135.

719 Offb 12, 7: Michaels Sieg über den Drachen; KELLER, 1968, 2001, S. 405.

720 LCI 3, 1971, Sp. 258f., Stichw. *Michael, Erzengel* (RED.).

721 LCI 3, 1971, Sp. 256f., Stichw. *Michael, Erzengel* (RED.).

722 BA Zug, A39 Nr. 26, 75 S. 206 (Ratsprotokolle). Den gelben Umhang schuf Röttinger mittels Überfangglases, das dunklere Gelb wurde nicht mit Silbergelb erzeugt, sondern man verwendete durchgefärbtes Glas; den Drachen gestaltete der Glasmaler mit Emailfarben.

723 Auf dieselbe Art schuf Kellner das Beinzeug des Königs Emanuel auf den oben erwähnten Glasmalereien für das Kloster in Belém/Lissabon.

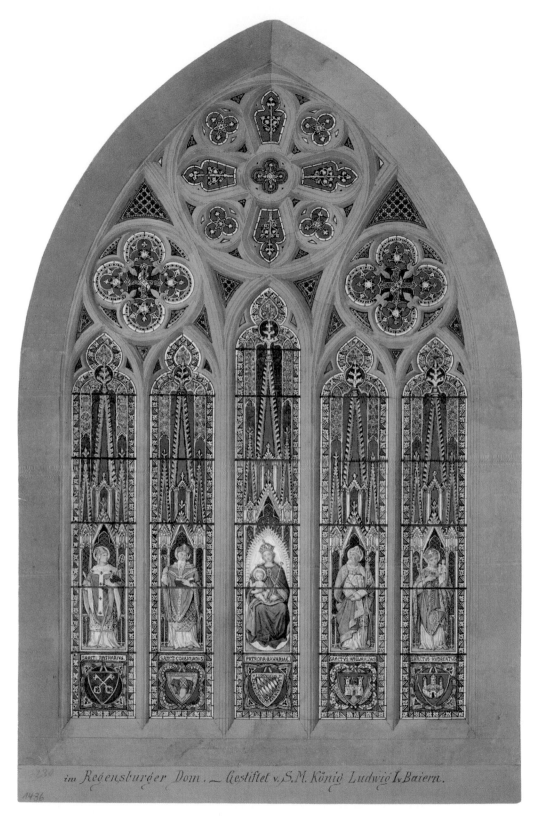

102. H. M. v. Hess/M. Ainmiller, Farbenskizze zum Patrona Bavariae-Fenster, Feder über Bleistift, aquarelliert, 52.5×35 cm, um 1851, Museen der Stadt Regensburg, (Inv. Nr. G 1964/37).

163

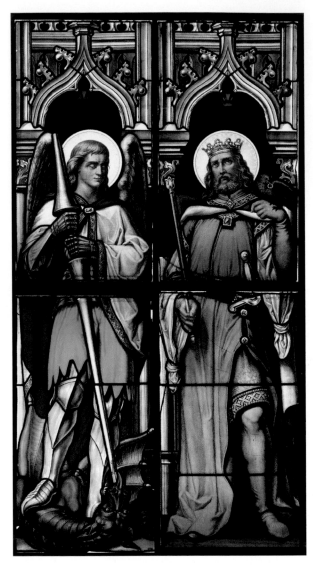

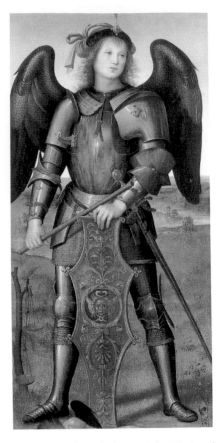

104. Pietro Perugino, Ausschnitt aus: The Virgin adoring the Christ Child, the Archangel Michael, and the Archangel Raphael with Tobias, side panels, 126.5×58 cm [PETRUS PERUSINUS PINXIT], Oil with some egg tempera on poplar, 1499–1500, The National Gallery London (NG 288.1–3).

103. Johann Jakob Röttinger, Sankt Michael, Sankt Oswald, Katholische Kirche Sankt Oswald, ehem. Chorfenster n II, 1866, Depot Bauhütte Sankt Oswald, Zug.

Die kriegerische Tracht sowie die statische Haltung der Figur lassen an das Vorbild Peruginos[724] (Abb. 104) denken, das Einstechen auf den Drachen mit beiden Händen wiederum an einen Kupferstich Martin Schongauers (Abb. 105), ein Blatt, das sich auch im Nachlass erhalten hat[725]. Ähnlich in der Komposition erscheint ein Glasgemälde von Bernhard Mittermaier (1838–1885), das 1865 für die Stadtpfarrkirche in Donauwörth geschaffen wurde[726].

724 National Gallery, London [Online-Galerie]: Pietro Perugino (1445–1523), Sankt Michael (Altartriptychon für die Certosa in Pavia, linker Flügel), Öl auf Holz, 1499, 126.5×58 cm.
725 Martin Schongauer (1445/1450–1491), Sankt Michael, Kupferstich, 1470, Museum of Art in Cleveland, Ohio, USA und in der Albertina, siehe Abbildung 105. ZB Nachl. Röttinger 4.5.6. Unter den Druckgraphiken im Nachlass hat sich außerdem ein «Saint Michel» (31.7×24.3 cm) von P.A. Varin 1848 erhalten, der vermutlich ebenfalls zu Studienzwecken herangezogen worden war. (ZB Nachl. Röttinger 4.5.7).
726 VAASSEN, 1993, S. 140, Kat. Nr. 45.

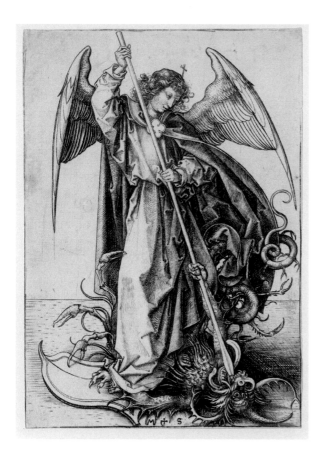

105. Martin Schongauer, Hl. Michael, Kupferstich, 16.2×11.3 cm, Wien Albertina (Inv. DG 1926/1501).

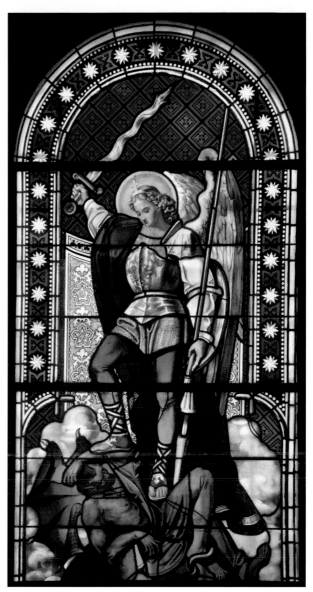

106. Johann Jakob Röttinger, Sankt Michael, Chorfenster I, Alte Pfarrkirche Heitenried FR, 1863.

Sehr schwungvoll hingegen präsentiert sich der Erzengel in der alten Pfarrkirche Heitenried FR (Abb. 106)[727]. Das Chorfenster wurde 1863 von Johann Jakob Röttinger angefertigt[728] und zeigt einen temperamentvollen Engel mit Flammenschwert, Schild und Speer, bekleidet mit roter Tunika und goldenem Panzerhemd; ein Diadem schmückt den blonden Lockenkopf.

Beinahe barfüßig, nur mit leichten Schnürsandalen, nimmt er auf dem sich unter ihm krümmenden, geflügelten Satan Stellung, in der Rechten das Flammenschwert schwingend, in seiner Linken den Speer nach unten richtend, wo sich der Böse im Schmerz windet und eine Schlange – als Attribut des Teuflischen – sich um dessen Fuß ringelt. Bewegung, Impetus und Art der Darstellung erinnern an Vorbilder wie Raffael, Guido Reni (Abb. 107)

727 Die alte Kirche, neben der zur Jahrhundertwende ein Kirchenneubau entstand, wird heute als Mehrzwecksaal genutzt. Das Chorfenster I ist in situ erhalten.

728 PA Heitenried, 1862/63: Korrespondenz zwischen J. Röttinger und dem Auftraggeber Pfr. Spicher in Heitenried.

165

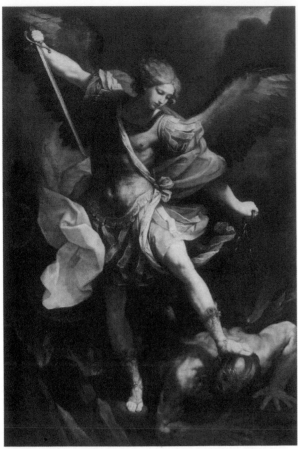

180. *The Archangel St Michael.* 1635. Rome, S. Maria della Concezione. (Cat.no.154)

107. Guido Reni, Der Erzengel Michael, Seide 293×202 cm, S. Maria della Concezione, Rom, 1635.

oder Luca Giordano; von letzterem haben sich in Berlin und Wien Gemälde mit der Darstellung des Erzengels erhalten[729]. Auf dem Berliner Gemälde sticht der Engel die Lanze mit beiden Händen in den Brustkorb des Höllenmenschen. Die Schnürsandalen sind jenen bei Röttingers Erzengel in Heitenried ähnlich. Das Motiv der Schlange kommt bei Giordano ebenfalls zum Tragen; insgesamt lehnt sich der Barockmaler stark an die Darstellung Raffaels an. Johann Jakob Röttinger hat sich wohl ebenfalls auf letztere gestützt, wobei dessen Kenntnis der Gemälde Renis, den er schon in Mariendarstellungen zum Vorbild genommen hatte, und Giordanos vorausgesetzt werden kann. Der Reproduktionsstich hatte nicht nur die Aufgabe Originale zu vervielfältigen, sondern trug auch wesentlich zu deren Rezeption bei. Die Tradierung

durch die Stecher erfolgte sehr facettenreich, so dass die Gemälde der Künstler einem ständigen Wandel unterzogen waren, was nicht zuletzt die Vorstellung späterer Generationen vom Urbild formte[730]. So brachte das 19. Jahrhundert qualitativ äußerst unterschiedliche Reproduktionen vor allem Guido Renis hervor, bevorzugte Halbfiguren männlicher oder weiblicher Heiliger, allen voran das himmelwärts blickende Haupt des dornenbekrönten Christus. Josef Grünenfelder, der Zuger Kunstdenkmäler-Inventarisator, hat nach eigenen Aussagen anlässlich der Aufhebung des Kapuzinerklosters in Zug die verbleibenden Scheibenfragmente, eine «Mater Dolorosa nach Dolci» sowie einen «Ecce Homo nach Reni», inventarisiert[731] und die Schaffung der Scheiben vor 1904 datiert. Stilistisch passen sie nicht in das Werk Röttingers und sind eher dem Jahrhundertende zuzuordnen. Nicht mehr erhalten haben sich Scheiben der genannten Sujets in Sankt Gallen, wo Johann Jakob Röttinger laut Skizzenbuch in der ehemaligen *«Rottmonten-Kapelle»* zwei Fenster mit den Bildern *«Ecce Homo»* und *«Mater Dolorosa»* in gotischer Architektur mit den Wappen der Stifter geschaffen hatte[732]. Guido Renis Image, der von seinen Zeitgenossen noch als «Il Divino» gefeiert wurde, verblasste gegen Ende des 19. Jahrhunderts, als seine Heiligenfiguren hauptsächlich noch als Hülsen der Bigotterie und als frömmelnde Andachtsbilder bekannt waren. Im 20. Jahrhundert erfolgte unter Weglassung emotionaler Verschleierungen eine neue Sichtweise der Gemälde Renis und brachte schließlich eine Neubewertung unter Berücksichtigung der tiefen religiösen Empfindung im 17. Jahrhundert[733].

729 SCHLEIER, 1998, S. 396. Hier auch die Abb. von Giordanos Berliner Gemälde: Luca Giordano (1634–1705), Der heilige Michael. Um 1663, Leinwand, 198×147 cm, Eigentum des Kaiser-Friedrich-Museums-Vereins, KFMV.261 (S. 397).

730 KAT. AUSST. WIEN, 1988, S. 12.

731 Freundliche Mitteilung Josef Grünenfelders (Inv. Nr. 181, 182). Röttinger hat für die Zuger Kapuzinerkirche tatsächlich Glasmalereien hergestellt, wobei die Ikonographie nicht bekannt ist (ZB Nachl. Röttinger 1.195).

732 ZB Nachl. Röttinger 1.202.69.

733 KAT. AUSST. WIEN, 1988, S. 12f.

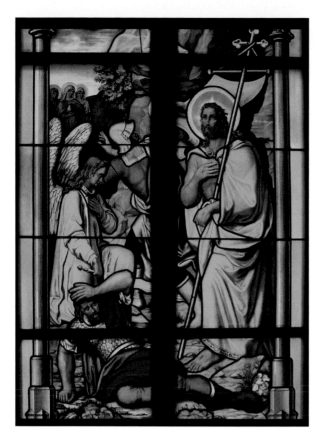

108. Johann Jakob Röttinger, Auferstehung Christi, Chorfenster S'II, Katholische Pfarrkirche Bünzen AG, 1862.

Die nachgeahmten Heiligenbilder des 19. Jahrhunderts hingegen verloren nicht zuletzt wegen der ausschnitthaften Verwendung ihre Ausdruckskraft und verkamen zu kitschigen Devotionalien. Die Rezeption von Guido Renis Bildern schuf angesichts deren «Grazie» eine «Beziehung» zwischen Betrachter und Bild. Dieses «gewisse Etwas», das in seinem Gegenüber ein sehnsuchtsvolles Verlangen auszulösen vermag, wurde als Grund für die Trivialisierung erkannt[734]. Johann Jakob Röttingers Michael in Heitenried fällt nicht unter diese Art der Bildzitate, sondern ist als eigenständige Komposition in Anlehnung an berühmte und durch Reproduktionstechniken verfügbare Vorbilder zu bezeichnen[735]. Gleichzeitig mit dem Heitenrieder Michael entstand eine Farbenskizze von Moritz von Schwind[736] für London, die in der zentralen Lanzette (1 c, 2 c) eine ähnliche Michaelsdarstellung zeigt. Der geflügelte Teufel scheint

beinahe identisch zu sein, was für ein gemeinsames Vorbild spricht. Für die Pfarrkirche zu Breitbrunn am Chiemsee schuf die Königliche Glasmalereianstalt ebenfalls einen Erzengel Michael mit Luzifer nach einem Entwurf von Heinrich Maria Hess. Diese Figur des Michaels vereint gewissermaßen die beiden unterschiedlichen Erzengelinterpretationen Röttingers. Der Breitbrunner Vertreter[737] trägt eine Rüstung wie der Erzengel in Sankt Oswald, zeigt jedoch eine weniger statische Haltung (vgl. Abb. 97); Flammenschwert, Luzifer und das lockige Blondhaar hingegen sind Attribute in Heitenried – auch in der Komposition lehnt sich der freiburgische Erzengel an die bayerische Variante an.

Weitere Heiligenfenster beziehungsweise szenische Darstellungen haben sich in der Pfarrkirche Bünzen AG und in Sankt Oswald in Zug erhalten. Für beide katholische Kirchen wurden Glasmalereien mit der Auferstehung Christi geschaffen. Während sich das Chorfenster S II auf der Chorempore in Bünzen noch in situ präsentiert (Abb. 108), wird das ehemalige Zuger Chorfenster I in der Bauhütte zu Sankt Oswald aufbewahrt. Für dieses Gotteshaus schuf Röttinger außerdem, analog zum Sankt Michael, den Kirchenpatron Sankt Oswald (n II), den heiligen Franziskus und die heilige Elisabeth (s II) als Ganzfiguren (Abb. 36)[738]. Im Skizzenbuch werden «W.[eitere] Damast-Fenster mit 16 St.[ück] Medaillon[s] wie folgt» genannt: «Fenster links: Kaiser Heinrich, Joh[annes] d. Täufer, Conrad, Bisch.

734 SCHMIDT-LINSENHOFF, 1988, S. 62 ff; vgl. Anm. 209, 211, 213.

735 KAT. AUSST. WIEN, 1988, S. 103 bzw. PEPPER, 1984, S. 272: Erzengel Michael, 1635, Öl, Seide, 2.93×2.02 m, Rom, S. Maria della Concezione, 1635: Auftraggeber des Gemäldes war Kardinal Antonio Barberini, Schirmherr der Kapuziner von S. Maria della Concezione, der in den Dreißigerjahren des 17. Jahrhunderts die Kirche ausschmücken ließ. Kupferstich 1636 von De Rossi (De Rubeis).

736 VAASSEN, 1997, Tafel 80, Abb. 143. München, Staatl. Graph. Sammlung, «Farbenskizze» für London, Sankt Michael, M. von Schwind, um 1862.

737 Abb. in KAT. AUSST. ERFURT, 1993, S. 127, Kat. Nr. 38.1.

738 ZB Nachl. Röttinger 1.194. Die Ikonographie der Chorfenster wurde im Vertrag von 1866 festgehalten.

[of] v. Constanz, Carlo Borromäo[739], Hl. Drei König St. Balth[asar], Joh.[ann] v. Nepomuck, Nicklaus v. der Flühe, Joseph; Fenster rechts: Maria, Catharina, Helena (Kaiserin), Maria Magd[alena], An[n]a Mutter, Cäcilia, Angnes [sic!], Agatha»[740]. Die Fenster sind lange Zeit unsachgemäß gelagert worden und haben sich daher in der Bauhütte in unterschiedlichem Zustand erhalten. Diese Art der Medaillons, mit Brustbildern von (überwiegend) Heiligen und deren Attributen, wurden für zahlreiche weitere Kirchen geschaffen, wie beispielsweise in Nottwil LU, Glis VS oder in der Kirche Wildhaus SG. In letzterer präsentieren sich die 14 Nothelfer neben Namenspatronen.

Christliche «Monogramme»

Für katholische Kirchen kamen häufig so genannte christliche «Monogramme» zur Ausführung, deren Anschaffung bisweilen in den Quellen des Nachlasses erwähnt werden[741]. Dabei handelt es sich um farbig gestaltete Medaillons, auf denen nicht nur Buchstabenkürzel, sondern auch Symbole der christlichen Lehre festgehalten sind[742]. Symbole, religiöse und andere, repräsentieren die verehrungswürdige Person oder das Objekt insofern, indem sie diese in sich tragen[743]. Die Symbolik der christlichen Zeichen beruft sich auf die platonische Überlieferung: So nimmt beispielsweise der Pelikan, der seine Jungen mit seinem eigenen Blut speist, Christus und seine Liebe zu uns vorweg[744]. Die Motivpalette zeigt sich vielfältig und reicht von Buchstabenfolgen, wie IHS, IMAR (das A im M einbeschrieben für «MARIA», Abb. 109), INRI (Abb. 110), OISP (das I im O einbeschrieben für «JOSEPH») über Herz-Jesu- und Herz-Mariä-Abbildungen, Schweißtuch (Abb. 111), Pelikan, Lamm Gottes (Abb. 112), Taube, Kelch (Abb. 113) bis hin zur Darstellung von Leidenswerkzeugen. Die Inanspruchnahme von Bildern für Tröstung und Unterweisung war im Kunstverständnis der Romantik verankert und kam dem Bildgebrauch der katholischen Kirche entgegen[745]. Ausgehend von der Erzbruderschaft des heiligsten und unbefleckten Herzens Mariä der Pfarrkirche «Unserer lieben Frau zum Siege» (Paris) beziehungsweise des durch Marguerite Marie Alacoque im späten 17. Jahrhundert wieder aufgeflammten Herz-Jesu-Kults, der im 19. Jahrhundert durch die Jesuiten neue Popularität erlangte, bekam dieser eine kirchenpolitische Bedeutung als Zeichen der Restauration und der Wiedergutmachung der Schrecken der französischen Revolution[746]. Die Nazarener ließen die Sinnbildkunst wieder aufleben[747] – man denke an die Darstellungen von «Dürer und Raffael vor dem Throne der Kunst» oder an die «Allegorie der Freundschaft» (1808)[748] –

739 Das zentrale Chorfenster der Pfarrkirche Finstersee ZG zeigt ebenfalls den heiligen Borromäus in der Darstellung, wie er die Kranken heilt.

740 ZB Nachl. Röttinger 1.202.19, 1.202.37 *«ferner in den oberen Theil das Wappen vom Kloster Frauenthal:»* (Wappen skizziert).

741 Der Begriff des christlichen «Monogramms» wurde im Fachjargon offensichtlich für *alle* Symbole, Bilder *und* Buchstabenfolgen, verwendet. Beispiele: Für die Pfarrkirche in Selzach SO im Skizzenbuch, ZB Nachl. Röttinger 1.202.86 *(«…die anderen Fenster mit Monogramm»)*; die ehemalige Klosterkirche in Alt Sankt Johann, ZB Nachl. Röttinger 1.202.123 *(«…zwei Fenster neben dem Hauptaltar ganz Damast, die oberen Teile gemalt mit Monogramm»)*; die Pfarrkirche Sankt Nikolaus in Wil in einem Brief der Witwe Röttinger vom 8. Juni 1877, ZB Nachl. Röttinger 1.182 *(«…5 Fenster mit gemalten Bogen und Monogramm»)*; die Kirche in Dessenheim, Elsass im Werkvertrag, ZB Nachl. Röttinger 1.35 *(«…in den Bogenstücken kommt in jedes Fenster ein Monogramm, z. B. der heilige Name Jesu, Herz Maria, Herz Jesu usw.»)*.

742 ATZ, 1876, S. 153–156. Karl Atz misst den Symbolen höchste Bedeutung zu, da Jesus als Urheber der Symbolik in Gleichnissen und Bildern sprach.

743 LEHMANN, 2009, S. 84.

744 GOMBRICH, 1986, S. 176–178. Gombrich betont, dass in der Bibel Gott zu uns häufig in Symbolen spricht, die ein neuplatonisches Universum enthüllen. Vgl. Anm. 742.

745 MEYER, 1995, S. 333 f.: Nach Meinung Schlegels galten «Religion, Mystik, christliche Gegenstände, oder wie es heißt Sinnbilder», für die Malerei als unerlässlich.

746 BRÜCKNER, 2003, S. 55 ff.

747 SCHOLL, 2007, S. 290 ff.; vgl. MATTER/BOERNER, 2007, S. 214.

748 MATTER/BOERNER, 2007, S. 188 bzw. 214. Einerseits wurde die Kunst in Gestalt einer Frau personifiziert, andererseits die Bräute Sulamith und Maria als Metapher für die Freundschaft eingesetzt. Letzteres gilt als Anstoß für Overbeck nach dem Tode seines Malerfreundes Pforr das Gemälde «Italia und Germania», eine Allegorie für die Sehnsucht des Nordens nach dem Süden, zu schaffen.

109. Johann Jakob Röttinger, Monogramm Mariae, Medaillon, Schifffenster mit Ornament, s III, Katholische Pfarrkirche Alterswil FR, 1873.

110. Johann Jakob Röttinger, INRI, Madaillon, Schifffenster mit Ornament, s VII, Katholische Pfarrkirche Alterswil FR, 1873.

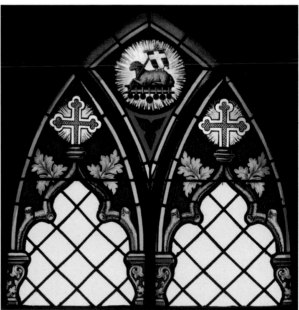

111. Johann Jakob Röttinger, Schweißtuch der Veronika, Medaillon, s V, Katholische Pfarrkirche Alterswil FR, 1873.

112. Johann Jakob Röttinger, Lamm Gottes, Medaillon, s IV, Katholische Pfarrkirche Alterswil FR, 1873.

was sich auch darin offenbarte, dass jeder der Lukasbrüder ein persönliches Zeichen besaß, das ihn zu charakterisieren vermochte[749]. Die kommunikative Seite der nazarenischen Kunst implizierte Kritik an der Aufklärung sowie die Sehnsucht nach religiöser Erklärung. Die so genannten Autonomieästhetiker, wie Johann Wolfgang von Goethe, Johann Heinrich Meyer oder Basilius von Ramdohr, lehnten diese Haltung vehement ab und sahen die Würde des Kunstwerks in der künstlerischen Überwindung des Gehalts[750]. Außerkünstlerische Belege, wie Quellen, Zitate und Symbole, waren in der sakralen Ikonographie wichtige Elemente zur Ergänzung und Erklärung der Abbildungen und insbesondere in der Glasmalerei sehr beliebt. Sie gehörten zum ikonographischen Repertoire der Glasmaler und sind daher in deren Skizzen- und Auftragsbüchern zu finden[751]. Die gebräuchlichsten Symbole sollen in Folge kurz erläutert werden.

Die Buchstabenfolge IHS entstand im 8. Jahrhundert aus der partiellen Umwandlung der griechischen Initialen Jesu ins Lateinische ‚Iota-Eta-Sigma‘ (IHS), die seit dem Spätmittelalter mehrheitlich durch die konstantinische «Schreibweise» XP (Chi-Rho) abgelöst wurde. Bernhardin von Siena förderte die Verehrung des durch IHS geschriebenen Namens Jesu, was seither auch volksetymologische Varianten hervorbrachte: «Iesus Hominum Salvator» oder «In hoc signum»; die Jesuiten interpretierten das Kürzel in: «Iesum Habemus Socium» beziehungsweise «Iesum Humilis Societas»[752]. Johann Jakob Röttinger verwendete die bei den Jesuiten übliche Version mit den drei Nägeln unter dem H und dem Kreuz darüber und umgab die graphische Einheit mit einem Strahlenkranz. Der Pelikan wird seit dem Mittelalter im Rahmen einer Kreuzigungsdarstellung als Symbol für den Opfertod Christi gedeutet. Der Pelikan erweckt seine toten Jungen, indem er diese mit seinem eigenen Blut besprengt, wofür er seine Seite öffnet, was einer legendenhaften Deutung aus dem Physiologus entspricht[753]. Das Lamm Gottes wird im Alten Testament Ex 12, 3 im Rahmen des Passah-Festes und an anderen Stellen

als tägliches Morgen- und Abendopfer genannt; im Neuen Testament bezeichnet das Lamm die Allegorie Christi[754]. In der Neuzeit gilt das Lamm als Sinnbild der Menschwerdung Gottes und das gebratene Lamm als Symbol für den festen Glauben an die Gottheit Christi[755].

Ebenfalls aus der Johannesoffenbarung stammt die Vorstellung des Buchs mit den sieben Siegeln, das vielfach zusammen mit dem Lamm zur Darstellung kommt: durch das Öffnen der Siegel wurde die Apokalypse ausgelöst[756]. Johann Jakob Röttinger setzte dieses und andere Motive beispielsweise in der Kapelle des Frauenklosters Mariä Opferung in Zug sowie in den Pfarrkirchen Alterswil FR (vgl. Abb. 109–113), Selzach SO und Herdern TG um. Ebenfalls aus der Apokalypse stammt das «A und Ω» (Alpha und Omega), der Erste und der Letzte, der Anfang und das Ende, als Schlüssel zum Universum (Offb 22, 13). Auf den Medaillons erscheint häufig nur das Omega über einem anderen Monogramm als «Kürzel vom Kürzel», weil mit dem Verständnis des Betrachters der Semantik zu rechnen war. Dies, obwohl schon 1839 ein zeitgenössischer Autor die wachsende Unkenntnis des Publikums bezüglich Legenden und Symbolen beklagte[757]. Nach den Acta Pilati (Apokryphen: Nikodemusevangelium) wischte Christus seinen Schweiß in das Tuch der heiligen Veronika, was das Abbild seines Antlitzes und dabei den Topos der *Vera Icon* hinterließ. Johann Jakob Röttinger ahmte bei diesem mehrmals eingesetzten Motiv die seit 1400 übliche Darstellung des dornenbekrönten, leidenden Christus in der Art des Meisters der heiligen Veronika nach und

749 SCHOLL, 2007, S. 295 f. So sollen Friedrich Overbeck ein Palmenzweig und Ludwig Vogel eine Gämse zugeordnet gewesen sein.
750 SCHOLL, 2007, S. 336 f.
751 Vgl. Kap. ‹Auftrags- und Skizzenbuch›.
752 WOELK, 1994, Sp. 1178, Stichw. *Christusmonogramm*.
753 LCI 3, 1971, Sp. 390–392, Stichw. *Pelikan* (RED.); LThK 8, 2009, Sp. 253 Stichw. *Pelikan* (E. Sauser).
754 Jo 1, 29 36; 1 Petr 1, 19; Apk 5, 6, 8 12 etc.
755 LCI 3, 1971, Sp. 7 f., Stichw. *Lamm, Lamm Gottes* (RED.).
756 5. Vision Offb 8, 1–9, 21, Das siebte Siegel.
757 HELMSDÖRFER, 1839, S. IX.

übernahm auch den geteilten Bart[758]. Anstelle der Gestalt der Veronika, die üblicherweise das Tuch an den oberen beiden Enden hält, platziert Röttinger nur zwei die beiden Tuchzipfel fassende Bänder, um das Symbolhafte der Darstellung zu unterstreichen (Abb. 111). Georg Kellner schuf 1851 für die Kirche in Neuendettelsau (Bayern) eine Darstellung der *Vera Icon* mit der Bildlegende: «Des Christen Herz auf Rosen geht/Wenns mitten unter Dornen steht»[759]. Aufgrund der Einheitlichkeit und der Häufigkeit der christlichen «Monogramme» ist davon auszugehen, dass es sich bei den christlichen Motiven, die meist auf Medaillons dargestellt sind, um eine kostengünstige Variante der Fenstergestaltung in der Zeit um die Jahrhundertmitte gehandelt hatte. Auf einer Farbenskizze für die Wallfahrtskirche Arenenberg/Koblenz im Stadtmuseum München von 1850 erscheinen zwei Medaillons mit Symbolen, eines mit dem Kelch für die Eucharistie und eines mit den Leidenswerkzeugen mit Bezug auf den abgebildeten Engel, der die Dornenkrone hält[760]. Johann Jakob Röttinger setzte einen Kelch in ein kleines Rundfenster der Ölbergkapelle auf dem Gubel ZG und weitere in Bogenausmündungen in Herdern und Alterswil (Abb. 113).

113. Johann Jakob Röttinger, Kelch, Medaillon, n V, Katholische Pfarrkirche Alterswil FR, 1873.

In den von der Werkstatt Röttinger belieferten Schweizer Kirchen erscheinen Symbole nur vereinzelt in protestantischen Kirchen, beispielsweise in der Pfarrkirche zu Niederhasli ZH, wo die Gesetzestafeln Moses' (n II) und die Biblia Sacra mit zwei Kreuzen und einem Kelch dargestellt sind (s II)[761]. Unter den Gesetzestafeln finden wir das Zitat *«Fürchte Gott und halte seine Gebote, Pred. XII, 13»*; unter der Biblia Sacra *«Das Evangelium ist eine Kraft Gottes zum Heil einem Jeden, der daran glaubt, Röm 1, 16».* Nach Luther wird durch die Beifügung von Bibelzitaten die Rolle der Bilder als Merkzeichen und Erinnerungshilfen vergrößert, indem wieder auf das Wort Gottes hingelenkt wird. Bilder und Zitate sind für ihn äußere Zeichen, die der Rezipient nicht verehrt, sondern interpretiert[762]. Im reformatorischen Bildverständnis deuten sich Wort und Bild gegenseitig. Während das Bild dem Wort die «Anschauung» verleiht, trägt das Schriftwort zum Verständnis des Bildes bei[763].

Symbolik und Inszenierung

Die sakrale Ikonographie im 19. Jahrhundert zeigt also nicht nur die üblichen theologisch bedingten konfessionellen Unterschiede, sondern zeichnet sich sowohl in katholischen wie in protestantischen Kirchen durch einen hohen Symbolgehalt aus. Die Kunst nach der Revolution, der eine Krise des

758 BAUMSTARK, 2002, Abb. 17: Meister der Münchner Hl. Veronika (1400–1425), Hl. Veronika mit dem Schweißtuch Christi (um oder nach 1425), Tannenholz 78.1×48.2 cm, Alte Pinakothek München, erworben 1827 aus der Sammlung Boisserée, Inv. Nr. 11866.

759 VAASSEN, 1997, Tafel 30, Abb. 53; Dabei handelt es sich um die abgewandelte Umschrift auf Luthers Wappen: LÖWITH, 1995, S. 32: «Des Christen Herz auf Rosen geht, wenn's mitten unterm Kreuze steht».

760 VAASSEN, 1997, Tafel 77, Abb. 136.

761 ZB Nachl. Röttinger, 1.115, Vertrag von 1854: *«In den beiden Seitenfenstern soll in das Eine die Gesetzzahl des Alten Testaments, in das Andere im offenen Evangelienbuch in passender, ornamentaler Einfassung angebracht werden. […]»* In der Pfarrkirche Rapperswil BE zeigen Medaillons in der Bogenausmündung der Chorfenster n II die Taube, in s II die Biblia Sacra.

762 BELTING, 1990, S. 610, Punkt III.

763 POSCHARSKY, 1998, S. 11–16.

traditionellen ikonographischen Systems nachgesagt wird, brachte eine Aufwertung des Symbols. Vor allem Friedrich Schlegel erhob den Anspruch das «Bedeutende» als eigentliche Aufgabe der Malerei zu sehen[764]. In der Schweiz haben sich aus der Zeit zwischen 1845 und 1877 mit Ausnahme einiger umfassender Fensterzyklen szenische Darstellungen seltener erhalten als beispielsweise in Deutschland[765]. Die oftmals nur in verkürzter Form als «Monogramme» gestalteten Glaubenswahrheiten sind auf Medaillons in ornamental verzierte Fenster eingearbeitet. Sie bilden in katholischen Kirchen neben ganzfigurigen Darstellungen und Szenen mit Heiligen als Namenspatrone und Fürbitter, mit Evangelisten, Propheten und ihren Attributen, die häufigste Art der Bildlichkeit. In Fenstern protestantischer Kirchen erscheinen mehrheitlich Einzelfiguren beziehungsweise Brustbilder der Evangelisten, Apostel oder Reformatoren. Dabei ist es vor allem das Bild des «Lehrenden Christus», das für die Werte der protestantischen Lehre ein Zeichen setzt, nämlich die Verkündung des Wortes, die Verhinderung von Idolatrie sowie die daraus resultierende Schnörkellosigkeit der Predigträume. Friedrich Schlegel (1772–1829)[766] maß der menschlichen Gestalt höchste Symbolkraft bei und führt zur Abgrenzung des «Gestaltssymbols» bei Goethe den Begriff der «Hieroglyphe» ein, um den Verweis auf das Göttliche auch terminologisch zu untermauern. Die Hieroglyphe wird zur Bedeutungsträgerin und verweist auf die Transzendenz[767]. Johann Jakob Röttinger gelang trotz der Anlehnung an die kanonische Darstellungsweise eine, wenn auch marginale, Individualisierung seiner Figuren, die den Symbolgehalt nach bestimmten Regeln tradierten, jedoch nicht auf vorwiegend christliche «Monogramme» reduziert werden wollten. Die Ikonographie des 19. Jahrhunderts verweist über die Frömmigkeit hinaus auch auf politische Standpunkte. Am Beispiel des heiligen Joseph konnte eine politisch-ideologische Vereinnahmung festgestellt werden, indem der Nährvater Christi von der katholischen Kirche als christliches Ideal des Arbeiters und als Antipode gegen die sozialdemokratische Gesinnung

eingesetzt wurde[768]. Darüber hinaus korrelierte die Ikonographie der Marienbilder mit der zeitgenössischen kirchengeschichtlichen Situation, als die päpstliche Bulle «Ineffabilis Deus» Mariens Freiheit von der Erbsünde dogmatisch festschrieb. Weitere ikonographische Besonderheiten sowie Auswirkungen des Kulturkampfes auf Bildinhalte werden im Kapitel ‹Konfessionelle Spaltung› angesprochen. Die inhaltliche Steigerung sowie der Anspruch an die Ausführung von Glasmalereien innerhalb des Gotteshauses gegen den Chor hin sind bei beiden Konfessionen zu beobachten. Obwohl in katholischen Kirchen ausgeprägter, wird das Chorachsenfenster in reformierten Kirchen ebenfalls ikonographisch akzentuiert. Eine Rhythmisierung der Langhausfenster durch Farbverschränkungen beziehungsweise abwechselndes Auftreten mehrerer Ornamentmotive in Richtung Chor ist in den Kirchen beider Konfessionen zu beobachten[769].

Wappenzyklen in öffentlichen Bauten als Reminiszenzen Eidgenössischer Aristokratie

Die mittelalterlichen monumentalen Glasmalereien in den Kirchen und Klöstern gingen hauptsächlich aus Stiftungen hervor, die als Seelgerät im Sinne einer Güterübertragung an eine Kirche gegen das Versprechen der Fürbitte im Gebet zu verstehen sind[770]. Schon die frühesten schweize-

764 BÜTTNER/GOTTDANG, 2006, 2009, S. 273–275.

765 Auf das Fehlen monastischer Auftraggeber sowie eine teilweise beobachtete konfessionsübergreifende Angleichung der Ikonographie wurde bereits hingewiesen.

766 Vgl. Kap. ‹Philosophisch-kunsthistorischer Diskurs›.

767 SCHÖNWÄLDER, 1995, S. 30f. In der Interpretation Goethes bedeutet das symbolische Götterbild lediglich «anschauliche, unwandelbare Fülle menschlichen Wesens».

768 KORFF, 1973, wie Anm. 689.

769 Ganz ähnlich erscheint die Situation in Thüringen. Vgl. BORNSCHEIN/GASSMANN, 2006, S. 37–38.

770 LEXMA VII, 2003, Sp. 1680, Stichw. *Seelgerät* (K. Kroeschell). Vgl. KURMANN-SCHWARZ, 2008, S. 39: Eine der ersten überlieferten Handlungen von Königin Agnes im Zusammenhang mit Königsfelden soll die Seelgerätsstiftung für ihren verstorbenen Gemahl, König Andreas III. von Ungarn, gewesen sein, zu deren Zweck sie 1317 habsburgische Güter einlöste.

rischen Beispiele in Münchenbuchsee, Blumenstein und Kappel zeigen die Wappenschilde der adligen Donatoren wie Cunos von Buchsee, des Klerikers Johannes von Weissenburg sowie Walthers von Eschenbach. An den Glasgemälden des Berner Münsters aus der Mitte des 15. Jahrhunderts sind zahlreiche Wappen wohlhabender, scheibenstiftender Bürger und Handwerker fassbar[771]. Anders als in Bayern, wo noch im 19. Jahrhundert König Ludwig I. in München und Regensburg, aber auch in Speyer und Köln als Stifter von prächtigen Glas- und Wandmalereien in Erscheinung trat, fehlten in der Schweiz entsprechende Auftraggeber aus dem Hochadel. Anstelle dessen entwickelte sich in der Eidgenossenschaft seit dem 15. Jahrhundert eine ganz spezielle Art des Stiftertums, nämlich die Tradition der Schenkung von Einzelscheiben. Bereits in der ersten Hälfte des 15. Jahrhunderts beschenkten sich befreundete Städte mit gläsernen Wappen – vorrangig zum Schmucke ihrer Rathäuser[772]. Aus den Quellen über die Bautätigkeit der Herzöge von Burgund wird deutlich, dass die Potentaten, deren Wappen wie auch die Wappenschilde, in ihrem Besitz stehende Territorien nicht nur in religiösen Gebäuden als Stiftungen, sondern auch in Rathäusern und ähnlichen profanen Einrichtungen anbringen ließen[773]. Entsprechend der für die Schweiz typischen Entwicklung der politischen Strukturen entsprangen die Stifter dieser Wappen der eidgenössischen Aristokratie beziehungsweise dem Patriziat und rekrutierten sich aus den Obrigkeiten, Behörden und Zünften in Städten sowie wohlhabenden Bürgern und Schützengesellschaften aus Stadt und Land. Die Entfaltung der neuzeitlichen Glasmalerei in der Schweiz korreliert demnach mit der politischen Geschichte der Eidgenossenschaft – wohl in Anlehnung an adelige Gepflogenheiten. Die eidgenössischen Erfolge in den Burgunderkriegen und der daraus entstandene Reichtum förderte die heraldische Selbstdarstellung; soweit geht die Begründung des älteren Forschungsstandes. Eine Relativierung dieser Verbindung bringt jedoch die Nachahmung der höfischen Sitten in den Diskurs mit ein[774]. Zuerst als Subvention der Obrigkeiten an Neubau-

ten gedacht, wurde aus den Scheibenschenkungen Usus und schließlich sogar Ausdruck gleichgesinnter Eliten. Diese Sitte förderte die Zusammengehörigkeit und das Selbstbewusstsein innerhalb der Eidgenossenschaft. Die schweizerischen Wappenscheiben sind daher immer vor dem Kontext dieser geschichtlichen Entwicklung zu sehen und nicht nur Hinweis auf eine für die Schweiz charakteristische Elitenbildung, die aus einem starken und wohlhabenden Bürgertum entstanden ist, sondern auch Zeichen der Religiosität, wenn Stiftungen an Kirchen und Klöstern gemacht wurden. Zur Zeit der Reformation setzen sich zunehmend säkulare Themen in der Glasmalerei durch, ein Trend, der die Schaffung von Wappenscheiben noch begünstigte. Dabei konnte die Forschung eine gewisse Strenge der in den eidgenössischen Städten entstandenen Malerei konstatieren, die auf eine Einengung von Erfindergeist und Fantasie der Künstler zurückzuführen war – ein Repräsentant dieser Strömung war der bekannte Maler Tobias Stimmer (1539–1584) aus Schaffhausen[775]. Wie Hermann Meyer in seiner immer noch gültigen Studie über «Die Schweizerische Sitte der Fenster- und Wappenschenkungen» für das 15. bis 17. Jahrhundert festhielt, waren die eidgenössischen Tagsatzungsabschiede[776] reich an Gesuchen um Fenster- und Wappenschenkungen in Neubauten[777], was in der Blütezeit der Sitte, Ende des 15. und im 16. Jahrhundert, auch die Zahl der Glasmaler sprunghaft ansteigen ließ. Die Schenkungen erfolgten durch Bezahlung eines Fensters, in das man die gewünschten, in Glasmalerarbeit ausgeführten Wappen einsetzen ließ. Rolf Hasler

771 Boesch, 1955, S. 27.
772 Boesch, 1955, S. 27 f.
773 Kurmann-Schwarz, 2012 (1), S. 128.
774 Kurmann Schwarz, 2012 (1), S. 149.
775 Kurmann-Schwarz, 2010 (1), S. 64 f.
776 Abschied=Protokoll.
777 Meyer, 1884, S. V.; Boesch, 1955, S. 29 f. Die Tagsatzung fasste 1517 den Beschluss, das allgemeine «Fensterbetteln» abzustellen und nur noch für Kirchen, Ratsstuben und Gesellschaftshäuser zu gestatten.

konnte im Rahmen seiner Forschungen über die Glasmalerei in Schaffhausen Dokumente ausfindig machen, die die Schenkungen in ein neues Licht rückten. Diese ermöglichten dem Autor Fensterstiftungen mit baupolitischen Absichten in Verbindung zu bringen. Weil der kleine Stadtstaat Schaffhausen sich bezüglich der Scheibenstiftungen besonders großzügig zeigte und dementsprechend viele Bittgesuche der Bürgerschaft eingingen, war die Einführung einschränkender Auflagen notwendig. Die Hausbesitzer wurden demnach gezwungen, ihr Haus für mindestens 100 Gulden zu erneuern, um ihren Anspruch auf eine Scheibenstiftung geltend zu machen[778]. Mit dem Ende des 17. Jahrhunderts ebbte der Brauch der Fensterschenkung ab und verlor sich schließlich gegen die Mitte des 18. Jahrhunderts[779]. Das Aufkommen der kollektiven Identität, die von der Helvetischen Gesellschaft ab 1761 initiiert wurde[780], sowie die Renaissance der Glasmalerkunst im frühen 19. Jahrhundert ließen jedoch das Ansehen der Wappenscheibe wieder aufkeimen[781]. Die Zusammenführung der Schweizerischen Kantone zum Nationalstaat 1848 war Ausdruck eines neuen vaterländischen Bewusstseins, damit erlangten die Wappenscheiben als «spezifisch schweizerische Kunstproduktion»[782] eine besondere Bedeutung. Erst mit der Eröffnung des Schweizerischen Landesmuseums 1898 in Zürich, dem Hort eidgenössischer Geschichte, erhielt die nationale Identifikation einen Ort. Dem drohenden Verlust von vaterländischen Altertümern durch Verkäufe ins Ausland[783], wovon auch Glasmalereien, ja selbst die Standesscheiben des Tagsatzungssaals zu Baden[784], betroffen waren, konnte auf diese Weise Einhalt geboten werden. Die neue museale Einrichtung brachte einer breiten Bevölkerungsschicht die Veranschaulichung der Schweizer Geschichte und das nötige Verständnis dafür. Der Einzelscheibe kam in dieser Hinsicht schon im Vorfeld als Patrimonium mit hohem Bekanntheitsgrad eine wichtige Rolle zu[785]. Analog der religiös bebilderten Medaillons[786], den Sinnbildern für die konfessionelle Haltung, sind die Einzelscheiben Symbole, die als nationales Gedenk-

ken Metaphern für die Besonderheit der eidgenössischen Geschichte – einer Präsenz von Aristokratie, die der bürgerlichen Elite entstammt – sein wollen. Johann Wolfgang von Goethe nannte 1836 in seinen Bemerkungen über eine «sehr ansehnliche Sammlung gemalter Fenster zu Köln am Rheine» die Glasmalereien nicht nur in künstlerischer Beziehung schätzbar, sondern auch im historischen Sinne, weil sie Bildnisse denkwürdiger Personen und Wappenschilde vormals blühender Familien enthielten[787].

Johann Jakob Röttinger zeigte sich in seiner Zeit als Gehilfe beim Glasmaler Sauterleute für die Schaffung der Wappenscheiben in die Gruftkapelle derer von Thurn und Taxis zu Regensburg (Abb. 1, 2) verantwortlich. Ebenfalls noch unter Lehrmeister Sauterleute soll Röttinger die Wappenscheiben im Schloss Lichtenstein ausgeführt haben[788].

778 HASLER/BERGMANN, 2010, S. 133.

779 Die letzten Glasmaler dieser Epoche waren in Zürich Konrad Meyer (†1766), in Bern Samuel Küpfer (†1786), in Basel Michael David Lorentz aus Münster (tätig um 1781) sowie in Konstanz Joseph Anton Spengler (†1780), (BOESCH, 1955, S. 32–45).

780 TANNER, 2002, S. 180 f.: Unter den Mitgliedern der Helvetischen Gesellschaft findet der Autor die eigentlichen Inventoren des schweizerischen Nationalbewusstseins im Sinne der Behauptung eines gemeinsamen Vaterlandes. Die Alte Eidgenossenschaft wurde zum Sinnbild für die heroische Vergangenheit, die Begeisterung für die Schweizer Natur und Alpen stellte die Charakteristika des Schweizers – Freiheit, Tugendhaftigkeit und Patriotismus.

781 KÖPPEL, 2007, S. 143.

782 HESS, 2010, S. 220.

783 DE CAPITANI, 2011, HLS, Stichw. *Schweizerisches Landesmuseum*.

784 SCHNEIDER, 1954, S. 57: 1812 fasste der Rat der Stadt Baden den Entschluss, die Glasgemälde an Interessenten zu verkaufen – «[…], wenn aus selben genügsam erlöst werden könne».

785 KÖPPEL, 2007, S. 144.

786 Vgl. Kap. ‹Christliche «Monogramme» bzw. ‹Symbolik und Inszenierung›.

787 GOETHE, 1836, S. 208. Barbara v. Orelli-Messerli machte mich freundlicherweise auf die Textstelle aufmerksam.

788 Vgl. Kap. ‹Schloss Lichtenstein – Nördlingen – Rottweil›.

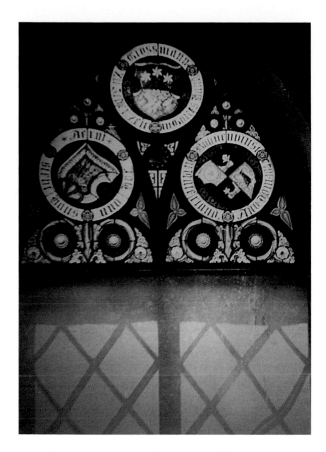

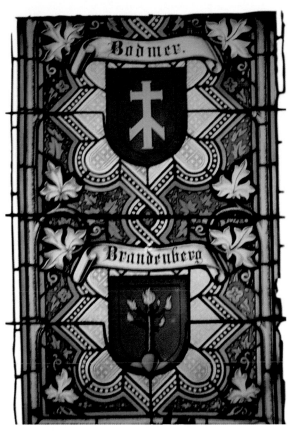

114. Johann Jakob Röttinger/A. Hirnschrot/R. Weiss, Fotografie der ehemaligen Wappenscheiben Grossmann, Aerni und Bohnenblust in der Evangelisch Reformierten Stadtkirche Aarburg (Kopie), 1844/45, Originalfoto GA Aarburg.

115. Johann J. Röttinger, Fragmente «Geschlechterwappen» Bodmer und Brandenberg, ehemals Pfarrkirche Unterägeri (Kopie), 1859, Originalfoto PA Unterägeri.

Diese Arbeiten zählt er in seinem Empfehlungsschreiben 1872 für die Rütlikommission auf, um sich für geplante Wappenfenster im Haus auf dem Rütli zu bewerben[789]. Trotz der innovativen Ideen, die in der Offerte zum Ausdruck kommen, erhielt Röttinger keinen Zuschlag. Zur Ausführung kamen hingegen andere wichtige Mandate, wie die Fertigstellung des Wappenzyklus' für die Kirche in Aarburg nach dem Ableben seines Arbeitgebers Johann Andreas Hirnschrot (Abb. 114), der Auftrag über die Glasmalereien in der Pfarrkirche zu Unterägeri unter Einbezug von Geschlechterwappen (Abb. 115), ein Stadtwappen und das Stifterwappen der Familie Dür in der reformierten

789 ZB Nachl. Röttinger 1.144: *«Zürich, den 18. Juni 72, Tit: Rütli Kommission. Habe die Ehre mich um die Ausführung der projektierten Glasmalerei in die Fenster auf dem Rütli zu bewerben und lege Ihnen zur Veranschaulichung meiner Idee, wie ich die Aufgabe zu lösen mir denke, leicht entworfene Zeichnungen bei, immerhin in der Meinung Ihre gefällige Korrektur oder Zusätze entgegen zunehmen. Wie Sie sehen, dachte mir im ersten mit dem Schilde der Gesamteidgenossenschaft zu beginnen und mit der Entstehung des Bundes mit fortzufahren und zwar mit dem Eintritt Genfs 1815. Soviel über die Anordnung der Wappen Schilder. Ferner als Verzierung über jeden Schild eine Strophe des Rütli Schwures, so dass derselbe gewisser Massen durch die ganzen Fenster als ein einiger Gedanke sich durchbewegt und den einfachen Schildern etwas Leben und Sinn mitteilen soll. Das letzte Schild als überzählig denke mir durch einen einfachen Sinnspruch auszufüllen und zwar in italienischer Sprache und zwar aus dem Grunde, weil 3 Hauptsprachen in der Schweiz gesprochen werden auch diese in*

116. Johann Jakob Röttinger, Stadtwappen Burgdorf, n IX,
Evangelisch-Reformierte Stadtkirche Burgdorf, 1868.

Stadtkirche zu Burgdorf[790] (Abb. 116) sowie die im Empfehlungsschreiben erwähnte Gestaltung und Ausführung der Wappenfenster in der Friedhofkapelle Bifang in Schwyz mit Geschlechterwappen, die von den Familien im Andenken an ihre Verstorbenen gestiftet wurden.

Im selben Schreiben erwähnt Röttinger neben Schwyz auch Stans[791], wo sich in der 1865–1866 von Baumeister Alois Amstad[792] erbauten Friedhofkapelle bis heute Wappenfenster mit den Wappen der Stanser Geschlechter in situ erhalten haben.

Der Scheibenzyklus für das Rathaus mit den Wappen der damals lebenden Ortsbürger der Stadt Rapperswil SG, der die Stelle von Standesscheiben einnimmt, wird 1855 als Prestigeauftrag fassbar und von den Auftraggebern entsprechend gewürdigt[793]. Mit diesem Werk trat Johann Jakob Röttinger in die Fußstapfen der großen Glasmaler wie Lukas Zeiner (um 1454–vor 1513) oder Carl von Egeri (1510/1515–1562), die Standesscheiben im Tagsatzungssaal zu Baden, in den Rathäusern Stein am Rhein SH und Rheineck SG sowie im Kreuzgang in Muri ausgeführt haben[794]. Standesscheiben wurden jeweils von einem der eidgenössischen Stände, der alten Orte, in öffentlichen Gebäuden, Rats- und Zunfthäusern, gestiftet (Abb. 117).

Die von Lux Zeiner eingeführte Anordnung der ikonographischen Elemente, das traditionelle Schema des Wappenaufbaus mit den zugehörigen Schildhaltern, ist auf Darstellungen in Diebold Schillings Chronik zurückzuführen, in der auf

den Bildern präsentiert sein sollen. Somit der Schwur deutsch im Schilde von Waadland Liberte et Patrie die frz. Sprache, die italienische als Sinnspruch. Als Schluss die vom durch die wenigen Worte anno domini 1872 als Erstellung der Fenster selbst. Soviel über die Idee meiner Auffassung. Nun zur Ausführung selbst. Darüber bemerke Ihnen nur, dass ich die sämtlichen Wappenfenster für Fürst Thurn und Taxis in der Familien Gruft in Regensburg, die Wappenfenster auf Schloss Lichtenstein, die Wappenfenster der Friedhofkapelle zu Schwyz und Stans ausführte, so dass ich mit Zuversicht sagen kann, dass ich im Stande bin Ihnen eine gelungene Arbeit zu liefern. Den Preis für die ganze Ausführung würde ich von 500 Fr. an bestimmen, immerhin aber für eine ganz besonders schöne Ausführung mich erst mit Ihnen über den Preis vereinbaren. In der Hoffnung Sie werden mir die Ehre schenken, diesen Auftrag auszuführen zu dürfen zeichne mit hochachtungsvoller Ergebenheit J. R. Glasmaler.»

790 ZB Nachl. Röttinger 1.26.
791 Vgl. Anm. 789.
792 INSA 9, 2003, S. 279, *Stans* (Reto Nussbaumer).
793 ZB Nachl. Röttinger 1.134; Das beiliegende Zeugnis des Ortsverwaltungsrates würdigt das Werk gebührend und empfiehlt den Künstler J. Röttinger bestens.
794 BHATTACHARYA, 2002, HLS, Stichw. *Aegeri [Egeri], Carl von*; SCHNEIDER, 1988, S. 10–16.

117. Hans Gitschmann von Ropstein, Rathaus Rheinfelden, Rathaussaal mit Glasmalereien, nach 1531.

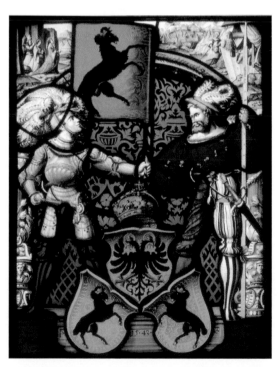

118. Carl von Egeri, Standesscheibe Schaffhausen, Maße 41×31 cm, Rathaus Stein am Rhein, 1542, Vitrocentre Romont Bilderarchiv.

einer Abbildung des Spalentors zur Zeit der Burgunderkriege das Basler Wappenschild von zwei Löwen gehalten wird[795]. Der so genannte Pyramidenaufbau der Wappenscheiben setzt sich aus Orts- beziehungsweise Reichsadlerschild und Krone zusammen, die von Schildhaltern flankiert wurden. Der Reichsschild, als wesentlicher Bestandteil der Standesscheibe, weist auf die Reichsunmittelbarkeit der Eidgenossen hin und ziert die Wappen, wohl aus Stolz über die erworbenen kaiserlichen Privilegien, häufig über die Zeit des westfälischen Friedens 1648 hinaus. Das Schenken von Standesscheiben (Abb. 118) hat also einen besonderen Stellenwert, der über dem eigentlichen Mäzenatentum liegt; die Sitte ist als Hoheitszeichen und Dokument für politische Beziehungen, als eigentliche Ehrengabe[796] sowie als Charakteristikum der Eidgenossenschaft zu verstehen.

795 SCHNEIDER, 1954, S. 135.
796 SCHNEIDER, 1954, S. 13 ff.

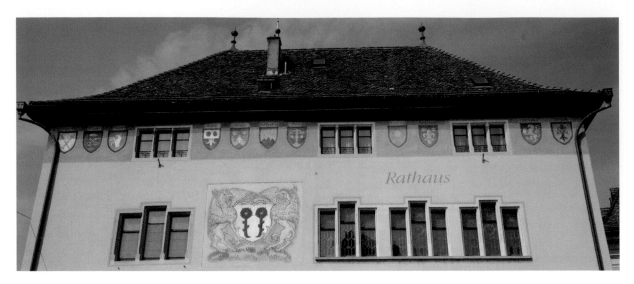

119. Rathaus Rapperswil SG, Wappenfries Fassade und Stadtwappen.

Der Wappenzyklus im Rathaus zu Rapperswil

Bernhard Anderes berichtet im Kunstdenkmäler-band[797] über die Präsenz von Standesscheiben im Rapperswiler Rathaus (1433 erstmals als Ratsstube erwähnt) – vor der Schaffung des Scheibenzyklus' Johann Jakob Röttingers –, was eine Abbildung von 1853 belegt[798]. In den Abschieden soll jedoch die Schenkung von Wappenscheiben nicht erwähnt sein. 1855 erhielt Röttinger den Auftrag über die Erstellung neuer Fenster im großen Ratssaale, der am 20. Januar zwischen der Baukommission, dem Bevollmächtigten des Ortsverwaltungsrates und dem Glasmaler vertraglich festgelegt wurde. Dabei ging es um die Erstellung sämtlicher Fenster, 9 Längsfenster mit 27 Abteilungen sowie die Ausführung der Glasmalerei inklusive Glaserarbeit. Das Dokument beinhaltet nicht nur die Einteilung der Scheiben, sondern auch die Festlegung des Materials. Bezüglich Ikonographie orderte der Auftraggeber: *«Die Glasmalereien betreffend wird a. in das Fenster dem Haupteingang gegenüber in die Mitte das Stadtwappen von Rapperswil, von zwei Schildhaltern gehalten, nach vorgelegter Zeichnung angebracht. b. in das Mittelfenster auf der Ostseite kommt die Ansicht von Rapperswil wie es zu Ende des achtzehnten Jahrhunderts sich darstellte nach vorgewiesener Kupferplatte und Plan zur Aufn. c. Ins Mittelfenster auf der Westseite werden die sieben Familienwappen der gegenwärtig in Amtsfunktion stehenden Verwaltungsräte* nach vorzulegendem Plan erstellt. d. 24 anderen oberen Teile der Fenster werden je in eine Scheibe zwei Wappen der gegenwärtig bestehenden ortsbürgerlichen Familien zu Rapperswil und zwar in chronologischer Ordnung je nach der Bürgerrechtserlangung jeder betreffenden Familie mit bezüglicher Namens- und Jahresbezeichnung und mit den dazu gehörigen Verzierungen in abwechselnder Folge zur Ausfüllung der ganzen Scheibe angebracht.»* Zur künstlerischen Umsetzung wurde angemerkt, dass sämtliche Arbeiten – von Glaserei über Glasmalerei bis zur Zeichnung – fein, kunstgerecht und solide gearbeitet sein sollen. *«Nach vollendeter Arbeit ist die Baukommission befugt, darüber eine Expertise vornehmen zu lassen und Herr Röttinger hat sich den Ihrigen Anspruch über kunstgerechte und solide und vertragsgemäße Erstellung gefallen zu lassen. Für obige Arbeiten wird dem Herrn Röttinger nach stattgehabter Expertise dem sonstigem Richtigbefinden durch die Baukommission die Summe von 1260 fr. ausbezahlt[799].»* Unterzeichnet wurde das Dokument vom Präsidenten der Baukommission, Breny.

Der Ratssaal zu Rapperswil konnte seine spätgotische Eigenart trotz der 1855 durchgeführten allgemeinen Erneuerung weitgehend erhalten. Er

797 ANDERES, 1966, S. 360. Bemerkenswerterweise erwähnen die Autoren der Geschichte des Rathauses, Helbling und Rickenmann, den Standesscheibenzyklus nicht (S. 360, Anm. 2).

798 ANDERES, 1966: Zeichnung von Vogel, Abb. 413.

799 ZB Nachl. Röttinger 1.134.

nimmt im zweiten Stock des Gebäudes die nördliche Hälfte der Geschossfläche ein und wird durch die dreiteiligen Reihenfenster, die von innen säulenabgestützte Joche aufweisen, erhellt (Abb. 119). Ein Brand im Jahr 1866 machte die Neuverkleidung der Decken und Wände mittels Kopien des ursprünglichen, mit Flachschnitzereien verzierten Täfers notwendig. Den Blickfang im Raum bildet ein großer gusseiserner Renaissanceofen aus dem Jahre 1572, der neben zahlreichen szenischen Darstellungen aus Antike und Altem Testament, die von Engeln gehaltene Rapperswiler Doppeltartsche mit den Rosen und dem darüber ragenden Adler sowie die Wappen der Schirmorte Uri, Unterwalden, Schwyz und Glarus zeigt. Auf dem Supraportae des spätgotischen Kielbogenportals erscheint das Rapperswiler Wappen ebenfalls im Doppel mit Wappenhaltern und reichem Rankendekor[800]. Dem Glasmaler blieb also die Herausforderung Glasmalereien für diesen bereits reich geschmückten Saal zu schaffen, die die Wirkung der Gemälde und Reliefs nicht beeinträchtigten, hingegen das Ambiente, das die früheren Standesscheiben ausstrahlten, wiederherstellten.

In die oberen Teile der hochrechteckigen Fensterbahnen malte Johann Jakob Röttinger jeweils ein nach oben hin spitz zulaufendes gotisches Maßwerkelement, das seiner Form entsprechend als Nonnenköpfchen bezeichnet wird. In diese geometrischen Figuren sind jeweils, wie oben im Vertrag angeführt, zwei Familienwappen einbeschrieben. Dabei hatte der Glasmaler die Wappenbilder auf die Schilde reduziert, das heißt Helm, Helmzier und Helmdecke wurden weggelassen. Die Wappenschilde (Abb. 5) neigen sich gemäß heraldischer Höflichkeit[801] einander zu und weisen an ihren zugewandten Seiten jeweils eine Tartsche auf. Diese Schildform kam im zweiten Viertel des 14. Jahrhunderts auf und verschwand zu Ende des 15. Jahrhunderts, um jedoch in der Heraldik erhalten zu bleiben[802]. Die beschriebene Einkerbung wird auch Speerruhe oder Degenbrecher genannt und diente ursprünglich dem Abfangen der gegnerischen Waffe. Nach den heraldischen Regeln muss das Heroldsbild des heraldisch nach links

(optisch nach rechts) geneigten Schildes gespiegelt sein, eine Übereinkunft, der hier nicht entsprochen wurde[803]. Anstelle von Helmzier und -decke gestaltete Röttinger die freibleibende Fläche oberhalb der Wappen mit mannigfaltigem Rankenwerk und Blattformen nach Akanthus und Wein – auf dieselbe Art wurden auch die Zwickel behandelt. Die Schilde selbst weisen feine Damaszierungen in der entsprechenden Wappenfarbe, der so genannten Tinktur, auf. Jenny Schneider bemerkt in ihrer Studie zu den Standesscheiben Lukas Zeiners, dass die von ihm geschaffene Anordnung der Wappenelemente sehr häufig nachgeahmt wurde[804].

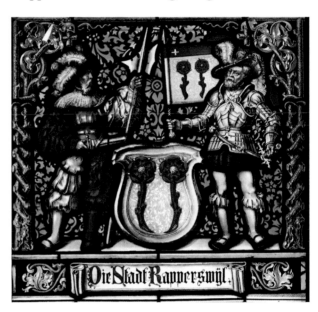

120. Johann Jakob Röttinger, Stadtwappen von Rapperswil, Rathaus, Ratssaal, Rapperswil SG, 1855.

So hielt sich Röttinger bei der Ausführung des Stadtwappens von Rapperswil an der Nordseite des Saales (Abb. 120) ebenfalls an die Tradition

800 ANDERES, 1966, S. 354 f.
801 Den Begriff der heraldischen Höflichkeit verwendet SCHNEIDER, 1954, S. 12.
802 LEXMA VIII, 2003, Sp. 484, Stichw. *Tartsche* (O. Gamber). Röttinger nahm dabei wohl Bezug auf die oben genannte Rapperswiler Doppeltartsche.
803 HANDBUCH DER HERALDIK, 2007, S. 50.
804 SCHNEIDER, 1954, S. 63 f.; GIESICKE/RUOSS, 2012, S. 103. Die beiden Autorinnen attestieren der Darstellungsweise von Standesscheiben mit Bannerträgern einen Ausdruck für die Einigkeit des Bundes und des Selbstverständnisses.

und stellte Schildhalter und «Bannerträger» [alte
Schreibweise: Pannerträger] unter eine angedeute-
te Arkade aus goldenem Rankenwerk. Es sind zwei
einander zugewandte, bärtige Männer mit Feder-
hut, als Eidgenossen dargestellt, der linke mit
Hellebarde und Kurzschwert, goldenem Brust-
panzer und Mipartikleidern in rot und weiß, der
rechte im Halbharnisch und grün-weißen Miparti-
beinkleidern mit dem Banner. Der Schild zwischen
beiden Figuren zeigt das Stadtwappen – zwei
rote Rosen in Silber – diese erscheinen darüber
hinaus auf der Standarte der rechten Figur, dort
jedoch mit Eckquartier, dem weißen Kreuz in rot.
Darunter fügt sich ein Schriftband ein mit der In-
schrift: «Die Stadt Rapperswyl». Die Frontmitte der
Wappenreihe auf der Westseite des Ratssaals ziert eine
Inschriftenrolle mit dem Chronogramm (Abb. 121):

122. Johann Jakob Röttinger, Stadtvedute von Rapperswil nach
Merian, Rathaus, Ratssaal, Rapperswil SG, 1855.

121. Johann Jakob Röttinger, Chronogramm, Rathaus, Ratssaal,
Rapperswil SG, 1855.

*GLorIa DeCVsqVe aVorVM eXIstet posterItas sCIen-
tIa VirtVte parIqVe pIetate nobILIs* (1855), dem Ent-
stehungsjahr der Glasmalereien. Diese Ausführung
weicht vom ursprünglich vereinbarten Modus ab,
der in dieser Scheibe *die sieben Familienwappen der
gegenwärtig in Amtsfunktion stehenden Verwaltungsräte*
vorsah»[805]. Die Ostseite zeigt als Auflockerung der
Wappenreihe eine Kopie der Rapperswiler Stadt-
vedute von Merian in Grisaillemalerei (Abb. 122);

beide Rollen, das Chronogramm und die Vedute,
werden jeweils von einem Mann und einem Kna-
ben in spätmittelalterlich historistisch anmutender
Kleidung gehalten. Unter den einzelnen Familien-
wappen sind Schriftbänder angebracht, die die Wap-
pen mit den entsprechenden Geschlechternamen
bezeichnen und die Jahreszahl ihrer Einbürgerung
nennen[806]. Einige Ortsbürger stachen im 19. Jahr-
hundert besonders hervor; so gab der Chronist
Xaver Rickenmann eine Stadtgeschichte bis zum
Jahr 1803 heraus, dem Jahr der Einverleibung der
Stadt Rapperswil in den Kanton Sankt Gallen.
Weitere ortsansässige Bürger beschäftigten sich

805 ZB Nachl. Röttinger 1.134.

806 Die Namen erscheinen von West nach Ost wie folgt als
 Einzelinschriften: «*Nägeli 1819, Bleile 1819, Dresseli 1842,
 Gruber 1841, Kuster 1852, Lütinger 1855, Mächler 1802, Decret-
 te 1804, Müller 1807, Suter 1819, Perrola 1784, Gaudy 1784,
 Michel 1784, Delemontey 1785, Diogg 1791, Real 1795; Zimmer-
 mann 1621, Crivelli 1636, Bernodet 1572, Reimann 1615, Helbling
 1544, Ziegler 1562, Breny und Rüssi vor 1400, Wettstein 1496,
 Rotenfluh 1500, Büler 1516, Kunz 1511, Oswald 1541, Fuchs
 1516, Daumeisen 1534, Rikenmann 1544; Höfliger 1657, Curti
 1665, Feurer 1696, Karpf 1698, Brentano 1699, Dillier 1709,
 Greith 1709, Rosshardt 1719, Fornaro 1721, Schneider 1749,
 Dormann 1775, Ill 1779, Diethelm 1781 und Lumpert 1784*».

damals mit der Geschichte ihrer Heimat, wie Siegfried Domeisen, Carl Helbling und Alfons Curti – letzterer mit der Kirchengeschichte. Außer den historisch interessierten Bürgern ist Regierungsrat Josef Büeler zu nennen, die beiden Fuchs, als Senator und Maler, zwei Stadtammänner namens Helbling, Major Felix Diogg, Sohn des bekannten Porträtmalers Felix Maria Diogg, ferner Bonifaz, Xaver und Bertold Rickenmann, Basil Ferdinand und Theodor Curti, die Brüder Greith, der Bischof und der Musiker – Carl Greith als Domkapellmeister in München –, Landammann Felix Helbling, Kommandant Fornaro und Oberst Breny, die Nationalräte J. B. Gaudy und A. Mächler[807]. Die hier angeführte, unvollständige Aufstellung ist, obwohl sie den Status einzelner Personen hervorhebt, in erster Linie als Argument für den hohen Stellenwert von Scheibenzyklen mit Geschlechterwappen in Rathäusern und öffentlichen Profanbauten im 19. Jahrhundert zu verstehen. Die Tradition elitärer Stiftungen von Wappenscheiben in Rathäuser muss, wie schon erwähnt, im burgundischen Herrschaftsgebiet gesucht werden, wo Brigitte Kurmann-Schwarz in ihren jüngsten Forschungen Wappenstiftungen reicher Bürger als Reflex der herzoglichen heraldischen Donationen nachweisen konnte[808]. Neben der Oberschicht waren es die vielen Handwerkerfamilien und Künstler, die der Stadt deren Stolz und Prägung verliehen. So werden in Rapperswil beispielsweise schon im 16. und 17. Jahrhundert zahlreiche Glasmaler mit den alten Geschlechternamen fassbar, wie Hans Heinrich Breny (1582–1605), Wolfgang Breny (†1613), Hans Heinrich Schnyder (†1616), Hans Ulrich (†1635) und Hans Jakob Breny (†1637), Johann Jakob Rothenfluh als Großweibel 1627 und Balthasar Wetzstein als Stadtschreiber (†1635)[809]. Die Ortsbürger von Rapperswil erlangten im 19. Jahrhundert bedeutende Funktionen, bildeten sie doch seit der Kantonsgründung 1803 als Teilhaber des Gemeindegutes die gesamte Vermögensverwaltung. Erst im Laufe der Zeit wurden die Obliegenheiten der Ortsbürger – Verwaltung der Besitztümer, Fürsorge der verarmten Bürger sowie die Einbürgerungen – vom allgemeinen Gemeindewesen getrennt[810].

Die Herausforderung passende Fenster für einen reich verzierten, nach spätgotischer Manier gestalteten Raum, mit weiteren Stilelementen zu entwerfen, hat Röttinger dank seiner Erfahrung bestens gemeistert. Die Reduktion der Wappen auf den Schild unter Weglassung von Helm, Kleinod und Helmdecke brachte nicht nur die für die Wirkung des Saals notwendige Schlichtheit, sondern entspricht auch den heraldischen Gesetzen. Denn für ein bürgerliches Wappen stellt der Blason, wie der Schild in der Fachsprache genannt wird, die einzig richtige Wappenform dar – hingegen entstand aus der Verbindung von Helm, Helmzier und Helmdecke, auch Oberwappen genannt, ein ritterliches Wappen. Die Attribute des Ritters auf bürgerliche Wappen zu übertragen, war zwar Usus, galt jedoch aus heraldischer Sicht als unzulässig[811]. Alfons Curti bemängelte 1949 die nicht immer einwandfreie Verwendung der heraldischen Tinkturen im Wappenzyklus, gesteht der Glasmalerarbeit jedoch eine Verschönerung des Saales zu, die nach dem Brand 1866 geringfügig beschädigt war und repariert werden musste[812]. Bernhard Anderes würdigte diese noch in situ erhaltene Arbeit Röttingers als ansprechenden, wenn auch bunten Wappenzyklus[813], der die damaligen Auftraggeber zufriedenstellte und bis heute den Ansprüchen der Ratssaalbenut-

807 HALTER, 1974, Vorwort.
808 KURMANN-SCHWARZ, 2012 (1), S. 127–149.
809 BOESCH, 1955, S. 42 ff.
810 Rapperswil SG, Homepage der Ortsbürgergemeinde.
811 STYGER, 1936, S. 15. Erst die Verleihung eines Titels des so genannten Briefadels bei Magistratspersonen ermöglichte eine entsprechende Ausstaffierung des Schildes durch ein Oberwappen. Im zeitgleich publizierten Rapperswiler Wappenbuch von J. Kull, das als Vorlage gedient haben wird, sind die ritterlichen Attribute noch vorhanden. Ob der eine oder andere Namensträger ritterliche Vorfahren hatte, wurde von der Verfasserin nicht überprüft. Eventuell ist der Wunsch nach einer ritterlichen Ausführung der Wappen ebenfalls als Anpassung an die adelige Heraldik zu verstehen.
812 CURTI, 1949, S. 40 ff.
813 ANDERES, 1966, S. 360 f.

zer genügt[814]. Den hier tafelnden Bankettgästen bietet der Saal mit dem Scheibenzyklus ein angemessenes und geschichtsträchtiges Ambiente.

Durch die Ausführung der ortsbürgerlichen Wappen, unter Einbindung von graphischen Elementen mit Bezug auf die Stadt Rapperswil, gelang es dem Glasmaler das Selbstverständnis der eingesessenen Rapperswiler Familien darzulegen sowie an die lange Tradition heraldischer Glasmalereien in Schweizer Rathäusern – nach dem Vorbild adeliger Machthaber – anzuknüpfen und diese bis in die Gegenwart fortzuführen.

Die Wappenscheiben der Geschlechter von Schwyz

Vor einem anderen Kontext, jedoch ebenso bedeutend, ist ein Zyklus von ehemals zirka 80 Wappenscheiben im Flecken Schwyz einzustufen, der von Angehörigen der Verstorbenen Schwyzer Geschlechter der Friedhofskapelle Bifang gestiftet worden ist. Die hohe Achtung der Vorfahren und das damit verbundene Selbstverständnis der Bürger von Schwyz ist hauptsächlich vor dem Hintergrund der Entstehung der mittelalterlichen Talgemeinde im Talkessel von Schwyz, im Muotatal und um den Lauerzersee zu verstehen. Ab dem 10. Jahrhundert werden dank des Benediktinerstifts im «Finstern Wald», dem Kloster Einsiedeln, Schriftquellen fassbar, die die Entwicklung der Talgemeinde nachvollziehbar machen. Das von deutschen Königen reich beschenkte Kloster bildete zwei Schwerpunkte aus, die adlige Grundherrschaft sowie die sich unter der Ägide des heimischen Patriziats ausbreitenden Hirten von Schwyz, wobei sich in der Auseinandersetzung um Wälder, Weiderechte und Alpen die Talgemeinschaft immer deutlicher formierte. Es entstand eine Oligarchie aus führenden Geschlechtern – «fromme redliche lantlüt», die den einheimischen Adel stellten, wie dies der Glarner Ägidius Tschudi (1505–1572) konstatierte, der aus dem Selbstverständnis des Patriziers heraus den führenden Geschlechtern von Anfang an deren Dominanz an der eidgenössischen Entwicklung zuwies[815]. Macht und Selbstbewusstsein der Leute von

Schwyz erhärteten den Wunsch nach Autonomie, der 1240 nach erhaltener Reichsunmittelbarkeit von Kaiser Friedrich II. den Versuch, sich gegen die regionale Autorität der Habsburger zu wappnen, mitbestimmt. Die erfolgreiche Politik – spätestens seit 1315 gehört Schwyz zu den Orten der Alten Eidgenossenschaft – weckte schließlich wirtschaftliche Interessen im Handel mit dem Süden. Im 14. Jahrhundert expandierte Schwyz anstelle der habsburgischen Herrschaft in die Gebiete der Waldleute[816] und entwickelte dabei Bewegungen, die ebenfalls von Hegemonie geprägt waren. In diesem sehr knappen Abriss über die Entstehung des Alten Landes Schwyz[817] tritt das harte Ringen nach Selbstständigkeit und Eigenverantwortung sowie der damit einhergehende Machtzuwachs in Erscheinung, was den Stolz der nachfolgenden «ehrenden Geschlechter» auf ihre Ahnherren nachvollziehbar macht. Die so genannte Oberallmeind ist die flächenmäßig größte Korporation der Schweiz und geht auf die mittelalterliche Siedlungs- und Flurgenossenschaft zurück. 1816 wurde das Oberallmeindgericht gegründet, das dem heutigen «Verwaltungsrat» entspricht. Noch in den Statuten von 1997 werden als Genossenbürger 97 nutzungsberechtigte Geschlechter der Genossame Schwyz genannt, deren Exklusivität erst 2006 aufgehoben wurde. Mit der Präsenz der Oberallmeindkorporation Schwyz[818] legitimiert sich neben der historischen eine aktuelle Bedeutung der alten Geschlechternamen beinahe bis in die Gegenwart.

814 ZB Nachl. Röttinger 1.134. Dem Vertrag liegt ein Zeugnis bei, das die außerordentliche Zufriedenheit der Auftraggeber bescheinigt. Heute befindet sich im Rathaus ein Restaurant, in dem der Ratssaal für besondere Anlässe geöffnet wird.

815 MARCHAL, 2007, S. 42 f.

816 MÜHLEMANN, 1990 S. 49 ff.; LANDOLT, 2011, HLS, Stichw. *Schwyz (Kanton)*.

817 Ab dem 19. Jahrhundert wurde das Land Schwyz auch als Altes Land bezeichnet (vgl. LANDOLT, 2011, Anm. 816).

818 WIGET, 2009, HLS, Stichw. *Oberallmeind*.

123. Ehemalige Friedhofkapelle Schwyz, erbaut 1863 von Ferdinand Stadler, Staatsarchiv Schwyz.

Schon vor Baubeginn der Friedhofskapelle ließen sich die Schwyzer Auftraggeber von keinem Geringeren als dem Architekten und Professor in Zürich, Gottfried Semper, ein Gutachten über den von Architekt Ferdinand Stadler eingesandten Plan ausstellen. Davor wurden bereits vier von Architekt C. Reichlin eingesandte Projekte abgelehnt[819]. Semper bestätigte die Einwände der Baukommission, nämlich, dass die geplante Arkadenhalle zu wenig Tiefe für die Aufnahme von Denkmälern aufweise und dass das Portal zu schmal konzipiert sowie der Zutritt durch eine Säule verstellt sei. «*Die Bestimmung einer Grabkapelle erheischt durchaus eine möglichst weite und bequeme Öffnung, welch' letztere ihr erst den wahren Charakter giebt, indem dieses weite Portal zu der sonst kleinen Kapelle in ganz anderem Verhältnis stehen muß und soll, als z. B. dieses bei dem Verhältnisse eines Kirchenportals zu der Größe des Kirchenschiffes der Fall ist*»[820]. Der große Aufwand der Baukommission bezüglich der Planung des Kapellenneubaus zeigt unter anderem den hohen Stellenwert des Gebäudes und gleichermaßen des Auftrags, der an

Johann Jakob Röttinger ergangen war. Die Kapelle auf dem Bifang (Abb. 123), deren Vorhallen das Vorbild der Kirchhofhallen in Luzern nachahmten[821], wurde 1863 schließlich dennoch von Architekt Ferdinand Stadler um 28 000 Franken an der Stelle der alten Allerheiligenkapelle erbaut. Der in der Mitte des neuen Friedhofs gelegene Sakralbau war als schlichte tonnengewölbte Saalkirche konzipiert mit zwei Achsen von Rundbogenfenstern und einer Chorapside, die mit drei Seiten des Achtecks abschloss. Die Betonung der Mittelachse entstand durch eine giebelüberdachte Arkade, die den Eingang zur Vorhalle bildete und mit den vorgelagerten Arkadengängen in Verbindung stand[822]. Bezüglich der Planung der Fenstergestaltung, die ein Jahr später begann, kam von Landammann Styger die Anregung: «*ob nicht in den 6 Fenstern die Wappen der jetzt lebenden Gemeindebürger (nach den 6 Vierteln eingeteilt) in Glasgemälden angebracht die dahierigen Kosten durch freiwillige Beiträge der rep.[utablen] Geschlechter bestritten werden könnten*»[823]. Johann Jakob Röttinger, der häufig durch Ferdinand Stadlers Empfehlung Aufträge erhalten hatte, veranschlagte pro Fenster 300 Franken. 1866 beschloss man, «*einen dahierigen Aufruf an die ehrenden Geschlechter drucken und verbreiten zu lassen und die eingesendeten Angebote für freiwillige Angebote zu gewärtigen*»[824]. Im Dezember desselben Jahres war das Projekt soweit gediehen, um die Details zu besprechen. Laut dem ursprünglichen Plan waren 84 Wappen zu Gruppen von 14 Schilden aufzuteilen,

819 MEYER, 1978, S. 227.
820 StASZ, Akte 12.06.21: «Beleuchtung des Stadler'schen Bauplanes und Kostenberechnung für die Friedhofkapelle in Schwyz», Herbst 1863, verfasst von Franz Triner, Bauführer; darin Abdruck des Gutachtens Sempers (Zitat) an den Präsidenten des Gemeinderats, Kündig, S. 7, vom 19. Januar 1863.
821 StASZ, Akte 12.6.21, S. 2, gemeint ist die Hofkirche Sankt Leodegar und Mauritius mit ihren offenen Gräberhallen.
822 MEYER, 1978, S. 227.
823 GASZ, I.94.4: Protokolle der für die Baute der Friedhofkapelle bestellten Kommission: 10. Mai 1864.
824 GASZ, I.94.4: Protokolle der für die Baute der Friedhofkapelle bestellten Kommission: 18. Mai 1866.

183

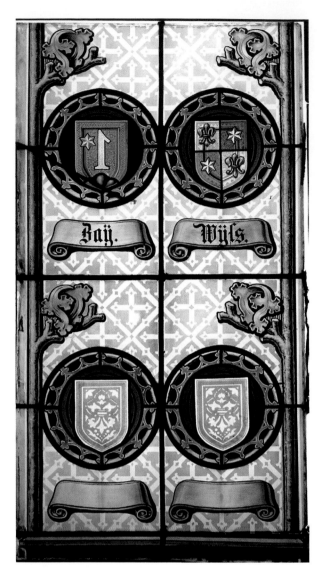

124. Johann Jakob Röttinger, «Geschlechterwappen» Zay und Wyss, «leere Felder» zur Aufnahme von Geschlechterwappen für die ehemaligen Friedhofkapelle Schwyz, 1867.

nierung alles Schützenswerten vor allem der Geschlechter-wappen» ist Bestandteil der Aktion, für die der Gemeinderat 20 000 Franken bereitstellte[826]. Die Untersuchung der Scheiben und Fragmente im Herbst 2009 brachte Ergebnisse, die unter Einbindung des Archivmaterials im Nachlass der Röttinger eine Vorstellung vom Aussehen der ehemaligen Kapellenfenster zulassen. So könnten von den sechs in den Schwyzer Schriftquellen vorgesehenen Fenstern, mit je 14 Familienwappen, nur vier zur vollständigen Ausführung gekommen sein, die dann jeweils Platz für 20 Wappen boten. Diese Annahme wird vom Eintrag Röttingers im Skizzen- und Auftragsbuch gestützt, wo er die Ausführung von vier Fenstern inklusive der Maße notiert: *«Kapelle in Schwyz, kth., 4 Fenster jedes 3'5" breit und 8' hoch im Licht, der Falz beträgt durchschnittlich 9'''. Mit 80 Wappen in Damast und gotischen Ornamenten. Rundbogen: die Hälfte der Breite bildet den Zirkel»*[827]. Aus der Offerte, die Röttinger an den Gemeindeschreiber Triner in Schwyz sandte, geht hervor, dass vier Fenster mit Wappen bestückt werden sollen und zwei weitere Fenster für die *«folgenden Geschlechter im Vorrate»* bleiben (Abb. 124), wobei diese so vorzubereiten seien, dass nur noch die Medaillons mit den Wappen einzusetzen sind[828]. Die einzelnen Wappen sind in Medaillons – von Ranken umrahmt – dargestellt, deren Grundfarbe einheitlich in violett gehalten ist. Die Schilde sind dabei exakt

«das größere Wappen oben in der Mitte solle analog eines Beschlusses vom 3. September wegfallen und durch eine entsprechende Zeichnung ersetzt werden». Des Weiteren wurden die «ehrenden Geschlechter» ersucht, sich mit 20 Franken pro Wappen zu beteiligen. Die Differenz zum Preisangebot von 2 000 Franken leistete die Gemeinde[825]. Im Protokoll des Gemeinderats Schwyz vom 6. April 1973 wird schließlich nach Feststellung der totalen Baufälligkeit der Kapelle der *Beschluss für ein Detachement durch eine Luftschutzeinheit im Mai»* festgehalten. Die *«Magazi-*

825 GASZ, I.94.4: Protokolle der für die Baute der Friedhof-kapelle bestellten Kommission: 10. Dezember 1866.

826 GASZ, 07.01, 07.09, Protokolle: 25. August 1972, 6. April 1973. Bis 2009 waren die Scheiben in einem schwer zugänglichen Außendepot der Gemeinde untergebracht, von wo sie dank des Verständnisses und Einsatzes von Gemeindeweibel Beat von Euw in die Zivilschutzanlage gebracht wurden. Dort war es schließlich möglich, die Scheiben unter der Leitung von Stefan Trümpler, Vitrocentre Romont, fotografisch aufzunehmen, zu untersuchen und zu inventarisieren.

827 ZB Nachl. Röttinger 1.202.39; Für die Maßangaben: 'Fuß, "Zoll und '''Linien vgl. Anm. 289. Als Faustregel kann gelten: Fuss = 30 cm, Zoll = 3 cm, Linie = 3 mm. Die Fenster hätten demnach im Licht Ausmaße von etwa 240×105 cm gehabt.

828 ZB Nachl. Röttinger 1.153.

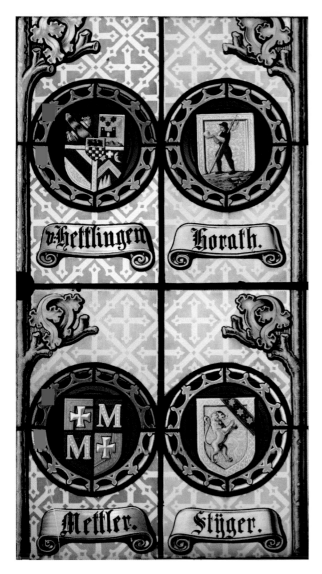

dern auch leere erhalten haben, ist davon auszugehen, dass die heraldischen Einträge nach der Erstellung eines gewissen Grundstocks an Wappenscheiben tatsächlich erst Schritt für Schritt erfolgten. Und zwar jedes Mal, wenn sich eine Familie entschloss, zum ehrenden Andenken ihrer verstorbenen Vorfahren eine Wappenscheibe zu stiften, wurde diese nach Einzahlung der geforderten 20 Franken ergänzt. Das nachträgliche Einsetzen von Stifterwappen lässt sich an der Rückseite der Scheiben an den überhöhten Bleilinien erkennen. Die später aufgemalten Namenszüge wurden kalt, das heißt mit Ölfarbe oder Schwarzlot, jedenfalls ohne Brand aufgetragen. Diese Technik unterscheidet sich im optischen Ergebnis von der eingebrannten Methode durch eine schlechtere Haltbarkeit – die Schriftzüge verblassen schneller oder weisen Fehler auf (Abb. 126).

125. Johann Jakob Röttinger, «Geschlechterwappen» von Hettlingen, Horath, Mettler und Styger, Rautenmuster mit Kreuzen, ehemalige Friedhofkapelle Schwyz, 1867.

126. Johann Jakob Röttinger, Namenszug mit Kaltfarbe, «Geschlechterwappen» der ehemaligen Friedhofkapelle Schwyz, 1867.

in die Rundscheiben eingepasst und heben sich farblich gut vom dunklen Hintergrund ab. Das in Grisaille gehaltene, geometrische Damastmuster der Fenster – Rauten, denen Kreuze einbeschrieben sind – lässt die Herstellung mittels Schablonen erkennen[829]. Die Grisaillen kontrastieren mit den goldenen Arabesken, die in einem reichen Ranken- und Blätterwerk kulminieren (vgl. Abb. 65); die Geschlechternamen erscheinen auf weißen Schriftrollen unterhalb des jeweiligen Wappens (Abb. 125). Da sich neben den mit Schilden ausgefüllten Fel-

829 SCHOLZ, 1991, S. 281, Hartmut Scholz stellt eine konstante Gleichförmigkeit der Damastmuster im 15. Jahrhundert für die Nürnberger Glasmalerei, was die Verwendung entsprechender Model bzw. Formschablonen voraussetzt.

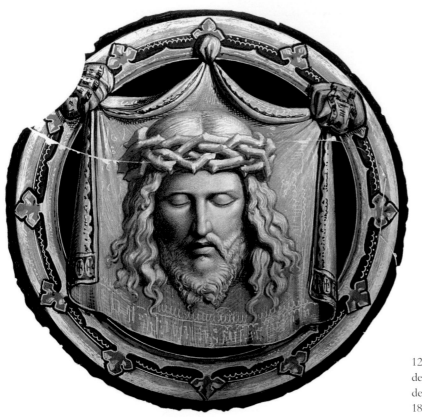

127. Johann Jakob Röttinger, Schweißtuch der Veronika, Geschlechterscheibenzyklus der ehemaligen Friedhofkapelle Schwyz, 1867.

128. Johann Jakob Röttinger, Leidenswerkzeuge, Geschlechterscheibenzyklus der ehemaligen Friedhofkapelle Schwyz, 1867.

Als Vorlage stand Johann Jakob Röttinger ein im Nachlass erhaltenes Blatt mit Schwyzer Familienwappen zur Verfügung – von einem Heraldiker namens J. Bettschart angefertigt und 56 Stifternamen enthaltend[830]. Röttinger hielt sich mit Ausnahme der Schildform, die er vereinfachte, an die vorgegebenen Musterwappen. Er verwendete die Form des im 13. Jahrhundert in Spanien entstandenen Halbrundschilds mit nahezu parallel verlaufenden Außenseiten[831]. Statt einer Rundung, was einer U-Form entsprechen würde, ließ er die Ränder zu einem angedeuteten, nach unten zeigenden Spitzbogen zusammenlaufen. Wie schon in der Rapperswiler Ratsstube kommt auch hier der Schild allein ohne Oberwappen zur Ausführung. Johann Jakob Röttinger gibt bereits in seiner Offerte an Gemeindeschreiber Triner zu bedenken, dass im Rahmen der vorgeschlagenen Ausführung kein Platz für Wappen mit Helm beziehungsweise Helmzier vorhanden sei[832]. Dank des einheitlichen Hintergrunds wirken die Fenster schlicht und ruhig – des ehrenden Andenkens verstorbener Bürger würdig. Dazu passend wurden die Bogenfelder der Fenster mit Medaillons gestaltet, die die Thematik von Passion und Tod symbolisch aufnehmen. Johann Jakob Röttinger arrangierte auf einer der Rundscheiben eine Urne sowie die Arma Christi – Geißeln, Kette und Seil – auf einer zweiten Kreuz und Kelch mit den Inschriften INRI beziehungsweise «*Non mea sed tua voluntas*». Auf einem weiteren Medaillon erscheint das Schweißtuch der Veronika mit dem Antlitz Christi (Abb. 127)[833] und auf dem vierten ebenfalls Leidens- beziehungsweise Kreuzigungswerkzeuge (Abb. 128).

Dabei werden Lanzenspitze, Zange, Dornenkrone, Essigschwamm, Hammer, Nägel und Würfel von einem mit INRI beschrifteten Band zusammengehalten. Die in Grisaillemalerei ausgeführten Glasmalereien wirken zurückhaltend und für die Ausstattung einer Friedhofkapelle inhaltlich wie formal passend. So sind die aus dem Gemeindedepot hervorgeholten Scheiben und Fragmente als Ausprägung des Geschichtsverständnisses im 19. Jahrhundert sowie als Bekenntnis zum historisch

bedingten Selbstbewusstsein der Schwyzer anzusprechen und sind darüber hinaus, dank der qualitätsvollen Glasmalereiarbeit, wert einer Wiederverwendung im geplanten Alters- und Pflegeheim zugeführt zu werden[834]. Auf diese Weise kann das ehrenvolle Andenken der alten Schwyzer Geschlechter, einer die ländlichen Stände beherrschenden Elite, weiterhin tradiert werden und als «*Zierde der Gemeinde*»[835] Senioren und Besuchern die Geschichte ihres Kantons erfahrbar machen. Nach der Intention der damaligen Auftraggeber galt schließlich die Schaffung der Geschlechterscheiben als «*bleibendes Denkmal der Bürger für jetzt und spätere Zeiten*»[836].

830 GASZ: Rechnung 1866 «*für das Malen der Fensterwappen (Vorlagen) für Herrn Röttinger (Hr. Bettschart) 38.50 Franken. An Röttinger 1867 2000 Franken für die Wappenfenster bezahlt. Für die Drahtgitter vor die Fenster an Herrn Millot 146.15 Franken.*» GASZ: Friedhofskapellenbaukommission, S. 8: Ab 2. September 1866 wurden Ansuchen von Kantonsbürgern, ihr Familienwappen in die *Friedhofskapelle* zu stiften, ebenfalls stattgegeben. ZB Nachl. Röttinger 1.1.7.: Vorlagenblatt von Bettschart.

831 HANDBUCH DER HERALDIK, 2007, S. 50.

832 ZB Nachl. Röttinger, 1.153.

833 Unter dem Antlitz Christi sind Zeichen eingeritzt, die eventuell eine Signatur «*Fries(s)*» darstellen könnten. VAASSEN, 1983, S. 15–17, Anm. 41 u. 46: In der Bonner Friedhofskapelle (der Bau wurde 1847 nach Bonn versetzt) befand sich eine Darstellung der hl. Veronika mit dem Schweißtuch, eine Stiftung von Mathilde Boisserée, gemalt 1854 von Sänftle.

834 Laut Mitteilung des Gemeindeweibels in Schwyz, Beat von Euw, vom 7. Dezember 2011 sollen ausgewählte Stücke der Geschlechterscheiben in die Fenster des neu zu erbauenden Alters- und Pflegeheims eingearbeitet werden. Begleitet wird das Projekt von einem Glasmaler, der zusammen mit dem Architekten die Auswahl geeigneter Scheiben treffen wird.

835 StASZ, Akte 12.04.03, Bote der Urschweiz, Nr. 46, 8. Jg., 9. Juni 1866.

836 StASZ, Akte 12.04.03, Bote der Urschweiz, Nr. 98, 8. Dezember 1866.

Die Namen der Geschlechter von Schwyz

In einer handschriftlichen Aufzeichnung aus dem Staatsarchiv Schwyz werden die Geschlechternamen der Stifter den einzelnen Vierteln im Land Schwyz zugeordnet[837]. Die Namenslisten wurden durch eine Zeichnung des Kapellengrundrisses ergänzt und die geplanten Fenster nach Vierteln bezeichnet. Den durchgestrichenen und überschriebenen Angaben zufolge war man sich über die Zuteilung der Namen an die Lage beziehungsweise Hierarchie der Kapellenfenster uneinig und diskutierte vermutlich über die verschiedenen Möglichkeiten. Die Verteilung der Namen auf sechs Fenster widerspricht, wie bereits ausgeführt, den Einträgen im Auftragsbuch des Glasmalers und war daher vermutlich ein möglicher Vorschlag während der Planungszeit. Die Zuordnung der Geschlechter nach ihrer Herkunft bewahrte jedoch seine Gültigkeit und soll daher in der nachfolgenden Aufzählung beibehalten werden[838].

- Alt-Viertel: *Ab Yberg, Ehrler, Göldlin, Kälin, Kothing, Müller, Nauer, Schorno, Steiner, Studiger, Lindauer, Krämer, Erb, Benziger.*
- Neu-Viertel: *Appert, Bruhin, Dusser, Hettlingen, Horat, Jütz, Mettler, Lüönd, Styger, Deck, Trütsch, Ulrich, Gasser, von Euw.*
- Steinen-Viertel: *Abegg, Amgwerd, Anderrütti, Holdener, Kündig, Märchy, Reichlin, Schuler, Beeler, Schnüringer, Inglin, Camenzind, Diethelm, Gyr.*
- Muotathaler-Viertel: *Bellmont, Bürgler, Castell, Pfyl, Real, Rhiner, Schatt, Suter, Föhn, Bettschart, Knobel, Krieg, Stutzer, Eberle.*
- Niederwässer-Viertel: *Aufdermauer, Bürler, Dettling, Ender, Häring, Inderbitzin, Marty, Niederöst, Reichmuth, Schilter, Triner, Tschümperlin, Wiget, Bücheler.*
- Arther-Viertel: *Fischlin, Faßbind, Eichhorn, Gemsch, Heinzer, v. Reding, Rickenbach, Schnider, Weber, Zay, Hediger, Hiklin, Lagler, Wyss.*

Ungeachtet dessen, dass sich nicht alle Wappen und Namensschilder vollständig erhalten haben, ließ sich feststellen, dass die Wappenscheiben *grosso modo* tatsächlich in Anlehnung an diese

Viertel-Ordnung zusammengefügt worden sind. Einige Namen erlangten dank früher überlieferter Leistungen ihrer Träger einen hohen Bekanntheitsgrad; so nahm Werner Reding 1311 am Raubzuge Heinrich Stauffachers nach Finstersee teil, wurde Rudolf Reding um 1400 der Alte von Biberegg beziehungsweise der alte Reding us der Öy (Eumatt Sattel) genannt, waren die Redings im 15. Jahrhundert in Arth fassbar, um von dort ihren Wohnort nach Schwyz zu verlegen[839]. Im Staatsarchiv Schwyz werden folgende Namen im 14. bis 18. Jahrhundert als Landammänner, Ammänner, Räte oder mit einem Landrechtsbrief ausgestattete Personen, also als Teil des Schwyzer Patriziats, betitelt: Ab Yberg, Bruhin, Lüönd, Mettler, Gilg, Uf der Mur, Knobel, Krieg, Pfyl; in der Genossenlade Schübelbach Ab Yberg als Landschreiber, Beeler als Landvogt und Betschart als Landsfähnrich 1637; in der Genossenlade Sattelegg in Altendorf, Horat und Inderbitzin als Ratsherren zu Schwyz 1608[840] – die Liste wäre noch verlängerbar, die aufgeführten Namen haben freilich nur exemplarischen Charakter.

837 StASZ, Akte 12.04.03, Namensliste. Nachzeichnung Geschlechterwappen (der ursprünglich veranschlagte Betrag von 15 Franken pro Stifter musste schließlich auf 20 Franken erhöht werden).
838 StASZ, Akte 12.04.03, Namensliste.
839 Iten, 1948, S. 39.
840 Styger, 1936, S. 19 ff. Der Schwyzer Dialekt mit seinen Quetschlauten oder anderen regionalen Ausdrucksformen führte dazu, dass aus manchem Vornamen ein Familienname entstand, wie Betschard aus Peter, Trütsch aus Trutmann bzw. Lüönd aus Leonhard, Inglin von Ingold, Triner von Kathrin oder Beeler von Berta (Iten, 1948, S. 38, S. 54: Peter – Betsch – Betschhard; Leonhard – Liend – Lüönd; Berta – Beli – Beeler etc.).

129. Friedhofkapelle Stans, erbaut 1865/1866 von Baumeister Alois Amstad.

Das äußere Erscheinungsbild der 1865–1866 erbauten Friedhofkapelle in Stans (Abb. 129, vgl. Abb. 123) entspricht in wesentlichen Zügen der abgebrochenen Friedhofkapelle Schwyz, denn auch hier tritt eine Anlehnung an die Luzerner Kirchhofhallen zutage. Die Kapelle mit Vorhalle – letztere wird durch eine Arkade betreten – trägt ebenfalls ein Satteldach mit Dachreiter. Die 14-achsige Korbbogenhalle[841] übertrifft an Größe den kompakten Bau der Schwyzer Kapelle – weitere Arkaden kamen im frühen 20. Jahrhundert hinzu. Die architektonische Gestaltung der Stanser Kapelle scheint jedoch einfacher ausgeführt worden zu sein. Im Inneren des kleinen Kapellenraums zeigen drei der vier Rundbogenfenster je zwölf Abbildungen von Stanser Familienwappen[842]. Im vierten Fenster (s III) wird anhand der drei leeren Wappenschilde (1 a, b) dieselbe Vorge-

hensweise wie in Schwyz evident, nämlich die schrittweise Wappenstiftung der Nachkommen für ihre Verstorbenen[843]. Dieses Fenster zeigt außerdem die Werkstattsignatur Röttingers mit der Jahreszahl 1871[844] (Abb. 130).

841 Bauinventar Gemeinde Stans.
842 Die Namen der Geschlechter werden im Katalog aufgeführt.
843 Dies bestätigt ein Beschluss im Kirchenratsprotokoll, PA Stans, S. 216/217 unter 4. b «Die verschiedenen Geschlechter, welche Ihre Geschlechterwappen in diesen Fenstern anbringen lassen wollen, sollen dieses dann auf ihre eigenen Kosten thun […]» (Abschrift).
844 Die Signatur erscheint hier nicht in den üblicherweise mit Schwarzlot gemalten Buchstaben, sondern wurde aus einem Schild aus rotem Überfangglas herausgeätzt. Der Stanser Glasmaler José de Nève ist derzeit mit der Restaurierung der Scheiben beauftragt.

189

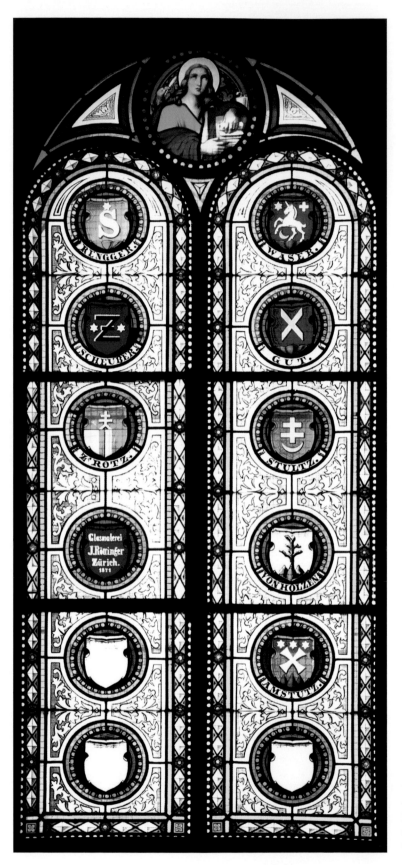

130. Johann Jakob Röttinger, «Geschlechter-
wappen», s III, Evangelist Johannes, «leere
Felder» zur Aufnahme von Geschlechter-
wappen für die Friedhofkapelle Stans, 1871;
Werkstattsignatur (erneuert).

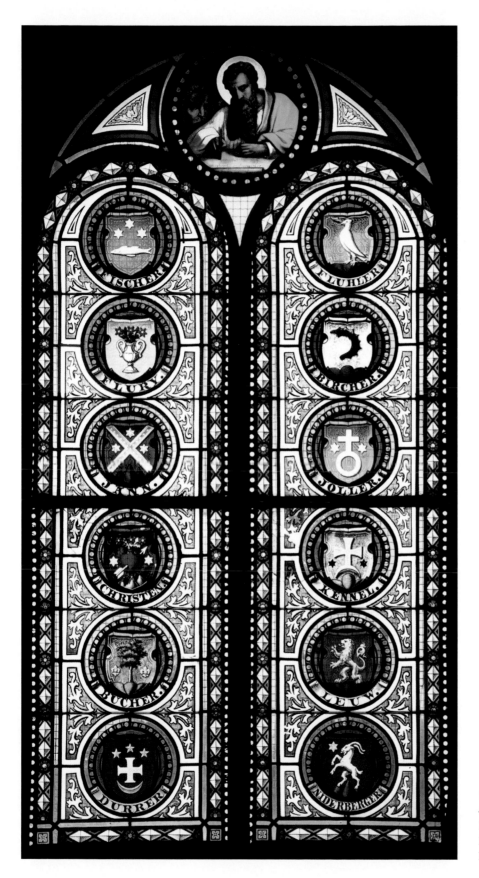

131. Johann Jakob Röttinger,
«Geschlechterscheiben», n II,
Evangelist Markus, Grisaille-
Blattornament, Friedhof-
kapelle Stans, 1871.

Die Bogenfelder der in kräftigen Farben gestalteten Fenster zeigen Medaillons mit den vier Evangelisten und ihren Symbolen; die Zwickel und der Hintergrund der Wappenmedaillons sind mit Grisailleornament ausgefüllt. Anders als in Schwyz, wo die Schriftbänder unterhalb der jeweiligen Wappen angebracht waren, sind in Stans die *Rotuli* aus Platzgründen in den Perlschnurrahmen der Medaillons integriert. Die farbliche Gestaltung der einzelnen Medaillons entspricht mit violettem Hintergrund und gelbem Rand denen in der Schwyzer Kapelle. Eingefasst werden die Stanser Fenster mit bunten Zierleisten aus Rauten und Blüten in Blau, Rot und Weiß. In einer Beilage des «Nidwaldner Volksblattes», dem «Nidwaldner Stubli», wird erwähnt, dass die Friedhöfe in Obwalden und vermutlich auch in Nidwalden ursprünglich nach Sippen in Quadern eingeteilt waren. Von dieser Tradition haben sich die Familiengräber erhalten – besonders verdiente Verstorbene erhielten eine Ehrentafel[845]. So sind die kleinen Wappenfelder in den Kapellenfenstern in Anlehnung an die frühere Friedhofstruktur als nach Geschlechtern bezeichnete Quader anzusehen und ermöglichen *allen* Verstorbenen, deren Familien ein ehrendes Andenken stifteten, ein gläsernes Epitaph.

Die Wappenfenster in der Kirche zu Unterägeri (Abb. 115), die Johann Jakob Röttinger zwischen dem Auftrag in Rapperswil (1855) und dem in Schwyz (1866) im Jahr 1860 ausführte, zeigen ebenfalls eine intensivere Farbgestaltung als die Schwyzer Fenster. Die Schilde weisen dieselbe Form auf wie in Schwyz, auch die Namensschilder und die Arabesken sind auf ähnliche Weise gestaltet. Die goldenen Ranken sind jedoch mit weißen Weinblättern belaubt, was vor dem blauen Tapetenmuster einen angenehmen Kontrast zu den mit «Goldband» eingefassten Grisaille-Kartuschen bildet. In Stans wurde auf Arabesken gänzlich verzichtet; hier wurde offenbar eine schlichtere Variante bevorzugt. Bezüglich der Gestaltung der von Johann Jakob Röttinger überlieferten Wappenscheiben zeigt ein Vergleich mit den frühen Wappenscheiben des Glasmalers in der Gruftkapelle derer von Thurn und Taxis in Regensburg sowie in der Burg Lichtenstein

(Abb. 4), dass er sich sowohl in Rapperswil (Abb. 5) wie auch in Schwyz und Stans (Abb. 125, 130) von den gesammelten Erfahrungen und Vorbildern leiten ließ. Die Nonnenköpfchen in der Rapperswiler Ratsstube[846] waren zum Beispiel baulich bereits in den Fenstern der Regensburger Gruftkapelle vorgegeben – dort setzte er in die dreiteiligen neugotischen Säulenfenster jeweils ein Medaillon mit einem Wappen der Reichsgrafen, in derselben Weise wie auch die Rundscheiben in Schwyz geschaffen wurden. Für die Gestaltung der Fenster in der Burg Lichtenstein wählte der Glasmaler ebenfalls die Form des Nonnenköpfchens, worin jeweils ein Wappenschild zu integrieren war. In der Kirche zu Aarburg waren je drei Wappenmedaillons in einem Bogenfeld eingepasst, so dass diese die Eckpunkte eines Dreiecks bildeten. Die beiden an der Basis gelegenen Medaillons weisen jeweils ein nonnenkopfförmiges Element auf, das in eine Lanzette ausläuft. Dabei erschienen die Namen der Stifter auf einem konzentrischen Rahmen um das eigentliche Wappenmedaillon – ähnlich wie später in Stans. Der Auftrag in Aarburg wurde noch unter Meister Johann Andreas Hirnschrot begonnen und nach dessen plötzlichem Tod im Dezember 1845 von Johann Jakob Röttinger fortgeführt und abgeschlossen[847]. Ganz gleich, ob für den Adel im bayerischen Regensburg beziehungsweise in Lichtenstein (Baden Württemberg) oder für die bürgerliche Führungsschicht der Landammänner, Vögte und Ratsherren in Schwyz, Stans, Rapperswil SG, Aarburg und Unterägeri, überall, wo im 19. Jahrhundert für öffentliche Gebäude Wappenscheiben geschaffen wurden, geschah dies als sichtbares Signum der Personalpräsenz[848] der von den Wappen vertretenen Persönlichkeiten sowie zur Hervorhebung einer Elite in der Bevölkerung und deren Bedeutung für einen Ort oder für eine Region.

845 Nidwaldner Stubli 1945, Nr. 5, S. 2.
846 Vgl. Kap. ‹Schloss Lichtenstein – Nördlingen – Rottweil›.
847 Vgl. Kap. ‹Zürich – Johann Andreas Hirnschrot›.
848 WOLF, 2010, S. 83. Christina Wais-Wolf prägte im Rahmen ihrer Forschungen über «die Glasgemälde des Kardinals Matthäus Lang von Wellenburg» für das Wappen des Bischofs in Kirchen den Begriff der Personalpräsenz.

Künstler und Werkstatt

Geschäftliche und gesellschaftliche Integration Johann Jakob Röttingers

Anfang Mai 1844 zog der damals 27-jährige Glasmaler von Nürnberg nach Zürich in das Haus «Zum Talgarten», um bei Meister Johann Andreas Hirnschrot seine Arbeit aufzunehmen. Nach dem frühen Tod des Arbeitgebers im Dezember 1845 verblieb Röttinger bis auf Weiteres in der Werkstatt der Witwe Hirnschrot und reüssierte am 13. März 1848 als selbstständiger Glasmaler mit eigenem Atelier in der Zürcher Neustadt. Wie weit der anfängliche Zusammenschluss mit dem Glaser Weiss, der ebenfalls bei Johann Andreas Hirnschrot gearbeitet hatte, eine formale Notwendigkeit der Integration war, geht aus den Quellen nicht hervor[849]. Seit 1844 wird Johann Jakob Röttinger als «Ansäßer in Zürich» und ab 1846 in den Akten als Niedergelassener genannt, ein Status, der sich 1863 mit der Einbürgerung änderte[850]. Im «Auszug aus dem Protocoll des Stadtrathes» vom 7. März 1863 wird in der Antwort auf Röttingers Gesuch um das hiesige Bürgerrecht für sich und seine Familie bestätigt, dass alle gesetzlichen Erfordernisse erfüllt und die Bedingungen für eine erleichterte Einbürgerung[851] gegeben seien. Gegen die ermäßigte Gebühr von 1500 Franken und unter Vorbehalt der «Landrechtsertheilung»[852] durch den Regierungsrat solle die Erteilung des Stadtbürgerrechts rechtswirksam werden. Die «Eventuelle Bürgerrechtsurkunde» wurde am 26. März 1863 aufgrund der vom Antragsteller «eingelegten glaubwürdigen

Ausweisschriften» erstellt und vom Stadtschreiber Dr. E. Escher unterzeichnet. Das Dokument gemahnt den Verfall seiner Gültigkeit, sofern der Inhaber nicht innerhalb Jahresfrist das Landrecht erwirbt. Schließlich wird am 10. Oktober desselben Jahres das Kantonsbürgerrecht verfügt, das die Landrechtserteilung einschloss und vom ersten Staatsschreiber Gottfried Keller (1819–1890)[853] unterzeichnet ist. Die Bürgerrechtsurkunde, datiert vom 19. November 1863, machte den Antragsteller mit «*seiner Ehefrau Verena Fehr von Ossingen ZH, geboren 1826, und folgende Kinder derselben: Susanna Helena, geboren 1849, Clara Louise, geboren 1852, Anna Elisabetha, geboren 1856, Verena Karolina, geboren 1859, Ida Karolina, geboren 1861, Jakob Georg, geboren 1862*» zu Bürgern der Stadt Zürich und konzedierte ihnen «*die den Bürgern von Zürich zustehenden Rechte zu genießen, sowie die entsprechenden Verpflichtungen zu tragen*»[854].

849 Vgl. Kap. ‹Gründung von Werkstatt und Familie›; vgl. Anm. 97, 102.

850 Vgl. Kap. ‹Auswanderung in die Schweiz›; ZB Nachl. Röttinger 1.71, 1.192.

851 Die Möglichkeit einer erleichterten Einbürgerung war seit dem 6. Juni 1859 rechtskräftig.

852 ELEXIKON, Meyers, Bd. 10, S. 10.464, Stichw. *Landrecht*: Im Mittelalter als das gemeine Recht, später als Partikulargesetzgebungen eingesetzt; in der Neuzeit werden jene Landesgesetzgebungen als Landrecht bezeichnet, die an die Stelle der Quellen des gemeinen Rechts getreten sind. Vgl. KÖBLER, 2003, LEXMA, Sp. 1672, Stichw. *Landrecht*.

853 Gottfried Keller bekleidete von 1861–1876 das Amt des Staatsschreibers in Zürich.

854 Zitate aus der Bürgerrechts-Urkunde, ZB Nachl. Röttinger 1.38. Der jüngste Sohn, Heinrich Röttinger, wird 1866 als Schweizer Staatsbürger geboren.

Die traditionellen Kriterien für den bürgerlichen Ein- oder Ausschluss vor 1848, nämlich die soziale Schicht, das Geschlecht, die Konfession beziehungsweise Religion und der Leumund, wurden nach der Einführung der neuen Bundesverfassung mittels moderner Kriterien ergänzt, welche durch die Nation und den rechtlichen Status des Ausländers mitbestimmt waren[855]. In Europa standen die sozialen Unterschichten und die Vorstellungen des nationalen Kollektivs im krassen Gegensatz, ein Umstand, der erst durch die zunehmende Demokratisierung entschärft wurde. Der soziale Status und das Geschlecht blieben jedoch im 19. und 20. Jahrhundert die wichtigsten Argumente für die Ausschließung aus dem Bürgerrecht. Bis 1952 wurden Schweizerinnen bei der Verheiratung mit einem Ausländer des Bürgerrechts verlustig[856]. Verena Fehr erhielt demnach anlässlich ihrer Verehelichung 1848 beziehungsweise nach der kirchlichen, in Bayern gültigen Trauung 1849[857] mit Johann Jakob Röttinger, obwohl aus Ossingen ZH stammend, die bayerische Staatsbürgerschaft und wurde erst wieder 1863 anlässlich der Verleihung des Schweizer Bürgerrechts in Zürich zusammen mit ihrem Ehemann und den Kindern Schweizer Staatsbürgerin. Die konfessionelle gesetzliche Gleichstellung von katholischen und evangelischen Antragstellern erfolgte 1848, obwohl für das «nationale Gefühl des täglichen Gebrauchs» stets ein konstruiertes Feindbild präsent war: Die geistigen Grundlagen einer «Schweizerischen Nation» – die moralphilosophischen Kriterien der Aufklärung, die schweizerische Alpenwelt und die Freiheit von Fremdherrschaft als das Bild des Nationalen – genügten offenbar nicht, um die innere Übereinstimmung zu konsolidieren. Selbst «schweizerische» Tugenden wie Redlichkeit, Biedersinn, Tapferkeit und Treue sowie der Zusammenhalt in Vereinen beziehungsweise die Durchführung von gesamteidgenössischen Schützen-, Turner- und Sängerfesten vermochten den Sinn für Zusammengehörigkeit nicht im ausreichenden Maß zu verbessern. Im vierten Dezennium des 19. Jahrhunderts kristallisierte sich der «innereidgenössische Feind» als Förderer einer neuen Solidarität

heraus, die «Jesuiten und die katholischen Kantone» waren fortan Gegenstand von Debatten in Vereinen und innerhalb der Gesellschaft. Die Schweizer Nation galt als fortschrittlich und liberal, den Katholiken hingegen wurden Konservatismus, Ultramontanismus und antinationale Haltung insinuiert[858]. Die sieben katholisch-konservativen Kantone (Luzern, Uri, Schwyz, Unterwalden, Zug, Freiburg und Wallis) schlossen 1845 ein Separatbündnis als Schutzvereinigung zur Wahrung der katholischen Religion und der Souveränität der Kantone – von den Liberalen als Sonderbund bezeichnet. 1847 eskalierte die Krise im Sonderbundskrieg[859]. Die Ausgrenzung der Katholiken ging soweit, dass zum Beispiel in Basel eine Beschränkung der Aufnahme von Katholiken als Stadtbürger vorgenommen wurde. Die Konflikte entstammten jedoch meist sozialen Gegensätzen, die im 19. Jahrhundert häufig ins «Konfessionelle verdreht»[860] wurden. Anlass für dieses Verhalten gaben obendrein die zahlreichen Arbeitssuchenden aus ländlichen Schweizer Gebieten und vor allem aus dem Ausland. So gesehen erfüllte Johann Jakob Röttinger die zur Integration beziehungsweise Einbürgerung geforderten Kriterien bestens: Er entstammte einer Schicht des aufstrebenden Gewerbes – der Glasmalerei – und nannte als etablierter Glasmaler seit vielen Jahren eine prosperierende Werkstatt sein Eigen, gehörte von Geburt an der evangelischen Konfession an und besaß einen ausgezeichneten Leumund[861]. Das professionelle Ansehen konnte bereits in vielen

855 ARGAST, 2007, S. 70 ff.

856 ARGAST, 2007, S. 73.

857 SA Nürnberg: C7_II_11886_7, 8, 17 («*Copulationsanzeige*» des Grossmünsters in Zürich). Vgl. Kap. ‹Gründung von Werkstatt und Familie›.

858 ARGAST, 2007, S. 94 ff.

859 ROCA, 2012, HLS, Stichw. *Sonderbund*.

860 ARGAST, 2007, S. 143 f: Argast zitiert Philipp Sarasin, Stadt der Bürger, Basel 1990, S. 35.

861 Diesen bestätigt in Form eines «*günstigen Leumundzeugnisses der Stadtrath Zürich v. 30. März 1863*»; in Röttingers Heimatland Bayern wurde ihm im Rahmen seines Antrags auf Schutzbürgerschaft 1849 ebenfalls ein guter Leumund bestätigt (C7_II_11886_09).

Glasmalereiaufträgen dargelegt werden. Abgesehen von den Glasmalereien erledigte die Werkstatt Röttinger auch Verglasungen «ohne künstlerischen Wert», jedoch mit viel Prestige, was als Zeichen der Wertschätzung des etablierten Geschäfts zu werten ist. Als einer der herausragenden Aufträge im säkularen Bereich kann die Verglasung der Einsteighalle im Zürcher Hauptbahnhof genannt werden. Aus dem Vertrag der Maschinenbaugesellschaft Klett & Comp. und «Glasermeister Röttinger», als der er darin angesprochen wird, geht hervor, dass es sich um ein beachtliches Mandat für die monumentale Verglasung des Bahnhofsgebäudes[862] gehandelt hatte – allerdings um eine Glaserarbeit ohne maltechnische Gestaltung, die daher in das Metier des Glaser-Handwerks fällt. Als weiterer bedeutsamer Auftrag dieser Art kann derjenige gelten, den Johann Jakob Röttinger über den Architekten Johann Christoph Kunkler (1813–1898) im Neorenaissancebau des Museumsgebäudes[863] in Sankt Gallen erhalten hatte, für dessen Fenster eine Verglasung mit sechseckigen Bleischeiben bestellt worden war. In einem Schreiben des Glasmalers an den Architekten, dem auch die Rechnung beigelegt wurde, reklamiert dieser einen höheren Preis, da er die Bleistücke in eisernen Rahmen auf so genannten «Schweinsrücken»[864] einsetzen musste, was einen erheblichen Mehraufwand an Material – Blei und Zinn – erforderte[865]. Diese Großaufträge an das Atelier Röttinger stellen nicht nur die wirtschaftliche Prosperität unter Beweis, sondern zeigen auch die Anerkennung, die Röttinger als Glasmaler bei potentiellen Auftraggebern und namhaften Architekten erfahren hat. Die fachlichen Qualitäten Röttingers umfassten offensichtlich nicht nur künstlerisches Können, sondern schlossen auch die Fähigkeiten für das solide Handwerk mit ein, was ihm ermöglichte, technisch höchst anspruchsvolle Aufträge auszuführen.

Häuslichkeit und öffentliches Leben – die Rolle der Ehefrau

Bei welcher Gelegenheit sich Verena Fehr aus Ossingen ZH und Johann Jakob Röttinger kennengelernt haben, lässt sich aus den Quellen nicht erschließen. Tatsache ist, dass sich der Glasmaler 1849[866] mit der neun Jahre jüngeren Verena (*«dem schöö Vreeli»*)[867], geboren am 27. Januar 1826 als neuntes Kind von Hans Jakob Fehr und Anna Magdalena Wespi[868], vermählte und sie im Laufe ihrer Ehe mit Johann Jakob sieben Kindern, fünf Töchtern und zwei Söhnen, das Leben schenkte (Abb. 132, 133).

Aufgrund der so genannten «Heiratsregel» gehörte der Verlust des Schweizerischen Bürgerrechts der Frau, infolge Heirat mit einem Ausländer, bis 1952 zum ungeschriebenen Gewohnheitsrecht. Im Todesfalle des Ehemannes konnte sich die Witwe eines Ausländers wieder einbürgern lassen – jedoch unter denselben Bedingungen, wie dies für Ausländer galt. Diese Klausel diente zum Schutz der Witfrau vor einer Ausweisung in das Heimatland

862 ZB Nachl. Röttinger 1.196. Die Bahnhofshalle des Zürcher Hauptbahnhofs wurde 1867–1869 von der renommierten Nürnberger Firma Klett&Co, dem Vorgängerunternehmen der MAN AG, gebaut. Inhaber Theodor Cramer (1817–1884) heiratete 1847 Emilie Klett, die Tochter des Firmengründers. Ob Johann Jakob Röttinger den gleichaltrigen Theodor Cramer aus seiner Nürnberger Zeit kannte, geht aus den überlieferten Dokumenten nicht hervor.

863 Es handelt sich dabei um das heutige Kunst- und Naturmuseum, Museumstrasse 32 (Anm. d. Verf.).

864 Dabei hat man sich wohl ein verstärkendes Element vorzustellen, das die Stabilität des Fensters zu erhöhen vermochte (von dieser Funktion geht auch Stefan Mathies, Kunstglaser in Sankt Gallen, aus, wobei ihm der Begriff in diesem Zusammenhang nicht geläufig ist).

865 ZB Nachl. Röttinger 2.371, 211, 213 Sankt Gallen/Museumsgebäude/Kunkler 1876.

866 Vgl. Kap. ‹Gründung von Werkstatt und Familie›.

867 Dieser Übername für Verena Röttinger-Fehr hat sich in der Familie Röttinger mündlich tradiert.

868 StAZH E III 86.3, S. 202; E III 86.7, S. 98 (Taufbuch und Haushaltungsrödeln von Ossingen). Vater: geb. 28. Februar 1773, cop. 1804, gest. 1837; Mutter: geb. 21. Dezember 1783, cop. 1804, gest. 1830 (Bürgerbuch E III 86.8, S. 32).

132. Verena Röttinger-Fehr und Johann Jakob Röttinger, o.J., Fotoalbum Familie, Zürich, Zentralbibliothek, (ZB Nachl. Röttinger 2.1.1).

ihres verstorbenen Gatten[869]. Bis zum Jahr 1881 behielt in der Schweiz die Geschlechtervormundschaft sowohl für verheiratete wie auch für unverheiratete Frauen ihre Gültigkeit. Ohne Vormund war es den Frauen nicht möglich Rechtsgeschäfte zu tätigen, Verträge abzuschließen, über ihr Vermögen zu verfügen oder vor Gericht zu klagen[870]. Die Einbürgerung Johann Jakob Röttingers und seiner Familie im Jahre 1863 gab Verena Röttinger-Fehr deren angestammtes Bürgerrecht wieder zurück. Nach dem Tod Johann Jakob Röttingers 1877 ergaben sich daher bezüglich Staatsbürgerschaft für die Witwe keine Unannehmlichkeiten. Zur Weiterführung des Glasmalereibetriebes benötigte sie allerdings einen Vormund[871].

Johann Jakob Röttinger gehörte als etablierter Gewerbetreiber und Kunstschaffender der wirtschaftlichen, politischen und bildungsbürgerlichen Führungsschicht an, mit der Restriktion bis 1863

den Status des Niedergelassenen statt des Bürgers zu haben, der ihm die politische Betätigung bis zu diesem Zeitpunkt verwehrte. Ebenfalls als Einschränkung mochte sich – zumindest zu Beginn der Ehe – die fehlende lokale Verwurzelung und die abgerissenen Familienbande sowie die damit verbundene gesellschaftliche Stellung ausgewirkt haben. Wie weit Verena Fehr dieses Manko auszugleichen vermochte, wird in den Quellen nicht fassbar. Da Verena Fehr jedoch im Alter von vier Jahren die Mutter und im elften Lebensjahr den Vater verloren hatte und danach bei ihrer ältesten Schwester aufgewachsen war, ist davon auszugehen, dass die gesellschaftliche Reichweite der jungen

869 ARGAST, 2007, S. 135.
870 ARGAST, 2007, S. 133. Die faktische Bevormundung durch den Ehemann wurde erst 1985 abgeschafft.
871 Mehr dazu im entsprechenden Kap. ‹Die Werkstatt nach dem Tode Johann Jakob Röttingers († 29. Januar 1877)›.

133 Verena Röttinger-Fehr mit den beiden Söhnen Jakob
Georg (re.) und Heinrich (li.), o.J., Fotoalbum Familie, Zürich,
Zentralbibliothek, (ZB Nachl. Röttinger 1.1.1).

Verena eher bescheiden gewesen sein dürfte[872].
Dass Johann Jakob Röttinger bereits in den frühen
Fünfzigerjahren mit gesellschaftlich wichtigen
Personen verkehrte, geht aus dem Briefwechsel
der Jahre 1851/1852[873] mit Ferdinand Keller[874]
hervor, in dem Johann Jakob Röttinger den bevor-
stehenden Besuch bei Dr. Bluntschli[875] in München
ankündigt, die Empfehlung Kellers an den Rats-
schreiber August Näf (1806–1887) in Sankt Gallen
erwähnt, mit dem er nun bezüglich der Glasmale-
reien in der Sankt Lorenzkirche in Kontakt stand
oder Oberst Oeri in Zürich, dem er Zeichnungen
im Namen Ferdinand Kellers abzuliefern hatte.
Von Statthalter Freudweiler in Zürich[876] habe er
ein «Zimmer, in welchem er arbeite», gemietet. Ein
weiterer wichtiger Zeitgenosse, der zum Bekann-
tenkreis Röttingers zählte, war Johann Rudolf
Rahn[877], der in seinen «Erinnerungen aus den

ersten 22 Jahren seines Lebens» von einer Über-
nachtung in Röttingers Gesellenstube und dem
daran anschließenden Fußmarsch von Zürich nach
Muri berichtete, wo die beiden Männer jene Glas-
gemälde inventarisierten, die bis zur Aufhebung
des Klosters den Kreuzgang schmückten. Rahns
Lehrer, Wilhelm Lübke (1826–1893), unterstützte
die Begeisterung seines Studenten für Schweize-
rische Kunsterzeugnisse, vor allem auch wegen des
gemeinsamen Faibles für die Glasmalerei[878]. Fer-
dinand Keller, der Altertumsforscher, wird als
väterlicher Freund Rahns genannt, der schon früh
verwaist von Vormund Fürsprech Eduard Meyer
sowie von Ferdinand Keller sekundiert und geför-
dert wurde[879]. Johann Jakob Röttingers Netzwerk
entsprang folglich zum großen Teil der Freund-
schaft mit Ferdinand Keller sowie der Bekannt-
schaft mit Johann Rudolph Rahn, dem späteren

872 ZB Nachl. Röttinger 1.184 bzw. 1.178. In dieser hand-
 schriftlichen Aufstellung vom 18. Februar 1877 vermerkt
 Verena Röttinger ihre persönlichen Daten. Vgl. Anm. 868
 u. 888.
873 StAZH W I 3 AGZ 174 12, Müller-R 1851–58, hier
 193/1852.
874 StAZH W I 3 AGZ 174 12, Müller-R 1851–58.
875 Schmid, 2003, HLS, Stichw. *Bluntschli, Johann Caspar*. Dr.
 Johann Caspar Bluntschli (1808–1881), ref. von Zürich,
 liberal-konservativer Rechtsgelehrter und Politiker, lehr-
 te nach seinem Misserfolg in der Bürgermeisterwahl 1844
 von 1848–1861 an der Universität München, bevor er die
 Venia legendi in Heidelberg erhielt; Freimaurer; verheiratet
 mit Emilie Vogel von Zürich.
876 Mitglied der Schweizerischen Gemeinnützigen Gesell-
 schaft (gegr. 1810).
877 Rahn, 1920, S. 29; vgl. Anm. 248, 270. Johann Rudolf
 Rahn (1841–1912) wird auf dem Flyer zur Ausstellung an-
 lässlich seines 200-jährigen Todestages (27. Oktober 2011
 bis 25. Februar 2012) als zeichnender Forscher und Pionier
 der Denkmalpflege genannt. Als Professor der Kunstge-
 schichte an der Universität Zürich und Ordinarius am
 Polytechnikum verfasste er das erste Überblickswerk der
 Schweizer Kunstgeschichte 1873–1876. Vgl. Kap. ‹Zeich-
 nungen und Lichtpausen mittelalterlicher Glasmalereien›.
878 Isler-Hungerbühler, 1956, S. 14 ff.
879 Ausstellung, Zürich Predigerchor, Johann Rudolf Rahn
 (1841–1912), wie Anm. 270, 877. Isler-Hungerbühler nennt
 das von Ferdinand Keller besetzte Büro der Antiquari-
 schen Gesellschaft im Helmhaus die zweite Heimat Rahns.
 Der noch nach dem früheren «Gelehrtentypus» gebildete
 Keller blieb Vorbild für J. R. Rahn.

Universitätsprofessor, Begründer der Denkmalpflege und des Studienfachs Kunstgeschichte, womit der Glasmaler in den erlauchten Kreis der Antiquarischen Gesellschaft Zürich eintauchte, ohne selbst Mitglied gewesen zu sein[880]. Wie in Pfarrhaushalten oder Ärztehaushaltungen mit angeschlossener Praxis, so richteten auch die meisten Gewerbetreibenden eine Verbindung zwischen öffentlicher und privater Sphäre ein[881]. Vergleichbar mit der Situation Röttingers war dort die Konstellation einer fehlenden lokalen Beheimatung, wie dies bei Pfarrern zumeist ebenfalls der Fall war sowie die Mitbewohnerschaft von Arbeitskräften. Waren bei Pfarrherrn Vikare und andere Hilfskräfte in den Haushalt eingebunden, ist in Glasmalereiateliers mit Glasern, Glasmalern und eventuell Kartonzeichnern sowie Hilfspersonal zu rechnen. Die Ehefrau half bei der Pflichterfüllung des Mannes mit, was in diesem Falle die Verköstigung und teilweise die Bereitstellung von Wohnraum für die Mitarbeiter beinhaltet hatte. Auch aufgrund des fehlenden militärischen und politischen Engagements des Hausvaters ist von einer engeren Zusammenarbeit zwischen Johann Jakob Röttinger und seiner Gattin auszugehen. In Ehen mit stark der Öffentlichkeit verpflichteten Männern zogen sich diese in ihre «männliche Welt» zurück, um die Frauen vermehrt in ihren innerhäuslichen Lebensraum zu verweisen. Die Familie wurde in diesen Fällen zum privaten Rückzugsort des Hausvaters, was einer Ausgrenzung der Ehefrauen aus dem Betrieb gleichkam[882]. Verena Röttinger-Fehr schien zumindest in den ersten Ehejahren, die wohl mit Kindererziehung und Schwangerschaften ausgefüllt waren, während temporärer Phasen der Abwesenheit ihres Ehemannes *nicht* die ganze Verantwortung über das Geschäft zu tragen. Johann Jakob Röttinger ersuchte im erwähnten Brief den Adressaten Ferdinand Keller *«in meinem Arbeitslocal einen Besuch zu machen um zu vernehmen, ob alles in Ordnung ist»*[883]. Die Erziehung der Kleinkinder sowie die Ausbildung der Töchter oblag im allgemeinen der Hausmutter – vermehrt brachte sich der Vater hingegen in die Ausbildung der heranwachsenden Söhne ein, wo-

bei sich diese häufig nach den Bedürfnissen des Unternehmens zu richten hatte[884]. Aus einem Brief vom 19. Juli 1870 an Ehefrau Verena, die an einem nicht genannten Ort in den Ferien weilte, geht auch ganz klar die Rollenteilung zwischen den Ehepartnern hervor. Die Kinder und der Haushalt funktionierten unter der Ägide der Hausmutter, was Johann Jakob Röttinger in wenigen Worten deutlich macht: *«[…] beschränke mich daher nur auf die kurze Mittheilung, daß deine Haushaltung, wenn auch nicht in den ganz gleichen Tackt und Verhältniß geht, als wen [sic!] du selbst das Ruder führen würdest, immerhin zu Zufriedenheit geleidet ist. Neuigkeiten habe dir keine mitzutheilen, da ja erst gestern Susettli dich besuchte und dich von allem in Kentniß [sic!] gesetzt haben wird […].»* Im selben Brief überließ ihr der Gatte 100 Franken und bemerkte dazu: *«Um dir daher in deinem Vorhaben nicht hinderlich zu sein sende Dir in der Beilage 100 fr. in der Meinung daß du, wen [sic!] du noch länger im Sinn hast, noch länger zu bleiben es ganz deinem freien Willen überlassen bleiben soll. Ich denke du wirst selbst wissen was du zu thun hast, […]»*[885]. Es scheint, dass Verena Röttinger eine kleine Auszeit brauchte, um sich von den Strapazen der Haushaltung und den Erziehungsaufgaben zu erholen. Die Beschwerlichkeiten des weiblichen Aufgabenbereichs innerhalb der Familie werden in einem weiteren Brief deutlich, den Verena Röttinger bereits im Sommer 1867 aus Feusisberg SZ an ihren Mann richtete. Sie hielt sich mit dem kleinen Heinrich, dem Jüngsten, gerade erst einjährigen Sohn (1866–1948) bei der Familie Richmuth auf, in deren Haus sie sich gut aufgehoben fühlte. Sie bewohnte ein hübsches

880 StAZH, Mitgliederbuch aus dem 19. Jahrhundert (kein Eintrag bezüglich J. Röttinger); an dieser Stelle bedanke ich mich bei Barbara Stadler im Staatsarchiv Zürich für die Recherche im Mitgliederbuch und für viele weitere Auskünfte bezüglich der Antiquarischen Gesellschaft Zürich.
881 JORIS/WITZIG, 1992, S. 59 ff. Das von Röttinger gemietete Zimmer stellt eventuell den Versuch dar, Beruf und Privatsphäre zu trennen.
882 JORIS/WITZIG, 1992, S. 59 ff.
883 StAZH W I 3 AGZ 174 12, Müller-R 1851–58, hier 193/1852.
884 JORIS/WITZIG, 1992, S. 59 ff.
885 ZB Nachl. Röttinger 1.183.

Zimmer, hörte «*der Vögel Sang*», genoss die schöne Aussicht und die gesunde Luft, lobte den guten Kaffee und den schmackhaften und kräftigen Mittagstisch. Der Preis für die Pension schien angemessen – für Mutter und Kind 5 Franken pro Tag. Der kleine Heinrich sei halt lustig und munter, schlafe höchstens zwei Stunden am Tag, sei jedoch ganz auf die Mutter angewiesen. «*[...] ist halt für mich eine Plage, bin natürlich auch schiniert [sic!]. Habe geglaubt meine Elisa komme heut' mit seinem Lehrer [...] möchte dich fragen ob Luisa nicht mitkommen dürfe, dann würde beide zwei Tage bei mir behalten und würden den Samstag oder Montag miteinander heimkommen, den die Ausgabe für weiters [sic!] wär' verschwenderisch. Das ist mit dem Kleinen keine große Erholung sondern eine Plage*», wiederholt Verena Röttinger. Ihre anderen Kinder vermisst die Mutter sehr, allen voran den Schorschli (Georg Jakob Röttinger 1862–1913), obwohl sie einsieht, dass es mit den kleineren Kindern an diesem Ort nicht praktisch wäre zu logieren, da der Weg von Richterswil auf den Berg weit sei und das Fahrgeld teuer. Fürsorglich erkundigt sich die Mutter nach der ältesten Tochter, dem 18-jährigen Susettli (Susanna Helena Röttinger 1849–1900), die während der Abwesenheit der Mutter den Haushalt führte und für die es ein gutes Wort beim Vater einzulegen galt: «*Es ist doch ein gutes, williges Kind, man sieht es auch wie andere sind; Denn da geht es auch nicht so einfach zu, wie mir mitgetheilt worden ist [...]*», bemerkte Verena Röttinger mit Bezug auf die Töchter der Herbergsfamilie wahrscheinlich als Verweis auf innerfamiliäre Diskussionen mit den eigenen heranwachsenden Töchtern. In den Briefen wird die innige Beziehung zwischen der Mutter und den älteren Töchtern evident, nicht zuletzt auch wegen deren Mithilfe im Haushalt und der Betreuung der kleinen Geschwister, die sie von diesen erwarten durfte. Aus dem schmalen privaten Nachlass wird ersichtlich, dass die Thesen von Joris/Witzig über «die Frau im bürgerlichen Haushalt»[886] weitgehend mit der familiären Situation der Familie Röttinger übereinstimmen. Die kleineren Kinder bleiben in der Obhut der Mutter, bis der Vater die männliche Nachkommenschaft etwa ab dem 12. Lebensjahr unter seine Fittiche

nimmt. Die Töchter verbleiben in der Reichweite ihrer Mutter, lernen von ihr die Haushaltsführung und währen unter ihrer schützenden Hand. Die Ideologie einer untrennbaren Verbindung von Weiblichkeit, Liebe, Haushalt, Tugend und Religion prägte die jungen Frauen, die durch ihre enge Bindung an die Herkunftsfamilie die Heirat meist als tiefen emotionalen Einschnitt empfanden, der nicht für alle gleich gut verkraftbar war. Nicht zuletzt deshalb, weil die Heiratspolitik häufig politische und ökonomische Interessen verfolgte[887]. Diesbezüglich hatte Verena Fehr wohl Glück, dass Johann Jakob Röttinger aus Bayern eingewandert war und daher die sonst üblichen, wirtschaftlichen Interessen lokal verankerter Familien weit weniger zum Tragen kamen[888]. Ob es sich bei Röttingers um eine Liebesheirat gehandelt haben mochte, lässt sich hier nicht beantworten – es scheint jedoch zwischen den Ehepartnern ein sehr respektvoller Umgang geherrscht zu haben. Johann Jakob Röttingers Schlussworte im Brief, in welchen er seine tiefe Zuneigung ausdrückt und Verena Röttingers Gruß, der die Sorge um das Wohlergehen ihres Gatten und der Kinder während ihrer Abwesenheit bekundet, lassen eine ökonomisch motivierte Vernunftehe unwahrscheinlich erscheinen[889].

Lebensstandard

Die überlieferten Buchhaltungsbücher[890] geben – anhand der eingetragenen Privatausgaben für Kleider und Lebensmittel – einen Einblick in den Lebensstandard der Familie Röttinger. So erhielt die Hausfrau im Durchschnitt pro Woche mindes-

886 Joris/Witzig, 1992, S. 59 ff.

887 Joris/Witzig, 1992, S. 70 ff.

888 Weder Taufbuch (StAZH E III 86.3, S. 202), Bürgerbuch (E III 86.8) und Haushaltungsrödel (E III 86.7, S. 98) von Ossingen geben über den Beruf Verena Röttinger-Fehrs Vater Auskunft.

889 ZB Nachl. Röttinger 1.184 oder 1.178: In der handschriftlichen «*Notiz von lb. Familie*» [sic!] betont Verena Röttinger: «*unsere Ehe war glücklich und zufrieden [...]*».

890 ZB Nachl. Röttinger 1.204, 1.205, 1.206, 1.207; vgl. Kap. ‹Organisation der Werkstatt›.

tens zwanzig Franken Haushaltsgeld, wobei zu beachten ist, dass zusätzliche Einkäufe in größeren Mengen, wie Erdäpfel, Fleisch, Kohlen etc., nicht darin enthalten waren. Die Auslagen für den täglichen Bedarf variierten insofern stark, als sich die Belegschaftsmitglieder häufig auf Montage befanden und die jungen schwer arbeitenden Männer scheinbar den Hauptanteil des Lebensmittelverbrauchs ausmachten. Auf der Signaturscheibe, die die Namen der an den Glasmalereien der Kirche in Unterägeri beteiligten Arbeiter enthält, sind unter anderem die Lebensmittelpreise von August 1860 in Zürich angegeben: *«1 Pfund Weissbrod 25 Rp, 1 Pfund Rindfleisch 5 Rp*[891]*, 1 Centner Erdäpfel 7 frs, 1 Pfund Butter 1 fr, 1 Mass vom gewöhnlichsten Wein 80 Rp, 1 Maß Kirschenwasser 2 frs 40 Rp, 1 Ei 5 Rp, 1 Klafter Buchenholz von 3 Fuß Länge 42 frs»*[892]. Ein neuer Hut für Johann Jakob Röttinger wurde in der Buchhaltung mit dem Betrag von 8.50 Franken und ein Paar Schuhe mit 4.40 Franken eingetragen. Schnupf- und Pfeifentabak leistete sich der Hausherr ein- bis zweimal im Monat für je 30 bis 60 Rappen. Der Wein, der in größeren Mengen vom Schwager Hagenbach in Ossingen bezogen wurde, belief sich per 100 Maß auf 30 Franken für die weiße Sorte und 50 Franken für den Rotwein[893]. 1873 werden in Kappel anlässlich der Restaurierung in der ehemaligen Klosterkirche die damaligen Preise genannt. Dabei fällt auf, dass der Brotpreis stabil geblieben war, während für ein Ei das Doppelte zu bezahlen war, nämlich 10 Centimes und ein Klafter Buchenholz nun 48 Franken kostete. Für 3 Deziliter Bier galt es 20 Centimes zu berappen, was als *«sehr teuer»* empfunden wurde[894]. Der im zitierten Brief angegebene Pensionspreis – für Verena Röttinger und Söhnchen Heinrich von 5 Franken pro Tag – erscheint im Vergleich zu einem Gesellenlohn recht hoch, der lag 1867 bei etwa 4 Franken pro Arbeitstag. Die von Ehemann Johann Jakob im Brief mitgesandten 100 Franken für eine eventuelle Verlängerung des Ferienaufenthalts seiner Gattin sind daher als großzügige Geste einzustufen und weisen auf die Sorge des Hausvaters um das Wohlergehen und die Zufriedenheit seiner Familie hin. Zur Entlas-

tung der Hausfrau dürfte auch zeitweise ein «Maidli» entlohnt worden sein[895]. Zusammenfassend lässt sich der Lebensstandard der Röttinger, zumindest ab den Sechzigerjahren, als gut bürgerlich und der gehobenen Mittelschicht angehörend umreißen. Die Aussage der Gattin im obigen Brief, nicht mehr als nötig ausgeben zu wollen, deutet auf eine grundsätzlich sparsame Haltung hin – eine weibliche Tugend, die sicher geschätzt wurde. Da beide Ehepartner aus eher einfachen Verhältnissen stammten, erhielt die Verbesserung des Lebensstils eine entsprechende Wertschätzung. Laut den Erhebungen Erich Gruners kam der Durchschnitt der etwa 700 in Zürich ansässigen Meister in den 1840er Jahren auf ein Salär von 600 bis 1 000 Franken[896]. Dies entspricht genau Röttingers Angaben zur Erlangung der bayerischen Schutzbürgerschaft 1849, als er bekennt, dass sich mit seiner beruflichen Selbstständigkeit das Jahreseinkommen von 600 auf 1 000 Franken vergrößerte[897].

Organisation der Werkstatt

Schriftquellen auf Papier und auf Glas

Im Nachlass des Firmengründers sind ausreichend Schriftquellen erhalten, um sich einen Einblick in die Strukturen des Ateliers zu verschaffen. Sehr aufschlussreich dafür ist das Kopierbuch Johann Jakob Röttingers, das Aufzeichnungen für den Zeitraum der letzten 15 Monate vor seinem Able-

891 Wegen der Platzierung einer Bleirute ist nur die Zahl 5 lesbar. In der Buchhaltung erscheint das Pfund Rindfleisch mit 80 Rappen.
892 KGA Unterägeri; die Angaben sind mit den in der Buchhaltung aufgeführten Preisen vergleichbar.
893 Der Wein war für die ganze Belegschaft gedacht und ist dementsprechend mit den Mitarbeitern verrechnet worden.
894 Vgl. Kap. ‹Schriftquellen auf Papier und auf Glas›.
895 Ein kleiner Betrag erscheint ab und an in der Buchhaltung.
896 GRUNER, 1968, S. 36 f.
897 Vgl. Anm. 108.

ben verfügbar macht. Die entsprechenden Bücher aus der Zeit davor dürften wohl im Zuge der Geschäftsauflösung nach dem plötzlichen Tod des Glasmalers verloren gegangen sein. Es scheint, als hätte sich dieses eine Dokument deshalb erhalten, weil es aufgrund des abrupten Abbruchs der Eintragungen im Januar 1877 noch sehr viele leere Seiten enthielt, die später von der Witwe und nach der Geschäftsübernahme 1887 von Sohn Jakob Georg weiterverwendet wurden. Die Kopien der ausgehenden Briefe beginnen also am 1. November 1875 und enden am 29. Januar 1877, dem Todestag Johann Jakob Röttingers. Der letzte darin dokumentierte Brief ist bereits von Gattin Verena signiert worden, einmal im Namen ihres Gatten und einmal mit ihrer eigenen Unterschrift[898]. Das Kopierbuch umfasst insgesamt 234 Einträge, wobei längere Briefe und Verträge über mehrere Nummern verteilt wurden. Einige Texte konnten wegen des zu schwachen Schriftbildes nicht mehr ausgewertet werden. Ebenfalls informativ sind freilich die Akkorde, die einerseits aufgrund der Auftragsvolumina eine gewisse Mitarbeiterzahl voraussetzen, andererseits auch die Preise und die Zahlungsmodalitäten nennen. Aus der Buchhaltung, die sich hauptsächlich aus den Sechzigerjahren erhalten hat, lassen sich die Löhne und somit auch Namen und Anzahl der Mitarbeiter entnehmen[899]. Die verlässlichsten Angaben bezüglich der Mitarbeiterschaft bieten zweifellos die in manchen Kirchen überlieferten «Signaturscheiben» oder «Mitarbeiterscheiben» als Künstlerinschriften, auf denen sich der Meister mit der ganzen Belegschaft namentlich verewigt hatte[900]. Diese beschrifteten Rundscheiben, die teilweise auch die damals aktuellen Lebensmittelpreise enthalten, auf durchgemachte Epidemien hinweisen beziehungsweise den Segen Gottes und der Heiligen erbitten, lassen sich für das Basler Münster, die katholischen Pfarrkirchen Unterägeri und Leuggern, die ehemalige Klosterkirche Kappel am Albis und die evangelische Kirche in Meilen ZH nachweisen. Indem sich Meister und Gesellen ein Denkmal setzten, empfahlen sie sich dem Schutz Gottes und der Heiligen, lehnten sich dabei an alte Traditionen an und

verbanden so das künstlerische Selbstverständnis mit ihren persönlichen Anliegen nach Sicherheit, Gesundheit und Erfolg. Ein sehr aussagekräftiges Beispiel stellt die Wappenscheibe von Zürich aus dem ehemaligen Zisterzienserkloster Kappel am Albis dar, die «1871» zum Andenken an die teilweise Erneuerung der Kirchenfenster angebracht wurde. «*Diese Fenster wurden neu gemacht unter der Leitung des Herrn Cant. Bauinspekr. [sic!] Müller [Kantons-Bauinspektor], Herrn Roth Bauführer, von J. Röttinger, Glasmaler Zürich 1871.*» Die diese Inschrift ergänzenden Bemerkungen haben keinerlei despektierlichen Hintergrund, sondern sind als «zeitgenössische» Nachricht der Künstler und Bauhandwerker zu verstehen, wie solche beispielsweise in Turmknöpfen – als Zeitkapseln – überliefert sind, jedoch auf Glasmalereien eher ungewohnt erscheinen: «*Der Wein war heuer so sauer, dass er fast nicht trinkbar, [...]. Die Arbeiter machen Strike [...], Die Herren verlumpen bald alle; Unterdessen ist unserm Bleuler seine Brille gebrochen [...]*»[901]. Offensichtlich fiel dem Autor der Scheibe das ehrliche Bekenntnis aktueller Sorgen leicht, da die Lesbarkeit der auf Weitsicht angelegten Kirchenfenster zur Zeit ihrer Montage sicher nicht gegeben war. Dies umso mehr, als die 1873/74 von Röttinger erneuerten Scheiben die Maßwerkzone der Glasmalereien in der nördlichen Obergadenwand betrafen[902].

898 ZB Nachl. Röttinger 2.371, 234 Alterswyl/Bäriswyl 1877; vgl. Kap. ‹Wünsche der Auftraggeber›; vgl. Anm. 660. Die Kopien sind etwa so entstanden, dass das frisch geschriebene Schriftstück jeweils mit der noch nassen Tinte zwischen zwei Blätter gelegt und auf diese Art und Weise abgedruckt worden ist. Die noch feuchte Tinte wurde vom dünnen saugfähigen Papier aufgenommen und überlieferte die ausgehenden Briefschaften des Glasmalers.

899 ZB Nachl. Röttinger 1.204, 1.205, 1.206, 1.207.

900 Vgl. Kap. ‹Signaturen› sowie die folgenden Kapitel über ‹Mitarbeiter und Infrastruktur›.

901 HAUSER, 2001, S. 119.

902 BÖHMER, 2002, S. 22. Weitere Künstlerinschriften der Werkstatt sind in der Suisse romande erhalten, die in der Publikation von Fabienne Hoffmann besprochen werden.

Mitarbeiter und Infrastruktur

Grundvoraussetzungen zum Gewerbebetrieb

Zur Bewerkstelligung der vielen Aufträge war, außer dem Mitarbeiterstab, eine geräumige und gut eingerichtete Werkstätte vonnöten. Johann Jakob Röttinger war von der Fortunagasse 36 (vormals «Kleine Stadt», Nummer 359, Haus zur Königskrone), wo er mit seiner Familie von 1854 bis 1869 und ab 1857 als Eigentümer[903] gewohnt hatte, in die Oetenbachgasse 13 übergesiedelt[904], nicht zuletzt, weil am neuen Ort die Einrichtung eines größeren Ateliers in einem Nebengebäude möglich war. Die Ende 1867 erworbene Liegenschaft nannte sich «Zum Sankt Paulus» und lag entsprechend der Zürcher Adressbezeichnungen vor 1865 in der so genannten «Kleinen Stadt, Nummer 325a»[905]. Ab 16. September 1869 nahm die Familie Röttinger dort ihren Wohn- und Geschäftssitz[906] und ist bis heute an diesem Ort domiziliert. Die Nähe der Werkstatt zur Wohnung des Glasmalers war wohl in verschiedener Hinsicht vorteilhaft. Wie den Quellen zu entnehmen ist, befand sich der Meister häufig auf Reisen zu seinen Kunden, um Aufträge anzunehmen, Maße aufzunehmen oder Besuche zu tätigen – gewissermaßen als Akquisition und Kundenpflege[907]. Während der Abwesenheit des Meisters war die Ehefrau Verena Röttinger-Fehr vor Ort, empfing allfällige Besucher und nahm die Ereignisse im Geschäftsalltag auf, um sie an ihren Gatten bei seiner Heimkehr weiterzuleiten. Die Sorge für das leibliche Wohl der Mitarbeiterschaft wurde bereits als Aufgabengebiet der Hausfrau angenommen, obwohl dies nicht explizit in den Schriftquellen erscheint[908]. Allerdings wurde im vorangegangenen Kapitel auf Schwankungen der Haushaltsauslagen hingewiesen, die die Verpflegungssituation einer unterschiedlichen Zahl von Mitarbeitern bekräftigen. Ein Arbeiter namens Paulo – nach dessen Wochenlohn von einem bis zwei Franken ist auf eine Beschäftigung als Hausdiener beziehungsweise Hilfskraft zu schließen – erhielt Schuhe, Hemden, Wäsche etc., was wiederum auf die Wohnhaftigkeit im Hause Röttinger hindeutet. Es darf ohnehin von der Beherbergung der Mitarbeiter ausgegangen werden, weil der junge Johann Rudolf Rahn im bereits erwähnten Zürcher Taschenbuch[909] von Gesellen sprach, in deren Schlafstube ihm ein Nachtlager zugewiesen worden war. Rahn beschrieb die *«dicke Schwüle»* als schier unerträglich, was beengte Verhältnisse in einem voll belegten Schlafraum vermuten lässt. Das Angebot von Nachtlagern für die Arbeiter macht die Verpflegung derselben gewissermaßen zur Voraussetzung. Deshalb umfasste die Bereitstellung entsprechender Infrastruktur für Mitarbeiter im Gewerbebetrieb höchstwahrscheinlich das, was man unter Kost und Logis verstand.

Mitarbeiter verschiedener Berufe, Künstler und deren Selbstverständnis

Dass Johann Jakob Röttinger mehrere Arbeiter beschäftigte, geht aus verschiedenen Schriftquellen hervor, etwa wenn es um die Abberufung eines Mitarbeiters zur Versetzung von Fenstern ging: *«Sobald Sie im Besitze der Waare [sic!] gelangt sind, werden Sie die Güte haben und mir Anzeige machen, damit ich einen Arbeiter zum Einsetzen senden kann»*[910]. Einen Hinweis auf mehrere Arbeiter liefert der Brief an Pfarrer Knecht in Dorf ZH: *«[...], daß Ihre Kirchenfenster vollständig fertig sind und ich dieselben die kommende Woche versenden werde, sobald einer meiner Arbeiter*

903 StadtA Zürich, Haus- und Familienbögen 1850–1865. V.E.c.22.:24.; Brandassekuranz 1809–1925, V.L.1.:12.

904 StadtA Zürich, Haus- und Familienbögen 1865–1880. V.E.c.25.:25.

905 Die «Große Stadt» breitete sich auf dem rechten Limmatufer und den Gehängen des Zürichberges aus, während die Besiedelung des linken Limmatufers als «Kleine Stadt» bezeichnet wurde.

906 ZB Nachl. Röttinger 1.192.

907 ZB Nachl. Röttinger 2.371, 72 Bendern/Hänsle 1876; ZB Nachl. Röttinger 2.371, 81 Mümliswyl/Sury 1876.

908 Dank einer freundlichen Mitteilung von R. H. Röttinger ist die (damals übliche) Verpflegung aller Arbeiter am Mittagstisch der Familie durch Verena Röttinger-Fehr mündlich tradiert.

909 Vgl. Anm. 877.

910 ZB Nachl. Röttinger 2.371, 1 Schwyz/o. Tit. 1875; ZB Nachl. Röttinger 2.371, 6 Mümliswyl/Dekan Sury 1875.

heimkommt welche in Folge des vor einiger Zeit gehabten Sturmes fast immer nur mit in Ordnung stellen der durch dieses Ereignis zerstörten Kirchenfenster beschäftigt sind, so werde sofort Ihre Arbeit einsetzen lassen»[911]. Zum Hotelier Seiler nach Brig fuhren die Gesellen offenbar besonders gerne: «[…], bedarf es nur einen Wunsch Ihrerseits, denn meine Leute sind sehr gern für Sie beschäftigt»[912]. Die Korrespondenzen belegen die Arbeitsteilung auf eine Gruppe von Mitarbeitern, ohne jemals explizit auf Zahlen hinzuweisen. Es ist davon auszugehen, dass zur Montage der Fenster häufig nur ein Arbeiter geschickt wurde, der mit Hilfe von anderen Bauhandwerkern, wie Maurern, Steinhauern oder Schlossern, die Fenster einzusetzen hatte. Schon wegen der hohen Auftragszahlen muss in der Werkstatt ein Mitarbeiterstab von mehreren, differenzirt ausgebildeten Berufsleuten vorausgesetzt werden. Außer den Glasmalern[913] waren zweifellos auch Glaser beschäftigt, wie die Inschrift des Fensters von Schlieren/ Sankt Agatha zeigt: «Gemalt von J. Röttinger, Zürich 1854, Geschnitten und verbleit von Joh. Bräm von Schlieren»[914] oder 1853 in Leuggern «Als Glaser arbeiteten an diesen Fenstern: Egidius Bonker von Bairouth u. Joh. Bräm v. Schlieren [...] Zürich»[915]. Darüber hinaus erwähnte Röttinger seine Mitarbeiter in der Buchhaltung bezüglich der Lohnabrechnung. Im Januar 1860 nannte er beispielsweise Schellenberg, Klaus, Hesse, Schweizer, Bräm und Paulo[916]. In einem Fotoalbum sind zum Andenken an ehemalige Mitarbeiter einige Fotos auf der Rückseite mit Namen des Abgebildeten und mit Berufsbezeichnung – Maler, Glaser oder Arbeiter – versehen[917]. Adolph Kreuzer[918] bezeichnete seinen ehemaligen Lehrmeister in einem Brief als «Prinzipal»[919] und Johann Bräm lernte bei Röttinger das Glaserhandwerk[920]. Diese Beispiele zeigen, dass die Zürcher Werkstatt Ausbildungsstätte sowohl für Glaser als auch für Glasmaler war. Es haben sich Quellen aus Glas – Rundscheiben mit Künstlerinschriften – erhalten, die Namen und Herkunftsorte der Mitarbeiter nennen. Einen wertvollen Hinweis auf den Mitarbeiterstab Röttingers gibt die kleine Scheibe im Basler Münster, nämlich zwei runde Aussparungen im Zentrum der südlichen Seitenschifffenster: Auf einer der

Scheiben verewigte sich der Meister selbst: «Gemalt von J. Röttinger Zürich 1856». Auf der zweiten Scheibe steht geschrieben: «Als Maler arbeiteten an diesen Fenstern: H. Schellenberg v. Bülach Cant. Zürich & Cl. Bettelini v. Ascona, Ct. Tessin; als Glaser Joh. Bräm v. Schlieren, Ct. Zürich & J.L. Aichinger v. Heidenheim [...]»[921]. 1853 werden für die Arbeiten in der Pfarrkirche zu Leuggern drei Glasmaler und die zwei oben aufgeführten Glaser genannt. Es sind dies neben dem Patron, [...] Sperli von Kilchberg am Zürichsee und H. Schellenberg von O.[ber] Rüti bei Bülach. Die im Kirchgemeindearchiv zu Unterägeri[922] erhaltene «Mitarbeiterscheibe» zeigt die eigentliche Werkstattsignatur auf einem Medaillon: «Sämtliche Fenster dieser Kirche wurden verfertigt von J. Röttinger Glasmaler Zürich.» In der konzentrisch angeordneten Scheibe um das Medaillon sind die Mitarbeiter genannt. Der Meister erscheint hier bemerkenswerterweise nochmals als mitarbeitender Künstler: «An den Fenstern dieser Kirche haben gearbeitet als Maler: J. Röttinger v. Nürnberg, Königreich Bayern; J. Klaus auch von Nürnberg; H. Schellenberg von Rüti-Bülach, Cant. Zürich; P. Bettelini v. Ascona, Cant. Tessin – als Glaser: J. Bräm v. Schlieren, Cant. Zürich; Wilhelm Hesse v. Burg in Preussen.» An dieser Stelle geht es demnach um Individualität und Reputation

911 ZB Nachl. Röttinger 2.371, 28 Dorf/Knecht 1875.

912 ZB Nachl. Röttinger 2.371, 85 Brig/Herr Seiler 1876.

913 ZB Nachl. Röttinger 1.79 (Korrespondenz Kreuzer).

914 GRUNDER, 1997, S. 207/208.

915 Die Kenntnis dieser Inschriften in der Kirche Sankt Peter und Paul zu Leuggern verdanke ich Franziska Schärer von der Denkmalpflege Aargau, die mir eine CD mit Aufnahmen glasmalerischer Details zukommen ließ, die für den Betrachter vom Boden aus nicht erkennbar sind.

916 ZB Nachl. Röttinger 1.205.

917 ZB Nachl. Röttinger 1.1.4.

918 *1843 in Furtwangen, †1915 in Zürich; 1883 eigene Werkstatt in Zürich (SIKART).

919 ZB Nachl. Röttinger 1.79 (Korrespondenz Kreuzer).

920 GRUNDER, 1997, S. 208.

921 NAGEL/VON RODA, 1998, S. 45; vgl. Kap. ‹Signaturen› Anm. 188.

922 KGA Unterägeri ZG. Im weiteren Verlauf werden auf der Rundscheibe die wichtigsten Lebensmittelpreise (Stand August 1860) genannt, verbunden mit der Bitte: «Möge der allmächtige Gott, die heilige Jungfrau und alle Heiligen dieser Kirche vor allem Unglück gnädig behüten und bewahren! Amen!»

der einzelnen Personen, daher wird nicht Zürich – der Standort der Werkstatt –, sondern die Heimat jedes einzelnen Künstlers beziehungsweise Handwerkers genannt. Jakob Röttinger, der um diese Zeit noch nicht in der Schweiz eingebürgert[923] war, trat stolz als Franke (Bayer) aus Nürnberg[924] auf, sofern es sich um die eigene Person als Glasmaler handelte und er nicht ausschließlich seine Firma in Zürich zu repräsentieren hatte. Diese Art der Bauinschriften spiegeln temporäre oder dauerhafte Arbeitsgesellschaften wider, die auch werkstattübergreifend agiert haben könnten und sind daher nicht nur willkommene Hilfsmittel, die Zuschreibungen erleichtern, sondern lassen den formalen, rechtlichen und medialen Rahmen dieser sozialen Gruppe erkennen[925]. Aus diesem Grund können diese mit Namen beschrifteten Rundscheiben als Indizien der Werkstattorganisation gelten.

Eine weitere Berufsgruppe wird im Schreiben von Tafelmaler Melchior Paul Deschwanden offenbar, in dem dieser die mangelnden Proportionskenntnisse des Zeichners in Röttingers Atelier kritisiert: *«Sollte Ihr Zeichner keine Proportionslehren besitzen, so sei ihm hier in Kürze das Wesentlichste mitgeteilt [...]»*[926]. Inwiefern diese Tätigkeit auf einen Maler übertragen wurde oder ob sich ausschließlich der Meister selbst zeichnerisch betätigte, geht aus den Quellen nicht ausdrücklich hervor. Als gesichert gilt jedoch eine Zusammenarbeit mit dem oben erwähnten Kirchenmaler aus Stans sowie mit dem Maler und Zeichner Felix Bleuler aus Zollikon[927].

Aufgrund der Namensauflistungen auf verschiedenen Medien ist davon auszugehen, dass Röttinger in seiner Werkstatt seit Mitte der Fünfzigerjahre mindestens zwei bis drei Glasmaler sowie zwei Glaser beschäftigte, eine Anzahl, die sich im Laufe der Sechzigerjahre verdreifachte. In der zweiten Hälfte des Dezenniums, in einer Zeit, da Glasmalerwerkstätten wie Pilze aus dem Boden schossen[928], musste also das Atelier besonders floriert haben – in Meilen werden gar sieben Glaser und sechs Maler genannt: *«Glaser: Joh. Bräm Schlieren, Kirsteiner aus Schlesien, Merzweiler aus Freiburg, Lingenhell Tirol, S. Kellner Nürnberg, Haas Basel, Erni Thiengen; Maler: J. Röttinger Zürich, F. Bleuler Zollikon, R. Spinner Aeugst,*

Betetini Ancona, Morat Schlesien, Kellner Nürnberg, [1867 war die Cholera in Zürich]»[929].

Einige Mitarbeiter, wie Schellenberg und Bräm, schienen zur Stammmannschaft gehört zu haben; Bräm tauchte, wie schon angesprochen, bereits 1853 in Leuggern, 1854 als «Glaserlehrling» von Schlieren auf, der Maler Schellenberg in den Jahren 1853, 1856 und 1860. Rudolf Spinner und Felix Bleuler erscheinen noch 1873 auf der Inschrift anlässlich der Renovierung in Kappel, die Adolph Kreuzer unter Mitarbeit von Fritz Berbig, Rudolph Thym, Christian Härer und Heinrich Trinkhahn [Drenckhahn] durchgeführt hatte[930].

923 Die Einbürgerungsurkunde wurde am 19. Oktober 1863 ausgestellt.

924 Die Stadt Nürnberg wurde am 15. September 1806 anlässlich der Reichsbundakte an Bayern übergeben. (KÖBLER, 1990, Historisches Lexikon der Deutschen Länder, S. 376f., Stichw. *Nürnberg,)* Franken bildet keine politische Einheit und definiert sich mehrheitlich durch den fränkischen Dialekt und die Geschichte.

925 DIETL, 2009, S. 31. Auf einer weiteren gläsernen Bautafel in Unterägeri erscheinen daher alle Mitglieder der Baukommission sowie alle beteiligten Handwerksfirmen als zeitlich begrenzte Gemeinschaften mit dem gemeinsamen Ziel, das Bauwerk zu vollenden. HAUSER, 2001, S. 119: Renovierung des ehemaligen Zisterzienserklosters Kappel ZH: Scheibe mit Inschriften bezüglich der Renovierung, der beteiligten Personen in leitender Funktion, Jahreszahl *«1871»* sowie zeitgenössischen Nachrichten über Preise etc.

926 ZB Nachl. Röttinger 1.4. (Korrespondenz Alt Sankt Johann/Deschwanden).

927 ZB Nachl. Röttinger 1.1.4; vgl. Kap. ‹Die Werkstatt Röttinger als Wiege berühmter Glasmaler›.

928 VAASSEN, 1993: So beschreibt die Autorin die Situation zwischen 1860 und 1870, als Betriebe wie Melchior in Köln, Oidtmann in Linnich, Zettler und Mayer in München, die Tiroler Glasmalereianstalt Innsbruck u.v.m. eröffnet wurden.

929 ZB Nachl. Röttinger 1.94; neben dem Akkord von 1867 fand sich eine Notiz von Sohn Heinrich Röttinger mit den Namen der ursprünglich auf den Chorfenstern zu Meilen erwähnten Glasmalern und Glaser der Werkstatt seines Vaters. Die beiden Mitarbeiter Bleuler und Spinner erhielten den Vermerk *«taubstumm»*. Beim Namen *«Betetini»* dürfte es sich wohl um den schon mehrmals aufgeführten Namen Bettelini (aus Ascona CH) gehandelt haben. Elgin Vaassen nennt eine Firma Bertini, die 1857 in Glasgow an der Saint Mungo's Cathedral mitgearbeitet hatte (VAASSEN, 1997, S. 206). Vgl. Anm. 963.

930 TRÜMPLER/DOLD, 2005 o.p.; Fenster N IX.

134. Skizze der Bauinschrift
Kreuzgang Nord Sankt Emmeram
in Regensburg (Kopie),
Thurn und Taxis Zentralarchiv,
Regensburg (Sign. A.01.06).

Eine Vorlage für Scheiben mit der Aufzählung beteiligter Künstler, sogar mit Beifügung zeitgeschichtlich relevanter Mitteilungen sowie einer Bitte um Benediktion, könnte ein heutzutage nicht mehr lesbarer Schlussstein vor dem Eingang der Gruftkapelle der Thurn und Taxis zu Regensburg sein. Dessen Entwurf (Abb. 134)[931] weist nämlich die Form der von Röttinger bevorzugten «Mitarbeiterscheiben beziehungsweise -signaturen» auf, was diese Variante, die für die Glasmalerei eher ungewöhnlich zu sein schien, erklären würde. Es sind konzentrische Kreise mit einer rundumlaufenden Inschrift: «D. Ren. d. Kreuzganges geschah u. Anordnung u. unter d. Leitung d. F.T.T. Baumeisters Karl Keim – Die Renov. kostete 24.000f.»[932] Der innere Teil – ein Schild – zeigt die Inschrift: «*S.H.D.d.H.R. Maximilian Karl F.T.u.T. hat den Kreuzgang zw. d. J. 1839 b. 41 Renov. lassen.*»[933] Da sich aufgrund einer Planänderung bei den Wappenscheiben wahrscheinlich eine Verzögerung des Einbaus einstellte[934], ist anzunehmen, dass Johann Jakob Röttinger den Entwurf oder gar den ausgeführten Schlussstein noch zu Gesicht bekommen hätte. Dieser könnte als Inspiration gedient haben, die spezielle Art von Künstlerinschriften später

im eigenen Atelier in sein künstlerisches Repertoire aufzunehmen und die am Bau beteiligten Glasmaler ausdrücklich zu erwähnen[935].

Aufgrund der heterogenen Quellenlage, den Nennungen von Mitarbeitern auf Scheiben, in der Buchhaltung, in den Lohnbüchlein oder beiläufigen Erwähnungen in der Korrespondenz, wäre es jedoch vermessen, sich zu irgendeinem Zeitpunkt

931 Sauer, 2003, S. 104, Abb. 55. (FZA A.01.06).
932 «Die Renovation des Kreuzganges geschah unter Anordnung und unter der Leitung des Fürst Thurn und Taxi'schen Baumeisters Karl Keim – Die Renovation kostete 24.000 f.»
933 «Seine Hoheit Durchlaucht des Heiligen [Römischen] Reichs Maximilian Karl Fürst Thurn und Taxis hat den Kreuzgang zwischen den Jahren 1839 bis 41 Renovieren lassen.»
934 Die Kapellenscheiben wurden im August 1840 eingesetzt (Sauer, 2003, S. 39); Ha 1840, Bericht vom 30. April 1840, vgl. Anm. 82.
935 Eine in die Glasmalerei integrierte Bautafel, die *alle* am Bau Beteiligten berücksichtigte und auch die Personen der Baukommission nannte, schuf Röttinger z. B. 1861 in der Pfarrkirche zu Bünzen und 1859/60 in Unterägeri. Friedrich H. Pfort, ein Mitarbeiter Sauterleutes, der als Regensburger die Gruftkapelle (und somit den Schlussstein) ebenfalls gekannt hatte, fertigte 1844 in der evangelischen Pfarrkirche Gönningen bei Reutlingen ebenfalls eine Bautafel an. (Abb. 7 bei Vaassen, 1997).

auf die Festlegung absoluter Mitarbeiterzahlen einzulassen. Jean-François Luneau teilt in seiner Publikation über den Glasmaler und Mosaisten Félix Gaudin die in Frankreich domizilierten Glasmalerateliers des späten 19. Jahrhunderts in drei Kategorien: große Werkstätten, wie die des Glasmalers Caspar Gsell (Gaspard Gsell) mit 30 bis 35 Mitarbeitern, mittlere mit bis zu zehn Mitarbeitern und die kleinen Familienbetriebe, wobei die meisten bekannten Ateliers, wie das Beispiel von Charles-Ambroise Leprévost 1878, häufig eine mittlere Größe aufwiesen[936]. Nach dieser Klassifizierung war Johann Jakob Röttingers Werkstatt ebenfalls als Betrieb mittlerer Größe anzusehen.

Verdienst und Betriebsklima

Meister Röttinger kann eine ausgeprägte soziale Verantwortung nachgesagt werden, die wohl über das verpflichtende Maß des Arbeitgebers hinausging, dies obwohl die gesetzlichen Vorschriften damals zugunsten der Arbeitgeber ausfielen[937]. Aus einem Brief an Herrn Guhl, Mechanikermeister in Aussersihl und Vermieter einer Wohnung, wird ersichtlich, dass Johann Jakob Röttinger für den bei ihm beschäftigten Gesellen Herrmann Glaser die Miete bezahlte, da er mit dessen Familie wegen schwieriger Verhältnisse Mitleid gehabt hatte[938]. Sein Entgegenkommen für die betroffene Familie ließ Röttinger – wider seines Gespürs für die Redlichkeit neuer Mitarbeiter – handeln, indem er diesen Mann um seiner Familie willen einstellte. Überhaupt schwingt ein väterlich besorgter Ton mit, wenn der Meister seine Arbeiter erwähnt: *«Für Ihre freundliche Aufnahme und Behandlung meines Arbeiters bin ich Ihnen sehr dankbar er wird ebenfalls das Kloster nicht vergessen, zumal er sich früher einen ganz anderen Begriff von so einem Institut gemacht hatte»*[939]. Für Röttingers Großzügigkeit gegenüber seinen Mitarbeitern spricht auch folgende Textpassage an Pfarrer Thierren in Promasens: *«[...]den V Fr. Thl. [«5 Franken-Thaler»] welche [sic!] Sie meinem Arbeiter für die Reparatur gaben, habe ich nicht angenommen, sondern meinem Arbeiter gelassen, ich danke Ihnen dafür»*[940]. Der Glasergeselle Johannes Bräm[941] aus Schlieren

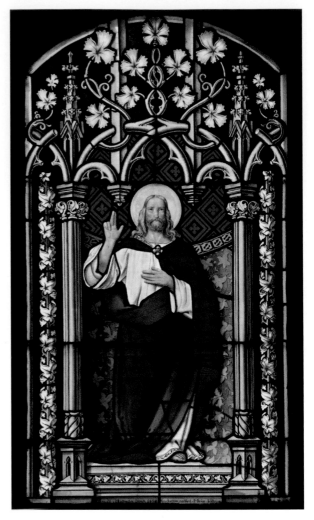

135. Johann Jakob Röttinger/Joh. Bräm, «Lehrender Christus», Chorfenster I, Evangelisch-Reformierte Pfarrkirche Schlieren, 1854.

936 LUNEAU, 2006, S. 144.

937 GRUNER, 1968, S. 96 f.

938 ZB Nachl. Röttinger 2.371, 94 Aussersihl/Guhl, 1876: *«[...], daß der bei Ihnen in Miethe wohnende Herrmann Glaser, Geselle bei mir seit 8 Tagen nicht mehr in mein Geschäft gekommen ist. Da ich diesem Manne gegenüber aus Mitleid für seine Familie in der Meinung Gutes zu thun ihn mit Wiederwillen [sic!] in meinem Geschäft Aufnahme gab und Ihnen gegenüber Verpflichtungen betreffend die Miethe in Ihrem Hause eingegangen habe [...]».* Vom Arbeitgeber verbilligte Wohnungen für Arbeiter waren allerdings Usus (GRUNER, 1968, S. 155).

939 ZB Nachl. Röttinger 2.371, 205, 206 Kloster Berg Sion/ Aloisia Müller 1876.

940 ZB Nachl. Röttinger 2.371, 42 Promasens/Thierren 1875.

941 Zivilstandsamt Dietikon, Familienregister Bd. III von Schlieren, S. 53: Johannes Bräm «Büebels» (1825–1870), verheiratet 1853, 8. von 12 Kindern des Rudolf Bräm (1773–1835), erstes Kind dessen zweiter Frau.

schuf zum Dank an seine Heimatgemeinde Schlieren ein Turm- beziehungsweise Chorfenster für die Pfarrkirche. Um nicht in finanzielle Verlegenheit zu geraten, erkundigte sich der Pfarrer bei Meister Röttinger nach dem Preis der den «Lehrenden Christus» darstellenden Glasmalerei (Abb. 135). Dieser wusste die löbliche Geste seines ehemaligen Lehrlings anscheinend zu schätzen und veranschlagte lediglich die Auslagen von 30 fl. für Zeichnung, Farbe und Brennen[942]. Der Maler Rudolf Spinner, dessen Erinnerungsfoto auf den 15. April 1869 datiert ist, musste «taubstumm» gewesen sein; darüber gibt ein entsprechender Vermerk des Arbeitgebers Auskunft[943]. Wie bereits angeführt, litt auch der Maler Felix Bleuler unter einer Störung der auditiven Wahrnehmung mit Beeinträchtigung des Sprachvermögens[944]. Das heißt, dass Johann Jakob Röttinger trotz der komplizierteren, umständlichen Kommunikation bereit war Menschen mit Handikap in sein Team zu integrieren. Dies vermag wohl auch die Bemerkung auf der Zürcherscheibe aus Kappel zu relativieren: «Unterdessen ist unserm Bleuler seine Brille gebrochen [...]»[945]; wurde doch durch dieses Malheur das Sprachverständnis des geschätzten Mitarbeiters, der auf die Hilfe des Lippenlesens angewiesen war, weiter eingeschränkt. Über die Löhne der Arbeiter gibt unter anderem das Kopierbuch Auskunft; so heißt es in einer Rechnung an den Pfarrer in Waasen: «Der Arbeiter 3 Tage in Mayen gearbeitet, per 1 Tag Arbeitslohn an denselben 5 Fr.=15 Fr. bezahlt. Provision für diese 3 Tage = 5 Fr»[946]. Demzufolge erhielt ein Mitarbeiter, der auswärts tätig war, zusätzlich zum Lohn eine Provision, die dem Drittel des Salärs entsprach. Kost und Logis waren während der Montagearbeiten entweder frei oder möglichst günstig und wurden vom Meister übernommen[947]. «[...] dem Arbeiter des Herrn Röttinger Trinkgeld 3 mal 1 Fr., denselben für Kost 9 Tage à 1.80», heißt es in einer Kostenaufstellung für die Kirche Bellikon[948]. Der Betrag für «eine Kost mit Verpackung» betrug beispielsweise 2 Franken[949]. In der Rechnung für den Architekten Kunkler in Sankt Gallen erscheinen die Lohnkosten für den Arbeiter wie folgt: «Arbeiter vom 19.–27. Novb. in St. Gallen

40.50 Fr. sowie Bahngeld [Zürich – St. Gallen retour] und Zehrung 10.00 Fr.»[950]. Der Tageslohn betrug in diesem Fall «4.50 Fr.[951], Bahngeld, Zehrung und Lohn nach und von St. Gll. [Sankt Gallen] 15.00 Fr.»[952]. 1867 wurden dem Glasergesellen Merzweiler bei Röttinger 4 Franken pro Tag für seinen Arbeitseinsatz in der Kirche zu Männedorf ZH ausbezahlt[953]. Im Januar des Jahres 1860 waren in der Werkstatt Röttinger folgende Wochenlöhne üblich: «Klaus 20 Fr., Hesse 2 Fr., Schweizer 5 Fr., Paulo 1.80 und Wäsche»[954]. Die aufgelisteten Beträge fielen sehr unterschiedlich aus, da einerseits Vorschüsse geleistet und Zulagen nachträglich für das Halbjahr ausbezahlt wurden, andererseits die Tarife je nach Arbeitsaufkommen variierten. Arbeiter, die berufsbedingt einer längeren Abwesenheit ausgesetzt waren, sandte der Meister Geld nach. So erhielt

942 KGA Schlieren IV.B.03.02, Seite 190, Stillstandsprotokoll 1854 (siehe Armenpflegeprotokoll p. 153, No. 7), Schlieren 1854. «fl.» galt als Abkürzung für den Gulden, der in den Kantonen GR, GL, LU, SZ, ZH, UR, SG 1850 durch die Einheitswährung des Franken abgelöst wurde.

943 ZB Nachl. Röttinger 1.1.4.

944 Felix Bleuler schrieb im Alter von 12 Jahren über seine Kindheit, die er seit 4 Jahren in einer Anstalt zubrachte: Felix Bleuler, Kurze Lebensgeschichte des taubstummen Knaben Felix Bleuler von Zollikon, in: Kalender für Kinder auf das Jahr 1835, hrsg. von J. J. Bär, Lehrer, Zürich in der Schultheß'schen Buchhandlung, S. 49/50, [Online-Ressource: http://www.e-rara.ch/sikjm/content/pageview/2989953].

945 HAUSER, 2001, S. 119.

946 ZB Nachl. Röttinger 2.371, 224 Waasen, Kapelle in Mayen UR/Pfarrer in Waasen 1876.

947 ZB Nachl. Röttinger 2.371, 44 Oberbüren/Kirchenverwaltung 1875: «Noch ersuche um billige Berechnung der Kost und Logis meines Arbeiters um nicht zu sehr in Nachteil zu kommen [...]».

948 PA Oberrohrdorf, Theke 136.

949 ZB Nachl. Röttinger 2.371, 224 Waasen, Kapelle in Mayen UR/Pfarrer von Waasen 1876.

950 ZB Nachl. Röttinger 2.371, 211 Sankt Gallen Museum/Kunkler 1876.

951 In den Rechnungen der Gebrüder Helmle für die Glasfenster im Freiburger Münster wird ein Tageslohn von 3 f (Gulden) aufgeführt, was in etwa vergleichbar ist. (PARELLO, 2000 (1), Regesten).

952 ZB Nachl. Röttinger 2.371, 214 Sankt Gallen Museum/Kunkler 1876.

953 ZB Nachl. Röttinger 1.206.

954 ZB Nachl. Röttinger 1.205. Zur Anstellung Klaus' bei Röttinger vgl. VAASSEN, 1997, S. 175.

Klaus im Januar 1860 von seinem Chef 36.65 Franken nach Frankfurt «an baar gesendet». Aus Friedrich Berbigs Lohnheft 1875/1876[955] lässt sich entnehmen, dass häufig im «Accord», also im Stücklohn, gearbeitet wurde. So zahlte man ihm für die «Helfenschwiler Fenster mit breiten Bordüren und einer Höhe von 402 in Accord gemacht» 90 Franken, Gehilfe Herrmann erhielt 25 Franken[956]. Zwei Tage später setzte Berbig fünf Fenster in Oberhelfenschwil SG ein, wofür er mit 20 Franken entlohnt wurde. Für zwei Damastfenster, die der Glasmaler im «Accord» für Oberbüren hergestellt hatte, bekam er 48.60 Franken. Üblicherweise schien ein Teil der Arbeit auch am Sonntag verrichtet worden zu sein und zwar jeweils halbtags, wofür 2.50 Franken ausbezahlt wurden. Die sonntäglichen Stunden nutzte man für Werkstattarbeiten wie Zuschneiden, Ware auflegen oder das Schneiden von Schablonen. Für eine geleistete Überstunde galt ein Ansatz von 50 bis 55 Rappen. Ende der Siebzigerjahre scheint sich die Anhebung des Tagessatzes für die Gesellen auf 5 Franken durchgesetzt zu haben. Das Fernbleiben wegen Krankheit wurde offensichtlich bis zu einem gewissen Grad ermöglicht, so trug sich Friedrich Berbig im Januar 1876 für einen halben Tag als krank ein. Die Freitage für das Weihnachtsfest unterstanden einer Beschränkung von 1.5 Tagen, wobei einem halben Tag am 24. und einem freien Tag am 25. Dezember stattgegeben wurde. Die Gesellen mit entsprechender Berufsausbildung, künstlerischer Bildung oder als Lehrlinge waren im Atelier Röttinger im Vergleich mit den männlichen Fabrikarbeitern, die in den Jahrzehnten von 1850 bis 1870 am Tag 1.50 bis 2 Franken verdienten[957], gut bezahlt. Zu ergänzen sind diese Zahlen durch Handwerkerlöhne, die während des Baus der Kirche Unterägeri zwischen 1857 und 1860 entrichtet wurden. Diese betrugen für den Maurer und Zimmermann 2.50 Franken, für den Steinmetz und Schreiner 3 Franken und den Handlanger beziehungsweise Erdarbeiter 2 Franken pro Tag. Nicht immer herrschte uneingeschränkte Zufriedenheit bei den Mitarbeitern. In einem Brief von Friedrich Berbig an seinen Meister beklagt sich dieser über die fehlende finanzielle Anerkennung für die in kürzester Zeit und zur Zufriedenheit aller geleisteten Arbeiten in Kappel, Alterswil, Rossens, Sierre, Glis und Zermatt[958]. Er sei nun seit drei Jahren in Röttingers Werkstatt beschäftigt, schätze seinen Vorgesetzten sehr, verdiene jedoch mit dem Wochenlohn von 30 Franken weniger als in den vorangegangenen Stellungen. Nun bitte er um Zulagen bei auswärtigen Arbeiten oder um die Umwandlung des Wochenlohns in einen regulären Monatslohn.

Die Quellen attestieren Johann Jakob Röttinger durchwegs Eigenschaften eines gerechten und fürsorglichen Arbeitgebers, der seine Mitarbeiter korrekt behandelt und darüber hinaus in finanziellen Härtefällen helfend eingegriffen hat. Der Meister musste trotz der günstigen Auftragslage sparsam wirtschaften, was sich nicht zuletzt in der Bezahlung der Mitarbeiter niederschlug. Darüber hinaus war Röttinger stets auf Empfehlungen angewiesen, um als verantwortungsbewusster Familienvater und Chef seinen sozialen Verpflichtungen nachkommen zu können.

Die Werkstatt Röttinger als Wiege berühmter Glasmaler

Die Glasmaler Johann und Christian Klaus, Adolph Kreuzer, Mitglieder der Kellner-Familie sowie einige andere Mitarbeiter der Werkstatt Röttinger

955 ZB Nachl. Röttinger 1.208, 14./15. September.

956 ZB Nachl. Röttinger 1.208; ob Berbig 25 Fr. an Herrmann abgeben musste, geht aus dem Eintrag nicht hervor. Die Zahl 402 steht ohne Maßeinheit.

957 GRUNER, 1968, S. 102 ff. Weibliche Arbeitskräfte erhielten 0.80 bis 1 Franken Taglohn.

958 ZB Nachl. Röttinger 1.18, o. D. Berbig gibt an die Arbeit in Kappel geleitet zu haben, für die er eine zusätzliche Belohnung verdient hätte; in Alterswyl und Glis hätte er jeweils abends die Scheiben zugerichtet, um am Tag einsetzen zu können und habe kaum Zeit zum Essen gefunden. Er würde sich schämen, wenn er so langsam arbeiten würde als Thym – er arbeite insgesamt schneller und daher mehr als die Kollegen. Der Brief ist nicht datiert, auf Grund der erwähnten aktuellen Arbeiten kann die Zeit zwischen 1873 und 1875 angenommen werden. Signiert wurde die Arbeit in Kappel jedoch von Adolph Kreuzer. Vgl. Anm. 1224.

haben in späteren Jahren eigene Ateliers eröffnet und sich durch die Ausführung von Aufträgen in repräsentativen Bauwerken einen Namen gemacht. Ein Großteil der erfolgreichen nachfolgenden Glasmalergeneration war für eine kürzere oder längere Zeit bei Johann Jakob Röttinger beschäftigt. Die Gebrüder Christian und Johann Klaus, ersterer im Album der Ehemaligen erscheinend, letzterer als Mitarbeiter in Unterägeri genannt, werden in den späten Sechzigerjahren in ihrer Heimatstadt Nürnberg fassbar[959]. Den Akten für die von ihnen ausgeführten Glasmalereien der evangelischen Kirche Sankt Mang in Kempten lag ein Werbeblatt bei, auf welchem Johann Klaus sich und seine kürzlich gegründete Firma empfohlen hatte: «*Seit Jahren habe ich meine ganze Thätigkeit diesem Kunstzweige gewidmet und in dem ersten Atelier der Schweiz die verschiedenen Glasgemälde componirt und ausgeführt, wie zum Beispiel folgende: in dem Basler Münster in einer 11 Fuß hohen Rosette die Taufe Christi darstellend; in der Kathedrale Sion die vier Evangelisten, dann Kaiser Karl und Kaiser Sigismund; in der Kathedrale zu Lausanne ein Wappenfenster; ferner im Grossmünster zu Zürich einen Christus nebst zwei Aposteln u.s.w. [...]*»[960]. Wobei Klaus hier freilich die Glasmalereien der repräsentativsten Bauten aus der Werkstatt Röttinger nannte. Johann Klaus und sein Bruder Christian, ein Schüler August von Krelings[961], schufen außer den genannten Glasmalereien in der Kemptener Sankt Mangkirche Glasgemälde für die evangelische Kirche in Fürth-Poppenreut nach Entwürfen Friedrich Wilhelm Wanderers (1840–1910), dem Urheber der Kaiserfenster in der Nürnberger Lorenzkirche, und waren darüber hinaus in der Nürnberger Frauenkirche unter August Ottmar Essenwein (1831–1892) tätig, dem ehemaligen Leiter des Germanischen Nationalmuseums[962]. Inwiefern es sich bei den genannten Mitarbeitern P. Bettelini beziehungsweise Cl. Bettelini[963] um Brüder gehandelt hatte und ob sich die verschiedenen Schreibweisen aus Schreibfehlern ergaben, kann nicht mehr sichergestellt werden. Plausibel scheint die Überlegung, dass P. Bettelini und Cl. Bettelini Verwandte des bekannten Luganeser Kupferstechers Pietro Bettelini (*1763 in Caslano TI, †1829

in Rom) gewesen waren[964]. Cl. Bettelini erscheint als Glasmaler 1856 im Basler Münster, P. Bettelini 1860 in Unterägeri – für Meilen im Jahr 1867 wird keiner der beiden Glasmaler mehr fassbar. Zweifellos handelte es sich jedoch beim Glaser Merzweiler aus Freiburg im Breisgau, der in Meilen genannt wird, um Ferdinand Albert Merzweiler (1844–1906)[965], der sich später als Glasmaler mit den Söhnen des Lorenz Helmle, Ferdinand und Heinrich, in seiner Heimatstadt Freiburg zusammenschloss. Im Jahr 1875 wurde die Werkstattgemeinschaft mittels eines Gesellschaftsvertrags rechtskräftig und bereits in den Achtzigerjahren konnte die Belegschaft auf acht Mitarbeiter aufgestockt werden. Der Firmenentscheid lautete ausschließlich musivische Glasmalereien herzustellen, die Technik war vom Erzbischöflichen Bauamt Freiburg vorgeschrieben und ermöglichte der Werkstatt deren Monopol in Südbaden zu verteidigen[966]. Merzweiler soll in der Schweiz jahrelang Studien von Wappenscheiben getätigt haben und

959 VAASSEN, 1998, L.-Z., S. 887 f., Stichw. *Röttinger, Johann Jakob*. «Zeitweise waren Johann Klaus, Gustav van Treeck und ein J. Kellner als Glasmaler sowie Albert Merzweiler als Glaser Gehilfen Röttingers».; VAASSEN, 1997, S. 174 ff.

960 PA Kempten – Sankt Mang, Nr. 316 (o. Dat.). Elgin Van Treeck-Vaassen stellte freundlicherweise eine Kopie des Blattes zur Verfügung; vgl. VAASSEN, 1997, S. 175.

961 Deutscher Maler und Bildhauer (1819–1876).

962 VAASSEN, 1997, S. 174 f.

963 Bettelinis erscheinen als Maler in Basel und Unterägeri; die Auflistung Heinrich Röttingers bezügl. Meilen erwähnt den Namen Betetini, Ancona, wobei es sich ev. um einen Abschreibfehler handelt. Guiseppe Bertini war in Mailand als Glasmaler tätig (NAGLER'S KÜNSTLER-LEXICON 1, 1835, S. 468, Stichw. *Bertini, Johann*). Vgl. Anm. 929.

964 SIKART, Stichw. *Bettelini*; NAGLER'S KÜNSTLER-LEXICON 1, 1835, S. 476–477, Stichw. *Bettelini, Pietro*.

965 VAASSEN, 1997, S. 44 u. S. 302, Anm. 38; vgl. PARELLO, 2009, S. 114 f.; PARELLO, 1997 (2), S. 12 f.: Merzweiler und Helmle führten in den Sechziger- und Siebzigerjahren umfassende Restaurierungen an den Münsterchorfenstern durch, entfernten die angegriffene Schwarzlotmalerei vollständig und vernichteten somit praktisch die Glasmalereien von acht Chorkapellenfenstern. Dem guten Geschäftsgang tat dies offenbar keinen Abbruch.

966 PARELLO, 2009, S. 115, S. 120, Anm. 17–19: Parello zitiert in Anm. 19. einen Firmenprospekt, in dem die Manufaktur-Technik der Werkstatt hervorgehoben wird.

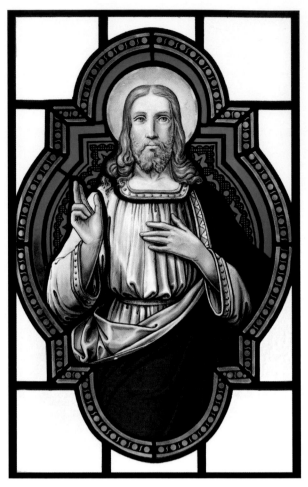

136. Adolph Kreuzer, Christus als Halbfigur, Inschrift: «Christus gestiftet v. A. Kreuzer, Zürich 1872», Sakristei, Evangelisch-Reformierte Kirche Mellingen AG.

sich mit seinem späteren Kompagnon, dem Maler Karl Jennes (1852–1924), in einer Zeit, in der das Geschäft mit den Kirchenfenstern abflaute, der Pflege und Neuschöpfung von altschweizerischer Glasmalerei gewidmet haben[967].

Adolph Kreuzer (1843–1915) aus Furtwangen erlernte die Glasmalerei bei Johann Jakob Röttinger in Zürich. In einem Brief von Januar 1866 berichtet Kreuzer seinem ehemaligen Prinzipal, vom Aufbau des eigenen Geschäfts in der Heimat und erwähnt stolz den Artikel in der Karlsruher Zeitung, der als *belobende Anerkennung für die hiesigen Kirchenfenster* in weiteren vier Zeitungen abgedruckt worden sei[968]. Die Chorfenster waren einer 1853 nach einem Brand wieder aufgebauten katholischen Pfarrkirche in seinem Heimatort Furtwan-

gen gewidmet und haben sich nicht erhalten. Auf einem alten Schwarzweiß-Foto lässt sich jedoch das Thema der Auferstehung schemenhaft erkennen. *«[...] zwei gemalte Fenster im Chor, von dem damals bestandenen Kreuzerverein gestiftet, sind von Adolf Kreuzer von Furtwangen ausgeführt worden»*, berichtete der Arzt Romulus Kreuzer in der «Zeitgeschichte für Furtwangen»[969]. Tatsächlich wurde zwischen Adolph beziehungsweise Romulus (!) Kreuzer und Johann Jakob Röttinger ein Vertrag abgeschlossen, in dem sich letzterer verpflichtete zwei Chorfenster bis November 1865 in meisterhafter Ausführung für den Preis von 500 Gulden zu liefern: *«Auf das eine Fenster soll der auferstandene Christus, auf das andere die unbefleckte Empfängnis Mariens gemalt werden. Die Kosten der Einsetzung sowie der Schlosserarbeit und Fracht besorgen Romulus und Adolph Kreuzer»*[970]. Im Juli 1869 beruft sich Kreuzer in einem Schreiben an seinen ehemaligen Arbeitgeber auf ein 1868 von Röttinger ausgesprochenes Anerbieten, wieder zu ihm zurückzukehren, und bittet um Wiederaufnahme unter den damals offerierten Bedingungen, nämlich für einen Wochenlohn von 20 Franken im Sommer und 3 Franken pro Tag im Winter. In Furtwangen fehle der Sinn und das Verständnis für Kunst – eine Erfahrung, die schon Kreuzers seliger Onkel, Hofmaler Kirner[971], gemacht hatte. Daher schließe er sein Geschäft und kehre in die Schweiz zurück. Aus der Zeit des zweiten Schweiz-Aufenthalts, nämlich

967 PARELLO, 2000 (1), S. 130, 124 ff.
968 ZB Nachl. Röttinger 1.79; ALLGEMEINES LEXIKON DER BILDENDEN KÜNSTLER 21, 1927, S. 521, Stichw. *Kreuzer, Adolf.* Dort wird erwähnt, dass Kreuzer sich 1866 dank eines badischen Staatsstipendiums in München aufgehalten und anschließend bei G. Eberlein in Nürnberg gearbeitet habe.
969 Elke Schön, Museumsleiterin in Furtwangen, vermittelte die Anfrage an den Stadtarchivar und sandte mir das Foto zu; beiden danke ich an dieser Stelle für die Auskünfte. Nachdem A. Kreuzer nicht im Bürgerbuch erscheine, sei eine Verwandtschaft mit dem Verfasser der «Zeitgeschichte» und in Furtwangen geschätzten Bürger, Dr. Romulus Kreuzer, nicht zu eruieren, so die Auskunft des Archivars in Furtwangen.
970 ZB Nachl. Röttinger 1.49.
971 Es handelte sich wohl um Johann Baptist Kirner (1806–1866), dem Furtwanger Kunstmaler, seit 1840 großherzoglicher badischer Hofmaler in Karlsruhe (Deutsche Nationalbibliothek, Katalog).

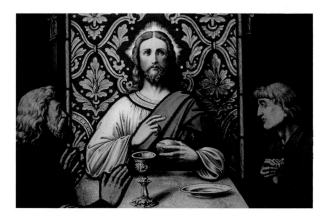

137. Adolph Kreuzer, Werkstattsignatur J. Röttinger und Mitarbeitertafel der ehem. Klosterkirche Kappel ZH, N IX, 1873.

138. Adolph Kreuzer, Emmausmahl, Ausschnitt Chorfenster I, Evangelisch-Reformierte Stadtkirche Solothurn, 1897.

aus dem Jahr 1872, stammt auch eine Scheibenstiftung Kreuzers, die sich bis heute in der Sakristei der reformierten Kirche zu Mellingen AG erhalten hat: Die kleinformatigen Fenster zeigen Christus und Paulus als Halbfiguren mit einem Zitat aus dem Korintherbrief: «*Der Herr ist der Geist; wo aber der Geist des Herrn ist, da ist Freiheit 2 Kor 3, 17*», (Abb. 136). Inwieweit sich die Stiftung des Glasmalers auf dessen geglückte Rückkehr in die Schweiz bezieht und in welche Kirche diese ursprünglich erfolgte, ist unklar[972]. Ebenfalls selbstbewusst gibt sich Adolph Kreuzer, als er sich und andere Beteiligte anlässlich der Restaurierung von fünf Obergadenfenstern 1873 in der ehemaligen Klosterkirche zu Kappel am Albis verewigte (Abb. 137)[973].
Zeitweilig soll Adolph Kreuzer Geschäftsführer bei Carl Wehrli in Aussersihl[974] gewesen sein, bevor er sich 1883 schließlich mit einem eigenen Atelier in Zürich etablierte. Wichtige Aufträge stellten die Chorfenster im Bonner Münster[975] dar, die Fenster der Grafen Almeida in Lissabon[976] sowie 1897 die Schaffung der beiden Glasgemälde, das Emmausmahl (Abb. 138) und die Auferstehung, für die reformierte Stadtkirche in Solothurn[977]. Bereits 1888 schuf er Glasmalereien für die kleine Kreuzkapelle in Wettingen[978]. Ein von Kreuzer signierter Christus in Ganzfigur aus dem Jahr 1890 konnte im Kunsthandel gesichtet werden[979].

972 Das genannte Gotteshaus der protestantischen Teilgemeinde Mellingen wurde erst 1910 eröffnet. Daher ist davon auszugehen, dass die beiden Scheiben umplatziert wurden. Die Signatur Kreuzers (am Gürtel Christi) lehnt sich an die Signatur Michelangelo Buonarottis an: Pietà, Marmor, 1499, Rom San Pietro in Vaticano (GLUDOVATZ, 2011, S. 126).

973 Inschrift im Fenster N IX: «*1873 Renovirt von J. Röttinger Zürich, 1 Pfund Brod 1 frk., 1 Pfund Butter 1.50, 3/10 Liter Bier 20 cts sehr teuer. Die Welt steht nimmer lang. – 1 Klfter. Holz 48 fr, buchen, 1 Ei 10 cts. [sic!], Grosse Pfaffenjagd in der Schweiz, Rud. Spinner Maler, Bell Maurer, zugeschaut u. Adolph Kreuzer, Maler, dies gesch[affen] [...] an der Oettenbach Gasse 13 St. Paul, Fritz Berbig, Rudolph Thym, Glaser gefasst, Christian Härer, Maler, restaurirt, August S..., [Hei]nr[ich] Trinkhahn, Glaser, Felix Bleuler*».

974 KAISER TRÜMPLER, 2002, S. 21. 1891 wurde Adolph Kreuzer Stadtbürger in Zürich.

975 SIKART, Stichw. *Kreuzer, Adolph*.

976 ALLGEMEINES LEXIKON DER BILDENDEN KÜNSTLER 21, 1927, S. 521, Stichw. *Kreuzer, Adolph*.

977 Stefan Trümpler erfasste die Glasmalereien Röttingers und Kreuzers 2009 anlässlich einer Bestandsaufnahme für die Denkmalpflege Solothurn. Die noch erhaltenen Scheiben werden im Depot der reformierten Stadtkirche Solothurn aufbewahrt.

978 KAISER TRÜMPLER, 2002, S. 21.

979 Das stark beschädigte Fragment stand 2010 bei einem Kunsthändler in Langrickenbach TG zum Verkauf (signiert: AK Z. 1890) und soll nach Auskunft des Eigentümers aus der Gegend von Andelfingen ZH stammen (Anm. d. Verf.).

Johann Stephan Kellner I. (1812–1867), zweitältester Sohn des Johann Jakob Kellner (1788–1873) aus der für die Glasmalerei berühmten Kellner-Familie, argumentierte in den Niederlassungsgesuchen (1846) in Nürnberg um als *Insasse* aufgenommen zu werden, dass er beim Vater beschäftigt sei und pro Jahr 600 fl. verdiene[980]. Im Jahr 1867, im Todesjahr Stephans, wird *«S. Kellner»* in der Kirche zu Meilen als Glaser genannt, während unter den Malern nochmals der Name *«Kellner aus Nürnberg»* erscheint. Dabei dürfte es sich entweder um Stephans Sohn Samuel Benjamin (Glasmaler, 1848–1905) gehandelt haben oder um Johann Stephan II, Sohn des Gustav Hermann (1814–1877). Stephan II ist 1851 in Nürnberg geboren, arbeitete bei seinem Vater in Friedrichshafen und starb dort unbekannten Datums[981]. Über die jüngere Generation der Kellner ist nicht mehr viel überliefert. Georg Kellner (1811–1892), dem hierzulande vor allem wegen der Entwürfe für die Chorverglasung im Großmünster Achtung gebührt, erfuhr 1867 von der Vergabe des Ulmer Doms und stellte sich dort nach dem Tode seines Bruder Stephans «lediglich im Interesse der beiden Söhne desselben» vor. Diese waren damals zwar noch Schüler der Kunstschule zu Nürnberg, hatten sich aber bereits an den Arbeiten in Rothenburg beteiligt[982]. Elgin Vaassen verweist auf den «unheilvollen Weg» der Kellner von Nürnberg über Ingolstadt nach Ulm und spricht damit die häufig zerstörende Wirkung der Restaurierungstechniken im 19. Jahrhundert an[983]. In Hersbruck und in Bachhagel haben sich signierte Fenster von Samuel Kellner (Nürnberg) aus dem Jahr 1898 erhalten[984]. Stephan Kellner erscheint darüber hinaus im Fotoalbum Johann Jakob Röttingers[985] mit einem Andenken an seine Mitarbeit im Atelier Röttinger. Sein Name taucht 1875 im Kopierbuch Röttingers auf, wo dieser den *«Frauen Kellner in Friedrichshafen»* in einem Brief antwortete, sich über den Besuch der beiden Jungen zu freuen und er gerne den von Stephan gewünschten Kontakt zur Antiquarischen Gesellschaft in Zürich herstellen wolle[986].

Der aus dem Toggenburgischen Krummenau stammende Jakob Kuhn (1845–1888)[987] absolvierte seine Lehre in der Werkstatt Johann Jakob Röttingers und ließ sich 1871 als Glasmaler in Basel nieder. Als vielseitig talentierter und ambitionierter Glasmaler schuf er Kabinettscheiben und Farbverglasungen in Gasthäusern[988] und privaten Gebäuden, beispielsweise Glasmalereien für die 1885 erbaute Villa Gelpke, ehemals Villa Reseda beziehungsweise Villa Thommen, in Waldenburg BL[989]. Kuhn lieferte in zahlreiche Kirchen im Elsass und gestaltete 1885/1886 den signierten neugotischen Glasgemäldezyklus in der Pfarrkirche zu Doppleschwand LU (Abb. 139).

Nach seinem frühen Tod führte seine Witwe Emilie Kuhn-Helmle[990] das Geschäft bis zur Übernahme durch Sohn Max[991]. Ebenfalls in Basel etablierte sich der ehemalige Mitarbeiter,

980 VAASSEN, 1997, S. 168: Glasmalereien Stephan Kellners: die Hl. Drei Könige, der Hieronymus, Franz von Sickingen, eine Maria mit Kind, eine Madonna nach dem Volckamer-Fenster in der Lorenzkirche sowie Sixtus und Barbara nach dem Kaiserfenster.

981 NÜRNBERGER KÜNSTLERLEXIKON 2, 2007, S. 763, Stichw. *Kellner, Johann Stephan II*, Stichw. *Kellner, Samuel Benjamin*.

982 VAASSEN, 1997, S. 167 ff.

983 VAASSEN, 1997, S. 174; vgl. Parello über Merzweiler in Freiburg in diesem Kapitel, Anm. 965.

984 VAASSEN, 1997, S. 329, Anm. 96; SCHOLZ, 2002, S. 218, Anm. 2, Abb. S. 221, Fig. 110.

985 ZB Nachl. Röttinger, 1.1.4, ohne Datum.

986 ZB Nachl. Röttinger, 2.371, 8 Friedrichshafen/Frauen Kellner 1875: Offensichtlich planten die beiden Jungen (Stephan und Samuel) Glasmalereien an die Sammlung der Antiquarischen Gesellschaft zu verkaufen; vgl. Anm. 1032.

987 ZB Nachl. Röttinger, 1.1.4, Inschrift an der Rückseite des in Nürnberg hergestellten Fotos: *«Erinnerung an Ihren Lehrling Jacob Kuhn»*, Röttinger notierte: *«Später in Basel als Glasmaler etabliert»*.

988 NAGEL/VON RODA, 1998, S. 27 f.

989 STEINMANN/REY, 2002–2004, Bericht zu Renovierungsarbeiten Villa Gelpke, Waldenburg BL. Hier handelt es sich um ein gemaltes Treppenhausfenster mit dem heiligen Hubertus.

990 NAGEL/VON RODA, 1998, S. 28 u. 112; Französisches Kulturministerium-Online-Verzeichnis, Stichw. *Kuhn-Helmle, Emilie*.

991 TRÜMPLER KAISER, 2002, S. 22; NAGEL/VON RODA, 1998, S. 28.

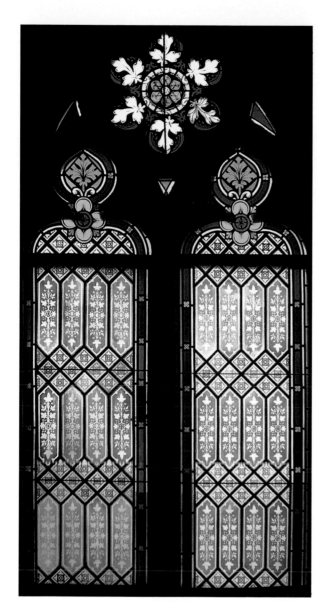

139. Jakob Kuhn, Ornament im Maßwerk, Schweizerrauten mit Damast, Schifffenster der Katholischen Pfarrkirche Doppleschwand LU, 1885.

Heinrich Drenckhahn[992], der im Jahr 1873 im Atelier Röttinger aktenkundig wird und sich später vor allem in der Ausführung von Wappenscheiben profilierte. Zusammen mit dem Glasmaler Franz Joseph Merzenich schuf er für den Schützensaal der Gesellschaft der Feuerschützen in Basel die Wappen Egger, Lotz, Glaser beziehungsweise Gürtler, Georg und Lüdin. Beide Glasmaler betätigten sich in den Jahren 1882/1883 und 1905/1906 als Restauratoren der älteren Wap-

pengemälde im Obergeschoss des Gebäudes[993]. Ebenfalls mit Restaurierungen beschäftigte sich Drenckhahn in der Basler Theodorskirche, wo er 1880 die spätmittelalterlichen Fragmente in den Chorfenstern ausbesserte, ergänzte und neu verbleite[994]. Schließlich ist die Beteiligung an den über hundert gestifteten, bürgerlichen Wappenscheiben für die 1894 als Historisches Museum umgestaltete Barfüsserkirche zu erwähnen, für die sich Heinrich Drenckhahn zusammen mit Franz Joseph Merzenich und dem Atelier Meyner & Booser in Winterthur verantwortlich zeichnete[995]. Der Glasmaler Christian Härer, genannt 1873 auf der Mitarbeiterscheibe in Kappel, schuf unter anderem Glasmalereien für die Pfarrkirche Sankt Aldarich in Freienbach SZ, für die Schlosskapelle in Pfäffikon und für die Pfarrkirche Sankt Jakob in Feusisberg[996].

Friedrich Berbig (1845–1923) aus Magdeburg – lange Zeit Mitarbeiter bei Röttinger – richtete sich 1877, nach dem Tod seines Arbeitgebers, ein eigenes Atelier in Zürich ein. In der Agenda von 1877 notierte die Witwe Verena Röttinger im April: *«Die Aufkündigung von Berbig erhalten, weil ich seine Bedingungen nicht eingegangen bin»*[997]. Im Nachlass der Röttinger haben sich zwei Lohnhefte Berbigs aus dessen letzten beiden Arbeitsjahren bei Röttinger erhalten[998]. Darin sind beispielsweise die Arbeiten beziehungsweise die Mitarbeit Friedrich Berbigs in Oberhelfenschwil SG, Dorf ZH, Rue FR, Fislisbach AG, Henau SG, Waldkirch SG, Eschenbach, Sion VS, Bendern FL sowie Jettingen, Dessenheim und in Hagenthal (Elsass) eingetragen.

992 Vgl. Anm. 188: 1873 wird er als Mitarbeiter, Heinrich Trinkhahn, auf der Signaturscheibe (N IX) anlässlich der Restaurierung der Obergadenfenster in der ehemaligen Klosterkirche Kappel a. A. genannt.
993 NAGEL/VON RODA, 1998, S. 273 f.
994 NAGEL/VON RODA, 1998, S. 85 f.
995 NAGEL/VON RODA, 1998, S. 294.
996 BUSCHOW OECHSLIN, 2010, S. 83, S. 148 bzw. 152, S. 276.
997 ZB Nachl. Röttinger 1.201; vgl. Kap. ‹Die Werkstatt nach dem Tode Johann Jakob Röttingers († 29. Januar 1877)›.
998 ZB Nachl. Röttinger, 1.208, 1.209.

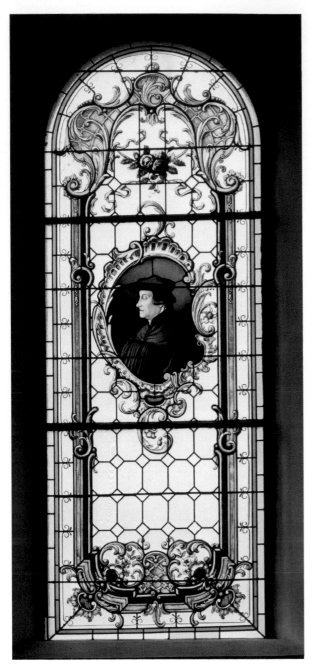

140. Friedrich Berbig, Reformator Ulrich Zwingli, Chorfenster, Evangelisch-Reformierte Pfarrkirche Birrwil AG, 1891.

Als Mitarbeiterkollegen nennt Berbig ausschließlich Herrmann[999] und Haas; bei Letzterem handelt es sich wohl um den auf der Meilener Scheibe angeführten *«Haas, Basel»*. Astrid Trümpler Kaiser zitiert aus einer Geschäftsanzeige, in der sich Berbig für «Eingebrannte Glasmalereien für Kirchen- und Profanbauten – Moderne Bleiverglasungen

– Kunstverglasungen in Messing-, Kupfer-, Nickel-, Altmessing- und Altsilberfassung – Geätzte Scheiben jeder Größe – Facettieren von Spiegelglasscheiben [...]» empfiehlt und weist auf zahlreiche Glasmalereien in der Schweiz hin, die aus der Werkstatt Berbigs hervorgegangen sind. Friedrich Berbig schuf 1888 Glasmalereien im großen Bürgersaal des Rathauses zu Frauenfeld TG, ein Chorfenster der Kollegiatskirche Notre-Dame de l'Assomption in Romont FR (1889), 1890 ein Fenster mit dem auferstandenen Christus in der Kirche Betschwanden GL, 1889/1890 Emporenfenster für die Kirche Sankt Mauritius in Appenzell AI[1000], des Weiteren die Fenster der Kirche in Zürich-Enge (1892–1894), Sankt Joseph in Kleinbasel und viele mehr. Zu seinen größten Werken zählt der ab 1886 begonnene Fensterzyklus in der Kathedrale Saint-Pierre in Genf, wo Friedrich Berbig Glasmalereien in Anlehnung an die aus dem 15. Jahrhundert stammenden Verglasungen herstellte, das heißt meist Ganzfiguren vor Damastvorhängen mit giebelartiger Architektur aus durchbrochenen Wimpergen[1001]. Außerdem erhielt er dort 1885 den Auftrag für die von Marie Ador gestifteten Fenster in der Chapelle des Macchabées. Die Donatorin wünschte sich Glasmalereien nach «altem Genre», die mit dem Stil des Gebäudes eine Einheit zu bilden hatten[1002]. Ein weiteres Beispiel aus der Werkstatt Berbig sind die 1891 geschaffenen Reformatorenscheiben in der Kirche von Birrwil (Abb. 140)[1003].

999 Dabei handelt es sich möglicherweise um den Arbeiter Herrmann Glaser; vgl. Kap. ‹Verdienst und Betriebsklima›.

1000 Hinweise auf Arbeiten in Appenzell, Romont, Dussnang etc. gehen außerdem aus einem Briefwechsel zwischen Berbig und dem Sankt Galler Architekten Hardegger (1889/90) hervor. Die Korrespondenz wird im Landesarchiv Appenzell aufbewahrt.

1001 DEUBER, 2002, S. 36 f.; SAUTEREL, 2008, S. 78, 263–268; LAPAIRE, 1989, o. p.

1002 SAUTEREL, 2008, S. 78.

1003 Astrid Kaiser nennt weitere Beispiele: KAISER TRÜMPLER, 2002, S. 18–23.

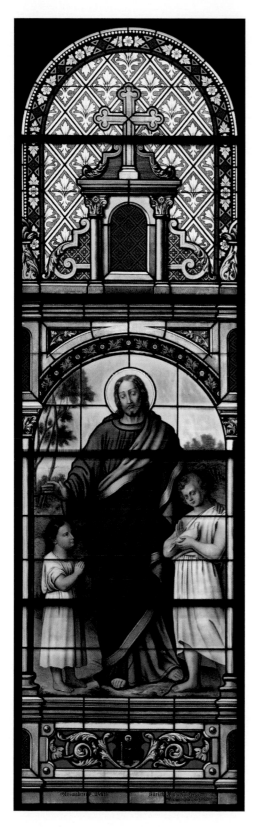

141. Carl Wehrli, Christus als Kinderfreund, Evangelisch-Reformierte Pfarrkirche Ennenda GL, 1885.

Im Briefkopf seiner Geschäftskorrespondenz weist Berbig auf seine Auszeichnungen hin, nämlich auf ein Diplom 1883 in Zürich und auf eine Silbermedaille 1885 in London[1004].

Felix Bleuler (1821–1878) wird als Maler von Zollikon 1869 auf der Signaturenscheibe in Meilen wie auch in Kappel[1005] erwähnt und erscheint obendrein im Fotoalbum der ehemaligen Mitarbeiter[1006]. Der als Kartonzeichner für Röttinger arbeitende Bleuler war vor allem für seine Porträts, Genre- und Historienbilder bekannt. Die Ausbildung erhielt der Künstler, der sich auf Bildnisse Verstorbener spezialisierte, in München und Paris[1007].

Gustav van Treeck (1854–1930)[1008], der Begründer der Bayerischen Hofglasmalerei[1009] an der Münchner Schwindgasse, lernte beim angesehenen Nürnberger Glasmaler Johann Georg Kellner, studierte bei August Kreling und Friedrich Wanderer in Nürnberg Malerei und hospitierte im Jahre 1872 in Röttingers Atelier in Zürich. Vor seiner Etablierung als Selbstständiger vertiefte er sein Können zehn Jahre lang in der renommierten Glasmalereifirma Franz Xaver Zettler in München[1010].

Über Carl Wehrli (1843–1902), dem ebenfalls renommierten Zürcher Glasmaler, der in der Zeit zwischen dem Ableben Johann Jakob Röttingers und der Wiederaufnahme des Ateliers durch dessen Sohn Jakob Georg (1862–1913) das Geschäft käuflich erworben hatte, wird im Kapitel über die Zeit nach dem Tod des Werkstattgründers ausführlicher berichtet (Abb. 141, signiert: Carl Wehrli, Aussersihl).

1004 LA Appenzell, Kirchenrenovation 1889.
1005 Vgl. Anm. 188.
1006 ZB Nachl. Röttinger 1.1.4.
1007 Bhattacharya, 2003, HLS, Stichw. *Bleuler, Felix.*
1008 Vgl. Anm. 295, 296, 297. Vaassen, 1997, S. 261; Anwander-Heisse, 1992, S. 36 ff.
1009 Homepage der Bayerischen Hofglasmalerei: Gründung der Werkstatt 1887, Ernennung zur Hofglasmalerei 1903.
1010 Vgl. Kap. ‹Auftrags- und Skizzenbuch›.

Die vorgestellten Mitarbeiter aus der Zeit der Fünfziger-, Sechziger- und Siebzigerjahre, die bei Johann Jakob Röttinger ihre Sporen verdient, ihr Wissen vertieft oder als Gesellen den Meistertitel angestrebt haben, lassen das Zürcher Atelier mit Recht als «Keimzelle einer ganzen Glasmalergeneration» erscheinen. Röttingers Anziehungskraft als angesehener Lehrmeister und Vorbild in Verbindung mit gangbaren Arbeitsbedingungen in der Schweiz schien in den genannten Dezennien ungebrochen und kann darüber hinaus als wichtiges Argument für den Kulturtransfer zwischen Süddeutschland und der Schweiz, in beiden Richtungen, gesehen werden. Dazu lassen sich anhand des Fotoalbums, das im Sommer 1865 angelegt wurde, weitere Mitarbeiter aus dem In- und Ausland ergänzen. Es sind Peter Sodberg, Glasergeselle aus Kopenhagen, der seit April 1864 bei Röttinger arbeitete, Reimer aus Sonderburg/Dänemark, zumindest in den Jahren 1874–1876 archivalisch fassbar, Peter Asmussen aus Flensburg für die Jahre 1863/1864 belegt, Schulze aus Leipzig 1863 sowie im Jahr 1867 H. Erne, Glaser aus Tiengen bei Waldshut[1011]. Auf den «Signaturenscheiben» erscheinen außer den bereits genannten, die Glaser Hesse von Burg in Preußen (1860), Kirsteiner aus Schlesien, Lingenhell aus Tirol (1867), der Maler Morat ebenfalls aus Schlesien (1867) sowie der Glaser Aichinger aus Heidenheim (1856); im Fotoalbum präsentierte sich zudem ein Glaser namens Rudolf Thym (o. D.), der aus Bayern stammte[1012]. Als einheimische Mitarbeiter werden unter anderem der Maler H. Schellenberg aus Rüti-Bülach ZH (1856, 1860), die Mitarbeiter Haas aus Basel (1875/1876), R. Spinner aus Aeugst ZH (1869), ein Mitarbeiter namens Schweizer[1013], Paulo, der Gehilfe, sowie die erwähnten P. und Cl. Bettelini aus Ascona TI[1014] aktenkundig. Angesichts der Herkunftsländer kann das Team um Röttinger als heterogen bezeichnet werden. Neben einheimischen sind es vor allem Personen deutscher sowie vereinzelt dänischer und österreichischer Nationalität, die in der Zürcher Werkstatt für kürzere oder längere Zeit Arbeit beziehungsweise einen Ausbildungsplatz gefunden haben und

dem Atelier Röttinger beinahe schon ein internationales Flair verleihen. Die Auswanderung junger Männer aus dem Grenzgebiet Schleswig-Holstein und Dänemark ist möglicherweise durch die deutsch-dänischen Kriege 1848–1851 und 1864 erklärbar, nach deren Ausgang die Städte Flensburg und Sonderburg preußisch wurden. Schon vorher waren Wandermaler aus dieser Gegend in der Schweiz beschäftigt. In der Synagoge Lengnau AG, deren Planung und Ausführung dem Architekten Ferdinand Stadler oblag, arbeiteten 1846 Dekorationsmaler aus Flensburg beziehungsweise Rendsburg[1015]. Der relativ hohe Ausländeranteil bei den Arbeitern scheint zu dieser Zeit üblich; so sollen 1837 von zirka 3 600 Gesellen in Zürich etwa 1 500 den Status als Ausländer gehabt, um 1850 sollen etwa 12 000 bis 15 000 ausländische Arbeiter in Zürich gelebt haben und im Jahr 1873 bei Escher-Wyß (Maschinenbauunternehmen, gegr. 1805) von insgesamt 1309 Mitarbeitern 112 deutscher, 19 französischer und 9 österreichischer Herkunft gewesen sein[1016], was einer rückläufigen Tendenz entspricht.

1011 ZB Nachl. Röttinger 1.1.4; Erne wird auch Erni geschrieben und erscheint zumindest für das Jahr 1867.

1012 Der Glaser Thym bleibt auch nach seiner Rückkehr nach München mit der Familie Röttinger in Verbindung, was aus der im Nachlass erhaltenen Korrespondenz der Witwe hervorgeht: ZB Nachl. Röttinger 1.165: Thym bestellte Grüße von Herrn Sator, der in Passau eine Glasmalerei gründen wolle sowie von Van Treeck, welcher *«[...] vom Millietär [sic!] losgekommen»* sei und nun wieder bei ihnen (wohl bei F. X. Zettler) arbeite. FISCHER, 1910, S. 108, 109.

1013 Schweizer: ohne weitere Angaben.

1014 P. Bettelini wird 1860 in Unterägeri, Cl. Bettelini 1856 in Basel und Bettelini (bzw. Betetini) ohne Hinweis auf den Vornamen 1867 in Meilen genannt. FISCHER, 1910, S. 107 nennt einen Glasmaler namens T. Bettetini bei Zettler zu Beginn der Siebzigerjahre. Vgl. Anm. 929, 963.

1015 WETTSTEIN, 1996, S. 11 u. 12, Anm. 1. Es handelte sich um H. Petersen aus Flensburg und W. Jensen aus Rendsburg.

1016 GRUNER, 1968, S. 86 f.

Glasmalerwerkstätten: Konkurrenz und Zusammenarbeit

Das im frühen 19. Jahrhundert neu erwachte Interesse an der Vergangenheit förderte die Beschäftigung mit Kabinettscheiben, deren Restaurierung sowie die Sammelleidenschaft. Nachahmungen und Neuschöpfungen von teils aus dem Ausland beauftragten Glasmalern ließen die Sitte der Wappenschenkungen wieder aufleben. Die Restaurierungen mittelalterlicher Kirchen und deren Glasmalereien regten die Glasmaler an, Kirchenneubauten im Stil der Neugotik mit passenden farbigen Fenstern zu gestalten. Der Standpunkt, dass die Werkstatt Johann Jakob Röttingers die erste und einzige dieser Art in der Schweiz gewesen sei[1017], der von Autoren zum Teil übernommen wurde, ist an dieser Stelle zu relativieren[1018]. Die Aussage im Textausschnitt (Anmerkung 1017), die die Auffassung der Mutter Röttingers vertritt, ist demnach zwar durch Schriftquellen belegbar, berücksichtigt jedoch die übrigen in der Schweiz tätigen zeitgenössischen Glasmalerei-Ateliers nicht. Die Gebrüder Beck aus Schaffhausen, die sich 1821 mit dem Glaser Johann Jakob Müller (1803–1867) aus Grindelwald zusammengeschlossen haben, um das Atelier Müller in Bern zu gründen, gelten als die frühesten auf dem Boden der Eidgenossenschaft ansässigen Glasmaler im 19. Jahrhundert[1019]. Ferdinand Alexander Beck (1814–1892) widmete sich der Kabinettglasmalerei und erforschte die Emailtechnik[1020]. Die Werkstatt Jakob Müllers in Bern, an der nicht nur dessen älterer Bruder Georg (* 1797), sondern auch Neffe Heinrich (1822–1903) beteiligt waren, befasste sich vor allem mit der Heraldik. Letzterer wechselte 1849 in die Werkstatt des Dr. Ludwig Stantz, ebenfalls in Bern, und machte sich nach einem Aufenthalt in Amerika und einem erneuten Arbeitsverhältnis bei Stantz schließlich selbstständig. Darüber hinaus war der Zeichner für Wappenscheiben und Sammler von Rissen, Emanuel Wyß, in Bern tätig. Die 1826 und 1836 entstandenen Wappenscheiben im Berner Münster können gewissermaßen als Zusammenarbeit der Müllers und

Wyß gesehen werden[1021]. Dies stellte Johann Rudolf Wyß in seinem 1826 verfassten Traktat «Über die neuerstandene Glasmalerey in Bern» fest und betonte die bedeutenden Impulse der ausgereiften Technik Müllers und der hohen Zeichenkunst seines Bruders für das Aufleben der Glasmalerei[1022]. Ludwig Stantz (1801–1871) war Arzt, Heraldiker und Glasmaler und baute sich zunächst in Konstanz eine Existenz als Glasmaler auf, kehrte aber aufgrund der Folgen der Revolution, die sich nicht zuletzt auch auf die Auftragslage auswirkten, in seine Heimatstadt Bern zurück, wo er offizielle Aufträge im Bundeshaus und im Berner Münster ausführte[1023]. Aus der Region Ostschweiz ist Johann Caspar Julius Gsell (1814–1907) als weiterer einheimischer Vertreter der Glasmalerkunst zu nennen, der 1851 in der reformierten Stadtkirche Sankt Gallen Sankt Laurenzen den Auftrag für das große Chorfenster erhielt. Die Sankt Galler ehrten damit den in Paris lebenden, gebürtigen Sohn der Stadt und erwarben ein Glasgemälde mit der Darstellung des Abendmahls (Abb. 142).

1017 SA Nürnberg C7_II_11886_09, Protokoll vom 17. März 1849, Gesuch der Nadlermeisterswitwe Röttinger beim Magistrat der Stadt Nürnberg um Aufnahme ihres Sohnes J. Röttinger als Schutzbürger, Protokollführer Nachtigall, Antragstellerin Susanna Helena Röttinger: *«Mein Sohn J. J. Röttinger, 32 Jahre alt, […]. Er hat sein Geschäft, welches das Einzige der Art in der Eidgenossenschaft ist, möglichst zu vergrößern und zu vervollkommen versucht, so dass er gegenwärtig sein Auskommen findet […]».*

1018 ZB Nachl. Röttinger 2.384, Text für das Lexikon am 17. Juli 1905 gesendet an H. Appenzeller, Olgastrasse 10: *«[…] Röttinger hat sich große Verdienste erworben, da er der erste war, welcher die kirchlichen und Cabinettglasmalereien in der Schweiz wieder einführte.»*

1019 MICHEL, 1986, S. 11; GESSERT, 1839, S. 296 ff.

1020 VAASSEN, 1997, S. 45 ff.; Ferdinand Alexander Beck notierte «die Wiederauffindung der Glasmalerei in Schaffhausen» (S. 46); Rolf Hasler stimmt Johann Martin Beck dem Älteren zu, wenn er sich Wiederentdecker der in Schaffhausen seit über 100 Jahren nicht mehr praktizierten Glasmalkunst nannte; die Söhne Ferdinand Alexander und Johann Jakob der J. führten das künstlerische Schaffen weiter. (HASLER, 2010, S. 68).

1021 Vgl. Anm. 559; VAASSEN, 1997, S. 45; KURMANN-SCHWARZ, 1998, S. 97 ff.

1022 HASLER, 1996, S. 9.

1023 VAASSEN, 1997, S. 47 f.

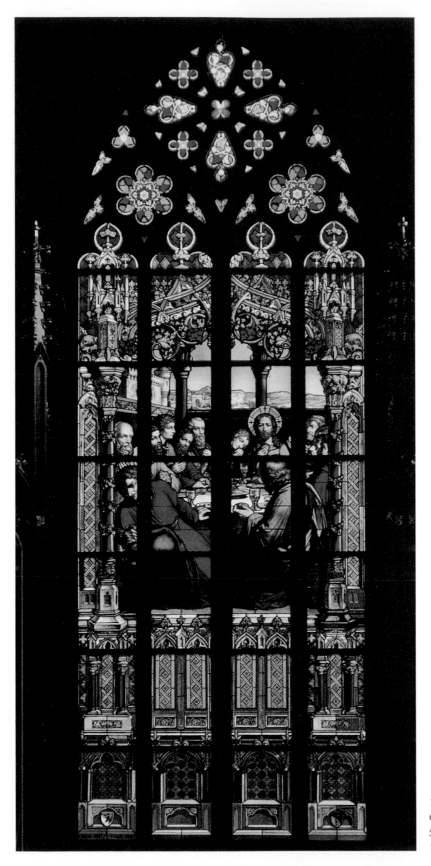

142. Caspar J. Gsell, Abendmahl,
Chorfenster I, Evangelisch-Reformierte
Stadtkirche St. Laurenzen St. Gallen,
1853.

Johann Jakob Röttinger, der alle übrigen Fenster mit Maßwerk und Ornamenten (Abb. 50–53) mit einem Volumen von 3477.88 Franken lieferte[1024], setzte auch das Abendmahlfenster ein[1025]. Röttinger und seine zeitgenössischen Berufskollegen bildeten also zwei größere Glasmalerei-Zentren auf Schweizer Boden, die Müllers sowie Ludwig Stantz in Bern und Hirnschrot beziehungsweise Röttinger in Zürich[1026]. Nachdem Röttinger seine eigene Werkstatt erst nach dem Tod Hirnschrots aufzubauen begann, war er in Zürich wohl der wichtigste Glasmaler am Platze – nicht der erste, aber lange Zeit der einzige mit einem angesehenen Atelier. Über die Zusammenarbeit zwischen einzelnen Glasmalereiwerkstätten gibt es im Nachlass nur wenige Hinweise. Die Arbeit für die Kirche in Furtwangen und die damit verbundene Zusammenarbeit zwischen Adolph Kreuzer und Johann Jakob Röttinger fand bereits im Kapitel ‹Die Werkstatt Röttinger als Wiege berühmter Glasmaler› Erwähnung. Dabei sind die bestellten Chorfenster offensichtlich von Meister Röttinger ausgeführt worden und von Adolph Kreuzer in Furtwangen eingesetzt. Als junger Selbstständiger hatte dieser nun Aussicht auf einen Auftrag mit seinem eigenen Geschäft für die Schönwälder Kirche[1027], deshalb bat er seinen ehemaligen Lehrmeister in einem Brief die Architekturzeichnungen in natürlicher Größe aufzubewahren: «*[...] da Sie mir seiner Zeit eine große Gefälligkeit damit leisten würden, wenn Sie so freundlich wären, mir dieselben zur Ausführung überlassen; natürlich gegen Vergütung oder Zurückerstattung nach Gebrauch*»[1028]. Im selben Brief vom Januar 1866 nimmt Kreuzer Bezug auf den Weihnachtsbesuch Röttingers in Nürnberg und auf den Umstand, dass sich Paulo, der Gehilfe Röttingers, nun für eine gewisse Zeit bei «*Hans Claus in Nürnberg*» aufhalte. Ob ein Personalaustausch zwischen befreundeten Glasmaler-Werkstätten der Grund dafür war, kann nur vermutet werden. Der 1853 ausgeführte Auftrag, die Chorverglasung des Grossmünsters, beinhaltete für das Atelier Röttinger die Umsetzung der Kartonzeichnungen des Glasmalers Georg Kellner[1029]. Diese Aufteilung der Arbeiten soll aus der Situation entstanden sein,

dass Johann Jakob Röttinger durch zahllose Aufträge jahrzehntelang überlastet gewesen sei[1030]. Wenn auch nicht im selben Jahrgang, so besuchten Georg Kellner und Johann Jakob Röttinger dieselbe Schule, die Königliche Kunstgewerbeschule in Nürnberg, und lebten in derselben Stadt; es darf also davon ausgegangen werden, dass sich die beiden kannten. In den Quellen wird deutlich, dass der Auftraggeber in einer Order im Werkvertrag Georg Konrad Kellner[1031] Verantwortung über das künstlerische Ergebnis der Glasmalereien übertragen hatte: «*Nach Maßgabe des Vorrückens wird er [Röttinger] solche dem Ausschuße des Vereins zur Ersichtigung [sic!] vorlegen, sollten hiebey einzelne Theile dem Ausschuße nicht gelungen erscheinen, so verpflichtet sich Herr Röttinger solche umzuarbeiten; oder aber auf Verlangen des Vereins durch Herrn Kellner in Nürnberg anfertigen zu laßen.*» Gegenseitige Gefälligkeiten, wie die Vermittlung eines Kontaktes für die junge Kellner-Generation zur Antiquarischen Gesellschaft in Zürich oder die Aufnahme der Nachwuchsglasmaler für Praktika in Zürich ließen sich bis zu

1024 Ortsbürgergemeinde Sankt Gallen: Tr XI, Nr. 13f. Akkord vom 1. Juli 1852.

1025 VAASSEN, 1997, S. 50; KNÖPFLI, 1979, S. 138, Anm. 113 u. 114.

1026 Die Becks in Schaffhausen hatten um die Jahrhundertmitte nur noch kleinere Aufträge (VAASSEN, 1997, S. 45 ff.).

1027 Dabei handelt es sich vermutlich um die Pfarrkirche Schönwald im Schwarzwald nördlich von Furtwangen.

1028 ZB Nachl. Röttinger 1.79.

1029 Vgl. Anm. 657.

1030 Vgl. MÖRGELI, 1988, S. 46. Christoph Mörgeli stieß im Rahmen seiner Recherchen bezüglich der Kirche in Stäfa auf einen Tagblatt-Artikel, der diese Überlastung bestätigen soll (Tagblatt der Stadt Zürich, 14. März 1868).

1031 ZB Nachl. Röttinger 1.198; StAZH W I 3 AGZ 174 12, Müller-R 1851–58, hier 195/1852: Aus dem Brief an Ferdinand Keller vom 15. Juni 1852 ist zu entnehmen, dass Röttinger nun endlich das Vergnügen habe über die Zeichnungen der Grossmünsterfenster Nachricht zu geben: «*Herr Georg Kellner hat mir ‚um nicht aufgehalten zu sein‘ den dritten Theil des Hauptfensters, von oben herab, bis zu der Figur Christus zu gesendet und mir die Zusicherung ertheilt an den übrigen ungesäumt fort zu arbeiten.*»

einem gewissen Grad archivalisch belegen[1032]. Darüber hinaus erscheint in der Buchhaltung von 1875 ein Eintrag, der Röttingers Ausführung von zwei Zeichnungen und zwei geschnittenen Scheiben, eine Partie Glasstücke sowie Butzenscheiben für Glasmaler Kellner in Friedrichshafen für den Preis von 169.25 Franken bestätigt[1033]. In Basel soll als erster Glasmaler Adolf Mieg (1812–1857) ab 1854 aktenkundig geworden sein. Angesichts mangelnder Glasmalerateliers erstaunt es nicht, dass in den frühen Jahrzehnten Entwürfe des ambitionierten Basler Historienmalers Hieronymus Hess (1799–1850) vom etablierten Freiburger Atelier Andreas und Lorenz Helmle in Glas umgesetzt wurden[1034]. Mieg war dank der Einsendung zweier Zeichnungen für einen Auftrag im Basler Münster qualifiziert und erhielt daher im Januar den Zuschlag für die Ausführung der sechs Rosetten. Die Weitergabe des Auftrags an Johann Jakob Röttinger, mit der Erlaubnis die eingesandten Kartons zu verwenden[1035], wird wegen des krankheitshalber frühen Ablebens Miegs im November 1857 vermutet[1036]. Die runden Signaturscheiben der Werkstatt Röttinger in den Fenstern des südlichen Seitenschiffs werden durch eine Signatur des Glasers Rudolf Roth (*Rud. Roth. Glaser. Basel. 1856*) ergänzt. Die über Jahrzehnte währende Zusammenarbeit belegt ein Brief an Frau Roth, die Witwe des Glasers, aus dem Kopierbuch Röttingers am 13. Februar 1876: «*[…] so bin ich so frei Sie höflichst darauf aufmerksam zu machen, daß Sie die Rechnung welche noch Ihr selg. Mann an mir zu fordern, ausstellen möchte*»[1037]. Auf eine Kooperation mit dem Innerschweizer Maler Melchior Paul Deschwanden wurde schon im Kapitel über zeitgenössische Vorbilder hingewiesen. Als Deschwanden für die Klosterkirche in Alt Sankt Johann eine Farbskizze erarbeitete, teilte er dem Glasmaler mit, «*[…], die Sie wahrscheinlich auszuführen bekommen werden […] erbiete mich zur Korrektur der durch Sie in die Naturgröße zu übersetzende Zeichnung seiner Zeit, wobei ich dann in Köpfen und Gliedern nachholen kann, was im Kleinen zurückblieb […].*» Als «*wohlmeinender Freund*» erlaubte er sich Kritik an «*jenem großen Christus*» zu üben, «*dessen Ausführung in solcher Unkorrektheit und Häss-*

lichkeit Ihrem Rufe nur Nachtheil bringen würde, […].» Die Schlussworte «*Ihr teilnehmender, bereitwilliger M. Paul Deschwanden*» lassen hingegen eher auf eine konstruktive Arbeitsgemeinschaft als auf respektlose Missbilligung schließen, was im folgenden Briefabschnitt, in dem er um die Rückgabe von Mustern bittet, zum Ausdruck kommt: «*Da die Glasmalereien für Frauenthal vollendet und somit meine Vorlagen nicht mehr nöthig sind, so bitte um baldige Retournierung dieser 3 Gemälde, deren ich eben wieder bedarf. Freue mich darauf, die letzten Arbeiten für Frauenthal zu sehen. Schon die Früheren gefielen mir gut. […]*»[1038]. Auf manchen Glasmalereien ist die Handschrift Deschwandens direkt ersichtlich, wie zum Beispiel in Bünzen, wo figürliche Glasmalereien nach Deschwanden[1039], die Verkündigung Mariens und die Auferstehung, neben gemalten Altarbildern zu sehen sind. Der Kunstmaler bot noch über den Tod Röttingers hinaus seine Unterstützung an, was aus einem Brief der Witwe Verena Röttinger an einen Auftraggeber unbekannten Namens hervorgeht[1040]. Ein weiterer

1032 Vgl. Anm. 986. Stephan II und Samuel Kellner, 1867 in Meilen: Die beiden jungen Männer waren damals 16 bzw. 19 Jahre alt, im passenden Alter, um einmal außerhalb der väterlichen Werkstatt, jedoch bei einem der Familie bekannten Meister eine Zeit zu verbringen. Der Brief J. Röttingers an die Frauen Kellner vom 7. November 1875 gibt Ausdruck über die Freude die Jungen wiederzusehen und verspricht das Möglichste zu tun, damit die Reise keine vergebliche sei. Nach dem Umzug der Kellners von Ulm nach Friedrichshafen sei die Reise nicht mehr so weit (ZB Nachl. Röttinger 2.371, 8 Friedrichshafen/Frauen Kellner 1875).

1033 ZB Nachl. Röttinger 1.207, S. 307.

1034 NAGEL/VON RODA, 1998, S. 28.

1035 StABS 319 I D1.

1036 NAGEL/VON RODA, 1998, S. 44 f.

1037 ZB Nachl. Röttinger 2.371, 99 Basel/Roth 1876. Im Brief macht er vertrauliche Bemerkungen zu seiner Gesundheit, die eine längere freundschaftliche und geschäftliche Beziehung vermuten lassen. Zu Rudolf Roth vgl. NAGEL/VON RODA, 1998, S. 45, Abb. 20b.

1038 ZB Nachl. Röttinger 1.34 (Korrespondenz mit M.P. Deschwanden).

1039 KAISER TRÜMPLER, 2002, S. 18 f.

1040 ZB Nachl. Röttinger 1.182: «*[…] Herr Kunstmaler P. Deschwanden in Stanz seinen Beistand angeboten jeden bei mir gezeichneten Carton nach zu sehen und erst nach seinem Gutbefinden werden sie weiter ausgeführt […]*». Brief an einen «*Hochwürdigen Herrn*» im März 1877.

Malername erscheint im Pfarrarchiv Heitenried FR, wo neben der Korrespondenz Röttingers mit Pfarrer Spicher bezüglich des Michaelfensters die Briefe des Kunstmalers Heinrich Kaiser (1813–1900) aus Stans aufbewahrt werden. Ob der Freund Deschwandens, dessen Bilder bis in die USA verkauft wurden, die Kartons für das Michaelsfenster (Abb. 106) schuf, geht aus den Briefen nicht hervor[1041]. Für die Kirche Sankt Martin in Jonschwil scheint jedoch eine Zusammenarbeit mit dem Innerschweizer Künstler und Johann Jakob Röttinger stattgefunden zu haben. *«[...]Da Herr Maler Keiser in Stans die Vorlagen zurückwünscht[...]»*, forderte der Aktuar der Baukommission endlich die Zustellung der im Zürcher Atelier in Auftrag gegebenen Glasmalereien[1042].

Die größte Konkurrenz an Glasmalern war in München zu finden, wo Glasmaler Franz Xaver Eggert (1802–1876) wirkte. An der Münchner Akademie ausgebildet und zwanzig Jahre für die Königliche Glasmalereianstalt tätig, nahm er die Fenster des Chorobergadens im Basler Münster in Auftrag. Darüber hinaus schuf er einige Glasgemälde, um die wichtigsten zu nennen: die Münchner Maria Hilf-Kirche in der Au, für den Regensburger Dom, den Kölner Dom sowie das Konstanzer Münster[1043]. Rivalen im Wettstreit um große Aufträge waren auch die Gebrüder Heinrich (1823–1906) und Christian (1824–1893) Burkhardt, die ebenfalls die Münchner Ausbildung genossen hatten. Christian war als Porzellanmaler vielmehr der technischen Perfektion der Glasmalerei zugeneigt, während sich Heinrich als Kartonzeichner in der Glasmalereianstalt profilierte. Die Brüder zeichneten sich einer Anfrage der Bauherrschaft folgend für den Hauptteil der Glasmalerei in der Basler Elisabethenkirche verantwortlich; Röttinger erhielt den Auftrag für das große Fenster über dem Hauptportal hinter der Orgel und die Firma Dr. Heinrich Oidtmann & Cie in Linnich bekam die Fenster im östlichen Treppenhaus zur Ausführung[1044]. Mit dem Bau der reformierten Kirche Sankt Martin in Kilchberg BL hielt man sich eng an das Vorbild der Basler Elisabethenkirche; so war es naheliegend, für das große Chorfenster mit der Darstellung des Abendmahls erneut die Glasmalereiwerkstatt der Gebrüder Burkhardt zu beauftragen[1045]. Der Glaser J. Beck aus Basel fertigte die Schablonen für das dreiteilige Chorfenster sowie für die Rosetten und setzte schließlich die aus München eingetroffenen Scheiben ein. Im Jahr 1870 lieferten die Gebrüder Burkhardt Entwürfe für die Pfarrkirche Uznach SG. Dabei handelte es sich um zwei Chorfenster mit Darstellungen von «Mariä Verkündigung» sowie «Anbetung der Heiligen drei Könige» mit Wappen der Donatoren und zwei Fenstern aus Damastglas mit Ansichten der ehemaligen Sankt Antoniskirche beziehungsweise der jetzigen Pfarrkirche. *«Da die Zeichnungen der 2 ersten Fenster ziemlich getreue Copien von 2 Entwürfen von Hr. Glasmaler Burkhart in München sind, welche dieser eingesandt und die Hr. Röttinger zur Einsicht übergeben wurden, so verpflichtet sich Hr. Röttinger, falls Reklamationen wegen Eigentumsverletzung gemacht werden sollten, allfälligen Spesenersatz an Hr. Burkhart selbst zu tragen»*[1046]. Zusätzliche Konkurrenz aus dem süddeutschen Raum kam auch aus Freiburg im Breisgau. So vergab Bauherr Eduard Merian 1850 für das im neugotischen Stil umzubauende Schloss

1041 PA Heitenried, «Briefe von Kunstmaler Kaiser/Stans und Glasmaler Roettinger/Zürich etc.» Die Briefschaften der beiden Künstler richten sich jeweils ausschließlich an den Pfarrer Spicher und betreffen bei Röttinger das Chorfenster und bei Kaiser vier Ölgemälde, alle Kunstwerke Ende 1862 bestellt und 1863 geliefert. Bezugl. des Malers Heinrich Kaiser: STEINER, 2008, HLS, Stichw. *Keyser, Heinrich*; STEINER, 2008, HLS, Stichw. *Keyser [Kaiser, Kayser, Keiser]*.

1042 ZB Nachl. Röttinger 1.160; TOBLER, 1985, S. 86: Der häufig überlastete Maler M.P. Deschwanden setzte fortgeschrittene Schüler, Heinrich Keyser, Theodor von Deschwanden oder Dominik Annen aus Arth, zum Untermalen seiner Gemälde ein, um sich selbst auf die Fertigstellung von Köpfen und Händen zu konzentrieren.

1043 NAGEL/VON RODA, 1998, S. 46 ff.

1044 NAGEL/VON RODA, 1998, S. 71. Die Glasmalereiausstattung der Elisabethenkirche stammt aus den Jahren 1864/1865.

1045 KRÄUCHI, 2002, S. 18. Die Einweihung der Kirche erfolgte 1868.

1046 ZB Nachl. Röttinger 1.169. Der oben zitierte Satz wurde unter Punkt 2 vertraglich festgehalten. Weder die Fenster der Uznacher Kirche noch die Entwürfe sind erhalten.

Teufen im Kanton Zürich die Aufträge für Glasmalereien an den Historienmaler Hieronymus Hess aus Basel, die Ausführung den Gebrüdern Helmle aus Freiburg sowie Ferdinand Beck und schließlich der Werkstattgemeinschaft Müller und Stantz in Konstanz[1047]. Als «lokalen Futterneid» könnte man die polemischen Äußerungen des Glasers J. B. Birchmeier aus Rieden bezeichnen, der ein Musterfenster für Baden geliefert hatte und weder dort noch in Leuggern Aufträge akquirieren konnte: *«[...] habe einen schönen Theil Opfern müssen hätte aber nie geglaubt das ich samt H. Weiss von Zürich durch einen Ausländer* [gemeint ist J. Röttinger] *müsse verdrängt werden ich glaube H. Weiss würde ihnen wahrscheinlich genügende Bürgschaft geleistet haben für die gemalten Fenster u glaube jedenvals wen* [sic!] *ich dabei gewesen wäre so hätte es Ihnen jedenvals keinen Schaden gethan»*[1048]. Wie hart der Konkurrenzkampf tatsächlich war, lässt sich archivalisch nicht im vollen Umfang erfassen. Tatsache ist jedoch, dass sich ab den Sechzigerjahren immer mehr Glasmaler mit einem eigenen Geschäft etablierten und daher stellte die Zusammenarbeit mit den ausführenden Architekten eine wichtige Voraussetzungen für den Erhalt von Aufträgen dar.

Vertragsbestimmungen

Die überlieferten Briefe und Verträge im Nachlass Johann Jakob Röttingers zeigen, dass die Bestellungen durch so genannte *«Akkorde»* festgelegt worden sind. Akkordant[1049] wie Auftraggeber verpflichteten sich gegenseitig für bestimmte Leistungen und gaben sich durch ihre Unterschriften die größtmögliche Sicherheit, die aufgelisteten Vereinbarungen einzuhalten. Schriftliche Verträge zwischen Bauherrn und Handwerkern werden erst aus dem 19. Jahrhundert häufiger überliefert[1050]. In vielen Fällen ging dem Akkord eine *«Devis»* – eine Offerte – voraus, die vom Akkordant verfasst wurde und bereits das Wesentliche enthielt. So wurde 1833 beispielsweise für die Neuverblei-

ung von drei Chorfenstern in Königsfelden folgendes protokolliert: «[...] Über eine Herstellung dieser Fenster wurde von Glaser Meier in Lenzburg eine Devis beigebracht. Derselbe fordert für die Fassung der drei Fenster mit gutem Blei Fr. 251 unter der Bedingung jedoch, daß ihm von der Verwaltung das benöthigte Gerüstholz verabfolgt werde.[...]»[1051]. Johann Jakob Röttinger verfasste 1865 eine *«Devise für Erstellung von zwei Glasfenstern mit Glasmalereien oder weißer Verglasung»* in die katholische Kirche Oberlunkhofen mit den Darstellungen der *«Verkündigung Mariens»* und des *«Josephs mit dem Kinde»*[1052], die sich nicht erhalten haben. Der Akkord nannte zuerst die beiden Parteien, verband sie vertraglich und führte nachstehend das Objekt auf. Im Anschluss daran listete man die Bedingungen auf, die beide Geschäftspartner zu erfüllen hatten. Häufig bezeichneten die Paragraphen 1–3 die verschiedenen Fensterarten, Chorfenster, Schifffenster, Turmfenster etc. und hielten die Vorstellungen des Auftraggebers fest. Wiederholt

1047 PARELLO, 2000 (1), S. 110 f. Lorenz Helmle starb im Februar 1849, Hieronymus Hess im Juni 1850, daher kam es zu Wechseln der ausführenden Künstler.

1048 KGA Leuggern: K III 2 4: Kirchenvorstand: Akten des Kirchenbaues 1838–1855, Band 2: Nr. 287 bis 392, Belege der Kirchenbau-Rechnung, Nr. 308. Mit Dank an R.H. Röttinger und J.A. Bossardt für die Zustellung der Dokumente. Bezüglich Zusammenarbeit zwischen dem Architekten C. Jeuch (u.a. Architekten) und J. Röttinger vgl. Kap. ‹Akquisition – Werbung – Wettbewerb›.

1049 Das Fremdwörterbuch DUDEN bezeichnet «Akkordant» als v.a. in der Schweiz gebräuchlichen Begriff für einen kleinen Unternehmer (bes. im Bauwesen o.ä.), der Aufträge zu einem Pauschalpreis je Einheit auf eigene Rechnung übernimmt.

1050 OSSENBERG, 2004, S. 71. Schriftliche Abmachungen aus dem Mittelalter und der frühen Neuzeit waren seltener oder gingen häufig verloren.

1051 KURMANN-SCHWARZ, 2008, S. 402 (ungedruckte Quellen und Regesten aus Quellen), Nr. 17, zitiert nach: Aarau, StAAG R01.F14/0008, Nr. 24, Aarau, 24. Juni 1833, S. 40.

1052 ZB Nachl. Röttinger 1.88: *«Das Fenster links soll darstellen ‹Maria Verkündigung› mit den zwei Bildern der hl. Jungfrau und des Engels Gabriel in entsprechender Größe, mit schönen und angemessenen Verzierungen und der Inschrift: ‹Ave gratia plena›. 2. Das Fenster rechts soll enthalten das Bild des «Hl. Joseph mit dem Kinde Jesu an der Hand führend», ebenfalls mit entsprechender Ornamentik und der Inschrift: ‹cum esset justus›.»*

finden sich hier Angaben über Ikonographie und Form der auszuführenden Objekte. In weiteren Paragraphen definierte der Kunde die Art der Materialien; meist wurde «*Halbdoppelglas*» in reiner Qualität gewünscht, die Glasmalereien sollten gebrannt sein, die Fassung der Gläser in starkem Blei und zwar gut gelötet und beidseitig mit Zinn überlegt. Die Abdichtung hatte mit gutem Ölkitt zu erfolgen. Auch die Stabilität der Fenster ist ein Anliegen: «*der Übernehmer hat das Einsetzen der Fenster zu besorgen und für gute und solide Befestigung diejenige Anordnung zu treffen, daß die Fenster sowohl dem Wind als auch dem Regen widerstehen können*»[1053]. Windeisen und Gitter waren nicht in jedem Fall Sache des Glasmalers, häufig organisierte die Bauherrschaft deren Herstellung und Montage. Maurer oder Steinmetz mussten bei Bedarf seitens des Bauherrn zur Verfügung gestellt werden und sei es nur, um die Löcher zur Befestigung der Eisen zu schlagen. Einzelne Auftraggeber übertrugen dem Glasmaler wiederum die ganze Verantwortung: «*Herr Röttinger übernimmt den Transport der Fenster nach Wollerau, besorgt die Einsetzung derselben und bestreitet alle und jede Unkosten an Schlosser, Schmied, Gehilfen usw.*»[1054]. Die im Akkord aufgezählten Parameter hatten nicht nur für das Metier der Glasmaler Gültigkeit, sondern waren allgemein im Bauhandwerk üblich. So interessierten neben der Qualität des Materials vor allem die Lieferfristen, die mit dem Bauverlauf harmonieren mussten und die Kosten, Zahlungsmodalitäten und Garantieleistungen sowie in manchen Fällen die Verpflegung der Arbeiter[1055]. Die Anforderungen an die Kunstfertigkeit und die Einhaltung konfessionell bedingter Regeln der Kunst erhielten im Kapitel ‹Wünsche der Auftraggeber› gebührend Aufmerksamkeit: «*Die sämtlichen Arbeiten in Bezug auf Glaserei und Glasmalerei müssen in allen Teilen gehörig fein, kunstgerecht und solid hinsichtlich der Zeichnung und Ausführung erstellt werden*»[1056]. Daher sollen in der Folge die Abkommen bezüglich des infrastrukturellen und handwerklichen Teils, der Finanzen und der Garantieforderungen zur Sprache kommen.

Transport der Fenster

Ein in den Verträgen häufig erwähntes Anliegen war der Transport der zerbrechlichen Ware. Immer geschah die Beförderung der Fenster mit der Bahn bis zum nächstgelegenen Bahnhof des Zielortes. Von dort aus war in der Regel der Auftraggeber für die Fracht mit dem Pferdefuhrwerk bis zur Baustelle haftbar. «*[...] unter allen Umständen bis Samstag Abend zu vollenden, so daß ich diese noch zur Bahn bringen kann. Gestützt auf dieses, mache ich Ihnen die Anzeige, daß die Fenster Montag morgen in Olten abgeholt werden können, ein Arbeiter von mir wird gleichzeitig in Olten eintreffen und mit dem von Ihnen gesendeten Fuhrwerk zu Ihnen kommen. [...] Sie fragen, welche Art Wagen Sie senden sollen? Darauf bemerke Ihnen, das dies ganz gleichgültig ist, die Kisten haben eine Länge von 3 ½ Schuh [sic!] und 2'5" Höhe, 1' Breite. Die Eisen lassen sich der Länge nach legen. Sie sehen daß ein Pferd genügt und daß es kein großes Fuhrwerk bedarf. [...]*»[1057]. Wichtig für die Beförderung war die Verantwortung im Falle des Glasbruchs. «*Muß die zu liefernde Arbeit so gut verpakt werden, daß dieselbe während des Transports keinen Schaden leiden kann[...]*»[1058]. Bei Beschädigung wurde der Ersatz der defekten Ware durch den Lieferanten vereinbart. Johann Jakob Röttinger haftete bis zu dem Zeitpunkt, wenn die Fenster mit der Bahn im nächstmöglichen Bahnhof ankamen; das letzte Wegstück lag in der Verantwortlichkeit des Auftraggebers. Daher geschah es gelegentlich, dass der Glasmaler dem Empfänger der Ware Unterweisungen für den Weitertransport der Scheiben gab: «*Sie sind höflichst ersucht dafür zu sorgen, dass die Kisten in Olten abgeholt, nur aufrecht, d.h. nicht gelegt nach Mümliswyl transportiert werden [...]*»[1059].

1053 ZB Nachl. Röttinger 1.5.
1054 ZB Nachl. Röttinger 1.191.
1055 OSSENBERG, 2004, S. 73.
1056 ZB Nachl. Röttinger 1.134.
1057 ZB Nachl. Röttinger 2.371, 6 Mümliswyl/Sury 1875.
1058 ZB Nachl. Röttinger 1.75, Punkt 6 im Vertrag mit der Pfarre Isny (Allgäu).
1059 ZB Nachl. Röttinger 2.371, 123 Mümliswyl/Sury 1876.

So wird auch in einer Lieferungsanzeige an Herrn Pfarrer Herzog in Jettingen appelliert: *«Sie werden die Güte haben und darauf Rücksicht nehmen, dass die Kisten beim Transport nicht gelegt werden und auch beim Öffnen der Kisten Ihrerseits, ein Brett an die Wand gestellt wird, an welches die Fenster gelehnt werden müssen, sonst brechen sie zusammen»*[1060].

Lieferfristen – Garantie – Zahlungsmodalitäten – Konventionalstrafen

Die «Anpassung» der Arbeiter in den Fabriken durch entsprechende Disziplinierung stand im 19. Jahrhundert an der Tagesordnung, war doch den Fabrikherren die Regelung des Dienstverhältnisses überlassen, was Kontrolle und Ordnung bezüglich des Verhaltens der Arbeiter mit einschloss. Dabei wurde besonders die Unpünktlichkeit streng geahndet; für Zuspätkommen war ein Abzug von 10–20 Prozent des Tageslohns keine Seltenheit. Dementsprechend war der Anteil der «Erziehungsarbeit», was die Zuverlässigkeit und Disziplin des Schweizervolkes betrifft, ebenso hoch wie in den Schulen[1061].

Angesichts dieser Haltung überrascht es nicht, dass die Pünktlichkeit bezüglich Lieferfristen der Bauherren großes Anliegen war. Nahezu in jedem Vertrag – mit einigen wenigen Ausnahmen – wurde eine Konventionalstrafe bei Nichteinhaltung der Termine vereinbart. *«Das große Rundlicht ist bis Ostern des Jahres fertig einzusetzen. Die übrigen bis spätestens Pfingsten des Jahres. Ist das Rundlicht bis Ostern nicht eingesetzt, so fällt der ganze Vertrag dahin (zusätzlicher Abzug 20% der Akkordsumme)»*[1062]. Die Androhung von Abzügen führte manchmal zu zeitlichen Engpässen, wie aus einigen Schreiben Johann Jakob Röttingers an den Schlosser und Gitterstricker C. Vogel in Sankt Gallen hervorgeht: *«Sende Ihnen nachträglich folgende Masse für 3 kleine Gitter, welche Sie die Güte haben werden mir schnellstens anzufertigen, [...] welche 3 Gitter Sie nicht hierher senden, sondern mir bloß Anzeige machen würden, wenn diese fertig sind. Bis den 25. muss ich die Fenster einsetzen, d.h. fertig sein [...]»*[1063]. Ebenfalls an Herrn Vogel geht die Anfrage: *«Ferner habe 7 große Gitter anzufertigen. Haben Sie die Zeit diese zu machen so zeigen Sie mir dieses umgehend an und bemerken die Zeit wie lange Sie Zeit bedürfen [sic!] [...]»*[1064]. Der Druck, den die Bauherren auf die Glasmaler auszuüben vermochten, war groß, dementsprechend wurde dieser auf andere Handwerker weitergegeben, wollte man nicht Teile der Akkordsumme verlieren. Im Falle von Streitereien sahen die Verträge ein Schiedsgericht von drei Sachkundigen vor, wovon jede Partei ein Mitglied und das Bezirksgericht Zürich den Obmann zu ernennen hatte, wie dies im Vertrag für die paritätische, nicht mehr erhaltene Kirche in Dietikon, Sankt Ulrich und Agatha, festgelegt ist: *«[...] Das Schiedsgericht ist berechtigt nach seinem Gutfinden die Arbeit gut zu heißen oder den Herrn Röttinger anzuhalten, dieselbe wegzunehmen im Falle sie nicht solid und kunstgerecht erstellt wäre, oder auch einen Abzug an der Akkordsumme nebst entsprechender Entschädigung aufzuerlegen. [...] es darf der Streit vor keine weitere Instanz gezogen werden»*[1065].

Die Kirchgemeinden verhielten sich betreffend Einhaltung von Garantieleistungen sehr unbeugsam. Die Kapellenbaukommission von Bellikon Sankt Josef legte die Übernehmergarantie wie folgt fest: *«Der Übernehmer garantiert für die kunstgerechte und planmäßige Vollendung sowie die Solidität seiner Arbeiten vom Tage ihrer Befestigung an. Dagegen wird die Gemeinde dem Übernehmer Fr. 700.– ausbezahlen und zwar 200.– bei Ablieferung der vollständigen Arbeiten und die übrigen Fr. 500.– in den folgenden zwei Jahren je zur Hälfte, doch können dieselben bei einem Mangel an Geldkräften von der Baukommission vom 14. Januar 1856 an wenigstens ein Jahr lang alljährlich zu 4% verzinst, dann auf eine vorhergehende gehörige Abkündung samthaft bezahlt werden»*[1066]. Aus den Beispielen gehen Forde-

1060 ZB Nachl. Röttinger 2.371, 163, 164 Jettingen/Herzog 1876.
1061 GRUNER, 1968, S. 98 ff.
1062 ZB Nachl. Röttinger 1.152.
1063 ZB Nachl. Röttinger 2.371, 182 Sankt Gallen/C. Vogel 1876.
1064 ZB Nachl. Röttinger 2.371, 199 Sankt Gallen/C. Vogel 1876.
1065 ZB Nachl. Röttinger 1.36.
1066 ZB Nachl. Röttinger 1.16.

rungen hervor, die in den Quellen sehr häufig zum Ausdruck kommen, woraus auch die finanziell schwierige Situation der Künstler und Handwerker ersichtlich wird. Wegen der langfristigen Garantieversprechen dauerte es oft Jahre bis die Fenster vollständig bezahlt waren. Um die nötige finanzielle Liquidität im Geschäft sicherzustellen, war es üblich, die Kunden um Abschlagszahlungen (Akontozahlungen) zu bitten: *«Es wäre mir sehr erwünscht, wenn Sie im Falle wären mir eine Abschlags Zahlung machen zu können da ich auf kommenden Martini unsere Geld Angelegenheiten zu ordnen habe»*[1067]. Vom reformierten Kirchenvorstand Baden AG erhielt Röttinger 1867 für ein Gesamtvolumen von 1600 Franken, 1000 Franken nach termingerechter Erstellung und den Restbetrag von 600 Franken ein halbes Jahr nach Fertigstellung aller Fenster[1068], was vergleichsweise einer außerordentlich schnellen Begleichung der offenen Beträge entsprach.

An weiteren Darstellungen wird offenkundig, dass es mitunter aufwendig war, die ausstehenden Gelder bei den Kunden einzutreiben. Sowohl Privatpersonen wie auch Kirchgemeinden mussten bisweilen mehrmals gemahnt werden, damit wenigstens Teilbeträge der geforderten Summe bezahlt wurden. Das erste Schreiben des Glasmalers war meist mit Bedacht formuliert, was sich bei hartnäckiger Zahlungsverweigerung verständlicherweise änderte. Die im 19. Jahrhundert in der Korrespondenz übliche Höflichkeit gebot dem Handwerker wie dem Künstler große Geduld und Toleranz. Dies geht beispielsweise aus einem Schreiben an den *«hochgeehrten Herrn Pfarrer Bölsterli»* in Murten hervor: *«Unterm 10ten Aug. d. J. habe Ihnen meine Rechnung für die in Ihre Capelle gemachten Fenster eingegeben da ich aber bis heute ohne Antwort und Bezahlung geblieben bin so nehme mir die Freiheit Sie zu bitten diese Angelegenheit zu regulieren»*[1069]. Im folgenden Fall sind seit der ersten Aufforderung bereits dreieinhalb Monate vergangen. An die Familie Rauhs in Fribourg schrieb Röttinger: *«Sie hatten die Güte mir unterm 13. Octb. zu schreiben, daß Sie mir mein Guthaben von 310 fr für die Ihnen gelieferten Gläser bis Ende dieses nehml[ichen] Oktober bezahlen wollen. Leider*

ist mir aber bis heute noch nichts zugekommen. [...] habe ohnehin durch die Zufälligkeit [sic!] Nachtheil genug und hoffe daher Sie werden dieses einsehen und nicht verlangen, daß ich noch weitere Unannehmlichkeiten haben soll»[1070]. Nach längerem Hin und Her wurde der Glasmaler in der Ansprache an Herrn Rauhs, Metzgermeister in Fribourg, noch etwas deutlicher. Er erlaubte sich im Jahr darauf, nochmals an die Bezahlung der gelieferten Spiegelgläser zu erinnern: *«Ich kann wirklich nicht begreifen wie Sie glauben können daß ich Ihnen diese Gläser vergebens liefern soll. Sie sind im Besitz der Gläser wie auch der Rechnung. [...], bin ich genöthigt, Sie gerichtlich zur Zahlung anhalten zu lassen»*[1071]. Zwischen diesen beiden Ermahnungen verstrichen sogar sieben Monate. Manchmal wurde fremde Hilfe notwendig, wie im Falle der Kirchenfenster in Muri, der den Beirat eines Rechtsagenten erforderte. Dieser erhielt von Johann Jakob Röttinger eine Vollmacht, um den seit zwei Jahren ausstehenden Betrag inklusive Zins einzutreiben[1072]. Ebenfalls unter Androhung gerichtlicher Schritte und unter Beiziehung eines Fürsprechers in Münster (Kanton Bern) musste der stattliche Betrag von 5106.27 Franken von der Ratsgemeinde Sankt Immer (Saint-Imier) eingefordert werden: *«[...] für gelieferte Arbeit in dortige kath. Kirche einzutreiben und dafür alle nötigen Schritte zu thun, welche wenn die Angelegenheit nicht in Güte beseitigt werden kann, gerichtlich erforderlich sind. «Unter Schadloshaltung» Zürich, den 8. August 1876»*[1073]. Aus diesen Textpassagen wird deutlich, dass es Glasmaler Johann Jakob Röttinger, der immerhin eine neunköpfige Familie zu ernähren, die Angestellten zu bezahlen und den Materialbedarf einzukaufen hatte, nicht immer leicht gefallen sein musste, allen Forderungen gerecht zu werden.

1067 ZB Nachl. Röttinger 2.371, 212 Henau/Casanova 1876.
1068 ZB Nachl. Röttinger 1.10.
1069 ZB Nachl. Röttinger 2.371, 30 Murten/Bölsterli 1875.
1070 ZB Nachl. Röttinger 2.371, 29 Fribourg/Rauhs 1875.
1071 ZB Nachl. Röttinger 2.371, 139 Fribourg/ Rauhs 1876.
1072 ZB Nachl. Röttinger 2.371, 107 Muri/Oberli 1876.
1073 ZB Nachl. Röttinger 2.371, 166 Sankt Immer/kath. Kirche 1876.

Akquisition – Werbung – Wettbewerb

Aus Gründen der damals gültigen, für den Akkordanten denkbar ungünstigen Zahlungsmodalitäten ist es nicht verwunderlich, dass Johann Jakob Röttinger trotz der guten Auftragslage laufend Werbung in eigener Sache machte, die Kundschaft bat ihn zu empfehlen und versuchte Folgeaufträge zu gewinnen. Im Kapitel über die Integration Johann Jakob Röttingers wurde konstatiert, dass sowohl das professionelle wie auch das gesellschaftliche Netzwerk zu einem guten Teil dank der Freundschaft mit Ferdinand Keller sowie der Bekanntschaft Johann Rudolph Rahns initiiert wurde. Auf diese Art gelang es dem Glasmaler Erstkontakte zu namhaften Architekten herzustellen, allen voran Ferdinand Stadler in Zürich[1074], Caspar Jeuch in Baden und Wilhelm Keller in Luzern, und dadurch seine professionelle und gesellschaftliche Reputation zu festigen. Ferdinand Stadler (1813–1870) führte in den Fünfziger- und Sechzigerjahren zahlreiche Kirchenbauten und -renovierungen in der Schweiz aus. Orte, an denen Stadler und Röttinger möglicherweise gemeinsam gewirkt haben, sind das Grossmünster, weitere reformierte Stadtkirchen, wie Sankt Laurenzen in Sankt Gallen (Planung Stadlers), Solothurn und Glarus, die reformierte Kirche Baar ZG, die Elisabethenkirche und die Französische Kirche in Basel, die reformierten Pfarrkirchen in Oberentfelden AG, Meilen ZH[1075] und Thalwil ZH sowie die katholischen Kirchen Sankt Oswald in Zug, Unterägeri ZG und die Friedhofkapelle in Schwyz[1076]. Wilhelm Keller (1823–1888) erhielt Aufträge in katholischen Kirchen zu Villmergen AG (Bau und Ausstattung), Grosswangen LU, Meggen LU, Kappel SO (Kapelle auf dem Born), Uznach SG, Hünenberg ZG (Sankt Wolfgang)[1077], Menzingen ZG (Finstersee), Bünzen AG (projektiert von Caspar Jeuch), Cham ZG (Planung für Kloster Heiligkreuz)[1078], um nur einige Bauten Kellers zu nennen, an denen auch Johann Jakob Röttinger als Glasmaler tätig war. Aus der Zeit nach dem Tode des Meisters sind nicht nur private Briefwechsel zwischen der Witwe und der Baumeisterfamilie Keller überliefert, sondern auch eine Aufstellung ausstehender Beträge, die eine intensive Zusammenarbeit zwischen dem Architekten und dem Glasmaler belegen. So schuldete Wilhelm Keller den Erben 1878 *«laut Abrechnung für gelieferte Arbeiten»* unter anderem *«ein Obligo vom 28. Januar 1868 im Betrag von Frk. 6000»*, das jährlich mit 5 Prozent verzinst wurde[1079]. Eine Rechnung *«für Herrn Glasmaler Röttinger seligen Erben»* dokumentiert überdies auch die Zusammenarbeit in den Kirchen des Kantons Luzern, Nottwil, Meierskappel, Neuenkirch, Uffikon und Udligenswil sowie in Olten AG

1074 Bezüglich der Zusammenarbeit mit Architekt Ferdinand Stadler vgl. HAUSER, 1976, S. 300: Kath. Pfarrkirche Unterägeri, S. 306f.: Evang. Reformierte Kirche Oberentfelden, S. 308: Reformierte Pfarrkirche Solothurn, S. 309: Paritätische Stadtkirche, S. 310: Protestantische Pfarrkirche Baar, S. 311: Sankt Oswaldkirche in Zug, S. 312: Französische Kirche Basel. In der reformierten Kirche zu Entfelden hat sich am Fenster n V das Wappen Stadlers und eine Inschrift *«Ferdinand Stadler Arch. d. Kirche zu Entfelden»* aus dem Jahr 1866 erhalten; für die Glasmalereien der nicht mehr erhaltenen Französischen Kapelle in Basel wurde 1867 ein Vertrag zwischen F. Stadler und J. Röttinger abgeschlossen; in Glarus waren, falls es zu Vertragsstreitigkeiten kam, diese nicht über ein Gericht, sondern über den Architekten Stadler abzuwickeln; in Schwyz wurden die Verhandlungen mit J. Röttinger bezüglich der Geschlechterwappen in der Friedhofkapelle z.T. via Architekt Stadler geführt (GASZ: Friedhof-und Beerdigungswesen I 94.4, 21. November 1864); Zwei Fenster in Baar ZG stiftete Architekt F. Stadler 1871 (nII und sII zeigen im axialen Zwickel die Namen des Erbauers der Kirche: n II Ferdinand Stadler als Stifter der beiden Fenster und s II J. Röttinger als Glasmaler).

1075 ZB Nachl. Röttinger 1.94: «[…] 1. Rundbogenfenster nach Zeichnung des Arch. F. Stadler in Zürich in das Kirchenschiff […]».

1076 Im Nachlass J. Röttingers hat sich keinerlei Korrespondenz zwischen J. Röttinger und dem Architekten Stadler erhalten. Aktenkundig wird die Zusammenarbeit z.B. in Glarus oder Meilen bzw. in Schwyz, wo Gottfried Semper beigezogen wurde, um eine Expertise des Stadlerschen Entwurfs auszuarbeiten, vgl. Anm. 820.

1077 GRÜNENFELDER, 2006, S. 311.

1078 GRÜNENFELDER, 2006, S. 238ff. Bezügl. der hier genannten Bauten vgl. Kunstführer durch die Schweiz 1 (AG, AI, AR, LU, SG, SH, TG, ZG, ZH), 2005; 3 (BL, BS, BE, SO), 2006.

1079 ZB Nachl. Röttinger 1.187.

und im Frauenkloster Sarnen OW[1080]. Gemeinsame Projekte mit Architekt Caspar Jeuch (1811–1895) beschränkten sich vermutlich auf die katholischen Kirchen in Leuggern AG, Bellikon AG und die so genannte Schulkapelle in Baden AG. Bezüglich letzterer haben sich drei Briefe des Architekten an den Glasmaler erhalten, nicht zuletzt deshalb, weil sich die Bezahlung der von Röttinger gelieferten Fenster für diesen als besonders schwierig gestaltete. Die Kapuzinerkapelle außerhalb des Stadtgrabens von Baden überstand die Aufhebung des Klosters 1841 und erhielt in der Folge einen neugotischen Charakter[1081]. Johann Jakob Röttinger lieferte im Auftrage Caspar Jeuchs sechs Fenster mit Glasmalereien: *«Wollen Sie gefälligst (in) die hiesige Kapelle beim Schulhause neue Fenster mit biblischen Figuren zeichnen und malen, damit ich ein solches Projekt nebst [...] Liste in den Weihnachtstagen, [...], herumbieten kann.»* Jeuch forderte außerdem die Anfertigung von Mustern, *«damit die Leute einen Begriff von der Sache erhalten. Man muss den Leuten klarer zeigen, sonst treten sie nicht darauf ein. Ihre Eile in dieser Sache wird erheblich zum Gelingen dieser Sache mitwirken»*[1082]. 1876 musste die Kapelle schließlich wegen Baufälligkeit abgerissen werden. Der Gemeinderat teilte Johann Jakob Röttinger den Beschluss wie auch die Rechtslage in einem Brief vom 12. Juli 1876 bezüglich der noch immer nicht bezahlten Glasmalereien mit. *«[...] Sie haben die Fenster für diese Kapelle geliefert und sollen dafür, wie uns Herr Fürsprech Bürli mitgetheilt hat, noch nicht bezahlt sein. Die fraglichen Fenster sind nun allerdings von der Gemeinde resp. der für dieselbe zu handeln berechtigte Behörde bei Ihnen nicht bestellt worden. [...].»* Mit einem finanziellen Entgegenkommen der Gemeinde von 500 Franken ermöglichte man Röttinger den Ausbau der Fenster in eigener Regie und deren Rücknahme. Fast ein Jahr nach Röttingers Tod nahm die Kirchenpflege die Korrespondenz bezüglich der Glasmalereien mit der Witwe Verena Röttinger wieder auf. Die Fenster wurden schließlich aufgrund eines Gutachtens von Architekt Johann Caspar Wolff (1818–1891) der Witwe um 900 Franken abgekauft und in der Michaelskapelle zu Ennetbaden einer Weiterverwendung zugeführt[1083]. Das letzte Beispiel zeigt, dass Ar-

beiten des Glasmalers für einen Architekten, die ausschließlich auf Vertrauensbasis geleistet wurden, ohne im Hintergrund eine Baukommission der Gemeinde beziehungsweise Kirchgemeinde zu wissen, zu erheblichen pekuniären Verlusten führen konnten. Dies bekräftigt die Bedeutung der Akkorde, die wesentlich zur Sicherheit beider Kontrahenten beigetragen haben. Um sich für einen Auftrag zu bewerben, waren schriftliche Empfehlungen der Glasmaler Usus; ein Exemplar hat sich im Nachlass Johann Jakob Röttingers bezüglich eines Anerbietens für Glasmalereien auf dem Rütli erhalten[1084]. Ein weiteres Empfehlungsschreiben wurde bereits im Rahmen des Ansuchens der Gebrüder Klaus für die Kemptener Kirche Sankt Mang zitiert[1085]. Zweifellos erschienen in diesen Schreiben nur die für den begehrten Auftrag relevanten Objekte mit Prestige, wusste man sich doch in den Bewerbungen ins rechte Licht zu rücken. Die Abgabe von Visitenkarten war eine gängige Art der Künstler und Handwerker, um den eigenen Namen oder den Namen der Firma bei potenziellen Auftraggebern zu deponieren:

J. J. Röttinger, Glasmaler, hintere Hofgasse Nr. 339 in Zürich. Verfertigt gebrannte Glasmalereien in jeder Manier hauptsächlich Kirchenfenster mit historischen Bildern, wie auch mit ornamentalen Verzierungen in jedem Styl, Familienwappen, Dessinscheiben (sogenanntes Mousselineglas) für Fenster, Thüren, Glaswände etc. und empfiehlt sich unter Zusicherung prompter und billiger Bedienung[1086].

1080 ZB Nachl. Röttinger 1.76.

1081 TREMP, 2006, S. 18 und 23.

1082 ZB Nachl. Röttinger 1.11., 18. Dezember 1857.

1083 TREMP, 2006, S. 18 f. Der Fenstereinbau in die Michaelskapelle erfolgte nicht vor dem Jahre 1880. StadtA Baden: A 06.46, A 06.47. Die Glasmalereien wurden beim Abbruch der Michaelskapelle 1966 wieder entfernt und im Keller der damals neu erbauten Pfarrkirche Sankt Michael deponiert. Sie sind in mit Holzwolle gepolsterten Kisten verpackt, jedoch in schlechtem Erhaltungszustand. Das Auspacken derselben und eine allfällige Restaurierung wurde aus Kostengründen verschoben.

1084 In Anm. 789 ist der gesamte Text des Bewerbungsbriefes abgedruckt.

1085 Vgl. Anm. 960.

1086 Vgl. Anm. 456.

Auf den Inhalt der Karte wurde im Kapitel ‹Wünsche der Auftraggeber› ausführlich eingegangen. Layout und Schriftbild waren vom Stil des Historismus geprägt und der Text auf zwei angedeuteten Schriftrollen verteilt. Künstlerisch gestaltetes Briefpapier, wie es im letzten Drittel des 19. Jahrhunderts die Auftritte der Firmen und deren Geschäftskorrespondenz bestimmte, sucht man bei Johann Jakob Röttinger vergeblich. Er setzte auf ein schlichtes Erscheinungsbild, meist ohne vorgedruckten Briefkopf, jedoch immer mit der gut leserlichen Unterschrift: *«J. Röttinger, Glasmaler»* (Abb. 48)[1087].

Als eine im 19. Jahrhundert geläufige Form des Wettbewerbs kann die so genannte «Absteigerung» bezeichnet werden. Im Kirchgemeindearchiv Schlieren ist aus den Jahren 1842/1843 ein solches Konkurrenzunternehmen schriftlich überliefert: *«Die Absteigerung soll den 10. November bei Herrn Friedensrichter Meier gehalten werden»*[1088]. *«[...] Mindestfordernde für Fenster mit eisernem Rahmen sind Glasermeister Zweifel in Höngg mit 74 F. und Kirchenpfleger Bräm in Schlieren mit 57 F. [...]. Die Kommission beschließt, es sollen in der Zwischenzeit noch Fenster besichtigt werden, welche Glasermeister Weiss in Zürich gerade für den Grossmünster in Zürich in Arbeit habe, damit entschieden werden könne, ob nicht diese Art von Fenster der Vorschlag geben möchte [sic!]»*[1089]. Schließlich erhielt Weiss, obwohl ursprünglich nicht an der Absteigerung teilnehmend, für 60 Franken den Zuschlag. Der Glaser stellte außerdem Bedingungen, ihm die alten Fenster nicht nur zu überlassen, sondern diese obendrein nach Zürich geliefert zu bekommen und die neuen dort abzuholen. Offensichtlich konnte ein Handwerker, der Aufträge im Grossmünster vorzuweisen hatte, was wohl als eine Art Qualitätssiegel galt, Forderungen an die Auftraggeber stellen. Solche Reklamemodelle fallen unter die Mund-zu-Mund-Propaganda, der wirksamsten und kostengünstigsten Form der Kundenwerbung, der daher in jedem Schreiben impulsgebend Vorschub geleistet wird. So gibt Johann Jakob Röttinger in einem Brief an den Pfarrer von Mümliswyl der Hoffnung Ausdruck, dass die vollendeten Fenster zu dessen werter Zufriedenheit ausfallen würden

und die Gemeinde noch im Laufe dieses Winters die anderen Fenster in Auftrag geben würde[1090]. Nach Bellikon ging das Versprechen: *«Dass ich im Fall mit benanntem Auftrag beehrt werden sollte, alles mögliche aufbieten werde, die Arbeit so auszuführen, dass Sie Ihnen zur Freude, mir aber zur Rekommandation für weitere Aufträge gereichen soll»*[1091]. Dem Schreinermeister Caspar Knecht in Thal SG empfiehlt sich J. Röttinger anlässlich einer Rechnungsstellung für gelieferte Bleifenster: *«Recht sehr würde es mich freuen wenn Sie einmal Gelegenheit haben würden in Ihrer Gegend Kirchenfenster übernehmen zu können oder gegen Erkenntlich[zeigen] von meiner Seite Ihnen gegenüber mir davon Anzeige zukommen zu lassen»*[1092]. Dass die Mund-zu-Mund-Propaganda funktionierte, geht aus einem weiteren Schreiben Röttingers an den Kirchenpfleger von Waldkirch hervor: *«Es freut mich recht sehr, dass Ihre Tit. Gemeinde in Folge der von mir in die Kirche von Niederhelfenschwil angefertigten Fenster geneigt, auch in Ihre Kirche neue Fenster anzuschaffen und sich bereits zu 2 solchen entschlossen hat. [...]»*[1093]. Als langjähriger Beobachter, was die Besetzung von Pfarrstellen betrifft, erwähnt der Glasmaler in einem Dankesschreiben ganz nebenbei: *«Es sollte mich freuen, wenn es sich einmal fügen sollte mit Ihnen wieder einmal in geschäftlichen Verkehr zu treten, denn ich denke Sie werden nicht ewig in Bollingen bleiben wollen und wenn Sie wieder wo anders sind, wäre es leicht möglich, dass Sie ein leichtes Baufieber überfallen könnte zu dessen [...] Sie*

1087 In ausgewählten Fällen erscheint die Visitenkarte als Briefkopf, wie auf Abb. 48 (PA Court, Korrespondenz, 1862).

1088 KGA Schlieren II B. 05.03, Sitzungsprotokolle der Baukommission für die Reparatur der Kirche 1842/1843. Herrn Peter Ringger danke ich an dieser Stelle für die Archivrecherchen.

1089 Es handelt sich bei Glasermeister Weiss um den späteren Kompagnon J. Röttingers, der offensichtlich in den Jahren 1842/43 Fenster (ohne Glasmalerei) in das Grossmünster lieferte.

1090 ZB Nachl. Röttinger 2.371, 2, Mümliswil/Pfarrer kath. Kirche 1875.

1091 PA Oberrohrdorf, Theke 136. Bellikon, 30. Juli 1854.

1092 ZB Nachl. Röttinger 2.371, 17 Thal/Knecht 1875.

1093 ZB Nachl. Röttinger 2.371, 35 Waldkirch/Baumgartner 1875.

mich vielleicht auch brauchen könnten»[1094]. Entsprechend formulierte Dankesschreiben der Auftraggeber brachten die nötige Motivation: «[...] musste zwar lange warten, habe nun aber herrlichen Schmuck für die Kirche ... Ihre Bilder machen einen wohltuenden religiösen Eindruck auf das christliche Gemüt. [...] Fahren Sie fort, schöne Arbeiten für die Kirchen zu liefern. Ihr Fleiß wird Ihnen zeitlich, wie ich hoffe, auf ewig belohnt werden»[1095]. In manchen Fällen war es notwendig Glasmalereien als Muster einzusenden, die in der Kirche aufgestellt, Anklang oder Ablehnung erfuhren. In Thalwil schienen die eingesandten Fenster der Kirchgemeinde zu einfach – so bestellte man schließlich Glasmalereien figürlicher Art[1096].

Johann Jakob Röttinger hofierte seine Kunden mit Charme und einer Prise Schalk, aber immer mit der angemessenen Ehrerbietung, besonders wenn er mit weiblichen Auftraggeberinnen korrespondierte: «[...] in Ihre Kirche drei neue Fenster erstellen zu lassen. Es freut mich dies ganz besonders und zwar aus dem Grunde weil ich schon im Jahre 1863 das Vergnügen hatte [...] Ihre Schwestern kennen zu lernen. So manche wird aber von diesen bis jetzt in die ewige Heimat abberufen worden sein, um den Lohn für Ihre Tugend und christliche Liebe zu empfangen [...]»[1097]. Die wirksamste Werbung waren zweifellos seine Werke selbst, die in den umliegenden Gemeinden wahrgenommen wurden. Die liebenswürdig gewinnende Wesensart, der Röttinger auch schriftlich gerne Ausdruck gab, verschaffte ihm den Zugang zu verborgenen Klöstern, wo seine Werke größte Wertschätzung erfuhren. So stiftete er dem Kloster Frauenthal ZG «2 Sakristeifenster mit dem Wappen der gnädigen Frau Hochpriorin als Zeichen meiner Hochachtung gemacht ohne Entschädigung»[1098] in Dankbarkeit für Aufträge im Umfang von 2 300 Franken. Bei so viel Wertschätzung den Kunden gegenüber muss es selbst Ordensfrauen schwer gefallen sein, sich dem kultivierten Charme seiner Courtoisie zu entziehen.

Johann Jakob Röttinger lag es nicht daran plakativ Werbung zu betreiben, wie es Heinrich Oidtmann aus Linnich (1833–1890) mit den damals verfügbaren Mitteln verstanden hatte. Dieser bediente sich gedruckter Kataloge, Prospekte und Anzeigen und schöpfte die Möglichkeiten von Firmenvertretern und Ausstellungen aus, um seinen Betrieb auf eine gewerbliche Großproduktion umzustellen[1099]. Beiden Glasmalern kann ein hohes Maß an Geschäftstüchtigkeit zugeschrieben werden, zugeschnitten auf Ihre persönlichen Neigungen und Leistungen und die Erfolge der Firma.

Produktion

Die Produktion im Atelier Johann Jakob Röttingers vom zeichnerischen Entwurf bis zum Einsetzen des fertigen Fensters nachzuvollziehen, ist wegen des Fehlens von Kartons nicht möglich. Die Summe kleiner Bausteine aus dem schriftlichen Archivmaterial lässt jedoch eine gewisse Vorstellung von Röttingers Schaffen entstehen. Obschon sich der Konkurrenzkampf in den Sechzigerjahren verschärfte, verzichtete man in der Werkstatt Röttinger auf Rationalisierungsmaßnahmen im großen Stil, wie sie der Arzt und Glasmaler Heinrich Oidtmann in den Werkprozess der Glasmalereiherstellung eingeführt hatte. Das rasche Wachstum dieses Kunstzweiges in der zweiten Jahrhunderthälfte erforderte diese Vorgehensweise – unter anderem eine thematische Katalogisierung der Kartons, die auf entsprechende Anfragen hin als Vorlagen weiterverwendet wurden[1100]. Wiederverwendungen gab es auch bei Röttinger, wie die Beispiele der Heiligendarstellungen in Medaillons und Kartuschen zeigen. Die so genannten christlichen «Monogramme» scheinen überhaupt standardisiert gewesen zu sein, was ihrer

1094 ZB Nachl. Röttinger 2.371, 54 Bollingen/Birchler 1876.
1095 ZB Nachl. Röttinger 1.88. Pfarrer Birchmeier in Lunkhofen bedankt sich 1866 für die Glasmalereien «Mariä Verkündigung» und «Joseph mit dem Kinde».
1096 Vgl. Anm. 226, 227. Abb. 17–21.
1097 ZB Nachl. Röttinger 2.371, 149 Kloster Berg Sion/ Aloysia Müller 1876.
1098 ZB Nachl. Röttinger 1.207, Buchhaltung 1869, S. 65.
1099 PARELLO, 1995, S. 150–156.
1100 PARELLO, 2009, S. 115.

Funktion der Symbolik und Semantik durchaus entsprach[1101]. Bei den Figuren legte Meister Röttinger Wert auf Individualität. Anhand immer wiederkehrender Sujets wie der Darstellung des «Lehrenden Christus» lassen sich die feinen Unterschiede der einzelnen Figuren erkennen. Die Zuschnitte eigenständiger Schablonen werden für etliche Aufträge in den Eintragungen der beiden überlieferten Lohnhefte Friedrich Berbigs fassbar[1102]. Karl Jennes (1852–1924), ein Schüler Oidtmanns, nutzte wie viele andere seiner Berufskollegen ein fotografisches Projektionsverfahren zur Vergrößerung der Vorlagen[1103]. Johann Jakob Röttinger, der noch das Durchpausen von mittelalterlichen Glasmalereien beherrschte, wandte diese Art der Übertragung aller Wahrscheinlichkeit nach nicht an[1104].

Preis und Leistung

Heinrich Oidtmann stellte Glasmalereien auf Vorrat her und konnte damit Lieferzeit und die Kosten reduzieren sowie die Leistungsfähigkeit optimieren[1105]. Unterdessen setzte Johann Jakob Röttinger weiterhin auf seine persönliche Note. Einem Brief nach Rodersdorf wurde mit gleicher Post eine «Preisliste» beigefügt. Bei einer Größe von 38.5 Quadratfuß kämen die *«einfachsten gemalten Fenster mit einer hübschen Randverzierung und im Inneren mit einem Damastdekor* auf 150 Franken. *Wollten Sie aber, dass in die gleiche Arbeit ein Bild, d.h. ein Brustbild eines beliebten Heiligen angebracht wird, so käme dies auf 50 Fr. mehr, somit 200 Fr. ein Fenster franco Basel und durch meine Leute in die Fensteröffnungen eingesetzt».* Bei der Bemalung mit einer ganzen Figur mit Architektur müsse man mit einem noch höheren Preis rechnen[1106]. *«Zur näheren Verständigung des Gesagten lege ich Ihnen 2 Skizzen bei, damit Sie sich im Falle der Anschaffung entschließen können, leichter eine Idee [der] Ausführung haben»*[1107]. Wenn dem Meister allzu einfach ausgeführte Fenster in einer Kirche nicht gefielen und es der Kirchgemeinde finanziell nicht möglich war, mehr auszugeben, schlug er für einen sehr kleinen Aufpreis verzierte Fenster vor. *«Sie*

dürfen versichert sein daß ich dieses Anbieten nicht des Gewinnes halber stelle sondern weil mir um die Sache zu thun ist»[1108]. In diesem Falle fand der Glasmaler, dass die Fenster ohne Schmuck allzu ärmlich aussehen würden; daher verpflichte er sich diesen Übelstand zu beseitigen und für die geringe Zulage von 15 Franken pro Fenster eine Verzierung anzubringen[1109]. Dieser Mehraufwand zeigt die Eigenständigkeit Röttingers sehr deutlich. Seine Angebote waren individuell auf den jeweiligen Kunden zugeschnitten, was zwar zeitaufwendig gewesen sein musste, jedoch sowohl dem Charakter des Übernehmers wie auch den Erwartungen des Klientels entsprochen hatte. Ebenfalls um Ausführung und Preise geht es in der Offerte für die Kirche in Libingen, wo die insgesamt zu verglasende Fläche 412 Quadratfuß betrug. Bei einer Dekoration mit Randverzierung und der Verwendung vorhandener Eisen kostete die Arbeit 716 Franken. Wenn die Eisen neu erstellt und in den Bogen ein Medaillon eingesetzt würde, *«so käme ein Fenster mit den Eisen auf 40 Fr. mehr. Ein Luftflügel kommt auf 12–15 Fr»*[1110]. In einer Offerte für die

1101 Vgl. Kap. ‹Christliche «Monogramme».

1102 ZB Nachl. Röttinger 1.208, 1.209. «17. Oct. 1875: Architektur für Dessenheim die Schablonen gemacht.» «Febr. 1875: Ein Johannes Baptist für Dessenheim. Schablonen zu 6 Fenstern nach Zeiningen.»

1103 PARELLO, 2009, S. 115.

1104 Vgl. Kap. ‚Zeichnungen und Lichtpausen mittelalterlicher Glasmalereien‘.

1105 PARELLO, 1995, S. 151: In einem vor 1880 zu datierenden Katalog werden folgende Quadratmeterpreise genannt: unbemalte Fenster 7–18 M[ark], musivisch gestaltete, farbige Glasmalereien mit Teppichmuster 25–90 M, Einzelfiguren in architektonischer Formierung auf Sockeln unter Baldachinen 90–140 M.

1106 ZB Nachl. Röttinger 2.371, 89 Rodersdorf/Jaeggi 1876; MARTIN, 2009, S. 101: Bei Glasmaler Müller (ca. 1860–70) in Berlin bezahlte man für ein Fenster mit Teppichmuster zwischen 50 und 70 Mark und im königlich bayerischen Glasmalereiinstitut bis zu 80 Mark – für große Figuren bei Müller 180 und bei den Münchnern bis zu 500 Mark.

1107 ZB Nachl. Röttinger 1.28 (Cham, Kloster Frauenthal).

1108 ZB Nachl. Röttinger 2.371, 104 Olten/A. Glutz 1876.

1109 ZB Nachl. Röttinger 2.371, 104 Olten/A. Glutz 1876.

1110 ZB Nachl. Röttinger 2.371, 136 Libingen/kath. Kirche 1876.

Kirche in Lindtal wurden die Preise per Quadratfuß angegeben: *«Kirchenfenster mit in Blei gefaßten Scheiben 1.25 Franken, in gleicher Weise jedoch mit [...] Randverzierung 1.50–1.75 Franken, ganz gemalte Fenster mit Grisaille und Randverzierung reich ausgestaltet 3.00–3.50 Franken»*[1111]. Für Dessinglas, das häufig an Privatpersonen, wie hier an den Hotelbesitzer Seiler in Zermatt, verkauft wurde, verlangte der Meister 1.50 Franken per Quadratfuß[1112]. Allfällige Zeichnungen beziehungsweise Maquetten wurden separat verrechnet. Der Kantonsrat des Kantons Waadt bat Johann Jakob Röttinger für ein Fenster im Glockenturm der Kathedrale von Lausanne eine kolorierte Zeichnung auf eine exakte Art und Weise im Maßstab von 1 Zoll auf einen Fuß herzustellen, nach der das Glasfenster ausgeführt werden könne. Für die Zeichnung wurden 80 Franken bezahlt[1113]. An Herrn Eberhard, Glaser in Schänis, ging eine Rechnung unter anderem für *«1 Diamant 12.00 Franken, 25 Rahmen Blei 6.25 Franken, Zinn und Blei 11.00 Franken»*[1114]. Restaurierungen und Reparaturen waren wegen der tiefen Löhne relativ günstig, so sind für die Restaurierung und Reinigung der Fenster im Grossmünster, das heißt für drei Arbeitstage mit zwei Arbeitern 36 Franken und für den Austausch von 98 Scheiben 40 Franken, also insgesamt 76 Franken bezahlt worden[1115].

Aufgrund der überschaubaren Größe der Werkstatt Röttinger mit entsprechend weniger Personalkosten kann davon ausgegangen werden, dass trotz individueller Kundenberatung und «vernachlässigbarer» Rationalisierungsmaßnahmen die Preise im marktüblichen Rahmen gehalten werden konnten. Zweifellos hatte das angemessene Preis-Leistungsverhältnis des geschäftstüchtigen fränkischen Meisters[1116] mit Handschlagqualität die anspruchsvolle Schweizer Kundschaft zu überzeugen vermocht. Der Umstand, dass bis 1865, als sich in Zürich Aussersihl Carl Wehrli als Glasmaler etablierte, auf Stadtboden keine vergleichbare Glasmalerwerkstatt als Konkurrenz auftrat, kam der Auftragslage des Unternehmens wohl ebenfalls entgegen.

Material und Maltechnik

Farbiges Glas

Bei der Anfertigung von Glasmalereien ist die Wahl der Glassorte von besonderer Relevanz. Die streng flüssigen Gläser mit hohem Kieselsäureanteil sind den weicheren vorzuziehen, obwohl sie die Farben schwerer annehmen, hingegen beim Brennen nicht völlig aus der Form geraten. So haben sich in der Glasmalerei französisches Glas, so genanntes Kalk-Natronglas mit blaugrünem Stich, die gelblichen und grünlichen Flaschengläser (Kieselglas), das weiße belgische Glas und besonders die eigens für die Zwecke der Glasmalerei produzierten Antik-, Kathedral- und Überfanggläser bewährt[1117]. In den Akkorden des 19. Jahrhunderts wird von den Auftraggebern praktisch immer «Halbdoppelglas» gefordert[1118], wobei manchmal eine zusätzliche Qualitätsbezeichnung beigefügt wurde, wie etwa *«Halbdoppelglas in zweiter Qualität»*[1119]. In Frauenfeld präzisierte man und verlangte belgisches Halbdoppelglas[1120].

1111 ZB Nachl. Röttinger 2.371, 161 Lindtal/Kälin 1876.

1112 ZB Nachl. Röttinger 2.371, 83 Zermatt/Seiler 1876.

1113 ZB Nachl. Röttinger 1.81.

1114 ZB Nachl. Röttinger 2.371, 188 Schänis/Eberhard 1876.

1115 ZB Nachl. Röttinger 1.198.

1116 Bezüglich der Bezeichnung der Einwohner Nürnbergs: Bayern oder Franken vgl. Anm. 924.

1117 JAENNICKE, 1898, S. 154 ff. VAASSEN, 2013, S. 35. Elgin Vaassen zitiert aus einer alten Kölner Handschrift, in der «Burgundisch glaß» erwähnt wird (S. 444, Anm. 88).

1118 Hierbei ist vermutlich eine Stärkenangabe gemeint, welche heutzutage nicht mehr verwendet wird. Die Befragung von Berufsleuten verschiedener Ateliers ergab, dass diese Bezeichnung in der heutigen Zeit nicht bekannt ist. J. Röttinger stellt *«einfaches Glas III»* dem oft mehr denn *«½ doppel starken Glas»* gegenüber (ZB Nachl. Röttinger 2.371, 19). Bei JAENNICKE, 1898 kommt die Bezeichnung nicht vor; er gibt jedoch an, dass die Antikglas-Tafeln (70×40 cm) in den Stärken zwischen 2 bis 5 mm zu haben waren, was einen Spielraum für «halbdoppelstarkes» Glas einräumt (dort S. 158).

1119 ZB Nachl. Röttinger 1.134, Rathaus/Wappenscheibenzyklus.

1120 PARELLO, 2000 (1), S. 233: In den Regesten der Brüder Helmle in Freiburg erscheinen um 1830 die Materialien:

Kathedralglas ist ein eher minderwertiges, gegossenes und gewalztes Fabrikat, das wegen der Farbenvielfalt, der unregelmäßigen Oberfläche und nicht zuletzt wegen des billigen Preises geschätzt wurde. Wohingegen das nach alten Mustern fabrizierte Antikglas, das 1855 zuerst in England wieder hergestellt wurde, ein hochwertiges, teures und für die Glasmalerei bestens geeignetes Glas war, das in Leuchtkraft und Farbtiefe den mittelalterlichen Gläsern nahe kam.

Nicht nur stilistisch, sondern auch bezüglich der glastechnischen Möglichkeiten sowie der Maltechnik lässt sich das 19. Jahrhundert in zwei Zeitabschnitte gliedern, in die Zeit von 1830 bis 1860/1870 und dem Aufschwung der Gründerzeit danach, als eine große Zahl von Werkstätten ihre Tore öffnete[1121]. Johann Jakob Röttinger gehörte der erstgenannten Generation an, die jedoch schon eine Anzahl wegbereitender Wiederentdecker hinter sich ließ. Die eigene Herstellung von Farben und farbigem Glas war für die Glasmaler ab den Vierzigerjahren nicht mehr zwingend, denn es konnten bereits Fertigprodukte bei einschlägigen Händlern erworben werden. So werden in der Agenda Johann Jakob Röttingers von 1874 diverse Vermerke bezüglich Glasbestellungen fassbar: *«Meier Sibler, 7 Kisten Glas von ihm erhalten. Camionnage 3.20 Fr.»; «Müller, Glashandlung 71.10 Fr.»; «Zollinger, Glashändler, Rechnung bezahlt 1356.65»*[1122]. Bereits 1859 war die Werkstatt Röttinger Kunde bei Meier, Sibler & Cie in Luzern und Zürich[1123] sowie bei einem Glashändler namens Leemann. Im Februar 1860 bestellte man aus Wolferding (bei Vilsbiburg, Bayern) farbiges Glas und bezahlte bei Saint-Gobain für dasselbe Material in Mannheim einen Wechsel über 119.40 Franken[1124]. Darüber hinaus bezog Röttinger im Oktober 1867 300 Stück Nabelscheiben bei Hegendorfer in der Rue Laffitte[1125], verschiedene farbige Glastafeln bei Aubriot[1126], beide in Paris, unter anderem 100 Tafeln gelbes, 12 Tafeln rotes, 12 Tafeln hellblaues und 12 Tafeln violettes Glas sowie 3 Tafeln blaues Überfangglas. Weitere Notizen für Glaseinkäufe in der Solm'schen Fabrik im heutigen Kliczków (Südpolen)[1127], bei Châtelain

«weisses Doppelglas, Bley und Zinloth»,die für die Münsterfenster bestellt worden waren.

1121 VAASSEN, 2000, S. 43.

1122 ZB Nachl. Röttinger 1.201, Agenda 1874.

1123 ZB Nachl. Röttinger 1.201, Agenda 1874: *«Rechnung für 1859 bezahlt 1642.76 Fr.»* ZB Nachl. Röttinger 1.51: NZZ, Sonntag, 8. August 1948, Nr. 1657, Blatt 4: «Sibler&Cie., Glas und Porzellan. Die Wiege der Glasindustrie steht im Schwarzwald. Von dort kam sie durch die so genannten Glasträger [...] nach der Schweiz und vor allem nach Zürich. Besonders soll es ihnen beim Storchenbogen und beim Weinplatz gefallen haben, der als gute Geschäftslage galt. Im Jahre 1814 haben sie sich im Hause «Rosmarin» angesiedelt, und nach und nach wurden Filialen in der Umgebung Zürichs eröffnet. Die ursprüngliche Firma trug den Namen Meyer, Schropp u. Cie., und als die Schropp starben, veranlaßte die Personenänderung die Gesellschaft, eine Umtaufe vorzunehmen. In den Dreißigerjahren des 19. Jahrhunderts wurde der Name der Firma in Meyer, Sibler u. Cie. umgewandelt.»

1124 ZB Nachl. Röttinger 1.205. Wolferding: *«2 Kisten 36.85»*; Mannheim, Saint-Gobain, Homepage: ein ursprünglich französischer Glashersteller, gründet 1853 die erste deutsche Niederlassung im badischen Waldhof, das später ein Stadtteil Mannheims wird. Zur Flachglashütte Waldhof bei Mannheim vgl. MOSER, 1969, S. 33.

1125 ZB Nachl. Röttinger 1.207: Buchhaltung 1869: *«Von ihm erhalten verschiedenes farbiges Glas 650.- Franken».* PILLET, 2010, S.160 f., bes. Anm. 536: Annuaire Almanach [...], 1861, p. 956 et 959: Hegendorfer figure à la fois dans la rubrique des peintres en bâtiments et vitriers et celle des peintres-verriers artistes et demeure 18, rue Laffitte. Répertoire des peintres-verriers [...]. Le 17 août 1858, Lafaye écrit dans son journal: «Chez Frédéric, lui parler de la rue Laffitte» (Arch. privées).

1126 ZB Nachl. Röttinger 1.124: Rechnung der Firma Aubriot vom 6. Mai 1874 über *«2 Caisses verdâtre à 1.50 10 feuilles [...]»* Dazu werden eine Kiste gelbes Glas à 2.25 10 Tafeln, 6 Tafeln rotes Glas (rouge vif) à 4.50, je 20 Tafeln violettes Glas in drei verschiedenen Ausführungen (clair, mixte und foncé) à 2.25, je 20 Tafeln blaues Glas ebenfalls (clair, mixte, foncé) à 2.25 aufgezählt.
Paris, Verrerie Aubriot, Pressglas-Korrespondenz-online: Die Verrerie La Planchotte wird im 15. Jahrhundert in den Vogesen gegründet und 1860 samt Inventar nach Clairey an der Ourche übertragen. Schwiegersohn Edmond Aubriot übernimmt zu diesem Zeitpunkt die Firma.

1127 Wehrau, Solm'sche Glasfabrik, Pressglas-Korrespondenz-online: Die Solm'sche Glasfabrik wurde 1820 als Andreashütte («Gräflich zu Solm'sche Glasfabrik») in Wehrau/Klitschdorf (Kliczków) im Landkreis Bunzlau gegründet (Eigentümer: Fürst zu Solm-Baruth) und hatte bis 1930/31 Bestand.

in Moutier BE, in der bayerischen Vopelius Glashütte, bei Schrader Rudolf in der norddeutschen Glashütte Gernheim sowie bei Geck&Cie in Offenburg erweitern das Spektrum der geschäftlichen Beziehungen[1128]. Die genannten Nabelscheiben, auch als Mondscheiben bekannt, wurden vom Glasbläser durch eine einseitige Öffnung der Glasblase und anschliessend eine schnelle Drehung um die eigene Achse hergestellt. Die dabei entstandene kreisrunde Scheibe weist einen zentralen Nabel auf, an der Stelle, wo das «Pontil», der Eisenstab, das Glas während der Rotation berührt. Das Herstellungsverfahren der Mondscheiben war traditionell eine Spezialität der Glasbläser in der Normandie[1129], daher ist es nicht verwunderlich, dass Röttinger Nabelscheiben in Paris bezogen hatte. Eine weitere Glasbestellung des Meisters geht aus einer Reklamation hervor, die er an die Glashandlung Ernst Wieser in Winterthur adressierte. Wieser schickte ihm sechs Kisten Glas statt der bestellten zwei und der Preis war im Vergleich mit der Bezugsquelle Zollinger in Trier beträchtlich höher[1130].

Über die Bearbeitung des Glases, die Farben und deren Gebrauch sowie über die Technik der Glasmalerei im Atelier wird im Nachlass nur wenig überliefert. Eine einzige Nachricht ist uns erhalten, die darauf hinweist, dass sich Johann Jakob Röttinger bezüglich des Einfärbens von Glas durchaus experimentierfreudig und innovativ zeigte. Er bestellte bei der Firma Wagner in Saarbrücken[1131] vier Kisten einfaches Glas III, das «oft mehr denn Doppel stark» war. Davon schickte er ein Muster an Alfred Châtelain in Moutier[1132] mit der Bemerkung: «Weniger stark als das Muster dürfte das Glas nicht sein, auch nicht grüner, ich würde es lieber sehen, wenn es eher etwaß gelber ausfallen würde. Nur möchte ich Sie ersuchen, dass die Tafeln möglichst gleichmässig gearbeitet sind. [...]»[1133]. Der Glasmaler hatte also Glas in grösseren Mengen aus der Glashütte bei Saarbrücken bezogen und beabsichtigte es in Moutier einfärben zu lassen, um möglichst gleichmässig gefärbte, gut für die Weiterverarbeitung geeignete Glastafeln zu erhalten. Aus dem folgenden Briefausschnitt geht hervor, dass J.J. Röttinger etwas ausprobieren wollte: «Leiste Ihnen die Zusicherung, dass dieses am Ende gleichgültig wäre ob gerathe diese oder eine andere Farbe heraus käme, wenn das Glas nur nicht weiß sondern grünlich gelb wäre ungefähr, wie die Boutellen [sic!] in Farbe sind. Ich bin im Besitze einer größeren Partie gelber und grüner Stücke, wenn ich Ihnen diese senden würde, könnten Sie einmal den Versuch machen diese mit den [sic!] Rest

1128 ZB Nachl. Röttinger 1.206. BANKEN, 2003, S. 537 f.: Die Firma Chevandier&Vopelius errichtete 1858 eine weitere Hütte auf bayerischem Staatsgebiet. In Sulzbach baute Ed. Vopelius nahe des Bahnhofs eine Fensterglashütte. Petershagen-Ovenstädt, Glashütte Gernheim, Pressglas-Korrespondenz-online: Die norddeutsche Glashütte Gernheim in Petershagen-Ovenstädt, westlich von Hannover, produzierte von 1812–1877 und wurde von Joh. Chr. Friedrich Schrader und Cornelius Lampe aus Bremen gegründet. Zu Vopelius vgl. KÜHNERT, 1973, S. 397, Vater-Stammreihe aus dem Wentzelschen Geschlecht.
Offenburg, Glasfabrik Geck&Cie, A. Schell, Homepage: Die heutige Firma Borsi, bekannt für 3D Kunststoff-Leuchtwerksysteme, geht auf das Jahr 1821 zurück, als Jak. Anton Derndinger eine Glashütte in Niederschopfheim gründete. 1857 wird die Glasfabrik «Derndinger& Brost» unter Carl Nikolaus Geck und Carl Ludwig Weißkopf zur Firma «C. Geck&Cie». 1862 trat Adolf Schell ein und begründete mit C. Weißkopf eine Werkstatt für die Musselinglasfabrikation. Ab 1868 nennt sich der Betrieb «Geck&Vittali», seit 1934 «Borsi». VAASSEN, 1997, S. 56 f. BEINES, 1979, S. 110: H. Drinneberg übernahm nach seiner Ausbildung als Glasmaler in der Firma Geck & Vittali sowie bei Zettler erstere als künstlerischer Leiter, um schon bald eine eigene Glasmalereianstalt in Karlsruhe zu gründen. Zu Adolf Schell & Otto Vittali vgl. MOSER, 1969, S. 32, zu den Datierungen der Glashütten vgl. dort S. 34–36.

1129 TRÜMPLER, 2002 (2), S. 42 f.

1130 ZB Nachl. Röttinger 2.371, 197 Winterthur/ Wieser Glashandlung 1876.

1131 BANKEN, 2003, S. 537 ff: Die Firma A. Wagner errichtete 1857 am Bahnhof Louisenthal eine neue Glashütte als Ersatz für den alten Betrieb am Lumpenberg.

1132 WISARD, 2009, HLS, Stichw. Moutier (Gemeinde). Die von Célestin Châtelain gegründete Verrerie de Moutier nahm ihren Betrieb 1842 auf und wurde in der Folge zur bedeutendsten Fensterglasfabrik in der Schweiz.

1133 ZB Nachl. Röttinger 2.371, 19 Moutier/Hr. Châtelain 1875.

eines Tiegels[1134] *zusammen schmelzen, käme herraus [sic!] was da wolle [...], die Sache hat Zeit»*[1135]. Diese Zeilen lassen vermuten, dass Johann Jakob Röttinger einen größeren Glasposten erwerben konnte und nun den Versuch in Auftrag gab, mithilfe eines mitgeschmolzenen Stoffes eine gleichmäßige Färbung zu erzielen. Im Vordergrund stand das technische Prinzip, das Farbergebnis selbst würde er vorerst dem Zufall überlassen. Wie das Morgenblatt für gebildete Stände 1826 berichtete, richteten die Gebrüder Müller in Bern das Glas, das sie für ihre Malereien verwendeten, in den Glashütten selbst zu. Es sei ganz verschieden von dem Glas, das die Pariser Fabriken lieferten. Denn Letzteres sei durch und durch gefärbtes Glas und wird aus dem Tiegel zu Fensterglas verarbeitet. Auf dieses Glas lasse sich «keine andere, noch hellere Dinte» auftragen, für die Glasmalerei sei es folglich unbrauchbar. Das Überfangglas hingegen sei nur auf einer Seite (rot, blau usw.) koloriert und wird von den Gebrüdern Müller wie folgt eingefärbt: *«Wenn in zwey besonderen Tiegeln der eine mit farbigem, der andere mit weißem Glas gefüllt, das Glas in seinem gehörigen Fluß ist, taucht der Arbeiter zuerst sein Blasrohr in die gefärbte hernach in die weiße Masse, bläset eine Kugel, und verfährt übrigens wie mit dem Fensterglase. Der innere Theil der Kugel wird dann ganz vom farbigen, der äußere vom weißen Glas gebildet [...]»*[1136]. Überlieferungen über individuelle Rezepte und Techniken bei der Glas- und Farbherstellung sind schon im Mittelalter bekannt; oft wurden sie nur mündlich tradiert, um geheim zu bleiben[1137].

Die Erwähnung eines Diamanten im Kapitel ‹Preis und Leistung› gibt Hinweise auf die in der Werkstatt Röttinger angewandten Methoden der Ritztechnik beziehungsweise der Schablonentechnik. Der Gebrauch von Schablonen wird im schriftlichen Nachlass mehrmals erwähnt[1138]. Friedrich Berbig notiert in seinem Lohnheft häufig das Zuschneiden von Schablonen, Medaillons, farbigen Gläsern oder Dessinscheiben[1139]. Dabei unterscheidet er zwischen Schablonen für die gemalten Architekturornamente und für das Zuschneiden der Figuren, Vorlagen aus Papier oder Pappe, die dem korrekten Ausschneiden der Glasstücke dien-

ten. Hartmut Scholz konstatiert bezüglich der Damastmuster bereits für das 15. Jahrhundert die Verwendung von Schablonen in den Nürnberger Werkstätten[1140] und verweist auf die Problematik der Zweit- und Drittausführungen dank arbeitstechnischer Verfahrensweisen, die sich aufgrund des Auftretens von Formelhaftigkeit und Schematismus nachweisen ließen[1141]. Die Arbeit mittels Schablonen ist ab zirka 1800 eine Standardmethode, bei der der Glasmaler die jeweilige Schablone auf eine sorgfältig ausgesuchte Stelle im Glas legte. Mit Hilfe des Diamanten wurde das Glas entlang der Kanten der Vorlage geschnitten[1142], was, wie auch bei der Verwendung eines Trenneisens, glatte Schnittränder ergab[1143]. Sebastian Strobl erwähnt, dass bis zum Ende des 19. Jahrhunderts die Ritztechnik schließlich soweit ausgearbeitet gewesen sei, dass die meisten Modellzuschnitte im Diamantschnitt möglich waren. Bei besonders komplizierten Umrisslinien griff man jedoch weiterhin auf das Trenneisen (Krösel- oder Rieseleisen)[1144] zurück. Darüber hinaus kamen Diamanten für das Einritzen eines Motivs in Überfangglas zum Einsatz, bevor dieses in einem weiteren Arbeitsgang ausgeschliffen wurde. Seit

1134 Zum Begriff *Tiegel*: PARELLO, 2009, S. 120 Anm. 19: In einem 1910 verfassten Prospekt der Firma Merzweiler & Jennes in Freiburg im Breisgau heißt es: «[...] Bei Kirchenfenstern verwenden wir nur in Tigel gefärbtes Glas und Silbergelb; außer Eisenrot keine Schmelzfarben, wie es die richtige Technik der Glasmalerei bedingt, um unbegrenzte Haltbarkeit der Farben zu erzielen. [...]» (Augustinerbibliothek).

1135 ZB Nachl. Röttinger 2.371, 21 Moutier/ Chatelain 1875.

1136 Morgenblatt für gebildete Stände, 1826, S. 244.

1137 TRÜMPLER, 2002 (2), S. 41.

1138 Als Beispiel: ZB Nachl. Röttinger 1.202.84 o. J. Fintersee/kath. Kirche, Sankt Karl Borromäus.

1139 ZB Nachl. Röttinger 1.208, 1.209.

1140 SCHOLZ, 1991, S. 281.

1141 SCHOLZ, 1991, S. 134 ff.

1142 STROBL, 1999, S. 87 f.; STROBL, 1990, S. 12 ff. mit Abbildungen auf S. 12 und 14.

1143 TRÜMPLER, 2002 (2), S. 46 f.; FROMBERG, 1844, S. 132 ff.

1144 FROMBERG, 1844, S. 132: Der Zeitgenosse Röttingers erwähnt die Methode des Einschneidens mittels Diamant und die Weiterführung des die Glasflächen trennenden Schnittes mit einer angezündeten Sprengkohle.

etwa 1430 kannte man zumindest im Ulmer Werkstattkreis neben der Methode des Ausschleifens auch Ätzverfahren mit Salpeter- oder Salzsäure; seit dem 17. Jahrhundert wird Flusssäure verwendet[1145], um die Überfangschicht zu entfernen. Indessen ist nicht gesichert, wie Vertiefungen erzeugt wurden. Es ist möglich die Glasoberfläche mit Steinen – Bergkristall, Diamant oder Silikaten – zu bearbeiten, auch Schmirgel ist bekannt sowie die punktuelle Verwendung eines Drillbohrers[1146].

Farben und Maltechnik

In der Einleitung des Restaurierungsbefundes des Glasgemäldes «Anbetung der Hirten» (Abb. 144) in Pieterlen[1147] findet sich eine Beschreibung der Maltechnik Johann Jakob Röttingers von den Expertinnen, die mit der Restauration der wiedergefundenen Glasmalereien betraut waren. Anhand dieses Berichts sollen im folgenden Kapitel Merkmale der Arbeitsweise der Werkstatt Röttinger sowohl mit Quellen des verwendeten Materials als auch mit Ergebnissen der Forschung in Beziehung gesetzt werden. Die zur Herstellung der Glasmalereien benötigten Schmelz- und Emailfarben bezog Johann Jakob Röttinger gemäß einem Eintrag in der Buchhaltung aus dem Jahre 1868 bei der Thüringer Firma Elias Greiner: «Greiner Vettersohn, Lauscha: 10 Schwarz, 10 Weiß bestellt»[1148]. Da in den Quellen die Anwendung der Farben in der Werkstatt Röttinger nicht weiter erwähnt wird, soll der Gebrauch der beiden Farben Schwarz und Weiß und deren Angebot bei Elias Greiner eine kurze Darstellung finden. Friedrich Jaennicke erörtert die Charakteristika der Farben, bei der Farbe Weiß unterscheidet er zwischen Deckfarbe (Email) und Mattfarbe. Die Deckfarbe, die häufig für Stoffe und Pelze und in der Heraldik für Silber meist damasziert eingesetzt wurde, sei darüber hinaus wegen ihrer Kontrastwirkung – idealerweise in sparsamem Gebrauch – gerne verwendet worden. Jaennicke bespricht Greiners Mattweiß Nr. 00 (für 24 Pfennige)[1149], das bei dickerem Auftrag ins Graubräunliche gehe, Nr. 0 noch mehr in Richtung braun. Das Auftragen, Vertreiben und

Radieren von Mattweiß erfolgt erst für den dritten Brand und gibt – über andere Farben gelegt – diesen größere Kraft und Tiefe[1150]. Schwarz kommt in der Glasmalerei am häufigsten zur Anwendung, als Umrisslinien, zur Modellierung und Schattierung – zu diesem Zweck stets mit Terpentin angerieben, als Lasurfarbe mit einem mehr oder weniger hohen Grad der Verdünnung. Beschriftungen werden ebenfalls zumeist mit Schwarz wiedergegeben, deren Wirkung kann auf weißem oder gelbem Glas durch «Ausschablonierung in schwarzem Grund» gesteigert werden. Die Beigabe von Kupferoxid und verschiedenster Gemenge erzielt zudem unterschiedlichste Nuancen, durch Zusatz von Glasfluss kann selbst Mattschwarz in Grau übergeführt werden[1151]. Aus dem Farbenangebot Greiners hebt Jaennicke das «strengflüssige Schattierschwarz C XXV» (für 34 Pfennige) hervor und dessen «Mattschwarz E 28» (für 20 Pfennige) als hübsches Blauschwarz. In Melchior Boisserées Nachlass wurden zahlreiche Notizen über die zeitgenössische Glasmalereitechnik überliefert, das Herrichten der Glasplatten, der Malvorgang selbst, die dabei angewandte Methode der Aquarellmalerei, vom Gebrauch der Pinsel und Radiernadeln,

1145 VAASSEN, 1983, S. 24.; SCHOLZ/HESS, 1999, S. 19 ff.: Die Flusssäure sei um 1670/75 vom Nürnberger Glasschneider, Heinrich Schwanhardt, entdeckt worden.

1146 TRÜMPLER, 2002 (2), S. 45. Zur Auffindung der Glasmalereien in Pieterlen vgl. ‹Vorwort und Dank›.

1147 GYSIN/REHBERG, 2003, o. p.; vgl. RAUSCHER, 2008, S. 68 f.

1148 ZB Nachl. Röttinger, 1.206. BRÜCKNER, 1853, S. 472 ff.: Die Firma Elias Greiner-Vetters-Sohn erzeugte Farben für die Glas- und Porzellanmalerei. Elias Greiner (genannt Vetters Sohn) begründete nach langem Suchen und Tüfteln die noch heute bestehende Farbglashütte (Seppenhütte). JAENNICKE, 1898, S. 301: Abb. eines Inserates der Firma Elias Greiner Vetters Sohn Lauscha (in Thüringen): «Schmelzfarben, Lustres, Emails und Metalloxyde für Porzellan-, Glas-, Email- und Thonwaren offeriert in anerkannter Güte zu den billigsten Preisen». KÜHNERT, 1973, S. 394–395, Auflistung der Vater-Stammreihe aus dem Greinerschen Geschlecht.

1149 JAENNICKE, 1898, S. 99: Die Preise der Farben beziehen sich auf je 10 Gramm.

1150 JAENNICKE, 1898, S. 100 f.

1151 JAENNICKE, 1898, S. 101 ff.

welche Farben auf Vorder- und/oder Rückseite der Glasplatten aufzutragen sind, welche davon eines Zwischenbrands bedürfen, das Anreiben der Farben mit verschiedenen Ölen beziehungsweise mit Gummiarabicum, die Veränderung der Farben beim Brand, um nur die wichtigsten Punkte zu nennen[1152]. Die Glasmalereien aus der Zeit Röttingers sind zumindest bis in die Sechzigerjahre durch so genannte Farbwerte entstanden. Wie bei der zeitgleichen Ölmalerei baute man die Farben durch Übereinanderlagerung und Schraffuren Schicht für Schicht auf, bis der gewünschte Effekt erzielt wurde. Die Beigabe von verschiedenen Bindemitteln erlaubte das Übereinanderlegen einzelner Farbtöne ohne Zwischenbrand. Die Mattierung der Rückseiten ließ die bemalten Glasflächen als transluzides Porzellan erscheinen[1153]. Die Autorinnen des Restaurierungsbefundes stellen der Arbeitsweise Röttingers insgesamt ein gutes Zeugnis aus, sei doch die Malerei differenziert, fein und mit äußerst hochstehender Technik professionell gefertigt. Kontur und Überzugsfarbe seien mit feinen Schraffuren überarbeitet, so dass die räumliche, dreidimensionale Wirkung des Dargestellten zur Geltung komme. Die Farbgebung zeige neben farbig geblasenem Antikglas auch gekonnt eingesetzte Emailfarben. Dabei sind Auftragsfarben wie Silbergelb und Jean Cousin, eine rosa-bräunliche Hautfarbe, die heute nicht mehr erhältlich ist[1154], sowie gelbe, blaue und rote Emailfarbe verwendet worden. Diese Farben wurden mit Wasser angerührt und entweder mit einem Dachshaarpinsel auf der Glasoberfläche vertrieben oder aber – um größere Intensität und Farbdichte zu erreichen – an den gewünschten Orten wässrig aufgetragen beziehungsweise wurden Farbpigmente durch leichtes Klopfen an den Glasstückrand gleichmäßig verteilt[1155]. Die Malerei ist in mehreren Schritten aufgebracht und eingebrannt worden. Schließlich nennen die Restauratorinnen Beispiele von weißen Glasstücken, die mit Glasmalfarben überarbeitet worden sind: Stalldach, Holzboden, Gesichter, Hände, Jesuskind, Himmel, Rundbogenarchitektur oder der Mantel von Joseph. Diese Schilderung der in Röttingers Atelier traditionellen

Malweise entspricht der von Peter van Treeck formulierten Beschreibung eines üblichen Aufbaus einer Glasmalerei. In den ersten beiden Dritteln des 19. Jahrhunderts bestimmten demnach halbtransparente, verschiedenfarbige Malflüssigkeiten, die als Überzug, Lavierung oder Lasur beziehungsweise als feine Schraffierung eingesetzt wurden, die Glasmalerei bis in die Siebzigerjahre. Bis zu sechs Schichten konnten übereinander beziehungsweise ineinander liegen. Die additive Malweise, die hauptsächlich mit dem Pinsel ausgeführt wurde, stand im Gegensatz zur späteren «Negativ-Technik», bei der Farbschichten zur Aufhellung des Glasgemäldes entfernt wurden. Inkarnat, Engelsflügel (beispielsweise auf Abb. 40 ersichtlich) und Landschaften zeigten besonders ausgeprägte Nuancierungen – ihr Farbaufbau geschah meist auf weißem Glas mit creme- und rosafarbenen bis ins grünliche und violett übergehende Schattierungen, die der Malerei die porzellanhafte Dichte verliehen[1156]. Die häufige Erwähnung von «gebrannter Glasmalerei» in den Verträgen hatte wohl damit zu tun, dass bei zu niedriger Hitze im Brennofen das Farbmaterial nicht dauerhaft auf der Glasoberfläche haftete[1157]. «[...] und namentlich die Bilder in gut gebranntem und mit gehörigen Farbmischungen versehenem Glas [...]» kunstgerecht auszuführen, war in vielen Kontrakten eine Forderung, so auch in der Kirchgemeinde in Leuggern[1158]. Im Restaurationsbericht von Pieterlen wird bemerkt, dass die

1152 VAASSEN, 1983, S. 24.

1153 VAASSEN, 2007, S. 40 ff.

1154 KUNSTBLATT, 1823, Nr. 81, S. 321 f.: Jean Cousin († nach 1589), französischer Maler, Entwerfer von Glasmalereien. Zur sehr schwierig herzustellenden Farbe mit Eisenrot (sanguine) vgl. VAASSEN, 2013, S. 34, Anm. 88–92.

1155 GYSIN/REHBERG, 2003, o.p.: Im Spitzbogen konstatierten die Restauratorinnen schuppenartiges Abblättern der Konturfarbe, was kleine offene, weiß leuchtende Stellen hinterließ – dort, wo die Farbe am dichtesten aufgetragen wurde. Als Ursache vermuteten sie den zu früh stattgefundenen Auftrag der frisch angerührten Farbe, die noch Luftbläschen enthielt.

1156 VAN TREECK, 1993, S. 31 ff., eine aktuelle Zusammenfassung der Erkenntnisse in: Vaassen, 2013, S. 357/358.

1157 STROBL, 1999, S. 15.

1158 ZB Nachl. Röttinger 1.83.

Jean-Cousin-Farbe an einigen Stellen nicht kratz-fest sei, was auf einen ungenügenden Brand hin-weise. Die Farbe ist auf der Rückseite aufgetragen und daher auf der Außenseite dem Wetter ausge-setzt, was zu einem flockigen Erscheinungsbild des Inkarnats führte. Das Einbrennen der Glas-malereien ist ein entscheidender Schritt in der Arbeitskette und erscheint in Anbetracht der technischen Möglichkeiten als schwieriges Unter-fangen. Neben dem Umgang mit den Farben ge-hörte die Schichtung der Gläser innerhalb des Ofens, die Beurteilung der Temperatur und das dosierte Aufheizen und Abkühlen zu den wich-tigsten professionellen Kenntnissen der Glasmaler – Informationen, die sich unter Berufskollegen von Generation zu Generation tradiert hatten[1159]. Im ausgehenden Mittelalter war es üblich Farben auf Öl-Basis ebenso kalt aufzutragen. Es handelte sich um grünliche, gelblich-grüne und bräunliche Töne. Das Problem schien damals weniger die Haltbarkeit als vielmehr die fehlende Transparenz zu sein[1160]. Kalt aufgetragene Farben wurden auch immer wieder auf unbemalten Glasrückseiten zur Retusche eingesetzt[1161]. Johann Jakob Röttinger ergänzte auf den Geschlechterscheiben der Fried-hofkapelle Schwyz später aufgetragene Namens-züge mit Kaltfarbe. Er verwendete dafür Ölfarbe oder Schwarzlot und brachte die Schrift ohne Brand auf die vorbereiteten, auf Glas gemalten Schriftrollen auf (Abb. 126). Optisch ist der Auf-trag von Kaltfarbe auf der Rückseite der Scheiben erkennbar.

Blei, Zinn und Ölkitt

Nahezu in jedem Akkord wird der Glasmaler an die Forderung der Auftraggeber erinnert, die Blei-ruten von beiden Seiten sorgfältig zu verzinnen. Peter van Treeck weist darauf hin, dass dies mit der Stabilisierung der Felder begründet wird, ob-wohl deren Wirkung vom physikalischen Stand-punkt her zweifelhaft sei und favorisiert daher eher den ästhetischen Aspekt des Vorgehens[1162]. Johann Jakob Röttinger beantwortete in einem Brief an Architekt Kunkler verschiedene offene Fragen

bezüglich der Neuverglasung im Museumsgebäu-de Sankt Gallen. Als besonderen Hinweis fügt er hinzu: *«Noch bemerke daß die Scheiben mit ganz guten Löthzinn verbleiet werden müßen um das Schwarzwerden der Bleie möglichst weit hinaus zu schieben»*[1163]. Der Erfahrungswert des Meisters klingt überzeugend, hat er doch diese Prozesse seit Jahrzehnten beob-achten können. Stefan Mathies, Kunstglaser in Sankt Gallen, erklärte aus der Sicht des Praktikers die Anwendung der Verzinnung mit dem Phäno-men der vergleichsweise geringeren Oxydation des Zinns und der damit einhergehenden Verzögerung der Schwarzfärbung des Bleis. Wenn das Blei punktuell mit Zinn belegt sei, man nennt dies *punkten* oder *knöpfeln*, breche es an der Lötstelle im Übergang vom verzinnten zum nicht verzinnten Teil. Ein durchgehender Überzug des Bleis mit Zinn kann die Stabilität verbessern. Der Zinnge-halt des Bleis betrage meist 2–3 Prozent, je höher der Anteil, desto härter ist das Blei, was sich schließlich auf die Beständigkeit auswirke. Stark gebogene Bleiruten für die figürliche Glasmalerei sollen weicher, das heißt mit weniger Zinn ange-reichert sein[1164]. Die Analyse eines Bleirutenstü-ckes aus der ehemaligen, von Ferdinand Stadler 1867 erbauten reformierten Stadtkirche in Solo-thurn, deren Glasmalereien aus der Werkstatt Röttinger stammten, ergab einen Zinnanteil von 3.3 Prozent sowie Spuren von Kupfer und Anti-mon[1165]. Das gerade Bleistück mit dem hohen Zinnanteil – im Verbund als elastisches Bleinetz die Glasteile zusammenhaltend – wurde demnach

1159 TRÜMPLER, 2002 (2), S. 56.
1160 TRÜMPLER, 2002 (2), S. 55 f.
1161 VAN TREECK, 1993, S. 37 f.
1162 VAN TREECK, 2007, S. 185.
1163 ZB Nachl. Röttinger 2.371, 106 Sankt Gallen/ Kunkler 1876.
1164 Dank einer freundlichen Mitteilung von Stefan Mathies, Atelier für Kunstglaserei und Glasmalerei, Mathies & Co, Sankt Gallen.
1165 Das Bleistück aus der reformierten Stadtkirche Solothurn wurde mir freundlicherweise vom Sigrist Heinz Däppen zur Verfügung gestellt. Die Analyse führte Christian Droz (Chemiker) in Sankt Gallen aus, wofür ich herzlich danke.

seiner ursprünglichen Aufgabe gerecht, gemeinsam mit den Windstangen die Stabilität des Fensters zu gewährleisten. Im Restaurierungsbericht der Glasmalereien von Pieterlen[1166] sprachen die Restauratorinnen der Verbleiung des untersuchten Fensters einen stabilen Zustand zu, obwohl die waagrechte Faltung in der Mitte des Glasfeldes einem enormen Druck ausgesetzt war. Das Blei an sich sei hart und weise an den intakten Stellen fast keine Risse auf. Das gesamte Bleinetz sei durchgehend punktverlötet, wobei man 6.5–7 mm starkes Blei mit einem 3 mm-Kern verwendet habe. Im Nachlass hat sich eine Quittung aus dem Jahr 1876 erhalten, in welcher Joh. Fretz die Bezahlung von Zinn und Blei durch Johann Jakob Röttinger bestätigt. Für ein Pfund Zinn mussten 1.22 Franken bezahlt werden, 1 Pfund altes Blei kostete 24 Cts und Teller-Zinn per Pfund 90 Cts[1167]. In manchen Fällen wurde dem Glasmaler das Blei, das beim Ausbau von alten Fenstern anfiel, zur Verfügung gestellt und vertraglich festgehalten[1168]. Das Altblei konnte recycelt, das heißt eingeschmolzen und der Wiederverwendung zugeführt werden. Häufig wird in den Verträgen bemerkt, dass die Scheiben mit gutem Ölkitt eingesetzt werden müssten, was einem Pleonasmus gleichkommt, da Kitt aus Teilen Kreidemehl und Leinöl besteht. Ohne Öl als Bindemittel würde keine Paste entstehen; alter Kitt, dessen Ölanteil verloren gegangen ist, zerbröckelt[1169]. Das untersuchte Fenster in Pieterlen wies eine sehr harte Verkittung auf. Die Restauratorinnen vermuteten die Beifügung von Menninge[1170], was den Kitt rot färbt und die Verbindung von Kitt und Blei fördert. Ihre Annahme, rötliche Kittmasse sei kein reines Gemisch aus Leinöl und Kreide, ergab sich aus der Feststellung einer ungewöhnlichen Körnigkeit, die bei der Entfernung der Verkittung zutage getreten war. Aus den Quellen geht hervor, dass Röttinger die Rohstoffe bei einem Händler namens Kaufmann in Zürich bezogen hatte und 1866 für *«rohes Leinöl, gekochtes Leinöl, Kreide 38.55 fr.»* bezahlte[1171].

Vermessen und Montage, Windstangen und Gitter

Die Forderung, das Vermessen der Lichtöffnung sei Sache des Unternehmers, ist gut nachvollziehbar. Der *«[…] Übernehmer hat die genauen Masse am Baue selbst zu nehmen, die Construktion dauerhaft zu veranstalten, so dass Wasser- noch Wind-Beschädigungen eintreten können […]»*[1172]. Doch gab es offenbar Ausnahmen, wie für die Kirche in Oberbüren, wo Johann Jakob Röttinger Pfarrer Germann bittet, die Öffnung der Fenster von Papier ausschneiden zu lassen, damit er das Glas danach anfertigen könne[1173]. So genannte Windstangen, die seitlich verankert waren, hatten die Aufgabe die Fenster bei Wind und Sturm vor Bruch zu schützen, indem sie das elastische Bleinetz stabilisierten. Die Fenster wurden durch kräftige, waagrecht angebrachte Eisenstäbe in meist regelmäßigen Abständen untergliedert. Die Glasfelder lagen auf kleinen Trageisen auf, die auf den Querstangen montiert waren. Festgehalten wurden sie mittels flacher, mit Splinten an den Trageisen befestigten Eisenschienen[1174]. Im 19. Jahrhundert wurde die Befestigung der Windstangen am Glasfeld bevorzugt mit Hilfe von Bleischnecken bewerkstelligt, wobei die Bleihafte zur Schnecke gedreht und verlötet wurde. Franz Joseph Sauterleute wandte an den Gruftfenstern in Regensburg eine andere Methode an, er bog die Windstangen, um sie entlang der Bleiruten zu führen (Abb. 143) und sie vom Kircheninneren

1166 Vgl. Anm. 1147.

1167 ZB Nachl. Röttinger 1.46. Die Abkürzung cts [ct] steht für Centime und entsprach damals einem Hundertstel des Franken.

1168 ZB Nachl. Röttinger 2.371, 60 Zeiningen/Kirche 1876.

1169 Freundliche Mitteilung von Stefan Mathies (s.o.).

1170 Zu Mennige: Im Vertrag mit Kilchberg (ZB Nachl. Röttinger 1.77) wird verlangt, dass *«ein Drahtgitter vor dieses Fenster mit eisernem Rahmen und mit Minien und Ölfarbe angestrichen, […]»* eingesetzt wird. *Minien* steht für Mennige oder Blei(II)-orthoplumbat, lat. *minium*. Es wurde zusammen mit Leinöl als Rostschutz verwendet.

1171 ZB Nachl. Röttinger 1.206, S. 47.

1172 KGA Leuggern: K III 2 4: Kirchenvorstand: Akten des Kirchenbaues 1838–1855, Band 2: Nr. 382, Verträge & Rechnung über die Glasmalerei & Fensterarbeiten.

1173 ZB Nachl. Röttinger 2.371, 96 Oberbüren/Germann 1876.

1174 TRÜMPLER, 2002 (2), S. 59.

143. Franz J. Sauterleute, Detail Windeisen,
Fenster der Gruftkapelle Thurn und Taxis,
Regensburg, 1837–1843.

aus praktisch unsichtbar zu machen. Die Gitter hingegen sollten das Glas vor größeren Hagelkörnern abschirmen. Trotzdem erlitten Fenster immer wieder Sturm- und Hagelschäden, wie die Korrespondenz zeigt[1175]. Johann Jakob Röttinger wies wiederholt darauf hin, dass das Einsetzen der Fenster gegen Ende der Bauzeit zu erfolgen hatte: *«Mein Arbeiter wird sobald die Eisen bei Ihnen angelangt sind bei Ihnen eintreffen nur die nöthige Anleitung zum Setzen der Stäbe geben und im Falle daß die Fenster jetzt schon gesetzt werden können dieses thun oder erst wenn dieses nicht gerade nöthig sein sollte, erst nach seiner Rückkunft von Mümliswyl dieses besorgen, die Fenster kommen sofort, sobald die Eisen gesetzt sind, Muster der Gitter bringe selbst mit»*[1176]. Ebenfalls an Herrn Glutz in Olten geht die Mitteilung: *«Glaube jedoch im Inderesse [sic!] der Arbeit die Bemerkung beifügen zu sollen daß das Einsetzen der Fenster erst dann zu geschehen hätte wen [sic!] der Verputz der Kirche sowohl von Innen als auch von Außen vollendet ist»*[1177]. Bezüglich der Montage bewährte es sich seit Jahrhunderten die Fenster mittels eines «mageren» Mörtels direkt in den Stein einzubauen. Die Fenstergewände wurden zu diesem Zweck mit Falzen beziehungsweise Rillen versehen, in die die Scheiben mittels des porösen Mörtels eingepasst wurden, jener ließ sich bei Bedarf wieder gut entfernen. Unbemalte Randstreifen leisteten dabei oft gute Dienste als Pufferzone[1178]. Der Falz der einzelnen Fenster war jeweils

im Auftrags- beziehungsweise Skizzenbuch exakt vermerkt und betrug in den meisten Fällen zwischen 3''' und 1''2'''[1179], häufig mit der Bemerkung, dass die Maße im Falz gemessen seien. In seltenen Fällen hatten die Auftraggeber derart genaue Vorstellungen von der Montage der Fenster, wie dies für die Sankt Galler Laurenzenkirche belegt ist: *«Überall wo zwei Rahmen aufeinander zu stehen kommen, müssen die Fugen derselben und der in den Stein eingelassene Fensterstab nach Zeichnung mit einem Bleistreifen abgedeckt werden. Bei den Maßwerköffnungen und den Giebelplatten ist das Glas nur in den Kittfalz zu setzen und längs demselben dauerhaft zu verkitten. Alle Scheiben, die in Folge unzweckmäßiger Fassung oder Einsetzung*

1175 Sturm: ZB Nachl. Röttinger 2.371, 28 Dorf/ Knecht 1875; ZB Nachl. Röttinger 2.371, 65 Dessenheim/ Bgm. Meyer 1876; ZB Nachl. Röttinger 2.371, 141 Oberrüti/ Stammler 1876; Hagel: ZB Nachl. Röttinger 2.371, 151 Bischofszell/Zündeler 1876; ZB Nachl. Röttinger 2.371, 215 Sankt Gallen/Gitterstricker Vogel 1876.

1176 ZB Nachl. Röttinger 2.371, 124 Olten/Glutz 1876.

1177 ZB Nachl. Röttinger 2.371, 90 Olten/Glutz 1876. Solche Bemerkungen waren wichtig, um die Ungeduld der Bauherren zu mildern und möglichen Konventionalstrafen vorzubeugen. Der Verzicht auf Teilbeträge der Akkordsumme war schmerzhaft und musste wenn möglich vermieden werden, vor allem, wenn die Verzögerung am Bau nicht selbstverschuldet war, sondern an der mangelnden Koordination der Bauleitung lag.

1178 TRÜMPLER, 2002 (2), S. 59.

1179 Zwischen 3 Linien und 1 Zoll und 2 Linien.

zerspringen, hat der Übernehmer durch andere zu ersetzen»[1180]. Für das Schlagen der Löcher, eine Arbeit, die für das Einbringen der Quereisen notwendig war, musste der Bauherr einen Steinhauer zur Verfügung stellen. War kein Steinhauer vor Ort, griff der Monteur des Fensters selbst zum Werkzeug und stellte diese Leistung separat in Rechnung: «*Für Schlagen der Dübellöcher, welche in Ermangelung eines Steinhauers durch den Arbeiter von mir gemacht werden mussten, 3 Tage 9.50 Franken*»[1181]. Zur Belüftung der Gebäude waren Luftflügel zu montieren, die mit Scharnieren und Riegel beziehungsweise Schließkolben ausgestattet entweder nach rechts oder nach links zu öffnen waren. Um eine ausreichende Luftzirkulation zu gewährleisten wurden die Öffnungen bevorzugt in gegenüberliegende Fenster eingebaut[1182].

Materialbezogene Qualitätslabels waren im 19. Jahrhundert Usus. In Zeiten der Industrialisierung und damit verbundenen Innovationen stachen immer wieder einzelne Produkte in verschiedenen Ländern hervor, deren Wetteifer durch eine meist zeitlich begrenzte Bezeichnung ihrer Herkunft belohnt wurde[1183].

In Dietikon wünschte der Bauherr französisches Eisen und englisches Blei. Letztere waren schwere klobige Bleiprofile mit halbrundem bis rundem Querschnitt. Der Vorteil lag vor allem in der längeren Haltbarkeit des in England hergestellten Bleis[1184]. In Rafz bestellte man «*bestes englisches Eisen*»; hier verrät das Adjektiv bereits, dass es sich um ein Gütesiegel handeln musste. Darüber hinaus war französisches Zinn im Angebot, das man beispielsweise in den Pfarrkirchen zu Ossingen und Dietikon zu verwenden gedachte[1185]. Peter van Treeck zitiert im Kongressband von Namur nach Nicole Blondel, «Vitrail. Vocabulaire typologique et technique», Paris 1993: «[…] Le catalogue récent d'une manufacture des plombs belge présente des plombs à revêtements divers […]»[1186]. Solche Herkunftsbezeichnungen haben meist eine beschränkte Zeit Gültigkeit, dann ändert sich die Qualität oder ein Produkt wird unmodern[1187].

Kunst – Kunsthandwerk, Restaurierung

Von vielen Kunsthistorikern noch immer als Randgebiet der Kunstgeschichte herabgewürdigt und als Spezialgebiet für Anhänger des Kunstgewerbes deklariert, ist die Diskussion noch lange nicht abgeschlossen, ob es sich bei der Glasmalerei um freie Kunst handle oder um die Herstellung getreuer Kopien aus künstlerischer Hand stammender Kartons. Seit der Gründung des «Corpus Vitrearum Medii Aevi» im Jahr 1952 hat es sich die internationale Organisation zur Aufgabe gemacht durch Erforschung und Dokumentation der mittelalterlichen Glasmalereien, die Disziplin der «Malerei mit Glas» der Gattung der Monumentalmalerei zuzuordnen[1188]. Nachdem für die mittelalterlichen Glasmaler die klassische Arbeitsteilung des 19. Jahrhunderts – zwischen Zeichnern der Kartons und Herstellern der Glasmalereien – quellenmäßig nicht nachweisbar ist, muss einerseits von einer Situation des freien Kunstwerks ausge-

1180 ZB Nachl. Röttinger 1.158.

1181 KGA Leuggern: K III 2 4: Kirchenvorstand: Akten des Kirchenbaues 1838–1855, Band 2: Nr. 287 bis 392 Belege der Kirchenbaurechnung, Nr. 382 Verträge und Rechnung über die Glasmalerei & Fensterarbeiten (Rechnung über Arbeiten, die nicht im Akkord enthalten sind).

1182 Eine Kirche in der Größe der Kirche Sankt Peter und Paul in Leuggern mit 10 großen Fenstern erhielt 6 Luftflügel.

1183 Z.Bsp. «Belgisches Glas» und «Französisches Glas», Bezeichnungen, die nicht nur ihre Herkunft angeben, vgl. Anm. 1117.

1184 Dank einer freundlichen Mitteilung von Fritz Dold, Glasmaler in Zürich.

1185 ZB Nachl. Röttinger 1.36, Dietikon/kath. Pfarrkirche; ZB Nachl. Röttinger 1.190, Wil bei Rafz/ U. Demuth; ZB Nachl. Röttinger 1.123, Ossingen/ref. Kirche.

1186 Van Treeck, 2007, S. 185.

1187 Herkunftsbezeichnungen als Qualitätsmerkmal haben sich bis heute erhalten: Aktuell soll deutsches Blei von guter Qualität sein.

1188 Vgl. Kurmann-Schwarz, 2010 (2), S. 231–441. Brigitte Kurmann-Schwarz erörterte in «Kreatives Kopieren und Paraphrasieren in der Glasmalerei des Mittelalters» diese Problematik und bezog darüber hinaus die Sichtweise über die Restaurationen und Neuschöpfungen des 19. Jahrhunderts mit ein.

gangen werden, andererseits verpflichteten Auftraggeber die Glasmaler bestimmte Vorlagen zeitgenössischer Künstler für die Kartons zu verwenden[1189]. Hartmut Scholz gelang es für die Zeit um 1500 bezüglich der Nürnberger Glasmalerei den Prozess der Entstehung nachzuweisen, von der ersten Skizze mit der Aufnahme von Wünschen des Auftraggebers über die Vorzeichnung zur Begutachtung bis zur maßstabgetreuen Reinzeichnung und des danach angefertigten, im Maßstab 1:1 hergestellten Kartons[1190]. Rolf Hasler erforschte die komplexe Funktion der frühneuzeitlichen Scheibenentwürfe in der Schweiz[1191]. Die größte Unsicherheit in der Anerkennung der Glasmalerei als künstlerische Tätigkeit scheint den Ablauf des Herstellungsprozesses zu betreffen, an dem immer mehrere Personen beteiligt gewesen waren. Brigitte Kurmann-Schwarz attestiert den mittelalterlichen und frühneuzeitlichen Glasmalern keinesfalls sklavisches Kopieren, sondern spricht von «Paraphrasieren», was den künstlerischen Freiraum für die Kreativität bei der Umsetzung und Gestaltung offenhält[1192]. Eine modifizierende Wiederverwendung einmal vorhandener Entwurfszeichnungen gehörte hingegen zur Werkstattpraxis der Glasmaler – nicht erst zu Dürers Zeiten, auch vorher (seit dem 12. Jahrhundert) und nachher war diese Vorgehensweise selbst bei namhaften Künstlern Usus[1193]. Für das 19. Jahrhundert, als die Glasmalerei noch als Kunst aus erster Hand empfunden wurde[1194], lässt sich die Mitarbeit mehrerer Hände im Prozess der Schaffung von Glasmalereien auf verschiedenen Ebenen nachweisen. War es in den großen Glasmalerei-Anstalten üblich, ein in der Münchner Porzellanmanufaktur erprobtes Schema der Klassifizierung von Mitarbeitern, im Sinne einer Spezialisierung für Teilgebiete, wie Schrift und Ornament, Draperien und der Malerei von Köpfen als höchste Disziplin auf die Glasmalerei zu übertragen[1195], wird in den kleineren Betrieben hauptsächlich nach der Berufsangehörigkeit unterschieden. Wie bereits im Kapitel ‹Mitarbeiter verschiedener Berufe, Künstler und deren Selbstverständnis› verdeutlicht, ließen sich in der Werkstatt Röttinger

aufgrund der überlieferten «gläsernen Schriftquellen» mit namentlichen Angaben der einzelnen Mitarbeiter lediglich zwei Berufsgruppen – Glaser und Maler – erkennen. Im Fotoalbum, das ehemalige Werkstattmitarbeiter zeigt, sind die Fotografien rückseitig mit Namen, Datum und Berufsbezeichnung versehen, das heißt hier wird zwischen Glasern, manchmal als Arbeiter bezeichnet, und Malern beziehungsweise Glasmalern unterschieden[1196]. Felix Bleuler und Christian Klaus erscheinen als Maler, Stephan Kellner als Maler und Glaser, Adolf Kreuzer und Jakob Kuhn als Glasmaler, Bräm, Sodberg, Erne, Schulze und Asmussen als Glasergesellen, Glaser oder Arbeiter. Aus dem Lohnheft Friedrich Berbigs geht hervor, dass dieser als Glasmaler im Atelier Röttinger einerseits Bleizeichnungen, Schablonen für Architekturen, «1 Johannes Baptist für Dessenheim» hergestellt, andererseits «für Bleuler zu 12 Aposteln das Weiß zugeschnitten», Fenster eingesetzt und daneben «mit Haas die Kisten zur Bahn gebracht» habe[1197]. Die Beispiele zeigen, dass in Werkstätten kleiner bis mittlerer Größe zwar eine professionelle Aufteilung vorlag,

1189 KURMANN-SCHWARZ, 2010 (2), S. 238.

1190 SCHOLZ, 1991, S. 1–15.

1191 HASLER, 1999, S. 40–46.

1192 KURMANN-SCHWARZ, 2010 (2), S. 231 bzw. 239.

1193 SCHOLZ, 2007, S. 81; KURMANN-SCHWARZ, 2010 (2), S. 235, bes. Anm. 30, die Autorin erörtert die Untersuchungen von Madeline Harrison Caviness in Reims (M. H. Caviness 1990, Sumptuous Arts in the Royal Abbeys of Reims and Braine, Princeton 1990).

1194 VAASSEN, 1983, S. 21, zitiert nach Herbert Rode: Im Museum war den Glasgemälden «ein eigenes Kabinett zugewiesen. Damals noch wurde Glasmalerei als Kunst aus erster Hand empfunden. Später rangierte sie fälschlicherweise unter Kunstgewerbe, so daß folgerichtig auch die Boisserée-Scheiben ins Kunstgewerbemuseum abwanderten, wo sie im Depot aufbewahrt wurden.»

1195 VAASSEN, 1993, S. 23; BEINES, 1979, S. 95: Als Charakteristika der Königlichen Glasmalereianstalt in München werden die der Ausbildung der Glasmaler vorangehende Wissensvermittlung in Tafelmalerei sowie das Prinzip der Spezialisierung angeführt, die nicht nur die Berufsgruppen unterschied, sondern auch die Fokussierung auf einzelne Bildelemente durch verschiedene Personen.

1196 ZB Nachl. Röttinger 1.1.4, vgl. Anm. 917.

1197 ZB Nachl. Röttinger 1.208, 1.209.

dass jedoch innerhalb der Berufsgruppen keine weiteren Hierarchien, im Sinne von Spezialisierungen auf Ornamente, Köpfe etc. existierten[1198]. Nachdem bis auf zwei signierte Zeichnungen und einige wenige zuschreibbare Blätter der graphische Nachlass aus der Zeit Johann Jakob Röttingers fehlt, was Vergleiche zwischen Vorzeichnungen, Kartons und Glasmalereien unmöglich macht, kann die «Beweisführung» – soweit vertretbar – nur über schriftliche Hinweise erfolgen. In der Werkstatt Röttinger ist demnach davon auszugehen, dass sich die beiden Maler, Felix Bleuler und Christian Klaus, ausschließlich für das graphische Metier verantwortlich zeichneten, dass jedoch die Glasmaler Berbig, Kreuzer, Kuhn, Kellner etc. sowie der Meister selbst ebenfalls Zeichnungen und Entwürfe anfertigten und daneben andere Tätigkeiten, wie das Übertragen auf Glas, Zuschneiden, Verbleien und Einsetzen der Fenster ausführten[1199]. Die schriftlich belegte zeitweilige Mitarbeit Melchior Paul Deschwandens entsprang wohl einerseits Auftraggeberwünschen, dort wo der Innerschweizer Maler auch Tafelgemälde zu schaffen hatte, andererseits trat dieser im Sinne einer freundschaftlich-respektvollen Kollegialität mit Johann Jakob Röttinger als «Supervisor» auf, wenn er Proportionsfehler von in der Werkstatt hergestellten Zeichnungen korrigierte und wiederum besonders gelungene Werke lobte und hervorhob[1200]. Angesichts der vielfältigen Aufgabenstellung der Glasmaler in den kleineren bis mittleren Betrieben, wo neben der Umsetzung von Kartons auch das Zeichnen von Entwürfen und Bleirissen gefordert war, ist durchaus von einer künstlerischen Tätigkeit der Glasmaler auszugehen. So kam die Glasmalereiwerkstatt Linnemann aus Frankfurt gänzlich ohne externen künstlerischen Beistand aus, indem sich Alexander Linnemann (1839–1902) und seine Söhne Rudolf und Otto konsequent für die Einheit von Künstler und Glasmaler einsetzten[1201]. Im Sinne der technischen Raffinesse und der Abwägung materialbedingter Machbarkeit darf bei der Umsetzung der Kartons in Glas und deren Bemalung keineswegs von unfreier Nachahmung gesprochen werden, sondern

es ist eine freie, sinngemäße Übertragung der Kartons in transluzide Gemälde mit schöpferischem Anspruch[1202]. Die Glasmaler zeichnete ein überaus großes technisches Wissen im handwerklichen Bereich aus, das mit der künstlerischen Betätigung untrennbar ineinandergriff. Friedrich Baudri vertrat 1864 die Meinung, dass je nach Arbeitsschritt, der Künstler auch Handwerker wie der Handwerker auch Künstler sein müsse[1203]. Kunstschaffenden wegen zusätzlicher Kompetenzen im handwerklich-technischen Bereich die künstlerisch-kreative Meisterschaft abzusprechen, ist nicht vertretbar. Diese Erkenntnis verdeutlichte Paul Frankl bereits im Jahr 1911: «[…] Die technischen Bedingungen spielen keine so wesentliche Rolle, daß Glasmalerei und Malerei zu zwei verschiedenen Dingen würden […]»[1204]. Franz Joseph Sauterleute wandte 1837–1840 bei der Herstellung der Glasmalereien in der Gruftkirche derer von Thurn

1198 Mit einer Ausnahme in ZB Nachl. Röttinger 1.18: In diesem Brief an J. Röttinger bezeichnet Friedrich Berbig den Mitarbeiter Thym (Glaser) despektierlich als *Schneider*, was sich vermutlich auf dessen hauptsächliche Aufgabe des Zuschneidens bezog.

1199 VAN TREECK, 2007, S. 180, zitiert nach E.O. FROMBERG, 1844, Handbuch der Glasmalerei, Quedlinburg-Leipzig 1844, S. 125, der 1844 die Handhabung der provisorischen Verbindung der Glasstücke mit Blei, der Anwendung von Wachs gegenüberstellt: «[…] Außerdem ist der teurere Preis der Verbleiung nur illusorisch, wenn es der Maler selbst ist, der die Stücke durch Wachse befestigt; denn der Wert seiner Zeit ersetzt mehr als reichlich die Kosten der Verbleiung, weil letztere durch einen Glaser ausgeführt wird, der nur die Enden der Bleistreifen zusammenlötet.» Dass Johann Jakob Röttinger vermutlich neben der künstlerischen Tätigkeit mit Akquisition, Arbeitsbesuchen und Administration zusätzlich belastet war und in einem kleineren Betrieb auch berufsübergreifend aushalf, nicht zuletzt aus ökonomischen Gründen, muss innerhalb der Arbeitsgemeinschaft als Selbstverständlichkeit gesehen werden.

1200 Vgl. Anm. 926.

1201 SCHÜPKE, 2009, S. 132.

1202 KURMANN-SCHWARZ, 2010 (2), S. 238 f.

1203 PARELLO, 2003, S. 173 zitiert nach Friedrich Baudri, Organ für christliche Kunst 14, 1864, S. 278.

1204 WENTZEL, 1949, S. 53 zitiert nach Paul Frankl, Beiträge zur Geschichte der süddeutschen Glasmalerei im 15. Jahrhundert, Straßburg 1911.

und Taxis die Technik der interimsmäßigen Verbleiung an. Für dieses Vorhaben wählte er den Zeitpunkt nach dem Auftragen der ersten Farbüberzüge, um die Schattierungen mit Schwarz- und Braunlotfarbe im provisorisch verbleiten Zustand anzubringen. Die Methode, die auch andernorts zur Anwendung kam, lässt auf eine sehr freie Bemalung der Architektur- und Gewandteile schließen[1205]. Peter van Treeck erklärt diese Herangehensweise mit der besonderen Art der Bildentwicklung um die Jahrhundertmitte, bei der der Künstler – [und das ist der Glasmaler!] – die zu visualisierenden, substanziellen und organischen Formen aus den Malschichten herausentwickelte, was das starre Festhalten an der Zeichnung und das Arbeiten von der Kontur her ausschließt[1206]. Vielschichtig und kreativ umschreibt Peter van Treeck die komplexe Kunstform der Glasmalerei bis etwa 1880 mit einigen Ausläufern. In der darauffolgenden Zeit hat sich eine stereotype Praktik mit betont technischem Akzent durchgesetzt – ein Bruch, der schon den Zeitgenossen unangenehm aufgefallen war[1207]. Die Optimierung der Produktions- und Vertriebsbedingungen im Bereich der christlichen Kunst – massenhaft hergestellte Öldrucke und Gipsfiguren – hat auch vor Kunstgattungen wie der Holz- und Steinskulptur und der Glasmalerei nicht Halt gemacht[1208]. Insofern zog dieser Trend weittragende Folgen nach sich, indem er die Mitschuld an der Diskussion der fraglichen Akzeptanz der Glasmalerei des 19. Jahrhunderts als Zweig der Monumentalmalerei trägt. So drängten in der zweiten Jahrhunderthälfte Glasmalereiwerkstätten auf den Markt, die auf eine möglichst rasche Erweiterung des Betriebs und vor allem auf gewinnsteigernde Produktionsweisen abzielten. Heinrich Oidtmann[1209], als Chemiker und Arzt einer pragmatisch-technischen Orientierung verschrieben, suchte nach preisgünstigen technischen Herstellungsmethoden und entwickelte das Verfahren des Glassteindrucks, einer fabrikmäßigen Anfertigung von Glasmosaikteppichen sowie den Glaslichtdruck, um den «Entwurf des Künstlers unverfälscht auf das Glas» zu übertragen[1210]. So darf es nicht wundern, wenn die pauschalisierende

Kritik die Erzeugnisse der Glasmalerei als unschöpferische, industrielle Kunst[1211] abtat und der Faksimilierung beschuldigte, statt zwischen künstlerischem Schaffen und fabrikmäßiger Herstellung von Glasmalerei zu differenzieren.

Weitere Gründe für die Angriffe auf das Metier der Glasmaler im 19. Jahrhundert sind bisweilen unsachgemäß vorgenommene Ausbesserungen an Schäden wie auch Restaurierungen, die häufig in Unkenntnis der in Vergessenheit geratenen alten Technik der Glasmalereien unschöne Spuren oder gar Zerstörungen hinterließen. Daniel Parello spricht bezüglich der Rolle Heinrich Helmles als Restaurator von «Restaurierungsvandalismus», als dieser noch vorhandene Braunlotzeichnungen der Freiburger Chorkapellenfenster zuerst kopierte, danach mit radikalen Reinigungsmaßnahmen auslöschte und das Glas neu bemalte[1212]. Mit der Sammeltätigkeit und der Konservierung überkommener Glasmalereien kam der Wunsch auf, die Verkrustungen, Korrosionen und Fehlstellen zu beseitigen, was häufig mit aus heutiger Sicht barbarischen Putzaktionen geschah. Anlässlich der Restaurierungsmaßnahmen in der Oppenheimer Katharinenkirche 1837 wurden zur Reinigung der Fenster beim Apotheker Chemikalien wie «kaustische Ammoniumflüssigkeit, gereinigte Potasche,

1205 VAN TREECK, 2007, S. 179 f. zitiert Sandra Williger, Die Fenster von F. J. Sauterleute 1837–40 in der Gruftkapelle von Schloss Thurn und Taxis in Regensburg. Bestandsuntersuchung, Erstellung eines Konservierungskonzepts und modellhafte Bearbeitung von Musterachsen, Diplomarbeit an der FH Erfurt, Fachbereich Konservierung und Restaurierung (Mschr.), Erfurt, 2006.
1206 VAN TREECK, 2007, 181 f.
1207 Vgl. Anm. 496, ORGAN FÜR CHRISTLICHE KUNST, 1863.
1208 LUBOS-KOZIEL, 2007, S. 185; BEINES, 1979, S. 129 ff.
1209 Vgl. Kap. ‚Preis und Leistung‘.
1210 PARELLO, 1995, S. 151.
1211 KURMANN-SCHWARZ, 2010 (2), S. 232.
1212 PARELLO, 2000 (2), S. 20; vgl. PARELLO, 2000 (2), S. 38 f. über Fritz Geiges als Restaurator, dem noch im ersten Viertel des 20. Jahrhunderts «starres Verhalten an überkommenen Restaurierungsmethoden» vorgeworfen wurde, was zu einer «Verunklärung und Zerstörung mittelalterlicher Kunstwerke geführt hätte».

Essig, venetianische Seife und concentrierte Salz-säure»[1213] bestellt. Für die «Geschichte der Wie-derherstellung» von Kunstwerken beanstandet Günter Bandmann die häufig angewandte Entfer-nung von Firnis, um die scheinbar originalen Farben hervortreten zu lassen[1214]. Darüber hinaus wurden Schadstellen durch weißes Glas oder aus Teilstücken stark zerstörter Glasmalereien ge-schlossen sowie Originalverbleiungen entfernt und durch neue ersetzt[1215]. August Reichensperger rät in seinem «Fingerzeige» 1854 das Fehlen farbiger Scheiben, die nicht unmittelbar zu ersetzen sind, mit gewöhnlichem Fensterglas zu flicken[1216]. In der Schweiz wandte man diese Flicktechnik bei-spielsweise für die Reparatur der frühgotischen Glasmalereien in der Kathedrale von Lausanne 1816/17 an, hier allerdings mit neuem Farbglas aus Lothringen sowie anlässlich einer Restaurierung der Glasmalereien in Königsfelden, die ein Gla-sermeister aus Lenzburg zwischen 1828 und 1840 mit Altglas bewerkstelligte[1217]. Für die vertiefte Betrachtung des pauschalen und nicht immer differenzierten Urteils der Forschung über die Restaurationen im 19. Jahrhundert fordert Elgin Vaassen nicht zu Unrecht eine eigenständige Un-tersuchung, da sich die Vorgehensweisen nicht nur auf ein einziges Jahrhundert beschränkten[1218]. Gottfried Frenzel macht falsch verstandenen Ehr-geiz sowie den Hochmut der Glasmaler zu Beginn des 19. Jahrhunderts für die Vernichtungswelle durch Übermalung und Erneuerung – zum Teil durch Originalscheiben anderer Fenster – verant-wortlich; damals glaubte man, besseren Wissens zu sein als die Alten[1219]. Glasmaler Richard A. Nüscheler (1877–1950) stellte nach der Bestands-aufnahme für die Restaurierung in Königsfelden 1897 fest, dass «alles frisch übermalt, retuschiert und gebrannt werden» müsse. Der für das Unter-nehmen Verantwortliche, Professor Dr. Rudolf Rahn, befürwortete die Erneuerung der Bleie sowie die Entfernung der Flickstücke, hegte jedoch Bedenken gegen die Übermalung mit Schwarz-lot[1220].
Wie bereits im Kapitel ‹Zeichnungen und Licht-pausen mittelalterlicher Glasmalereien› erörtert,

waren Johann Jakob Röttingers Durchpausen der Glasmalereien in den Kirchen von Königsfelden, Hauterive, Oberkirch und Kappel einerseits aus restauratorischen Gründen, andererseits aus denkmalpflegerisch-dokumentarischer Intention heraus für die Antiquarische Gesellschaft Zürich angefertigt worden, wobei die eingeritzte Signatur in Königsfelden auf der Außenseite der Scheiben eher für eine Reparatur beziehungsweise Restau-rierung der Fenster spricht[1221]. August Reichen-sperger postulierte bezüglich der Restaurierung von alten Glasmalereien die Herstellung eines Faksimile – eines eigentlichen Abklatsches, woraus Verbleiung, Farben, Risse und alle «kleinsten Zu-fälligkeiten» zu ersehen seien und zwar vor dem Herab- oder Auseinandernehmen der Fenster[1222]. Die Restaurierungen der mittelalterlichen Glas-malereien in der ehemaligen Klosterkirche Kappel und in der Kirche zu Frauenfeld Oberkirch durch die Werkstatt Röttinger fanden in den Corpusbän-den Erwähnung[1223]. Darüber hinaus haben sich

1213 RAUCH, 1996, S. 176, Anm. 85 u. 86.

1214 BANDMANN, 1971, S. 129 ff.

1215 SCHUMACHER, 1998, S. 114 f.; TRÜMPLER, 2002 (1), S. 74 f.: Reinigung der Scheiben in Königsfelden Ende des 19. Jahrhunderts mittels Säuren – vgl. Anm. 1213; BORN-SCHEIN, 1999, CVMA NewsLetter 46, S. I.; BORNSCHEIN, 1996, S. 48: dort Anm. 136; PRANDTSTETTEN, 1985, S. 3285.

1216 REICHENSPERGER, 1854, S. 36 f.

1217 KURMANN-SCHWARZ, 2008, S. 94 f., TRÜMPLER, 2002 (1), S. 70 f.

1218 VAASSEN, 1997, S. 174, bes. Anm. 95: Skrupelloses Vor-gehen sei nicht nur dem 19. Jahrhundert vorzuwerfen, da die bis in die Gegenwart andauernde «Neuverbleiungs-Wut» etc. vielen Scheiben geschadet hätte.

1219 FRENZEL, 1993, S. 243 ff.

1220 KURMANN-SCHWARZ, 2008, S. 95 ff.; TRÜMPLER, 2002 (1), S. 73 ff.

1221 KURMANN-SCHWARZ, 2008, S. 94, Abb. 86; vgl. Kap. ‹Zeichnungen und Lichtpausen mittelalterlicher Glas-malereien›.

1222 REICHENSPERGER, 1854, S. 37.

1223 BEER, 1965, S. 18 und 42; vgl. Kap. ‹Zeichnungen und Lichtpausen mittelalterlicher Glasmalereien›. Ellen J. Beer erwähnt die zwischen 1873 und 1876 durchgeführte Gesamtrenovation der ehemaligen Klosterkirche in Kappel unter der Leitung von S. Vögelin und J. R. Rahn.

im Nachlass für den Auftrag in Hauterive der Werkvertrag mit Johann Jakob Röttinger sowie ein Briefwechsel mit Architekt Hochstaettler erhalten. Während es in Kappel das beinahe gänzlich zerstörte Maßwerk der nördlichen Obergadenfenster zu renovieren galt – die Signaturen «Röttinger» auf den Fenstern N XI und N IX zeugen davon[1224] (Abb. 137) – musste in Oberkirch das Chorachsenfenster in toto restauriert werden[1225]. Gleichzeitig entstanden originalgroße kolorierte Pausen aller noch vorhandenen Scheiben. Johann Rudolf Rahn berichtete darüber in den «Mitteilungen», dass der gute Erhaltungszustand der Scheiben in Oberkirch «vornehmlich einer langen Verschollenheit» beizumessen wäre, wollte doch der für die Restaurierung in den Fünfzigerjahren verantwortlich zeichnende Glasmaler Johann Jakob Röttinger wissen, dass das Fenster «bis kurz vorher in einem Backsteinmantel versteckt gewesen» sei[1226]. In Kappel scheinen anlässlich der Restaurierung durch die Werkstatt Röttinger selektiv Ergänzungen von Franz Hegi und Johann Martin Usteri aus dem Jahr 1820 ausgewechselt worden zu sein, was die lokalen Beschädigungen an der Verbleiung verdeutlichen. Dies geschah vermutlich aus Gründen der mangelnden glasmalerischen Kenntnisse während der Zeit der Wiederaufnahme der Glasmalerei im frühen 19. Jahrhundert. Anlässlich einer Bestandsaufnahme im Jahr 2005 attestierten die Begutachter dem für die Werkstatt Röttinger signierenden Maler Adolph Kreuzer bei der Herstellung der Ergänzungen und Nachahmungen der originalen Malereien eine hervorragende Malweise[1227].

Zwischen 1848, der Aufhebung des Zisterzienserstifts Hauterive FR und der Einsetzung der Glasmalereien in das Münster zu Fribourg, ergab sich aus der Behandlung dieses Kulturguts eine Leidensgeschichte, von der einige Abschnitte bis heute im Dunkeln liegen. Die folgenden Ausführungen – bezüglich der Restaurierung und Versetzung der aus dem frühen 14. Jahrhundert stammenden Glasmalereien – beziehen sich ausschließlich auf die im Nachlass der Röttinger verbliebenen drei Dokumente und die Kommen-

tare von Autoren, die sich bis dato mit diesem Kapitel der Restaurierungsgeschichte beschäftigt haben[1228]. Am 6. März 1854 war zwischen dem Architekten Joseph Emil Hochstaettler, als «Intendant Gen. des bâtiments de l'Etat de Fribourg et Monsieur J. Röttinger, Peintre sur verre, à Zürich», eine Konvention «pour la restauration des vitraux provenant de l'Eglise d'Hauterive pour les placer dans les fênetres du Choeur à la Cathédrale de St. Nicolas à Fribourg» vereinbart worden[1229]. Der Auftrag an Johann Jakob Röttinger umfasste die Restaurierung sämtlicher Scheiben des großen Chorfensters der Klosterkirche Hauterive und deren Versetzung in die drei Chorfenster der Kirche Saint Nicolas in Fribourg. Im Akkord wurde festgehalten, dass zu diesem Zweck die alten Scheiben zu verpacken und durch Herrn Röttinger selbst auf dessen Kosten und Risiko nach Zürich zu transportieren seien, wo sie in seiner

Bei dieser Gelegenheit unterzog man die Glasmalereien einer weiteren Restaurierung, nachdem eine erste durch J. M. Usteri (1819–1821) durchgeführt wurde. HAUSER, 2001, S. 119: Scheibe mit Bauinschrift, Signaturen der leitenden Beteiligten und zeitgenössischen Nachrichten, Jahr «1871». Die Arbeiten in Kappel haben sich wohl über eine längere Zeitspanne hingezogen.

1224 BEER, 1965, S. 18: H. Röttinger. Heinrich (Henri) Röttinger signierte auf dem Fenster N XI, 5 b offenbar für alle bisher an den Scheiben von Kappel tätig gewesenen Familienmitglieder: «J. J. Röttinger, Glasmaler, Zürich 1817–1877†, Georg Röttinger 1862–1913†, Heinrich Röttinger geb. 1866, hat erstellt am 30. Juni 1931». Friedrich Berbig moniert in einem bereits zitierten Brief (o. D., um 1874) nicht erhaltene Zulagen für seine verdiente Arbeit in Kappel. (ZB Nachl. Röttinger 1.18). Der Signatur bzw. Bauinschrift auf dem Fenster N IX nach zu schließen, war jedoch Adolph Kreuzer bei der Restaurierung federführend: «[...] Adolph Kreuzer, Maler, dies gesch[affen] [...]». Als weitere Beteiligte aus dem Atelier J. Röttinger nennt er «Rud. Spinner, Maler, Fritz Berbig, Rudolph Thym, Glaser, Christian Härer, Maler, August S..., H. Trinkhahn, Glaser, Felix Bleuler.» (TRÜMPLER/DOLD, 2005).

1225 BEER, 1965, S. 42.

1226 RAHN, 1901–1910, S. 1.

1227 TRÜMPLER/DOLD, 2005 o.p.

1228 Eine vertiefte Erforschung unter Einbeziehung aller (noch) verfügbaren Quellen und der Suche nach wie vor verschollener Teile der Glasmalereien kann im Rahmen der vorliegenden Arbeit nicht geleistet werden.

1229 ZB Nachl. Röttinger 1.47 bzw. 1.48.

Verantwortung bleiben würden. Dort habe er sie zu reinigen und ihnen ihren ursprünglichen Glanz wiederzugeben. Die fehlenden Teile würde er mit neuen gotischen Ornamenten ergänzen, wie in den Zeichnungen angegeben, die er der Verwaltung unterbreitet hatte. Unter Paragraph 4 wird Röttinger verpflichtet die alten Scheiben für die beiden seitlichen Fenster, die dem Hochaltar am nächsten liegen, zu verwenden, er würde für das mittlere Fenster neue Scheiben fertigen, thematisch der Zeichnung entsprechend, die er vorgelegt hat und die den *«Heiligen Nikolaus, der die jungen aufgegebenen und verdorbenen Mädchen auf den Weg der Tugend zurückbringt»* darstellt[1230]. Um die Kosten der Reise und des Transports zu entschädigen, sollte Röttinger die alten Scheiben der drei Fenster, die zu ersetzen waren, bei sich behalten – mit Ausnahme einer bemalten Scheibe mit dem Kantonswappen von Fribourg, die im Museum für Altertümer im Lyzeum aufbewahrt werden sollte[1231]. Für diese Arbeiten war eine Summe von 6 560 Franken (francs fédéraux) vorgesehen, wovon 500 Franken nach altem Wert abgezogen werden[1232]. Der Betrag würde in drei Stufen dem Fortschritt der Arbeit folgend[1233] ausbezahlt werden. Röttinger war es freilich erlaubt die Restaurierung und Versetzung früher als vereinbart vorzunehmen, der Bezahlung wird jedoch innerhalb der drei Jahre stattgegeben. Dieser Vertrag wurde vom Regierungsrat des Kantons Freiburg am 8. 3. 1854 auf demselben Dokument bestätigt. Johann Jakob Röttinger erhielt diesen verantwortungsvollen Auftrag der Freiburger Regierung wohl einerseits aufgrund seiner Bekanntschaft mit Ferdinand Keller, dem Präsidenten der Antiquarischen Gesellschaft Zürich, der als Garant für die gute Ausführung der Arbeit eine vom Auftraggeber vertraglich festgelegte Bürgschaft leistete[1234], andererseits wahrscheinlich wegen der Zeichnungen, die Röttinger auf Anweisung der Antiquarischen Gesellschaft in Hauterive angefertigt hatte[1235]. Dies geht aus einem Brief von 1851 an Ferdinand Keller hervor, in dem Röttinger diesen bittet *«die Zeichnung der Freiburger Fenster, welche ich Ihnen seiner Zeit übergeben habe ohne Ihnen geradeviel Mühe zu machen zu erhalten?*

Sie wurden verlangt. Bitte Sie mir darüber Nachricht zu ertheilen»[1236]. Hinsichtlich des Akkords hat sich im Nachlass nur noch ein einziger Brief erhalten, der sich an Johann Jakob Röttinger richtet und am 29. Juni 1853 vom Architekten Hochstaettler verfasst wurde. Darin berichtet der Architekt von der Akzeptanz der Regierung gegenüber der vorgelegten Vorschläge [Röttingers und die des Architekten] bezüglich des Sujets unter dem Vorbehalt der Ratifikation durch den Großen Rat, welcher einen zusätzlichen Kredit für dieses Objekt sprechen müsse. Aufgrund politischer Ereignisse habe der Regierungsrat *«le moment favorable pour présenter cette affaire au Grand-Conseil»* noch nicht gefunden, er (Hochstaettler) wolle sich jedoch für das Vorantreiben der Sache einsetzen, da er die Vorschläge, die Röttinger seinen Auftraggebern unterbreitet habe, *«tres favorable»* finde, um die Arbeit zur Ausführung zu bringen. Die Auskünfte Röttingers

1230 ZB Nachl. Röttinger 1.47, 1.48. REICHENSPERGER, 1854, S. 37: August Reichensperger warnte vor dem Wegtransport alter Gläser und rät die Herstellung und Restaurierung von Gläsern vor Ort. «Ersteres führt vielfache Gefahren mit sich und erschwert überdies die Controle [sic!].»

1231 Ob es sich dabei um die 1870 wieder aufgefundene Freiburger Standesscheibe von 1478 handelt, die vom Berner Glasmaler und Ratsherrn Urs Werder signiert wurde, konnte nicht nachgeprüft werden (über Urs Werder: KURMANN-SCHWARZ, 2001).

1232 Diesen Betrag habe er bereits 1850 für restaurierte Glasmalereien eines von M. Weibel genehmigten Auftrags erhalten. 1851–52 wurde das alte Schweizer Geld (Silberwährung von unterschiedlichem Gehalt, Gepräge und Gewicht) gegen den einheitlichen *Franken* ausgetauscht (DEGEN, 2005, HLS, Stichw. *Franken*).

1233 2'000 Franken 1854 nachdem das erste Fenster platziert sein würde, 2 000 Franken 1855 nach Einsetzen des zweiten Fensters, der Restbetrag von 1 830 Franken nach Vollendung und Abnahme der Arbeiten.

1234 Unter Paragraph 9 des Vertrags.

1235 Zwei dieser Blätter haben sich im Nachlass der Antiquarischen Gesellschaft Zürich erhalten: StAZH W I 3 410 70: Inv. Nr: 1847/1848: *«Copie eines Theils der gemalten Fenster des ehemaligen Klosters Altenriff, Cant. Freiburg vor deren Restauration u. Versetzung in das Chor der Cathedrale St. Nicolas in Freiburg»* (ohne Signatur und Datum).

1236 StAZH W I 3 AGZ 174 12, Müller-R 1851–58, hier: 194/1851 Zürich, 23. Juli 1851.

würden ihm genügen, um die Kostenberechnung aufzustellen, die an die nächste Sitzung des Großen Rats gelangen werde und – so hoffe er – bald behandelt würde. Johann Rudolf Rahn bedauerte 1876 (!) den beklagenswerten Zustand der aus dem ursprünglichen Zusammenhang gerissenen Glasmalereien, bei deren Versetzung man «gezwungen» war, die alten Scheiben «einer Reihe schonungsloser Proceduren» zu unterziehen[1237]. Die ursprüngliche Anordnung sei leider nicht mehr bekannt, was aus heutiger Sicht schwer nachvollziehbar scheint, da im Jahre 1876 noch eine Rekonstruktion zusammen mit dem ausführenden Restaurator, Johann Jakob Röttinger, möglich gewesen wäre. Im Jahr 1924 gelangte der Kantonsarchitekt von Fribourg an Röttinger Junior mit der Bitte um Aushändigung verschiedene Entwürfe, die seiner Zeit an den Kantonsarchitekten Johann Jakob Weibel geschickt worden seien, beziehungsweise von erklärenden Briefen, die dem Fribourger Kunstmaler Henri Broillet bei seinen Recherchen und Rekonstruktionsversuchen dienlich wären[1238]. So stützen sich denn auch die Forschungen Ellen J. Beers[1239] und Stefan Trümplers[1240] auf die Arbeiten Broillets, der zuvor alle verfügbaren Schriftdokumente, Maquetten und Kartons in die Untersuchung miteinschloss. Zusammen mit dem Atelier Kirsch&Fleckner in Fribourg erfasste er mehr als 40 Felder und 30 Maßwerkscheiben für das ursprüngliche Fenster und ergänzte 19 alte erhaltene Fragmente[1241]. Einige der von Röttinger ausgebauten Scheiben gelangten in der Folge in den Kunsthandel, wovon sich ein großer Teil wiederum auffinden ließ[1242]. Henri Broillet fügte die Reste schließlich zu vollständigen Fenstern zusammen. Stefan Trümplers Rekonstruktionsversuch ergab, dass das Ostfenster ursprünglich Darstellungen aus dem Leben Christi in den beiden mittleren Bahnen enthielt, die zu beiden Seiten von zisterziensischen Ornamenten gerahmt wurden. Er datierte die Fensterstiftung zwischen 1323 und 1328. Etwas später wären demnach die beiden seitlichen Chorfenster mit figürlichen Glasmalereien – Aposteln, Propheten und Heiligen – ausgestattet worden[1243]. Zuletzt beschäftigte sich

Daniel Parello mit den «Zisterziensischen Prachtfenstern», der die bisherige Datierung der mittelalterlichen Scheiben in Frage und die Glasmalereien in die Nachfolge des Bebenhäuser Chorfensters (1340–1350) stellte. Er versuchte das Bildprogramm sowohl auf formale wie auch ikonographische Kriterien hin zu strukturieren und entwirft dabei einen Entwicklungszyklus, der schließlich im Altenberger Westfenster gipfelt. In seiner Studie erhielt die Restaurierung der Fenster im 19. Jahrhundert zwar Erwähnung, wurde jedoch nicht thematisiert[1244]. Der Blick auf die verschiedenen Restaurierungsaufträge der Werkstatt Johann Jakob Röttingers zeigt somit zufriedenstellende wie auch fragwürdige Ergebnisse. Elgin Vaassen beurteilt die Ergänzungen Röttingers für die damalige Zeit als durchaus respektabel[1245]. Ohne die drakonischen Maßnahmen beschönigen zu wollen, entstanden solche Pannen nicht zuletzt auch in Übereinstimmung mit den Auftraggebern, wie dies zumindest die beiden überkommenen Dokumente im Nachlass glauben machen. Dieser Umstand lässt vom Standpunkt der nach heutigen Erkenntnissen gemessenen Qualität von Restaurierungen auf eine andere Betrachtungsweise im Umgang mit überlieferten Kunstgegenständen beziehungsweise Kulturgütern durch die Zeitgenossen schließen. Als Beispiel können einerseits im ästhetischen Sinne verzinnte Bleinetze[1246] genannt werden, während Bleiruten im allgemeinen noch 1910 als jene Teile der zu restaurierenden alten Glasgemälde galten, «die ohne weiteres erneuert werden» durften. Denn das Blei an sich

1237 RAHN, 1876, S. 599 f.
1238 ZB Nachl. Röttinger 1.47. Dies erklärt auch die diesbezüglich schmale Quellenlage im Nachlass.
1239 BEER, 1965, S. 79 ff.
1240 TRÜMPLER, 1999, S. 59–65.
1241 TRÜMPLER, 1999, S. 61.
1242 BEER, 1965, S. 82 f.
1243 TRÜMPLER, 1999, S. 65.
1244 PARELLO, 2004, S. 165–180.
1245 VAASSEN, 1998, L-Z, S. 887 f., Stichw. *Röttinger, Johann Jakob.*
1246 Vgl. VAN TREECK, 2007, S. 179–190.

habe gar kein Recht auf etwaige künstlerische Erwägungen, es ist eine derart untergeordnete Materialfrage, dass deren Erneuerung ohne ästhetische Zwischenfragen erledigt werden könne[1247]. Josef Ludwig Fischer monierte die in den Fünfzigerjahren des 19. Jahrhunderts von Kellner im Ulmer Münster durchgeführten Restaurierungen. Dabei wurden neben der materiellen Einschränkung, der Verwendung des glatten, so genannten französischen Glases (Kathedralglas) mit nur fünffacher Farbenskala, die «Fehler seiner [Kellners] Zeit», nämlich große farbige Flächen, perspektivische Zeichnung beziehungsweise Mangel an gotischem Empfinden den Restauratoren zum Vorwurf gemacht[1248]. Hartmut Scholz bestätigt die damalige Verfügbarkeit einer eingeschränkten Palette relativ greller Tongläser für Restaurierungsmaßnahmen mittelalterlicher Glasmalereien im Verlauf des 19. Jahrhunderts und gemahnt das gehörige Maß an Selbstüberschätzung, das die Restauratoren im Zuge ihrer als Ersatz für defekte Glasmalereien geschaffenen Neuschöpfungen an den Tag legten[1249].

Der schon mehrfach zitierte Zeitgenosse August Reichensperger erkannte bereits 1854 die oft ungeeigneten Maßnahmen, die an den Glasmalereien zur Anwendung kamen und forderte unter anderem eine «nicht eben gewöhnliche antiquarische Bildung» der Restaurierungen leitenden Personen sowie Kenntnisse und Erfahrung im Umgang mit historischen Bauten[1250]. Wie der Architekt Eugène Emanuel Viollet-le-Duc (1814–1879) bevorzugte auch Reichensperger das 13. Jahrhundert und die Gotik – Viollet-le-Duc schätzte an den Glasmalern dieser Epoche vor allem deren Naturstudium und die Überwindung des byzantinischen Stils[1251], Reichensperger hingegen die durch gleichmäßige Behandlung der Figuren und Verzierungen erzeugte Einheitlichkeit und Einfachheit, was die Fenster als lichtdurchwirkte Teppiche erscheinen ließ[1252].

Die Werkstatt nach dem Tode Johann Jakob Röttingers († 29. Januar 1877)

Im Dezennium zwischen 1877 und 1887, also bis zur Wiederaufnahme des Glasmalereigewerbes an der Oetenbachgasse durch die Nachkommen, war es der Familie nicht möglich die Werkstatt selbst weiterzuführen, was schließlich zum Verkauf der Firma «J. Röttinger Glasmaler in Zürich» führte[1253]. Die hier dargestellten Quellen aus dem Nachlass sollen das Bestreben und die Anstrengungen der Witwe den Betrieb fortzusetzen nachzeichnen und – trotz der zeitlich begrenzten Schließung des Gewerbebetriebs – die Kontinuität verdeutlichen, die durch den Erhalt der Liegenschaft und des in der Familie angestrebten Vorhabens einer geschäftlichen Wiederaufnahme indiziert war.
Angesichts der hohen Wertschätzung des Familienoberhaupts und Meisters waren Familie und Geschäft vom plötzlichen Tod des Glasmalers im Januar 1877 besonders schwer betroffen. Dem 60. Geburtstag entgegensehend wurde Johann Jakob Röttinger durch eine akute Lungenentzündung[1254] aus seinem arbeitsreichen Leben gerissen. Trotz des unerwarteten Hinscheidens war der pflicht-

1247 FISCHER, 1910, S. 96 ff.
1248 FISCHER, 1910, S. 98; vgl. VAASSEN, 1997, S. 173 f.
1249 SCHOLZ, 2007, S. 13 ff.
1250 REICHENSPERGER, 1854, S. 38.
1251 VIOLLET-LE-DUC, 1868, S. 407; LDK 7, 2004, S. 641 f., Stichw. *Viollet-le-Duc*.
1252 REICHENSPERGER, 1854, S. 47.
1253 Im Rahmen der vorliegenden Arbeit, die vor allem das Werk Johann Jakob Röttingers fokussiert, war eine Vertiefung dieses Zeitraums nicht möglich. Verzichtet wurde daher auf Einzelheiten bezüglich der finanziellen Belange und der Erbschaft etc., die in diesem Zusammenhang nur am Rande interessierten.
1254 Der mündlichen Überlieferung der Familie zufolge erkältete sich der Glasmaler in Ausübung seiner Arbeit im Atelier. Die durch die Brennöfen in der Werkstatt erzeugte Hitze im Wechsel mit den winterlichen Temperaturen im Freien sollen die Krankheit ausgelöst haben. Um die Schmelzfarben dauerhaft einzubrennen, mussten in den so genannten Muffelöfen Temperaturen von 600 Grad erzeugt werden.

bewusste Hausherr nicht ohne Vorbereitungen seinem Ableben entgegengegangen. So schreibt er im Februar 1876 in einem Brief an eine Glaserswitwe in Basel, deren verstorbener Mann noch offene Rechnungen hinterlassen hatte: *«Es ist dies umso notwendiger, da in der letzten Zeit es mit meiner Gesundheit nicht gar … mehr aussieht und das Geschäft am leichtesten mit mir selbst geordnet werden kann [...]»*[1255]. Im Juli desselben Jahres erging eine Zahlungsaufforderung an den Kirchenrat von Glis: *«Ich bitte Sie daher diese Angelegenheit an [die] Hand zu nehmen, damit Ordnung in der Sache ist. Es ist Ihnen durch die jetzt gesendete Generalrechnung ein Leichtes und die Sache ist in Ordnung. Denn wie leicht wäre es möglich, dass der eine oder andere nicht mehr auf dieser Erde sein dürfte und andere Menschen bekümmerten sich nicht stark um unsere Machenschaften [...]»*[1256]. Diese Bemerkungen offenbaren, dass Johann Jakob Röttinger, im Bewusstsein der eigenen Endlichkeit, pflichtbewusst seine Finanzen und Geschäfte geregelt und seine Familie versorgt wissen wollte. Im Vormundschaftsbericht erscheinen von den fünf Töchtern und zwei Söhnen, die aus der Ehe mit Verena Röttinger-Fehr hervorgegangen waren, die jüngeren vier Nachkommen, Verena Carolina (*1859), Ida (*1861), Jakob Georg (*1862) und Heinrich (*1866) als *«minore»*, die drei älteren Töchter, Susanna Helena, Clara Louisa und Anna Elisabeth als *«majore Kinder»*, die als Erbengemeinschaft am Nachlass des Erblassers partizipierten. Verheiratet war zu diesem Zeitpunkt erst Tochter Clara Louisa Leemann-Röttinger. Im Bericht des bestellten Vormundes, Oberst Heinrich Cramer von Wyss, der die Witwe gesetzlich vertrat, wird deutlich, dass *«die Oeconomie der Familie als eine geordnete betrachtet werden»* konnte[1257]. Aus der alten Heimat beziehungsweise aus dem nahe gelegenen Ansbach kondolierte Andreas Rück, ein Neffe des Verstorbenen, der von seiner betagten und kränklichen Mutter berichtete, der Schwester des Verstorbenen und letzten Überlebenden der Nürnberger Familie[1258].

Die Suche nach einem Geschäftsführer

Die überlieferte Korrespondenz der Witwe Verena Röttinger-Fehr veranschaulicht, dass die Geschäfte unterdessen weitergingen; begonnene Arbeiten mussten fertiggestellt, neue Aufträge ausgeführt werden und vor allem galt es offene Beträge abgeschlossener Arbeiten einzufordern. Es war zu dieser Zeit nicht ungewöhnlich, dass Witwen die Betriebe ihrer verstorbenen Ehegatten weiterführten. Johann Jakob Röttinger fand einst nach dem frühen Tod seines Arbeitgebers, J. A. Hirnschrot, den Einstieg in die Selbstständigkeit als Geschäftsführer im Betrieb der Witwe. Künstlerische Beratung erhielt das Atelier weiterhin von Melchior

1255 ZB Nachl. Röttinger 2.371, 99 Basel/Fr. Roth Glaserwitwe 1876.

1256 ZB Nachl. Röttinger 2.371, 143 Glis/Kirchenrat, 1876.

1257 ZB Nachl. Röttinger 1.177; ZB Nachl. Röttinger 2.371, S. 237. In einem Brief an Stadtrat Baldensberger vom 9. Februar 1877 bedankte sich die Witwe für die Kondolenz und schilderte die Situation ihrer Familie: Der jüngste Knabe zähle 11 Jahre, der zweite 14 und besuche die II. Klasse der Sekundarschule, das jüngste Mädchen, geb. 1861, die III. Klasse; das Mädchen, geb. 1859, sei 17 Jahre, konfirmiert und habe alle vier Sekundarschuljahre absolviert, besuche noch die hiesige Musikschule (*«dem selg.Vater war viel daran gelegen»*), die Zweitälteste sei seit August 1875 verheiratet und die dritte Tochter helfe im Haushalt. Verena Röttinger habe seit 1869 keine Magd mehr eingestellt. In gesunden Zeiten habe sich das Ehepaar Röttinger besprochen, was im Falle eines plötzlichen Todesfalls des Vaters geschehen solle. Herr Honegger Fügli, als getreuer Freund und Götti des jüngsten Knaben, solle dann beigezogen werden [...] Dieser habe nun Oberst Cramer als Vormund empfohlen [...].

1258 ZB Nachl. Röttinger 1.141 (Brief v. 7. Februar 1877). Als Dichter und Schriftsetzer beschenkte dieser das Ehepaar Röttinger anlässlich ihrer Hochzeit mit einem gerahmten Gedicht, das sich im Familienbesitz befindet. (Freundliche Mitteilung v. Rudolf H. Röttinger). Die «Hebamme Rück» wird im Stadtarchiv Nürnberg 1852 aktenkundig, als sie den Heimatschein ihres Bruder in dessen Auftrag der zuständigen Behörde übergibt. (SA Nürnberg, C7_II_11886_23). Im Nürnberger Künstlerlexikon erscheint Andreas Rück (*1830 in Nürnberg, † 1898 in Ansbach) als Schriftsetzer in Nürnberg und München 1857–1866 sowie als Kustos und Mitarbeiter in verschiedenen Abteilungen des GNM Nürnberg, später als Redakteur der «Fränkischen Zeitung» in Ansbach (NÜRNBERGER KÜNSTLERLEXIKON 3, 2007, S. 1280, Stichw. *Rück, Andreas*).

Paul Deschwanden (1811–1881), der in einem Schreiben an Verena Röttinger darlegte, dass der heilige Carolus ein purpurnes Gewand trage, das mit weißem Hermelin zu besetzen sei. Er bedauerte keine Abbildung der heiligen Eremita zur Verfügung zu haben und verwies die Witwe auf den Auftraggeber, der gewiss eine Idee einer Darstellung der Heiligen habe, an welche das Volk gewohnt sei[1259]. Verena Röttinger betonte in einem Antwortschreiben an einen nicht namentlich genannten, geistlichen Auftraggeber auf die künstlerische Ausführung hinweisend, *«was die Figuren anbetrifft, hat mich [sic!] Herr Kunstmaler P. [Paul] Deschwanden in Stanz seinen Beistand angeboten, jeden bei mir gezeichneten Carton nachzusehen und erst nach seinem Gutbefinden werden sie weiter ausgeführt und werden dann erst noch nach gänzlicher Vollendung von einen hiesige [sic!] Kunstkenner ein Freund meinerseel. [meines seligen] verstorbenen Mannes durchgesehen.»* Einerseits scheint die künstlerische Autonomie mit dem Ableben Johann Jakob Röttingers verloren gegangen zu sein, andererseits versuchte die Witwe die Aufträge mittels ästhetischer Qualitätskontrollen abzusichern und das gute Renommee des Geschäfts zu bewahren[1260]. *«Sie dürfen daher in der festen Überzeugung sein, daß Ihre besagten 2 Fenster in jeder Beziehung künstlerisch und solid ausgeführt werden um den guten Ruf, welcher mein seel. [seliger] Mann genossen aufrecht zu erhalten»*[1261]. Wenn sich auch Verena Röttinger-Fehr für die Weiterführung des Betriebs einsetzte, konnte sie die Werkstattarbeit nicht ohne die tatkräftige Unterstützung eines Glasmalers überblicken. So bemerkte sie in einem Brief an einen Kunden zwölf Tage nach dem Tod ihres Gatten: *«Da mir gute und langjährige Arbeiter meines sel. [seligen] Mannes zu Gebote stehen bin ich in den Stand gesetzt das Geschäft fortführen zu können, um die angefangenen Arbeiten zu vollenden und so auch die Ihrigen langersehnten Fenster. […] Mein Geschäftsführer, ein langjähriger Mitarbeiter meines sel. [seligen] Mannes hat mir versprochen bis Ende Mai […]».* Friedrich Berbig schien für diese Aufgabe prädestiniert gewesen zu sein. In einem Brief vom 19. März 1877 erwähnte er eine seit sechs Jahren bestehende Loyalität gegenüber seinem Arbeitgeber und die vielen Gespräche mit dem Meister.

Zuletzt stand das Versprechen am Sterbelager der Familie beizustehen, all das in der Hoffnung, dass der späte Lohn und Dank nicht ausbleiben würde. Demzufolge habe er bereits zweimal einer ihm angebotenen *«sichern Zukunft»* entsagt[1262]. Dem Schreiben ging anscheinend eine für Berbig unerträgliche Situation der Herabwürdigung voraus. Die Witwe habe im Beisein der Arbeiter, die Friedrich Berbig in seiner Stellung als Vorgesetzten zu respektieren hatten, in einem Ton zu ihm gesprochen, der ihn vor den Augen der Mitarbeiter lächerlich gemacht habe. Dabei ging es um die dringende Reparatur eines im desolaten Zustand befindlichen Brennofens, die von Berbig nach Rücksprache mit Verena Röttinger-Fehr in die Wege geleitet worden war. Aus der Sicht der Witwe sei die Bestellung des zuständigen Handwerkers als Eigenmächtigkeit verstanden worden, was den unschönen Wortwechsel vor versammelter Belegschaft zur Folge gehabt habe. Nun bat er die Witwe in diesem Brief, der auf viereinhalb Seiten ausschließlich dieses Thema abhandelte, um eine Aussprache und gab der Hoffnung Ausdruck, als Familienvater weiterhin die nötige Sicherheit für seine Familie bieten zu können. Der Friede, sofern überhaupt eingekehrt, hielt nicht für lange Zeit. Bereits am 10. April gab Friedrich Berbig bekannt, seine Stellung bei Röttinger auf den 21. April zu kündigen. Der Glasmaler monierte in einem weiteren Brief vom 23. April nicht vom Unterwaisenamt beziehungsweise vom Vormund Cramer von Wyss als offizieller Geschäftsführer eingesetzt worden zu sein, sondern nur die Stellung eines *«Geschäftsführers wie es Haas und Härer auch waren […]»* innegehabt zu haben[1263]. Die Differenzen zwischen

1259 ZB Nachl. Röttinger 1.182.
1260 Beim erwähnten befreundeten Kunstkenner könnte es sich um Ferdinand Keller († 1881) oder allenfalls um Johann Rudolf Rahn (†1912) gehandelt haben.
1261 ZB Nachl. Röttinger 1.182.
1262 ZB Nachl. Röttinger 1.18.
1263 ZB Nachl. Röttinger 1.18, Brief vom 23. April 1877. *«[…] haben ja selbst zu den Leuten gesagt, ich bin so gut ein Arbeiter wie andere auch […]».* In einer schriftlichen Aufforderung vom 26. Mai 1877 an Verena Röttinger-Fehr ein Johann Jakob Röttinger slg. geliehenes Buch zurückzugeben,

250

der Geschäftsinhaberin und ihrem «Werkstattleiter» mussten sich seit März massiv vergrößert haben. Dies zeigt die Zuschrift des ehemaligen Mitarbeiters R. Thym aus München vom 4. April an Verena Röttinger-Fehr, in dem er bedauert ihren Wunsch – einen geeigneten Glasmaler für das Zürcher Atelier anzuwerben – nicht erfüllen zu können[1264]. *«Daß es Ihnen schwer wird das Geschäft zu leiten begreife ich sehr wohl, kann es Ihnen auch nichtverdenken daß Sie es abgeben wollen, nur möchte ich Ihnen rathen mit Herrn Ruf sehr vorsichtig zu sein, ich habe von dem Herrn schon genug gehört, nur noch nichts Gutes [...].»* Des Weiteren wusste Thym zu berichten, dass der besagte Herr Ruf[1265] hier (in München) bankrott gegangen ist und dass er sich nun wieder in der Schweiz aufhält, nachdem sich dessen reicher Schwiegervater mit den Gläubigern geeinigt hatte. Ruf interessierte sich für das Atelier Röttinger, um es für seinen Bruder zu kaufen, einem Glasmaler, der aus Amerika zurückkehren und sich hier niederlassen wollte[1266].

Der Konflikt zwischen Friedrich Berbig und seiner Arbeitgeberin mochte bereits am Tage des Begräbnisses des verstorbenen Geschäftsinhabers seinen Anfang genommen haben. Dementsprechend äußert sich zumindest ein weiterer ehemaliger Mitarbeiter, der Glasmaler J. Kuhn-Helmle aus Basel, in einem Brief vom 15. März 1877 an die Witwe, dass er es als seine heilige Pflicht gegenüber Verena Röttinger-Fehr und ihrer Familie erachtete *«solchen taktlosen und unvorsichtigen Äusserungen [sic!] von Berbig, Glaser»*, in den sie alles Vertrauen setzten, entgegenzutreten. Bis zu seinem persönlichen Erscheinen sollte sich Verena Röttinger an Frau Kramer[1267] halten, die ihr wohl gesinnt sei, und deren Aussagen über Berbig nur allzu wahr und bei Bedarf durch Zeugenaussagen belegbar seien[1268]. Nach der zitierten Korrespondenz zu urteilen, deren Kernaussagen sich den damaligen Gepflogenheiten entsprechend hinter langatmigen und vorsichtig formulierten Floskeln verbargen, ist anzunehmen, dass Friedrich Berbig eine möglichst rasche Übernahme des Geschäftes anstrebte, was bereits zu Lebzeiten des Prinzipals aus seinen Äußerungen, die seine Person und Leistung in den Vordergrund gestellt hatten, deutlich geworden war[1269].

Verkauf an den Glasmaler Carl Wehrli

Offenbar ließ sich weder in der Schweiz noch in München ein adäquater Geschäftsführer für das Zürcher Atelier finden und nachdem der männliche Nachwuchs der Familie noch zur Schule ging, entschloss sich die Witwe gemeinsam mit ihrem gesetzlichen Vertreter die Firma zu veräußern. Nun musste alles ziemlich schnell gehen, denn Zeitverlust hätte finanzielle Einbußen bedeutet. Wie der zukünftige Eigentümer Carl Wehrli mit den Erben ins Geschäft kam, wird in den Quellen nicht fassbar. Carl Andreas Wehrli der Ältere[1270] von Küttigen AG und Zürich (1843–1902), der seit 1865 seine eigene Glasmalereifirma betrieb, war

erscheint bereits der Briefkopf der Firma *«Fr. Berbig & Cie. Glasmalerei, Anfertigung aller Arten Kirchenfenster, Wappenscheiben, Dessinglas für Corridorabschlüsse etc. etc. [sic!]»*.

1264 ZB Nachl. Röttinger 1.165, 4. April 1877.

1265 Ein gewisser Heinrich Ruf erscheint zwischen 1. April 1897 – 12. Mai 1898 im Grundbuch des Pensionsvereins der Tiroler Glasmalereianstalt in Innsbruck als «Maler». (Dieterich Schneider-Henn, Die Tiroler Glasmalereianstalt im Zeitalter der Weltausstellungen, in: Antiquitäten-Zeitung Nr. 16, 1983, S. XIV); dank einer freundlichen Mitteilung von Elgin Vaasen.

1266 StdA München, PMB R 279: Im Stadtadressbuch München von 1877 (S. 257) werden die beiden Glaser Michael (1842–1919) und Melchior Ruf (1841–1910) aufgeführt. Michael erhielt 1872 das Münchner Bürger- und Heimatrecht und war 1871 bei Riepold sowie 1872 bei Hildebrand als Geselle beschäftigt. Melchior Ruf wird in der Steuerliste als Glasermeister und Zinngießermeister, Glas- und Porzellanwarenhändler geführt; 1878 verehelicht er sich mit Elisabetha Weixelstorfer und wird als Bürger von München aufgenommen. Die beiden Arbeitgeber Michael Rufs, Riepold [Riepolt] und Hildebrand, erscheinen bei VAASSEN, 1997, S. 348, Anm. 72. Eine definitive Zuordnung der im Nachlass genannten Brüder Ruf kann mangels präzisierender Angaben bis dato nicht erfolgen.

1267 Es dürfte sich um die Gattin des Vormunds, Cramer von Wyss (bei wechselnder Schreibweise), gehandelt haben.

1268 ZB Nachl. Röttinger 1.182.

1269 ZB Nachl. Röttinger 1.18; vgl. Kap. ‹Verdienst und Betriebsklima›.

1270 Namensvarianten: Wehrle (laut SIKART und Stadtarchiv Zürich auch Weerli); StadtA Zürich, Register Aussersihl, NL-Kontrolle Schweizer und Ausländer, Reg. 1876–1879 VI.AS.C.48.:3, 7389 Wehrli-Scheller Carl Andreas, Glasmaler Zürich (*1843).

seit 1869 mit Anna Louise Scheller verheiratet. Von insgesamt neun Kindern erlernten zwei Söhne, Eduard (*1872) und Karl Wehrle (*1874), ebenfalls den Beruf des Glasmalers. Die Familie Wehrli wohnte von Oktober 1866 bis April 1879 in der Stadt Zürich an verschiedenen Adressen[1271], ab April 1879 in Aussersihl[1272]. Durch den Kaufvertrag, der zwischen «H. [Herrn] Carl Wehrli, Glasmaler in Zürich und Herrn Cramer v. Wyss als Vormund der Erben des selg. [seligen] Herrn J. Röttinger Glasmaler in Zürich» abgeschlossen wurde, kam der Erwerb des Glasmalerei-Geschäfts zustande, «nebst den in der Beilage verzeichneten Inventur mit dem Recht sich als alleiniger Nachfolger dieser Firma zu zeichnen. [...] Es ist indeßen beiden Söhnen des Herrn Röttinger selg. [selig] nach Verfluß von zehn Jahren gestattet unter ihrem Namen ein gleiches Geschäft zu etablieren»[1273]. Carl Wehrli bezahlte für die Abtretung der Firma und des Inventars eine Summe von 6 000 Franken. Für abgegebene Aufträge, Bestellungen und Verträge laut beiliegender Aufstellung war ein Betrag von zusätzlich 1 000 Franken zu berappen[1274]. Die im Keller unter der Werkstatt befindlichen Brennöfen waren – unter Vorbehalt des Hausverkaufs – während drei Jahren an Ort und Stelle stehen zu lassen. Herr Wehrli habe sich im Falle ausnahmsweiser Benutzung derselben mit dem möglichen neuen Mieter der Räumlichkeiten zu einigen. Das gesamte übrige Inventar, Mobiliar, Werkzeug und Material erging an den neuen Inhaber[1275].

Ende 1877 vertraute sich die Witwe Herrn Pfarrer Gaille in Rorschach an: «[...] und ich belange [warte voller Ungeduld] auf den Bauschluss wie auch auf den Geschäftsschluss gibt mir beides viel zu thun. Komme mit vielen Leuten in Berührung [...] alle Tage vorsichtig zu sein. Betrug ist ein Handwerk geworden erst jetzt denk ich viel an die Mahnungsworte m. [meines] Mannes ich habe zu viel Menschen Vertrauen.» Sie würde nun zuerst in die Augen ihres Gegenübers schauen, bevor sie etwas aus den Händen gibt – die Kinder täten es ihr gleich. Sie wohnten in Frieden und Eintracht artig beieinander und es sei ihr großer Wunsch noch alles selbst zu ordnen, dass sie den Vormund so wenig als möglich belasten müsse. Mit ihren Mietern sei sie wohl zufrieden, diese seien ordent-

1271 StadtA Zürich, Alte Einwohnerkontrolle 1836–1892; Erster Wohnsitz Carl Wehrlis in Zürich Neumarkt 4, im Haus zum Untern Rech, dem heutigen Sitz des Stadtarchivs (Vermieter Johannes Seebach, Spengler); ab April 1868 Steingasse 26, heute Spiegelgasse 26, im Haus zum Obern Rech (Vermieter Caspar Schulthess, Fabrikant von Metallgeweben und eisernen Gartenmöbeln); ab März 1869 Rindermarkt 21, der Adresse von Wehrlis Schwiegervater, Kaspar Scheller, des Schirmfabrikanten und Vize-Sigristen am Grossmünster; ab September 1871 Falkengasse 25 als Eigentümer der Liegenschaft, ab 16. April 1879 nach Aussersihl, Sankt Jakobsquartier (V.E.c.26.:17, Falkengasse 25/Wegzug, Familienbogen Wehrle); 3. Mai 1879 Bäckerstrasse 997 (VI.AS.C.45.:4, Nr. 7389); 1882 Müllerstrasse 997; 1885–1890, Glasmalerei und Dessinglasfabrik, Glasmalergasse 5, Aussersihl. Bei der Bäckerstrasse 997 bzw. Müllerstrasse 997 handelt es sich um dasselbe Haus und dieses entspricht der späteren Glasmalergasse 5 (StadtA Zürich VI.AS.C.23.:7, Nr. 997); Aussersihl wird 1893 eingemeindet. Die Brandassekuranznummer Aussersihl 997 blieb bestehen (freundliche Auskunft von Robert Dünki, Stadtarchiv Zürich). Tagblatt der Stadt Zürich vom 24. September 1902, S.7: Todesanzeige der Familie für «Carl Andreas Wehrli, Glasmaler in Zürich III». Er starb «an einem Herzschlag in Dallenwyl, Kant. Unterwalden».

1272 Die Adresse Glasmalergasse 5 blieb über den Tod Carl Wehrlis hinaus bestehen, da Sohn Karl Wehrle [Wehrli] dort als Glasmaler weiterarbeitete. Auf der Suche verlorengegangener Archivalien anlässlich der Geschäftsübernahme, wie Kartons, Maquetten oder Verträge wurden Nachforschungen bezüglich der Nachkommen Carl Wehrlis angestellt, die jedoch infolge deren Auswanderung nach Italien abgebrochen wurden: Sohn Karl Wehrli hatte drei Kinder: Karl, Viktor und Fiora Lina. Karl und Viktor reisten nach Italien aus und sind dort verstorben. Fiora Lina (*1904) verheiratete sich 1942 mit Hans Alois Heinrich Brugger (*1901) aus Basel, wonach das Ehepaar zu einem unbestimmten Zeitpunkt ihr Domizil nach Mailand verlegte (Quelle: Zivilstandsamt Basel: PD-REG 14a 12–4, Nr. 42 303).

1273 ZB Nachl. Röttinger 1.189.

1274 Von diesen 7 000 Franken waren nach der Ratifikation des Vertrags 2 000 Fr. in bar zu bezahlen, der Rest von 5 000 Fr. mit 5 prozentiger Verzinsung in zwei Jahresraten, die erste am 1. Mai 1878, die zweite am 1. Mai 1879 zu tilgen und die Summe in der Zwischenzeit durch einen Bürgen zu garantieren. Der Antritt musste per sofort stattfinden und das Geschäftslokal per 1. Juni 1877 geräumt sein. Für acht von J. Röttinger angefangenen oder bereits fertig hergestellten Aufträgen vom Januar verpflichtete sich der Nachfolger C. Wehrli auf Kosten der Erben zu vollenden (April 1877). Weitere acht von der Witwe aufgelisteten Bestellungen übergab diese an C. Wehrli im Mai 1877 (ZB Nachl. Röttinger 1.189).

1275 ZB Nachl. Röttinger 1.187, unterschrieben u. a. von Adolph Kreuzer, Glasmaler, der damals in der Werkstatt

lich und bescheiden. Sie hätten somit ihr Auskommen – ein Hausverkauf stünde folglich nicht zur Debatte[1276]. Ein weiterer Brief vom Juni 1877, aus dem Stadtarchiv Wil SG überliefert, gibt vertieft Aufschluss über die Sorgen der Witwe. Sie hat das Geschäft ihres seligen Mannes an Herrn Wehrli abgetreten, da sie selbst eingesehen hat, dass sie im Falle einer Weiterführung des Betriebs alles, was ihr Mann verdient und erspart hat, zu verlieren droht. Von sechs Mitarbeitern hätten es drei nicht ehrlich gemeint und sie betrogen, dass ihr Angst und Bange geworden ist[1277]. Zahlreiche Briefe aus dem Jahr 1878 zeugen von den Bemühungen der Witwe, ausstehende Gelder einzutreiben: *«[...] durch den Todesfall m. selg. [meines seligen] Mannes bin ich vom Unterwaisenamt beauftragt worden alle unsere ausstehenden Guthaben einzuziehen, wovon ich Sie in Kenntnis setzen muss [...]».* Dementsprechend konnten nach diesem Aufruf eine Reihe von Einzahlungen verbucht werden – wohl eine der letzten eingegangenen Beträge erlebte die Witwe nicht mehr. So teilte das Notariatsbüro Moser&Geissbühler in Biel am 28. August 1887 mit, dass von Pfarrer Cäsar (unbekannten Ortes) endlich die geforderten 4000 Franken einbezahlt wurden: *«Es ist mir leid, daß Ihre werthe Frau Mutter sel. [selig] das Endergebnis nicht erlebt hat [...]»*[1278]. Verena Röttinger-Fehr qualifizierte sich mithilfe ihrer Hartnäckigkeit und dem Willen, sich und ihre Familie durchzubringen, als gute Geschäftsfrau. Sie wusste sich Angriffen wirtschaftlicher Art sowie ungerechtfertigter Forderungen zu erwehren. Die «Gräflich Solm'sche Glashütte» nahm auf die Administration von 1867 Bezug und versuchte einen Geldbetrag einzukassieren. Die Witwe konnte jedoch anhand der ordnungsgemäß geführten Buchhaltung und der archivierten Korrespondenz die Bezahlung belegen und bat in Zukunft von weiteren Briefen verschont zu bleiben[1279]. Seit ihrem 12. Lebensjahr, bedingt durch den frühen Tod ihrer Eltern, ist sie es gewohnt, selbstständig den Lebensunterhalt zu berechnen. *«[...] wie es gegenwärtig ist, es bekümmert sich kein Mensch wie ich's mache mit meinen Kindern»*, wichtig schienen nur die Zahlungseingänge sowie die Belege des Kassenstandes[1280]. Mit der Fertig-

stellung angefangener Aufträge durch Nachfolger Carl Wehrli war Verena Röttinger nicht restlos zufrieden und antwortete auf eine entsprechende Reklamation eines Kunden: *«[...] es ist mir leid genug daß sich die Arbeiten m. lb. slg. [meines lieben seligen] Mannes so weit und lang ausgezogen worden sind m. [meine] Absicht war es nicht. Bereue es genug daß ich die eingegangenen Arbeiten nicht in unserem Hause vollführen ließ»*[1281]. Manche Kunden, wie Pfarrer Gaille in Rorschach, hätten die unter Johann Jakob Röttinger angefangenen Arbeiten lieber von Friedrich Berbig ausgeführt gewusst als von Carl Wehrli[1282]. Vertraglich war das jedoch nicht möglich, weil Wehrli für die Vollendung der Arbeiten im Rahmen des Vertrags bezahlt worden war.

Die Nachkommen

Indessen wuchsen die Kinder zu jungen Erwachsenen heran. Während die Mädchen im Hinblick auf ihre weibliche Pflichterfüllung erzogen und ausgebildet wurden, erhielten die beiden männlichen Nachkommen von Kindesbeinen an eine Erziehung, die eine Zukunft im Geschäftsleben beziehungsweise als Glasmaler ermöglichte. Im Jahr 1875 – noch zu Lebzeiten Johann Jakob Röttingers – erkundigte sich die Mutter in einem Brief, den sie vom Kuraufenthalt in Baden an den jüngeren Sohn Heinrich richtete, ob dieser wohl brav lerne. Darin wird er aufgefordert, gehorsam und

K. Wehrlis in Stellung war. ZB Nachl. Röttinger 1.189: Elf Jahre später pochte K. Wehrli auf seinem Recht und verlangte die Bereitstellung der *«Brennöfen Sachen»* vor dem Hause des Ateliers Jakob Georg Röttinger, damit er sie dort abholen lassen könne.

1276 ZB Nachl. Röttinger 2.371, S. 271.

1277 StadtA Wil SG, Akten KiAW1, Sign. 40.10.05.01, 7. Juni 1877.

1278 ZB Nachl. Röttinger 1.101.

1279 ZB Nachl. Röttinger 2.371, S. 291.

1280 StadtA Wil SG, Akten KiA W1, Sign. 40.10.05.01, 7. Juni 1877.

1281 ZB Nachl. Röttinger 2.371, Oct. 1877, Pfarrer Wissmann.

1282 ZB Nachl. Röttinger 1.180, 17. Dezember 1877: *«dabei ginge nicht darum Ihre Person zu schikanieren [...]».*

bereitwillig zu sein, damit er dem lieben Vater große Freude und Ehre mache. Georg bescheinigte sie eine gute *«Geschäfts- und Kellerordnung»* und bezeichnete ihn als große Hilfe für den Vater, was ihm sehr zur Ehre gereiche[1283].

Nach Beendigung der Sekundarschule 1879 arbeitete der ältere Sohn, Jakob Georg Röttinger (1862–1913), beim Nachfolger seines Vaters in der Werkstatt Carl Wehrlis, wo er sich unter dem damaligen Geschäftsführer Adolf Kreuzer die ersten Sporen verdiente. Nach einem Jahr wechselte der junge Jakob Georg zu Glasmaler Hans Klaus nach Nürnberg, einem weiteren Ehemaligen der väterlichen Werkstatt, und besuchte dort als Abendschüler die Königliche Kunstgewerbeschule. In Nürnberg konnte er sich durch die Mitarbeit an Prestigearbeiten der Glasmalerei – in der Frauenkirche und der Sankt Lorenzkirche – für den zukünftigen Künstlerberuf profilieren. Nach weiteren Aufenthalten in München, Offenburg und Genf[1284] beschloss er seine Ausbildung mit einem Sprachunterricht in Lausanne. Verena Röttinger-Fehr gedachte in einem Brief am 21. April 1887 des Namenstags ihres älteren Sohnes: *«[…] nach dem Fest und bis dann würdest du bei dem D. [Deutschen] Maler bleiben, übernimmt er nicht auch Kirchen? Durch das lerntest du die Architekten kennen […]»*[1285]. Etwa zur selben Zeit machte die Mutter Sohn Heinrich die Mitteilung, dass Schorsch [Jakob Georg], wahrscheinlich wegen des kommenden Schützenfestes, Arbeit bei einem Wappenmaler gefunden hätte – jetzt sei *«er einmal an einem Ort, wo er das Frz. [Französisch] lernen muss, mit beihülfe den Stunden und beihülfe der Mutter, die giebt immer noch ein wenig warm […]»*[1286].

Das jüngste der sieben Kinder, Heinrich Röttinger [nannte sich Henri], absolvierte nach Besuch des Gymnasiums eine kaufmännische Ausbildung im Kaufhaus Arnold und Wegmann am Rennweg in Zürich. Ab 1885 vertiefte er seine merkantilen Kenntnisse bei der Import-Export-Firma für Südfrüchte und Öle *«Charles Host»* und später bei *«Avril Frères»* in Aix-en-Provence[1287]. Jakob Georg begründete nach dem Tod der Mutter (†16. Mai 1887) die Wiederaufnahme der väterlichen Werk-

statt an der Oetenbachgasse 13[1288]. So erfüllten sich die Wünsche der Witwe im Hinblick auf die Weiterführung des Ateliers, alle *«Altlasten»* selbst geregelt, die Liegenschaft erhalten und der Arbeit ihres verstorbenen Ehegatten die verdiente Wertschätzung entgegengebracht zu haben. Nach dem Einstieg Heinrich Röttingers, der ab 1889 die kaufmännische Geschäftsleitung übernahm und wohl auch noch Aufbauarbeit zu leisten hatte[1289], konzentrierte sich Jakob Georg bis zu seinem Tod am 28. Februar 1913 auf den künstlerischen Bereich des Betriebs. Mit diesem Schritt war das künstlerische und geschäftliche Erbe Johann Jakob Röttingers gefestigt und die Kontinuität des Glasmalereibetriebs am bisherigen Standort bis 1948 sichergestellt[1290].

1283 ZB Nachl. Röttinger 1.181. Jakob Georg Röttinger soll sich schon früh für die Arbeit des Vaters interessiert haben und half wohl auch bei kleineren Arbeiten wie dem Bleiziehen mit. (Zangger, 2007, S. 119, Anm. 1).

1284 Zangger, 2007, S. 119, Anm. 3.

1285 ZB Nachl. Röttinger 1.181.

1286 ZB Nachl. Röttinger 1.181; Röttinger R. H., Zürich, Homepage. Bezüglich Jakob Georg Röttinger verweise ich auf die Arbeiten Eva Zanggers (siehe Literaturliste).

1287 Röttinger R. H., Zürich, Homepage.

1288 ZB Nachl. Röttinger 2.371, S. 313: Schreiben von Jakob Georg Röttinger an Carl Wehrli (17. Juni 1888): *«Da mit Herbst I. Jahres 1887 das Haus käuflich notarisch an mich übergegangen ist, versteht es sich von selbst, dass ich es mit allen nit- und nagelfest [sic!] darin befindlichen Gegenständen übernommen habe folgedessen ich auch die im Keller befindlichen Öfen dazu rechne. Sie haben ja Zeit genug gehabt, Ihr allfälliges Recht früher zur Geltung bringen zu können, warum haben Sie sogar 11 Jahre gewartet, vielleicht um den Moment abzuwarten, wo sich Röttinger etabliert, um ihn dann zu chicanieren zu suchen?»*

1289 ZB Nachl. Röttinger 2.47, S. 1–5: Brief von Heinrich an Jakob Georg 1902, anlässlich einer innerfamiliären Unstimmigkeit: *«Anfang April 1889 habe ich meine Stelle in Frankreich aufgegeben und bin auf deine Veranlassung hin und im besten Vertrauen mit dir die Berufung des sterbenden Vaters zusammen zu leiten ins elterliche Haus zurück gekehrt. Bei meinem Eintritt in dein Geschäft also im April 1889 (du selbst funktioniertest schon seit 1887) war keine Arbeit vorhanden.»*

1290 Röttinger R. H., Zürich, Homepage. Darüber hinaus finden sich hier Informationen über die Weiterführung des Geschäftes bis 1983.

Stellung des Werks

Das abschließende Kapitel der vorliegenden Arbeit impliziert einerseits die Positionierung von Person und Werk Johann Jakob Röttingers vor dem historisch-politischen Kontext der ersten Jahrhunderthälfte, andererseits wird eine kunsthistorische Situierung des glasmalerischen Oeuvres innerhalb der Tafelmalerei, Bildhaucrei beziehungsweise Glasmalerei in den ersten zwei Dritteln des 19. Jahrhunderts angestrebt. Dabei wird auch die Frage des Kulturtransfers zwischen den Regionen zu erörtern sein. Schließlich sollen zeitgenössische konfessionelle und philosophische Tendenzen besprochen und deren Auswirkungen auf Rezeption und Wertschätzung der überlieferten Glasmalereien geprüft werden.

Historische Grundlagen

Nicht nur in der deutschen Heimat Röttingers, auch hierzulande waren die Auswirkungen der Französischen Revolution zu spüren. In der Schweiz wurde während der Helvetischen Republik (1798–1803) die alte Eidgenossenschaft vorübergehend in einen nationalen Einheitsstaat umgestaltet[1291]. Der von Napoleon initiierte Rheinbund vom 12. Juli 1806 zwischen sechzehn süd- und südwestdeutschen Fürsten, die sich unter dem französischen Protektorat souverän erklärten, führte zum Sturz der alten europäischen Strukturen. Die Niederlegung der Reichskrone durch Kaiser Franz II. bewirkte die Auflösung des fast tausendjährigen Bestandes des Heiligen Römischen Reichs Deutscher Nation und verlangte nach einer Neuordnung Europas[1292]. Um den Übergang von einer Ständegesellschaft zu einer stärker marktorientiert definierten Klassengesellschaft nachzuzeichnen, werden die verschiedenen Entwicklungen in der Schweiz und in Deutschland in Folge einzeln behandelt.

Von der Revolution zum neuen Bundesstaat

Die Zeit der Helvetik brachte der Schweiz neben anderen Reformbestrebungen erstmals eine Proklamation der Gewerbefreiheit als Folge der Aufhebung des Zunftzwanges, was die bisherigen Fesseln zwar zu sprengen vermochte, die Situation der Wirtschaft dagegen nicht wesentlich verbesserte[1293]. Schon damals wurden auf Schweizer Territorium niedergelassene Ausländer helvetischen Bürgern privatrechtlich gleichgestellt, eine Novität, die den Immigranten neben Handels-, Gewerbe- und Niederlassungsfreiheit auch das Recht des Erwerbs von Liegenschaften zugestanden hatte[1294].

Ein kurzer Abriss der Geschichte über die erste Hälfte des 19. Jahrhunderts soll die Zeit vor und

1291 FANKHAUSER, 2011, HLS, Stichw. *Helvetische Republik.*
1292 LEHNER-HELBIG, 2011, HLS, Stichw. *Rheinbund.*
1293 STAEHELIN, 1980, S. 822. Eine diesbezügliche Gesetzesänderung erfolgte am 19. Oktober 1798.
1294 STAEHELIN, 1980, S. 824; vgl. Anm. 99.

während der Einwanderung Johann Jakob Röttingers beziehungsweise seiner Etablierung in Zürich veranschaulichen und neben wirtschaftlichen, politischen und religiösen Aspekten die damalige Stellung der ausländischen Bevölkerung in der Schweiz berücksichtigen. Viele dem Volk fremd gebliebene, in der Zeit der Helvetik von Frankreich aufgezwungene Maßnahmen – häufiger als Schmach denn als Reformierung althergebrachter Strukturen empfunden – konnten sich demnach im Dezennium der Mediation (1803–1813) nicht weiter entwickeln. Folglich kehrten die alten Landkantone möglichst schnell in ihre vorrevolutionären Gefüge zurück und verschlossen sich alsbald wieder gegenüber Einwanderern, nicht zuletzt, um in katholischen Kantonen eine Durchmischung des Religionsverbands zu vermeiden[1295]. Auch in den so genannten Städtekantonen blieben nicht alle Neuerungen bestehen – so führte der Kanton Zürich den Zunftzwang wieder ein, was bei den Handwerkern verständlichen Unmut auslöste. Gleich zu Beginn der Restauration musste die nach Außerkraftsetzung der Mediationsakte wiedererstandene Eidgenossenschaft den Durchmarsch der Alliierten hinnehmen[1296]. Die Entzweiung der Mächte, Paris und Wien, und die daraus entstandenen europäischen Probleme vermischten sich mit landesinternen Konflikten, die sich an der Ablösung der alten und der Entstehung einer neuen Schweiz entzündeten[1297]. Die frühen Jahre der Restauration wirkten sich auf die Wirtschaft, vor allem auf die heimischen Betriebe, negativ aus. Die Einmischung der Großmächte, die Vielfalt der Zölle und eine unüberschaubare Anzahl verschiedener Längen- und Hohlmaße beziehungsweise Gewichte blockierten den Handel[1298].

Wachstum und Selbstbewusstsein

Erst ab 1820 zeichnete sich ein spürbarer Aufschwung der Textil- und Metallindustrie ab und ein neuer Zweig, die Uhrenindustrie, etablierte sich mit einem bedeutenden Marktpotenzial[1299]. Die aufstrebende Wissenschaft und eine patriotische Verbundenheit, die in Universitätsgründungen

sowie Schützenfesten in Erscheinung traten, begleiteten die wachsende Konjunktur und stärkten unter anderem mit der Einrichtung von Militärschulen die nationale Einheit[1300]. Das Volk war gegenüber Ausländern, insbesondere politischen Flüchtlingen – den «Märtyrern der Freiheit» – ab etwa 1830 überwiegend positiv eingestellt. Bei den Asylsuchenden handelte es sich häufig um Intellektuelle, die einerseits dem geistigen Leben hierzulande Impulse verliehen, andererseits hingegen die Schweiz bezüglich ihrer Neutralität in Verlegenheit und wegen der Fortsetzung der politischen Tätigkeit in ihren Herkunftsländern (u.a. Österreich, Russland) in Schwierigkeiten brachten. Die laizistische Einstellung der politischen Flüchtlinge verstärkte die ohnehin präsenten konfessionellen Spannungen unter den Eidgenossen, die sich an eigenen Problemen zwischen Radikalen, Liberalen und ultramontanen Katholiken aufrieben. J.-C. Biaudet nennt die Jahre der Regeneration auch eine Zeit der Gärung, aus der 1848 die moderne Schweiz entstand. Die Krise beinhaltete in ihrer Vielschichtigkeit kantonale und nationale Aspekte, politische und religiöse Probleme, innenpolitische Belange sowie die schwierigen Auslandsbeziehungen[1301]. Der Zürcher Putsch von 1839 ist ein beredtes Beispiel für das Selbstbewusstsein der Landbevölkerung, die von der Finanz- und Religionspolitik der Obrigkeit enttäuscht den Sturz der liberalen Regierung erwirkte. Das neue geistige Oberhaupt der Zürcher Regierung wurde Johann Caspar Bluntschli – später von Johann Jakob Röttinger in München besucht –, der das konservativ protestantische Lager vertrat[1302]. Weitere Kantone

1295 Frei, 1980, S. 852 ff., Kästli, 1998, S. 279: Die Rückkehr zu altständischen Verhältnissen blieb ein Versuch.
1296 Biaudet, 1980, S. 873 ff.
1297 Biaudet, 1980, S. 878.
1298 Biaudet, 1980, S. 910. Z.B. rechnete die Schweiz mit 11 verschiedenen Fuß- und 60 Ellenmaßen.
1299 Biaudet, 1980, S. 912.
1300 Biaudet, 1980, S. 914 f.
1301 Biaudet, 1980, S. 936 ff., bezüglich Flüchtlinge vgl. Lüthi, 1936, S. 52 ff.
1302 Biaudet, 1980, S. 938; bezüglich J.C. Bluntschli vgl. Anm. 875; bezüglich Zürich-Putsch Anm. 572.

folgten diesem Diktum, allen voran Luzern, wo der katholische Konservatismus seine höchste Ausprägung innerhalb der Eidgenossenschaft erhalten sollte. Die Aargauer kämpften für die Aufhebung der konfessionellen Parität, was 1841 gelang und die Katholiken auf den Plan rief. Nach kurzen Kampfhandlungen siegte die protestantisch liberale Mehrheit, was zwar die Aufhebung der Parität ermöglichte, den Konflikt jedoch weiter schwelen ließ. Dieser verdichtete sich in der Bildung eines geheimen Bündnisses der konservativen katholischen Kräfte – der Basis für den Sonderbund. Nun sollten Jesuiten, Vertreter der ultramontanen Interessengemeinschaft innerhalb der Kirche, nach Luzern geholt werden. Der Streit eskalierte und verschob die Macht an die Radikalen, die nach Zürich nun auch die Waadt eroberten. Gründe dafür waren unter anderem die neuen wirtschaftlichen Verhältnisse in der Schweiz. Die wachsende Bevölkerungszahl konnte durch den einheimischen Getreideanbau nicht mehr ernährt werden, was die Herstellung von Manufakturerzeugnissen vorantrieb und die Industrialisierung initiierte. Der kantonale Föderalismus behinderte jedoch sowohl den Handel mit dem Ausland wie auch den uneingeschränkten Warenaustausch innerhalb des Landes, während die Tagsatzung der souveränen kantonalen Wirtschaftspolitik machtlos gegenüberstand[1303]. Ohne tiefgreifende Reform des Bundesvertrags von 1815, eine Forderung sowohl Radikaler wie Liberaler, war die Situation nicht zu ändern[1304]. Ein Freischarenzug unter dem Bernischen Anwalt Ulrich Ochsenbein endete blutig, das Eintreffen der Jesuiten in Luzern und die Ermordung des ehemaligen Freischärlers Joseph Leu verhärteten die Fronten und lösten schließlich die Sonderallianz der Kantone Luzern, Uri, Schwyz, Unterwalden, Zug, Freiburg und Wallis aus. Die Bemühungen der Radikalen, zwei weitere Kantone gegen den Sonderbund und die Jesuiten aufzubringen, eskalierten in Genf 1846 zur Revolution, der bereits im Jahr zuvor der Lausanner Umschwung voranging. Auch in Wien und Paris war man ob der Auseinandersetzungen in der Schweiz beunruhigt und stellte im Falle einer

Eskalation und eines Bürgerkrieges Hilfe in Aussicht. Unter dem Oberbefehl von General Henri-Guillaume Dufour galt es nun, den Sonderbund auf Befehl der Tagsatzung mittels einer Truppe von 100000 Mann aufzulösen; auf der Gegenseite standen die Truppen unter General Salis-Soglio. Nach einem 26 Tage dauernden Feldzug konnte dank des strategischen und durchwegs menschlichen Vorgehens General Dufours der Auftrag erfüllt und Schlimmeres vermieden werden. Die Kantone kehrten zu ihren inneren Aufgaben zurück, die Sonderbunds-Kantone verzichteten auf ihre Allianz, die Jesuiten wurden ausgewiesen und die Kantonsregierungen befürworteten schließlich die Revision des Bundesvertrags von 1815[1305]. Mit dem Wiederaufbau der Eidgenossenschaft wurde die Entstehung der modernen Schweiz eingeleitet, deren Verfassung die Stabilität des Landes sicherte[1306].

Johann Jakob Röttinger kam im März 1844 nach Zürich, als der Jesuitenstreit im vollen Gange war und sich die Unzufriedenheit der Handwerker mit der Tagsatzung, angesichts deren Ohnmacht bezüglich der Handelsfreiheit, zuzuspitzen begann. Die Radikalen waren auf dem Vormarsch und die Konservativen begannen sich heimlich zu formieren. Es stellt sich die Frage, ob die damalige Schweiz für einen jungen, gut ausgebildeten Glasmaler ein erstrebenswertes Land mit sicherer Zukunft dargestellt haben mag. In Deutschland, dem Heimatland Johann Jakob Röttingers, herrschten allerdings nicht weniger angespannte Zeiten, die im folgenden Abschnitt mit Fokus auf die Stadt Nürnberg Beachtung finden.

1303 BIAUDET, 1980, S. 940 ff.
1304 KÄSTLI, 1998, S. 323.
1305 BIAUDET, 1980, S. 918 ff.; vgl. KÄSTLI, 1998, Freischarenzüge und Sonderbundskrieg, S. 335–344.
1306 BUCHER, 1980, 989 ff.

Restauration und Vormärz in Deutschland

Der Wiener Kongress 1848/1849 gilt als Endpunkt der Ära der französischen Revolution und als Versuch einen liberal-demokratischen National-staat zu gründen – zwei bedeutsame Ereignisse in der Geschichte Deutschlands und ganz Euro-pas[1307]. Dazwischen werden zwei Zeitabschnitte unterschieden, die Restauration (1815–1830) und der Vormärz (1830–1847), an deren Übergang die so genannte Julirevolution von 1830 stand[1308]. Das Biedermeier, ein von der Politik losgelöster Begriff, bezeichnet die bürgerliche Kultur dieser Jahrzehn-te und wird vor allem in der bildenden Kunst, der Literatur und teilweise auch in der Musik als Ent-wicklungslinie der Kunst des 19. Jahrhunderts gesehen[1309]. Während dieser «Stillhaltekultur»[1310] passierten jedoch bahnbrechende Umwälzungen mit nachhaltigen Wirkungen, wie die Einführung der industriellen Marktwirtschaft und der allge-meinen Mobilität dank neuer Transportmittel, des Übergangs von der ständischen zur bürgerlichen Gesellschaft und deren Bildungsmöglichkeiten, die Hervorbringung von Wissenschaften, die Er-findung der Fotografie, um nur einige Faktoren zu nennen.

Veränderungen in Europa

In der ersten Hälfte des 19. Jahrhunderts war Deutschland noch kein Nationalstaat und die Habsburger Monarchie die führende Kraft im Verbund – Wien kulturelle und politische Metro-pole. Kaiser Napoleon musste aufgrund der Be-setzung von Paris durch die Alliierten 1814 die Hauptstadt verlassen. Daraufhin erfolgte 1815 eine Neuordnung der Monarchien nach dynastischer Legitimation mit dem Ziel, die französischen Er-oberungen wieder rückgängig zu machen und die Gefahr einer neuerlichen Hegemonie in Zukunft zu bannen[1311]. Die Heilige Allianz (Russland, Österreich und Preußen) und eine Pentarchie zwischen Russland, Großbritannien, Österreich, Preußen und Frankreich ordneten die Außen-politik der ersten Jahre. Für Deutschland war der

Grundlagenvertrag eines föderalen Staatenbundes als übergreifende politische Struktur maßgeblich, worin die beiden Schwerpunktländer, Österreich und Preußen, enormen Druck ausübten[1312]. Die von Jena ausgehende politische Jugendbewegung der studentischen Burschenschaften trat 1817 auf dem Wartburgfest in Erscheinung, wo die Mark-steine nationaler Befreiung, 300 Jahre Reformati-on und vierter Jahrestag der Leipziger Völker-schlacht, gefeiert wurden. Das Befreiungsfest von römisch-papistischer wie napoleonischer Xenokra-tie initialisierte trotz des preußischen Verbots der Burschenschaften einen regen Zustrom der Bewe-gung bis hin zu politisch motivierten Attentaten. «Die revolutionären Umtriebe und demagogischen Verbindungen» wurden mithilfe der «Karlsbader Beschlüsse» eingedämmt. Auf eine vielverspre-chende Reformperiode folgte eine Zeit der politi-schen Stagnation, die dennoch von bestimmten Ereignissen unterbrochen wurde, wie die Inter-vention in Griechenland – Otto von Bayern wird 1832 König – oder das öffentliche Wirken der Vereine in Bezug auf Wohlfahrt, Bildung und Kultur. Die Julirevolution 1830 erzwang die Flucht des restaurativen französischen Herrschers, König Charles X., und die Einsetzung Louis-Philippes, Belgien trennte sich vom Königshaus der Nieder-lande, hingegen misslangen Aufstände in War-schau gegen die russische Herrschaft wie auch Auflehnungen in Ober- und Mittelitalien[1313].

Deutschland formiert sich

In Deutschland führte vor allem die Unzufrieden-heit mit der Verwaltung, der Teuerung und den Erwerbskrisen im Handwerk zu lokalen Unruhen. Mancherorts wurden die Aufständischen durch die Einführung konstitutioneller Verfassungen

1307 Vgl. dazu OSTERHAMMEL, 2009, S. 77 ff.
1308 GEISTHÖVEL, 2008, S. 9.
1309 LDK 1, 2004, S. 533, Stichw. *Biedermeier.*
1310 GEISTHÖVEL, 2008, S. 9.
1311 GEISTHÖVEL, 2008, S. 12 ff.
1312 GEISTHÖVEL, 2008, S. 15 f.
1313 GEISTHÖVEL, 2008, S. 28 f.

belohnt[1314]. Im ganzen Vormärz bildete die Zensur ein wichtiges Signum der Unterdrückungspolitik, die nicht nur die Medien, sondern auch junge deutsche Literaten betraf und eine Welle der politischen Auswanderung auslöste. Nach der Julirevolution erstarkte die Fraktion der Liberalen, die ständische Privilegien wie auch berufsständische und religiöse Einschränkungen ablehnten, sich hingegen nicht, weil nicht demokratisch gesinnt, für gleiche politische Rechte einsetzten. Das Vereinswesen der 1840er Jahre bildete eine Plattform des nationalen Gemeinschaftsgefühls; die Bewegung der Turner und Sänger war in verschiedenen bürgerlichen Schichten vertreten und patriotisch-volkstümlich einsetzbar. Wegen der Nähe zu den Burschenschaften wurden diese Vereinigungen im Zuge der Demagogenverfolgung verboten. In den Dreißiger- und Vierzigerjahren, als das Vereinswesen weniger restriktiv gehandhabt wurde, traten mehrheitlich mittelständische erwachsene Berufsleute zusammen, in den Gesangsvereinen eher die Handwerksmeister und bei den Turnern die Gesellen, und nutzten vor allem die Feste als Aktionsplattform. In Abgrenzung ihrer weltanschaulichen Profile begannen sich Gruppierungen zu formieren, die als Vorläufer des parlamentarischen Parteiensystems gesehen werden können. Der Bevölkerungszuwachs lag in Deutschland zwischen 1816 und 1847 bei etwa 30 Prozent und initiierte 1816/1817 anlässlich einer Hungersnot eine erste Wanderungswelle von Kleinbauern und Handwerkern. Weitere Jahre der Lebensmittelknappheit waren 1822, 1830/1831, 1838/1839, bevor in den Jahren 1846/1847 abermals eine große Hungersnot eintrat[1315]. Die ökonomische Krise der Vierzigerjahre – Symptom war unter anderem der starke zahlenmäßige Anstieg der Gesellen – löste eine erste große Migrationswelle nach Übersee aus; viel häufiger waren jedoch Binnenwanderungen vom Land in die Städte.

Johann Jakob Röttingers Heimatstadt Nürnberg bildete wie Bamberg und Würzburg eine bayerische Hochburg des Liberalismus. Große Hoffnungen setzte man auf König Ludwig I. (1825–1848), der dem Ruf des liberalen Herrschers gerecht wurde,

indem er der geforderten Lockerung der Zensur entsprach und die Handels- und Gewerbegesetze liberalisierte. Alsbald spalteten Konflikte mit dem Bürgermeister die Bürgerschaft und brachten die Stadt während der Julirevolution an den Rand eines Aufruhrs, worauf der König wegen der landesweiten Krawalle zu einer autokratischen Herrschaftsform überging. 1832 waren anlässlich der Unruhen zwei Todesopfer zu beklagen. Die liberale Bewegung ging trotz der Restriktionen weiter und unter der Tarnung von Unterstützervereinen (für Griechen, Polen) formierten sich erste Parteigruppen. Gegen Mitte der Vierzigerjahre nahmen die Unruhen erneut zu und nötigten die bayerische Regierung zur massiven Aufstockung der Nürnberger Garnison[1316].

Die Schweiz als Symbol für die Freiheit

Für Auswanderungen in die Schweiz gaben die bereits im 18. Jahrhundert aufgekommenen Schweizerreisen nicht zu unterschätzende Anregungen, obwohl in der ersten Hälfte des 19. Jahrhunderts nicht die Deutschen den Hauptteil der Reisenden stellten. Natur- und Kunstfreunde, Schriftsteller, Professoren und Studenten ließen sich von den neuen Reisebüchern und -karten (um 1810) leiten und besuchten das gelobte, viel beneidete Land der romantischen Sehnsucht mit dem Bergmassiv der Rigi als Hauptanziehungspunkt. Während in Deutschland in den Dreißigerjahren die Liberalen zur Bildung eines Volksstaats gegen die absolute Monarchie kämpften, ging es in der Schweiz «nur noch» um die Ausformung des Volksstaats – ob als moderne nationale Demokratie oder als der regionale altertümliche Stammstaat[1317]. Die große

1314 GEISTHÖVEL, 2008, S. 30 ff.
1315 GEISTHÖVEL, 2008, S. 82 ff.
1316 Vgl. MERTENS, SA Nürnberg online-Service, Stichw. *Vormärz*.
1317 NÄF (Hrsg.), 1936, S. 5 ff. Bekannte Schweizerreisende im 19. Jahrhundert waren unter anderem Freiherr vom Stein und Joseph Görres um 1820, dessen Sohn Guido Görres 1839, Johann Nep. v. Ringeis 1844 – sie alle interessierten sich für die katholische Schweiz, für Ringeis galt der Liberalismus als «antiklerikal und irreligiös» (S. 46).

Faszination der Reisenden galt wahrscheinlich dem Symbolcharakter der Schweizerischen Freiheit – ein Ideal, das sich damals im eigenen Land nicht verwirklichen ließ.

Kunst- und kulturgeschichtliche Kriterien

Zu Beginn des 19. Jahrhunderts kollidierten zwei Geschichtsepochen – das heidnische Altertum und das christliche Mittelalter. Die statischen, überschaubaren Formen der aufgeklärten, ruhigen Grazie der Antike mit klaren Begrenzungen zeugen von Anmut, Harmonie und Kultur – des Klassizisten «irdisches Paradies», wo dieser in der aufgeklärten Philosophie die Wiederkehr des Goldenen Zeitalters erwartete. Der Mensch des frühen 19. Jahrhunderts verlangte nach der Illusion eines «irdischen Paradieses», da die Welt, in der er lebte, immer kruder wurde[1318]. Andererseits erstaunt es nicht, dass die Kunst der Romantik und vor allem der Nazarener von der «Rückkehr des Religiösen» überformt an Bedeutung gewann. Die ausgeprägte Rationalisierung zu Beginn der industriellen Revolution und die Vorzugsstellung der sich anbahnenden Wissenschaften, von vielen als Krisis verstanden, löste eine Bedrängnis aus, die für das Religiöse empfänglich machte. Die Monarchien der Heiligen Allianz wählten die christliche Religion als höchstes Gebot ihrer Macht, um den Feudalismus zu bewahren und sich der Bedrohung der Reformen und Revolutionen zu erwehren[1319]. In der Zeit von 1790 bis 1830 polarisierte sich eine Gegenbewegung zur Aufklärung, die im Sinne einer Rückwendung zur Kunst des «Mittelalters», allen voran die altdeutschen Meister und die Künstler der italienischen Renaissance, verehrte und nachahmte[1320]. So meinte auch der Stuttgarter Maler, Architekt und Landschaftsplaner der Neugotik, der «Künstler-Architekt» Carl Alexander Heideloff (1789–1865), «mit der romantischen Kategorie die altdeutsche Architektur und ihre

Eignung zur Erinnerung an die phantasievolle und christliche Werte bergende Epoche der Gotik»[1321]. Heideloff wünschte sich die Dogmatisierung der «altdeutschen Baukunst», um diese als nationales Integrationsinstrument einzusetzen sowie die Aufhebung der Autonomie der Kunst und deren Vereinigung mit dem Kunstgewerbe[1322]. Demgegenüber wird mit dem Beginn des 19. Jahrhunderts eine Konfrontation mit der Freiheit des Künstlers initiiert, als Teil des Kampfes um die Eigenständigkeit des Individuums, wie dies in der Französischen Revolution proklamiert worden war[1323]. Dies betraf sowohl die klassizistischen Künstler wie auch diejenigen, die sich mit der rückwärts gewandten Kunst des Mittelalters beschäftigten, um dabei «in den Schoss der Mutter zurückzukehren und so eine Kunstepoche zu begründen»[1324]. Gemeint sind die Nazarener, die ihren Bund dem heiligen Lukas unterstellten, sich der Wiener Akademie widersetzten und sich so als Pioniere der Moderne, als frühe Sezessionisten, zu erkennen gaben, während sie programmatisch, mit Dogma und Strategie, Kunstschaffen und kollektive Existenzform zu verbinden wussten[1325]. Dabei ist die politische Dimension der Nazarener nicht außer Acht zu lassen, die sich vor und während der Befreiungskriege von 1813 in Rom zur Ponte-Molle Gesellschaft zusammengeschlossen haben und die Wiederkehr der alten Zustände sowie die Befreiung und Erhebung des Vaterlandes feierten[1326].

1318 HOFMANN, 1991, S. 230 ff. Werner Hofmann verweist auf Schinkel und Ingres.
1319 STEINLE, 2005, S. 15 ff.
1320 STEINLE, 2005, S. 26.
1321 HEINIG, 2010, Elektronische Ressource (Rezension), Andrea Knop zitiert nach Heideloff.
1322 GÖTZ, 1981, S. 107.
1323 KOCH, 1962, S. 41 f.
1324 WYSS, 2005, S. 155. Wyss zitiert ein Goethe-Zitat aus Gallwitz, KAT. AUSST. FRANKFURT, 1977: Goethe an Sulpiz Boisserée.
1325 HOLLEIN, 2005, S. 9.
1326 HUBER, 1981, S. 44 ff.: Zu Ostern 1819 wurde das österreichische Kaiserpaar anlässlich ihres Papstbesuches vor den «Künstlern im deutschen Rock» gewarnt, ereignete sich doch einige Wochen vorher der Mord August von

Schließlich führte die Spaltung heterogener historischer Elemente, die von der «Dekontextualisierung christlicher Kunst» nach der Revolution und von der damit einhergehenden Empfindsamkeit und Rückbesinnung begleitet wurde, zu einer auf den Historismus hinweisenden Situierung unter Einbezug von Geschichte, Kunst und Denkmalpflege[1327]. Voraussetzung für den Historismus waren nach Reinhart Koselleck die im 18. Jahrhundert in Angriff genommene geschichtliche Gliederung, also die «Erfindung des Mittelalters» und des im 19. Jahrhundert entstandenen Nachfolgebegriffs der «Renaissance». Die Reflexion der geschichtlichen Welt war erst mit der Entdeckung des Fortschritts, der neuen Zeit nach der Revolution, möglich und entfaltete im Historismus ungeahnte Möglichkeiten[1328]. 1828 wird das Dilemma des Stilpluralismus von Heinrich Hübsch aufgegriffen, 1844 vom Philosophen und Theoretiker Friedrich Theodor Vischer fortgeführt, bis schließlich 1874 Friedrich Nietzsche in «Vom Nutzen und Nachteil der Historie für das Leben» den zur Wissenschaft avancierten Historismus reflektierte[1329].

August Reichensperger stellt in seiner Streitschrift, anlässlich einer Publikation von Julius Lessing (1843–1908)[1330] über «die Renaissance im heutigen Kunstgewerbe», den Kunsthandwerkern des Historismus ein schlechtes Zeugnis aus, indem er «dem Gemische von vielen Stilen» nur im höchsten Ausnahmefall eine «Befriedigung des Kennerauges» zugesteht. Darüber hinaus kritisiert er die zeitgenössische Ausbildung der Kunsthandwerker in den Zeichen- und Meisterschulen, gerade weil vor allem erstere der gegenwärtigen Stilmengerei nur Vorschub leistete. Solche Zeit- und Papierverschwendung wären den alten Meistern fremd gewesen, diese hätten sich direkt mit dem Material ihres Kunsthandwerks beschäftigt. Nicht anders sei es bei den Vertretern der hohen Künste, die durch die «Anklammerung an die Renaissance» mit dem Attribut «deutsch» ihrem Werk einen nationalen Touch verleihen wollten. Reichensperger postulierte die Rückkehr zu Kunst und Kunsthandwerk auf einer festen, religiös-sittlichen Basis,

eine Situation, die das frühere Innungswesen gewährleistet habe. Die Abkehr von der Architektur übte vor allem auf das Kunstgewerbe einen nachteiligen Einfluss aus, dies gelte auch für die ornamentale Glas- und Wandmalerei, die sich mit dem naturalistischen Staffeleistil, mit akademischer Korrektheit und Perspektive nicht vertrage[1331].

Johann Jakob Röttinger zwischen den Stilen

Die Vielschichtigkeit seiner Zeit brachte dem Glasmaler Johann Jakob Röttinger einerseits eine außerordentliche Vielfalt an künstlerischen Möglichkeiten, andererseits verdichteten ökonomische, soziale und künstlerisch-religiöse Parameter die Palette seines Schaffens auf die schmale Bühne sakraler und heraldisch-patriotischer Kunst. Darüber hinaus musste der Glasmaler seine Vorstellungen als Künstler *und* Kunsthandwerker an die Ansprüche der Auftraggeber anpassen und im Einvernehmen mit Bauherren, Architekten und Stiftern akzeptable Lösungen finden. August Reichenspergers Pamphlet gegen die zeitgenössische Arbeit der im Dienste des Historismus wirkenden Künstler und gegen die Ausbildung in den Zeichenschulen musste vor diesem Hintergrund eher Unverständnis ausgelöst haben, denn welcher Künstler wie auch Kunsthandwerker konnte es

Kotzebue durch den Studenten Sand. Die Ponte-Molle Gesellschaft muss als eine Art Empfangskomitee für neu eintreffende deutsche Künstler in Rom gesehen werden.

1327 OEXLE, 2007, S. 30 f.

1328 OEXLE, 2007, S. 26 ff. Gerhard Oexle bezieht sich auf Reinhart Koselleck, Moderne Sozialgeschichte und historische Zeiten, in: Pietro Rossi (Hrsg.), Theorie der modernen Geschichtsschreibung, Frankfurt am Main 1987, S. 173–190.

1329 OEXLE, 2007, S. 38 f.

1330 Deutscher Kunsthistoriker und Direktor des Berliner Kunstgewerbemuseums.

1331 REICHENSPERGER, 1879, S. 32–43. Diese Anschauung korreliert mit den «Regeln der christlichen Kunst» wie sie Karl Atz in seinem Handbuch proklamierte. Vgl. Kap. ««…gemäß den Regeln und Gesetzen der Ästhetik und der christlichen Kunst […]».

sich leisten Kunst zu produzieren, ohne auf die Wünsche seiner Kunden einzugehen? Es galt zuletzt, inhaltlich wie formal die Vorgaben inklusive des vereinbarten Kostenrahmens einzuhalten. Die Ausführung nach den «Regeln der christlichen Kunst» wurde bereits als konfessionelles, mehrheitlich katholisches Desiderium innerhalb der sakralen Kunst definiert, während die Protestanten ihr Augenmerk auf Kunstgerechtigkeit und Solidität der Arbeit legten, allerdings die Vermeidung der «katholischen Manier» anstrebten. Da sich fast ausschließlich Hinweise auf sakrale Kunst überliefert haben, fällt das profane Werk Röttingers in Bezug auf die kunsthistorische Stellung kaum in Betracht. Die beiden erhaltenen Wappenzyklen sind thematisch und formal in der heraldischen Kunst verhaftet und lassen nur einen kleinen künstlerischen Freiraum offen[1332]. In den meisten Kirchen galt die von ikonographischen Aspekten geleitete mittelalterliche Hierarchie der Bildwerte, was die Verortung szenischer Glasmalereien im Chor und ornamentaler Fenster im Kirchenschiff implizierte. Die Auswahl der Ikonographie durch die jeweiligen Pfarrer, Kirchenvorstände beziehungsweise Kirchgemeinderäte wird unter anderem auch für die Glasmalereien in den Kirchen von Thüringen bestätigt[1333]. Darüber hinaus bekräftigt das Autorenteam, Falko Bornschein und Uwe Gaßmann, die unterschiedlichen Bedürfnisse großer Stadtkirchen, kleiner Pfarrkirchen, Klosterkirchen, Friedhofkapellen etc., wobei – dieser Aspekt muss betont werden – das jeweilige Budget eine bedeutende Rolle bei der Gestaltung und somit auch für den Bildinhalt spielte.

Werkstattstil

Für das Œuvre Johann Jakob Röttingers sind, abgesehen von der Situation der notwendigen Abstimmungen mit den Auftraggebern, vor allem drei Faktoren von künstlerischer Relevanz. Die Nürnberger Periode, also die Ausbildung an der Kunstgewerbeschule sowie die Gehilfenzeit beim Glasmaler Franz Joseph Sauterleute, die Aufenthalte in München, die unter anderem dem Studium

der Glasmalereien in der Maria-Hilf-Kirche gedient haben sowie die Selbsteinschätzung Johann Jakob Röttingers als Spätnazarener. Mangels graphischer wie auch glasmalerischer Überlieferung aus der Frühzeit seines Schaffens wäre jede Beurteilung seines ursprünglichen Mal- und Zeichenstils rein spekulativ[1334]. Die kleinen Wappenscheiben der Gruftkapelle in Regensburg sowie dieselben im Schloss Lichtenstein aus den späten Dreißiger- und frühen Vierzigerjahren könnten bestenfalls zur Bestimmung des Kolorits herangezogen werden, jedoch nicht für die Verifizierung stilistischer Merkmale. Eine Ausnahme würden die Kirchenväter-Fenster auf der Chorempore in Leuggern von 1854 bilden, wo persönlich gestaltete Signaturen (Abb. 9, 10) auf die Autorschaft des Patrons selbst hinweisen, wären die Figuren nicht nach Vorlagen der Münchner Glasmalereianstalt entworfen worden[1335]. Vor allem Kirchenvater Gregorius' Gesicht zeigen Entsprechungen in der Augenpartie, mit Hervorhebung von Augapfel und Iris, wie sie in Röttingers Werk immer wieder vorkommen[1336]. Die Figuren, die vom Kirchenschiff aus nicht erkennbar sind, zeichnen sich durch sehr unterschiedliche Physiognomien aus, Persönlichkeit und Eigenart treffen auch auf Habitus und Haltung zu. Die schweren Körper werden durch üppige liturgische Kleider verhüllt – nur die Schuhspitzen schauen hervor. Darüber hinaus muss davon ausgegangen werden, dass viele Glasmalereien Röttingers als Werkstattproduktionen anzusprechen sind, an welchen mehrere Hände beteiligt

1332 Vgl. Kap. ‹Wappenzyklen in öffentlichen Bauten als Reminiszenzen Eidgenössischer Aristokratie›. Hier stand vor allem das ehrende Andenken der altehrwürdigen Geschlechter im Vordergrund sowie die distinguierende Funktion der Heraldik.
1333 BORNSCHEIN/GASSMANN, 2006, S. 33 f.
1334 Die signierten oder durch Schriftdokumente zuschreibbaren Blätter wurden im Kap. ‹Maquetten› besprochen, die nicht signierten undatierten Zeichnungen sind häufig mit dem Firmenstempel der Söhne Jakob Georg und Heinrich versehen.
1335 Vgl. Anm. 192.
1336 Vgl. Abb. 36; Abb. 42–43, Sankt Oswald, Zug, v.a. Franziskus und Elisabeth; Abb. 100 die Muttergottes mit dem Jesuskind in Alterswil FR.

waren beziehungsweise nach Kartons interner oder externer Maler (Felix Bleuler, Melchior Paul Deschwanden, Georg Kellner) geschaffen wurden. So ist beispielsweise am Glasgemälde «Mariä Verkündigung» in Bünzen (N II) die Handschrift des Schweizer Kirchenmalers und «Apostels nazarenischer Malerei» schlechthin, Melchior Paul Deschwanden, anzunehmen, der in der Pfarrkirche zu Bünzen weitere Ölgemälde hinterlassen hatte, worauf schon Astrid Kaiser Trümpler hinwies[1337]. Deschwanden traf 1840 mit Friedrich Overbeck in Rom zusammen, eine Begegnung, die Deschwandens Entschluss zur ausschließlichen Hinwendung kirchlich-religiöser Malerei im nazarenischen Stil festigte und seinen Heiligenfiguren fortan demutsvollen Ernst verlieh. Overbeck riet seinem Schweizer Kollegen den schwärmerischen Stil der Romantiker zu verlassen und die Alten Meister zu vertiefen[1338], was beim Verkündigungsfenster in Anlehnung an italienische beziehungsweise flämische Meister vorstellbar ist. Die Darstellung der Auferstehung (S II) im gegenüberliegenden Fenster und dessen Entwurf möchte man hingegen gerne Johann Jakob Röttinger selbst zuschreiben. Im Vergleich zum Verkündigungsengel in N II sind die Züge des Engels am Grab gröber, die Statur wirkt weniger grazil, allgemein scheinen die Figuren jedoch natürlicher (Abb. 108). Außerdem zeigt keine der Personen den irdisch entrückten Blick, den Deschwanden im Sinne der von ihm nie vollständig abgelegten Sentimentalität in seinen Bildern umsetzte. In beiden Chorfenstern spielen die Szenen auf einer Bühne und geben den Ausblick in eine Landschaft frei, was Deschwanden auf seinen Ölgemälden gerne vermied, um bei der Betrachtung der heiligen Personen keinerlei visuelle Ablenkung auszulösen[1339]. Unter Berücksichtigung der genannten Argumente ist dem Entwurf, wahrscheinlich sogar der Anfertigung des Kartons, durch Johann Jakob Röttinger oder einem seiner Mitarbeiter der Vorzug zu geben. Wie aus der bereits zitierten Korrespondenz mit Deschwanden hervorgegangen, unterstützte dieser den Glasmaler und korrigierte, wenn die Umsetzung der Figuren auf die Originalgröße nicht nach dessen

Vorstellungen gelungen war oder lieferte erste Skizzen, deren künstlerische Bearbeitung bis hin zum Karton Röttinger selbst respektive Mitarbeiter im Atelier leisteten[1340]. Der Vergleich zwischen dem Weihnachtsfenster (s III) (Abb. 144) in der Pfarrkirche Pieterlen (1858/1859) und Deschwandens Darstellung der «Heiligen Familie mit Elisabeth und dem Johannesknaben» für das Minoritinnenkloster Sankt Joseph in Solothurn zeigt vor allem in der Figur des Josephs sowie in der Bildkomposition deutliche Ähnlichkeiten. Joseph, der stehend dem Betrachter zugewandt ist, blickt fürsorglich auf die Personengruppe seiner Familie herab und stützt sich mit übereinandergelegten Händen auf seinen Stock. Röttinger übernahm im Weihnachtsfenster auch Deschwandens Position der Maria in der linken Bildhälfte. Das ursprünglich vom Solothurner Maler Frank Buchser (1828–1890) geschaffene Bild musste auf Wunsch der Auftraggeber von Deschwanden übermalt werden und lehnt sich an Raffaels «Heilige Familie» aus dem Hause Canigiani von 1505/1506 (Abb. 145) in der Alten Pinakothek an[1341]. Röttingers Maltechnik – die Entwicklung der Figuren aus der Fläche und aus mehrfach additiv aufgetragenen Farbschichten – erzeugte einen Modus, der der flächenbetonenden Malerei der Gotik entgegengesetzt ist, nämlich eine plastische Formung der Figuren. Diese von den Neugotikern, die die Nachahmung der Kunst des 13. Jahrhunderts reklamierten, despektierlich als «Staffeleibilder» titulierte Art der Glasmalerei nach dem Münchner Schema wurde in Varianten für die Glasmalerei im gesamten deutschsprachigen Raum normativ[1342].

1337 wie Anm. 1039.
1338 Tobler, 1985, S. 53–96.
1339 Tobler, 1985, S. 63 ff.
1340 Zitat aus einem Schreiben Deschwandens an Röttinger: «[...], die Sie wahrscheinlich auszuführen bekommen werden [...] erbiete mich zur Korrektur der durch Sie in die Naturgröße zu übersetzende Zeichnung seiner Zeit, wobei ich dann in Köpfen und Gliedern nachholen kann, was im Kleinen zurückblieb [...].» Vgl. Anm. 1038.
1341 Tobler, 1985, S. 104, Katalognummer I/18, I/19.
1342 Vaassen, 1993, S. 19; vgl. Reichensperger, 1879 sowie Viollet-le-Duc, 1868; Anm. 1251, 1252.

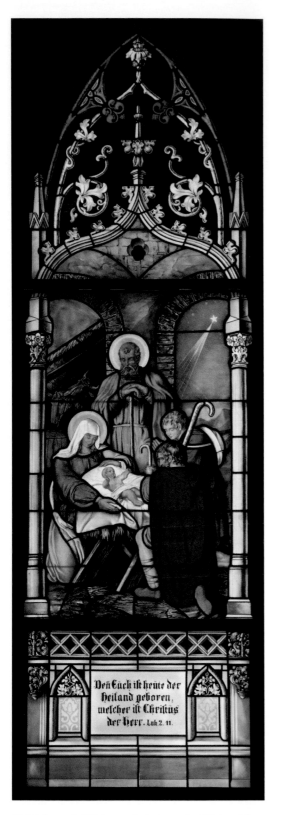

144. Johann J. Röttinger, Anbetung der Hirten, Chorfenster s III, Evangelisch-Reformierte Pfarrkirche Pieterlen BE, 1859.

So ist es nicht verwunderlich, dass die Münchner Maria-Hilf-Kirche mit ihren Glasgemälden – entstanden unter der Ägide des Malers Heinrich Maria v. Hess und ausgeführt von seinen Schülern – zum Mekka der Glasmaler wurde. Johann Schraudolph tat sich bereits 1828 als junges Talent anlässlich der Entwürfe für den Regensburger Dom hervor und arrivierte bald zum engen Mitarbeiter von Heinrich Maria v. Hess (1798–1863), dessen Nachfolge er als Professor an der Akademie 1849 antrat. Neben der Schaffung ausschmückender Malereien in der Münchner Allerheiligen-Hofkirche und in der Benediktinerabtei Sankt Bonifaz profilierte sich Schraudolph vor allem infolge seiner Arbeit im Speyerer Dom – einer Art «Konkurrenzunternehmen zum Kölner Dom»[1343], Entwürfen für die Maria-Hilf-Kirche in der Au, im Augsburger Dom, des Weiteren in England und im Vatikan. Hess und Schraudolph waren als «begnadete Kirchenmaler» vor allem von König Ludwig sehr geschätzt[1344]. Folglich wählte der König für die Ausmalung des Speyerer Doms Johann Schraudolph, zielte er doch mit seinem Vorhaben auf eine «Veredelung der Menschheit» durch Bildung, Kunst und Wissenschaft ab[1345]. Mit Vorliebe übernahm man Bildmaterial nach Raffael und seinen Zeitgenossen, nach frühen Nazarenern und kopierte sanktionierte Formen und Formeln zur Bestätigung der eigenen Arbeit[1346]. Die Übernahme von Motiven aus der Malerei erfreute sich schon in der spätgotischen Glasmalerei großer Beliebtheit, so adaptierten die Straßburger Glasmalereiwerkstätten Motive aus der burgundisch-niederländischen Kunst, indem sie Bildkompositionen selbstbewusst an veränderte Gegebenheiten anpassten[1347]. Joseph A. Fischer (1814–1859), Schüler der Münchener Akademie unter Joseph

1343 VERBEEK, 1961, S. 144f.
1344 VAASSEN, 2007, S. 32f., vgl. VERBEEK, 1961, S. 138–164.
1345 JÖCKLE, 2012, S. 26.
1346 VERBEEK, 1961, S. 156f.
1347 ROTH, 1995, S. 27–41.

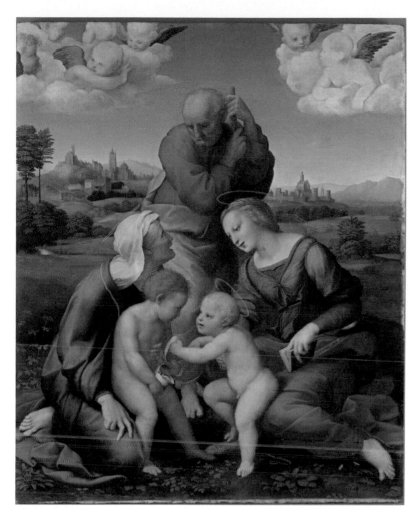

145. Raffael, Madonna Canigiani,
Holztafel 131×107 cm, 1505/06, München,
Bayerische Staatsgemäldesammlungen,
Alte Pinakothek (Inv. Nr. 476).

Schlotthauer (1789–1869) und Entwerfer ausschließlich religiöser Kunst, schuf nach Italienaufenthalten vor allem Kartons für die Maria-Hilf-Kirche und für den Kölner Dom[1348]. Röttingers Studium der Fenster in der Münchner Maria-Hilf-Kirche wurde bereits Rechnung getragen, so dass von einer Anlehnung an die Malerei der Protagonisten, unter anderem Heinrich Maria von Hess, Joseph A. Fischer und Johann Schraudolph auszugehen ist, «ohne aber die gleiche Qualität und den raffinierten Auftrag von Glasmalfarben zu erreichen», wie Elgin Vaassen in ihrer Stellungnahme festhielt[1349]. Wenngleich man Röttingers Figuren eine gewisse «Lebendigkeit» nicht absprechen kann, wirken sie weniger malerisch als die Münchener, hingegen bodenständig in Bezug auf seine Nürnberger Herkunft und Ausbildung. Norbert

Suhr ordnet insbesondere der spätnazarenischen Malerei Merkmale wie Symmetrie – oft als Erstarrung interpretiert – Frontalität und Akzentuierung der liturgischen Bedeutung zu[1350]. Irene Haberland rechtfertigt die häufige Kritik der regungslosen Haltung spätnazarenischer Heiligenfiguren in Einzelkompositionen. Die Auffassung als Schutzheilige befreit diese vom Agieren und legitimiert deren losgelöste Darstellung vor der Landschaft[1351].

1348 BOETTICHER, 1979, Bd. 1, S. 324, Stichw. *Fischer Joseph Anton.*
1349 BIOGRAPHISCHES LEXIKON DER SCHWEIZER KUNST 2, 1998, Stichw. *Johann Jakob Röttinger*, S. 887 (Elgin Vaassen).
1350 SUHR, 2012, S. 19.
1351 HABERLAND, 2012, S. 54; vgl. die Ausführungen im Kap. ‹Die Nazarener als Vorbilder für den Stil der Glasmalerei im 19. Jahrhundert› über die «Historie ohne Handlung».

Während der Vorwurf der Bewegungslosigkeit auf viele der von Röttinger in Tabernakeln eingestellten Einzelfiguren zutrifft, die dabei aufgrund ihres Stillstehens eine skulpturale Wirkung erzielen, erscheinen die Darstellungen von Szenen in harmonischer und ideenreicher Anordnung. Als Beispiel sei erneut auf das südliche Chorfenster der «Auferstehung» in Bünzen verwiesen (Abb. 108), dessen Grabwächter durchaus temperamentvoll auf den Schrecken reagieren. Dem Glasmaler gelang es auch bei der Schaffung der «Bergpredigt» in Oberentfelden, die Gläubigen in eine sehr wirklichkeitsnahe Stimmung zu versetzen. Während die Apostel und weitere Interessierte aufmerksam lauschen, unterhalten sich weiter hinten positionierte Zuhörer leise miteinander. Die Lichtführung akzentuiert die Situation und lässt die Personen im Hintergrund im Dämmerlicht verschwinden (Abb. 45). Die Zeit bei Sauterleute lehrte ihn nicht nur eine hervorragende Maltechnik – die Entwicklung plastischer Dreidimensionalität durch Schichtung von Lasuren, wie es die zeitgenössische Tafelmalerei vorgab[1352] –, sondern festigte die Beibehaltung der in der Kunstgewerbeschule zu Nürnberg unter dem Kupferstecher Albrecht Christoph Reindel gezeichneten Figuren. Etwas weniger körperbetont als diese, jedoch keineswegs frömmelnd und süßlich im Ausdruck, orientierte sich Röttinger Zeit seines Schaffens an der «Machart» seiner frühen Lehrer, um unter Einbezug der Rezeption von Dürer und Reni daraus seinen eigenen Stil zu entwickeln. Dass sich sowohl Röttinger als auch seine Lehrer Reindel, Sauterleute und Hirnschrot an die Nürnberger Vorbilder hielten, veranschaulicht die Gegenüberstellung ihrer Petrusgestalten (Abb. 26–29). Das Kolorit, dessen Farbkontrast von Kritikern zu stark und von der Wirkung her plakativ empfunden wurde, lässt sich wie bei Sauterleute oder den Mitgliedern der Kellner-Familie ebenfalls auf die künstlerische Heimat Nürnberg zurückführen. Sowohl die in der ersten Jahrhunderthälfte noch eingeschränkte Vielfalt an farbigem Glas wie auch

146. Franz J. Sauterleute, König David, Regensburg, Gruftkapelle Thurn und Taxis, 1837–1843.

der witterungsbedingte Verlust an Lasuren konnten diesen Effekt bisweilen verstärken (Abb. 146), wie dies schon mehrmals an den Glasmalereien der Gruftkapelle konstatiert wurde[1353]. Da Johann Jakob Röttinger selbst wohl nie in Italien gewesen sein dürfte, ist seine malerische Auffassung eher nach dem nördlich der Alpen geübten Modus – man denke an «Dürers vier Apostel» als Vorbild – als nach südlicher Manier angelegt, was seiner Kunst Authentizität und Ehrlichkeit verleiht. Die Vorbildwirkung Dürers läßt sich am Rapperswiler Beispiel gut veranschaulichen (Abb. 30, 91). Die

1352 NAGEL/VON RODA, 1998, S. 19.
1353 BIOGRAPHISCHES LEXIKON DER SCHWEIZER KUNST 2, 1998, S. 887, Stichw. *Johann Jakob Röttinger* (Elgin Vaassen); bezüglich Farbpalette vgl. VAASSEN, 1993, S. 23.

Diskussion um den so genannten «Nürnberger Stil», der deutschen Renaissance mit spezifisch Nürnbergischer Ausprägung, die die spätmittelalterliche Kunst Nürnbergs in den Achtziger- und Neunzigerjahren stark abwertete, klammerte Vischers Figuren am Sebaldusgrabe aus, da aus diesen «schlankeren und graziöseren Formen … einen wieder selige Erinnerungen an den schönen Süden …» anwehen[1354].

Die Verbindung Johann Jakob Röttingers zur so genannten Düsseldorfer Malerschule, die archivalisch bisher nicht belegbar ist, manifestiert sich möglicherweise bereits via Heinrich Maria von Hess, der als Schüler Peter Cornelius' 1825 aus Düsseldorf nach München gekommen war[1355] und dessen Werke (vgl. Abb. 81) von Röttinger in München rezipiert worden sind. Auf Cornelius folgte als Leiter der Düsseldorfer Akademie, Wilhelm von Schadow, ebenfalls aus dem Kreis der Deutsch-Römer stammend, welcher als Sohn des klassizistischen Berliner Bildhauers, Johann Gottfried Schadow (1764–1850), die Synthese von Malerei und Plastik in Hinwendung zur Natur, zum Modell und zum Kolorismus umsetzte. Die Brüder Karl Rudolf und Friedrich Wilhelm von Schadow lebten während ihrer Zeit in Rom mit dem dänischen Bildhauer Bertel Thorvaldsen[1356], dessen Christusfigur für die Kopenhagener Frauenkirche einen lehrenden beziehungsweise einladenden Christus darstellt und Johann Jakob Röttinger bei der Schaffung seiner Figuren neben Dannecker inspiriert haben wird. Die politische Lage in Deutschland, die Resignation des deutschen Bürgertums nach 1815 sowie die christlichen und monarchischen Gesichtspunkte boten einen guten Nährboden für die reaktionäre Ideologie der mittlerweile akademisch gewordenen nazarenischen Kunst. Während der Julirevolution 1830 nutzte Friedrich Wilhelm III. die Religion zur Immunisierung des Volkes gegen aufständisches Gedankengut und zur Festigung dessen Beziehung zum Herrscherhaus. Dies waren günstige Voraussetzungen für den eben wieder aus Rom heimgekehrten Wilhelm von Schadow und der Intensivierung der alten nazarenischen Ideale[1357]. Seine

Schüler interessierten sich für die Weiterführung der Ideologie der Lukasbrüder – zuerst Ernst Deger (1809–1885), später die Brüder Andreas (1811–1890) und Carl Müller sowie Franz Ittenbach (1813–1879), die die Protagonisten der Düsseldorfer Spätnazarener bildeten. Das Hauptwerk der Künstlergruppe stellte die malerische Ausstattung der 1838 neu erbauten neugotischen Kirche in Remagen dar, deren Ausmalung von 1843 bis 1853 dauerte und als Gesamtkunstwerk zu den Hauptleistungen der Neugotik wie auch der späteren nazarenischen Malerei zählt. Schon während der Ausführung wurden infolge der Zunahme von bürgerlich-liberalen Ideen Stimmen laut, die an den zärtlich schmachtenden, kindlich frommen Figuren keinen Gefallen mehr finden konnten[1358] – wohl ein Zeichen, dass diese Kunst im Begriffe war von der Zeit überholt zu werden. Der 1856 von M. P. Deschwanden, eventuell im Auftrag Röttingers (?) gezeichnete, nicht zur Ausführung gelangte Entwurf «Christus als Weltenrichter» (Abb. 147) für das Basler Münster lehnt sich möglicherweise an Ernst Degers Apsisfresko in der Sankt Apollinariskirche (1843–1853), der Darstellung der «Deësis», an (Abb. 148)[1359].

1354 GÖTZ, 1981, S. 166 ff., Götz zitiert aus einer Artikelserie der «Allgemeinen Zeitung», 1857, Beilage zu Nr. 229, 230, 231 der «Allgemeinen Zeitung», Jg. 1857: «Alt- und neudeutsche Kunst in Nürnberg»; Ebda. S. 193.

1355 HÜTT, 1984, S. 12.

1356 HÜTT, 1984, S. 12 ff.; HABERLAND, 2012, S. 47–48.

1357 HÜTT, 1984, S. 21.

1358 HÜTT, 1984, S. 22; vgl. BAUMGÄRTEL, 2011, S. 119.

1359 NAGEL/VON RODA, 1998, S. 56, Abb. 27 (Entwurf J. Röttingers), S. 54: «[…]vermutlich von Röttinger». ; VAASSEN 2013, S. 190, Anm. 196: Elgin Vaassen vermutet Johann Klaus (damals Mitarbeiter Röttingers) als Urheber des Entwurfs. Auf der Karteikarte des Objekts im Staatsarchiv BS (SMM: A. B. 342, 10. 10. 1994) wird Deschwanden als Künstler genannt. BAUMGÄRTEL, 2011, S. 119, Abb. Ernst Deger, «Deësis», 1843–1853, Remagen, Sankt Apollinaris, Apsis; S. 120 f.: William Dyce (1806–1864) liess sich von Degers Christus inspirieren und schuf für den Westminster Palace Wandmalereien im «germanic style».

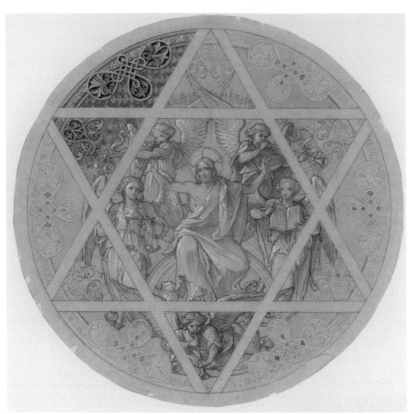

147. Melchior Paul Deschwanden (?),
Entwurf Christus als Weltenrichter
(nicht ausgeführt), aquarellierte Zeich-
nung, D: 26.5cm, für das Münster
in Basel, 1856, Staatsarchiv Basel Stadt
(SMM, Inv.AB.342).

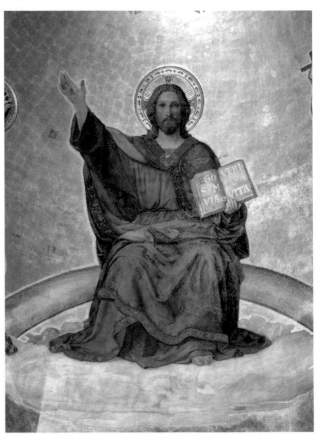

148. Ernst Deger, Christus Pantokrator, Apsiskalotte,
Wallfahrtskirche St. Apollinaris, Remagen, 1843–53.

Das Bildmaterial des 1841 in Düsseldorf gegründeten Vereins zur Verbreitung religiöser Bilder[1360] galt dem Glasmaler tatsächlich als Inspirationsquelle, haben sich doch einige Blätter im Nachlass erhalten. Das Spätnazarenertum überdauerte mit Franz Müller, dem Neffen Carl Müllers, die beide am Hauptaltargemälde der Sankt Apollinariskirche beteiligt waren, bis ins frühe 20. Jahrhundert[1361]. Daher erstaunt es nicht, dass der Stadtrat von Zug noch im Jahr 1866 für die Sankt Oswalder Chorfenster Farbenskizzen an die «Düsseldorfer Kunstschule» in Auftrag gab[1362].

Johann Jakob Röttinger ist also zeitlich den Spätnazarenern und stilistisch grundsätzlich den Nazarenern zuzuordnen, allerdings ohne sich jemals für deren kollektive Lebensform im Künstlerkreis interessiert zu haben. Seine Herkunft aus der Dürerstadt, die Ausbildung in der Kunstgewerbeschule Nürnberg und die Zeit als Gehilfe bei Sauterleute überformten bisweilen die nazarenische Prägung, um so eine originale Eigenständigkeit hervortreten zu lassen, die seiner Person als Künstler, Kunsthandwerker, Geschäftsmann und Familienvater entsprach, um künstlerischen, konfessionellen, gesellschaftlichen und nicht zuletzt ökonomischen Ansprüchen gerecht zu werden. Der Glasmaler bewegte sich innerhalb der genannten Kriterien als «Diener des Historismus» und erntete dafür von seinen Auftraggebern Zeit seines Lebens höchste Anerkennung[1363].

Religiöse Umwälzungen und deren Auswirkungen auf Architektur und Glasmalerei

Die Neugotik und ihre konfessionellen Ausprägungen

Das Wiederaufleben der Religiosität im frühen 19. Jahrhundert und die daraus entstandenen Konsequenzen für die Kunst sowie die Untrennbarkeit von Religion und Politik wurden in den vorangegangenen Kapiteln bereits thematisiert. Neben Stilwandel und Umkehr des Geschmacks wirkten die Konfessionen maßgeblich auf die sakrale Glasmalerei ein.

Der Rückgriff auf traditionelle Formen des mittelalterlichen Kirchenbaus im Bereich der Architektur basierte größtenteils auf theologischen und liturgischen Grundlagen. Dabei vermochten die farbigen Glasmalereien das mystisch rituelle Geschehen am Altar stimmungsvoll zu unterstützen. Der verschiedentlich zitierte Jurist, Politiker und Förderer des Kölner Dombauprojekts August Reichensperger (1808–1895) bevorzugte als Ultramontanist den Stil der Neugotik, der prädestiniert sei für die christliche Kunst und postulierte den «edlen, ernsten, kerngesunden Styl des dreizehnten Jahrhunderts»[1364]. So verweist auch Viollet-le-Duc die Vervollkommnung der Kathedrale als vornehmste und komplexeste Aufgabe der Gotik in die Zeit zwischen 1180 und 1220. Für den französischen Architekten und Theoretiker stammten «wirklich gute Glasmalereien» aus dem 12. Jahrhundert – er akzeptierte jedoch Qualität und Stil der Glasmalereien bis vor 1250[1365]. 1853 verbreitete das «Christliche Organ» die Feststellung, dass es hier [in der Region Köln] bereits zu den Ausnahmen gehöre, wenn eine Kirche nicht im gotischen Stil erbaut würde. Beim Bau evangelischer Kirchen sollten auf Empfehlung des preußischen Ministeriums für Handel, Gewerbe und öffentliche Arbeiten die traditionellen Formen der frühchristlichen Basilika, wie auch die quadratischen, polygonalen oder kreuzförmigen Grundrisse des byzanti-

1360 BAUMGÄRTEL, 2011, S. 120; HABERLAND, 2012, S. 47; vgl. KAT. AUSST. KÖLN, 1980; vgl. Kap. ,Ikonographie'.

1361 KNOPP, 2002, S. 52f. Zur Rezeption vgl. die Ausführungen im Kap. ,Rezeption'.

1362 BA Zug: A39 Nr. 26, 75, S. 206, Ratsprotokolle, Nr. 233, Stadtrat 14. April 1866.

1363 Die hohe Wertschätzung der Glasmalereien des 19. Jahrhunderts zur Zeit ihrer Entstehung bestätigen die beiden Autoren Falko Bornschein und Ulrich Gaßmann auch für Thüringen (BORNSCHEIN/GASSMANN, 2006, S. 7).

1364 FRAQUELLI, 2008, S. 163 ff.

1365 KURMANN, 2008, S. 159; KURMANN-SCHWARZ, 2012 (2), S. 345–346.

nischen Kirchenbaus zum Einsatz kommen[1366]. Trotz der ideologischen Vereinnahmung des Kathedralbaustils und der dazugehörenden, aus einzelnen farbigen Hüttengläsern hergestellten musivischen Glasmalereien im Sinne der Alten, wollten auch die Protestanten auf der gotischen Kirchenbauweise beharren, die sie im Sinne einer Rückkehr zur spätmittelalterlichen Bauweise – nicht etwa zum Renaissancestil – als Ausdrucksform der Reformation verstanden[1367]. Seit den Dreißigerjahren des 19. Jahrhunderts gewann in Deutschland das Neuluthertum an Einfluss und postulierte eine ablehnende Haltung gegenüber den nüchternen Predigträumen der Aufklärung. Man wusste sowohl die Verdunkelung der Räume wie auch die gewonnene Fläche für bildliche Darstellungen zu schätzen. «[…] Zum Kirchenfenster gehört, dass es keinen Blick, keinen Gedanken hinauslasse, dafür aber allem Himmlischen zum Eingang diene»[1368]. Die evangelische Friedrich-Werderkirche in Berlin, die einzige von Friedrich Schinkel im gotischen Stil realisierte Kirche, wies als erster protestantischer Kirchenbau des 19. Jahrhunderts monumentale Glasgemälde im Chor auf[1369] und stand am Beginn einer Reihe neugotischer Kirchenbauten, die noch die «klassische Grundkonzeption in gotischem Gewand aufweisen»[1370]. Eva-Maria Seng definiert diese Bauten als kastenförmige Blöcke in Anlehnung an den Klassizismus, deren gotische Formen «wie angeheftet» wirkten[1371]. Die dogmatische Phase der Neugotik entwickelte sich in den Vierzigerjahren, wobei die Lehrmeinungen der verschiedenen Länder durch einschlägige Zeitschriften Verbreitung fanden. In Deutschland waren dies das protestantisch ausgerichtete «Christliche Kunstblatt» und das katholische «Kölner Domblatt»; in England und Frankreich gab es Entsprechungen unter Mitwirkung der Architekten, wie beispielsweise George Gilbert Scott und Eugène Emmanuel Viollet-le-Duc. Da alle drei Länder Ansprüche auf die Gotik als ihren Nationalstil geltend machten, wurden anfänglich jeweils nationale Vorbilder gewählt, deren Einschränkungen sich um die Jahrhundertmitte lockerten[1372].

Historismus in der Schweiz

Den zwischen 1830 und 1860 ausgelösten profanen Bauboom der Schweiz schreibt André Meyer vor allem der politischen Neuorganisation zu, fielen doch die ersten Bauten der öffentlichen Wohlfahrt, der Wirtschaft und des Verkehrs in diese Phase. Für das Sakralbauwesen stellte demnach die erste Jahrhunderthälfte eine Zeit der Stagnation dar, die nach dem Ausgleich der politischen und konfessionellen Kräfteverhältnisse nach 1848 einen kräftigen Aufschwung erhalten hat. Nach dem Wegfall konfessioneller Schranken und der Durchmischung der Konfessionen innerhalb der Kantone sind Bauvorhaben entstanden, die für die Stilentwicklung und Durchsetzung der historisierenden Stilrichtung in der Schweiz maßgeblich waren[1373]. Wenngleich das Programmatische weit weniger ausgeprägt erscheint, gilt es zwei voneinander entgegengesetzte Ausrichtungen zu unterscheiden, den klassizistisch-romantischen Historismus mit

1366 FRAQUELLI, 2008, S. 167; SENG, 1995, S. 128 f.: Eva-Maria Seng bezeichnet die Strömung des Rundbogenstils bis zur Mitte des 19. Jahrhunderts als Misch- bzw. Integrationsstil, der zuerst von Schinkel, dann von Lassaulx im Rheinland, Gottfried Semper, Heinrich Hübsch, Friedrich von Gärtner in München proklamiert wurde. Ebda., S. 278: Das Eisenacher Regulativ von 1861 erließ einen Stilkompromiss, der neben dem gotischen und romanischen Stil auch die altchristliche Basilika erlaubte.

1367 PARELLO, 1997 (1), S. 213 ff.

1368 GRENTZSCHEL, 1989, S. 66 zitiert Ludwig Uhland (1787–1862), den Literaturprofessor und Rechtsgelehrten in Tübingen.

1369 PARELLO, 1997 (1), S. 213 ff.

1370 SENG, 1995, S. 130 f. Diesen undogmatischen Umgang mit dem gotischen Stil zeigen unter anderem die Bauten der Maria-Hilf-Kirche in München, die Apollinariskirche in Remagen wie auch teilweise die Elisabethenkirche in Basel.

1371 SENG, 1995, S. 129; MEYER, 1973, S. 36: zitiert nach Heinrich Habel: «[…] Stilreinheit und historische Genauigkeit, kulissenhafter Charakter […] versatzstückhaft […]».

1372 SENG, 1995, S. 130 ff.

1373 MEYER, 1973, S. 35 ff.

eklektisch-spielerischen Aspekten und den archäologisch orientierten dogmatischen Historismus. Der ersteren Stilgruppe, die sich mit einer äußeren gotischen Erscheinung, als «ornamentale Anwendung» der Gotik, begnügte, gehörte als einflussreichster Bau die katholische Pfarrkirche in Leuggern AG nach Caspar Joseph Jeuch (1851–1853) an[1374]. Während Sankt Peter und Paul vorbildgebend auch für nicht akademisch geschulte Baumeister wie Wilhelm Keller werden sollte, wurde der dogmatische Gotizismus von Johann Georg Müller (1822–1849), der die Umbaupläne für die reformierte Laurenzenkirche in Sankt Gallen entworfen hatte, sowie vom Protagonisten der Epoche, Ferdinand Stadler (1813–1817), vertreten. Die Vorbildwirkung in Architektur und Glasmalerei gingen damals Hand in Hand, so leitet sich die Kirche Sankt Peter und Paul in Leuggern von Joseph Daniel Ohlmüllers Maria-Hilf-Kirche in München ab, ohne jedoch für die Glasmalerei Programm zu sein. Als Wiederholung der Kirche zu Leuggern muss die katholische Pfarrkirche in Bünzen AG gesehen werden, die von Jeuch geplant und von Keller ausgeführt wurde. Eigene Entwürfe Kellers für Bünzen wurden nicht berücksichtigt; die Umsetzung seiner Ideen gelangen ihm in den katholischen Kirchen Grosswangen LU, Villmergen AG und Uznach SG – um als Stilbeispiele denjenigen Bauten zu folgen, für die Johann Jakob Röttinger Glasmalereien geschaffen hatte. Bei Ferdinand Stadler hinterließ die Begegnung mit Karl Friedrich Schinkel nachhaltigen Eindruck, was besonders im Konzept der Friedhofkapelle auf der hohen Promenade in Zürich ersichtlich wird. Mehr klassizistischen Charakter zeigt sein Entwurf für die reformierte Kirche Thalwil, um schließlich eine eigenständige Lösung in der katholischen Pfarrkirche Unterägeri zu präsentieren, die Anknüpfungspunkte an die Laurenzenkirche in Sankt Gallen sowie bezüglich der inkorporierten Vorhallen an die reformierte Kirche in Oberentfelden AG aufweist. Vor allem zwei Bauwerke Stadlers, die reformierte Elisabethenkirche in Basel[1375] und die Stadtkirche in Glarus, bezeichneten einen Wendepunkt der Baukunst des 19. Jahrhunderts in der Schweiz. Die Basler Kirche gilt als bedeutendster neugotischer Bau in der Schweiz, die Kirche in Glarus als freie Abwandlung historischer Elemente mit Motiven des Münchner Rundbogenstils, der Renaissance und aufgrund des Maßwerkes der Gotik sowie als Initialbau einer neuen Phase der Neugotik[1376]. Die Katholiken Berns erhielten erst 1853 von der Regierung die Erlaubnis eine eigene Kirche zu bauen, die schließlich von 1858 bis 1864 von Pierre-Joseph-Ed. Deperthes aus Reims, dem Architekten des Pariser Rathauses, realisiert wurde. Die entfernten Vorbilder französischer Kathedralgotik des 13. Jahrhunderts verleihen dem Bau zusammen mit den gedrungenen Formen des Kirchenschiffs eine Neuinterpretation des Stils im Geist des 19. Jahrhunderts – der streng dogmatischen Stilphase der Neugotik folgend. Die gotische Formensprache, als Sinnbild des Christlichen, ließ jedoch dem Architekten in der Ausführung Spielraum für die Anpassung an zeitgenössische Bedürfnisse und für dessen künstlerische Freiheit offen[1377]. Die Übernahme-Offerte Röttingers von 1862 der nicht mehr erhaltenen Fenster erwähnt neben den technischen und kommerziellen Angaben nur, dass die Fenster nach «den gegebenen Zeichnungen des bauleitenden Architekten»[1378] ausgeführt werden, beinhaltet jedoch keine Hinweise auf Ikonographie und Gestaltung. Die Kirche gehört seit 1875 dem christkatholischen Konfessionsteil an und schafft somit einen Übergang zum Kapitel über den Kulturkampf in der Schweiz.

1374 BOSSARDT/KAUFMANN, 2012, S. 12–17.
1375 J. Röttinger schuf in der Elisabethenkirche das große Westfenster W I (vgl. NAGEL/VON RODA, 1998, S. 71).
1376 MEYER, 1973, S. 35–64.
1377 MEYER, 1973, S. 125 ff.
1378 ZB Nachl. Röttinger 1.19.

Konfessionelle Spaltung

Im Jahre 1848 entstand in der Schweiz ein konfessionell neutraler Bundesstaat, der sich aus den glaubensgemeinschaftlich geschlossenen Gebieten der Alten Eidgenossenschaft entwickelte und nun als weltlicher Kulturstaat eigene Werte verfolgte. Startschuss der Konfliktreihe war der Sonderbundskrieg 1847, der zwar den Weg zum modernen Bundesstaat ebnete, die Katholiken jedoch in der Folge spaltete. Das ultramontane, romgetreue Lager der ehemaligen Sonderbundskantone stand einem elitären liberalen Katholizismus gegenüber, der sich in den industrialisierten, freisinnigen Regionen der Kantone Solothurn, Aargau, Zürich oder Genf etablierte[1379]. Im Grunde handelte es sich beim Kulturkampf[1380] um eine religiösweltanschauliche Auseinandersetzung zwischen papsttreuen Katholiken und dem antiklerikalen Radikalismus und daher im eigentlichen Sinne um den Konflikt zwischen Konservatismus und Fortschritt – Politik und Wirtschaft unterschieden demnach zwischen einer rückständigen und einer fortschrittlichen Variante des Christentums[1381]. Anstoß für die Abspaltung der Christkatholiken waren die beiden auf dem ersten Vatikanischen Konzil 1870 formulierten Dogmen, des Universalprimats und der Lehrunfehlbarkeit des Papstes. Die Abspaltung wurde von radikalen katholischen Politikern initiiert und sprach vorrangig urbane Bevölkerungsschichten an. Trotz der gezielten Unterstützung der Kantone Bern, Aargau und Solothurn konnten sich die Christkatholiken nicht auf breiter Basis durchsetzen. 1874 war der Höhepunkt des Kulturkampfes überschritten und die Rückkehr ausgewiesener katholischer Priester wieder möglich[1382]. Aus einem Geschäftsbrief Röttingers an den Siebmacher Vogel in Sankt Gallen geht hervor, dass der Radikalismus 1876 weiterhin Bestand hatte: «*[…] noch allen Schaden, welcher an Fenstern durch Einwerfen oder sonstiger Zerstörung verantwortlich bin. Es ist nämlich eine neue römisch kath. Kirche und in der Gemeinde wurde von freisinnigen Leuten gedroht, dass Sie die Fenster einwerfen wollen, weil das Bildnis vom Papst in einem derselben gemalt ist, Über-*

legen Sie sich dieses und im Falle Sie mir die Zusicherung geben, dass Sie im Falle nicht richtiger die Verantwortung mit mir teilen, so können Sie die Gitter gleich anfangen. Ist dieses aber nicht der Fall, so nehmen Sie diesen Auftrag nicht an»[1383]. Für die Kirche Sankt Oswald (Zug) sind Abbildungen des Papstes aus der Werkstatt Röttinger ebenfalls nur noch in den Archiven evident. So zeigen 1962 aufgenommene Fotografien von Schifffenstern aus dem Jahre 1870 einerseits Papst Pius IX. (Abb. 149) sowie «einen heiligen Papst mit einer Taube»[1384].

Die Kulturinferiorität der Katholiken, die nicht nur der Konfession entsprang, sondern vor allem strukturelle Ursachen hatte, umfasste wirtschaftliche, bildungspolitische und dadurch auch geistig-künstlerische Bereiche, was die Katholiken in eine Sonderwelt verbannte und eine Entfremdung zum liberal-urbanen Bürgertum initiierte.

1379 ALTERMATT, 2009, S. 111 f.; vgl. Kap. ‹Von der Revolution zum neuen Bundesstaat›.

1380 BISCHOF, 2008, HLS, Stichw. *Kulturkampf.* Es ging dabei um eine Auseinandersetzung zwischen Katholischer Kirche und politischem Katholizismus einerseits und antiklerikalem Liberalismus andererseits. In der Schweiz wurde dieser Kampf in den Sechziger- und Siebzigerjahren des 19. Jahrhunderts besonders vehement ausgetragen.

1381 ALTERMATT, 2009, S. 111 ff.; CONZEMIUS, 2008, HLS, Stichw. *Lachat, Eugène.* Bischof Lachat publizierte trotz des Verbots der Diözesanstände im Fastenhirtenbrief von 1871 die Beschlüsse des 1. Vatikanischen Konzils, weshalb er 1873 als Bischof von Basel abgesetzt wurde, den Kanton Solothurn verlassen musste und in der Folge von Luzern aus die Diözese verwaltete. Als «Bekennerbischof» erntete er Sympathien im Kirchenvolk.

1382 VON ARX, 2004, HLS, Stichw. *Christkatholische Kirche.*

1383 ZB Nachl. Röttinger 2.371, S. 155, Siebmacher Vogel, Sankt Gallen.

1384 Denkmalpflege Zug, Fotoarchiv, Sankt Oswald, ZO400. 01_019 1962/5 mit rückseitiger Beschriftung der Fotographien: «Nordseite v.l.n.r. 3. Fenster, Innenaufnahme 1962 (Stempel: E. Schwerzmann, Postplatz, Zug): li. Petrus, Kelch/Hostie, re. Papst Pius IX, Tiara mit 2 gekreuzten Schlüsseln; Nordseite v.l.n.r. 5. Fenster 1870, li. Hl. Bischof, re. Hl. Papst mit Taube» Auf dem ersten «südseitigen Fenster» signiert «Röttinger». Anlässlich der fotografischen Aufnahmen aller Glasmalereien in der Bauhütte fand sich aus dieser Fensterserie nur noch das 4. «nordseitige Fenster», das sich als Fragment erhalten hat.

149. Johann Jakob Röttinger, Papst Pius IX, Medaillon, Fotografie 1962 eines ehemaligen Fensters im Kirchenschiff (Kopie), Katholische Kirche St. Oswald, Zug 1870, Originalfoto: Denkmalpflege Zug, Fotoarchiv (ZO 400.01_019).

Ein historischer Kompromiss bahnte sich in den Achtzigerjahren an, als ausgerechnet der Katholik Josef Zemp, als erster katholisch-konservativer Bundesrat, eine Wende einleitete[1385]. Ein weiterer Vermittler – ein Heiliger mit politischer Dimension – besaß seit 1481 die historische Aura des

Friedensstifters und des Retters des Vaterlandes. Nikolaus von Flüe verlor zwar in der säkularisierten Gesellschaft der modernen Bundesverfassung an Bedeutung, zeigte jedoch weiterhin Präsenz als christlicher Hausvater für Land und Volk. Weder der «Große Christliche Hauskalender» wie auch die reformiert pietistische Zeitschrift «Des Volksboten Schweizer-Kalender» mochten auf die interkonfessionelle Integrationsfigur verzichten. Die Christkatholiken entsagten wegen dessen konfessioneller Einvernahme der Verehrung des Heiligen, sympathisierten jedoch weiterhin mit seiner schlichten, verinnerlichten Frömmigkeit. In den Achtzigerjahren sollte der Obwaldner Eremit schließlich seine Wirkung als gemeinsame Friedensfigur voll entfalten, um die politische Aussöhnung zwischen Katholiken und Liberalen zu unterstützen[1386]. Im toggenburgischen Wildhaus wurden im Jahre 1867 acht Fenster mit den *«14 Nothelfern und Carlo Boromeo [sic!], Niklaus v. d. Flühe [sic!]»* gestiftet. Dies notierte Johann Jakob Röttinger in seinem Skizzen- und Auftragsbuch[1387]. Bei diesem Auftrag ist kein sichtbarer Zusammenhang mit konfessionellen Konflikten auszumachen; es scheint sich hier um eine private Stiftung eines frommen Mannes für sich und seine Familie gehandelt zu haben. Weitere von Röttinger geschaffene Bruder-Klaus-Medaillons finden sich in den katholischen Kirchen Nottwil (s VII) von 1869 sowie in Zug aus dem Jahr 1866 (Abb. 150), aufbewahrt in der Bauhütte der Kirche Sankt Oswald. Im Jahre 1876, in einer Zeit, als der Heilige als Integrationsfigur immer noch von Interesse war, lieferte Johann Jakob Röttinger Glasmalereien für die *«Grab ‹Capelle› des sel[igen] Bruder Klaus»* in Sachseln. Dass Pfarrer Omlin von Sachseln ausgerechnet in krisenhaften Zeiten die Kultstätte des verehrten Vermittlers als Annex der Pfarrkirche künstlerisch gestalten wollte, ist nachvollziehbar.

1385 Altermatt, 2009, S. 123 ff.
1386 Altermatt, 2009, S. 161–169.
1387 ZB Nachl. Röttinger 1.202.41, S. 74, 75. «[...] diese beiden jedoch nicht in ein Fenster sondern in 2 und zwar einander gegenüber». Die Glasmalereien haben sich im Original erhalten, nur die Stifterinschriften sind nun jüngeren Datums.

150. Johann Jakob Röttinger, Bruder Klaus, Medaillon, ehem. Chorfenster n III, Katholische Kirche St. Oswald, Zug, 1866.

War doch das Grab des Heiligen zu allen Zeiten ein Anziehungspunkt für zahlreiche Pilger. *«[...] Sie werden finden, dass uns bei der Übernahme der Arbeit nur der Gedanke geleitet Ihnen zur Ausschmückung der für jeden [...] Schweizer denkwürdigen Ortes nach Kräften behilflich zu sein.»*[1388] Johann Jakob Röttinger fand auch bei konfessionell heiklen Aufträgen immer die richtigen Worte, was seinem Geschäftsgang außerordentlich zur Ehre gereichte.

Daher scheint die Ausstattung von Gotteshäusern beider Konfessionen, trotz glaubensbedingter Krisen kein Problem für den Glasmaler dargestellt

zu haben. Wie bereits erwähnt, war Röttinger als Protestant bei seinen katholischen Auftraggebern sehr geschätzt, was in den Quellen deutlich zum Ausdruck kommt. So artikuliert sich Pater Honorius aus dem Kapuzinerkloster in Zug in einem Dankesschreiben 1864 an den Glasmaler *«[...] wären wir nicht nur arme Kapuziner, so müssten Sie ein Trinkgeld haben [...]»* und Pater Guardian aus dem Kloster in Arth schreibt 1867 an Johann Jakob Röttinger *«Wahrhaft, Sie besitzen eine schöne Kunst. Der liebe Gott solle Sie noch viele Jahre in der besten Gesundheit erhalten. Geistliche und Weltliche loben Ihren so schönen Namen, den Sie in unserer Kirche verewigt haben [...]»*[1389]. Umgekehrt fanden die Glasmalereien Röttingers bei protestantischen Auftraggebern ebenso Anklang, was sich nur schon in der großen Zahl der Bestellungen für reformierte Kirchen widerspiegelt. Seine Darstellungen diskursiver Handlungen, wie der so genannte «Lehrende Christus», Apostel, Evangelisten und Propheten, entsprachen den damaligen protestantischen Bildvorstellungen. Nicht das Leiden, sondern der soteriologische Aspekt der Religion[1390] stehen im Bildprogramm des Glasmalers im Vordergrund[1391].

Die Realität der konfessionellen Krisenjahre sah allerdings anders aus. Adolph Kreuzer lässt den Ernst der Situation und die Beklemmung erkennen, wenngleich er die Formulierung seiner Inschrift in der ehemaligen Klosterkirche zu Kappel am Albis eher ironisch denn besorgt zum Ausdruck bringt: *«[...] Die Welt steht nimmer lang. Große Pfaffenjagd in der Schweiz [...].»* Für die Inschrift[1392] im Fenster des Obergadens N IX musste er jedenfalls kein Blatt vor den Mund nehmen, waren doch die geschriebenen Zeilen zwischen den Signaturen in schwindelnder Höhe für das Auge nicht erkennbar (Abb. 137). Die Mitteilungen waren freilich nicht an Zeitgenossen gerichtet, sondern an Empfänger einer anderen Zeit – und dort sind sie am Ende auch angekommen.

1388 ZB Nachl. Röttinger 2.371, S. 116, S. 210.
1389 ZB Nachl. Röttinger 1.195, ZB Nachl. Röttinger 1.8.
1390 THIMANN, 2005, S. 174.
1391 Vgl. Kap. ‹Der «Lehrende Christus»›.
1392 TRÜMPLER/DOLD, 2005, o. p.

Kulturtransfer

Auswirkungen der Revolution

Die Zeit der Spätaufklärung, der Französischen Revolution bis hin zu den Napoleonischen Kriegen hat zweifelsohne auch positive Aspekte in Bezug auf interkulturelle, grenzüberschreitende und somit transnationale Prozesse vorzuweisen. Während die politische und militärische Ausdehnung Frankreichs die Verbreitung von Ideen, Handlungsformen oder Rechtsnormen forcierte, sorgten die zunehmende Alphabetisierungsquote und die Entstehung von Medien für eine entsprechende Rezeption. Die französische Sprache und Kultur wie auch politische Ideen und Modelle fanden insbesondere an den Höfen ihre Propagierung, so dass zu Beginn des 19. Jahrhunderts große Auswirkungen auf den interkulturellen Wissenstransfer in Europa zu konstatieren sind. Umgekehrt funktionierte der Widerstand gegen die transnationalen Kulturströme als Impulsgeber für eigene Ideen in den verschiedenen Regionen[1393]. So bedeutete die Zeit der Helvetik für die Schweiz nicht nur Fremdherrschaft, Freiheitsentzug und Erniedrigung, sondern dank der Reflexion der vorrevolutionären Zustände sowie der Entwicklung eigener und fremder Impulse, die allerdings erst 1848 realisierbar wurden, auch Reform und Befruchtung[1394]. Auf die im späten 18. und 19. Jahrhundert bei Engländern, Deutschen und anderen Europäern beliebten Schweizerreisen wurde schon hingewiesen. Diese dienten häufig dem kulturellen beziehungsweise künstlerischen Austausch von Intellektuellen oder Künstlern und führten die Reisenden außer in die großen Städte vorwiegend in die Kantone der Innerschweiz. Die Schweiz galt als Mekka der Freiheit, Bodenständigkeit und Rechtschaffenheit, die Menschen als mutig und liberal – Eigenschaften, die imponierten. Umgekehrt profitierte die Schweiz von der Einwanderung meist hochgebildeter politischer Flüchtlinge aus den umliegenden Monarchien und dem damit verbundenen Kultur- und Wissenstransfer[1395]. Der Kulturimport aus England, nämlich der Bau anglikanischer Kirchen auf Schweizer Boden für Touristen aus England, die Einfuhr englischer Glasmalereien oder die von Johann Jakob Röttinger hergestellten Glasmalereien für entsprechende Kapellen, wurde bereits thematisiert[1396]. In der Romantik und deren Begeisterung für das Mittelalter besann man sich auf die Reisen Dürers und die befruchtende künstlerische Einwirkung des Südens auf die Kunst des Nordens. Spätestens seit Johann Ludwig Tiecks (1773–1853) «Franz Sternbalds Wanderungen» aus dem Jahre 1798 war die Italiensehnsucht geweckt, was in der Folge regelrechte Künstlerströme in den Süden auslöste. Deutsch-Römer, Nazarener, Spätnazarener – sie alle verbrachten eine kürzere oder längere Zeit ihres Lebens in der ewigen Stadt oder bereiteten sich dort unter anderem auf Großaufträge in der Heimat vor[1397].

Wissenstransfer und Glasmalerei

Trotz des geäußerten Wunsches Johann Jakob Röttingers Reisen nach Italien und Frankreich zu unternehmen und der Einholung entsprechender Bewilligungen bei den bayerischen Behörden im Jahr 1846, lassen sich archivalisch keinerlei Reisetätigkeiten nachweisen. Nach dem frühen Tod seines Prinzipals, Johann Andreas Hirnschrot Ende 1845 in Zürich, standen wohl die Chance einer Übernahme der Werkstatt beziehungsweise Verpflichtungen im Zusammenhang mit der Etablierung als selbstständiger Glasmaler im Vordergrund und ließen die Reisewünsche des bald

1393 LÜSEBRINK/REICHARDT, 1997, S. 9 ff.; KITSCHEN, 2010, S. 2: So brachte in der Kunst nur schon der Widerstand gegen die französische künstlerisch-ästhetische Position eine Auseinandersetzung, die sich für die Festigung der eigenen nationalen Kunst als konstruktiv erwies.

1394 STAEHELIN, 1980, S. 817 ff.

1395 Vgl. Kap. ‹Historische Grundlagen›.

1396 Vgl. Kap. ‹Ornamentik›, besonders Anm. 531.

1397 So auch die Maler Deschwanden, Schraudolph, Schadow etc.; bezüglich Spätnazarener vgl. BAUMGÄRTEL, 2011, S. 118.

Dreißigjährigen in den Hintergrund treten. Reisen nach München beziehungsweise in die Heimatstadt Nürnberg sind hingegen belegt[1398]. Gerhard Weilandt hat die Wanderungen der Künstler und Handwerker zu den spätmittelalterlichen Baustellen und Bauhütten für die Region Ulm zusammengetragen. Schon damals zogen die Künstler nach Beendigung ihrer vier- bis sechsjährigen Lehrzeit im Alter von 18–20 Jahren aus ihren Heimatorten aus und verdingten sich als Gesellen oder Gehilfen in den Zentren der Kathedralbauten. Dieser übliche Transfer künstlerischen Schaffens, aber auch Export und Import von Kunstwerken etablierter Künstler brachten Wissensaustausch und Qualitätssteigerung[1399].

Das wieder aufgeflammte Interesse an farbigen Fensterverschlüssen und der Wille diese zu restaurieren beziehungsweise zu ergänzen, stellten die Bauherren des 19. Jahrhunderts nicht nur vor technische, sondern auch personelle Probleme. So galt es Fachkräfte auszubilden, die diese Arbeiten sachgerecht in Angriff nehmen konnten, weshalb man in ganz Europa mithilfe überlieferter Schriften und Rezepturen mit der Wiederaufnahme der Glasmalerkunst begann und im Selbststudium experimentierte[1400]. Die Ausführungen im Kapitel über Konkurrenz und Zusammenarbeit der Glasmalereiwerkstätten haben gezeigt, dass sich in der Schweiz der ersten Jahrhunderthälfte zwei Kompetenzzentren etabliert haben, zum einen die der Müller und Stantz in Bern, zum anderen in Zürich mit Andreas Hirnschrot, nach dessen frühen Tod Johann Jakob Röttinger an die Tradition anknüpfte und diese erfolgreich ausbaute. Die Familie Müller, ursprünglich aus Grindelwald stammend, übersiedelte von Schaffhausen nach Bern und assoziierte sich mit den Becks, ebenfalls aus Schaffhausen; der Arzt, Heraldiker und Glasmaler Stantz kam hingegen aus Konstanz[1401]. Während sich in Bern also einheimische beziehungsweise aus der Region stammende Glasmaler und Glaser niederließen, gab es zumindest im ersten Drittel des Jahrhunderts in Zürich keine Konkurrenz aus dem Gebiet der Eidgenossenschaft. Andreas Hirnschrot wanderte wie Johann Jakob Röttinger aus

Nürnberg in die Schweiz ein. Zuerst als Porträtist in verschiedenen Schweizer Städten tätig, wurde er anlässlich einer Reise nach München und Nürnberg zur aufstrebenden Kunst der Glasmalerei angeregt und widmete sich daraufhin in Zürich diesem Metier[1402]. Dank der Nachfolge junger Künstler aus Deutschland, die für kürzere oder längere Zeit in der Zürcher Werkstatt eine Ausbildung genossen, strahlte das Atelier Röttinger auf wichtige Glasmalereizentren Süddeutschlands zurück. Der große Aufschwung der Glasmalerei in ganz Europa ab 1850 zeigte, zumindest was die Eröffnung neuer Werkstätten betraf, in der Schweiz noch wenig Niederschlag. Hierzulande waren immer noch vergleichsweise wenige Ateliers domiziliert, so dass große Aufträge auch an deutsche und französische Werkstätten vergeben wurden. Dementsprechend arbeiteten im Basler Münster und in der Elisabethenkirche (neben Johann Jakob Röttinger) Franz Xaver Eggert, Max Emanuel Ainmiller, Christian und Heinrich Burkhardt und der in Paris lebende Schweizer Glasmaler Johann Caspar Julius Gsell. Demgegenüber gelang es Röttinger sich durch zahlreiche Mandate im Welschland und im Wallis einen Namen zu verschaffen; so schuf er Glasmalereien beispielsweise für die Kathedralen von Lausanne und Sion, Kirchen in Saint-Imier, Glis, Leukerbad sowie für zahlreiche Kirchen im Kanton Freiburg[1403].

Nach dem Tod Johann Jakob Röttingers wurden die großen Zürcher Werkstätten – Berbig, Röttinger und Wehrli[1404] – marktführend in der Schweiz. Auf den Landesausstellungen wurde dies deutlich, weil regelmäßig Glasmalereien zur Präsentation auserkoren wurden. Die Deutschschweiz orientierte sich vornehmlich am nördlichen Nachbarn, was

1398 StAZH W I 3 AGZ 174 12, Müller-R 1851–58.
1399 WEILANDT, 1995, S. 50–56.
1400 KURMANN-SCHWARZ, 2012 (2), S. 343.
1401 VAASSEN, 1997, S. 45 ff.
1402 VAASSEN, 1997, S. 48 f.
1403 Das Werk der Röttinger in der Westschweiz wird von Fabienne Hoffmann bearbeitet.
1404 Als Beispiel für Carl Wehrlis Glasmalereien sei auf ein Fenster in der Pfarrkirche zu Ennenda verwiesen, Abb. 141.

das große Interesse an der deutschen Renaissance-
malerei wie auch am Kunsthandwerk bezeugte und
1875 zur Errichtung der Kunst- und Kunstgewer-
bemuseen in Zürich und Winterthur führte[1405].
Darüber hinaus hielt man sich im 19. Jahrhundert
hierzulande bezüglich Glasmalereien ebenso an
französische Theorien. Johann Rudolf Rahn, Be-
gründer der wissenschaftlichen Kunstgeschichte
sowie der modernen Denkmalpflege, folgte in
seiner Beurteilung mittelalterlicher Glasmalereien
nicht nur seinem Lehrer Wilhelm Lübke (1826–
1893), dem aus Dortmund stammenden Kunsthis-
toriker am Eidgenössischen Polytechnikum Zü-
rich, sondern rezipierte vor allem Viollet-le-Ducs
Thesen im Artikel «Vitrail» im 9. Band des «Dic-
tionnaire raisonné de l'architecture française du
XIe au XVIe siècle» von 1868. Die Frage nach der
Urheberschaft der Malkunst auf Glas, ob von
deutschen oder französischen Künstlern, wurde
im 19. Jahrhundert unter Kunsthistorikern noch
heftig diskutiert. Die teilweise ungerechtfertigte
Kritik des Theoretikers Viollet-le-Duc an der
Glasmalerei des 19. Jahrhunderts, als einer stilis-
tisch auf dem Charakter der Glasmalerei be-
schränkten Kunst, brachte dem Metier dieser
Epoche als Kunstrichtung sowie für deren Rezep-
tion keinen Vorteil[1406].

Johann Jakob Röttinger fügt sich mit seinem Ate-
lier als Vertreter der Glasmalkunst in den inner-
europäischen Kulturaustausch ein. Nicht nur die
Etablierung eines Glasmalereizentrums in Zürich
mit Ausstrahlung in Westschweizer Kantone und
der damit verbundene Kulturtransfer, auch sein
Ansehen als Lehrmeister und Patron festigte das
Zürcher Kompetenzzentrum über seinen Tod
hinaus und reflektierte Meisterschaft und Fach-
wissen in zahlreiche Werkstätten der Schweiz, des
süddeutschen Raums und ins Elsass. Der Erfolg
seiner beiden Söhne, Jakob Georg und Heinrich
Röttinger, bei der Wiederaufnahme des Geschäfts
1887, das noch jahrzehntelang den Markt beherr-
schen sollte, ist ein beredtes Beispiel dafür.

Philosophisch-kunsthistorischer Diskurs

«Der revolutionäre Bruch im Denken des neun-
zehnten Jahrhunderts»[1407] ist wesentlich von zwei
Philosophen geprägt – von Georg W.F. Hegel (1770–
1831) am Beginn und von Friedrich W. Nietzsche
(1844–1900) am Ende des Säkulums. So hatte
Hegel der Kunst die Absicht «das höchste Bedürf-
nis des Geistes zu sein», abgesprochen und den
Katholizismus in seiner Funktion als längst ver-
gangene Weltanschauung in Frage gestellt[1408].
Nietzsche verschärfte die antireligiösen Auffas-
sungen und bezichtigte Hegel der Retardation des
«aufrichtigen Atheismus». Dennoch spiegelte sich
Nietzsches christliche Prägung, die ihm im pietis-
tischen Elternhaus aufgedrückt worden war, in der
polemischen Auseinandersetzung im «Antichrist»
wie auch in seiner «Lehre von der ewigen Wieder-
kunft»[1409].

Angesichts der historischen Zäsur Ende des 18. Jahr-
hunderts empfand man die Kunst der Alten als
Historie, eine Vorstellung, die Anfang des 19. Jahr-
hunderts die abendländische «Bildauffassung von
Giotto bis Tiepolo» beendete. Wie bereits im
Kapitel ‹Ikonographie› ausgeführt, wirkten sich
die geschichtlichen Ereignisse nicht zuletzt auf die
Bildformeln der christlichen Ikonographie aus,
indem diese einen Wechsel vom kollektiven Han-
deln von Figurengruppen narrativer Situationen
hin zum kompositorischen Einsatz von Einzel-

1405 KURMANN-SCHWARZ/PASQUIER/TRÜMPLER, 1999,
 S. 134–140; MICHEL, 1986, S. 13.
1406 KURMANN-SCHWARZ, 2012 (2), S. 343–354. Brigitte
 Kurmann-Schwarz diskutiert in ihrem Aufsatz über
 «Johann Rudolf Rahn und die Erforschung der mittelal-
 terlichen Glasmalerei in der Schweiz» dessen Rezeption
 von Lübke und Viollet-le-Duc, die das Fundament für
 die schweizerische Glasmalereiforschung im 20. Jahr-
 hundert bildete. Zu Viollet-le-Ducs Urteil über die
 Glasmalerei des 19. Jahrhunderts, v.a. Anm. 30.
1407 LÖWITH, 1995, Buchtitel.
1408 LÖWITH, 1995, S. 49 f.
1409 LÖWITH, 1995, S. 392 ff.

figuren, im Sinne voneinander abgesetzter figuraler Elemente, auslösten[1410].

Der Idealisierung des christlichen Europas durch Novalis (1772–1801), dem «das ganze Leben Gottesdienst» bedeutete, wird nun eine «Religion ohne Gott» gegenübergestellt. Arbeit und Vergnügen sei die Devise und ebenfalls ohne Gott kommt das im kommunistischen Manifest determinierte «Reich der Freiheit» aus, in dem das Proletariat als «Retter der Menschheit» wirksam wird[1411]. Friedrich Schlegel polarisiert 1799 in seinem Roman «Lucinde» noch die Lebensformen zwischen Sinnlichkeit und Bürgerlichkeit, entscheidet sich aber im eigenen Leben schließlich für den Katholizismus[1412]. Goethe – obwohl ein Gegner Schlegels – würdigte indes dessen Einfluss auf die Kunsttheorie, so dass der programmatische Ausdruck seiner Kunstbeschreibungen tief in der Forschung des damals jungen Fachs der Kunstgeschichte verwurzelt war. Schlegels Interesse richtete sich zunächst auf die altitalienische und altdeutsche Malerei sowie auf seine «Materialtheorie» – jede Kultur suche sich für die Handhabung ihrer Kunst «vorsätzlich» das geeignete Material und verdichtete sich schließlich auf die Ausstattung christlicher Gotteshäuser, während er den Fokus auf Tafelbilder, Freskomalerei und Glasmalereien legte. Als einzig gültige Gattung der Malerei erscheint die Historienmalerei, wobei die «göttliche Bedeutung» den Inhalt hervorhebt und die Symbolik implizit auf die Transzendenz verweist[1413]. Schlegels Konzept erhöhte den Geist über die Form, was die Nazarener konsequent anwendeten, indem sie das Primitivistische aus der Malerei der Frührenaissance übernahmen und Fehler am Körperbau oder starke Buntfarbigkeit in ihren Gemälden akzeptierten, überzeugt, dadurch Garanten für Glaubwürdigkeit und Tugendhaftigkeit gefunden zu haben[1414]. Die Kunst der Nazarener, deren Publizität durch die Ausstellung im Palazzo Caffarelli initiiert wurde, rief prominente Kritiker auf den Plan, allen voran die Weimarer Kunstfreunde, mit deren Streitschrift «Neudeutsche religios-patriotische Kunst», die sich nicht gegen einzelne Künstler, sondern gegen die Programmatik dieser Kunst

richtete[1415]. In der Rolle des Mentors der jungen Künstlergruppe sah sich möglicherweise August Kestner (1777–1853), der mit seiner Schrift «Über die Nachahmung in der Malerei»[1416] auf den von Goethe in Auftrag gegebenen Artikel Heinrich Meyers (1760–1832) reagierte und die Haltung derjenigen Intellektuellen vertrat, die den Nazarenern nahestanden. Schließlich war es jedoch Carl F. von Rumohr, der sich als Erster in differenzierter Weise, ohne die Absicht zu richten, mit den Leistungen der einzelnen Künstler befasste. Während er einerseits vor einer Stilisierung der Malerei warnte, schätzte er vor allem die Leistungen Overbecks und Cornelius' und befleißigte sich an der Förderung deren neuer öffentlicher Monumentalmalerei. Johann David Passavent (1787–1861) brachte am Beispiel Giottos die künstlerische Fokussierung der Nazarener auf den Punkt, nicht die formale Perfektion als erstrebenswert zu erachten, sondern die «innere Wahrheit» zeigen zu wollen, was den Bogen zu Schlegels Akzentuierung des Inhaltes als «göttliche Bedeutung» spannt[1417]. Hegel zollte in den Schlussbetrachtungen seiner «Vorlesungen über die Ästhetik» der romantischen Epoche die Funktion der Unterbrechung der in der griechischen Kunst erreichten Einheit von Form und Inhalt und belegte die Ära mit Schlüsselwörtern wie «Innerlichkeit», «Vergeistigung», «Subjektivierung» und «Individualisierung»[1418]. Die kritische Reflexion sei nach Hegel nicht nur in der Kunst, sondern auch in der Religion – «als Richter, vor dem sich die Wahrheit bewähren müsse» – zutage getreten und mache die Kunst zur Kunstwissenschaft und die Religion zur Religionsphilosophie[1419]. Friedrich W. J. Schelling (1775–

1410 TELESKO, 2000, S. 40 ff.
1411 HOFMANN, 1991, S. 234 ff.
1412 PAULSEN, 1985, S. 170.
1413 SCHÖNWÄLDER, 1995, S. 22 ff.
1414 GREWE, 1998, S. 123.
1415 SCHÖNWÄLDER, 1995, S. 42 f.
1416 SCHÖNWÄLDER, 1995, S. 56 ff.; vgl. LENZ, 1977, S. 295–319.
1417 SCHÖNWÄLDER, 1995, S. 86 ff.
1418 SCHÖNWÄLDER, 1995, S. 154 ff.
1419 LÖWITH, 1995, S. 49 ff.

1854) entwickelte in seiner «Philosophie der Kunst» die Thesen Kants weiter, dem die Zeichnung das Wesentliche der Kunst bedeutete. Wie im Kapitel über die ‹Künstlerische Ausführung› erörtert, ist die «Wahrheit» die Hauptforderung an die Zeichnung wie auch der Anspruch, dass nur das Schöne, Notwendige und Wesentliche zu erfassen sei, das Akzidentelle und Unnütze sei zu unterlassen. Dieser Verzicht folgt Schellings Postulat und verdichtet sich in der umrissbetonten Zeichnung der Nazarener und deren beharrlichem Bemühen um den Wahrheitsanspruch[1420].

Niedergang der Nazarenischen Malerei

Trotz des angeregten, jedoch stets kritischen philosophisch-kunsthistorischen Diskurses um das Thema der nazarenischen Kunst begann die das Mittelalter heraufbeschwörende christliche Tafelmalerei ab den Zwanzigerjahren zu stagnieren. Die Künstlerpersönlichkeit Friedrich Overbecks ausgenommen, der bis an sein Lebensende in Rom verblieb, drohte sich der deutsch-römische Künstlerkreis langsam aufzulösen – erste Rückkehrtendenzen nach Deutschland waren zu beobachten. Der ursprüngliche Kanon der Lukasbrüder wurde jedoch in der christlichen Kunst noch für Jahrzehnte weitergetragen, allerdings zunehmend als Ausdruck einer naiven, sentimentalen Glaubenshaltung empfunden. Die notwendige Aktualisierung des Glaubensbildes durch zeitgenössische brisante Ereignisse politischer, religiöser oder gesellschaftlicher Prägung, blieb in allen die nazarenische Kunst tangierenden Kunstgattungen aus[1421]. Auch wenn Darstellungen, wie die «Schlüsselübergabe an Petrus» (J.J. Röttinger, katholische Kirche Saint-Imier, axiales Chorfenster I), auf die Bedeutung des Papstes als Nachfolger und Stellvertreter Christi hinweisen und vor allem ab 1870 die Verkündigung des Dogmas von der päpstlichen Unfehlbarkeit unterstreichen[1422], fehlte die künstlerisch-kritische Auseinandersetzung. Die nazarenische Kunst – nunmehr auf die Gefühlsebene verdrängt – beschränkte sich mehr und mehr auf Altarbilder, sakrale Glasmalereien sowie gegen Ende des Jahrhunderts auf die massenhaft hergestellten Devotionalien[1423]. In der Schweiz erschienen diese Gegenstände zur religiösen Andacht vor allem als Drucke der Firma Benziger in Einsiedeln, die als so genannte «Öldrucke» – Wandschmuck für diejenigen, die sich Ölgemälde nicht leisten konnten – zahlreich vertrieben wurden[1424]. Drucke von Bildern Deschwandens der Firma Benziger finden sich auch im Nachlass der Röttinger und dienten dort als Vorlagenmaterial[1425].

Rezeption

Die große Wertschätzung der Glasmalereien Johann Jakob Röttingers und seines künstlerischen Umfeldes wurde bereits mehrfach mit Quellen belegt, die hier nicht nochmals aufzuführen sind. Die Glasfenster waren sowohl bei den Pfarrern wie auch Laien beider Konfessionen hoch geschätzt. Zu diesem Ergebnis kam auch Mathilde Tobler in ihrer Untersuchung über den Maler M. P. Deschwanden[1426]. Die Forscherin geht davon aus, dass die besondere Ausdrucksform des Kirchenmalers wohl weiten Kreisen als Idealvorstellung religiöser Bilder entsprochen haben mochte. Das breite Publikum konnte sich mit den bürgerlich erscheinenden, wenngleich in mittelalterliches Gewand gehüllten Gestalten des 19. Jahrhunderts leicht identifizieren und schätzte deren Idealisierung sowie den heiligen Ernst, der von den dargestellten Personen ausging. Dank der Konzentration auf das Wesentliche und der Wahl von im Volk verankerten christlichen Themen, war der

1420 Büttner, 2001, S. 109 f.
1421 Spickernagel, 1977, S. 119.
1422 Tobler, 1985, S. 88.
1423 Spickernagel, 1977, S. 119.
1424 Tobler, 1985, S. 92.
1425 ZB Nachl. Röttinger 4.5.6.
1426 Über Deschwandens Arbeiten im reformierten Umfeld: Tobler, 1985, S. 66.

theologische und künstlerische Zugang für jedermann gegeben[1427]. Seitens der Auftraggeber galt die Einhaltung der Maxime – die Regeln der christlichen Kunst – , die Solidität und das Verhältnis von Preis und Leistung für die Zufriedenheit als maßgebend. Einer der wichtigsten Aufträge Johann Jakob Röttingers, die Chorverglasung im Grossmünster von 1853 (Abb. 151), die im Rahmen einer großangelegten Restaurierung mit einer weitgehend historisierenden Gestaltung des Innenraums einherging, führt die einst hohe Wertschätzung und deren allmählichen Verlust exemplarisch vor Augen.

Die Auftragserteilung erfolgte vom «Verein für das Grossmünster», Konzeption und Ausführung oblagen dem Architekten Ferdinand Stadler[1428]. Der Nürnberger Glasmaler Georg Konrad Kellner erhielt das Mandat für die Schaffung der Kartonzeichnungen, während die Werkstatt Johann Jakob Röttingers für die Umsetzung in das Medium Glas verantwortlich zeichnete. Die drei Chorfenster zeigten in ihrer ursprünglichen Position den «Lehrenden Christus» (I) sowie die Apostel Petrus (n II) und Paulus (s II), dargestellt in der üblichen gemalten gotischen Ziboriumsarchitektur. Nach Beendigung der Arbeiten erhielt Johann Jakob Röttinger ein Zertifikat vom «Stillstand[1429] des Grossmünsters und des Vereins für Verschönerung dieser Kirche»: «[...] *Der Künstler hat diese Aufgabe in der Weise gelöst, dass wir es für angemessen erachten demselben sowohl wegen der Billigkeit als Schönheit der gelieferten Arbeiten die vollste Zufriedenheit auszusprechen, und dessen Werkstätte den Kirchenvorstehern und Gemeinden, die sich ähnliche Gemälde anzuschaffen wünschen, bestens zu empfehlen»*[1430]. Darüber hinaus wurde dem Glasmaler ein Ehrenring verliehen, der sich bis heute im Besitz der Nachkommen befindet[1431]. 75 Jahre später, im Jahre 1928, urteilte der Zürcher Kunsthistoriker und Professor für neuere Kunstgeschichte, Konrad Escher (1882–1944), über die einst geschaffenen Glasmalereien: «Die Glasgemälde Johann Jakob Röttingers in den drei Fenstern der Chorschlusswand mochten das damalige künstlerische und antiquarische Bedürfnis befriedigen; für das Empfinden der Gegenwart jedoch

lassen sie kräftige Linien und gleichmäßige Leuchtkraft der Farben als Gegengewicht zu den hohen kahlen Wänden des Vorder- und Hinterchores schmerzlich vermissen [...]»[1432]. Pfarrer Paul Eppler[1433] ging in seiner Wertung noch härter vor und kritisierte «das gemalte gotische Maßwerk», das dem echten nicht nur ungeschickt nachgebildet sei, sondern in einer romanischen Kirche nichts verloren habe. Die beiden Apostelfürsten würden sich in ihrer Haltung Christus zwar zuwenden, seien jedoch trotz der Präsenz völlig «unbeteiligt». Christus habe ein ausdrucksloses Gesicht und der Segensgestus entspräche dem eines katholischen Bischofs. In seinen weiteren Ausführungen missbilligte der Pastor die Helligkeit des die gemalten Standbilder umgebenden Glases, das das Sonnenlicht ungebrochen hereinlasse sowie die Farbwahl bei den Figuren. Er wies auf die hohe Kunst der mittelalterlichen Glasfenster hin, deren Künstler es verstanden hätten, durch den Einsatz von Teppichmustern und unter Einbettung himmlischen Geschehens, ein leuchtendes, mosaikartiges Farbenspiel zu zaubern. Diese Qualität in der Glasmalkunst hätten die Maler des 19. Jahrhunderts nie erreicht. Im polarisierenden Artikel, der als Propagandaschrift für die geplante Neuverglasung durch den Künstler Augusto Giacometti zu verstehen ist, übersah der Verfasser jedoch, dass sich im Altarhausbogen, also in unmittelbarer Nähe

1427 TOBLER, 1985, S. 65.

1428 GUTSCHER, 1983, S. 175 f.

1429 Der Zürcher Stillstand stellt die älteste Aufsichtsbehörde der reformierten Kirchgemeinden dar. Der Name leitet sich vom wörtlichen «Stillstehen» nach dem Gottesdienst in der Kirche ab, wo monatlich die anfallenden Geschäfte der Kirchen-, Schul-, Armen- und Vormundschaftsbehörde bzw. des Sittengerichts unter dem Vorsitz des Pfarrers beraten wurde. Nach 1798 beschränkten sich die Aufgaben auf rein kirchliche Angelegenheiten. (StAZH Zürich, Online-Edition Stillstandsberichte).

1430 ZB Nachl. Röttinger 1.198, das Schreiben datiert vom 1. November 1853.

1431 Freundliche Mitteilung R.H. Röttingers.

1432 ESCHER, 1928, S. 90; vgl. dazu über frühere kritische Stimmen: GERSTER, 2012, S. 8–12.

1433 EPPLER, 1929, Artikel im Kirchenboten.

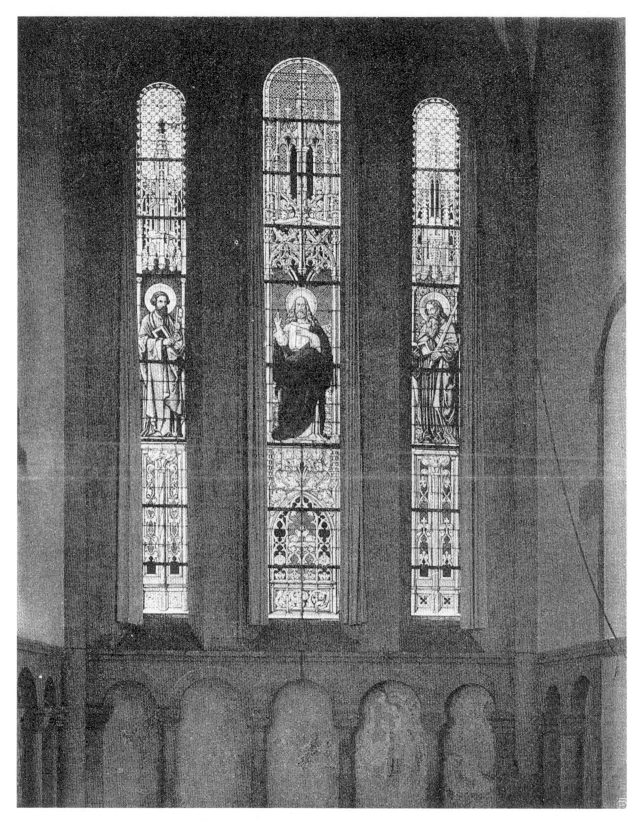

151. Georg Konrad Kellner (Entwurf)/Johann Jakob Röttinger, ehemalige Chorverglasung, Grossmünster Zürich, 1853.

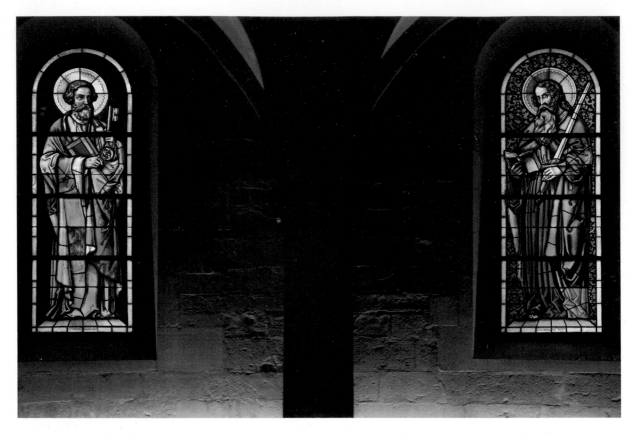

152. Georg Konrad Kellner (Entwurf)/Johann Jakob Röttinger, Teil der ehemaligen Chorverglasung in aktueller Anordnung, Grossmünster Zürich, 1853; seit 1933 Petrus ws II, Paulus wn II.

der Chorfenster gemalte Teppichmuster als Hintergrund für plastische Figuren befanden, die ebenfalls durch ein gotisches Maßwerk bekrönt waren sowie die Präsenz der neugotischen Kanzel Ferdinand Stadlers, die zeitgleich mit den Fenstern Röttingers geschaffen worden war. Ein verbaler Schlagabtausch zwischen dem Kunsthistoriker Escher, dem Theologen Eppler und dem Sohn Johann Jakob Röttingers, Heinrich Röttinger[1434], war die Folge, in dem die verschiedenen Standpunkte – künstlerische, konfessionelle und persönlich-emotionale – aufeinanderprallten. Schließlich fand 1933 die feierliche Enthüllung der vom Bergeller Künstler Augusto Giacometti (1877–1947) entworfenen und von Glasmaler Ludwig Jäger in Sankt Gallen[1435] ausgeführten Glasmalereien statt. Die beiden Apostelfürsten aus der Werkstatt Röttinger wurden unter Weglassung der gemalten Tabernakelarchitektur in die Westfenster

(Abb. 152) des Grossmünsters versetzt, wo sie sich als stimmungsvolle Zeugen des 19. Jahrhunderts bis in die Gegenwart erhalten konnten, während das Christusfenster (Abb. 49) seither im Karlsturm seiner Befreiung harrt.

Ein neuer Stil

Der allmähliche Wandel, weg von der historistischen Glasmalerei, zeichnete sich schon Jahrzehnte vorher ab, als um die Jahrhundertwende die Rezeption japanischer Holzschnitte sowie maltechnische Versuche der Postimpressionisten um Paul Gauguin (1848–1903) und Emile Bernard

1434 ZB Nachl. Röttinger 3.18.
1435 KAISER, 1999, S. 54: Ludwig Jäger (1877–1949), geb. in Deggendorf, Bayern.

(1858–1941) aufkamen, die wegen ihrer flächigen Malerei Verbindungen zum ästhetischen Charakter von Glasfenstern aufwiesen. Das Dekorative und die Verwendung reiner Farben mit dunklen an Bleilinien erinnernder Konturierung und der Verzicht auf räumliche Wirkung wurden als wichtige Kriterien hervorgehoben[1436]. Heute erinnern noch zahlreiche profane Glasfenster in Privathäusern und Hotels – so genannte «Vitraux domestiques» – an den Jugendstil, der in der Schweiz zwischen 1895 bis 1915 seine Blüte erreichte und dessen bedeutendstes sakrales Andenken sich im Glasmalereizyklus des polnischen Künstlers Jósef Mehoffer (1869–1946) in der Saint Nicolas Kirche in Fribourg erhalten konnte. Die Kritik an der Glasmalerei Johann Jakob Röttingers richtete sich vor allem gegen die in sich versunkenen, unbeteiligt wirkenden Figuren und die plakative Buntheit – statt des vermissten leuchtenden Farbenspiels, das der Jugendstil mit seiner musivischen Glasmalerei und der Nähe zum Naturalismus wieder hervorgebracht hatte. Augusto Giacometti, der sich in seiner Spätzeit auf einen symbolistischen Malstil und die Suche nach «der reinen Farbe» verlegte, entsprach den zeitgenössischen Wünschen nach Leuchtkraft und Sinnlichkeit[1437]. Darüber hinaus gab auch der religiöse Inhalt der alten und neuen Glasmalereien Anlass zur Diskussion. Der von Röttinger nach Entwürfen Kellners geschaffene «Lehrende Christus» mit den flankierenden Apostelfürsten, die sich durch das Attribut des Buches als Verbreiter der christlichen Lehre und des Wortes Gottes auswiesen, entsprachen in höherem Maße der protestantischen Doktrin als die fulminante Weihnachtsgeschichte Giacomettis, die mit ihrer sinnlichen Ausstrahlung und den leuchtenden Farben zwar allen ästhetischen Ansprüchen zu entsprechen vermochte, allerdings der Forderung nach einer bildarmen, der protestantischen Maxime folgenden Ausstattung nicht nachkam. Da Giacometti nie Vorgaben seitens der Kirchenpflege bekommen hatte[1438], war den Auftraggebern bei der Ausführung der neuen Chorfenster wohl die moderne künstlerische Lösung wichtiger als das konfessionelle Gebot. Offenbar veränderten

sich in den Dezennien nach dem Tod Johann Jakob Röttingers nicht nur das ästhetische Empfinden und die philosophischen Ideologien der Rezipienten, sondern es verlagerten sich auch deren Argumente bezüglich konfessionell-künstlerischer Kriterien, den «Regeln der christlichen Kunst» sowie die Vorstellungen der Auftraggeber, die den Künstlern vermehrt schöpferischen Freiraum konzedierten.

1436 MICHEL, 1986, S. 8 f.
1437 EPPLER, 1929, Artikel im Kirchenboten; POESCHEL, 1928, S. 51 f. Giacometti verändert die Technik der Glasmalerei, indem er die Bleifassungen immer enger knüpft, um so die Farben weicher ineinander zu überführen.
1438 STUTZER/WINDHÖFEL, 1991, S. 69.

Zusammenfassung und Ergebnisse

Die Werkstatt der Röttinger kann in verschiedener Hinsicht als Modell für das Metier der Glasmaler im 19. Jahrhundert herangezogen werden. Während sich Johann Jakob Röttinger in den ersten fünfzehn Jahren seiner selbstständigen Berufsausübung neben herausragenden Aufträgen von Stadtkirchen – dem Zürcher Grossmünster, dem Basler Münster, der Sankt Galler Laurenzenkirche – sowie für große Landkirchen in Leuggern und Unterägeri mit wichtigen Aufgaben der Denkmalpflege beschäftigte, profilierte er sich in den Sechzigerjahren, als das prosperierende Geschäft einen personellen Aufschwung nahm, als Prinzipal und Mentor für die nachfolgende Glasmalergeneration in der Schweiz und im süddeutschen Raum. Röttinger bewegte sich in Zürcher Kreisen der damals noch jungen Wissenschaft der Kunstgeschichte und Pionieren der Denkmalpflege mit Ferdinand Keller und Johann Rudolf Rahn, die ihm nicht nur den Zugang zu Mandaten zeichnerischer Inventarisation bedeutender mittelalterlicher Glasmalereien beziehungsweise deren Restaurierung verschafften, sondern darüber hinaus ein geschäftliches Netzwerk boten, das ihm die berufliche und gesellschaftliche Integration als Einwanderer wesentlich erleichterte. Als selbstständig Erwerbender und Künstler im aufstrebenden Metier der Glasmalerei und Eigentümer einer florierenden Werkstatt, ausgezeichnet beleumundet, evangelisch und mit der in Ossingen ZH beheimateten Ehefrau Verena Fehr vermählt, brachte er alle Voraussetzungen für eine reibungslose Eingliederung in seiner Wahlheimat Zürich mit, die schließlich mit der Einbürgerung für das Ehepaar und die Kinder 1863 seinen Abschluss fand. Die Rolle seiner Ehefrau, in erster Linie mütterlichen Aufgaben zugewandt, wandelt sich nach und nach zur eigentlichen Geschäftspartnerin, im Sinne ihrer Bereitstellung der für den Betrieb notwendigen Infrastruktur, für Kost und Logis der Mitarbeiter. Die Führung des «Unternehmens Geschäftshaushalt» erfährt vom Hausvater eine hohe Wertschätzung, was sich in manchen Erleichterungen für die Ehefrau offenbart, wie zum Beispiel Kuraufenthalten, Sommerfrische beziehungsweise der stundenweisen Beschäftigung einer Haushaltshilfe. Das Zürcher Atelier, das zahlreiche angesehene Glasmaler hervorbrachte, kann mit Recht als eine der Keimzellen dieser Kunstrichtung bezeichnet werden. Während zu Lebzeiten Johann Jakob Röttingers unter anderem Johann und Christian Klaus, Adolf Kreuzer, Mitglieder der Kellnerfamilie, Friedrich Berbig, Albert Merzweiler, Gustav van Treeck und Jakob Kuhn als Gesellen, Lehrlinge oder Hospitanten für kürzere oder längere Zeit beim Werkstattgründer beschäftigt waren, übernahm nach dessen Tod der Zürcher Glasmaler Carl Wehrli das Geschäft. Die Söhne, Jakob Georg und Heinrich Röttinger, führten ab 1887 das väterliche Glasmalerei-Unternehmen weiter, um sich schon bald wieder marktführend zu positionieren. Sowohl die Situation der Immigration des in Nürnberg ausgebildeten Glasmalers, die Auslieferung von Glasmalereien in den deutschen wie französischen Teil der Schweiz, ins Elsass und nach Deutschland wie auch die künstlerische Ausstrahlung der größten-

teils in den süddeutschen Raum zurückgekehrten ehemaligen Mitarbeiter ermöglichten einen weitgreifenden Kulturaustausch respektive Kulturtransfer, der auch geschäftliche Beziehungen mit Glashütten in Deutschland, Schlesien und Paris sowie die Rezeption englischer Glasmalereien in Schweizer anglikanischen Kirchen implizierte. Künstlerisch bleibt Johann Jakob Röttinger seiner Nürnberger Ausbildung an der Kunstgewerbeschule sowie dem Glasmaler Sauterleute treu und verschreibt sich Zeit seines Lebens den Vorbildern der Alten Deutschen Meister, den plastischen Figuren Vischers am Sankt Sebaldusgrab sowie den Idealen der sakralen Kunst, der Rezeption Raffaels und Renis, was sich in der kräftigen Farbgebung und den aus mehrschichtigen Lasuren entwickelten, «plastisch modellierten» Figuren zeigt. Röttinger, der sich selbst als Spätnazarener bezeichnete, passte sich den zeitgenössischen Kunstströmungen an und übernahm sowohl Motive und Komposition wie auch künstlerische Eigenarten der Nazarener, beispielsweise die Betonung der Einzelfigur und der Linie, die Darstellung von Scheinräumen oder die emblematisch geladene Rahmung der Bilder – Kriterien, die mit der Glasmalerei korrelieren. München galt im 19. Jahrhundert mit der Königlichen Glasmalereianstalt und dem Scheibenzyklus der neugotischen Maria-Hilf-Kirche für das Metier der Glasmalerei als Künstlermagnet, wo sich auch Röttinger mehrmals zum Studium einfand. Wichtige Vorbilder für seinen ikonographischen Protagonisten – den «Lehrenden Christus» – waren Johann Heinrich Dannecker und Bertel Thorvaldsen mit Christusskulpturen, wobei sich letzterer mit den Aposteln für die Kopenhagener Frauenkirche an Lavater und Peter Vischer orientierte, was den Kreis um Röttinger, der ebenfalls die «Physiognomischen Fragmente Lavaters» studierte, wieder schließt. Die enge Zusammenarbeit mit dem bekannten Stanser Kirchenmaler und Künstlerfreund Melchior Paul von Deschwanden hat sich in künstlerischer wie wirtschaftlicher Hinsicht als befruchtend herausgestellt. Im 19. Jahrhundert wies sowohl die sakrale als auch die profane Iko-

nographie einen hohen Symbolgehalt auf, so verdichteten sich die einst großen sakralen Szenen häufig auf Einzelfiguren, singuläre Medaillons mit heiligen Gestalten und deren Attributen respektive auf christliche «Monogramme» als Chiffren der Heilsgeschichte. Die vergleichsweise schlicht gehaltene Fenstergestaltung auf Schweizer Gebiet ist in den großen Stadtkirchen als Ausdruck konfessioneller Prägung des reformierten Bevölkerungsteils zu konstatieren, in den kleineren Land- und Klosterkirchen als Folge bescheidener finanzieller Verhältnisse in Zeiten des Aufholbedarfs im Kirchenbau nach der Gründung des modernen Bundesstaates 1848. Die erhaltenen Wappenzyklen in Rapperswil SG, Schwyz und Stans zeugen von der Wiederaufnahme der Schweizerischen Tradition der Wappenschenkungen und schaffen Bezüge zur großen Zeit der heraldischen Glasmalereizyklen in Rathäusern und anderen öffentlichen Gebäuden. Aus der Vergessenheit hervorgeholte Geschlechterwappen in Schwyz, als Stiftungen stolzer Nachfahren anzusprechen, lassen die Besonderheiten der frühen Innerschweizer Geschichte wieder aufleben und verweisen auf das Selbstverständnis der Altvordern, die sich von adliger Herrschaft zu befreien wussten, um die angestrebte Freiheit zu erlangen.

Johann Jakob Röttingers Kompetenz und Kundennähe wurde von Verhandlungspartnern beider Konfessionen gleichermaßen geschätzt; die hohe Qualität seiner Arbeiten, die Einhaltung der geforderten «Regeln der christlichen Kunst» sowie die ihm eigene Empathie sich auf die Wünsche seiner Auftraggeber einzustellen, brachten ihm laufend Empfehlungen und neue Mandate – eine zentrale Komponente der ökonomisch orientierten Geschäftswelt der damaligen Glasmaler.

Die Problematik der Rezeption von nazarenisch-historisierenden Glasmalereien aus der Epoche von 1840 bis 1880 wird vor dem Kontext politischer Veränderungen, des Gesellschaftswandels, der veränderten religiösen Haltung in Abhängigkeit philosophischer Anschauungen und wirtschaftlicher Umbrüche im Werk Johann Jakob Röttingers evident. Während das Œuvre des

Glasmalers als Spiegel einer bewegten Epoche – ohne jedoch diese Zeichen in den Kunstwerken kritisch zu thematisieren – dekodiert werden musste, wurden dank des überlieferten schriftlichen Nachlasses am Atelier der Röttinger Merkmale sowohl der Gesellschaft wie der Kultur- und Sozialgeschichte des 19. Jahrhunderts modellhaft und narrativ erfahrbar.

Abbildungsnachweis

aus Publikationen

aus Internet

Foto ab Foto

Bildmontagen

Verzeichnis der verwendeten Literatur

Nachschlagewerke

ALLGEMEINES KÜNSTLERLEXIKON 1–6, 1779–1816 – Allgemeines Künstlerlexikon oder: Kurze Nachricht von dem Leben und den Werken der Maler, Bildhauer, Baumeister, Kupferstecher, Kunstgiesser, Stahlschneider u.u.; nebst angehängten Verzeichnissen der Lehrmeister und Schüler, auch der Bildnisse, der in diesem Lexikon enthaltenen Künstler, 6 Bde., von Johann Rudolf Füssli, fortgeführt & erg. von Hans Heinrich Füssli, Zürich 1779–1816.

ALLGEMEINES LEXIKON DER BILDENDEN KÜNSTLER 1–37, 1907–1950 – Allgemeines Lexikon der Bildenden Künstler von der Antike bis zur Gegenwart, hrsg. von Ulrich Thieme und Felix Becker, 37 Bde. (ab Bd. 16 hrsg. von Hans Vollmer), Leipzig 1907–1950.

ATZ, 1876 – Carl Atz, Die christliche Kunst in Wort und Bild. Geschichtlich und vorzugsweise praktisch dargestellt nach den Vorschriften der Kirche und den allgemein giltigen Regeln der Gegenwart, Würzburg/Wien 1876.

ATZ, 1915 – Carl Atz, neubearbeitet von Stephan Beissel SJ, Die christliche Kunst in Wort und Bild. Praktisches, alphabetisch geordnetes Handbuch für Geistliche, Lehrer, Künstler sowie für Mitglieder des Kirchenvorstandes und des Paramentenvereines, München/Regensburg 1915.

BIOGRAPHISCHES LEXIKON DER SCHWEIZER KUNST 1–2, 1998 – Biographisches Lexikon der Schweizer Kunst. Unter Einschluss des Fürstentums Liechtenstein. Dictionnaire biographique de l'art suisse. Dizionario biografico dell'arte svizzera, hrsg. vom Schweizerischen Institut für Kunstwissenschaft, Zürich und Lausanne [Leitung: Karl Jost, Sandi Paucic], 2 Bde., Zürich/Lausanne 1998.

CHRISTLICHE KUNSTSYMBOLIK UND IKONOGRAPHIE, 1839 – Christliche Kunstsymbolik und Ikonographie. Ein Versuch die Deutung und ein besseres Verständniss der kirchlichen Bildwerke des Mittelalters zu erleichtern, hrsg. von Georg Helmsdörfer, Frankfurt am Main 1839.

DER KLEINE PAULY 1–5, 1979 – Der Kleine Pauly. Lexikon der Antike, auf der Grundlage von Pauly's Realencyklopädie der classischen Altertumswissenschaft unter Mitwirkung zahlreicher Fachgelehrter bearbeitet und hrsg. von Konrad Ziegler/Walter Sontheimer/Hans Gärtner, 5 Bde., München 1979.

HANDBUCH DER HERALDIK, 2007 – Handbuch der Heraldik, begründet durch Adolf Matthias Hildebrandt, 19. bearbeitete von Ludwig Biewer verbesserte und erweiterte Ausgabe, hrsg. von HEROLD, Verein für Heraldik, Genealogie und verwandte Wissenschaften, Hamburg 2007.

HISTORISCHES LEXIKON DER SCHWEIZ 1–11, 2002–2012 – Historisches Lexikon der Schweiz, hrsg. von der Stiftung Historisches Lexikon der Schweiz (HLS), Chefredaktor: Marco Jorio, 11 Bde. (bisher), Basel 2002–2012. (Verweise auf einzelne Artikel unter den jeweiligen Autoren siehe Reihenwerke und Einzelpublikationen).

INSA 1–11, 1982–2004 – Inventar der neueren Schweizer Architektur, Inventaire Suisse d'Architecture, Inventario Svizzero di Architettura 1850–1920, Städte, Villes, Città, hrsg. von der Gesellschaft für Schweizerische Kunstgeschichte, 11 Bde., Bern 1982–2004.

INSA 9, 2003 – Inventar der neueren Schweizer Architektur, Inventaire Suisse d'Architecture, Inventario Svizzero di Architettura 1850–1920, Städte, Villes, Città, Sion; Solothurn; Stans; Thun; Vevey, hrsg. von der Gesellschaft für Schweizerische Kunstgeschichte, 9. Bd., Bern 2003.

KELLER, 2001 – Hiltgart L. Keller, Reclams Lexikon der Heiligen und biblischen Gestalten. Legende und Darstellung in der bildenden Kunst, 9., durchgesehene Auflage, Stuttgart 2001.

KÖBLER, 1990 – Gerhard Köbler, Historisches Lexikon der deutschen Länder: die deutschen Territorien vom Mittelalter bis zur Gegenwart, 3., verbesserte, um ein Register erweiterte Auflage, München 1990.

KUNSTFÜHRER DURCH DIE SCHWEIZ 1–4, Bd. 1–2 2005/Bd. 3 2006/Bd. 4 2012 – hrsg. von der Gesellschaft für Schweizerische Kunstgeschichte GSK, 4 Bde., Bern 2005/2006/2012.

LCI 1–8, 1968–1976 – Lexikon der Christlichen Ikonographie, hrsg. von Engelbert Kirschbaum SJ; In Zusammenarbeit mit Günter Bandmann/Wolfgang Braunfels/Johannes Kollwitz/Wilhelm Mrazek/Alfred A. Schmid/Hugo Schnell, 8 Bde., Rom u.a. 1968–1976.

LDK 1–7, 2004 – Lexikon der Kunst. Architektur, Bildende Kunst, angewandte Kunst, Industrieformgestaltung, Kunsttheorie, 2., unveränderte Auflage 1987–1994, hrsg. von Harald Olbrich…[et al.], 7 Bde., Leipzig 1987–1994/2004.

LEXMA I-IX, 2003 – Lexikon des Mittelalters, Taschenbuchausgabe (Band- und seitengleich mit der Studienausgabe 1999), 9 Bde., München/Stuttgart 1999–2002/2003.

LThK 1–11, 2009 – Lexikon für Theologie und Kirche, begründet von Michael Buchberger, Sonderausgabe, durchgesehene Ausgabe der 3. Auflage 1993–2001, hrsg. von Walter Kasper … [et al.], 11 Bde., Freiburg im Breisgau 1993–2001/2009.

MARIENLEXIKON 1–6, 1988–1994 – Marienlexikon, hrsg. im Auftrag des Institutum Marianum Regensburg E.V. von Remigius Bäumer/Leo Scheffczyk, 6 Bde., St. Ottilien 1988–1994.

MEYERS ENZYKLOPÄDISCHES LEXIKON 1–25, 1975 – Meyers Enzyklopädisches Lexikon, 9., völlig überarbeitete Auflage zum 150-jährigen Bestehen des Verlages, 25 Bde., Mannheim 1975.

NAGLER'S KÜNSTLER-LEXICON 1–22, 1835–1852 – Neues allgemeines Künstler-Lexicon oder Nachrichten von dem Leben und den Werken der Maler, Bildhauer, Baumeister, Kupferstecher, Formschneider, Lithographen, Zeichner, Medailleure, Elfenbeinarbeiter, bearbeitet von Georg Kaspar Nagler, 22 Bde., München 1835–1852.

NÜRNBERGER KÜNSTLERLEXIKON 1–4, 2007 – Nürnberger Künstlerlexikon. Bildende Künstler, Kunsthandwerker, Gelehrte, Sammler, Kulturschaffende und Mäzene vom 12. bis zur Mitte des 20. Jahrhunderts, hrsg. von Manfred H. Grieb unter Mitarbeit zahlreicher Fachgelehrter, 4 Bde., München 2007.

SCHWEIZERISCHES KÜNSTLER-LEXIKON 1–4, 1905–1917 – Schweizerisches Künstler-Lexikon, hrsg. vom Schweizerischen Kunstverein, redigiert unter Mitwirkung von Fachgenossen von Carl Brun, 4 Bde., Frauenfeld 1905–1917.

STADTLEXIKON NÜRNBERG, 2000 – Stadtlexikon Nürnberg, 2., verbesserte Auflage, hrsg. von Michael Diefenbacher und Rudolf Endres, in Zusammenarbeit mit Ruth Bach-Damaskinos … [et al.], Nürnberg 2000.

WERNER, 1768 – Georg Heinrich Werner, Nöthige Anweisung in der Zeichenkunst, wie die Theile des Menschen durch Geometrische Regeln und nach dem vollkommnesten Ebenmaß ganz leicht zu Zeichnen zusammen zusetzen um die schön Gestalt eines Gantzen vorzustellen, Erfurt 1768.

Reihenwerke und Einzelpublikationen

ABEGG/WIENER/GRUNDER, 2007 – Regine Abegg/Christine Barraud Wiener/Karl Grunder, Die Kunstdenkmäler des Kantons Zürich. Die Stadt Zürich III.I. Altstadt rechts der Limmat, Sakralbauten (Die Kunstdenkmäler der Schweiz, hrsg. von der Gesellschaft für Schweizerische Kunstgeschichte GSK), Bern 2007.

ABEGG/WIENER, 2002 – Regine Abegg/Christine Barraud Wiener, Die Kunstdenkmäler des Kantons Zürich. Die Stadt Zürich II.I. Altstadt links der Limmat, Sakralbauten (Die Kunstdenkmäler der Schweiz, hrsg. von der Gesellschaft für Schweizerische Kunstgeschichte GSK), Bern 2002.

ALTERMATT, 2009 – Urs Altermatt, Konfession, Nation und Rom. Metamorphosen im schweizerischen und europäischen Katholizismus des 19. und 20. Jahrhunderts, Frauenfeld/Stuttgart/Wien 2009.

AMAN, 2003 – Cornelia Aman, Glasmalereien des 19. Jahrhunderts. Sachsen-Anhalt. Die Kirchen, hrsg. von der Arbeitsstelle für Glasmalereiforschung des Corpus Vitrearum Medii Aevi, Potsdam, der Berlin-Brandenburgischen Akademie der Wissenschaften, Berlin 2003.

ANDERES, 1985 – Bernhard Anderes, Zur Kirchenausstattung des 19. Jahrhunderts, in: Unsere Kunstdenkmäler, Mitteilungsblatt für die Mitglieder der Gesellschaft für Schweizerische Kunstgeschichte, Jg. 36, Heft 1 (1985), S. 3–16.

ANDERES, 1966 – Bernhard Anderes, Der Seebezirk (Die Kunstdenkmäler des Kantons St. Gallen, Bd. IV), hrsg. von der Gesellschaft für Schweizerische Kunstgeschichte GSK, Basel 1966.

ANWANDER-HEISSE, 1992 – Eva Anwander-Heisse, Glasmalereien in München im 19. Jahrhundert (Miscellanea Bavarica Monascensia, Dissertationen zur Bayerischen Landes- und Münchner Stadtgeschichte, hrsg. von Karl Bosl/Richard Bauer, Bd. 161), München 1992.

ANZELEWSKY, 1988 – Fedja Anzelewsky, Dürer. Werk und Wirkung, Erlangen 1988.

APPUHN, 1991 – Horst Appuhn, Einführung in die Ikonographie der Mittelalterlichen Kunst in Deutschland (Die Kunstwissenschaft, Einführung in Gegenstand, Methoden und Ergebnisse ihrer Teildisziplinen und Hilfswissenschaften), Darmstadt 1991.

ARGAST, 2007 – Regula Argast, Staatsbürgerschaft und Nation. Ausschliessung und Integration in der Schweiz 1848–1933 (Kritische Studien zur Geschichtswissenschaft, Bd. 174, Dissertation Universität Zürich, Referent Jakob Tanner), hrsg. von Helmut Berding/Jürgen Kocka/Paul Nolte/Hans-Peter Ullmann/Hans-Ulrich Wehler, Göttingen 2007.

ARNDT/MÖLLER, 2003 – Karl Arndt/Bernd Möller, Albrecht Dürers «Vier Apostel». Eine kirchen- und kunsthistorische Untersuchung (Nachrichten der Akademie der Wissenschaften zu Göttingen, I. Philologisch-historische Klasse, Jg. 2003, Nr. 4), Göttingen 2003.

BAERTSCHI, 2005 – Pierre Baertschi, Inventaire du vitrail à Genève, in: Forum, Kulturgüterschutz, Bundesamt für Bevölkerungsschutz, Thema: Glasmalerei 7/2005, S. 43–49.

BANDMANN, 1971 – Günter Bandmann, Der Wandel der Materialbewertung in der Kunsttheorie des 19. Jahrhunderts, in:

Beiträge zur Theorie der Künste im 19. Jahrhundert, Bd. 1, hrsg. von Helmut Koopmann/J. Adolf Schmoll gen. Eisenwerth (Studien zur Philosophie und Literatur des 19. Jahrhunderts, Bd. 12/1, Beiträge zur Theorie der Künste im 19. Jahrhundert, «Neunzehntes Jahrhundert» Forschungsunternehmen der Fritz Thyssen Stiftung), S. 129–157.

Banken, 2003 – Ralf Banken, Die Industrialisierung der Saarregion 1815–1914, Bd. 2: Take-off-Phase und Hochindustrialisierung 1850–1914, Stuttgart 2003.

Baumgärtel, 2011 – Bettina Baumgärtel, National, regional, transnational. Die Monumentalmalerei der Düsseldorfer Malerschule – Apollinariskirche und Schloss Heltdorf, in: Kat. Ausstellung Düsseldorf, Düsseldorf 2011/9, Petersberg 2011, S. 114–139.

Baumstark, 2002 – Reinhold Baumstark, Die Alte Pinakothek München, München 2002.

Beck, 1999 – James H. Beck, Italian Renaissance Painting, Köln 1999.

Beck, 1890 – P. Beck, «Sauterleute, Franz Joseph», in: Allgemeine Deutsche Biographie 30, 1890, URL: www.deutsche-biographie.de, Stichw. *Sauterleute, Franz Joseph*, 21. November 2010, S. 770–772.

Becksmann, 1967 – Rüdiger Becksmann, Die architektonische Rahmung des hochgotischen Bildfensters. Untersuchungen zur oberrheinischen Glasmalerei von 1250–1350 (Forschungen zur Geschichte der Kunst am Oberrhein 9/10), Berlin 1967.

Beer, 1965 – Ellen J. Beer, Die Glasmalereien der Schweiz aus dem 14. und 15. Jahrhundert ohne Königsfelden und Berner Münsterchor (Corpus Vitrearum Medii Aevi. Schweiz, Bd. 3), hrsg. von der Schweizerischen Geisteswissenschaftlichen Gesellschaft, Basel 1965.

Beer, 1956 – Ellen J. Beer, Die Glasmalereien der Schweiz vom 12. bis zum Beginn des 14. Jahrhunderts (Corpus Vitrearum Medii Aevi. Schweiz, Bd. 1), hrsg. von der Schweizerischen Geisteswissenschaftlichen Gesellschaft, Basel 1956.

Beines, 1979 – Johannes Ralf Beines/Suzanne Beeh/Waldemar Haberey, Farbfenster in Bonner Wohnhäusern, hrsg. im Auftrag des Kultusministers von Nordrhein-Westfalen und des Landschaftsverbandes Rheinland von Udo Mainzer, Landeskonservator Rheinland (Arbeitsheft 24), Bonn 1979.

Belting, 1990 – Hans Belting, Bild und Kult. Eine Geschichte des Bildes vor dem Zeitalter der Kunst, München 1990.

Benjamin, 2008 – Walter Benjamin, Der Begriff der Kunstkritik in der deutschen Romantik (Walter Benjamin Werke und Nachlass, Kritische Gesamtausgabe, Bd. 3), hrsg. von Uwe Steiner, Frankfurt am Main 2008.

Benjamin, 1977 – Walter Benjamin, Das Kunstwerk im Zeitalter seiner technischen Reproduzierbarkeit. Drei Studien zur Kunstsoziologie, Frankfurt am Main 1963, 1966, 1974, 1977.

Bergmann, 2004 – Uta Bergmann, Die Zuger Glasmalerei des 16. bis 18. Jahrhunderts (Corpus Vitrearum. Schweiz, Reihe Neuzeit, Bd. 4), Bern 2004.

Bezut, 1997 – Karole Bezut, The Stained Glass and Painting-on-Glass Workshop at Sèvres, in: The Sèvres Porcelain Manufactory. Alexandre Brongniart and the Triumph of Art and Industry, 1800–1847, hrsg. von Derek E. Ostergaard, New York/New Haven/London 1997.

Bhattacharya, 2008 – Tapan Bhattacharya, Historisches Lexikon der Schweiz, hrsg. von der Stiftung Historisches Lexikon der Schweiz (HLS), Stichw. *Kelterborn, Ludwig Adam,* Bd. 7 Jura – Lobsigen, Basel 2008, S. 177.

Bhattacharya, 2003 – Tapan Bhattacharya, Historisches Lexikon der Schweiz, hrsg. von der Stiftung Historisches Lexikon der Schweiz (HLS), Stichw. *Bleuler, Felix,* Bd. 2 Basel (Kanton) – Bümpliz, Basel 2003, S. 491.

Bhattacharya, 2002 – Tapan Bhattacharya, Historisches Lexikon der Schweiz, hrsg. von der Stiftung Historisches Lexikon der Schweiz (HLS), Stichw. *Aegeri [Egeri], Carl von,* Bd. 1 Aa – Basel (Fürstbistum), Basel 2002, S. 108.

Biaudet, 1980 – Jean-Charles Biaudet, Der modernen Schweiz entgegen, in: Handbuch der Schweizer Geschichte, Bd. 2, Zürich 1980, S. 871–988.

Bischof, 2008 – Franz Xaver Bischof, Historisches Lexikon der Schweiz, hrsg. von der Stiftung Historisches Lexikon der Schweiz (HLS), Stichw. *Kulturkampf,* Bd. 7 Jura – Lobsigen, Basel 2008, S. 484ff.

Boeck, 1958 – Urs Boeck, Karl Alexander Heideloff, in: Mitteilungen des Vereins für Geschichte der Stadt Nürnberg, Bd. 48, Nürnberg 1958, S. 314–390.

Böhmer, 2002 – Roland Böhmer, Das ehemalige Zisterzienserkloster Kappel am Albis. Haus der Stille und Besinnung (Schweizerischer Kunstführer GSK), Bern 2002.

Böning, 1993 – Monika Böning, Himmelfahrt und Krönung Mariens, in: Glasmalerei des 19. Jahrhunderts in Deutschland, Ausstellungskatalog Angermuseum Erfurt, Erfurt/Leipzig 1993, S. 48–51.

Boerner, 2004 – Bruno Boerner, Überlegungen zur Ikonographie des Marienportals, in: Die Kathedrale von Lausanne und ihr Marienportal im Kontext der europäischen Gotik, hrsg. von Peter Kurmann/Martin Rohde, Berlin 2004, S. 179–202.

Boerner, 1998 – Bruno Boerner, Par caritas par meritum. Studien zur Theologie des gotischen Weltgerichtsportals in Frankreich – am Beispiel des mittleren Westeingangs von Notre-Dame in Paris (Scrinium Friburgense, Bd. 7), Freiburg 1998.

Boesch, 1955 – Paul Boesch, Die Schweizer Glasmalerei (Schweizer Kunst, Monographienreihe, Bd. 6), hrsg. von der Kommission für die Ausstellung Schweizer Kunst in Paris 1924 unter der Direktion von Paul Ganz, Basel 1955.

Boetticher, 1979 – Friedrich von Boetticher, Malerwerke des 19. Jahrhunderts. Beitrag zur Kunstgeschichte in 8 Bden. (Nachdruck der Ausgabe von Dresden 1891–1901), Hofheim am Taunus 1979.

Bornschein, 1999 – Falko Bornschein, Die Restaurierung und Neuanfertigung von Glasmalereien am Erfurter Dom

unter Stanislaus von Pereira in den Jahren 1829 bis 1830/31, in: Corpus Vitrearum Medii Aevi, NewsLetter 46, 1999. URL: www.corpusvitrearum.org, 26. April 2012, S. I–5.

BORNSCHEIN, 1996 – Falko Bornschein, Die Erhaltung und Wiederherstellung der Erfurter Domfenster vom Mittelalter bis zur Gegenwart, in: Erfurt-Köln-Oppenheim. Quellen und Studien zur Restaurierungsgeschichte mittelalterlicher Farbverglasungen ([Corpus Vitrearum Medii Aevi. Deutschland, Studien], Bd. 2), Berlin 1996, S. 24–99.

BORNSCHEIN/BRINKMANN, 1996 – Falko Bornschein/Ulrike Brinkmann … [et al.], Erfurt-Köln-Oppenheim. Quellen und Studien zur Restaurierungsgeschichte mittelalterlicher Farbverglasungen ([Corpus Vitrearum Medii Aevi. Deutschland, Studien], Bd. 2), Berlin 1996.

BORNSCHEIN/GASSMANN, 2006 – Falko Bornschein/Ulrich Gaßmann, Glasmalereien des 19. Jahrhunderts. Thüringen. Die Kirchen, hrsg. vom Thüringischen Landesamt für Denkmalpflege und Archäologie und der Arbeitsstelle für Glasmalereiforschung des Corpus Vitrearum Medii Aevi, Potsdam, der Berlin-Brandenburgischen Akademie der Wissenschaften, Leipzig 2006.

BOSSARDT/KAUFMANN, 2012 – Jürg Andrea Bossardt/Urs N. Kaufmann, Die röm.-kath. Pfarrkirche St. Peter und Paul Leuggern (Schweizerischer Kunstführer GSK), hrsg. in Zusammenarbeit mit der Stiftung Kirche St. Peter und Paul Leuggern im Auftrag der Kirchenpflege Leuggern-Kleindöttingen, Bern 2012.

BOSSARDT, 2002 – Jürg A. Bossardt, Glasmalerei und Denkmalpflege im Kanton Aargau, in: Glasmalerei im Kanton Aargau. Einführung zur Jubiläumspublikation 200 Jahre Kanton Aargau, hrsg. von Jürg A. Bossardt/Astrid Kaiser Trümpler/Stefan Trümpler, [Buchs]: Lehrmittelverlag des Kantons Aargau 2002, S. 2–17.

BOSSARDT/KAISER TRÜMPLER/TRÜMPLER, 2002 – Jürg A. Bossardt/Astrid Kaiser Trümpler/Stefan Trümpler, in Zusammenarbeit mit Fritz Dold und Urs Wohlgemuth, Glasmalerei im Kanton Aargau. Einführung zur Jubiläumspublikation 200 Jahre Kanton Aargau, [Buchs]: Lehrmittelverlag des Kantons Aargau 2002.

BRASSAT, 2000 – Wolfgang Brassat, Gestik und dramaturgisches Handeln in Bilderzählungen Raffaels, in: Gestik, Figuren des Körpers in Text und Bild, hrsg. von Margreth Egidi/Oliver Schneider … [et al.], Tübingen 2000, S. 157–169.

BRINKMANN, 1996 – Ulrike Brinkmann, Die Wiederherstellung der Kölner Domfenster im 19. Jahrhundert, in: Erfurt-Köln-Oppenheim. Quellen und Studien zur Restaurierungsgeschichte mittelalterlicher Farbverglasungen ([Corpus Vitrearum Medii Aevi. Deutschland, Studien], Bd. 2), Berlin 1996, S. 100–149.

BROILLET, 1926 – Henri Broillet, Les Vitraux du Choeur de l'Abbaye d'Hauterive, in: Annales Fribourgeoises, No. 1, 1926, S. 30–46.

BROWN, 1999 – Sarah Brown, Sumptuous and richly adorn'd. The Decoration of Salisbury Cathedral, London 1999.

BRÜCKNER, 2007 – Wolfgang Brückner, Lutherische Bekenntnisgemälde des 16. bis 18. Jahrhunderts. Die illustrierte Confessio Augustana, (Adiaphora, Schriften zur Kunst und Kultur im Protestantismus, VI. Bd.), hrsg. von Hasso von Poser und Groß-Naedlitz im Auftrage des Landeskirchenamtes der Ev.-luth. Landeskirche Hannovers, Regensburg 2007.

BRÜCKNER, 2003 – Wolfgang Brückner, Marianischer Kult und Ikonographie im 19. Jahrhundert. Himmelblaue Immaculata – Handgestus und Strahlensymbolik – Hinterglasmotiv, in: Bayerisches Jahrbuch für Volkskunde, München 2003, S. 35–63.

BRÜCKNER, 1853 – Johann G. Brückner, Landeskunde des Herzogthums Meiningen, Bd. 2: Die Topographie des Landes, Meiningen 1853, S. 472 ff.

BRYAN, 1964 – Michael Bryan, Bryan's Dictionary of painters and engravers, hrsg. von George Charles Williamson, Port Washington/NY 1964.

BUCHER, 1980 – Erwin Bucher, Die Bundesverfassung von 1848, in: Handbuch der Schweizer Geschichte, Bd. 2, Zürich 1980, S. 987–1018.

BURG, 2007 – Tobias Burg, Die Signatur. Formen und Funktionen vom Mittelalter bis zum 17. Jahrhundert, (Kunstgeschichte, Bd. 80), Berlin 2007.

BUSCHOW OECHSLIN, 2010 – Anja Buschow Oechslin, Die Kunstdenkmäler des Kantons Schwyz. Der Bezirk Höfe (Die Kunstdenkmäler der Schweiz, hrsg. von der Gesellschaft für Schweizerische Kunstgeschichte GSK, Neue Ausgabe Bd. IV), Bern 2010.

BÜTTNER/GOTTDANG, 2006, 2009 – Frank Büttner/Andrea Gottdang, Einführung in die Ikonographie. Wege zur Deutung von Bildinhalten, München 2006, 2009.

BÜTTNER, 2001 – Frank Büttner, Der Wahrheitsanspruch der Linie. Die Umrißzeichnung im Werk von Peter Cornelius, in: Zeichnen in Rom, 1790–1830 (Kunstwissenschaftliche Bibliothek, Bd. 19), hrsg. von Margret Stuffmann/Werner Busch, Köln 2001.

BÜTTNER, 1994 – Frank Büttner, «Argumentatio» in Bildern der Reformationszeit. Ein Beitrag zur Bestimmung argumentativer Strukturen in der Bildkunst, in: Zeitschrift für Kunstgeschichte, Jg. 57, Heft 1 (1994), S. 23–44.

CHÂTELET, 1991 – Albert Châtelet, Biographische Dokumente, in: Der hübsche Martin. Kupferstiche und Zeichnungen von Martin Schongauer (ca. 1450–1491), Ausstellungskatalog Unterlinden Museum Colmar, hrsg. vom Museum Unterlinden, Strasbourg 1991, S. 37–54.

CHRISTLICHER KUNSTVEREIN FÜR DEUTSCHLAND, 1863 – Organ für christliche Kunst (Organ des christlichen Kunstvereins für Deutschland), hrsg. und redigiert von Friedrich Baudri, Jg. 13, Nr. 1–24, Köln 1863.

CONZEMIUS, 2008 – Victor Conzemius, Historisches Lexikon der Schweiz, hrsg. von der Stiftung Historisches Lexikon der Schweiz (HLS), Stichw. *Lachat, Eugène*, Bd. 7 Jura – Lobsigen, Basel 2008, S. 534 f.

CURTI, 1949 – Alfons Curti, Das Rathaus der Stadt Rapperswil, Rapperswil 1949.

DAHMEN, 2000 – Stephan Dahmen, Die Bayernfenster und die Entwicklung des Architekturfensters in der königlichen Glasmalereianstalt München, in: Kölner Domblatt, Jg. 65 (2000), S. 201–206.

DAVATZ, 2000 – Jürg Davatz, Die Stadtkirche Glarus 1861–1999. Ein Hauptwerk von Ferdinand Stadler und des Historismus in der Schweiz. Mit Beiträgen von Rino Fontana, Hans Beat Hänggi, Oskar Pekarek, hrsg. von der Gemeinde Glarus, in Zusammenarbeit mit der Erziehungsdirektion des Kantons Glarus, Kulturelle Angelegenheiten, Glarus 2000.

DE CAPITANI, 2011 – François de Capitani, Historisches Lexikon der Schweiz,
URL: www.hls-dhs-dss.ch/textes/d/D10350.php, Stichw. *Schweizerisches Landesmuseum (SLM)*, 28. Oktober 2011.

DEGEN, 2005 – Bernard Degen, Historisches Lexikon der Schweiz,
URL: www.hls-dhs-dss.ch/textes/d/D13671.php, Stichw.: *Franken*, 20. Dezember 2005.

DESCOEUDRES, 1999 – Georges Descoeudres, Gebärden des Todes, in: Georges-Bloch-Jahrbuch des Kunsthistorischen Instituts der Universität Zürich 6, Zürich 1999, S. 7–29.

DEUBER, 2002 – Gérard Deuber, Die Kathedrale Saint-Pierre in Genf (Schweizerischer Kunstführer GSK), Bern 2002.

DIETERICH, 2006 – Barbara Dieterich, Anastasis Rotunde und Heiliges Grab in Jerusalem. Überlegungen zur architektonischen Rezeption im Mittelalter, in: Georges-Bloch-Jahrbuch des Kunsthistorischen Instituts der Universität Zürich 2004/05, Bd. 11/12, Zürich 2006, S. 7–30.

DIETL, 2009 – Albert Dietl, Die Sprache der Signatur. Die mittelalterlichen Künstlerinschriften Italiens, Teil I–IV (Italienische Forschungen des Kunsthistorischen Instituts in Florenz, Max-Planck-Institut, 4. Folge, 6.2009), Berlin/München 2009.

DUBLER, 2009 – Anne-Marie Dubler, Historisches Lexikon der Schweiz, hrsg. von der Stiftung Historisches Lexikon der Schweiz (HLS), Stichw. *Masse und Gewichte, Übergang zu internationalen Systemen im 19. Jahrhundert*, Bd. 8 Locarnini – Muoth, Basel 2009, S. 351 ff.

EBERLEIN, 1982 – Johann Konrad Eberlein, Apparitio regis – revelatio veritatis. Studien zur Darstellung des Vorhangs in der bildenden Kunst von der Spätantike bis zum Ende des Mittelalters, Wiesbaden 1982.

EGGERS, 1819–1872 – Friedrich Eggers, Deutsches Kunstblatt «Stuttgart»: Zeitschrift für bildende Kunst, Baukunst und Kunsthandwerk; Organ des deutschen Kunstvereines &. &.., Stuttgart 1850 (hier: Deutsches Kunstblatt, Nr. 14 (1853), S. 117–118).

EGGERT, 1865 – Franz Eggert, Sammlung gothischer Verzierungen, gezeichnet von Franz Eggert, München 1865.

ENGEMANN, 1997 – Josef Engemann, Deutung und Bedeutung frühchristlicher Bildwerke, Darmstadt 1997.

EPPLER, 1929 – Paul Eppler, Von unseren Chorfenstern, in: Kirchenbote für den Kanton Zürich, Ausgabe für die Grossmünstergemeinde, Nr. 6, Juni 1929.

ESCHER, 1928 – Konrad Escher, Die beiden Zürcher Münster (Die Schweiz im deutschen Geistesleben. Der illustrierten Reihe, Bd. 10), Frauenfeld/Leipzig 1928.

FANKHAUSER, 2007 – Andreas Fankhauser, Historisches Lexikon der Schweiz, hrsg. von der Stiftung Historisches Lexikon der Schweiz (HLS), Stichw. *Helvetische Republik*, Bd. 6 Haab – Juon, Basel 2007, S. 258 ff.

FASTERT, 2010 – Sabine Fastert, (K)ein Platz neben Cornelius? Nationale Differenzen in der Nazarener-Rezeption am Beispiel von Heinrich Maria von Hess, in: Dialog und Differenzen. Deutsch-französische Kunstbeziehungen 1798–1870, hrsg. von Isabelle Jansen/Friederike Kitschen unter Mitarbeit von Gitta Ho (Passagen/Passages, Bd. 34), Berlin/München 2010, S. 283–296.

FELDER, 1967 – Peter Felder, Der Bezirk Bremgarten (Die Kunstdenkmäler des Kantons Aargau, Bd. IV), hrsg. von der Gesellschaft für Schweizerische Kunstgeschichte GSK, Basel 1967.

FEULNER, 2008 – Karoline Feulner, Ein Beitrag zur Rezeption Albrecht Dürers im 19. Jahrhundert: Die sieben Transparente der Nürnberger Dürerfeiern von 1828, in: Mitteilungen des Vereins für Geschichte der Stadt Nürnberg, Bd. 95, Nürnberg 2008, S. 275–315.

FICKER, 1886 – Paul Johannes Ficker, Die Quellen für die Darstellung der Apostel in der altchristlichen Kunst, Altenburg 1886.

FINANCE, 2003 – Laurence de Finance (Hrsg.), Un patrimoine de lumière, 1830–2000. Verrières des Hauts-de Seine, Seine Saint-Denis, Val de Marne, par Laurence de Finance [et al.], avec la collaboration de Nicole Blondel [et al.], (Cahiers du Patrimoine, Bd. 67), Paris 2003.

FISCHER, 1984 – Rainald Fischer OFM Cap, Die Kunstdenkmäler des Kantons Appenzell Innerrhoden, hrsg. von der Gesellschaft für Schweizerische Kunstgeschichte GSK, Basel 1984.

FISCHER, 1910 – Josef Ludwig Fischer, Vierzig Jahre Glasmalkunst. Festschrift der Kgl. Bayerischen Hofglasmalerei F.X. Zettler zum Gedächtnis ihres vierzigjährigen Bestehens, München 1910.

FLACH, 1997 – Hans Dieter Flach, Ludwigsburger Porzellan: Fayence, Steingut, Kacheln, Fliesen. Ein Handbuch, Stuttgart 1997.

FRAQUELLI, 2008 – Sybille Fraquelli, Im Schatten des Domes. Architektur der Neugotik in Köln 1815–1914 (Bonner Beiträge zur Kunstgeschichte, Bd. 5), Köln 2008.

FREI, 1980 – Daniel Frei, Mediation, in: Handbuch der Schweizer Geschichte, Bd. 2, Zürich 1980, S. 841–870.

FRENZEL, 1993 – Gottfried Frenzel, Probleme der Restaurierung, Konservierung und prophylaktischen Sicherung mittelalter-

licher Glasmalereien, in: Stained Glass, ICOMOS, Conseil international des monuments et des sites, Paris 1993, S. 238–257.

URL: www.international.icomos.org/publications/93stain 19.pdf, 14. März 2012.

FRODL-KRAFT, 1956 – Eva Frodl-Kraft, Architektur im Abbild. Ihre Spiegelung in der Glasmalerei, in: Wiener Jahrbuch für Kunstgeschichte, Bd. XVII, hrsg. vom Bundesdenkmalamt Wien und vom Institut für Kunstgeschichte der Universität Wien, Wien/Köln/Weimar 1956, S. 7–13.

FROMBERG, 1844 – Emanuel Otto Fromberg, Handbuch der Glasmalerei, oder: Gründliche Anweisung, die Glasmalerpigmente und Flussmittel darzustellen, dieselben nach den verschiedenen Manieren der Glasmalerei auf's Glas aufzutragen und mittelst des Schmelzbrandes auf demselben zu fixiren, nebst einer genauen Angabe, den Trockenschrank, den Schmelzofen und den Muffelofen auf die zweckmässigste Weise zu construiren: mit Benutzung der besten englischen, französischen und deutschen Materialien, so wie auch eigener Erfahrung/bearb. von Emanuel Otto Fromberg, Quedlinburg/Leipzig 1844.

FUNK, 1995 – Veit Funk, Glasfensterkunst in St. Lorenz, Nürnberg. Michael Wohlgemut, Peter Hemmel von Andlau, Hans Baldung Grien, Albrecht Dürer, Nürnberg 1995.

GEISTHÖVEL, 2008 – Alexa Geisthövel, Restauration und Vormärz 1815–1847 (Seminarbuch Geschichte, hrsg. von Nils Freytag), Paderborn 2008.

GERHARDS, 2004 – Albert Gerhards, Liturgie und Kunst – Zwischenbilanz einer schwierigen Beziehung, in: Christentum – Kirche – Kunst. Beiträge zur Reflexion und zum Dialog, hrsg. von Michael Durst/Hans J. Münk (Theologische Berichte, Bd. 27), Freiburg 2004, S. 103–136.

GERMANN, 1967 – Georg Germann, Der Bezirk Muri (Die Kunstdenkmäler des Kantons Aargau, Bd. V), hrsg. von der Gesellschaft für Schweizerische Kunstgeschichte GSK, Basel 1967.

GERSTER, 2012 – Ulrich Gerster, Die Kirchenfenster des Grossmünsters Zürich. Augusto Giacometti – Sigmar Polke (Schweizerische Kunstführer GSK, Serie 92, Nr. 915), Bern 2012.

GESSERT, 1839 – M.A. Gessert, Geschichte der Glasmalerei in Deutschland und den Niederlanden, Frankreich, England, der Schweiz, Italien und Spanien, von ihrem Ursprung bis auf die neueste Zeit, Stuttgart/Tübingen 1839.

GIRARDIN, 2008 – Sabine Girardin, Du projet à la réalisation de l'église catholique de Saint-Imier, in: L'église catholique romaine de Saint-Imier, Festschrift zum 150-jährigen Pfarr-Jubiläum, Saint-Imier 2008, S. 14–25.

GLUDOVATZ, 2011 – Karin Gludovatz, Fährten legen – Spuren lesen: die Künstlersignatur als poietische Referenz, Dissertation Universität Wien 2004, Paderborn 2011.

GOETHE, 1836 – Johann Wolfgang von Goethe, Goethes sämtliche Werke, 4. Bd., Paris 1836.

GOHR, 1977 – Siegfried Gohr, Die Christusstatue von Bertel Thorvaldsen in der Frauenkirche zu Kopenhagen, in: Bertel Thorvaldsen. Untersuchungen zu seinem Werk und zur Kunst seiner Zeit, hrsg. von Gerhard Bott, Köln 1977, S. 343–365.

GOMBRICH, 1986 – Ernst H. Gombrich, Das symbolische Bild. Zur Kunst und Renaissance II [Aus dem Englischen übersetzt von Lisbeth Gombrich], Stuttgart 1986.

GÖTZ, 1986 – Norbert Götz, Carl Alexander Heideloff und der «Typus der Stadt Nürnberg», in: «Vorwärts, vorwärts sollst du schauen...» Geschichte, Politik und Kunst unter Ludwig I., hrsg. von Claus Grimm, Bd. 9, Aufsätze, München 1986, S. 535–550.

GÖTZ, 1981 – Norbert Götz, Um Neugotik und Nürnberger Stil. Studien zum Problem der Künstlerischen Vergangenheitsrezeption im Nürnberg des 19. Jahrhunderts, (Nürnberger Forschungen, Bd. 23), hrsg. vom Verein für Geschichte der Stadt Nürnberg, Nürnberg 1981.

GRAVGAARD, 1997 – Anne-Mette Gravgaard, The Christ Statue in the Church of Our Lady, in: On the statue of Christ by Thorvaldsen, Copenhagen 1997, S. 55–61.

GRAWE, 2005 – Johannes Grawe, Einblicke in das Ganze der Kunst. Goethes graphische Sammlung, in: Räume der Kunst. Blicke auf Goethes Sammlungen, hrsg. von Markus Bertsch/Johannes Grawe, (Ästhetik um 1800, Bd. 3), S. 255–288.

GRENTZSCHEL, 1989 – Matthias Grentzschel, Kirchenraum und Ausstattung im 19. Jahrhundert. Untersuchungen zur bildkünstlerischen Ausstattung evangelisch-lutherischer Kirchenbauten des 19. und frühen 20. Jahrhunderts in Sachsen, (Europäische Hochschulschriften, Reihe XXVIII, Kunstgeschichte), Frankfurt am Main/Bern/New York/Paris 1989.

GREWE, 2006 – Cordula Grewe, Italia und Germania. Zur Konstruktion religiöser Seherfahrung in der Kunst der Nazarener, in: Rom-Europa. Treffpunkt der Kulturen, hrsg. von Paolo Chiarini/Walter Hinderer, Würzburg 2006, S. 401–425.

GREWE, 2005 – Cordula Grewe, Objektivierte Subjektivität: Identitätsfindung und religiöse Kommunikation im nazarenischen Kunstwerk, in: Religion Macht Kunst. Die Nazarener, Ausstellungskatalog Schirn Kunsthalle Frankfurt, hrsg. von Max Hollein/Christa Steinle, Köln 2005, S. 77–100.

GREWE, 2000 – Cordula Grewe, Historie ohne Handlung – zur Transzendierung von Zeitlichkeit und Geschichte, in: Kunsthistorisches Jahrbuch Graz, Bd. 27, hrsg. von Götz Pochat/Brigitte Wagner, Graz 2000, S. 61–78.

GREWE, 1998 – Cordula Grewe, Wir rufen zwar fortlaufend Rafael! Aber was ist von Rafael in uns?, in: Anzeiger des Germanischen Nationalmuseums 1998, Nürnberg 1998, S. 123–132.

GRIMM, 1991 – Claus Grimm, Rembrandt selbst. Eine Neubewertung seiner Porträtkunst, Stuttgart 1991.

GROBLEWSKY, 1986 – Michael Groblewsky, Die Gruftkapelle des Fürstlichen Hauses Thurn und Taxis im Kreuzgang

St. Emmeram. Überlegungen zum Verständnis der Gotikrezeption im fürstlichen Mausoleumsbau, in: TT Studien, Bd. 15, hrsg. von Max Piendl, Kallmünz 1986, S. 99–132.

GRUNDER, 1997 – Karl Grunder, Die Kunstdenkmäler des Kantons Zürich. Bd. IX. Der Bezirk Dietikon, Basel 1997.

GRÜNENFELDER, 2006 – Josef Grünenfelder, Die ehemaligen Vogteien der Stadt Zug (Die Kunstdenkmäler des Kantons Zug, Neue Ausgabe Bd. II), hrsg. von der Gesellschaft für Schweizerische Kunstgeschichte GSK, Bern 2006.

GRUNER, 1968 – Erich Gruner, Die Arbeiter in der Schweiz im 19. Jahrhundert. Soziale Lage, Organisation, Verhältnis zum Arbeitgeber und Staat (Helvetia Politica, Schriften des Forschungszentrums für Geschichte und Soziologie der schweizerischen Politik an der Universität Bern, Series A, Vol. III), hrsg. von Erich Gruner/Peter Gilg/Beat Junker, Bern 1968.

GUTSCHER, 1983 – Daniel Gutscher, Das Grossmünster in Zürich. Eine baugeschichtliche Monographie (Beiträge zur Kunstgeschichte der Schweiz, Bd. 5), Bern 1983.

GYSIN/REHBERG 2003 – Sabine Gysin/Noemi Rehberg, Restaurationsbericht der Fenster in der reformierten Pfarrkirche Pieterlen (unveröffentlicht, Bauordner PA Pieterlen), Basel 2002.

HABERLAND, 2012 – Irene Haberland, Düsseldorfer Nazarener in Rheinland-Pfalz, in: Die Nazarener – Vom Tiber an den Rhein. Drei Malerschulen des 19. Jahrhunderts, Ausstellungskatalog Landesmuseum Mainz, hrsg. von der Direktion Landesmuseum Mainz und Norbert Suhr/Nico Kirchberger, GDKE, Regensburg 2012, S. 47–64.

HALTER, 1974 – Eugen Halter, Rapperswil im 19. Jahrhundert. Beiträge zur Geschichte Rapperswils im 19. Jahrhundert, hrsg. von der Ortsbürgergemeinde Rapperswil (Schriftenreihe des Heimatmuseums, Nr. 2), Rapperswil 1974.

HASLER, 2010 – Rolf Hasler, Die Schaffhauser Glasmalereien des 16. bis 18. Jahrhunderts (Corpus Vitrearum. Schweiz, Reihe Neuzeit, Bd. 5), Bern 2010.

HASLER, 2002 – Rolf Hasler, Kreuzgang von Muri, in: Glasmalerei im Kanton Aargau, (Corpus Vitrearum. Schweiz, Reihe Neuzeit, Bd. 2), Lehrmittelverlag des Kantons Aargau 2002.

HASLER, 1999 – Rolf Hasler, «Hie Oben sol Eynner mitt Ennem Albhornn hornn». Die Scheibenrisse der Sammlung Wyss: ein verkannter Schatz in neuem Licht, in: Kunst und Architektur in der Schweiz, Jg. 50, Nr. 4 (1999), S. 40–46.

HASLER, 1996 – Rolf Hasler, Die Scheibenriss-Sammlung Wyss. Depositum der Schweizerischen Eidgenossenschaft im Bernischen Historischen Museum, Katalog Bd. 1, Bern 1996.

HASLER/BERGMANN, 2010 – Rolf Hasler/Uta Bergmann, Schaffhausen und Zug. Zeitdokumente zur Entstehung von Einzelscheiben in Schaffhauser und Zuger Werkstätten, in: Die Einzelscheibe (Kolloquiumsband des 24. Internationalen Kolloquiums des Corpus Vitrearum), Zürich 2010, S. 133–146.

HAUSER, 2001 – Andreas Hauser, Das kantonale Bauamt 1798–1895 (Das öffentliche Bauwesen in Zürich, Teil 1, Kleine Schriften zur Zürcher Denkmalpflege, Heft 4), Zürich 2001.

HAUSER, 1976 – Andreas Hauser, Ferdinand Stadler (1813–1870). Ein Beitrag zur Geschichte des Historismus in der Schweiz, Zürich 1976.

HEDIGER, 2010 – Christine Hediger, Überlegungen zur Funktion der Architekturrahmen in den frühneuzeitlichen Schweizer Einzelscheiben, in: Die Einzelscheibe (Kolloquiumsband des 24. Internationalen Kolloquiums des Corpus Vitrearum), Zürich 2010, S. 167–180.

HEIDELOFF, 1844–46 – Carl Heideloff, Ornamentik im Mittelalter. Eine Sammlung auserwählter Verziehrungen und Profile byzantinischer und deutscher Architektur/gezeichnet und hrsg. von Carl Heideloff, Nürnberg 1844–1846.

HEINIG, 2010 – Anne Heinig, Rezension von Andrea Knop, Carl Alexander Heideloff. Monographie und Werkkatalog, Neustadt an der Aisch 2009, in: Kunstform 11, Nr. 01 (2010), URL: www.arthistoricum.net/kunstform/rezension/ausgabe/2010/01/16518/cache.off, 27. Juni 2012.

HEINIG, 2004 – Anne Heinig, Die Krise des Historismus in der deutschen Sakraldekoration im späten 19. Jahrhundert, Regensburg 2004.

HEINRICHS, 2007 – Ulrike Heinrichs, Martin Schongauer: Maler und Kupferstecher. Kunst und Wissenschaft unter dem Primat des Sehens, München/Berlin 2007.

HELLER, 1827 – Joseph Heller, Das Leben und das Werk Albrecht Dürers, Bd. 2, Bamberg 1827.

HELMSDÖRFER, 1939 – Georg Helmsdörfer, Christliche Kunstsymbolik und Ikonographie. Ein Versuch die Deutung und ein besseres Verständnis der Kirchlichen Bildwerke des Mittelalters zu erreichen, Frankfurt am Main 1839.

HESS, 2010 – Daniel Hess, Auf der Suche nach einer helvetischen Identität: Die Erfindung der «Schweizerscheibe», in: Die Einzelscheibe, (Kolloquiumsband des 24. Internationalen Kolloquiums des Corpus Vitrearum), Zürich 2010, S. 205–220.

HESS, 1997 – Daniel Hess, Im Dämmerlicht des Mittelalters – Graf Franz von Erbach und die Wiederentdeckung der Glasmalerei zwischen Aufklärung und Romantik, in: Akademie-Journal. Mitteilungsblatt der Konferenz der Deutschen Akademien der Wissenschaften 1 (1997), S. 2–6.

HILLER VON GAERTRINGEN, 1999 – Rudolf Hiller von Gaertringen, Raffaels Lernerfahrungen in der Werkstatt Peruginos. Kartonverwendung und Motivübernahme im Wandel, (Kunstwissenschaftliche Studien, Bd. 76), Dissertation Universität Tübingen, München/Berlin 1999.

HINTERDING, 2011 – Erik Hinterding, Rembrandts Radierungen. Bestandskatalog. Ehemalige Großherzogliche und Staatliche Sammlungen sowie Goethes Sammlung, mit Beiträgen von Hermann Mildenberger und Christian Tümpel, hrsg. von der Klassik Stiftung Weimar/Graphische Sammlungen, Köln 2011.

HOEPS, 2010 – Reinhard Hoeps, Gottes Gegenwart im Bild? Vom Streit zwischen Bild und Sakrament, in: Peter Hofmann/Andreas Matena (Hrsg.), Christusbild Icon + Ikone. Wege zu Theorie und Theologie des Bildes (ikon Bild + Theologie), hrsg. von Alex Stock/Reinhard Hoeps, Paderborn/München/Wien/Zürich 2010, S. 101–116.

HOFFMANN, 2006 (1) – Fabienne Hoffmann, Les vitraux art nouveau de La Chaux-de-Fonds: l'étude d'un patrimoine domestique, in: L'art nouveau dans le canton de Neuchâtel, Revue historique neuchâteloise, No. 1–2, Neuchâtel 2006.

HOFFMANN, 2006 (2) – Fabienne Hoffmann, Un vitrail monumental et publicitaire, in: L'art nouveau dans le canton de Neuchâtel, Revue historique neuchâteloise, No. 1–2, Neuchâtel 2006.

HOFFMANN, 1942 – Hans Hoffmann, Das Grossmünster in Zürich (Mitteilungen der Antiquarischen Gesellschaft in Zürich, Bd. 32), Zürich 1942.

HOFMANN/MATENA, 2010 – Peter Hofmann/Andreas Matena (Hrsg.), Christusbild Icon+Ikone. Wege zu Theorie und Theologie des Bildes (ikon Bild+Theologie), hrsg. von Alex Stock/Reinhard Hoeps, Paderborn u.a. 2010.

HOFMANN, 1991 – Werner Hofmann, Das Irdische Paradies. Motive und Ideen des 19. Jahrhunderts, München 1960, 1974, 1991.

HÖGGER, 1995 – Peter Högger, Der Bezirk Baden II (Die Kunstdenkmäler des Kantons Aargau), hrsg. von der Gesellschaft für Schweizerische Kunstgeschichte GSK, Basel 1995.

HOLLEIN, 2005 – Max Hollein, Religion Macht Kunst. Die Nazarener, Ausstellungskatalog Schirn Kunsthalle Frankfurt, hrsg. von Max Hollein/Christa Steinle, Köln 2005.

HÖRIG, 2004 – Annette Hörig, Glasmalereien des 19. Jahrhunderts. Sachsen. Die Kirchen, hrsg. von der Arbeitsstelle für Glasmalereiforschung des Corpus Vitrearum Medii Aevi, Potsdam, der Berlin-Brandenburgischen Akademie der Wissenschaften, Berlin 2004.

HOWITT, 1886 – Margaret Howitt, Friedrich Overbeck. Sein Leben und sein Schaffen, nach seinen Briefen und anderen Dokumenten des handschriftlichen Nachlasses geschildert, hrsg. von Franz Binder, Freiburg im Breisgau, 1886.

HUBER, 1981 – Judith Huber, Ausstellungen deutscher Künstler in Rom 1800–1830, in: Die Nazarener in Rom. Ein deutscher Künstlerbund der Romantik, Deutsche Ausgabe des Ausstellungskatalogs «I Nazareni a Roma», hrsg. von Klaus Gallwitz, Passau 1981, S. 44–51.

HÜTT, 1984 – Wolfgang Hütt, Die Düsseldorfer Malerschule 1919–1869, Leipzig 1984.

ISLER-HUNGERBÜHLER, 1956 – Ursula Isler-Hungerbühler, Johann Rudolf Rahn, Begründer der schweizerischen Kunstgeschichte (Mitteilungen der Antiquarischen Gesellschaft in Zürich, Bd. 39, Neujahrsblatt 121, 1957), Zürich 1956.

ITEN, 1948 – Albert Iten, Geschlechter und Namen in Innerschwyz und im Aegerital, Sonderdruck aus: Heimat und Klänge, Zug 1948.

JAENNICKE, 1898 – Friedrich Jaennicke, Handbuch der Glasmalerei. Zugleich Anleitung für Kunstfreunde zur Beurteilung von Glasmalereien, Stuttgart 1898.

JANDL-JÖRG, 2008 – Eva Jandl-Jörg, Ein Ganzes also endlich. Die Glasmalerei der Jahrhundertwende am Beispiel von Kolomann Mosers Glasfenstern der Kirche am Steinhof, Dissertation Universität für angewandte Kunst Wien, Wien 2008.

JANDL-JÖRG, 2007 – Eva Jandl-Jörg, «Die Fenster müssen jedenfalls farbig sein». Kolo Mosers Glasmalereien für die Kirche am Steinhof, in: Koloman Moser: 1868–1918, hrsg. von Rudolf Leopold, München 2007, S. 130–141.

JENNY, 1945 – Hans Jenny, Kunstführer der Schweiz, Bern 1945.

JENNY, 1934 – Hans Jenny, Kunstführer der Schweiz. Ein Handbuch, unter besonderer Berücksichtigung der Baukunst, Bern 1934.

JÖCKLE, 2012 – Clemens Jöckle, Die Nazarener in der Pfalz, in: Die Nazarener – Vom Tiber an den Rhein. Drei Malerschulen des 19. Jahrhunderts, Ausstellungskatalog Landesmuseum Mainz, hrsg. von der Direktion Landesmuseum Mainz und Norbert Suhr/Nico Kirchberger, GDKE, Regensburg 2012, S. 25–34.

JÖCKLE, 1988 – Clemens Jöckle, Das Christusbild des 19. und frühen 20. Jahrhunderts, in: Das Münster. Zeitschrift für christliche Kunst und Kunstwissenschaft, Jg. 41, Heft 2 (1988), S. 119–126.

JOHANNES PAUL II, 1989 – Papst Johannes Paul II, Saint Joseph, in: Homepage des Vatikan, URL: www.vatican.va/holy_father/john_paul_ii/apost_exhortations/documents/hf_jp-ii_exh_15081989_redemptoris-custos_en.html, 15. Januar 2012.

JÖRG, 2005 – Eva Jörg, Die Kunst der Glasmalerei im 19. und frühen 20. Jahrhundert in Österreich. Ein teilerforschtes, weitgehend undokumentiertes Gebiet, in: Österreichische Zeitschrift für Kunst- und Denkmalpflege, Jg. 59, Nr. 1 (2005), S. 77–91.

JORIS/WITZIG, 1992 – Joris Elisabeth/Heidi Witzig, Brave Frauen – aufmüpfige Weiber. Wie sich die Industrialisierung auf Alltag und Lebenszusammenhänge von Frauen auswirkte (1820–1940), Zürich 1992.

JØRNÆS, 1993 – Bjarne Jørnæs, Dannecker und Thorvaldsen. Die Evangelistenstatuen auf dem Rotenberg, in: Schwäbischer Klassizismus zwischen Ideal und Wirklichkeit 1770–1830, Aufsätze hrsg. von Christian von Holst, Stuttgart 1993, S. 331–336.

KÄSTLI, 1998 – Tobias Kästli, Die Schweiz – eine Republik in Europa. Geschichte des Nationalstaats seit 1798, Zürich 1998.

KAISER, 1999 – Astrid Kaiser, Augusto Giacometti (1877–1947). «Malen mit Glas»: approches des vitreaux d'Augusto Giacometti à travers le vitrail de l'église de Thayngen SH. (Mémoire de licence présenté à la Faculté des Lettres de l'Université de Fribourg), Romont 1999.

KAISER TRÜMPLER, 2002 – Astrid Kaiser Trümpler, Die Glasmalerei nach 1800 im Kanton Aargau, in: Glasmalerei im

Kanton Aargau. Einführung zur Jubiläumspublikation 200 Jahre Kanton Aargau, Lehrmittelverlag des Kantons Aargau 2002, S. 18–30.

Kat. Ausst. Augsburg, 1990 – Nazarener in Schwaben. Sehnsucht nach Seligkeit, Katalog zur Ausstellung im Bezirkskrankenhaus Günzburg, hrsg. von Peter Fassl, Augsburg 1990.

Kat. Ausst. Colmar, 1991 – Der hübsche Martin. Kupferstiche und Zeichnungen von Martin Schongauer (ca. 1450–1491), Ausstellungskatalog Unterlinden Museum Colmar, hrsg. vom Museum Unterlinden, Strasbourg 1991.

Kat. Ausst. Düsseldorf, 1975 – Sèvres-Porzellan. Vom 18. Jahrhundert bis zur Gegenwart, Ausstellungskatalog, Hetjens-Museum, Düsseldorf 1975.

Kat. Ausst. Erfurt, 1993 – Glasmalerei des 19. Jahrhunderts in Deutschland. Ausstellungskatalog Angermuseum Erfurt, Textautoren Monika Böning … [et al.], Leipzig 1993.

Kat. Ausst. Frankfurt, 2005 – Religion Macht Kunst. Die Nazarener, Ausstellungskatalog Schirn Kunsthalle Frankfurt, hrsg. von Max Hollein/Christa Steinle, Köln 2005.

Kat. Ausst. Frankfurt, 1988 – Guido Reni und Europa. Ruhm und Nachruhm, Ausstellungskatalog Schirn Kunsthalle Frankfurt, hrsg. von Sybille Ebert-Schifferer/Andrea Emiliani/Erich Schleier, Bologna 1988.

Kat. Ausst. Frankfurt, 1977 – Die Nazarener, Ausstellungskatalog Städtische Galerie im Städelschen Kunstinstitut, hrsg. von Klaus Gallwitz, Frankfurt am Main 1977.

Kat. Ausst. Freiburg, 2000 – Aufleuchten des Mittelalters. Glasmalerei des 19. Jahrhunderts in Freiburg, Ausstellungskatalog bearbeitet von Daniel Parello, Augustinermuseum Freiburg in Zusammenarbeit mit dem Corpus Vitrearum Deutschland, Freiburg im Breisgau 2000.

Kat. Ausst. Hamburg, 1983 – Luther und die Folgen, Ausstellungskatalog Hamburger Kunsthalle, hrsg. von Werner Hofmann, München 1983.

Kat. Ausst. Köln, 1998 – Himmelslicht. Europäische Glasmalerei im Jahrhundert des Kölner Dombaus (1248–1349), Ausstellungskatalog Schnütgenmuseum Köln, hrsg. von Hiltrud Westermann-Angerhausen in Zusammenarbeit mit Carola Hagnau … [et al.], Köln 1998.

Kat. Ausst. Köln, 1980 – Religiöse Graphik aus der Zeit des Kölner Dombaus. 1842–1880, Ausstellungskatalog Diözesan-Museum Köln, hrsg. von Gierse Ludwig, Erzbischöfliches Diözesan-Museum Köln, Köln 1980.

Kat. Ausst. London, 2004 – Raphael: Von Urbino nach Rom in der National Gallery, hrsg. von Hugo Chapman/Tom Henry/Carol Plazotta, London 2004.

Kat. Ausst. Luzern, 1985 – Zur religiösen Schweizer Malerei im 19. Jahrhundert: «Ich male für fromme Gemüter», Ausstellungskatalog Kunstmuseum Luzern, hrsg. vom Kunstmuseum Luzern, bearbeitet von Tino Steinemann/Philipp Clemenz, Luzern 1985.

Kat. Ausst. Mainz, 2012 – Die Nazarener – Vom Tiber an den Rhein. Drei Malerschulen des 19. Jahrhunderts, Ausstellungskatalog Landesmuseum Mainz, Norbert Suhr, Nico Kirchberger, hrsg. von der Direktion Landesmuseum Mainz, GDKE, Regensburg 2012.

Kat. Ausst. Neuss, 1981 – Die Glasfenster der Maria-Hilf-Kirche in München-Au 1834–1844, in zeitgenössischen kolorierten Lithographien, Ausstellungskatalog Clemens-Sels-Museum Neuss, hrsg. vom Clemens-Sels-Museum, Neuss 1981.

Kat. Ausst. Nürnberg, 1973 – Das Dürer-Stammbuch von 1828, bearbeitet von Matthias Mende/Inge Hebecker, Ausstellungskatalog Museen Nürnberg (Ausstellungskatalog 4), Albrecht-Dürer-Haus, Nürnberg 1973.

Kat. Ausst. Rom, 1981 – Die Nazarener in Rom. Ein deutscher Künstlerbund der Romantik, Rom 1981, hrsg. von Klaus Gallwitz, Ingrid Sattel (Übersetz.), deutsche Ausgabe München 1981.

Kat. Ausst. Ulm, 1995 – Bilder aus Licht und Farbe. Meisterwerke spätgotischer Glasmalerei. «Straßburger Fenster» in Ulm und ihr künstlerisches Umfeld, Ausstellungskatalog Museum Ulm, hrsg. von Brigitte Reinhardt/Michael Roth, Ulm 1995.

Kat. Ausst. Wien, 1988 – Guido Reni und der Reproduktionsstich, Ausstellungskatalog Graphische Sammlung der Albertina Wien, hrsg. von Konrad Oberhuber, bearbeitet von Veronika Birke, Wien 1988.

Kemp, 1996 – Wolfgang Kemp, Kunstwerk und Betrachter: Der rezeptionsästhetische Ansatz, in: Kunstgeschichte. Eine Einführung, hrsg. von Hans Belting/Heinrich Dilly/Wolfgang Kemp/Willibald Sauerländer/Martin Warnke, Berlin 1996, S. 241–258.

Kemp, 1994 – Wolfgang Kemp, Christliche Kunst. Ihre Anfänge, ihre Strukturen, München u.a. 1994.

Kessler, 2000 – Herbert L. Kessler, Spiritual Seeing. Picturing God's Invisibility in Medieval Art, Philadelphia 2000.

Kitschen, 2010 – Friederike Kitschen, Französische Kunst und deutsche «Eigenheiten». Zur Einleitung, in: Dialog und Differenzen. 1789–1870 Deutsch-französische Kunstbeziehungen. Les relations artistiques franco-allemandes, hrsg. von Isabelle Jansen/Friederike Kitschen unter Mitarbeit von Gitta Ho (Passagen/Passages, Bd. 34), Berlin/München 2010, S. 1–12.

Klauke, 2009 – Angela Klauke, Glasmalereiwerkstätten des 19. Jahrhunderts in Niedersachsen, in: Das Münster. Zeitschrift für christliche Kunst und Kunstwissenschaft, Jg. 62, Heft 2 (2009), S. 91–98.

Klauke/Martin, 2003 – Angela Klauke/Frank Martin, Glasmalereien des 19. Jahrhunderts. Berlin Brandenburg. Die Kirchen, hrsg. von der Arbeitsstelle für Glasmalereiforschung des Corpus Vitrearum Medii Aevi, Potsdam, der Berlin-Brandenburgischen Akademie der Wissenschaften, Leipzig 2003.

Klauser, 1960 – Theodor Klauser, Der Vorhang vor dem Thron Gottes, in: Jahrbuch für Antike und Christentum, Bd. 3, 1960, S. 141–142.

Kluxen, 1999 – Andrea M. Kluxen, Die Geschichte der Kunstakademie in Nürnberg 1662–1998, in: Jahrbuch für fränki-

sche Landesforschung, Bd. 59, Neustadt/Aisch 1999, S. 167–207.

KNOPP, 2002 – Gisbert Knopp, Die Altargemälde der Spätnazarener in der Kirche St. Remigius in Bonn. Geschichte-Ikonographie-Restaurierung und Neuaufstellung, Worms 2002.

KNÖPFLI, 1979 – Albert Knöpfli, St. Laurenzen und seine baulichen Schicksale, in: Die Kirche St. Laurenzen in St. Gallen. Zum Abschluss der Restaurierung 1963–1979, hrsg. von der Evangelisch-reformierten Kirchgemeinde St. Gallen, St. Gallen 1979, S. 65–162.

KÖBLER, 2003 – G. Köbler, Lexikon des Mittelalters, Stichw. *Landrecht*, Bd. V Hiera-Mittel – Lukanien, Spalte 1672 f., Stuttgart 2003.

KOCH, 1962 – Georg Friedrich Koch, Die großen deutschen Maler. Die Geschichte ihrer Kunst vom 9. bis 20. Jahrhundert, Berlin 1962.

KÖPPEL, 2007 – Rebekka Köppel, Die frühneuzeitliche Schweizer Glasmalerei im Dienste der nationalen Selbstfindung, in: Zeitschrift für Schweizerische Archäologie und Kunstgeschichte, Bd. 64, Heft 3 (2007), S. 143–162.

KOLLWITZ, 1936 – Johannes Kollwitz, Christus als Lehrer und die Gesetzesübergabe an Petrus in der konstantinischen Kunst Roms, in: Römische Quartalsschrift, Heft 44, 1/2, Freiburg 1936, S. 45–66.

KORFF, 1973 – Gottfried Korff, Heiligenverehrung und soziale Frage. Zur Ideologisierung der populären Frömmigkeit im späten 19. Jahrhundert, in: Kultureller Wandel im 19. Jahrhundert. Verhandlungen des 18. Deutschen Volkskundekongress in Trier vom 13. September bis 18. September 1971, hrsg. von Günter Wiegelmann (Studien zum Wandel von Gesellschaft und Bildung im Neunzehnten Jahrhundert, Bd. 5), Göttingen 1973, S. 102–111.

KOZINA, 2011 – Elena Kozina, «Lauteres Gold wie durchsichtiges Glas» (Offb 21, 21). Einige Überlegungen zum Lichtbegriff in der Zeit der großen Kathedralen, in: ÖZKD (Österreichische Zeitung für Kunst und Denkmalpflege), LXV Heft 1/2, Horn/Wien 2011, S. 28–34.

KRÄUCHI, 2002 – Ueli O. Kräuchi, Die reformierte Kirche St. Martin in Kilchberg BL (Schweizerische Kunstführer GSK; Nr. 729), Bern 2002.

KRINGS/SCHMITZ/WESTERMANN-ANGERHAUSEN, 1999 – Ulrich Krings/Wolfgang Schmitz/Hiltrud Westermann-Angerhausen (Hrsg.), Thesaurus Coloniensis. Beiträge zur mittelalterlichen Kunstgeschichte Kölns. Festschrift für Anton von Euw (Veröffentlichungen des Kölnischen Geschichtsvereins e.V., Bd. 41), Köln 1999, Farbtafel S. 43.

KROLL, 1987 – Frank-Lothar Kroll, Das Ornament in der Kunsttheorie des 19. Jahrhunderts (Studien zur Kunstgeschichte, Bd. 42), Hildesheim/Zürich/New York 1987.

KUHL, 2001 – Reinhardt Kuhl, Glasmalereien des 19. Jahrhunderts. Mecklenburg-Vorpommern. Die Kirchen, hrsg. von der Arbeitsstelle für Glasmalereiforschung des Corpus Vitrearum Medii Aevi, Potsdam, der Berlin-Brandenburgischen Akademie der Wissenschaften, Leipzig 2001.

KUHN, 1882 – P. Albert Kuhn, Deschwanden. Ein Leben im Dienste der Kunst und der Religion, Einsiedeln 1882.

KÜHNERT, 1973 – Herbert Kühnert, Urkundenbuch zur thüringischen Glashüttengeschichte und Aufsätze zur thüringischen Glashüttengeschichte (Veröffentlichungen zur Geschichte des Glases und der Glashütten in Deutschland [Historische Topographie], Bd. 3), Wiesbaden 1973.

KULL, 1855 – Jakob Kull, Wappenbuch der löblichen Bürgerschaft von Rapperswil, Zürich 1855.

KUNSTBLATT, 1831 – Kunstblatt Nr. 99, 20. December 1831, Christus, von Dannecker, S. 393.

KUNSTBLATT, 1823 – Kunstblatt Nr. 81, 9. Oktober 1823, Jean Cousin, S. 321 f.

KURMANN, 2008 – Peter Kurmann, Viollet-le-Duc und die Vorstellung einer idealen Kathedrale, in: Reibungspunkte. Ordnung und Umbruch in Architektur und Kunst, Festschrift für Hubertus Günther, hrsg. von Hanns Hubach … [et al.], Petersberg 2008, S. 159–167.

KURMANN, 1998 – Peter Kurmann, «Architektur in Architektur»: Der gläserne Bauriß der Gotik, in: Himmelslicht. Europäische Glasmalerei im Jahrhundert des Kölner Dombaus (1248–1349), Ausstellungskatalog, hrsg. von Hiltrud Westermann-Angerhausen in Zusammenarbeit mit Carola Hagnau … [et al.], Schnütgen-Museum, Köln 1998, S. 34–43.

KURMANN-SCHWARZ, 2012 (1) – Brigitte Kurmann-Schwarz, Gläserne Bilder zur Zeit der burgundischen Herzöge. Überlieferung, Form und Funktion, in: Kunst und Kulturtransfer zur Zeit Karls des Kühnen, Akten der Tagung in Bern 2008, hrsg. von Norberto Gramaccini/Marc C. Schurr, Bern 2012, S. 127–149.

KURMANN-SCHWARZ, 2012 (2) – Brigitte Kurmann-Schwarz, «Eine specielle Gattung». Johann Rudolf Rahn und die Erforschung der mittelalterlichen Glasmalerei in der Schweiz, in: Zeitschrift für Schweizerische Archäologie und Kunstgeschichte, Direktion des Schweizerischen Landesmuseums, ZAK, Bd. 69, Heft 2 (2012), Zürich 2012, S. 343–354.

KURMANN-SCHWARZ, 2010 (1) – Brigitte Kurmann-Schwarz, Le vitrail en Suisse au temps de la Réforme. Destructions, conservation et nouvel essor, in: Revue de l'art 167 (2010), Paris 2010, S. 61–69.

KURMANN-SCHWARZ, 2010 (2) – Brigitte Kurmann-Schwarz, Original-Kopie-Zitat. Kunstwerke des Mittelalters und der Frühen Neuzeit: Wege der Aneignung – Formen der Überlieferung, (Veröffentlichungen des Zentralinstituts für Kunstgeschichte in München, Bd. 26), hrsg. von Wolfgang Augustyn/Ulrich Söding, Passau 2010, S. 231–251.

KURMANN-SCHWARZ, 2008 – Brigitte Kurmann-Schwarz, Die mittelalterlichen Glasmalereien der ehemaligen Klosterkirche Königsfelden (Corpus Vitrearum Medii Aevi. Schweiz, II), hrsg. von der Schweizer Akademie für Geistes- und Sozialwissenschaften, Bern 2008.

KURMANN-SCHWARZ, 2001 – Die Werkstatt von Urs Werder. Freiburger Standesscheibe 1478, in: Blätter des MKGF (Museum für Kunst und Geschichte Freiburgs), 2001-6, Freiburg 2001, o.S.

KURMANN-SCHWARZ, 1998 – Brigitte Kurmann-Schwarz, Die Glasmalereien des 15. bis 18. Jahrhunderts im Berner Münster (Corpus Vitrearum Medii Aevi. Schweiz, IV), hrsg. von der Schweizer Akademie für Geistes- und Sozialwissenschaften, Bern 1998.

KURMANN-SCHWARZ, 1988 – Brigitte Kurmann-Schwarz, Französische Glasmalereien um 1450. Ein Atelier in Bourges und Riom, Bern 1988.

KURMANN-SCHWARZ/PASQUIER/TRÜMPLER, 1999 – Brigitte Kurmann-Schwarz/Augustin Pasquier/Stefan Trümpler, Glasmalerei in der Schweiz, in: Glasmalereien aus acht Jahrhunderten. Meisterwerke in Deutschland, Österreich und der Schweiz. Ihre Gefährdung und Erhaltung, hrsg. von der Berlin-Brandenburgischen Akademie der Wissenschaften in Zusammenarbeit mit dem Österreichischen Bundesamt Wien und dem Schweizerischen Zentrum für Forschung und Information zur Glasmalerei in Romont, 2. überarbeitete Auflage, Leipzig 1999.

LANDOLT, 2011 – Oliver Landolt, Historisches Lexikon der Schweiz,
URL: www.hls-dhs-dss.ch/textes/d/D7385.php, Stichw. *Schwyz (Kanton),* 30. November 2011.

LANDOLT-WEGENER, 1959 – Elisabeth Landolt-Wegener, Die Glasmalereien im Hauptchor der Soester Wiesenkirche, in: Westfalen. Mitteilungen des Vereins für Geschichte und Altertumskunde Westfalens, 13. Sonderheft, Münster 1959.

LAPAIRE, 1989 – Claude Lapaire, Saint-Pierre Cathédrale de Genève. Les vitraux, Genève 1989.

LAQUÉ, 2009 – Stephan Laqué, Bericht über die Diskussion der vierten Sektion (Performative Praxis), in: Literarische und religiöse Kommunikation in Mittelalter und Früher Neuzeit (Tagungsband des DFG-Symposion 2006), hrsg. von Peter Strohschneider, Berlin/New York 2009, S. 1003–1012.

LAVATER, 1806 – Johann Caspar Lavater, Kupfersammlung aus Johann Caspar Lavaters Physiognomischen Fragmenten: zur Beförderung der Menschenkenntnis und Menschenliebe (Erstes Heft), Winterthur 1806.

LEHMANN, 2009 – Karl Lehmann, Das Bild zwischen Glauben und Sehen, in: Ikonologie der Gegenwart, hrsg. von Gottfried Boehm/Horst Bredekamp, München 2009, S. 83–98.

LEHNER-HELBIG, 2011 – Maria Lehner-Helbig, Historisches Lexikon der Schweiz, hrsg. von der Stiftung Historisches Lexikon der Schweiz (HLS), Stichw. *Rheinbund*, Bd. 10 Pro – Schafroth, Basel 2011, S. 281.

LEHNERT, 1983 – Detlef Lehnert, Nürnberg – Stadt ohne Zünfte, in: Deutsches Handwerk in Spätmittelalter und früher Neuzeit, hrsg. von Rainer S. Elkar, Göttingen 1983, S. 71–81.

LENZ, 1977 – Christian Lenz, Goethe und die Nazarener, in: Die Nazarener, Ausstellungskatalog Städtische Galerie im Städelschen Kunstinstitut, hrsg. von Klaus Gallwitz, Frankfurt am Main 1977, S. 295–319.

LESSING, 1994 – Gotthold Ephraim Lessing, Laokoon. Oder: Über die Grenzen der Malerei und Poesie. Mit beiläufigen Erläuterungen verschiedener Punkte der alten Kunstgeschichte (Reclams Universal-Bibliothek, Bd. 271), Stuttgart 1994.

LEUSCHNER, 2009 – Eckhard Leuschner, Der vermessene Christus. Metrologie und Gottesbild bei Lavater, Thorvaldsen, Schadow und Lenz, in: Das Bild Gottes in Judentum, Christentum und Islam. Vom Alten Testament bis zum Karikaturenstreit, hrsg. von Eckhard Leuschner/Mark R. Hesslinger, Petersberg 2009, S. 217–235.

LEVRON, 1941 – Jacques Levron, René Boyvin. Graveur angevin du XVIe siècle avec le catalogue de son oeuvre & la reproduction de 114 estampes, Angers 1941.

LIEBENAU/LÜBKE, 1861–1871 – Theodor von Liebenau/Wilhelm Lübke, Das Kloster Königsfelden, 1. Geschichte des Klosters Königsfelden, 2. Die Glasgemälde im Chor der Kirche zu Königsfelden (Denkmäler des Hauses Habsburg in der Schweiz; 3, 1867), Zürich 1867–1871.

LOHFINK/WEIMER, 2008 – Gerhard Lohfink/Ludwig Weimer, Maria – nicht ohne Israel. Eine neue Sicht der Lehre von der Unbefleckten Empfängnis, Freiburg im Breisgau 2008.

LÖWITH, 1995 – Karl Löwith, Von Hegel zu Nietzsche. Der revolutionäre Bruch im Denken des neunzehnten Jahrhunderts (Philosophische Bibliothek, Bd. 480), Hamburg 1995.

LÜDECKE/HEILAND, 1955 – Heinz Lüdecke/Susanne Heiland, Dürer und die Nachwelt, Berlin 1955.

LUBOS-KOZIEL, 2007 – Joanna Lubos-Koziel, «… zu den billigsten Preisen unter Garantie solider edler Ausführung.» Die Entwicklung des Marktes für kirchliche künstlerische Massenproduktion im 19. Jahrhundert, in: Kanonisierung, Regelverstoss und Pluralität in der Kunst des 19. Jahrhunderts, Frankfurt am Main u. a. 2007, S. 182–193.

LUNEAU, 2006 – Jean-François Luneau, Félix Gaudin. Peintre-verrier et mosaïste (1851–1930), Clermont-Ferrand 2006.

LUNEAU, 2000 – Jean-François Luneau, L'influence allmande dans le vitrail francais du XIX siècle, in: Art, téchnique et science, la création du vitrail du 1830 à 1930. Actes du Colloque de Liège, 11.–13. Mai 2000, S. 129–137.

LÜSEBRINK/REICHARDT, 1997 – Hans-Jürgen Lüsebrink/Rolf Reichardt (Hrsg.) zusammen mit Annette Keilhauer und René Nohr, Kulturtransfer im Epochenumbruch Frankreich-Deutschland 1770–1815 (Deutsch-Französische Kulturbibliothek, Bd. 9.1), Leipzig 1997.

LÜTHI, 1936 – Max Lüthi, Die Schweiz im Urteil deutscher Flüchtlinge um 1848, in: Deutschland und die Schweiz in ihren kulturellen und politischen Beziehungen während der ersten Hälfte des 19. Jahrhunderts (Berner Untersuchungen zur Allgemeinen Geschichte, Heft 9), 5 Untersuchungen hrsg. von Werner Näf, Bern 1936, S. 52–128.

LYMANT, 1980 – Brigitte Lymant, Die Glasmalereien des Kölner Domes, in: Der Kölner Dom im Jahrhundert seiner Vollendung. Ausstellungskatalog Historische Museen Josef-

Haubich-Kunsthalle Köln in 3 Bden, 2. Bd.: Essays zur Ausstellung der Historischen Museen in der Josef-Haubrich-Kunsthalle Köln, hrsg. von Hugo Borger … [et. al.], Köln 1980, S. 331–353.

MAHN, 1990 – Eva Mahn, Deutsche Glasmalerei der Romantik 1790–1850, Dissertation Universität Leipzig 1990 (Typoskript).

MAI, 1998 – Hartmut Mai, Lutherische Ikonographie im 16. und 19. Jahrhundert – ein Vergleich, in: Die Bilder in den lutherischen Kirchen. Ikonographische Studien, hrsg. von Peter Poscharsky, München 1998, S. 209–220.

MARADAN, 2004 – Evelyne Maradan, Historisches Lexikon der Schweiz, hrsg. von der Stiftung Historisches Lexikon der Schweiz (HLS), Stichw. *Châtonnaye*, Bd. 3 Bund – Ducros, Basel 2004, S. 310.

MARCHAL, 2007 – Guy P. Marchal, Schweizer Gebrauchsgeschichte. Geschichtsbücher, Mythenbildung und nationale Identität, Basel 2007.

MARTIN, 2009 – Frank Martin, Das königliche Glasmalerei-Institut in Berlin-Charlottenburg (1843–1905), in: Das Münster. Zeitschrift für christliche Kunst und Kunstwissenschaft, Jg. 62, Heft 2 (2009), Regensburg 2009, S. 100–110.

MARTIN, 2001 – Frank Martin, Vorwort in: Kuhl Reinhard, Glasmalereien des 19. Jahrhunderts. Mecklenburg-Vorpommern. Die Kirchen, hrsg. von der Arbeitsstelle für Glasmalereiforschung des Corpus Vitrearum Medii Aevi, Potsdam, der Berlin-Brandenburgischen Akademie der Wissenschaften, Leipzig 2001.

MATHIS, 1979 – Walter Mathis, Zürich – Stadt zwischen Mittelalter und Neuzeit. Gedruckte Gesamtansichten und Pläne, 1540–1875, hrsg. von Alexander Tanner, Zürich 1979.

MATTER/BOERNER, 2007 – Stefan Matter/Maria Christina Boerner, …kann ich vielleicht nur dichtend mahlen? Franz Pforrs Fragment eines Künstlerromans und das Verhältnis von Poesie und Malerei bei den Nazarenern (pictura et poesis, Bd. 25), Köln/Weimar/Wien 2007.

MATZKER, 2008 – Rainer Matzker, Ästhetik der Medialität. Zur Vermittlung von künstlerischen Welten und ästhetischen Theorien, Hamburg 2008.

MAURER, 1992 – Emil Maurer, Guido Reni: süchtig nach Perfektion. Zur Reni-Ausstellung in Bologna, 1988, in: Im Bann der Bilder. Essays zur italienischen und französischen Malerei des 15.–19. Jahrhunderts, Zürich 1992, S. 83–90.

MEYER, 1995 – Johann Heinrich Meyer, Neu-deutsche religiös-patriotische Kunst, in: Klassik und Klassizismus, (Bibliothek der Kunstliteratur, Bd. 3), hrsg. von Helmut Pfotenhauer/Peter Sprengel, Frankfurt am Main 1995. S. 109–354.

MEYER, 1978 – André Meyer, Die Kunstdenkmäler des Kantons Schwyz. Der Bezirk Schwyz I, Der Flecken Schwyz und das übrige Gemeindegebiet, hrsg. von der Gesellschaft für Schweizerische Kunstgeschichte Bern (Die Kunstdenkmäler der Schweiz), Basel 1978.

MEYER, 1973 – André Meyer, Neugotik und Neuromanik in der Schweiz. Die Kirchenarchitektur des 19. Jahrhunderts, Zürich 1973.

MEYER, 1884 – Hermann Meyer, Die schweizerische Sitte der Fenster- und Wappenschenkung vom 15.–17. Jahrhundert, Frauenfeld 1884.

MICHEL, 1986 – Pierre-Frank Michel, Jugendstilglasmalerei in der Schweiz, Weingarten 1986.

MICHEL, 1981 – Pierre-Frank Michel, L'image de la Suisse dans le vitrail 1900, in: Glass – Le verre – Vetro, Revue de l'Office national du tourisme, No. 12 (1981), S. 25–30.

MICHELS, 1967 – Thomas Michels, Segensgestus oder Hoheitsgestus? Ein Beitrag zur christlichen Ikonographie, in: Festschrift für Alois Thomas. Archäologische, kirchen- und kunsthistorische Beiträge; zur Vollendung des siebzigsten Lebensjahres am 18. Januar 1966 dargeboten von Freunden und Bekannten, Trier 1967.

MILLS, 2008 – Rosie Mills, Idol Worship in Canterbury Cathedral, in: Vidimus, on-line-magazine, Folge 23 URL: vidimus.org/issues/issue-23/panel-of-the-month/, 21. Mai 2012.

MÖRGELI, 1988 – Christoph Mörgeli, Reformierte Kirche Stäfa. Festschrift zur Renovation 1986–1988, Stäfa 1988.

MORGENBLATT FÜR GEBILDETE STÄNDE, 1826 – Nr. 61, Morgenblatt für gebildete Stände, Bde. 20–21, Bern, Montag, 13. März 1826, S. 244.

MORTZFELD, 1987 – Porträtsammlung der Herzog August Bibliothek Wolfenbüttel, Reihe A, bearbeitet von Peter Mortzfeld, München u.a. 1987.

MOSER, 1969 – Ludwig Moser, Badisches Glas. Seine Hütten und Werkstätten (Veröffentlichungen zur Geschichte des Glases und der Glashütten in Deutschland [Historische Topographie], Bd. 1), Wiesbaden 1969.

MRASS, 2005 – Marcus Mrass, Gesten und Gebärden. Begriffsbestimmung und -verwendung im Hinblick auf kunsthistorische Untersuchungen, Regensburg 2005.

MÜHLEMANN, 1990 – Louis Mühlemann, Ergänzungen von Günter Mattein, Von der Talgemeinschaft zum Kanton, in: Die Urschweiz und ihre Wappen. Die Gemeinden Uri, Schwyz, Obwalden und Nidwalden, Vorwort Ambros Gisler … [et al.], Texte Hans Achermann … [et al.], Chapelle-sur-Moudon 1990, S. 41–65.

MUNDT, 1971 – Barbara Mundt, Theorien zum Kunstgewerbe des Historismus in Deutschland, in: Beiträge zur Theorie der Künste im 19. Jahrhundert, Bd. 1, hrsg. von Helmut Koopmann/J. Adolf Schmoll gen. Eisenwerth (Studien zur Philosophie und Literatur des 19. Jahrhunderts, Bd. 12/1, Beiträge zur Theorie der Künste im 19. Jahrhundert, «Neunzehntes Jahrhundert» Forschungsunternehmen der Fritz Thyssen Stiftung), S. 317–336.

NÄF (Hrsg.), 1936 – Werner Näf, Deutschland und die Schweiz in ihren kulturellen und politischen Beziehungen während der ersten Hälfte des 19. Jahrhunderts (Berner Untersuchungen zur Allgemeinen Geschichte,

Heft 9), Fünf Untersuchungen hrsg. von Werner Näf, Bern 1936.

NAGEL/VON RODA, 1998 – Anne Nagel/Hortensia von Roda, «...der Augenlust und dem Gemüth». Die Glasmalerei in Basel 1830–1930, Basel 1998.

NATIONALGALERIE BERLIN – Das XIX. Jahrhundert, Katalog der ausgestellten Werke. Staatliche Museen zu Berlin, Leipzig 2001.

NEUMANN, 1965 – Gerhard Neumann, Gesten und Gebärden in der Griechischen Kunst, Berlin 1965.

NUSSBAUMER, 2003 – Reto Nussbaumer, Stans, in: INSA, Inventar der neueren Schweizer Architektur, Inventaire Suisse d'Architecture, Inventario Svizzero di Architettura 1850–1920, Städte, Villes, Città Sion, Solothurn, Stans, Thun, Vevey, hrsg. von der Gesellschaft für Schweizerische Kunstgeschichte, Zürich 2003, S. 217–294.

OEXLE, 2007 – Otto Gerhard Oexle, Krise des Historismus – Krise der Wirklichkeit. Eine Problemgeschichte der Moderne, in: Krise des Historismus – Krise der Wirklichkeit. Wissenschaft, Kunst und Literatur 1880–1932, hrsg. von Otto Gerhard Oexle, (Veröffentlichungen des Max-Planck-Instituts für Geschichte, Bd. 228), Göttingen 2007, S. 11–116.

OIDTMANN, 1906 – Heinrich Oidtmann, Über die Instandsetzung alter Glasmalereien, in: Zeitschrift für christliche Kunst, Nr. 9 (1906), Sp. 257 ff.

OIDTMANN, 1893 – Heinrich Oidtmann, Die Glasmalereien, 1. Teil: Die Technik der Glasmalerei, Köln 1893.

ORGAN FÜR CHRISTLICHE KUNST, 1863 – Organ des christlichen Kunstvereins für Deutschland, hrsg. und redigiert von Friedrich Baudri, Jg. XIII, Nr. 12, 15. Juni 1863 Köln.

OSSENBERG, 2004 – Horst Ossenberg, Haus + Hof. Im Sprach- und Kulturraum Alemannien und Schwaben von der Stein- bis zur Neuzeit, Norderstedt 2004.

OSTERHAMMEL, 2009 – Jürgen Osterhammel, Die Verwandlung der Welt. Eine Geschichte des 19. Jahrhunderts (Historische Bibliothek der Gerda Henkel Stiftung), 4. Auflage, München 2009.

OTTO, 1981 – Rita Otto, Zu den Lithographien romantischer Fenster der Maria-Hilf-Kirche in München-Au, in: Die Glasfenster der Maria-Hilf-Kirche in München-Au 1834–1844 in zeitgenössischen kolorierten Lithographien, Ausstellungskatalog Clemens-Sels-Museum Neuss, Neuss 1981, S. 7–11.

PANOFSKY, 2002 – Erwin Panofsky, Sinn und Deutung in der bildenden Kunst (Meaning in the Visual Arts, New York 1955), Köln 1975, 2002.

PARELLO, 2009 – Daniel Parello, Glasmalereiwerkstätten des 19. Jahrhunderts in Freiburg, in: Das Münster. Zeitschrift für christliche Kunst und Kunstwissenschaft, Jg. 62, Heft 2 (2009), S. 111–121.

PARELLO, 2005 – Daniel Parello, Architektur und Ausstattung im Spannungsfeld konfessioneller Rivalität. «Bedürfnis-Anstalten» versus Prachtbauten. Zur Theorie des protestanti-schen Kirchenbaus. Die Stildiskussion und die Folgen für die Entwicklung der Glasmalerei im 19. Jahrhundert. Luther in der wahren Nachfolge Christi. Zur Analyse des Bildprogramms. Vorwort, in: Monika Beck/Friedericke Landmesser/Daniel Parello, Die Glasmalereien der Speyerer Protestations-kirche, Speyer 2005 (unveröffentlichtes Manuskript).

PARELLO, 2004 – Daniel Parello, Neue Lösungen zur Bildpro-grammatik zisterziensischer Prachtbauten, in: Glas. Malerei. Forschung. Internationale Studien zu Ehren von Rüdiger Becksmann, hrsg. von Hartmut Scholz/Daniel Hess/Ivo Rauch, Berlin 2004, S. 164–180.

PARELLO, 2003 – Daniel Parello, Anspruch und Wirklichkeit in der religiösen Kunsttheorie des 19. Jahrhunderts am Beispiel der rheinischen Glasmalereiwerkstätten Baudri und Oidtmann, in: Renaissance der Gotik. Gesammelte Beiträge zum Colloquium über die Neugotik, Goch 26.–28. April 2002, Goch 2003, S. 171–185.

PARELLO, 2000 (1) – Daniel Parello, Von Helmle bis Geiges. Ein Jahrhundert historistischer Glasmalerei in Freiburg, Freiburg im Breisgau 2000.

PARELLO, 2000 (2) – Daniel Parello, Helmle – Merzweiler – Geiges. Die Glasmalerei des 19. Jahrhunderts in Freiburg, in: Aufleuchten des Mittelalters. Glasmalereien des 19. Jahrhunderts in Freiburg, Ausstellungskatalog Augustinermu-seum Freiburg in Zusammenarbeit mit dem Corpus Vitrearum Deutschland, Freiburg im Breisgau 2000, S. 7–42.

PARELLO, 1997 (1) – Daniel Parello, Die Chorverglasung des Melanchthonhauses – Ein katholischer Künstler am Bau der «evangelischen Christenheit», in: Das Melanchthonhaus Bretten. Ein Beispiel des Reformationsgedankens der Jahrhundertwende, hrsg. von Stefan Rhein/Gerhard Schwinge, Ubstadt-Weiher 1997, S. 213–234.

PARELLO, 1997 (2) – Daniel Parello, Die ersten Glasmalereien für den Hochchor des Freiburger Münsters. Rekonstruktion zweier Straßburger Scheiben von 1494, in: Jahrbuch der Staatlichen Kunstsammlung in Baden-Württemberg, Bd. 34, München/Berlin 1997, S. 6–31.

PARELLO, 1995 – Daniel Parello, Zur Firmengeschichte der Oidtmannschen Werkstatt, in: Hauset, Die neugotische St. Rochus- und Genovevakirche, hrsg. von Emil Ignace De Wilde ... [et al.], Antwerpen 1995, S. 150–156.

PAULSEN, 1985 – Wolfgang Paulsen, Friedrich Schlegels «Lu-cinde» als Roman, in: Friedrich Schlegel, Lucinde. Ein Roman, Mit Radierungen von M. E. Philipp und einem Nachwort von Wolfgang Paulsen, Frankfurt am Main, 1985, S. 143–172.

PEPPER, 1984 – D. Stephen Pepper, Guido Reni. A complete Catalogue of his works with an introductory Text, Oxford 1984.

PFEIFFER, 1907 – Albert von Pfeiffer, Herzog Karl Eugen von Württemberg, hrsg. vom Geschichts- und Altertumsverein, Bd. 1, Eßlingen 1907.

PIANTONI, 1981 – Gianna Piantoni, Einige Aspekte des Naza-renischen Gedankens, in: Ausstellungskatalog Rom, 1981

– Die Nazarener in Rom. Ein deutscher Künstlerbund der Romantik, Rom 1981, deutsche Ausgabe München 1981, S. 18–26.

PILLET, 2010 – Elisabeth Pillet, Le vitrail à Paris au XIX^e siècle. Entrenir. Conserver. Restaurer (Corpus Vitrearum Medii Aevi. France, Série «études»; 9), Dissertation Universität EPHE Paris, Rennes 2010.

POESCHEL, 1928 – Erwin Poeschel, Augusto Giacometti (Monographien zur Schweizer Kunst 3. Bd.), Zürich 1928.

POSCHARSKY, 1998 – Peter Poscharsky (Hrsg.), Die Bilder in den lutherischen Kirchen. Ikonographische Studien, München 1998.

POSSELT, 2010 – Christina Posselt, Kommentar vom 30. März 2010 bzgl. der Dürerkopien des Malers Georg Vischer, in: Teutsche Academie der Bau-, Bild- und Mahlerey-Künste, Joachim von Sandrart, Nürnberg 1675/1679/1680. Wissenschaftlich kommentierte Online-Edition, hrsg. von Thomas Kirchner/Alessandro Nova … [et al.], 2008–2012. URL: ta.sandrart.net/aw/3203, 1. Juli 2012.

PRANDTSTETTEN, 1985 – Rainer Prandtstetten, Glasmalerei-Textil. Zwei besonders gefährdete Kunstgattungen, in: Weltkunst, Heft 55, München 1985, S. 3284–3287.

PRIEBE, 1932 – Hermann Priebe, Das Christusbild in der Kunst des 19. und 20. Jahrhunderts, Berlin Grunewald 1932.

QUELLET-SOGUEL, 1996 – Nicole Quellet-Soguel, Clement Heaton, 1861–1940, Londres – Neuchâtel – New York, Hauterive 1996.

RAHN, 1920 – Johann Rudolf Rahn, Erinnerungen aus den ersten 22 Jahren meines Lebens. Aus hinterlassenen Aufzeichnungen von Prof. Dr. Johann Rudolf Rahn (†1912). (Schluß), in: Zürcher Taschenbuch auf das Jahr 1920, Neue Folge: 41. Jg., hrsg. mit Unterstützung der Antiquarischen Gesellschaft von einer Gesellschaft zürcherischer Geschichtsfreunde, Zürich 1920, S. 1–90.

RAHN, 1901–1910 – Johann Rudolf Rahn, Die Glasgemälde in der Kirche zu Oberkirch bei Frauenfeld (Kunstdenkmäler der Schweiz. Mitteilungen der Schweizerischen Gesellschaft für den Erhalt historischer Kunstdenkmäler. Neue Folge, Heft 1), Genf 1901–1910.

RAHN, 1897 – Johann Rudolf Rahn, Bericht über die Glasgemälde in Königsfelden, Basel 1897.

RAHN, 1876 – Johann Rudolf Rahn, Geschichte der Bildenden Künste in der Schweiz. Von den ältesten Zeiten bis zum Schlusse des Mittelalters, Zürich 1876.

RAUCH, 1996 – Ivo Rauch, Die Farbverglasung der Oppenheimer Katharinenkirche – Ihre Wiederherstellung zwischen Romantik und Historismus, in: Erfurt Köln Oppenheim. Quellen und Studien zur Restaurierungsgeschichte mittelalterlicher Farbverglasungen (Corpus Vitrearum Medii Aevi. Deutschland, Studien, Bd. II), Berlin 1996, S. 150–202.

RAUSCHER, 2008 – Heinz Rauscher, Die Kirchenfenster von Pieterlen – oder von großzügigen Spenden und Wandel des Geschmacks, in: Seebutz, Heimatbuch des Seelandes und Murtenbiets, Biel 2008 [Online-Version], S. 63–70.

URL: www.seebutz.ch/index.cfm?rubrik=2598&site=6870, 1. Juli 2012.

REICHENSPERGER, 1879 – August Reichensperger, Die Renaissance im heutigen Kunstgewerbe, Aachen, 1879.

REICHENSPERGER, 1854 – August Reichensperger, Fingerzeige auf dem Gebiete der kirchlichen Kunst, Leipzig 1854.

REINDEL, 1838 – August Reindel, Die wichtigsten Bildwerke am Sebaldusgrabe zu Nürnberg von Peter Vischer, Achtzehn Blätter gezeichnet und gestochen von A. Reindel, mit erläuternder Zugabe, in deutscher, englischer und französischer Sprache, Nürnberg 1838.

REUTHER, 1969 – Hans Reuther, «Heideloff, Dionysius Karl Christian Alexander von», in: NEUE DEUTSCHE BIOGRAPHIE 8 (1969), [Onlinefassung], S. 245. URL: www.deutsche-biographie.de/pnd118820117.html, 1. Juli 2012.

REVUE DE L'ART, 1986 – Ministère des universités, Centre national de la recherche scientifique. Comité français d'histoire de l'art. Paris: Centre national de la recherche scientifique, No. 72, Paris 1986.

RING, 1949 – Grete Ring, A Century of French Painting 1400–1500, New York/London 1949.

RIOU, 1986 – Yves-Jean Riou, Iconographie et attitudes religieuses. Pour une iconologie du vitrail du XIXe siècle, in: Revue de l'art. Ministère des universités, Centre national de la recherche scientifique. Comité français d'histoire de l'art. Paris: Centre national de la recherche scientifique, No. 72, Paris 1986, S. 39–49.

ROCA, 2012 – René Roca, Historisches Lexikon der Schweiz, URL: www.hls-dhs-dss.ch/textes/d/D17241.php, Stichw. *Sonderbund*, 13. Februar 2012.

ROMBOLD, 2004 – Günter Rombold, Die theologische Relevanz der Bildkunst, in: Christentum – Kirche – Kunst. Beiträge zur Reflexion und zum Dialog, hrsg. von Michael Durst/Hans J. Münk (Theologische Berichte, Bd. 27), Freiburg 2004, S. 27–63.

ROTH, 1995 – Michael Roth, «…haben nie veracht oder sich nie geschembt, yr vorältern kunst vor sich zu nemen und daruß zu lernen…», Vorlage und Komposition in der Straßburger Glasmalerei, in: Bilder aus Licht und Farbe. Meisterwerke spätgotischer Glasmalerei. «Straßburger Fenster» in Ulm und ihr künstlerisches Umfeld, Ausstellungskatalog, hrsg. von Brigitte Reinhardt/Michael Roth, Ulmer Museum, Ulm 1995, S. 27–41.

RUOSS/GIESICKE, 2012 – Mylène Ruoss/Barbara Giesicke, Die Glasgemälde im Gotischen Haus zu Wörlitz, 2 Bde. (Wissenschaftliche Bestandskataloge der Kulturstiftung Dessau/Wörlitz, Bd. 4), Berlin 2012.

SAINT-IMIER, 2008 – L'Eglise Catholique Romaine De Saint-Imier, hrsg. von Abbé Dominique Jeanneret, Festschrift zum 150-jährigen Pfarrjubiläum, Saint-Imier 2008.

SAUER, 2003 – Erich Sauer, Studien zur Gruftkapelle Thurn und Taxis im Kreuzgang St. Emmeram (unveröffentlichte Magisterarbeit an der Philosophischen Fakultät I Phil.,

Sport, Kunstwissenschaften der Universität Regensburg), Regensburg 2003.

SAUTEREL, 2008 – Valérie Sauterel, Les vitraux genevois entre 1830 et 1900 – Lumière sur une époque trop souvent dépréciée, in: émotion(s) en lumière – le vitrail à Genève, APAS, Genève 2008, S. 52–94.

SCHAWE, 2010 – Martin Schawe, Dürer, Albrecht: Vier Apostel, in: Historisches Lexikon Bayerns.
URL: www.historisches-lexikonbayerns.de/artikel/artikel_45639, 1. September 2010.

SCHAWE, 2006 – Martin Schawe, Alte Pinakothek München, hrsg. von der Bayerischen Staatsgemäldesammlung, München (Bd. 2: Altdeutsche und Niederländische Malerei), Ostfildern, 2006.

SCHEIWILLER, 2007 – Eva-Maria Scheiwiller-Lorber, Gebrannte Glasmalereien in jeder Manier. Neue Glasmalkunst des 19. Jahrhunderts im Werk Johann Jakob Röttingers (unveröffentlichte Lizentiatsarbeit der Philosophischen Fakultät der Universität Zürich), Zürich 2007.

SCHILLER, 1976 – Gertrud Schiller, Ikonographie der christlichen Kunst, Bd. 4/1, Die Kirche, Gütersloh 1976.

SCHLEIER, 1998 – Erich Schleier, Luca Giordano, Der heilige Michael. Um 1663, in: Gemäldegalerie Berlin. 200 Meisterwerke, hrsg. von den Staatlichen Museen zu Berlin – Preußischer Kulturbesitz, Berlin 1998, S. 396–397.

SCHLINK, 1991 – Wilhelm Schlink, Der Beau-Dieu von Amiens. Das Christusbild der gotischen Kathedrale, (Insel Taschenbuch, Bd. 1316), Frankfurt am Main/Leipzig 1991.

SCHMID, 2003 – Bruno Schmid, Historisches Lexikon der Schweiz, hrsg. von der Stiftung Historisches Lexikon der Schweiz (HLS), Stichw. *Bluntschli, Johann Caspar*, Bd. 2 Basel (Kanton) – Bümpliz, Basel 2003, S. 510.

SCHMIDT-LINSENHOFF, 1988 – Viktoria Schmidt-Linsenhoff, Guidos Grazie. Rezeptionsgeschichte und Rezeptionsästhetik, in: Guido Reni und Europa. Ruhm und Nachruhm, Ausstellungskatalog Schirn Kunsthalle Frankfurt, hrsg. von Sybille Ebert-Schifferer/Andrea Emiliani/Erich Schleier, Frankfurt am Main 1988, S. 62–70.

SCHMIDT-LINSENHOFF, 1979 – Viktoria Schmidt-Linsenhoff, Guido Reni im Urteil des 17. Jahrhunderts. Studien zur literarischen Rezeptionsgeschichte und Katalog der Reproduktionsgraphik (Dissertation Philosophische Fakultät Kiel 1974), Kiel 1979.

SCHNEIDER, 1988 – Jenny Schneider, «Lux Zeiner. Bahnbrecher der Wappenscheibenkunst», in: Turicum, 1988, S. 10–16.

SCHNEIDER, 1971 – Jenny Schneider, Glasgemälde. Katalog der Sammlung des Schweizerischen Landesmuseums Zürich, 2 Bde., Stäfa 1970.

SCHNEIDER, 1956 – Jenny Schneider, Kabinettscheiben des 16. und 17. Jahrhunderts (Hochwächter-Bücherei, Bd. 17), Bern 1956.

SCHNEIDER, 1954 – Jenny Schneider, Die Standesscheiben von Lukas Zeiner im Tagsatzungssaal zu Baden (Schweiz). Ein Beitrag zur Geschichte der schweizerischen Standesschei-

ben (Basler Studien zur Kunstgeschichte, Bd. XII), Basel 1954.

SCHOLL, 2007 – Christian Scholl, Romantische Malerei als neue Sinnbildkunst. Studien zur Bedeutungsgebung bei Philipp Otto Runge, Caspar David Friedrich und den Nazarenern, Berlin/München 2007.

SCHOLZ, 2007 – Hartmut Scholz, St. Sebald in Nürnberg (Meisterwerke der Glasmalerei 3), hrsg. von Hartmut Scholz, Corpus Vitrearum Medii Aevi Freiburg im Auftrag der Akademie der Wissenschaften und der Literatur Mainz und des Deutschen Vereins für Kunstwissenschaft, Berlin/Regensburg/Freiburg im Breisgau 2007.

SCHOLZ, 2002 – Hartmut Scholz, Die mittelalterlichen Glasmalereien in Mittelfranken und Nürnberg extra muros, (Corpus Vitrearum Medii Aevi. Deutschland; 10, Mittelfranken und Nürnberg 1), Berlin 2002.

SCHOLZ, 1994 – Hartmut Scholz, Die mittelalterlichen Glasmalereien in Ulm (Corpus Vitrearum Medii Aevi. Deutschland; 1, 3: Schwaben), Berlin 1994.

SCHOLZ, 1991 – Hartmut Scholz, Entwurf und Ausführung: Werkstattpraxis in der Nürnberger Glasmalerei der Dürerzeit, (Corpus Vitrearum Medii Aevi. Deutschland, Studienband 1: Entwurf und Ausführung), Im Auftrag des Deutschen Vereins für Kunstwissenschaft und des Nationalkomitees des Corpus Vitrearum Medii Aevi Deutschland, hrsg. von Rüdiger Becksmann, Berlin 1991.

SCHOLZ/HESS, 1999 – Hartmut Scholz/Daniel Hess … [et al.], Beobachtungen zur Ätztechnik an Überfanggläsern des 15. Jahrhunderts, in: Corpus Vitrearum Medii Aevi NewsLetter 46, 1999, S. 19–23,
URL: www.corpusvitrearum.org, 26. April 2012.

SCHÖNENBERG, 1989 – Marianne Schönenberg, Die Ausmalung des Speyerer Doms (1846–1853/1862) durch Johann Baptist Schraudolph und seine Gehilfen (Inaugural-Dissertation, Fachbereich Geschichtswissenschaften der Freien Universität Berlin), Köln 1989.

SCHÖNWÄLDER, 1995 – Jürgen Schönwälder, Ideal und Charakter. Untersuchungen zur Kunsttheorie und Kunstwissenschaft um 1800 (tuduv-Studien: Reihe Kunstgeschichte, Bd. 69), Dissertation Universität München, München 1993.

SCHÜPKE, 2009 – Bettina Schüpke, Von Schätzen in Kisten, Kellern und Kirchen. Die Wiederentdeckung der Glasmalereiwerkstatt Linnemann aus Frankfurt a. M. (1889–1955), in: Das Münster. Zeitschrift für christliche Kunst und Kunstwissenschaft, Jg. 62, Heft 2 (2009), S. 132–141.

SCHUHMACHER, 1998 – Claudia Schuhmacher, Zur Rezeption der Glasmalereien im 19. Jahrhundert, in: Himmelslicht. Europäische Glasmalerei im Jahrhundert des Kölner Dombaus (1248–1349), Ausstellungskatalog, hrsg. von Hiltrud Westermann-Angerhausen in Zusammenarbeit mit Carola Hagnau … [et al.], Schnütgen-Museum, Köln 1998, S. 111–117.

SENG, 1995 – Eva-Maria Seng, Der evangelische Kirchenbau im 19. Jahrhundert. Die Eisenacher Bewegung und der Architekt Christian Friedrich von Leins (Tübinger Studien

zur Archäologie und Kunstgeschichte, Bd. 15), hrsg. von Ulrich Hausmann/Klaus Schwager, Tübingen 1995.

SIMADER, 2005 – Friedrich Simader, Das so genannte «Reiner Musterbuch» – Notizen zum Forschungsstand, in: Zisterziensisches Schreiben im Mittelalter – Das Skriptorium der Reiner Mönche. Beiträge der Internationalen Tagung im Zisterzienserstift Rein, Mai 2003 (Jahrbuch für Internationale Germanistik, Reihe A, Bd. 71), Wien u.a. 2005, S. 141–150.

SMITMANS, 1980 – Adolf Smitmans, Die christliche Malerei im Ausgang des 19. Jahrhunderts – Theorie und Kritik. Eine Untersuchung der deutschsprachigen Periodica für christliche Kunst 1870–1914 (Kölner Forschungen zu Kunst und Altertum, Abt. B Kunstgeschichte, Bd. 2), Dissertation Universität Tübingen 1978, St. Augustin 1980.

SOMMER, 2007 – Anke Elisabeth Sommer, Glasmalereien der Protestantischen Landeskirche der Pfalz. Leuchtende Botschaft christlichen Glaubens im Kontext ihrer Zeit, (Veröffentlichungen des Vereins für Pfälzische Kirchengeschichte, Bd. 25), Regensburg 2007.

SPICKERNAGEL, 1977 – Ellen Spickernagel, «Das Innerste erschüttern und bewegen.» Zur religiösen Tafelmalerei der Nazarener, in: Die Nazarener, Ausstellungskatalog Städtische Galerie im Städelschen Kunstinstitut, hrsg. von Klaus Gallwitz, Frankfurt am Main 1977, S. 111–148.

SPIES, 2011 – Christian Spies, Ornament und Textil. Überlegungen mit Gottfried Semper, in: Kunst und Architektur in der Schweiz, Jg. 62, Heft 1 (2011), S. 38–43.

STAEHELIN, 1980 – Andreas Staehelin, Helvetik, in: Handbuch der Schweizer Geschichte, Bd. 2, Zürich 1980, S. 785–840.

STEINER, 2008 – Peter Steiner, Historisches Lexikon der Schweiz, hrsg. von der Stiftung Historisches Lexikon der Schweiz (HLS), Stichw. *Keyser [Kaiser, Kayser, Keiser]*, Bd. 7 Jura – Lobsigen, Basel 2008, S. 198.

STEINER, 2008 – Peter Steiner, Historisches Lexikon der Schweiz, hrsg. von der Stiftung Historisches Lexikon der Schweiz (HLS), Stichw. *Keyser, Heinrich,* Bd. 7 Jura – Lobsigen, Basel 2008, S. 198.

STEINLE, 2005 – Christa Steinle, Die Rückkehr des Religiösen. Nazarenismus zwischen Romantik und Rationalismus, in: Religion Macht Kunst, Ausstellungskatalog, Schirnkunsthalle Frankfurt 2005, hrsg. von Max Hollein/Christa Steinle, Köln 2005, S. 15–36.

STROBL, 1999 – Sebastian Strobl, Die Technik der Glasmalerei in Mittelalter und Neuzeit, in: Glasmalereien aus acht Jahrhunderten. Meisterwerke in Deutschland, Österreich und der Schweiz. Ihre Gefährdung und Erhaltung, hrsg. von der Berlin-Brandenburgischen Akademie der Wissenschaften, Leipzig 1999.

STROBL, 1990 – Sebastian Strobl, Glastechnik des Mittelalters, Stuttgart 1990.

STROTMANN, 2012 – Angelika Strotmann, Der historische Jesus: eine Einführung, Paderborn 2012.

STUDER, 2002 – Daniel Studer, Das ehemalige Kloster St. Johann im Thurtal. Alt St. Johann im Toggenburg, Kanton St. Gallen, hrsg. von der Gesellschaft für Schweizerische Kunstgeschichte, Bern 2002.

STUTZER/WINDHÖFEL, 1991 – Beat Stutzer/Lutz Windhöfel, Augusto Giacometti. Leben und Werk, Chur 1991.

STYGER, 1936 – Martin Styger, Wappenbuch des Kantons Schwyz. Opus posthumum, hrsg. von Paul Styger, Genf 1936.

SUHR, 2012 – Norbert Suhr, Nazarener in Rheinland-Pfalz – ein Überblick, in: Die Nazarener – Vom Tiber an den Rhein. Drei Malerschulen des 19. Jahrhunderts, Ausstellungskatalog Landesmuseum Mainz, Norbert Suhr, Nico Kirchberger, hrsg. von der Direktion Landesmuseum Mainz, GDKE, Regensburg 2012, S. 13–24.

SUHR, 1998 – Norbert Suhr, Quellen nazarenischer Kunsttheorie am Beispiel Philipp Veits, in: Anzeiger des Germanischen Nationalmuseums 1998, Nürnberg 1998, S. 116–122.

SUNTRUP, 1978 – Rudolf Suntrup, Die Bedeutung der liturgischen Gebärden und Bewegungen in Lateinischen und Deutschen Auslegungen des 9. bis 13. Jahrhunderts, (Münsterische Mittelalter-Schriften, Bd. 37), München 1978.

TANNER, 2002 – Albert Tanner, Willensnation versus Kulturnation. Nationalbewusstsein und Nationalismus in der Schweiz, in: Nation und Nationalismus in Europa. Kulturelle Konstruktion von Identitäten (Festschrift für Urs Altermatt, hrsg. von Catherine Bosshart-Pfluger/Joseph Jung/Franziska Metzger), Frauenfeld 2002, S. 179–204.

TELESKO, 2009 – Werner Telesko, Historia sacra? Zum Wechselverhältnis von Geschichte und Religion in der Historienkunst des 19. Jahrhunderts, in: Das Münster. Zeitschrift für christliche Kunst und Kunstwissenschaft, Jg. 62, Heft 4 (2009), S. 244–258.

TELESKO, 2000 – Werner Telesko, Friedrich Schlegel und die «Frühgeschichte» des Historismus. Zum Verhältnis von Religion und Geschichte der bildenden Kunst des 19. Jahrhunderts, in: Kunsthistorisches Jahrbuch Graz, Bd. 27, hrsg. von Götz Pochat/Brigitte Wagner, Graz 2000, S. 40–60.

TELESKO, 1996 – Christliche Kunst im Zeitalter des Historismus – Bemerkungen zu einigen Bruchlinien zwischen Religion und Geschichte im 19. Jahrhundert, in: Das Münster. Zeitschrift für christliche Kunst und Kunstwissenschaft, Jg. 49, Heft 4 (1996), S. 282–288.

THEISSEN/MERZ, 1996 – Gerd Theißen/Annette Merz, Der historische Jesus, Göttingen 1996.

THIMANN, 2005 – Michael Thimann, Der Bildtheologe Friedrich Overbeck, in: Religion Macht Kunst, Ausstellungskatalog, Schirnkunsthalle Frankfurt 2005, hrsg. von Max Hollein/Christa Steinle, Köln 2005, S. 169–177.

THÜRER, 1954 – Hans Thürer, Geschichte der Gemeinde Mollis, Glarus 1954.

TOBLER, 1985 – Mathilde Tobler, «Ich male für fromme Gemüter und nicht für Kritiker». Melchior Paul Deschwanden als Kirchenmaler, in: Zur religiösen Schweizer Malerei im 19. Jahrhundert: «Ich male für fromme Gemüter», Ausstellungskatalog Kunstmuseum Luzern, hrsg. vom Kunstmuseum Luzern, Luzern 1985.

TOURNIÉ/COLOMBAN/MILANDE, 2007 – Aurelié Tournié/ Philippe Colomban/Véronique Milande, Vitraux et peintures sur verre à la Manufacture de Sèvres, in: Techniques du vitrail au XIXe siècle (Les Dossiers de l'IPW, 3), Forum pour la conservation et la restauration des vitraux, Namur 14–16 juin 2007, Gilly 2007, S. 219–224.

TREMP, 2007 – Ernst Tremp, Historisches Lexikon der Schweiz, hrsg. von der Stiftung Historisches Lexikon der Schweiz (HLS), Stichw. *Hauterive (Kloster)*, Bd. 6 Haab – Juon, Basel 2007, S. 166f.

TREMP, 2006 – Josef Tremp, Badener Kapellen, Baden-Ennetbaden 2006.

TRÜMPLER, 2003 – Stefan Trümpler, Glasmalerei und Kunstverglasung (Merkblätter des Bundesamtes für Bevölkerungsschutz, Kulturgüterschutz), [Onlineversion], URL: <www.bevoelkerungsschutz.admin.ch/internet/bs/de/home/themen/kgs/publikationen_kgs/merkblatt/glas.parsys.0001.downloadList.00011.DownloadFile.tmp/glasmalereid.pdf>, 3. August 2011.

TRÜMPLER, 2002 (1) – Stefan Trümpler mit Beiträgen von Fritz Dold und Urs Wohlgemuth, Über die Restaurierungen der Aargauer Glasmalereien, in: Glasmalerei im Kanton Aargau. Einführung zur Jubiläumspublikation 200 Jahre Kanton Aargau, Lehrmittelverlag des Kantons Aargau 2002, S. 62–83.

TRÜMPLER, 2002 (2) – Stefan Trümpler mit Beiträgen von Fritz Dold und Urs Wohlgemuth, Zur Glasmalerei als Kunstform und zu ihrer Technik, in: Glasmalerei im Kanton Aargau. Einführung zur Jubiläumspublikation 200 Jahre Kanton Aargau, Lehrmittelverlag des Kantons Aargau 2002, S. 34–59.

TRÜMPLER, 1999 – Stefan Trümpler, Les vitraux du choeur de l'église, in: Patrimoine Fribourgeois, Freiburger Kulturgüter. L'Abbaye Cistercienne D'Hauterive, No. 11, Octobre 1999, S. 59–65.

ULLRICH, 2011 – Wolfgang Ullrich, An die Kunst glauben, Berlin 2011.

VAASSEN, 2013 – Elgin Vaassen, Die kgl. Glasmalereianstalt in München 1827–1874. Geschichte – Werke – Künstler, Berlin/München 2013.

VAASSEN, 2007 – Elgin Vaassen, Die Glasgemälde des 19. Jahrhunderts im Dom zu Regensburg. Stiftungen König Ludwigs I. von Bayern 1827–1857, Regensburg 2007.

VAASSEN, 2000 – Elgin van Treeck-Vaassen, Die Freiburger Glasmaler und ihre Stellung innerhalb der deutschen Werkstätten, in: Aufleuchten des Mittelalters. Glasmalereien des 19. Jahrhunderts in Freiburg, Ausstellungskatalog Augustinermuseum Freiburg in Zusammenarbeit mit dem Corpus Vitrearum Deutschland, Freiburg im Breisgau 2000, S. 43–54.

VAASSEN, 1998 – Elgin Vaassen, Artikel zu Johann Jakob Röttinger, in: BIOGRAFISCHES LEXIKON DER SCHWEIZER KUNST. Unter Einschluss des Fürstentums Liechtenstein, Bd. 2 L–Z, hrsg. vom Schweizerischen Institut für Kunstwissenschaft, Zürich/Lausanne 1998, S. 887–888.

VAASSEN, 1997 – Elgin Vaassen, Bilder auf Glas. Glasgemälde zwischen 1780 und 1870, München/Berlin 1997.

VAASSEN, 1993 – Elgin Vaassen, Glasmalereien des 19. Jahrhunderts, in: Glasmalerei des 19. Jahrhunderts in Deutschland. Ausstellungskatalog Angermuseum Erfurt, Erfurt/Leipzig 1993, S. 11–30.

VAASSEN, 1985 – Elgin Vaassen, Kaulbach skizzierte, was Hess erfand und Ainmiller auf Glas malte, in: Kultur und Technik, Das Magazin aus dem Deutschen Museum, Jg. 9 (1985), S. 14–21.

VAASSEN, 1983 – Elgin Vaassen, PEINTURES EN APPRET. Die zerstörten Glasgemälde der Brüder Boisserée, in: Kölner Domblatt, Jg. 48 (1983), S. 7–26.

VAASSEN/NIEDERHUBER, 2004 – Elgin Vaassen/Konrad Niederhuber, Zur neugotischen Farbverglasung der Stuttgarter Stiftskirche, in: Glas. Malerei. Forschung. Internationale Studien zu Ehren von Rüdiger Becksmann, hrsg. von Hartmut Scholz/Ivo Rauch/Daniel Hess, Berlin 2004, S. 303–314.

VAASSEN/VAN TREECK, 1981 – Elgin Vaassen/Peter van Treeck, Das Görresfenster im Kölner Dom. Geschichte und Wiederherstellung, in: Kölner Domblatt Jg. 46 (1981), S. 21–62.

VAN TREECK, 2007 – Peter van Treeck, Besondere ästhetische und technische Funktionen an Bleinetzen des 19. Jahrhunderts, in: Techniques du vitrail au XIXe siècle (Les Dossiers De L'IPW 3), Forum pour la conservation et la restauration des vitraux, Namur, 14–16 juin 2007, Gilly 2007, S. 179–190.

VAN TREECK, 1993 – Peter van Treeck, Konservierung und Restaurierung von Glasmalereien des 19. Jahrhunderts, in: Kat. Erfurt, 1993 – Glasmalerei des 19. Jahrhunderts in Deutschland. Ausstellungskatalog Angermuseum Erfurt, Erfurt/Leipzig 1993, S. 31–46.

VERBEEK, 1961 – Albert Verbeek, Zur spätnazarenischen Ausmalung des Speyerer Domes 1846–1854, in: 900 Jahre Speyerer Dom. Festschrift zum Jahrestag der Domweihe 1061–1961, hrsg. von Ludwig Stamer, Speyer 1961, S. 138–164.

VIOLLET-LE-DUC, 1868 – Eugène Emmanuel Viollet-le-Duc, Dictionnaire raisonné de l'architecture française du Xe au XVIe siècle, Bd. IX, Paris 1854–1868.

VITROCENTRE ROMONT, 2010 – Les panneaux de vitrail isolés. Die Einzelscheibe. The single stained-glass panel. Actes du XXIVe Colloque International du Corpus Vitrearum Zurich 2008. Textes réunis par Valérie Sauterel et Stefan Trümpler, Berne 2010.

VON ARX, 2004 – Urs von Arx, Historisches Lexikon der Schweiz, hrsg. von der Stiftung Historisches Lexikon der Schweiz (HLS), Stichw. *Christkatholische Kirche*, Bd. 3 Bund – Ducros, Basel 2004, S. 373 ff.

VON ARX, 1997 – Rolf von Arx, Origin and Early History of Anglican Worship in Zurich, hrsg. von der «Anglican Church, Zurich», Zürich 1997.

VON EINEM, 1972 – Herbert von Einem, Bemerkungen zum Christusbild Rembrandts, in: Das Münster. Zeitschrift für

christliche Kunst und Kunstwissenschaft, Jg. 25, Heft 5/6 (1972), Regensburg, 1972, S. 349–360.

VON ORELLI-MESSERLI, 2010 – Barbara von Orelli-Messerli, Gottfried Semper (1803–1879). Die Entwürfe zur dekorativen Kunst, Petersberg 2010.

VON RODA, 1990 – Hortensia von Roda, Die frühen Glasgemälde des Hieronymus Hess für die Allgemeine Lesegesellschaft in Basel 1833, in: Das Denkmal und die Zeit. Alfred A. Schmid zum 70. Geburtstag gewidmet von Schülerinnen und Schülern, Freunden und Kollegen, Luzern 1990, S. 231–243.

WACKER, 1997 – Bernd Wacker, «Dem Verteidiger der katholischen Wahrheit…». Das Görresfenster im Kölner Dom – Ikonographie und Geschichte, in: Kölner Domblatt, Jg. 62 (1997), S. 245–274.

WEDDIGEN, 2003 – Tristan Weddigen, Pittura ama Disegno. Zur Beziehung zwischen Malerei und Zeichenkunst, in: Venezianische Malerei von 1500 bis 1800. Kontur oder Kolorit? Ein Wettstreit schreibt Geschichte, Ausstellungskatalog Städtisches Museum Engen+Galerie, hrsg. von Michael Brunner/Andrea C. Theil, Stadt Engen 2003, S. 25–34.

WEILANDT, 1995 – Gerhard Weilandt, Künstlerwanderungen und Kunstexport im Spätmittelalter: Das Beispiel Ulm, in: Bilder aus Licht und Farbe. Meisterwerke spätgotischer Glasmalerei. «Straßburger Fenster» in Ulm und ihr künstlerisches Umfeld, Ausstellungskatalog, hrsg. von Brigitte Reinhardt/Michael Roth, Ulmer Museum, Ulm 1995, S. 50–56.

WEISS, 1989 – Reto Weiss, Die Säkularisierung der Ehe im 19. Jahrhundert. Eine rechts- und institutionengeschichtliche Untersuchung am Beispiel des Kantons Zürich, Universität Zürich, Historisches Seminar, Referent Peter Stadler, (unveröffentlichte Lizentiatsarbeit der philosophischen Fakultät der Universität Zürich), Zürich 1989.

WENTZEL, 1949 – Hans Wentzel, Glasmaler und Maler im Mittelalter, in: Zeitschrift des deutschen Vereins für Kunstwissenschaft 3 (1949), S. 53–62.

WESSELY, 1880 – Joseph Eduard Wessely, «Heideloff, Karl Alexander von», in: ALLGEMEINE DEUTSCHE BIOGRAPHIE 11, Leipzig 1880, [Online-Version], S. 299f, URL: www.deutsche-biographie.de, Stichw. *Heideloff, Karl Alexander von*, 1. Juli 2012.

WETTSTEIN, 1996 – Stefanie Wettstein, Ornament und Farbe. Zur Geschichte der Dekorationsmalerei in Sakralräumen in der Schweiz um 1890, Sulgen 1996.

WIGET, 2010 – Josef Wiget, Historisches Lexikon der Schweiz, hrsg. von der Stiftung Historisches Lexikon der Schweiz (HLS), Stichw. *Oberallmeind*, Bd. 9 Mur – Privilegien, Basel 2010, S. 311.

WIMBÖCK, 2002 – Gabriele Wimböck, Guido Reni (1575–1642). Funktion und Wirkung des religiösen Bildes, (Studien zur christlichen Kunst, Bd. 3), hrsg. von Frank Büttner/Hans Ramisch, Regensburg 2002.

WIRBELBAUER, 2002 – Eckhard Wirbelbauer, Aberkios, der Schüler des Reinen Hirten, im Römischen Reich des 2. Jahrhunderts in: Historia 51 (2002), S. 359–382 [Online-Version], URL: http://www.digizeitschriften.de/dms/toc/?PPN= PPN345204425_0051, S. 359–382, 1. Juli 2012.

WISARD, 2009 – François Wisard, Historisches Lexikon der Schweiz, hrsg. von der Stiftung Historisches Lexikon der Schweiz (HLS), Stichw. *Moutier (Gemeinde)*, Bd. 8 Locarnini – Muoth, Basel 2009, S. 773 f.

WOELK, 1994 – Moritz Woelk, Stichw. *Christusmonogramm*, in: Lexikon für Theologie und Kirche 2, Barclay – Damodos, Freiburg im Breisgau 2009, Sp. 1178.

WOLF, 2010 – Christina Wolf, Die Einzelscheibe als Medium kirchenfürstlicher Selbstinszenierung im Zeitalter der Reformation: Die Glasgemälde des Kardinals Matthäus Lang von Wellenburg (1468–1540), in: Die Einzelscheibe (Kolloquiumsband des 24. Internationalen Kolloquiums des Corpus Vitrearum), Zürich 2010, S. 81–94.

WOLFF, 2005 – Arnold Wolff, Der Dom zu Köln. Seine Geschichte – seine Kunstwerke, Köln 2005.

WYSS, 2005 – Beat Wyss, Die ersten Modernen, in: Religion Macht Kunst. Die Nazarener, Ausstellungskatalog Schirn Kunsthalle Frankfurt, hrsg. von Max Hollein/Christa Steinle, Köln 2005, S. 155–168.

ZANGGER, 2008 – Eva Zangger, Glasmalerei um 1900. Synergien und Ergebnisse bei der Erforschung des Zürcher Werks Georg Röttingers, in: Kunst+Architektur in der Schweiz, Jg. 59, Heft 3 (2008), S. 39–45.

ZANGGER, 2007 – Eva Zangger, Techniken der Glasmalerei an der Schwelle zum 20. Jahrhundert: Die Zürcher Werke des Glasmalers Georg Röttinger, in: Techniques du vitrail au XIXe siècle (Les Dossiers De L'IPW 3), Forum pour la conservation et la restauration des vitraux, Namur, 14–16 juin 2007, Gilly 2007, S. 119–128.

ZANGGER, 2006 – Eva Zangger, Glasmalereien um 1900. Das Zürcher Werk Georg Röttingers (unveröffentlichte Lizentiatsarbeit der Philosophischen Fakultät der Universität Zürich), Zürich 2006.

ZWICKY, 1995 – Hans Jakob Zwicky, Chronik der Gemeinde Thalwil, Thalwil 1995.

Internetadressen

Allgemeine Deutsche Biographie,
URL: www.deutsche-biographie.de, 1. Juli 2012.

Alte Pinakothek München, Sammlung,
URL: www.pinakothek.de, 1. Juli 2012.

Antiquarische Gesellschaft Zürich,
URL: www.antiquarische.ch/, 3. August 2011.

Bauinventar Gemeinde Stans,
URL: www.stans.ch/dl.php/de/0ct9t-jseld1/Friedhofkapelle _Friedhofhalle.pdf, 28. September 2013.

Bayerische Hofglasmalerei, Gustav van Treeck, Homepage,
 URL: www.hofglasmalerei.de/uber-uns, 2. Februar 2012.

Bildindex Kunst- und Architektur,
 URL: www.bildindex.de/obj20335520.html#|home, 14. Juni 2012.

British Library, London,
 URL: www.british-library.uk/onlinegallery/sacredtexts/bedford.html, 12. September 2011.

CARL, 2002–2010 – Marie-Luise Carl, Online-Bibliothek, Stichw. *Nadler*,
 URL: freepages.genealogy.rootsweb.ancestry.com/~mlcarl/Beruf/Nadler.htm, 21. Mai 2012.

Corpus Vitrearum International (CVMA), Richtlinien,
 URL: www.corpusvitrearum.org, 2. Februar 2012.

CVMA International (GB) Picture Archive,
 URL: www.cvma.ac.uk/jsp/index.jsp, 8. Juni 2012.

Deutsches Dokumentationszentrum für Kunstgeschichte,
 URL: www.bildindex.de/obj17010477.html#|home, 14. Juni 2012.

Deutsche Nationalbibliothek, Katalog,
 URL: portal.dnb.de/opac.htm, Stichw. *Kirner, Johann Baptist*, 21. Mai 2012.

ELEXIKON, Meyers Konversations-Lexikon, 1885–1892,
 URL: www.peter-hug.ch/, Stichw. *Nadeln*, 21. Mai 2012.

Französisches Kulturministerium,
 URL: www.culture.gouv.fr/documentation/memoire/LISTES/marque/noms-040.htm, Stichw. *Kuhn-Helmle, Emilie*, 17. Februar 2012.

Historisches Lexikon Bayerns,
 URL: www.historisches-lexikon-bayerns.de/base/start, 10. Juni 2012.

Jona SG, Pfarrei Maria Himmelfahrt,
 URL: www.krj.ch/index.php?geschichte_jon, 3. August 2011.

MERTENS – Rainer Mertens, Stadtarchiv Nürnberg online-Service, Stadtlexikon, Stichw. *Vormärz*,
 URL: www.stadtarchiv.nuernberg.de/stadtlexikon/, 21. Mai 2012.

National Gallery, London,
 URL: www.nationalgallery.org.uk/artists/, 4. November 2011.

Nürnberg, Evangelisch-Lutherisches Dekanat, Geschichte,
 URL: www.nuernberg-evangelisch.de, 21. Mai 2012.

Rapperswil SG , Ortsbürgergemeinde, Homepage der Ortsbürgergemeinde,
 URL: www.ogrj.ch/portraet/geschichte.php, 21. Mai 2012.

Röttinger R. H., Homepage Dr. Rudolf H. Röttinger, Zürich,
 URL: www.roettinger.ch/glasmalerei.htm, 21. Mai 2012.

SCHMID – Bruno Schmid, *Straussenhandel*, in: Historisches Lexikon der Schweiz (HLS),
 URL: http://www.hls-dhs-dss.ch/textes/d/D17239.php, 29. Juni 2012,

SIKART, Lexikon und Datenbank zur Kunst in der Schweiz und im Fürstentum Liechtenstein,
 URL: www.sikart.ch/KuenstlerInnen.aspx, 21. Mai 2012.

Staatsarchiv Zürich, Edition Stillstandsprotokolle online,
 URL: www.staatsarchiv.zh.ch/internet/justiz_inneres/sta/de/ueber_uns/organisation/editionsprojekte/stillstand.html, 29. Mai 2012.

Stans, Bauinventar der Gemeinde
 http://www.stans.ch/dl.php/de/0ct9t-jseld1/Friedhof-kapelle_Friedhofhalle.pdf, 18. April 2013.

Taylor & Francis Group, London
 URL: www.19thcenturyart-facos.com/artwork/religion-vision-sir-galahad-and-his-company, 14. Juni 2012.

Thalwil, Evangelisch-reformierte Kirchgemeinde,
 URL: www.kirche-thalwil.ch, 3. August 2011.

Thorvaldsen Museum Kopenhagen,
 URL: www.thorvaldsensmuseum.dk/en/collections, 9. Juni 2012.

Vitrocentre Romont
 URL: www.vitrocentre.ch, 7. Mai 2014

Glasfabrikation

Mannheim, Saint-Gobain,
 URL: www.saint-gobain.com/en/group/our-history/, 8. März 2012.

Offenburg, Glasfabrik Geck&Cie, A. Schell,
 URL: www.borsi.de/index.php?id=25, 8. März 2012.

Paris, Verrerie Aubriot,
 URL: www.pressglas-korrespondenz.de/aktuelles/pdf/pk-2006-2w-sg-clairey.pdf, 8. März 2012.

Petershagen-Ovenstädt, Glashütte Gernheim,
 URL: www.pressglas-korrespondenz.de/aktuelles/pdf/pk-1999-4w-parent-funk-gernheim.pdf, 8. März 2012.

Wehrau, Solm'sche Glasfabrik,
 URL: www.pressglas-korrespondenz.de/aktuelles/pdf/pk-2001-5w-05-exner-glaswerke-lausitz.pdf, 8. März 2012.

Restaurierungsberichte

GYSIN/REHBERG, 2002/2003 – Sabine Gysin/Noemi Rehberg, unveröffentlichter Restaurierungsbericht der Glasmalereien der Pfarrkirche Pieterlen (ARGE Gysin und Rehberg), Basel 2003.

STEINMANN/REY, 2002–2004 – Architekturbüro Steinmann& Rey, Bericht zu Renovierungsarbeiten der Villa Gelpke in Waldenburg BL, Liestal BL,
 URL: www.steinmann-rey.ch/bureau.htm, 21. Mai 2012.

TRÜMPLER/DOLD, 2005 – Stefan Trümpler/Fritz Dold, Kappel am Albis, ehemalige Klosterkirche Glasmalereien, Konservierung und Bestandskontrolle 2003–2005, Vitrocentre Romont 2005.

Quellenverzeichnis

Zentralbibliothek Zürich

Handschriftenabteilung
ZB Ms.T111.5: Actum vom 5. April 1852.
ZB Ms.T111.5: Kommissionalbeschluss vom 16. Juni 1852.

Schriftlicher Nachlass Röttinger
ZB Nachl. Röttinger 1.1, Aarburg AG.
ZB Nachl. Röttinger 1.4, Alt St. Johann SG.
ZB Nachl. Röttinger 1.6, Andelfingen TG.
ZB Nachl. Röttinger 1.5, Amden SG.
ZB Nachl. Röttinger 1.7, Appenzell.
ZB Nachl. Röttinger 1.8, Arth SZ, Kapuziner.
ZB Nachl. Röttinger 1.9, Baar ZG.
ZB Nachl. Röttinger 1.10, Baden AG, ref.
ZB Nachl. Röttinger 1.11, Baden AG, Schulkapelle.
ZB Nachl. Röttinger 1.12, Basel, Französische Kirche.
ZB Nachl. Röttinger 1.13, Basel, Münster.
ZB Nachl. Röttinger 1.16, Bellikon AG.
ZB Nachl. Röttinger 1.18, Berbig, F.
ZB Nachl. Röttinger 1.19, Bern, kath.
ZB Nachl. Röttinger 1.26, Burgdorf BE, ref.
ZB Nachl. Röttinger 1.28, Cham ZG.
ZB Nachl. Röttinger 1.29, Châtonnaye FR.
ZB Nachl. Röttinger 1.30, Court BE.
ZB Nachl. Röttinger 1.31, Dällikon ZH.
ZB Nachl. Röttinger 1.34, Deschwanden.
ZB Nachl. Röttinger 1.35, Dessenheim.
ZB Nachl. Röttinger 1.36, Dietikon ZH.
ZB Nachl. Röttinger 1.38, Einbürgerung.
ZB Nachl. Röttinger 1.45, Frauenthal ZG.
ZB Nachl. Röttinger 1.46, Fretz.
ZB Nachl. Röttinger 1.47, Fribourg Hauterive.
ZB Nachl. Röttinger 1.48, Fribourg St.Nicolas.
ZB Nachl. Röttinger 1.49, Furtwangen (A. Kreuzer).
ZB Nachl. Röttinger 1.51, Geschäftsjubiläum.
ZB Nachl. Röttinger 1.53, Gewerbeverband ZH.
ZB Nachl. Röttinger 1.56, Glarus, Stadtkirche.
ZB Nachl. Röttinger 1.58, Glis VS.
ZB Nachl. Röttinger 1.71, Hirnschrot Joh. A.

ZB Nachl. Röttinger 1.76, Keller W., Baumeister Luzern.
ZB Nachl. Röttinger 1.77, Kilchberg ZH.
ZB Nachl. Röttinger 1.78, Kirchdorf AG.
ZB Nachl. Röttinger 1.79, Kreuzer A., Furtwangen, priv.
ZB Nachl. Röttinger 1.81, Lausanne VD.
ZB Nachl. Röttinger 1.82, Lenzburg AG.
ZB Nachl. Röttinger 1.83, Leuggern AG.
ZB Nachl. Röttinger 1.88, Lunkhofen AG.
ZB Nachl. Röttinger 1.94, Meilen ZH.
ZB Nachl. Röttinger 1.99, Mollis GL.
ZB Nachl. Röttinger 1.101, Moser, Geissbühler.
ZB Nachl. Röttinger 1.115, Niederhasli ZH.
ZB Nachl. Röttinger 1.119, Nottwil LU.
ZB Nachl. Röttinger 1.122, Oberentfelden AG.
ZB Nachl. Röttinger 1.123, Ossingen ZH.
ZB Nachl. Röttinger 1.124, Paris.
ZB Nachl. Röttinger 1.125, Pieterlen BE.
ZB Nachl. Röttinger 1.133, Rapperswil BE.
ZB Nachl. Röttinger 1.134, Rapperswil SG Rathaus.
ZB Nachl. Röttinger 1.137, Regensdorf ZH, alte ref. Kirche.
ZB Nachl. Röttinger 1.140, Rüegsau BE.
ZB Nachl. Röttinger 1.141, Rück Andreas, Neffe J.J. Röttingers in Nürnberg.
ZB Nachl. Röttinger 1.143, Rüti ZH.
ZB Nachl. Röttinger 1.144, Rütli.
ZB Nachl. Röttinger 1.146, Salez SG.
ZB Nachl. Röttinger 1.152, Schwanden GL.
ZB Nachl. Röttinger 1.153, Schwyz, Friedhofskapelle Acher.
ZB Nachl. Röttinger 1.155, Stäfa ZH.
ZB Nachl. Röttinger 1.158, St. Gallen, St. Lorenzkirche.
ZB Nachl. Röttinger 1.159, Solothurn, ref.
ZB Nachl. Röttinger 1.160, Jonschwil SG.
ZB Nachl. Röttinger 1.162, Tavannes BE.
ZB Nachl. Röttinger 1.163, Thalwil ZH.
ZB Nachl. Röttinger 1.165, Thym, München.
ZB Nachl. Röttinger 1.168, Utzenstorf BE.
ZB Nachl. Röttinger 1.169, Uznach SG.
ZB Nachl. Röttinger 1.170, van Treeck-Vaassen Elgin.
ZB Nachl. Röttinger 1.173, Visitenkarte.
ZB Nachl. Röttinger 1.177, Vuadens FR.

ZB Nachl. Röttinger 1.178, Verena Röttinger-Fehr.

ZB Nachl. Röttinger 1.180, Adressaten an Verena Röttinger A-N.

ZB Nachl. Röttinger 1.181, Adressaten an Verena Röttinger O-Z.

ZB Nachl. Röttinger 1.182, Witwe Verenas Korrespondenz geschäftlich.

ZB Nachl. Röttinger 1.183, Verena Korrespondenz privat (Ehemann und Kinder).

ZB Nachl. Röttinger 1.184, Verena Röttingers Nachlass.

ZB Nachl. Röttinger 1.185, Wädenswil ZH.

ZB Nachl. Röttinger 1.187, Wappen Röttinger.

ZB Nachl. Röttinger 1.189, Wehrli Carl, Geschäftsübernahme.

ZB Nachl. Röttinger 1.190, Wil ZH.

ZB Nachl. Röttinger 1.191, Wollerau SZ, Pfarrkirche.

ZB Nachl. Röttinger 1.192, Zivilstandsamt ZH.

ZB Nachl. Röttinger 1.194, Zug, St. Oswald, Liebfrauenkapelle.

ZB Nachl. Röttinger 1.195, Zug, Kapuziner.

ZB Nachl. Röttinger 1.196, Zürich, Hauptbahnhof.

ZB Nachl. Röttinger 1.198, Zürich, Grossmünster.

ZB Nachl. Röttinger 1.199, Zürich, St. Anna.

ZB Nachl. Röttinger 1.201, Agenda 1874, 1877, 1889.

ZB Nachl. Röttinger 1.202, Auftragsbuch 1865–1870.

ZB Nachl. Röttinger 1.202.18, St-Imicr.

ZB Nachl. Röttinger 1.202.19, St. Oswald, Zug.

ZB Nachl. Röttinger 1.202.39, Schwyz, Kapuziner.

ZB Nachl. Röttinger 1.202.41, Pery.

ZB Nachl. Röttinger 1.202.47, Kraz/Steyermark [Graz/Steiermark].

ZB Nachl. Röttinger 1.202.69, Rotmonten.

ZB Nachl. Röttinger 1.202.84 Finstersee.

ZB Nachl. Röttinger 1.202.86, Selzach.

ZB Nachl. Röttinger 1.202.109, Gams.

ZB Nachl. Röttinger 1.202.110, Gams.

ZB Nachl. Röttinger, 1.202.123, Alt St. Johann.

ZB Nachl. Röttinger, 1.202.146, Zufikon.

ZB Nachl. Röttinger 1.206, Buchhaltung 1864–1866.

ZB Nachl. Röttinger 1.204–1.207, Buchhaltung.

ZB Nachl. Röttinger 1.208, Lohnheft Berbig 1875.

ZB Nachl. Röttinger 1.209, Lohnheft Berbig 1876.

ZB Nachl. Röttinger 2.219, Sion.

ZB Nachl. Röttinger 2.371, 1875–1877.

ZB Nachl. Röttinger 2.371, 1 Schwyz/o. Tit.

ZB Nachl. Röttinger 2.371, 2, Mümliswil/Pfarrer kath. Kirche.

ZB Nachl. Röttinger 2.371, 3 Jettingen/Herzog.

ZB Nachl. Röttinger 2.371, 6 Mümliswyl/Sury.

ZB Nachl. Röttinger 2.371, 8 Friedrichshafen/Frauen Kellner.

ZB Nachl. Röttinger 2.371, 9 Baden/Jeuch.

ZB Nachl. Röttinger 2.371, 12 Gündelhart/Erni.

ZB Nachl. Röttinger 2.371, 17 Thal/Knecht.

ZB Nachl. Röttinger 2.371, 19 Moutier/Châtelain.

ZB Nachl. Röttinger 2.371, 21 Moutier/Châtelain.

ZB Nachl. Röttinger 2.371, 22 Oberbüren/Kirchenverwaltung Oberbüren.

ZB Nachl. Röttinger 2.371, 28 Dorf/Knecht.

ZB Nachl. Röttinger 2.371, 29 Fribourg/Rauhs.

ZB Nachl. Röttinger 2.371, 30 Murten/Bölsterli.

ZB Nachl. Röttinger 2.371, 35 Waldkirch/Baumgartner.

ZB Nachl. Röttinger 2.371, 42 Promasens/Thierren.

ZB Nachl. Röttinger 2.371, 44 Oberbüren/Kirchenverwaltung.

ZB Nachl. Röttinger 2.371, 54 Bollingen/Birchler.

ZB Nachl. Röttinger 2.371, 59 Zeiningen/Architekt C. Jeuch.

ZB Nachl. Röttinger 2.371, 60 Zeiningen/Kirche.

ZB Nachl. Röttinger 2.371, 65 Dessenheim/Bgm. Meyer.

ZB Nachl. Röttinger 2.371, 67 Olten/A. Glutz.

ZB Nachl. Röttinger 2.371, 72 Bendern/Hänsle.

ZB Nachl. Röttinger 2.371, 78 Henau/Casanova.

ZB Nachl. Röttinger 2.371, 79 Zeiningen/Jeuch.

ZB Nachl. Röttinger 2.371, 81 Mümliswyl/Sury.

ZB Nachl. Röttinger 2.371, 83 Zermatt/Seiler.

ZB Nachl. Röttinger 2.371, 85 Brig/Seiler.

ZB Nachl. Röttinger 2.371, 86 Waldkirch/Baumgartner.

ZB Nachl. Röttinger 2.371, 89 Rodersdorf/Jaeggi.

ZB Nachl. Röttinger 2.371, 90 Olten/Glutz.

ZB Nachl. Röttinger 2.371, 94 Aussersihl/Guhl.

ZB Nachl. Röttinger 2.371, 96 Oberbüren/Germann.

ZB Nachl. Röttinger 2.371, 99 Basel/Roth.

ZB Nachl. Röttinger 2.371, 100 Waldkirch/Kirchenverwaltungs-Rathspräs.

ZB Nachl. Röttinger 2.371, 101 Gündelhart/Erni.

ZB Nachl. Röttinger 2.371, 104 Olten/Anton Glutz.

ZB Nachl. Röttinger 2.371, 106 St. Gallen/ Kunkler.

ZB Nachl. Röttinger 2.371, 107 Muri/Oberli.

ZB Nachl. Röttinger 2.371, 116 Sachseln/Pfarrer Omlin.

ZB Nachl. Röttinger 2.371, 121 St. Immer/Kirchen Rath.

ZB Nachl. Röttinger 2.371, 123 Mümliswyl/Sury.

ZB Nachl. Röttinger 2.371, 124 Olten/Glutz.

ZB Nachl. Röttinger 2.371, 130, 131 Geis LU/Andr. Oehen.

ZB Nachl. Röttinger 2.371, 136 Libingen/kath. Kirche.

ZB Nachl. Röttinger 2.371, 139 Fribourg/ Rauhs.

ZB Nachl. Röttinger 2.371, 141 Oberrüti/Stammler.

ZB Nachl. Röttinger 2.371, 143 Glis/Kirchenrat.

ZB Nachl. Röttinger 2.371, 149 Kloster Berg Sion/Aloysia Müller.

ZB Nachl. Röttinger 2.371, 151 Bischofszell/Zündeler.

ZB Nachl. Röttinger 2.371, 161 Lindtal/Kälin.

ZB Nachl. Röttinger 2.371, 163, 164 Jettingen/Herzog.

ZB Nachl. Röttinger 2.371, 166 St. Immer/kath. Kirche.

ZB Nachl. Röttinger 2.371, 182 St. Gallen/C. Vogel.

ZB Nachl. Röttinger 2.371, 188 Schänis/Eberhard.

ZB Nachl. Röttinger 2.371, 197 Winterthur/ Wieser Glashandlung.

ZB Nachl. Röttinger 2.371, 199 St. Gallen/C. Vogel.

ZB Nachl. Röttinger 2.371, 202 Jettingen/Herzog.

ZB Nachl. Röttinger 2.371, 205, Kloster Berg Sion/Aloisia Müller.

ZB Nachl. Röttinger 2.371, 206 Kloster Berg Sion/Aloisia Müller.

ZB Nachl. Röttinger 2.371, 210 Sachseln/Pfarrer Omlin.

ZB Nachl. Röttinger 2.371, 211 St. Gallen/Museumsgebäude/ Kunkler.

ZB Nachl. Röttinger 2.371, 212 Henau/Casanova.

ZB Nachl. Röttinger 2.371, 213 St. Gallen/Museumsgebäude/ Kunkler.

ZB Nachl. Röttinger 2.371, 214 St. Gallen Museum/Kunkler.

ZB Nachl. Röttinger 2.371, 215 St. Gallen/Gitterstricker Vogel.

ZB Nachl. Röttinger 2.371, 224 Waasen, Kapelle in Mayen UR/ Pfarrer in Waasen.

ZB Nachl. Röttinger 2.371, 234 Alterswyl/Bäriswyl.

ZB Nachl. Röttinger 2.371, 237 Zürich/Stadtrat Baldensberger.

ZB Nachl. Röttinger 2.371, 271 Rorschach/Pfarrer Gaille.

ZB Nachl. Röttinger 2.371, 291 Gräflich Solm'sche Glashütte.

ZB Nachl. Röttinger 2.371, o. p. Pfarrer Wissmann, Oct..

ZB Nachl. Röttinger 2.371, 313 Zürich/Carl Wehrli 1888.

ZB Nachl. Röttinger 2.379, Rechnungs- und Kopierbuch 1899–1901.

ZB Nachl. Röttinger 2.384, Rechnungs- und Kopierbuch 1905–1906.

ZB Nachl. Röttinger 2.47, S. 1–5, Korresp. (Postkarten) Röttinger Jakob Georg.

ZB Nachl. Röttinger 3.18, Grossmünster, Rezeption.

Graphischer Nachlass Röttinger

ZB Nachl. Röttinger 1.1.1.

ZB Nachl. Röttinger 1.1.4, Fotoalbum J.J. Röttinger und Mitarbeiter, 1865.

ZB Nachl. Röttinger 1.1.6, Blatt 1. Signiert Johann Jakob Röttinger.

ZB Nachl. Röttinger 1.1.6, Blatt 2. Signiert Johann Jakob Röttinger.

ZB Nachl. Röttinger 1.1.7, Signiert fremd.

ZB Nachl. Rottinger 1.1.8 Blatt 1, Werkstatt Röttinger vor 1887.

ZB Nachl. Röttinger 1.1.8 Blatt 2, Werkstatt Röttinger vor 1887.

ZB Nachl. Röttinger 1.1.8 Blatt 3, Werkstatt Röttinger vor 1887.

ZB Nachl. Röttinger 1.1.8 Blatt 4, Werkstatt Röttinger vor 1887.

ZB Nachl. Röttinger 2.1.1.

ZB Nachl. Röttinger 4.5.5, Lavater, Physiognomische Fragmente, 1806.

ZB Nachl. Röttinger 4.5.6, Nazarener diverse.

ZB Nachl. Röttinger 4.5.7, Ornamentik des Mittelalters, Carl Heideloff, 1845.

ZB Nachl. Röttinger 4.5.7, Saint Michel, P.A. Varin, 1848.

ZB Nachl. Röttinger 4.5.9, Christushaupt nach Dannecker, Benzigerverlag, Einsiedeln, o.J.

Schweizerisches Nationalmuseum Zürich

SNM, LM–30157.

SNM, LM–9209.1–16.

Staats- und Landesarchive

Aargau, Staatsarchiv

StAAG, Akten zu den Scheiben im Staatsbesitz, DB 01/05 91.

StAAG, R01.F14/0008, Nr. 24, Aarau, 24. Juni 1833, S. 40.

Appenzell, Landesarchiv

LA, Kirchenrenovation 1889.

Basel, Staatsarchiv

StABS, 319 I D1, Nachlass von Christoph Riggenbach.

StABS, 319 D6.

StABS, Planarchiv T 206.

StABS, SMM, Inv.AB.341.

StABS, SMM, Inv.AB.342.

Glarus, Landesarchiv

LA Glarus, Gemeinderatsprotokolle XI, 352, 363.

Schwyz, Staatsarchiv

StASZ, Akte 12.04.03.

StASZ, Akte 12.04.03, Bote der Urschweiz, Nr. 46, 8. Jg., 9. Juni 1866.

StASZ, Akte 12.04.03, Bote der Urschweiz, Nr. 98, 8. Jg., 8. Dezember 1866.

StASZ, Akte 12.04.03, Namensliste.

StASZ, Akte 12.06.21.

Zürich, Staatsarchiv

StAZH, E III 86.3, S. 202; E III 86.7, S. 98; Taufbuch und Haushaltungsrödeln von Ossingen.

StAZH, E III 86.8 S. 32; Bürgerbuch der Gemeinde Ossingen.

StAZH, W I 3 174 12, Müller-R 1851 58, 193/1852.

StAZH, W I 3 174 12, Müller-R 1851–58, 194/1851.

StAZH, W I 3 174 12, Müller-R 1851–58, 195/1852.

StAZH, W I 3 174 12, Müller-R 1851–58, 196/1851.

StAZH, W I 3 400. 9K 1–8.

StAZH, W I 3 400. 9C 1–25.

StAZH, W I 3 400. 22 1–12.

StAZH, W I 3 410. 70: Inv. Nr: 1847/1848.

StAZH, Mitgliederbuch des AGZ, 19. Jahrhundert.

Stadt- und Gemeindearchive

Aarburg, Gemeindearchiv

GA, Mappe Bauwesen, KBA 1841–1846.

Baden AG, Stadtarchiv

StadtA, A 06.46, A 06.47.

Basel, Zivilstandsamt

Zivilstandsamt, PD-REG 14a 12-4, Nr. 42 303.

Dietikon, Zivilstandsamt
Zivilstandsamt, Familienregister Bd. III von Schlieren.

Leukerbad, Gemeindearchiv
GA, XXV, 62, 64–67.

Rapperswil SG, Bürgerarchiv
BA, J01, J200.

Schlieren, Stadtarchiv
StadtA, Armenpflegeprotokolle 1839–1882, IV.B.1.1.

Schwyz, Gemeindearchiv
GASZ, Friedhofskapellenbaukommission.
GASZ, Friedhof-und Beerdigungswesen I 94.4, 21. November
 1864.
GASZ, Rechnung 1866.
GASZ, I.94.4, Protokolle der für die Baute der Friedhofkapel-
 le bestellten Kommission, 1864–1866.
GASZ, 07.01, 07.09, Protokolle, 25. August 1972, 6. April 1973.

St. Gallen, Ortsbürgergemeinde
Ortsbürgergemeinde, Tr XI, Nr. 13f. Akkord vom 1. Juli 1852.

Stans
Bauinventar Gemeinde Stans, Friedhofkapelle und Friedhof-
 halle, erstellt von Gerold Kunz, Architekt ETH SIA,
 2007/2008.

Stein am Rhein, Stadtarchiv

Wil SG, Stadtarchiv
StadtA, Akten KiAW1, Sign. 40.10.05.01.

Zug, Bürgerarchiv
BA, A14.20 Nr. 4, 7, 21, 24, 25.
BA, A39 Nr. 26, 75 S. 206, Ratsprotokolle, Nr. 233, Stadtrat 14.
 April 1866.

Zürich, Stadtarchiv
StadtA, Alte Einwohnerkontrolle 1836–1892.
StadtA, Brandassekuranz 1809–1925, V.L.1.:12.
StadtA, Falkengasse 25/Wegzug, Familienbogen Wehrle,
 V.E.c.26.:17.
StadtA, Haus- und Familienbögen 1850–1865, V.E.c.22.:24.
StadtA, Haus- und Familienbögen 1865–1880, V.E.c.25.:25.
StadtA, Register Aussersihl, NL-Kontrolle Schweizer und
 Ausländer, Reg. 1876–1879, VI.AS.C.48.:3, 7389.
StadtA, Tauf- und Ehebuch des Grossmünsters 1818–1856
 VIII.C.9.
StadtA, VI.AS.C.23.:7, Nr. 997.
StadtA, VI.AS.C.45.:4, Nr. 7389.

Pfarr-, Kirchen- und Kirchengemeindearchive

Alterswil, Pfarrarchiv
PA, Niederschrift (1900).

Alt St. Johann, Kirchengemeindearchiv
KGA, FI 1.2.

Alt St. Johann, Probsteiarchiv

Bünzen, Kirchengemeindearchiv
KGA, Nr. 29, 48, 77.

Court, Archives de la paroisse réformée évangélique
PA, lettre Röttinger (3), 25. Oktober 1862.

Dällikon, Pfarrarchiv

Fislisbach, Kirchengemeindearchiv
KGA, kath. Kirche Fislisbach.

Fislisbach, Pfarrarchiv
PA, kath. Kirche Fislisbach.

Gonten, Pfarrarchiv
PFA Gonten AI, Protokolle der Baukommission, 1865.

Heitenried, Pfarrarchiv
PA, 1862/63, Korrespondenz zwischen J.J. Röttinger und Pfr.
 Spicher.
PA, «Briefe von Kunstmaler Kaiser/Stans und Glasmaler
 Roettinger/Zürich etc».

Herdern, Kirchengemeindearchiv
KGA, 1AB5.

Leuggern, Kirchengemeindearchiv
KGA, K III 2 4, Kirchenvorstand, Akten des Kirchenbaues
 1838–1855, Band 2: Nr. 287 bis 392, Belege der Kirchenbau-
 Rechnung, Nr. 308.
KGA, K III 2 4, Kirchenvorstand, Akten des Kirchenbaues
 1838–1855, Band 2: Nr. 382, Verträge & Rechnung über
 die Glasmalerei & Fensterarbeiten.
KGA, K III 2 4, Kirchenvorstand, Akten des Kirchenbaues
 1838–1855, Band 2: Nr. 287 bis 392 Belege der Kirchen-
 baurechnung, Nr. 382, Verträge und Rechnung über die
 Glasmalerei & Fensterarbeiten (Rechnung über Arbeiten,
 die nicht im Akkord enthalten sind).

Mettmenstetten, Kirchengemeindearchiv
KGA, III.B.8.

Oberrohrdorf, Pfarrarchiv
PA, Theke 136.
PA, Theke 136. Bellikon, 30. Juli 1854.

Pieterlen, Pfarrarchiv

Rapperswil-Jona, Pfarrarchiv
PA, B 06.00, 10. Dezember 1851.
PA, B 06.00, 11. Oktober 1851.
PA, lose Materialsammlung.

Regensdorf, Pfarrarchiv
PA, 02. Protokolle der Kirchenpflege 02.02 1847–1901.
PA, Sitzungsprotokoll 1874.

Schlieren, Pfarrarchiv
PA, Kirchengutsrechnung.

Schlieren, Kirchengemeindearchiv
KGA, II B. 05.03, Sitzungsprotokolle der Baukommission für die Reparatur der Kirche 1842/1843.
KGA, III.B.01.119, Jahresrechnung 1854.
KGA, IV.B.03.02, S. 189, 190, 198, Stillstandsprotokoll 1854 (siehe Armenpflegeprotokoll S. 153, No. 7), Schlieren 1854, S. 363 (1861), S. 410, 412 (1871).

Stans, Pfarrarchiv
Kirchenratsprotokoll, 13. März 1870, S. 216/217 (Abschrift).

Thalwil, Kirchengemeindearchiv
KGA, IV.B.1.9. Protokoll der Kirchenpflege 1858–1874.

Unterägeri, Kirchengemeindearchiv
KGA, Rundscheibe mit Inschriften.

Unterägeri, Pfarrarchiv
PA, verschiedene Scheiben.
PA, Vertragsentwurf vom 28. Januar 1858.
PA, A8/85, A8/89.

Wil SG, Kirchenarchiv
KiA, 40.10.05.01; 40.10.05, Briefe und Verträge.

Zug, Pfarrarchiv St. Oswald
PA, A3 206.

Denkmalpflege und weitere

Aarau, Kantonale Denkmalpflege Aargau

St. Gallen, Kantonale Denkmalpflege

Stans, Kantonale Denkmalpflege Nidwalden

Thalwil, Ortsmuseum, Fotoarchiv

Vitrocentre Romont, Bildarchiv

Zug, Kantonale Denkmalpflege, Fotoarchiv, ZO 400.01_019 1962/5.

Zürich, Baugeschichtliches Archiv der Stadt Zürich

Zürich, ETH Bibliothek, Alte und Seltene Drucke

Zürich, Kantonale Denkmalpflege

Zeitschriften

NZZ, 5. Mai 1933, Blatt 5, Mittagsausgabe Nr. 811.
Tagblatt der Stadt Zürich vom 24. September 1902 (Todesanzeige Carl Wehrli).
Nidwaldner Stubli, 1945, Nr. 5 als Beilage in: NW-Volksblatt vom 14. April 1973, Vom neuen und alten Friedhof in Stans, S. 1–4.

Archive Deutschland

Berlin, bpk Bildagentur für Kunst, Kultur und Geschichte, Stiftung Preußischer Kulturbesitz

Nürnberg, Staatsarchiv
StA N, Nr. 95 Acta d. Königl. Kunstgewerbeschule zu Nürnberg, Betreff: versch. Betreffs 1824–1843.
StA N, Nr. 95 Acta d. Königl. Kunstgewerbeschule zu Nürnberg, Betreff: versch. Betreffs 1824–1843, Blatt 46, Blatt 60, 61, 69.
StA N, Nr. 252 Acta d. königl. Kunstgewerbeschule zu Nürnberg. Nr. 11: Verzeichnis der Schüler der Zeichnungsschule im Jahre 1830/31. Nr. 12: Verzeichnis der Schüler der Zeichnungsschule im Jahre 1831/32.
StA N, Nr. 253 Acta d. Königl. Kunstgewerbeschule zu Nürnberg. Schüler-Verzeichnisse d. Königl. Kunst- und Kunstgewerbeschule Nürnberg (1820–1853/54), Fasc.Nr. 2, 13.
StA N, Nr. 253 Acta d. Königl. Kunstgewerbeschule zu Nürnberg. Schüler-Verzeichnisse d. Königl. Kunst- und Kunstgewerbeschule Nürnberg (1820–1853/54), Fasc.Nr. 2, 14, Fasc.Nr. 2, 7.
StA N, Nr. 449 Akademie der Bildenden Künste, Blatt 94.

Nürnberg, Stadtarchiv
SA Nürnberg, C7_II_00984.
SA Nürnberg, C7_II_00984_01.
SA Nürnberg, C7_II_11886_00,
SA Nürnberg, C7_II_11886_01.
SA Nürnberg, C7_II_11886_03.
SA Nürnberg, C7_II_11886_04.
SA Nürnberg, C7_II_11886_05.
SA Nürnberg, C7_II_11886_06.
SA Nürnberg, C7_II_11886_07.
SA Nürnberg, C7_II_11886_08.

SA Nürnberg, C7_II_11886_09.
SA Nürnberg, C7_II_11886_11.
SA Nürnberg, C7_II_11886_17.
SA Nürnberg, C7_II_11886_18.
SA Nürnberg, C7_II_11886_20.
SA Nürnberg, C7_II_11886_21.
SA Nürnberg, C7_II_11886_22.
SA Nürnberg, C7_II_11886_23.
SA Nürnberg, C7/II NL, Nr. 2972.
SA Nürnberg, C7/II NL, Nr. 8906.
SA Nürnberg, C21/II Nr. 13, S. 26, Eintrag 205.

Düsseldorf, Archiv der Kunstakademie
Liste der Professoren.

Düsseldorf, Stadtarchiv
SA Düsseldorf.

Freiburg i. Breisgau, CVMA Bildarchiv

Kempten, Pfarrarchiv
PA Kempten-St. Mang, Nr. 316 (o. Dat.).

Marburg, Deutsches Dokumentationszentrum für Kunstgeschichte, Bildarchiv Foto Marburg

München, Graphische Sammlung
Signatur, Mappe 181 II (Fischer, Schraudolph).

München, Stadtarchiv
StdA München, Stadtadressbuch PMB R 279.

München, Wittelsbacher Ausgleichfonds
WAF Inv.-Nr.M VI a 48.

Nordrheinwestfalen, Landesarchiv
LA NRW Findbücher. 212.01 «Regierung Düsseldorf, Präsidialbüro», Seiten 250–260, Klassifikationspunkt «23. Kunstakademie Düsseldorf».
LA NRW Findbücher. 212.23.1 «Regierung Düsseldorf, Kunst-, Kultur- und Heimatpflege, Erwachsenenbildung», Seite 5, Klassifikationspunkt «Id. Kunstakademie Düsseldorf».

Regensburg, Fürst Thurn und Taxis Hofbibliothek und Zentralarchiv
FZA HFS 1770, 1836 IV 09.
FZA HFS 1767, 1836 V 24.
FZA A.01.06.
FZA Plansammlung Nr. 1.
Ha 1840, Bericht vom 30. April 1840.

Regensburg, Museen der Stadt Regensburg

Stuttgart, Hauptstaatsarchiv
E 14 Bü 1078 ff. (Stiftskirche Verglasung, Juni 1843).

Archive außerhalb Deutschlands

Kopenhagen, Thorvaldsen Museum

Wien, Albertina

York, CVMA Picture Archive

Katalog

Der Kurzkatalog beinhaltet die bisher bekannten, in der Deutschschweiz erhaltenen Glasmalereien aus der Werkstatt J. J. Röttinger. Im Titel erscheinen neben der Bezeichnung der Ortschaft, das Gebäude und die Jahreszahl. Die einzelnen Fenster wurden, wenn möglich, nach dem System des Internationalen Corpus Vitrearum nummeriert (CVMA, Erklärung unter «Hinweise», siehe Inhaltsverzeichnis). Mit n/a [not available] bezeichnete Glasmalereien haben keine aktuelle CVMA-Nummer. Der Typus gibt an, ob es sich um ein Medaillon oder eine Rosette handelt, ob die Malerei eine Ganzfigur beziehungsweise eine Szene darstellt oder ob sich die Malerei auf die Bogenausmündung des Fensters beschränkt etc.

Die Maße beziehen sich auf Angaben des Glasmalers im Skizzenbuch, auf eigene Messungen respektive Überschlagsmessungen, wenn genaues Messen nicht möglich war. Unter Bemerkungen finden sich weitere Daten wie Inschriften (in Anführungs- und Schlusszeichen), Signaturen, Angaben zum Depot, nähere Bezeichnungen von Ornament, Maßwerk, Ikonographie sowie Verweise auf mögliche Abbildungen. Abkürzungen und Signaturen von Quellen sind in den entsprechenden Verzeichnissen erfasst. Angaben zur Literatur signalisieren die Entnahme einzelner Parameter aus der betreffenden Publikation. Sofern Abbildungen vorhanden sind, wird im Katalog darauf hingewiesen.

Aarburg AG, ehemals Evangelisch-Reformierte Stadtkirche, 1845

CVMA	Ikonographie (Typus)	Maße in cm	Bemerkungen
n/a	St. Georg (Ganzfigur), Signatur	Ø 113	Rundscheibe. Signatur unten rechts beim Hinterlauf des Pferdes, umsigniert «H. Röttinger» (Restaurierung) Deponiert, Heimatmuseum Aarburg beim Rathaus

Quellen: ZB Nachl. Röttinger 1.1; GA; Bauakten

Alt St. Johann SG, Katholische Pfarrkirche, ehemalige Klosterkirche, 1869/1870

CVMA	Ikonographie (Typus)	Maße in cm	Bemerkungen
n/a	Christus (ehem. Ganzfigur)	Ø 30	Fragment: Nur das Haupt Christi erhalten (ehem. I), (Abb. 72) Deponiert im Archiv der ehem. Propstei. Ursprünglich flankiert von Johannes d. Täufer und Johann Evangelist
n/a	Hl. Nepomuk (Medaillon)	30×40	Fragment. Deponiert im Archiv der ehem. Propstei
n/a	Hl. Philippus (Medaillon)	Ø 30	Fragment. Deponiert im Archiv der ehem. Propstei

Quellen: ZB Nachl. Röttinger 1.4, 1.202; KGA FI 1.2

Alterswil FR, Katholische Pfarrkirche St. Nikolaus, 1873/74

CVMA	Ikonographie (Typus)	Maße in cm	Bemerkungen
n II	Heilige (Medaillon)	500×90	Anna Maria unterweisend, Katharina Ornament in den Bogenausmündungen. Grisaille Tapetenmuster
s II	Petrus und Paulus (Medaillon)	500×90	Ornament in den Bogenausmündungen. Grisaille Tapetenmuster, (Abb. 89)
n III	Christliche Symbole	500×90	«IHS». Ornament in den Bogenausmündungen. Grisaille Tapetenmuster
s III	Christliche Symbole	500×90	Maria. Ornament in den Bogenausmündungen. Zusätzlich mit Grisaille Tapetenmuster, (Abb. 109)
n IV	Christliche Symbole	500×90	«OSP». Ornament in den Bogenausmündungen
s IV	Christliche Symbole	500×90	Lamm Gottes, Buch mit 7 Siegeln. Ornament in den Bogenausmündungen, (Abb. 112)
n V	Christliche Symbole	500×90	Kelch mit Hostie. Ornament in den Bogenausmündungen, (Abb. 113)
s V	Christliche Symbole	350×90	Schweißtuch der Veronika. Ornament in den Bogenausmündungen (Abb. 111)
n VI	Christliche Symbole	500×90	Taube. Ornament in den Bogenausmündungen
s VI	Christliche Symbole	500×90	Pelikan. Ornament in den Bogenausmündungen
n VII	Christliche Symbole	500×90	Krone, Palmzweige. Ornament in den Bogenausmündungen
s VII	Christliche Symbole	500×90	«INRI». Ornament in den Bogenausmündungen, (Abb. 110)
W I	Maria mit Kind (Medaillon)	Ø 120	Rosette mit Ornament, (Abb. 100)

Quellen: PA, Bauakten; Niederschrift 1900

Andelfingen ZH, Evangelisch-Reformierte Pfarrkirche, 1862

CVMA	Ikonographie (Typus)	Maße in cm	Bemerkungen
W I	Ornamentfenster (Bogenausmündung)	117×91	In situ
n/a	Ornamentfenster (Bogenausmündung)	110×95	Einige Scheiben und Fragmente mit Grisaille Tapetenmuster, deponiert im Dachboden der Kirche
n/a	Maßwerk	60×60	2 Vierpässe (ehem. N II, S II), deponiert im Dachboden

Quellen: ZB Nachl. Röttinger 1.6, 1.202.62

Appenzell AI, Katholische Pfarrkirche St. Mauritius, 1870

CVMA	Ikonographie (Typus)	Maße in cm	Bemerkungen
s II, s III	Ornamentfenster (Ganze Fensterfläche), Maßwerk	650×132	Rautenteppichmuster, Maßwerk im Stil des Flamboyant; Maß nach Skizzenbuch 1.202
s II	Wappen- und Einzelscheibe		Ort Appenzell, Knill, Schild mit Inschrift
s III	Christliche Symbole		«Jahwe, OSP»
s III	Wappen- und Einzelscheibe		Knill

Quellen: ZB Nachl. Röttinger 1.7, 1.202

Baar ZG, Evangelisch-Reformierte Pfarrkirche, 1867

CVMA	Ikonographie (Typus)	Maße in cm	Bemerkungen
I	Lehrender Christus (Szene)	370×140	Christus mit Aposteln in der Auffassung: «Und er nahm ein Kind und stellte es in ihre Mitte und sprach: Wenn ihr nicht werdet wie die Kinder, so werdet ihr nicht in das Himmelreich kommen.» (Mt 18,1–5). Maßwerk
n II – n V	Ornamentfenster (Bogenausmündung)	je 375×75	n II: «Ferdinand Stadler» (axial im Spitzbogen), n III Granatapfel, n IV Rosen, n V Weinblätter
s II – s V	Ornamentfenster (Bogenausmündung), Signatur	je 375×75	s II: «Glasmaler J. Röttinger in Zürich 1867» axial im Spitzbogen: , s III Granatapfel, s IV Rosen, s V Weinblätter
WN II	Maßwerk (Rosette)	Ø 60	Vierpass
WS II	Maßwerk (Rosette)	Ø 60	Vierpass

Quellen: ZB Nachl. Röttinger 1.9, 1.202

Basel BS, Elisabethenkirche (evangelisch-reformiert), 1864/65

CVMA	Ikonographie (Typus)	Maße in cm	Bemerkungen
W I	Ornamentfenster (Ganze Fensterfläche)	970×290	Orgelempore, Maßwerk

Quellen: StABS 319 D6 (Planarchiv), Lit. NAGEL/VON RODA, 1998, S. 338.

Basel BS, Münster (evangelisch-reformiert) 1856/60

CVMA	Ikonographie (Typus)	Maße in cm	Bemerkungen
N IV	Taufe Christi (Szene mit Ornamentkranz)	485×515	Karton: Ludwig Adam Kelterborn
Trif. I	Ornamentfenster (Rosette)	Ø 260	
Trif. N II – n III	Ornamentfenster (Rosette)	je Ø 260	
Trif. S II – s III	Ornamentfenster (Rosette); Signatur	je Ø 260 je Ø 260	Trif. S II: «A.D. 1856» Trif. S III: «gemalt v: J. Röttinger in Zürich 1856»
n/a	Signatur	–	In den Maßwerken dreier südlicher Seitenschifffenster: «Gemalt v. J. Röttinger Zürich 1856» «Rud. Roth Glaser. Basel. 1856.» «Als Maler arbeiteten an diesen Fenstern: H. Schellenberg v: Bülach Cant. Zürich & Cl. Bettelini v. Ascona, Ct. Tessin; als Glaser Joh. Bräm v. Schlieren, Ct. Zürich & J.L. Aichinger v. Heidenheim [...]»

Quellen: ZB Nachl. Röttinger 1.13; StABS 319 I D1 (Planarchiv); StABS Planarchiv T206, Lit. NAGEL/VON RODA, 1998, S. 44, 45, 330.

Bundtels (Düdingen) FR, Katharinenkapelle , 1862 (erbaut)

CVMA	Ikonographie (Typus)	Maße in cm	Bemerkungen
I	Ornamentfenster, Maßwerk, Maria mit Jesuskind, Joseph, Anna Maria unterweisend (Medaillons)	400×180	Grisaille Tapetenmuster (Weinblätter)
W I	Rosette, Sechspass mit Weinranken	Ø 150	zentrales Medaillon (Bruder Klaus) neueren Datums

Bünzen AG, Katholische Pfarrkirche St. Georg und St. Anna, 1862

CVMA	Ikonographie (Typus)	Maße in cm	Bemerkungen
n IV	Ornamentfenster (Ganze Fensterfläche)	580×140	Ornament mit Vierpässen, (Abb. 62)
s IV	Wappen- und Einzelscheiben	580×140	Meyer (Wappen mit Blume), Ornament mit Vierpässen
s V	Wappen- und Einzelscheiben	580×140	Müller (Wappen mit Mühlrad)
s VI	Wappen- und Einzelscheiben	580×140	Meyer (Wappen mit Blume)
N II	Mariae Verkündigung (Szene)	400×120	(Abb. 40)
N II	Wappen- und Einzelscheiben	400×120	Waldhäusern
S II	Auferstandener Christus (Szene)	400×120	Alle Fenster weisen im Bogenfeld Maßwerk auf, (Abb. 108)
S II	Wappen- und Einzelscheiben	400×120	Bünzen
N III	Ornamentfenster (Ganze Fensterfläche)	400×120	
N III	Wappen- und Einzelscheiben	400×120	Waldhäusern 1862
S III	Ornamentfenster (Ganze Fensterfläche)	400×120	
W I		400×180	Fenster von innen nicht sichtbar
WN II	Ornamentfenster (Rosette)	Ø 150	12-teiliges Radfenster mit reichem Rankenmuster
WS II	Ornamentfenster (Rosette)	Ø 150	12-teiliges Radfenster mit reichem Rankenmuster
n IX		120×40	Bautafel: «Der Bau der neuen Kirche in Bünzen wurde beschlossen den 22. Febr. 1850. Mit dem Mauerwerk wurde begonnen den 3. Sept. 1859. Die feierliche Grundsteinlegung fand statt d. 13. Mai 1860. Der Dachstuhl wurde aufgerichtet im October 1860. Der Dachstuhl des Turmes wurde aufgerichtet im October 1861. Die Kirche wurde vollendet im Oct.1862.»
s IX		120×40	Inschrift: li. «Verstorbene oder ausgetretene Mitglieder der Baukommission: Gmdammann Pet. Müller v. Bünzen, Burkhard Ammann Pfleger Bünzen, J.M.Meyer Thierarzt v. Bünzen, Jos. Leonz Huber Altammann v. Besenbüren, Joseph … (Sprung im Glas) v. Besenbüren, J. Leonz Huber v. Besenbüren, Gmdammann Kuhn v. Waldhäusern, Ant. Kuhn v. Waldhausern» Inschrift: re. «Verzeichnis der Mitglieder der Kirchenbaukommission Bünzen 1862: Hr. Roman Abt v. Bünzen, Präsident, Pfr. J.J. Käzzeli vice Präsident, Bez.Richter A. Müller v. Bünzen Actuar, Cassier, Jos. Oswald, Baumeister v. Bünzen, Gmdammann A. Meyer v. Bünzen, Osw. Huber v. Besenbüren, Jos. Leonz Huber v. Besenbüren, Gmdrth. B. Villiger v. Waldhäusern, Jac. Leonz Kuhn v. Waldh., Gmdschr. G.L. Kuhn v. Waldhäusern»

Quellen: KGA Nr. 29, 48, 77

Burgdorf BE, Evangelisch-Reformierte Stadtkirche, 1867

CVMA	Ikonographie (Typus)	Maße in cm	Bemerkungen
n IX	Wappen- und Einzelscheiben	250×130	Medaillons je Ø 60: Burgdorf, Dür Franz August, (Abb. 116)

Quellen: ZB Nachl. Röttinger 1.26

Cham ZG, Kloster Frauenthal, 1869

CVMA	Ikonographie (Typus)	Maße in cm	Bemerkungen
n/a	Luitgard, Juliana (Medaillon)	–	Fragmente der ehemaligen Fenster in der Klosterkirche Versetzt in die Wandelhalle

Quellen: ZB Nachl. Röttinger 1.28; Denkmalpflege Zug

Dällikon ZH, Evangelisch-Reformierte Pfarrkirche, 1860

CVMA	Ikonographie (Typus)	Maße in cm	Bemerkungen
I	Engel (Medaillon)	270×100	2 Engelsköpfe im Bogenfeld
I	Ornamentfenster (Ganze Fensterfläche)	270×100	Grisaille Tapetenmuster

Quellen: ZB Nachl. Röttinger 1.31; PA

Einsiedeln SZ, Kapelle Maria End auf dem Katzenstrick (katholisch), [ohne Datum]

CVMA	Ikonographie (Typus)	Maße in cm	Bemerkungen
n II	Ornamentfenster (Ganze Fensterfläche)	150×60	Architekturornament, Grisaille Tapetenmuster
s II	Ornamentfenster (Ganze Fensterfläche)	150×60	Architekturornament, Grisaille Tapetenmuster
n III	Ornamentfenster	150×60	Blankverglasung mit blau-weißer Randverzierung
s III	Ornamentfenster	150×60	Blankverglasung mit blau-weißer Randverzierung

Lit. BUSCHOW OECHSLIN, 2010, S. 271, Anm. 33

Ennetbaden AG, Kapuzinerkapelle, Katholische Schulkapelle, 1858–1876; Michaelskapelle, 1880–1966

CVMA	Ikonographie (Typus)	Maße in cm	Bemerkungen
n/a	Verkündigung (Szene)		Fragmente, deponiert im Zivilschutzraum der St. Michaelskirche
n/a	Geburt Christi (Szene)		Fragmente, deponiert im Zivilschutzraum der St. Michaelskirche
n/a	Der zwölfjährige Christus im Tempel (Szene)		Fragmente, deponiert im Zivilschutzraum der St. Michaelskirche
n/a	Taufe Christi (Szene)		Fragmente, deponiert im Zivilschutzraum der St. Michaelskirche
n/a	Kreuzigung (Szene)		Fragmente, deponiert im Zivilschutzraum der St. Michaelskirche
n/a	Auferstehung (Szene)		Fragmente, deponiert im Zivilschutzraum der St. Michaelskirche

Quellen: ZB Nachl. Röttinger 1.11

Finstersee-Menzingen ZG, Katholische Pfarrkirche, 1869–1871

CVMA	Ikonographie (Typus)	Maße in cm	Bemerkungen
I	Karl Borromäus (Szene)	420×140	Die Pestkranken heilend. Oberhalb der Mensa statt eines Altarbildes, (Abb. 46)
s II	Heilige (Medaillon) teilweise mit Stifterinschriften	380×120	«St. Elisabeth», «Die Lehrschwestern in Menzingen St. Elisabeth»
n III	Heilige (Medaillon) teilweise mit Stifterinschriften	380×120	«Sta. Theresa»
s III	Heilige (Medaillon) teilweise mit Stifterinschriften	380×120	«St. Franziskus», «Die Klosterfrauen auf dem Gubel»
n IV	Heilige (Medaillon) teilweise mit Stifterinschriften	380×120	«St. German», «Gemeinde Abtwil Aargau»
s IV	Heilige (Medaillon) teilweise mit Stifterinschriften	380×120	«St. Leonz», «Kirchmeier L. Huwiler von Abtwil dem St. Leonz»
n V	Heilige (Medaillon) teilweise mit Stifterinschriften	je 380×120	«Sta. Barbara», «Geschwister Kinderli von Hohenrain der St. Barbara»
N II	Christliche Symbole	350×120	«IHS»
W I	Ornamentfenster (Rosette)	Ø 80	8er Schneuss mit Weinblättern und kleinen Dreiecken auf eine kleine zentrale Rundscheibe ausgerichtet.
n/a	Wappen- und Einzelscheiben	20×15	«Meier» (Vorhalle)
n/a	Wappen- und Einzelscheiben	20×15	«Etter» (Vorhalle)

Quellen: ZB Nachl. Röttinger 1.202; Kirchgenossenschaftsarchiv, Akten Chorfenster 1868–73, Korrespondenz

Fislisbach AG, Katholische Pfarrkirche St. Agathe, 1871

CVMA	Ikonographie (Typus)	Maße in cm	Bemerkungen
n/a	Jakobus (Medaillon)	Ø 60	Fragment; deponiert Archiv Pfarrgemeindehaus

Quellen: ZB Nachl. Röttinger 1.202; KGA, Rechnung; PA, Fotos

Gams SG, Katholische Pfarrkirche St. Michael, 1868

CVMA	Ikonographie (Typus)	Maße in cm	Bemerkungen
n II	Heilige (Ganzfigur), Signatur	540×100	«St. Christian, St. Joh. Bapt.», «Domini Christiani Carnotsch Parochi in Gams ab Anis 1820–1832»
s II	Heilige (Ganzfigur), Signatur	540×100	Inschrift in der Sockelzone: «St. Ulrich, St. Emil», «ex munificentia domini Emilii Alpiger» Rechts unten in der Sockelzone: «J. Röttinger Zürich AD 1868». Maße nach Skizzenbuch
WN II	Heilige (Medaillon)	Ø 30	Magdalena, Theresia von Avila. Medaillon in jüngerem Fenster
WS II	Heilige (Medaillon)	Ø 30	Hieronymus, Apostel Johannes. Medaillon in jüngerem Fenster

Quellen: ZB Nachl. Röttinger 1.202.108

Glarus GL, Evangelisch-Reformierte Stadtkirche, 1865

CVMA	Ikonographie (Typus)	Maße in cm	Bemerkungen
N III	Ornamentfenster (Rosette)	Ø 200	Achtteilige Rose mit zentralem Vierpass, Ranken, Weinblatt
S III	Ornamentfenster (Rosette)	Ø 200	Achtteilige Rose mit zentralem Vierpass, Ranken, Weinblatt
W I	Maßwerk (Rosette)	Ø 200	Kranz aus Vierpässen; auf Orgelempore
n/a	Engel (Medaillon)	80×165	Türoberlicht Südeingang (Abb. 57)
n/a	Wappen- und Einzelscheiben	80×165	Stadt Glarus (hl. Fridolin); Türoblicht Nordeingang, (Abb. 56)

Quellen: ZB Nachl. Röttinger 1.202; LA

Glis VS, Katholische Pfarrkirche, 1873–1875

CVMA	Ikonographie (Typus)	Maße in cm	Bemerkungen
n IV	Maßwerk	100×140	nur Bogenfeld vorhanden
n V	Heilige (Medaillon) mit Maßwerk	450×140	Jakobus, Johannes
s V	Petrus und Paulus (Medaillon)	450×140	Alle Fenster weisen Maßwerk auf
n VI	Christliche Symbole	450×140	«IHS», Maria
s VI	Heilige (Medaillon) mit Maßwerk	450×140	Andreas, Jakobus
n VII	Heilige (Medaillon) mit Maßwerk	450×140	Isidor, ev. Philippus
s VII	Heilige (Medaillon) mit Maßwerk	450×140	Unbek. Heiliger, Judas Thaddäus
s VIII	Heilige (Medaillon) mit Maßwerk	450×140	Simon, Thomas
n V n VII	Ornamentfenster (Ganze Fensterfläche)	je 450×140	Grisaille Tapetenmuster
s V – s VIII	Ornamentfenster (Ganze Fensterfläche)	je 450×140	Grisaille Tapetenmuster
s II	Propheten (Ganzfigur), Maßwerk	400×300	«Isaias, Jeremias, Ezechiel, Daniel» (als Inschrift unter jeder Figur) s II, 1d: «Glasmalerei J. Röttinger in Zürich 1873», «Renoviert 1979 Glasmalerei Naters» (Abb. 93)
s III	Evangelisten (Ganzfigur), Signatur, Maßwerk	400×300	Matthäus, Markus, Lukas, Johannes, jeweils mit Evangelistensymbolen. «Gestiftet von J. Leopold Zurwerra 1875» (s III 1d) «Glasmalerei J. Röttinger in Zürich 1875» (s III 1a), (Abb. 92)

Quellen: ZB Nachl. Röttinger 1.58

Gonten AI, Katholische Pfarrkirche St. Verena, 1864

CVMA	Ikonographie (Typus)	Maße in cm	Bemerkungen
I	Hl. Verena (Ganzfigur)	250×120	Als «Retabel» in den Altaraufbau integriert, (Abb. 34)
n II – n V	Maßwerk	je 480×180	Die Szenen im unteren Teil der Schifffenster sind neueren Datums
s II – s IV	Maßwerk	je 480×180	Die Szenen im unteren Teil der Schifffenster sind neueren Datums

Quellen: PA, Baukommissionsprotokolle 1863–66

Heitenried FR, Alte katholische Pfarrkirche, 1863

CVMA	Ikonographie (Typus)	Maße in cm	Bemerkungen
I	St. Michael (Ganzfigur)	300×140	(Abb. 106)

Quellen: PA

Herdern TG, Katholische Pfarrkirche St. Sebastian, 1876

CVMA	Ikonographie (Typus)	Maße in cm	Bemerkungen
I	Christliche Symbole (Rosette)	Ø 60	Auge Gottes
n III	Christliche Symbole	360×107	Kelch
n IV	Christliche Symbole	360×107	Brennendes Herz Mariens
s IV	Christliche Symbole	360×107	«OSP»
n V	Christliche Symbole	360×107	Dornenkrone mit Schriftband «INRI»
s V	Christliche Symbole	360×107	Herz Jesu
n VI	Christliche Symbole	360×107	Maria (Kürzel)
s VI	Christliche Symbole	360×107	Schweißtuch der Veronika
s VII	Christliche Symbole	360×107	«IHS»
N II	Christliche Symbole (Rosette)	Ø 60	Lamm Gottes auf dem Buch mit sieben Siegeln
S II	Christliche Symbole (Rosette)	Ø 60	Taube

Quellen: ZB Nachl. Röttinger 2.371.101; KGA 1AB5

Kappel SO, Kapelle auf dem Born (katholisch), 1865

CVMA	Ikonographie (Typus)	Maße in cm	Bemerkungen
n III, n IV	Ornamentfenster (Bogenausmündung)	je 339×80	Randverzierung, Maße laut Skizzenbuch
s III, s IV	Ornamentfenster (Bogenausmündung)	je 339×80	Randverzierung, Maße laut Skizzenbuch
N II	Ornamentfenster (Rosette)	Ø 66	Maßwerk. Vierpass mit Ornament, Maße laut Skizzenbuch
S II	Ornamentfenster (Rosette)	Ø 66	Maßwerk. Vierpass mit Ornament, Maße laut Skizzenbuch

Quellen: ZB Nachl. Röttinger 1.202.08

Kappel ZH, ehemalige Klosterkirche (evangelisch-reformiert) 1871/1873

CVMA	Ikonographie (Typus)	Maße in cm	Bemerkungen
N IX	Signatur	–	«1873 Renovirt von J. Röttinger Zürich, 4 Pfund Brod 1 frk., 1 Pfund Butter 1.50, 3/10 Liter Bier 20 cts sehr teuer. Die Welt steht nimmer lang. – 1 Klfter. Holz 48 fr, buchen, 1 Ei 10 cts. [sic!], Grosse Pfaffenjagd in der Schweiz, Rud. Spinner Maler, Bell Maurer, zugeschaut u. Adolph Kreuzer, Maler, dies gesch[affen] […] an der Oettenbach Gasse 13 St. Paul, Fritz Berbig, Rudolph Thym, Glaser gefasst, Christian Härer, Maler, restaurirt, August S…, H[ei]nr[ich] Trinkhahn, Glaser, Felix Bleuler»
n/a	Wappen, Signatur	–	Wappenscheibe von Zürich «1871»; «Diese Fenster wurden neu gemacht unter der Leitung des Herrn Cant. Bauinspekr. [sic!] Müller, Herrn Roth Bauführer, von J. Röttinger, Glasmaler Zürich 1871 […]»

Lit. TRÜMPLER/DOLD, 2005; HAUSER, 2001, S. 119

Kilchberg ZH, Evangelisch-Reformierte Pfarrkirche, 1858

CVMA	Ikonographie (Typus)	Maße in cm	Bemerkungen
I	Petrus und Paulus (Ganzfigur)	350×70	(Abb. 84)

Quellen: ZB Nachl. Röttinger 1.77

Kirchdorf AG, Katholische Pfarrkirche St. Peter und Paul, 1865/69

CVMA	Ikonographie (Typus)	Maße in cm	Bemerkungen
n III	Petrus (Ganzfigur)	350×130	«Petrus». Die ehemals als Chorfenster konzipierten Figurenfenster wurden 1869 bestellt, (Abb. 29)
s III	Paulus (Ganzfigur)	350×130	«Paulus». Die ehemals als Chorfenster konzipierten Figurenfenster wurden 1869 bestellt, (Abb. 88)
s IV	Signatur	350×130	«J. Röttinger in Zürich» in der Bogenausmündung
n III – n V	Ornamentfenster (Bogenausmündung)	je 350×130	Kreuze mit Weinlaub bzw. Rosen
s III – s V	Ornamentfenster (Bogenausmündung)	je 350×130	Kreuze mit Weinlaub bzw. Rosen
n VI	Ornamentfenster (Bogenausmündung)	350×130	«1865» (n VI), Kreuze mit Weinlaub
s VI	Ornamentfenster (Bogenausmündung)	350×130	Kreuze mit Weinlaub
WN II	Hl. Agnes (Medaillon)	180×100	Fenster ev. neueren Datums
WS II	Hl. Katharina (Medaillon)	180×100	Fenster ev. neueren Datums

Quellen: ZB Nachl. Röttinger 1.78, 1.202

Königsfelden AG, ehemalige Klosterkirche, 1851

CVMA	Ikonographie (Typus)	Maße in cm	Bemerkungen
n II	Anbetung der Könige (Szene)	–	Ritzinschrift auf der Außenseite des Glases (Geschenk des mittleren Königs, n II 5b)

Lit. Kurmann-Schwarz, 2008, S. 94, Abb. 86

Lenzburg AG, Kirche der Strafanstalt, 1862

CVMA	Ikonographie (Typus)	Maße in cm	Bemerkungen
n/a	Lehrender Christus (Ganzfigur)	–	Rundbau. «Ich bin der Weg u. die Wahrheit» (Joh. 14,6)
n/a	Moses (Ganzfigur)	–	Rundbau. «Haltet meine Gebote»

Quellen: ZB Nachl. Röttinger 1.82

Leuggern AG, Katholische Pfarrkirche St. Peter und Paul, 1853

CVMA	Ikonographie (Typus)	Maße in cm	Bemerkungen
s II	Johannes Evangelist, Johannes der Täufer (Ganzfigur), Maßwerk	400×150	Sockelfeld rechts: «Röttinger 1853»
s II			versteckte Inschriften im oberen Teil: «An diesen Fenstern haben gemalt: J. Jakob Röttinger v. Nürnberg. […] Sperli v. Kilchberg am Zürichsee H. Schellenberg von O[ber]. Rüti bei Bülach. Zürich 1853/Diese Fenster wurden angefang[en] im Juli 1853, vollendet im August 1853/Als Glaser arbeiteten an diesen Fenstern: Egidius Benker von Baireuth u. Joh. Bräm v. Schlieren […] Zürich»
n II	Joseph, Maria Immaculata (Ganzfigur), Maßwerk	400×150	Maßwerk: oben Dreipass, unten Vierpässe, (Abb. 95)

n V – n IX	Ornament in den Bogenausmündungen	je 660×144	abwechslungsweise Achtpass, Vierpass, Dreipass
s V – s IX	Ornament in den Bogenausmündungen	je 660×144	abwechslungsweise Achtpass, Vierpass, Dreipass
N III	Kirchenväter (Ganzfigur), Signatur	150×80	Gregor, Ambrosius «St: Gregorius Mag[nus]: patriarcha et doctor.» Auf dem Buch des Gregor signiert: «R 1854» «St: Ambrosius archi. Episcopus et doctor.» (Abb. 10)
S III	Kirchenväter (Ganzfigur), Signatur	150×80	Augustinus, Hieronymus «St: Augustinus episcopus et doctor.» «St: Hieronimus presbyter et doctor.» Im aufgeschlagenen Buch, das Augustinus in Händen hält: «Gemalt A:D:1854 von J:Röttinger, aus Nürnberg, in Zürich» (Abb. 9)
W I	Ornamentfenster (Rosette), Maßwerk	Ø 210	Maßwerk mit Blumenmotiven
WN II	Wappen- und Einzelscheiben	Ø 210	«Ignaz Rink von Baldenstein. Großmeister des Johanniterordens»
WN II	Ornamentfenster (Rosette), Maßwerk	Ø 210	Maßwerk mit Blumenmotiven
WS II	Wappen- und Einzelscheiben	Ø 210	«Franciscus von Sonnenberg» (Komptur in Leuggern 1648–1682)
WS II	Ornamentfenster (Rosette), Maßwerk	Ø 210	Maßwerk mit Blumenmotiven

Quellen: ZB Nachl. Röttinger 1.83; K III 2 4: Kirchenvorstand: Akten des Kirchenbaues 1838–55, Band 2: Nr. 287 bis 392, Belege der Kirchenbau-Rechnung, Nr. 308; Lit. BOSSARDT/KAUFMANN, 2012

Leukerbad VS, Katholische Pfarrkirche, 1864

CVMA	Ikonographie (Typus)	Maße in cm	Bemerkungen
I	Barbara (Ganzfigur)	396×132	Maße laut Skizzenbuch
n II	Maria mit Kind (Ganzfigur)	396×132	Maße laut Skizzenbuch, (Abb. 98)
s II	Joseph (Ganzfigur)	396×132	Maße laut Skizzenbuch, (Abb. 99)

Quellen: ZB Nachl. Röttinger 1.202.07; GA XXV, 62, 64–67

Meilen ZH, Evangelisch-Reformierte Pfarrkirche, 1868

CVMA	Ikonographie (Typus)	Maße in cm	Bemerkungen
n III – n VI	Ornamentfenster (Bogenausmündung)	je 390×120	
s V – s VIII	Ornamentfenster (Bogenausmündung)	je 390×120	
Türoberlicht	Maßwerk	–	

Quellen: ZB Nachl. Röttinger 1.94

Menzingen ZG, Ölbergkapelle auf dem Gubel (katholisch), 1865

CVMA	Ikonographie (Typus)	Maße in cm	Bemerkungen
W I	Christliche Symbole (Rosette)	Ø 65	Kelch, Ornament

Quellen: ZB Nachl. Röttinger 1.202

Mettmenstetten ZH, Evangelisch-Reformierte Pfarrkirche, 1869

CVMA	Ikonographie (Typus)	Maße in cm	Bemerkungen
I	Lehrender Christus (Medaillon) Petrus (Medaillon) und Paulus (Medaillon)	56×75	Medaillons in Rechteckscheibe Vlnr.: Petrus, Christus, Paulus, (Abb. 71)
s V	Maßwerk	30×30	Blankverglasung, Maßwerkfragment (Fischblase)
W I	Ornamentfenster (Rosette)	Ø 90	

Quellen: ZB Nachl. Röttinger 1.202; KGA, III.B.8

Mollis GL, Evangelisch-Reformierte Pfarrkirche, 1868

CVMA	Ikonographie (Typus)	Maße in cm	Bemerkungen
n II	Ornamentfenster (Ganze Fensterfläche)	440×118.5	Farbiges Ornamentmuster (im Stil von Salisbury), Maße nach dem Skizzenbuch
s II	Ornamentfenster (Ganze Fensterfläche)	440×118.5	Farbiges Ornamentmuster (im Stil von Salisbury), Maße nach dem Skizzenbuch, (Abb. 60)
s III–n VI	Randverzierung	440×118.5	s III, n III grün; s IV, n IV blau; s V, s VI, n V, n VI rot.
N III–n VI	Randverzierung	440×118.5	
WN II	Ornamentfenster (Rosette)	Ø 100	Fünfpass mit Rankenmuster
WS II	Ornamentfenster (Rosette)	Ø 100	Fünfpass mit Rankenmuster

Quellen: ZB Nachl. Röttinger 1.99, 1.202.96

Niederhasli ZH, Evangelisch-Reformierte Pfarrkirche, 1854

CVMA	Ikonographie (Typus)	Maße in cm	Bemerkungen
I	Lehrender Christus (Ganzfigur) Signatur	350×110	«Ich bin der Weg, die Wahrheit u. das Leben. Niemand kommt zum Vater, denn durch mich. Joh: XIV.6.» «Gemalt v. Röttinger. Zürich 1854» (unten rechts), (Abb. 67)
n II	10 Gebote	350×110 (95×53)	Inschrift: «Fürchte Gott und halte seine Gebote. Pred. XII,13.»
s II	Gesetzestafel	350×110 (95×53)	Inschrift: «Das Evangelium ist eine Kraft Gottes zum Heil eines Jeden, der daran glaubt. Röm. I,16.»

Quellen: ZB Nachl. Röttinger 1.115

Nottwil LU, Katholische Pfarrkirche St. Marien, 1869

CVMA	Ikonographie (Typus)	Maße in cm	Bemerkungen
n II	Jakobus (Ganzfigur, links) und Johannes Evangelist (Ganzfigur, rechts)	650×120	Im Maßwerk Herz Mariens mit Rosen. Alle Fenster weisen im Bogenfeld Maßwerk auf.
s II	Petrus und Paulus (Ganzfigur)	650×120	Im Maßwerk Herz Jesu mit Dornenkranz, (Abb. 86)
n III	Heilige (Medaillon)	650×120	Ambrosius, Hieronymus. Im Langhaus wechseln sich Dreipass und Vierpass ab.
s III	Heilige (Medaillon)	650×120	Augustinus, Gregor. Im Langhaus wechseln sich Dreipass und Vierpass ab.
N IV	Ornamentfenster, christliches Symbol	Ø 100	IHS, Maßwerk
S IV	Ornamentfenster, christliches Symbol	Ø 100	Maria, Maßwerk
s V	Propheten (Medaillon)	650×120	Abraham mit Sohn, Moses, Prophet Elisäus, Ezechiel (?) mit Schwert

n V	Propheten (Medaillon)	650×120	Daniel, Jeremia, Jesaja, Ezechiel (Abb. 94)
n VI	Heilige (Medaillon)	650×120	Apostel Simon, Jakob, Andreas, Judas Thaddäus
			Im Langhaus wechseln sich Dreipass und Vierpass ab.
s VI	Heilige (Medaillon)	650×120	Bartholomäus, Thomas, Antonius, Franziskus (?)
n VII	Heilige (Medaillon)	650×120	Stephanus, Barbara, Klara von Assisi, Katharina
			Im Langhaus wechseln sich Dreipass und Vierpass ab.
s VII	Heilige (Medaillon)	650×120	Sebastian, Georg, Meinrad, Franziskus
			Im Langhaus wechseln sich Dreipass und Vierpass ab.
n VIII	Heilige (Medaillon)	650×120	Anna und Maria, Rosa von Lima, Cäcilia, Verena
			Im Langhaus wechseln sich Dreipass und Vierpass ab.
s VIII	Heilige (Medaillon)	650×120	Antonius Einsiedler, Aloisius, Karl Borromäus, Bruder Klaus
			Im Langhaus wechseln sich Dreipass und Vierpass ab.
s IX	Ornament	650×120	
n IX	Ornament	650×120	
W I	Maßwerk	ca. 480×170	Dreipass, Schweizerrauten
WS II	Maßwerk, Signatur	250×90	im Dreipass: «Röttinger Zürich»
WN II	Maßwerk	250×90	im Dreipass: «1869»

Quellen: ZB Nachl. Röttinger 1.119, 1.202

Oberentfelden AG, Evangelisch-Reformierte Pfarrkirche, 1865

CVMA	Ikonographie (Typus)	Maße in cm	Bemerkungen
I	Bergpredigt (Szene), Maßwerk	300×100	Mt 5–7,1 ff., Vierpass, (Abb. 45)
n II – n V	Ornamentfenster (Bogenausmündung)	je 250×100	Rundbogenfenster, im Bogenfeld Gestaltung mit Ornament-tmedaillon (n II zwei alte Wappenscheiben)
s II – s V	Ornamentfenster (Bogenausmündung) (Bogenausmündung)	je 250×100	Rundbogenfenster, im Bogenfeld Gestaltung mit Ornament-medaillon
n V	Wappen- und Einzelscheiben	250×100	Stadler ; «Ferdinand Stadler Architekt der Kirche zu Entfelden»
s V	Wappen- und Einzelscheiben	250×100	Schmutziger; «D. Schmutziger Baumeister der Kirche zu Entfelden»
WN II	Ornamentfenster (Rosette)	–	Kreise und Dreiecke
WS II	Ornamentfenster (Rosette)	–	Kreise und Dreiecke
Tür-oberlicht	Wappenscheibe, Ornament	–	Oberentfelden, «Gemeinde Oberentfelden 1866»
Tür-oberlicht	Wappenscheibe, Ornament	–	Muhen, «Gemeinde Muhen 1866»

Quellen: ZB Nachl. Röttinger 1.122

Oberrüti AG, Katholische Pfarrkirche St. Rupert, 1866

CVMA	Ikonographie (Typus)	Maße in cm	Bemerkungen
n III	Maßwerk	je 389×122	n IV, n VI Dreipass
– n VII			n III, n V Vierpass
s III	Maßwerk	je 389×122	s IV, s VI Dreipass
– s VII			s III, s V Vierpass
n IV	Maßwerk; Signatur	389×122	«AD 1866 Glasmalerei J. Röttinger in Zürich»
s IV	Maßwerk	389×122	«Pfarrer und Bauleiter d. Kirche war Hochwürden J. Stammler v. Bremgarten 1866»
wn II	Maßwerk	120×40	Nonnenköpfchen
ws II	Maßwerk	120×40	Nonnenköpfchen

WI	Maßwerk	450×100	
WN II	Maßwerk	400×100	Vierpass
WS II	Maßwerk	400×100	Vierpass

Quellen: ZB Nachl. Röttinger 1.202

Ossingen ZH, Evangelisch-Reformierte Pfarrkirche, 1858

CVMA	Ikonographie (Typus)	Maße in cm	Bemerkungen
I	Wappen- und Einzelscheiben	300×90	Gemeindewappen im Bogenfeld. «Die Gemeinde Ossingen. Zum Andenken an Frau Verena Röttinger-Fehr geb. zu Ossingen 1826» (diese Inschrift entstand anlässlich der Restaurierung durch H. Röttinger 1922)
I	Ornamentfenster (Ganze Fensterfläche)	300×90	Gestaltung mit Architekturstab
n II, n IV, n V	Ornamentfenster (Bogenausmündung)	je 300×90	Randverzierung (ausgenommen n II)
s II, s IV, s V	Ornamentfenster (Bogenausmündung)	je 300×90	Randverzierung (ausgenommen s II)
s VI	Ornamentfenster (Rosette)	90×130	Ovalfenster
N III	Ornamentfenster (Ganze Fensterfläche)	280×90	Blankverglasung mit Randverzierung. Zusätzlich 3 Türoberlichter (je 60×140)
N VI	Ornamentfenster (Rosette)	90×130	Ovalfenster
S VI	Ornamentfenster (Rosette)	90×130	Ovalfenster

Quellen: ZB Nachl. Röttinger 1.123, KGA

Pieterlen BE, Evangelisch-Reformierte Pfarrkirche, 1859

CVMA	Ikonographie (Typus)	Maße in cm	Bemerkungen
s II	Kreuzigung (Szene)	280×90	Kreuzigungsgruppe mit Maria und Johannes, «Darum beweiset Gott seine Liebe gegen uns dadurch, dass Christus für uns gestorben ist. Röm 5,8»
s III	Weihnacht (Szene)	280×90	Anbetung der Hirten, «Denn Euch ist heute der Heiland geboren, welcher ist Christus der Herr. Luk 2,11», (Abb. 144)
s IV	Wappen- und Einzelscheiben	335×110	Wildermuth

Quellen: ZB Nachl. Röttinger 1.125; PA

Rapperswil BE, Evangelisch-Reformierte Pfarrkirche, 1861

CVMA	Ikonographie (Typus)	Maße in cm	Bemerkungen
I	Lehrender Christus (Ganzfigur), Signatur	400×125	«Ich bin der Weinstock, ihr seid die Reben, Joh XV,5» «Anno domini 1861», «Gemalt v. J. Röttinger Zürich 1861», (Abb. 79)
n II	Evangelisten (Ganzfigur)	400×125	Matthäus und Markus, jeweils mit Evangelistensymbolen. «1860, 1861, Diese Kirche wurde erbaut v. Architekt Stengeli, Kaiserstuhl», Taube in der Bogenausmündung. Die drei Chorfenster sind ein Vermächtnis des Johann Zingg aus Frauchwil †1861.

s II	Evangelisten (Ganzfigur)	400×125	Lukas und Johannes, jeweils mit Evangelistensymbolen. «Biblia Sacra» in der Bogenausmündung. Die drei Chorfenster sind ein Vermächtnis des Johann Zingg aus Frauchwil †1861, (Abb. 91).
n III	Ornamentfenster (Bogenausmündung)	400×125	Randverzierungen, «Dem verdienten Seelsorger und Bürger von Rapperswyl Franz Rud. Raz, Seine Gemeinde»
s III	Ornamentfenster (Bogenausmündung)	400×125	Fenster von Paul Zehnder, Louis Halter, 1947
n IV – n VII	Ornamentfenster (Bogenausmündung)	je 420×115	Randverzierungen; in den Bogenausmündungen per Joch dasselbe Muster in Farbvariationen
s IV – s VII	Ornamentfenster (Bogenausmündung)	je 420×115	Randverzierungen; in den Bogenausmündungen per Joch dasselbe Muster in Farbvariationen

Quellen: ZB Nachl. Röttinger 1.133

Rapperswil SG, Rathaus, 1855

CVMA	Ikonographie (Typus)	Maße in cm	Bemerkungen
n/a	Wappen- und Einzelscheiben (3-teilige Fenster mit quadratischen Wappen, 50×50)	Seitenteile je: 150×50 Mittelteil: 170×50	Wappenfenster im Ratssaal; vlnr. Westseite: «Nägeli, Bleile, Tresseli, Gruber, Kuster, Lütinger, Mächler, Decrette, Müller, Suter, Perola, Gaudi, Michel, Delemontey, Diog, Real» Nordseite: «Zimmermann, Crivelli, Bernodet, Reimann, Helbling, Ziegler, Breny, Rüssi, Stadt Rapperswil, Wettstein, Rotenfluh, Büler, Kunz, Oswald, Fuchs, Daumeisen, Rikenmann» Ostseite: «Höfliger, Curti, Feurer, Karpf, Brentano, Dillier, Greith, Rosshardt, Fornaro, Schneider, Dormann, Ill, Diethelm, Lumpert» (Abb. 5, 120, 121, 122)

Quellen: ZB Nachl. Röttinger 1.134; BA J01, J200

Regensdorf ZH, Evangelisch-Reformierte Pfarrkirche, 1875

CVMA	Ikonographie (Typus)	Maße in cm	Bemerkungen
I	Lehrender Christus (Ganzfigur)	240×70	«Friede sei mit Euch!», (Abb. 76)
n II	Paulus (Ganzfigur)	240×70	«St. Paulus.»
s II	Johannes (Ganzfigur)	240×70	«St. Johannes.»

Quellen: ZB Nachl. Röttinger 1.137; PA Sitzungsprotokoll 1874

Rüti ZH, Evangelisch-Reformierte Pfarrkirche, 1868

CVMA	Ikonographie (Typus)	Maße in cm	Bemerkungen
W I	Wappen- und Einzelscheiben Maßwerk	Ø 60	Gemeindewappen in Vierpassrosette eingeschrieben
n IV – n VII	Ornamentfenster (Bogenausmündung)	je 350×120	
s IV – s VIII	Ornamentfenster (Bogenausmündung)	je 350×120	s IV: Inschrift: «1868»

Quellen: ZB Nachl. Röttinger 1.143

Salez SG, Evangelisch-Reformierte Pfarrkirche, 1859

CVMA	Ikonographie (Typus)	Maße in cm	Bemerkungen
I	Lehrender Christus (Ganzfigur)	220×80	«Kommet her zu mir, die ihr mühselig und beladen seid, ich will euch erquicken. Math. XI,26.», (Abb. 80)
n II	Ornamentfenster (Ganze Fensterfläche)	220×80	Ornament Grisaille und farbiges Glas mit Randverzierung (Damastfenster), (Abb. 64)
s II	Ornamentfenster (Ganze Fensterfläche)	220×80	Ornament Grisaille und farbiges Glas mit Randverzierung (Damastfenster)

Quellen: ZB Nachl. Röttinger 1.146

Schlieren ZH, Evangelisch-Reformierte Pfarrkirche, 1854

CVMA	Ikonographie (Typus)	Maße in cm	Bemerkungen
I	Lehrender Christus (Ganzfigur), Signatur	160×95	«Gemalt v. J. Röttinger, Zürich 1854. Geschnitten u. verbleit v. Joh. Bräm v. Schlieren» (unten Mitte), (Abb. 135)

Quellen: PA Kirchengutsrechnung 1854; KGA Schlieren IV.B.03.02, Stillst.prot. S. 189/90, 1854, S. 198, S. 363, 1861, S. 410, 412, 1871; Zivilstandsamt, Fam. Reg. Bd. III, S. 53: Joh. Bräm (1825–70); StadtA Schlieren, Armenpflegeprot. 1839–82: IV.B.1.1., S. 153

Schwyz SZ, ehemalige Friedhofskapelle im Bifang (katholisch), 1866/1867

CVMA	Ikonographie (Typus)	Maße in cm	Bemerkungen
n/a	Christliche Symbole (Medaillon)	Ø 29	Urne mit Arma Christi Die Kapelle besteht nicht mehr. Scheiben deponiert
n/a	Christliche Symbole (Medaillon)	Ø 29	Kreuz (INRI), Kelch und Inschrift «Non mea sed tua voluntas» Die Kapelle besteht nicht mehr. Scheiben deponiert
n/a	Christliche Symbole (Medaillon)	Ø 29	Schweißtuch der Veronika, (Abb. 127) Die Kapelle besteht nicht mehr. Scheiben deponiert
n/a	Christliche Symbole (Medaillon)	Ø 29	Arma Christi und Kreuzigungswerkzeuge gefasst mit Band (INRI), (Abb. 128) Die Kapelle besteht nicht mehr. Scheiben deponiert
n/a	Wappen- und Einzelscheiben	je 264×114	Rundbogenfenster; «Real, Kälin, Rhyner, Knobel»; «Von Hettlingen, Horath, Mettler, Styger»; «Hediger, Heinzer, Von Reding, Von Rickenbach»; «Holdener, Inglin, Reichlin, Schnüringer»; «Fischlin, Gemsch»; «Ab Iberg, Erler»; Eichhorn, Fassbind»; «Erb, Göldlin»; «Krämer, Lindauer»; Bellmont, Bettschart»; «Walder»; «Ender, Häring, Reichmuth»; «Inderbitzin, Marty, Schilter, Triner»; «Zay, Wyss»; «Hiklin, Lagler, Niederöst, Weber»; «Studiger, Benziger; Krieg, Stutzer»; «Bürgler»; «Schibig»; «Eberle, Kothing, Müller»; «Bieler, Dettling»; «Aufdermaur, Bürcheler»; «Schatt, Suter, Föhn, Pfyl»; «Castell»; «Trütsch, Camenzind»; «Tschümperlin, Wiget, Schuler, Gasser, Anderrüthi, Mächy, Amgwerd, Kündig, Nauer, Schindler, Beeler, Deck, Appert, Lüönd, Dusser, Bruhin, Ulrich, Von Euw, Abegg, Jütz» (als Inschriften unter den jeweiligen Wappen), (Abb. 65, 124, 125, 126)
n/a	Signatur	99×55	«J. Röttinger in Zürich 1867» auf Schild

Quellen: ZB Nachl. Röttinger 1.1.7, 1.153, 1.202, 1.144; GASZ; StASZ Akte 12.04.03

Selzach SO, Katholische Pfarrkirche Mariae Himmelfahrt, 1867/68

CVMA	Ikonographie (Typus)	Maße in cm	Bemerkungen
n II	Wappen- und Einzelscheiben	455×120	Solothurn
n II	Ornamentfenster (Ganze Fensterfläche)	455×120	Grisaille Tapetenmuster, Gestaltung der Fenster mit Architekturstab
s II	Wappen- und Einzelscheiben	455×120	Bischof Lachat «Suaviter ac Fortiter»
s II	Ornamentfenster (Ganze Fensterfläche)	455×120	Grisaille Tapetenmuster, Gestaltung der Fenster mit Architekturstab
n III	Ornamentfenster (Bogenausmündung)	480×140	Kreuze und Blätter, Gestaltung der Fenster mit Architekturstab «Renov. […]»
s III	Wappen- und Einzelscheiben	480×140	«Selzach»
s III	Ornamentfenster (Bogenausmündung)	480×140	Kreuze und Blätter, Gestaltung der Fenster mit Architekturstab
n IV	Christliche Symbole	300×140	Maria
s IV	Christliche Symbole	300×140	«IHS»
n V	Christliche Symbole	300×140	Kreuz
s V	Christliche Symbole	300×140	Kreuz
s VI	Christliche Symbole	300×140	«OSP»
n IV–n VI	Ornamentfenster (Bogenausmündung)	300×140	Kreuze und Blätter; Gestaltung der Fenster mit Architekturstab, n VI «Renov. 1867»
s IV–s VI	Ornamentfenster (Bogenausmündung)	300×140	Kreuze und Blätter; Gestaltung der Fenster mit Architekturstab

Quellen: ZB Nachl. Röttinger 1.202.86, 1.202.88

Solothurn SO, Evangelisch-Reformierte Stadtkirche, 1866/67/71

CVMA	Ikonographie (Typus)	Maße in cm	Bemerkungen
I	Ölberg (Szene)	415×112	Wird später zum 1. Langhausfenster. Deponiert im Dachboden. Die Lagebezeichnungen nach CVMA beziehen sich ausschließlich auf den ehemaligen Standort der Fenster. Ursprünglich alle 14 Fenster mit Maßwerk, Maßwerkplan in Skizzenbuch
n II	Taufe Christi (Szene) Maßwerk	415×112	Christus und Johannes. Wird später (1871, 1897?) zu s II; deponiert im Dachboden. «verst. Johannes Güttinger Müllermeister †20.Dez.1867 [nachträglich eingesetzt], Zürich, 1871» «zum Andenken an seine selige Mutter» Sockelfeld links: «Susanna Güttinger v. Ober: Ottikon Gem: Gossau, Cant. Zürich» nII 1b: Sockelfeld rechts: «Dem Andenken ihres Bruders Joha(nnes) gewidmet, 1871» Signatur: nII 1a: «Glasmalerei J. Röttinger» «Glasmalerei Ad. Kreuzer» (1897)
s II	Lehrender Christus (Szene) Maßwerk	415×112	Christus sitzend im Profil mit Kind Wird später (1871, 1897?) zu n II; deponiert im Dachboden
n III	Langhausfenster	–	4 Langhausfenster (urspr. 8) mit Maßwerk (n=rot, s=blau); n III 1a Sockelscheiben einer Fensterstiftung von 1871, Röttinger, gemalt von Kreuzer: «Dem Andenken an Friedrich Rossel von Tramlingen, den Mitbegründer der protest=Gemeinde u. Kirche, gewidmet v. dessen Familie», «Der Kinder Ehr sind irr Väter Sprüche 17,6. 1871». 1b: Wappenscheibe Rossel «1207»
W I	Ornament, Schweizerrauten Maßwerk	–	Bordüren. Dreiteiliges Westfenster WI 7b Zwickelfeld mit Inschrift: «Ferd. Stadler Architect 1867»

Quellen: ZB Nachl. Röttinger 1.159, 1.202.39; Restaurierungsbericht 2000 (Martin Halter), Vitrocentre Romont; TRÜMPLER, 2009.

Stäfa ZH, Evangelisch-Reformierte Pfarrkirche, 1871

CVMA	Ikonographie (Typus)	Maße in cm	Bemerkungen
n II	Petrus (Medaillon), Ornamentfenster (Ganze Fensterfläche)	360×97	Grisaille Tapetenmuster, Rundbogen, (Abb. 87)
s II	Johannes (Medaillon), Ornamentfenster (Ganze Fensterfläche)	360×97	Grisaille Tapetenmuster, Rundbogen
n III–n V	Ornamentfenster (Bogenausmündung)	je 360×97	Rundbogen (Abb. 12)
s III	Ornamentfenster (Bogenausmündung)	360×97	Rundbogen
n VI –n VIII	Ornamentfenster (Bogenausmündung)	je 416×95	Rundbogen
s IV–s VI	Ornamentfenster (Bogenausmündung)	je 416×95	Rundbogen
W I	Wappen- und Einzelscheiben	380×155	Stäfa (Verena), Ornament, Architekturstab
WN II	Ornamentfenster (Bogenausmündung)	695×150	Spitzbogen, Ornament, Architekturstab
WS II	Ornamentfenster (Bogenausmündung)	695×150	Spitzbogen, Ornament, Architekturstab

Quellen: ZB Nachl. Röttinger 1.155

Stans NW, Friedhofkapelle, 1871

CVMA	Ikonographie (Typus)	Maße in cm	Bemerkungen
n II	Evangelist Markus (Medaillon) Wappen- und Einzelscheiben	185×100	Rundbogenfenster, li. «Fischer. Flury. Jann. Christen. Bucher. Durrer.», re. «Flühler. Bircher. Joller. Lennel. Leuw. Niderberger.», (Abb. 131)
s II	Evangelist Lukas (Medaillon) Wappen- und Einzelscheiben	185×100	Rundbogenfenster, li. «Amstad. Baggenstos. Blättler. Keiser. Laugenstein. Lussi.», re. «Achermann. Zelger. Von Matt. Businger. Deschwanden. Filliger.»
n III	Evangelist Matthäus (Medaillon) Wappen- und Einzelscheiben	218×100	Rundbogenfenster, li. «Wagner. Wirsch. Spichtig. Von Büren. Berlinger. Mathys.», re. «Odermatt. Rorer. Zimmermann. Zumbühl. Vokinger. Abry.»
s III	Evangelist Johannes (Medaillon) Wappen- und Einzelscheiben	218×100	Rundbogenfenster, li. «Rengger. Scheuber. Z'Rotz.» Werkstattsignatur: «Glasmalerei J. Röttinger Zürich 1871»; re. «Waser. Gut. Stultz. Von Holzen. Amstutz.», (Abb. 130)

Quellen: ZB Nachl. Röttinger 1.144, PA Stans, Kirchenratsprotokoll 1870 [Abschrift]

Steinmaur ZH, Evangelisch-Reformierte Pfarrkirche, 1857

CVMA	Ikonographie (Typus)	Maße in cm	Bemerkungen
n V	Wappen- und Einzelscheiben (Medaillon, Ø 30)	420×111	«Renovirt u. erweitert im Jahr 1857, Sünikon, Riedt und Neerach» (Bogenfeld)
s V	Wappen- und Einzelscheiben (Medaillon, Ø 30)	420×111	Steinmaur. «Die Gemeinde Ober- und Niedersteinmaur»

Quellen: ZB Nachl. Röttinger 1.202.109

St. Gallen SG, Evangelisch-Reformierte Stadtkirche St. Laurenzen, 1853

CVMA	Ikonographie (Typus)	Maße in cm	Bemerkungen
I	Szene, Maßwerk	–	Caspar Gsell, reiches Maßwerk von J. Röttinger
n VIII	Bordüren, Maßwerk	120×30	Nonnenköpfchen
N II	Bordüren, Maßwerk	420×124	Doppelschneuß; alle Langhaus-Emporenfenster zweibahnig
S II	Bordüren, Maßwerk	420×124	Doppelschneuß, Rankenornament (Abb. 50)
N III	Bordüren, Maßwerk	420×124	Doppelschneuß, Dreipass
S III	Bordüren, Maßwerk	420×124	Vierpass
N IV	Bordüren, Maßwerk	420×124	3 mal Dreipass
S IV	Bordüren, Maßwerk	420×124	Vierpass
N V	Bordüren, Maßwerk	420×124	Vierpass
S V	Bordüren, Maßwerk	420×124	3 mal Dreipass
N VI	Bordüren, Maßwerk	420×124	Doppelschneuß
S VI	Bordüren, Maßwerk	420×124	3 mal Dreipass spitz
N VII	Bordüren, Maßwerk	420×124	Dreipass spitz, Rankenornament (Abb. 51)
S VII	Bordüren, Maßwerk	420×124	Dreipass, Doppelschneuß
N VIII	Bordüren, Maßwerk	420×124	Fünfpass
S VIII	Bordüren, Maßwerk	420×124	3 mal Dreipass spitz
S IX	Bordüren, Maßwerk	420×124	Fünfpass
S X	Bordüren, Maßwerk	420×124	Dreierschneuß
wn II	Bordüren, Maßwerk	220×110	dreiteilige Fenster mit Nonnenköpfchen, 3 mal Vierpass
ws II	Bordüren, Maßwerk	220×110	dreiteilige Fenster mit Nonnenköpfchen, 3 mal Vierpass, (Abb. 52)
W I	Bordüren, Maßwerk	700×305	Vierbahniges Fenster, Blankverglasung, reiche Maßwerkmalerei, (Abb. 53)
WN II	Bordüren, Maßwerk	420×124	Dreipass
WS II	Bordüren, Maßwerk	420×124	Vierpass

Quellen: ZB Nachl. Röttinger 1.158

Thalwil, Evangelisch-Reformierte Pfarrkirche, 1860

CVMA	Ikonographie (Typus)	Maße in cm	Bemerkungen
n/a	Matthäus	–	Fensterfragment, (ehem. n II), deponiert im Ortsmuseum, (Abb. 20)
n/a	Evangelistensymbol des Markus, Löwe	–	Fensterfragment, «Alle Dinge sind möglich. Dem der da glaubt, Mk (10,42)», (ehem. n II, 2 b), deponiert im Ortsmuseum, (Abb. 21)
n/a	Bordüren	–	Fensterfragment, Blankverglasung, Rauten, Rankenornament, deponiert im Ortsmuseum

Quellen: KGA Thalwil IV.B.1.9 Protokolle 1858–1874

Unterägeri ZG, Katholische Pfarrkirche zur Hl. Familie, 1859

CVMA	Ikonographie (Typus)	Maße in cm	Bemerkungen
n/a	Markus (Ganzfigur)	–	Fenster deponiert im Pfarrarchiv
n/a	Matthäus (Ganzfigur)	–	Fenster deponiert im Pfarrarchiv
n/a	Jeremias (Ganzfigur)	–	Fenster deponiert im Pfarrarchiv
n/a	Jesaias (Ganzfigur)	–	Fenster deponiert im Pfarrarchiv
n/a	Wappen- und Einzelscheiben	–	«Bodmer, Brandenberg, Heinrich, Müller, Staub, Stadler, Unterägeri, Merz, Hugener, Seuz, Bossard, Nägeli, Häusler,

n/a	Signaturscheibe	–	Jäck, Trinkler, Schmid, Iten, Hess, Schlumberger, Düggeli, Suter»

Fenster deponiert im Pfarrarchiv, (Abb. 115)

Deponiert im Pfarrarchiv.

«Sämtliche Fenster dieser Kirche wurden verfertigt von
J. Röttinger Glasmaler Zürich 1860»

In den Randstücken steht geschrieben:

«An den Fenstern dieser Kirche haben gearbeitet: als Maler:
J. Röttinger v. Nürnberg, Königreich Bayern; J. Klaus, auch
von Nürnberg; […] vor allem Unglück gnädig behüten und
bewahren! Amen!» (Abb. 7, 8).

Rundscheibe als Bautafel:

Mitglieder der weiteren Kirchenbaukommission lt. Protokoll
(Foto)

1. Sr. Hochw. Hr. Pfarrer Alois Staub
2. Sr. Hochw. Hr. Caplan K. Jos. Trinkler
3. Hr. Nationalrath W. Henggeler, Zürich
4. Hr. Grossrath A. Henggeler, Baumeister, […]

Bei der Kirchenbaute betheiligte Personen, leitende und
führende

1. Herr Architekt Ferd. Stadler, v. Zürich
2. Hr. Grossrath A. Henggeler, Frohbühl, Baumeister
3. Hr. Hptm. Christ. Henggeler, Waldhof, Bauführer […]

Während des Baues wurde für ein Tagwerk bezahlt […];
(Maurer Zimmermann 2.50 Franken, Steinmetz, Schreiner
3.00 Franken, Erdarbeiter, Handlanger 2.00 Franken)

Der Bau wurde begonnen im Merz 1857, und vollendet
im October 1860. J. Röttinger, Glasmaler Zürich, 1860

Quellen: PA A8/85, A8/89

Utzenstorf BE, Evangelisch-Reformierte Pfarrkirche, 1873

CVMA	Ikonographie (Typus)	Maße in cm	Bemerkungen
I	Maßwerk	350×120	Vierpass (die Chorfenster und die beiden ersten Langhausfenster beinhalten alte Wappenscheiben)
n II	Maßwerk	350×120	Viererschneuß
s II	Maßwerk	350×120	Doppelschneuß
n III	Maßwerk	350×120	Dreipass
s III	Maßwerk	350×120	Dreierschneuß
n IV	Maßwerk	350×120	Fünfeckrosette im Maßwerk
s IV	Signatur	350×120	im Maßwerk: «Röttinger Glasmalerei Zürich 1873»
n V	Maßwerk	350×120	Doppelschneuß
s IV	Maßwerk	350×120	Dreierschneuß

Quellen: ZB Nachl. Röttinger 1.168

Villmergen AG, Katholische Pfarrkirche St. Peter und Paul, 1864

CVMA	Ikonographie (Typus)	Maße in cm	Bemerkungen
n III – n VIII	Maßwerk	480×180	
s III – s VI	Maßwerk	480×180	Vierpass im Langhaus vorherrschend

s VII	Maßwerk	480×180	Maßwerk auch in den Türoberlichtern
– s VIII	Maßwerk	480×180	Maßwerk auch in den Türoberlichtern
N IX	Ornamentfenster, Maßwerk (Rosette)	Ø 150	
S IX	Ornamentfenster, Maßwerk (Rosette)	Ø 150	
W I	Maßwerk, Signatur	ca. 550×250	Vierbahniges Fenster hinter der Orgel, «gemalt von J. Röttinger Zürich 1864»

Quellen: ZB Nachl. Röttinger 1.202

Wädenswil ZH, Evangelisch-Reformierte Pfarrkirche, 1862

CVMA	Ikonographie (Typus)	Maße in cm	Bemerkungen
I	Lehrender Christus (Zweidrittel Figur)	h=125	Ovalfenster, Beine beschnitten, (Abb. 83)
n II	Petrus (Ganzfigur)	400×125	Rundbogenfenster
s II	Paulus (Ganzfigur)	400×125	Rundbogenfenster
N II	Ornamentfenster (Ganze Fensterfläche)	h=125	Ovalfenster, Grisaille Tapetenmuster und Randverzierung
S II	Ornamentfenster (Ganze Fensterfläche)	h=125	Ovalfenster, Grisaille Tapetenmuster und Randverzierung

Quellen: ZB Nachl. Röttinger 1.185

Weiningen ZH, Evangelisch-Reformierte Pfarrkirche, 1860

CVMA	Ikonographie (Typus)	Maße in cm	Bemerkungen
I	Lehrender Christus (Ganzfigur)	150×50	Einfaches Maßwerk: Nonnenköpfchen, (Abb. 82)
s IV	Wappen- und Einzelscheiben	250×50	Segmentbogenfenster mit Inschrift über jedem Wappen: «H. Wolf, J. C. Kilchesperger, Hr. El. Cramer»
S II	Wappen- und Einzelscheiben	250×50	Weiningen

Quellen: ZB Nachl. Röttinger 1.204

Wigoltingen TG, Schloss Altenklingen, 1866

CVMA	Ikonographie (Typus)	Maße in cm	Bemerkungen
n/a	Randverzierungen	66.6×52.8	8 Flügel im Ahnensaal mit Randverzierungen. Bogenflügel in den Erkern.

Quellen: ZB Nachl. Röttinger 1.202.029

Wildhaus SG, Katholische Pfarrkirche, 1867–69

CVMA	Ikonographie (Typus)	Maße in cm	Bemerkungen
n II	Heilige (Medaillon)	450×93	«Karl Borromäus», «Erasmus» als Inschriften, je Medaillon auf Schriftband
n III	Heilige (Medaillon)	450×93	«Dionysius», «Pantaleon» als Inschriften, je Medaillon auf Schriftband
n IV	Heilige (Medaillon)	450×93	«Katharina», «Blasius» als Inschriften, je Medaillon auf Schriftband
n V	Heilige (Medaillon)	450×93	«Cyriacus», «Eustachius» als Inschriften, je Medaillon auf Schriftband

n VI	Heilige (Medaillon)	450×93	«Anna», «Antonius»
			als Inschriften, je Medaillon auf Schriftband
s II	Heilige (Medaillon)	450×93	«Nikolaus von Flüe», «St. Georg»
			als Inschriften, je Medaillon auf Schriftband
s III	Heilige (Medaillon)	450×93	«Achatius», «Ägydius»
			als Inschriften, je Medaillon auf Schriftband
s IV	Heilige (Medaillon)	450×93	«Vitus», «Christoph»
			als Inschriften, je Medaillon auf Schriftband
s V	Heilige (Medaillon)	450×93	«Margaretha», «Barbara»
			als Inschriften, je Medaillon auf Schriftband
s VI	Heilige (Medaillon)	450×93	«Gregorius», «Cecilia»
			als Inschriften, je Medaillon auf Schriftband
alle	Ornament (Bogenausmündung)	je 450×93	Segmentbogenfenster, Rahmenverzierung

Quellen: ZB Nachl. Röttinger 1.202

Würenlos ZH, Katholische Kirche Sta. Maria und St. Antonius (ehemals paritätisch), 1870

CVMA	Ikonographie (Typus)	Maße in cm	Bemerkungen
n/a	Antonius (Einzelscheibe)	20×20	Scheibe deponiert im Archivschrank des Pfarrhauses

Quellen: ZB Nachl. Röttinger 1.202.89

Zufikon AG, Katholische Pfarrkirche St. Martin, 1869

CVMA	Ikonographie (Typus)	Maße in cm	Bemerkungen
n II	Anna Maria unterweisend, Barbara (Ganzfigur), Magdalena (Medaillon)	570×138	«Magdalena Kaufmann von Zufikon Stifterin dieses Fensters. 1869.» (Sockelzone), Maße laut Skizzenbuch
s II	Joseph mit Kind, St. Martin (Ganzfigur), Franz Xaver (Medaillon), Signatur	570×138	«Xaver Kaufmann von Zufikon Stifterin dieses Fensters. 1869.» (Sockelzone)
			Signatur in der Randleiste des Sockelfeldes unten links: «Glasmalerei J. Röttinger», unten rechts: «Zürich 1869», Maße laut Skizzenbuch
W I	Christliche Symbole (Medaillon), Maßwerk	479×76	ZB Nachl. Röttinger, 1.202, S. 67, 2. in das mittlere Fenster der Heilige König «Kaspar», der einen Schild oder Schriftrolle hält mit den Namen der tit. Baukommission wie folgt: Mitglieder der Kirchenbaukommission in Zufikon:
			«Xav. Kaufman[sic!] geb. 1794
			Mart. Schuepp ” 1803
			Jos. Casp. Härli ” 1804
			Jos. Wertli ” 1804
			N[…] Kaufmann Präsit[sic!] 1816
			Jos. Lüthard gb 1818
			Kasp. Leonz Brunner 1822
			Jak: Brunner 1824
			Mart. Schuepp actuar 1827», «1866»
			Darüber eine Vierpass-Rosette Ø 68, von innen nicht sichtbar. Maße laut Skizzenbuch
WN II	Christliche Symbole (Medaillon), Maßwerk	421×78	Maria, Maße laut Skizzenbuch
WS II	Christliche Symbole (Medaillon), Maßwerk	423×77	«IHS», Maße laut Skizzenbuch

Quellen: ZB Nachl. Röttinger 1.202.17

Zug ZG, Katholische Kirche St. Oswald, 1866

CVMA	Ikonographie (Typus)	Maße in cm	Bemerkungen
n/a	Auferstandener Christus (Szene)	480×138	Deponiert in der Bauhütte , (ehem. I), (Abb. 36, 103)
n/a	Wappen- und Einzelscheiben, Maßwerk	480×138	Bossard, (ehem. I)
n/a	Heilige (Ganzfigur), Maßwerk	390×102	St. Michael, St. Oswald Deponiert in der Bauhütte (ehem. n II)
n/a	Heilige (Ganzfigur), Maßwerk, Signatur	390×102	St. Franziskus, St. Elisabeth Deponiert in der Bauhütte. «Gemalt von J. Röttinger, Zürich 1866» (ehem. s II 1b), (Abb. 42, 43)
n/a	Heilige (Medaillon), Wappen- und Einzelscheiben, Maßwerk	450×111	Eintrag im Skizzenbuch: «Fenster links» «Kaiser Heinrich, Johannes der Täufer, Bischof Konrad von Konstanz, Borromäus, Hl. Drei König Balthasar, Johannes Nepomuk, Bruder Klaus, Joseph» Wappen Frauenthal (im oberen Teil), deponiert in der Bauhütte (ehem. n III), (Abb. 150)
n/a	Heilige (Medaillon), Wappen- und Einzelscheiben, Maßwerk	450×111	Eintrag im Skizzenbuch: «dito rechts» «Katharina, Kaiserin Helena, Maria Magdalena, Anna mit Maria (im Skizzenbuch: Maria und Anna Mutter als eigenständige Darstellungen), Cäcilia, Agnes, Agatha» Deponiert in der Bauhütte (ehem. s III)
–	Maßwerk, Ornament	–	diverse Fragmente

Quellen: ZB Nachl. Röttinger 1.194, 1.202. 37; PA A3 206 (Zug, St. Michael, 1870–73); BA Λ14.20 Nr. 4, 7, 21, 24, 25; BA A39 Nr. 26, 75 S. 206

Zug ZG, Klosterkapelle Maria Opferung, 1866

CVMA	Ikonographie (Typus)	Maße in cm	Bemerkungen
n II	Christliche Symbole (Medaillons)	Ø 20	Herz Jesu (deponiert)
s II	Christliche Symbole (Medaillons)	Ø 20	Herz Mariens (versetzt; in neuerem Fenster [219×108])
s III	Christliche Symbole (Medaillons)	Ø 20	Auge Gottes (deponiert)
n IV	Christliche Symbole (Medaillons)	Ø 20	Heiliger Geist (deponiert)
n V	Christliche Symbole (Medaillons)	Ø 20	Lamm Gottes (versetzt; in neuerem Fenster [219×108])

Quellen: ZB Nachl. Röttinger 1.202

Zürich ZH, Grossmünster (Evangelisch-Reformiert) 1852/1853

CVMA	Ikonographie (Typus)	Maße in cm	Bemerkungen
n/a	Lehrender Christus (Ganzfigur)	916×125,5	Das Maß bezieht sich auf die Größe des heutigen Chorfensters I. Deponiert im Turm (ehemals I), (Abb. 33, 49, 151)
ws II	Petrus (Ganzfigur)	250×80	Seit 1933 versetzt in die Westfassade (ehemals n II). Die Maße beziehen sich auf die heutigen Westfenster (Originale beschnitten). Inschrift: «1853. Erstellung der Chorfenster durch J. J. Röttinger, Glasmaler Zürich», (Abb. 32, 151, 152)

| wn II | Paulus (Ganzfigur) | 250×80 | Seit 1933 versetzt in die Westfassade (ehemals s II). Die Maße beziehen sich auf die heutigen Westfenster (Originale beschnitten). Die Entwürfe der drei ehemaligen Chorfenster stammen von Glasmaler Georg Konrad Kellner, Nürnberg. Inschrift: «1933. Aus dem Chor an diese Stelle versetzt Heinrich Röttinger, Sohn Zürich», (Abb. 32, 151, 152) |

Quellen: ZB Nachl. Röttinger 1.198, 1.202; ZB Ms.T111.5: Actum 5.4.1852, Kommissionalbeschluß 16.6.1852

Zürich, St. Andrew, ehemalige Friedhofkapelle, Anglikanische Kirche, 1848

CVMA	Ikonographie (Typus)	Maße in cm	Bemerkungen
n III	Maßwerk	350×110	Bogenausmündung mit Dreipass; Signatur in Blankverglasung: «H. Röttinger 1915» (vermutlich Restaurierung und Anbringung einer ‹modernen› Bleiverglasung)
s III	Maßwerk	350×110	Bogenausmündung mit Doppelschneuß; ‹moderne› Bleiverglasung
n V	Ornamentfenster, Maßwerk,	350×110	Bogenausmündung: drei Granatäpfel, ganze Fläche Rautenornament
s IV	Ornamentfenster, Maßwerk als Türoblicht, Signatur	150×180	Signatur in der Mitte des Maßwerks: «IR RW» [Jakob Röttinger, R. Weiss]
s V	Ornamentfenster, Maßwerk, Signatur	350×110	Bogenausmündung mit Doppelschneuß, ganze Fläche Rautenornament; Signatur: «Architect FERD: STADLER. del.: J. RÖTTINGER u. R. WEISS Zürich 184[6 oder 8]»; vermutlich die ältesten erhaltenen Glasmalereien der Werkstatt Röttinger!
W I	Ornamentfenster, dreiteilig, Maßwerk	360(seitl.) 420(mittl.) ×430	Der mittlere Fensterteil überragt die beiden seitlichen; Ornament in rot-blau-weiß (Abb. 61)

Register

Orte

Namen-, Ikonographie- und Sachregister

Abkürzungen

ARCH = Architekt, Fa. = Firma, GL = Glaser, GLM = Glasmaler, M = Maler, PM = Porzellanmaler, ST = Stecher